EUROPEAN ART

YALE UNIVERSITY PRESS

New Haven and London

EUROPEAN ART

JOHN ONIANS

A NEUROARTHISTORY

Designed by Emily Lees
Printed in China

Library of Congress Cataloging-in-Publication Data

Names: Onians, John, 1942– author.
Title: European art : a neuroarthistory / John Onians.
Description: New Haven : Yale University Press, 2016.
Identifiers: LCCN 2015045225 | ISBN 9780300212792 (cl : alk. paper)
Subjects: LCSH: Art, European. | Neurosciences in art – History.
Classification: LCC N6750.O55 2016 | DDC 709.4 – dc23
LC record available at http://lccn.loc.gov/2015045225

A catalogue record for this book is available from the British Library

Alec, Ishtar and Oliver

contents

acknowledgements

Since one theme of this book is the way an artist's mature productions can be influenced by early experiences, I too must acknowledge hidden debts I never would have recognised before. Neuroscience has made me aware that when I stand today in front of a work of art my responses may involve the activation of networks formed decades ago, even when I was a child. It has also made me conscious that my observations on the responses of others that are contained in this book are the product of myriad neural connections formed and reformed during a lifetime of contacts with objects and people in many settings.

This process is obscure but palpable, as in the case of my encounter with the Robert and Lisa Sainsbury Collection. When I first looked at these objects from all over the world, I possessed few networks equipped to place them geographically and historically, still less re-insert them in the human context out of which they emerged, whether that was constituted by Bob and Lisa's aesthetic appetites or the beliefs and practices of those who made and first used them. Only with time and repeated exposure to the new material did my brain spontaneously develop the new resources needed to engage with it, resources that were then available to me in my contact with other works.

The debts associated with this obscure unconscious process are hard to calculate. Much easier to compute are those that are owed to more conscious activities, the reading of books and articles, listening to lectures and conference papers. These gave me access to the minds of the authors and speakers from whom they emanated, and ultimately to those individual authors' and speakers' personal neural resources, which we can now begin to reconstruct, shaped as they were by their own cumulative experiences of peoples and environments.

In my own case I owe the most to those individuals with whom I have had the most intense discussions over the last twenty-five years, especially colleagues and students in the School of World Art Studies at the University of East Anglia,

the other Fellows at the Wissenschaftskolleg Berlin in 1994–5 and at the Clark Art Institute in 2003, the other Scholars at the Getty Research Institute in 2008–9 and the members of the community at the Institut National pour l'Histoire de l'Art, Paris, where I was Chercheur Invité in 2012. Particularly rewarding were the discussions with the students who took my courses on Neuroarthistory when a Visiting Professor at the University of Leiden in 2002 and a William Evans Fellow, University of Otago, New Zealand, in 2005, with the participants in the 'Neuroaesthetics' conference at Goldsmiths, University of London, in 2005, in the 'Art History and Neuroscience' panel at the 2008 College Art Association (CAA) annual conference in Dallas, the 2009 Copenhagen Neuroaesthetics conference, and the Summer Institute in Cognitive Science and the Humanities at the Stanford Center for Advanced Study in the Behavioral Sciences in 2011, the first conference on Neuroarthistory at Torun, Poland, and the Summer School in Neuroarthistory at the University of East Anglia, both in 2013, as well as with Carl Schoonover during a public interview at the 2012 CAA in New York.

For sharpening my awareness of issues in neuroscience I owe most to conversations with leading specialists, first with Colin Blakemore in 1976 and more recently with Semir Zeki, Steve Kosslyn and Adam Zeman, as well as with Kalanit Grill-Spector of Stanford University, Michael Arbib of the University of Southern California, Alain Berthoz of the Collège de France, Keiji Tanaka of the Riken Institute, Tokyo, and, most recently, the Nobel Laureate Eric Kandel, who has himself provided one of the most penetrating explorations of the neural basis of artistic activity in his *The Age of Insight* (2012). For many opportunities to test the applicability of neuroscience to art history in lecture and argument my warmest thanks go to my colleagues at the University of East Anglia, Richard Cocke, Simon Dell, Sandy Heslop, Steve Hooper, Ferdinand de Jong, George Lau, John Mitchell, Sarah Monks, Stefan Muthesius, David Peters-Corbett, Joanne Pillsbury, Cesare Poppi, Margit Thøfner and Bronwen Wilson, and to the intellectually courageous graduate students, Helen Anderson, Kajsa Berg, Lauren Golden and Laura Williams. Elsewhere, particularly memorable were conversations, sometimes confrontations, with Emmanuel Adeyefa-Olasupo, Hans Belting, Paul Binski, Horst Bredekamp, Andrea Buddensieg, Yiqiang Cao, Alessandro Celani, Michael Conforti, Todd Cronan, Wilfried van Damme, Whitney Davis, Ellen Dissenayake, Eric Fernie, David Freedberg, Barbara Gaehtgens, Thomas Gaehtgens, Daniela Gallo, Ivan Gaskell, Derek Gillman, Yaël Gillman, Richard Gordon, Mark Haxthausen, David Hemsoll, Martin Henig, Michael Ann Holly, Thomas da Costa Kaufmann, Lukasz Kediora, Richard Kendall, David Kunzle, Harry Mallgrave, Dominic Marner, Keith Moxey, Kasia Muravska-Muthesius, Alva Noë, Elizabeth Pilliod, Alex Potts, Marty Powers, Denis Proffitt, François Quiviger, Philippe Sénéchal, Darius Sikorski, Michael Squires, Barbara Stafford, Brian Stock, David Summers, Raymond Tallis, Jeremy Tanner, Paul Taylor, John Varriano, Wendy Watson, Peter Weibel, Lauren Weingarden, Mariët Westermann, Erika Wolf, the late Richard Wollheim and Kitty Zijlmans.

Most inspiring was the opportunity to learn daily from Elisabeth de Bièvre's studies of the role of exposure to the natural, material and social environment in shaping Dutch art, as exemplified in her *Dutch Art and Urban Cultures, 1200–1700* (2015). Her insights often guided me in the development of this neuroarthistory.

Finally, I owe particular debts to those whose skills have contributed so much to the refinement of this book. These include, in the field of illustration, the dexterity of hand and eye of Nick Warr from UEA's Department of Art History and World Art Studies and the resourceful sleuthing of the picture researchers, Elizabeth Savage and Charles Campbell-Jones, and, in terms of text, the acuteness of mind and attention to detail of Katharine Ridler as editor. For the originality and beauty of the finished volume I owe everything to the imagination and visual sensitivity of its designer, Emily Lees. One debt, though, transcends all others, and that is the one I owe, for the third time in twenty years, to the Publisher at Yale, London, Gillian Malpass. From the first moment I mentioned to her this project that some at the time thought questionable not only did she courageously and enthusiastically support it, but by her comments and questions during many meetings ensured that it eventually met her exacting intellectual standards, standards that, like those she has set in the aesthetic domain, have long been the ones to which other publishers of art books aspire.

preface

This book is about something we are all aware of but which, until now, has been difficult to study. We all know that we do things without understanding exactly why. We also know that when we give reasons for our actions they frequently are not the real ones. Often they tell less about ourselves than what our listener would like to hear. This phenomenon is especially obvious in the field of art, as I discovered fifty years ago. Writing a doctoral thesis on the theory and practice of Renaissance architecture, I was disturbed to find that the choices of columnar orders that architects made for real buildings often did not match the recommendations in their written theories.[1] The theories, it became clear, were composed to be attractive to readers and potential patrons, making use of frameworks developed in such established fields as ethics, music and rhetoric. The choices of orders in practice, though, seemed to relate more to expectations of how people would react to buildings purely unconsciously.

To understand the history of built architecture, it seemed, one needed an understanding of the principles governing unconscious visual response. At that stage there was no tool providing access to those principles.

In the following decades I realised that there were many other phenomena in the history of art, such as broad changes in style, that could not be fully explained using available tools. Other scholars felt the same way. Some saw a solution to their problems in a better understanding of human physical makeup. My supervisor, E. H. Gombrich, had long been interested in the unconscious processes involved in perception, and in the preface to the second edition of his study of ornament, *The Sense of Order* (1984), made the general statement that it was written 'to establish and test the theory that there exists a Sense of Order which manifests itself in all styles of design and which I believe to be rooted in man's biological inheritance'.[2] Michael Baxandall, another of his

1

pupils, had already gone further in his *Painting and Experience in Fifteenth Century Italy* (1972). Explaining his revolutionary concept of the 'Period Eye' in neural terms, he noted that because 'each of us has had different experience . . . each of us . . . processes the data from the eye with different equipment'.[3] Soon I was moving in the same direction. Inspired by Colin Blakemore's 1976 BBC Reith Lectures on the brain, I began to feel that neuroscience might be useful for art historians and I went to meet him to discuss the possibility. Already in 1978 I was using my small knowledge of 'neurons' in an article on 'The Origins of Art',[4] and in 1988, in the introduction to *Bearers of Meaning*, the book based on my thesis, in my explanation of the unconscious responses that had puzzled me for so long I invoked the role of 'neurons in the visual cortex'.[5]

It was, however, only in 1992 that I set out to turn what was only a hunch into a tool. What provoked me was a belated response to the arrival at the University of East Anglia in 1978 of the gift of the Robert and Lisa Sainsbury Collection, with its extraordinary range of art from all over the world, from prehistory to the present. Conscious that the discipline of art history had little to say about many of the works on display, I suggested to my colleagues that we should acknowledge the challenge it posed by changing the name of our department from Art History to World Art Studies. This, I said, implied not just having specialists in the art of different areas of the world, as did departments in North America, but addressing the big questions no one was asking, such as 'why do humans make art?' and 'why do they do it differently at different times and in different places?' What I dreamed of was a framework for the study of variation in the artistic domain that had something of the coherence of those which Darwin had proposed first for the study of formal variation in the animal world in *The Origin of Species* (1859) and then for variation in behaviour in *The Expression of the Emotions in Man and Animals* (1872).

Darwin realised that variation in behaviour was largely influenced by the nervous system and I followed him. Recognising that elaborate art-making is found only in *Homo sapiens sapiens*, the species which, by 30,000 BC, had replaced all earlier human types, and aware that the species was distinguished above all by its new neural resources, I took an 'in principle' decision to immerse myself in the study of neuroscience. It was only luck that the decision was perfectly timed, since this was precisely the moment when new technologies, such as functional Magnetic Resonance Imaging (fMRI), were about to transform our understanding of the brain's structure and organisation.

For the next twenty odd years I was going to be on a roller-coaster of discoveries and revisions, constantly shifting my attention from one area or property of the brain to another, in a restless search for knowledge that might be helpful to me and might convince other art historians that neuroscience could aid them too. The search led me, early on, to a property of neurons that seemed to be potentially of great importance. This was their 'plasticity', that is the way the connections within neural networks are strengthened or weakened depending on how much we use them. D. H. Hubel and T. N. Wiesel, who had first identified banks of neurons in the mammalian visual cortex that respond to lines of different orientation, went on to discover that differential exposure to any one of these lines strengthened the preference for looking at it.[6] These and later findings encouraged me to formulate tentatively a general principle that might be applied to the art of all places and periods. This was that, if one knew what an artist had been looking at with sufficient frequency and/or intensity to cause changes in their neural networks that were salient enough to affect their visual preferences, then one might be able to infer how those particular networks would have guided the artist's hand.

One of the ways I wanted to test the usefulness of my hypothesis was by applying it to the explanation of some of the major innovations in the history of art which I felt were not fully explained by existing approaches. One such innovation was the Greek temple, and I had already proposed that many of its distinctive new attributes were the product of their designers' and patrons' intense visual interest in the configuration on which their survival and wellbeing most depended, the phalanx of armed warriors. I was happy with my suggestion, but realised that others might view it in the same way Gombrich used to view the first drafts of the chapters of my thesis. His first response was often to say: 'That is just an aperçu', a reaction that sent me back to rethink and rewrite until he and I both felt that I had turned

the aperçu into something more like a demonstration. How was I to do this in what was effectively a new field, in which no one yet knew what a demonstration would look like? Obviously, I could not scan the brains of ancient Greeks for evidence for my claim. Nor could I ask them whether they agreed with it. What I needed was an analogous explanation of a more recent innovation, one that, if I was lucky, I might test on a living artist.

One of the other major innovations that I felt was not yet fully explained was the emergence in the United States in the 1950s of a new type of Abstract Expressionist painting in which a large rectangle was covered with a more or less monotonous and often monochromatic layer of pigment. I had in mind the art of Jasper Johns, Barnett Newman, Mark Rothko and others. Was there something at which these artists might have looked with such frequency and intensity that it would have caused them to develop neural resources that could have contributed to their producing works that shared these qualities? The best answer that I could come up with was images of the Dustbowl, the 1930s disaster in which large areas of the American 'breadbasket' prairies turned to infertile powder. These were familiar to me from my school textbooks of the 1950s and they would certainly have been known to the artists in whom I was interested, albeit to different degrees, depending on their age and home background.

I never expected to be able to try out my suggestion on any of the artists involved, but that is exactly what I had the opportunity to do a few years later, when I found myself at a small dinner party in Manhattan sitting next to Jasper Johns. Because the host was one of the wealthiest men in America and among the other guests were the architect Philip Johnson and the painter Roy Lichtenstein, Johns took me more seriously than he otherwise might. Expoiting this situation, towards the end of the meal, I told him I had been developing a general explanation for some of the features that distinguished his art and that of his contemporaries and asked if I might run it past him. He said, 'Sure.' I did and, although his reaction was not exactly what I was after, in many ways it was even better. What he said, more or less, was: 'I can't speak for the others but in my case you may be on to something. You see I come from South Carolina farming stock and one of my most vivid memories as a child is of my

uncle driving me out one spring to show me his land. When we arrived he pointed at the different fields, which were still all virtually empty, and said: "Jasper, that'n's going to be good, that'n aint, and that'n I'm not sure about." That experience was certainly important for me.' His response is not a demonstration of my argument, which, in any case, assumes that artists are unlikely to be aware of the way their experiences have influenced their art. Still, I felt that Gombrich would have seen it as providing my aperçu with strong support.

Johns's response was particularly useful because it enabled me to dispose of Gombrich's typical final challenge to an improved chapter draft. This was: 'So what!', his way of indicating that he acknowledged my demonstration, but wanted to know what its implications were. Jasper Johns's story brings these out by recapturing the tensions associated with a period when the combination of Dustbowl and Depression raised spectres of disease and death, causing all farmers to look at their fields with new anxieties. It was these visceral anxieties that Johns's uncle had transmitted to him and which he then came to share when he looked at anything field-like. A neural approach had something new and important to add to art history. It could take us down past such familiar factors as an artist's formal concerns, political ideology, social preoccupations or personal affinities to the artist's deeper emotions, the hidden source of his or her inspiration. Standing before a blank canvas in his Manhattan studio in the 1950s, Johns felt unconsciously the hopes and fears of his farmer uncle at the time of the Dustbowl. As he mixed pigments and applied them to the barren surface, the emotional neurochemistry that drove the linkages between his eye and his hand was at least in part that of someone engaged in a struggle for life and death. He may have been more affected by a memory of the Dustbowl than others of his American contemporaries, but I suspect that in the case of all of them the fear with which it was associated, a fear that I later learned might have been associated with the production of noradrenaline in the amygdala, added a vital dimension to their art's distinctive power. Importantly too, the people who bought those paintings would have shared a similar exposure to Dustbowl imagery, and would unconsciously have shared a similar sensitivity to large featureless rectangles. Johns taught me how to answer the 'So what!'

challenge in relation to a neural approach. What he demonstrated was how neuroscience could bring out the importance of areas of experience often disregarded by both artists and art historians, the visceral and the emotional.

By 2000 I was increasingly confident that a knowledge of neuroscience could indeed contribute to the answering of art-historical questions. I was also finding support in the work of prominent neuroscientists. Already in 1994 Jean-Pierre Changeux had written an article on 'Art and Neuroscience'[7] and soon he was joined by others. In 1999 Vilanayur Ramachandran, with William Hirstein, wrote an article on 'The Science of Art: A Neurological Theory of Aesthetic Experience'[8] and Semir Zeki published a major book, *Inner Vision: An Exploration of Art and the Brain*.[9] Zeki was also then launching a new field, neuroaesthetics, and discussions with him in London, as well as attendance at meetings of his Institute for Neuroesthetics in Berkeley, California, provided further encouragement.

This was badly needed, because, to my continued astonishment, at just the time that Gombrich, Baxandall and I were turning to biology because it seemed an obvious way forward, many others in the field were turning their backs on it. Taking their cue from theories as diverse as Marxist economics, Freudian psychoanalysis and Saussurean linguistics, they looked instead to such approaches as Semiotics, Post-Structuralism and Critical Theory. Some even launched direct attacks on those who invoked non-conscious neural reactions. Norman Bryson, for instance, told us in *Vision in Painting* (1983) that he wrote it to prove that Gombrich's view that painting is a 'record of perception' and 'a mode of cognition' is 'fundamentally wrong'. What puzzled me most about this rejection of the biological was that many of the new notions, such as 'discourse', 'the unconscious', 'intertextuality', and 'embodiment', could all find sustenance in the new neuroscience. Indeed, it was becoming increasingly clear that the whole phenomenon of 'social construction', the key concept of the new theorists, could be shown to depend on processes that were ultimately neurological. If all our experiences are mediated, as they rightly pointed out, they are mediated first by our nervous system.

Fortunately, though, this front hostile to considering any role of nature in culture was already collapsing. The turn was led by the 'Post-Modern' Gilles Deleuze, who in 1984 clearly stated the superiority of neuroscience as a foundation for theory: 'It's not to psychoanalysis or linguistics but to the biology of the brain that we should look for principles, because it doesn't have the drawback, like the other two disciplines, of drawing on ready-made concepts'.[10] By 2001 W. J. T. Mitchell, one of the founders of the field of visual culture, was moving in the same direction. For him what was now needed was a study not of the 'social construction of the visual field' but of '*the visual construction of the social field*' (his emphasis). As he pointed out: 'It is not just that we see the way we do because we are social animals, but also that our social arrangements take the form they do because we are seeing animals'.[11] By 2003 even Bryson had freed himself from the constraining bewitchment of 'theory' and recognised the liberating and life-enhancing appeal of the new knowledge. The 'radicalism' of neuroscience, he pointed out, 'consists in its bracketing out the signifier as the force that binds the world together: what makes the apple is not the signifier "apple" . . . but rather the simultaneous firing of axons and neurons within cellular and organic life.'[12] This vital new world he contrasted with the poverty of Post-Structuralism in which 'Feeling, emotion, intuition, sensation – the creatural life of the body and of embodied experience – tend to fall away, their place taken by an essentially *clerical* outlook that centers on the written text.'[13] Bryson's characterisation of Post-Structuralism as 'clerical', like Deleuze's jibe about the 'ready-made concepts' of psychoanalysis and linguistics, was damning.

As the tide turned in favour of the use of neuroscience as an aid to the study of artistic activity, it became increasingly clear that such study had two widely different dimensions, the neuroaesthetic and the neuroarthistorical. Each showed how an existing field could be advanced and extended by the use of new knowledge of the brain. Neuroaesthetics generated new answers to the old questions of philosophical aesthetics regarding universals. It also reframed them, redefining beauty in terms that were not only philosophical but also physiological. Similarly, neuroarthistory did not just provide a new tool with which to find answers to traditional art-historical questions, it made it possible to answer new and larger ones. Besides helping art historians in the study of

individual artists, styles and traditions, it also allowed them to seek answers to such questions as 'why do humans make art at all?' and 'why do they make and engage with it in different ways in different times and places?'

It was a small step to recognise that there had been many earlier writers on art, including such founders of the discipline of art history as Winckelmann and Wölfflin, who had long ago used what they knew of the brain to move in a similar direction, and it was a survey of their contributions that I presented in *Neuroarthistory: From Aristotle and Pliny to Baxandall and Zeki* (2007). Such earlier writers were now joined by two powerful voices from the contemporary art-historical community, those of David Freedberg and Barbara Stafford, both of whom published important texts in that same year.[14] Soon, too, wider institutional support for the project emerged. In 2011 the cognitive scientist Steve Kosslyn invited me to join him and Ann Harrington, the Harvard historian of science, as co-organisers of a two-week Summer Institute in 'Cognitive Science/Neuroscience and the Humanities', held at the Stanford Center for Advanced Study in the Behavioral Sciences and funded by the Mellon Foundation, and in 2014 the neuroscientist Adam Zeman involved me in 'The Eye's Mind', a research project on the neuroscience of the imagination and its relevance to the humanities, funded by the British Arts and Humanities Research Council.

All this support helped to convince me that the time was right to fulfil the promise made in *Neuroarthistory*, to publish a second volume applying a 'neuroarthistorical approach to the art of Europe'.[15] This concentration on Europe may seem surprising, considering that the approach was originally conceived as a way of dealing with art as a worldwide phenomenon. It is motivated by two considerations. One is essential, the other contingent and personal. The essential reason is that, due in large part to Europe's economic and political power, the literature on European art's conscious background is richer than that on any other area of the globe, and consequently presents the most demanding standard against which to evaluate the merits of an approach that foregrounds non-conscious influences. The more personal reason is that, although I have travelled widely in every continent, European art is simply more familiar to me, making it much easier for me to test my individual interpretations against cases where analogous relations between context and culture, or more specifically, between neural formation and art, might be found. The assumption on which the whole project is based, the notion that the principles of neuroscience are relevant to the study of all the art produced and responded to by the brain of *Homo sapiens sapiens*, wherever and whenever it might be found, remains fundamental to the enterprise. This is why, in the final volume of the promised trilogy, I plan to apply a neuroarthistorical approach, as I started to do in the Introduction to the *Atlas of World Art* (2004), equally to all areas of the globe, with Europe treated alongside Africa, the Americas, Asia, and Australia.

introduction

Neuroarthistory is not a new project. As an approach that assumes some correlation between the mental and physical make-up of human beings and their art-related behaviours it has been around for thousands of years, ever since people anywhere in the world felt that those who made or responded to art were moved by 'spirits'. In literate cultures it is implicit in early texts. On the banks of the Nile it could be said to go back to the Edwin Smith papyrus of 1500 BC, which records the behavioural consequences of brain damage, while in Mesopotamia at the same period people were noting the consequences of strokes and epilepsy. Further east in Asia it goes back almost as far, to the first accounts of the relationships of body, mind and behaviour in the literatures of China and India. In Greece it goes back at least to Aristotle. Everywhere people sensed that there was an internal physical dimension to their relationship with art. Outside Europe they often felt that the whole body was involved. In the European tradition they concentrated more on the role of the brain, especially after they had learned from the eleventh-century Arab scholar, Ibn Al-Haytham (Alhazen), how that organ served the eye. It was out of this tradition that came such neuroarthistorical writers as Winckelmann and Ruskin, Wölfflin and Warburg, Gombrich and Baxandall. Their knowledge of the brain was, however, fragmentary, and their appreciation of its relation to the body incomplete. Only since 1990 can we talk of an integrated understanding of the brain's anatomy and its function in the service of the body. It is this understanding that allows neuroarthistory to come of age as a comprehensive approach. Coming of age does not mean attaining maturity, and it is important not to overstate what can be achieved in this phase of the field's development. Still, that development will be more productive if we begin to test its procedures and explore its limits. To do that we need to

6

outline the provisional new knowledge of the brain and the current understanding of its functions.

First, though, we should be aware of the basis for such knowledge and understanding in new technologies such as PET (Positron Emission Tomography), MEG (Magnetoencephalography), TMS (Transcranial Magnetic Stimulation) and fMRI (functional Magnetic Resonance Imaging). The most important of these is fMRI, which makes it possible to track the movement of oxygenated blood to different areas of the brain as it is required to provide the energy for different neural activities. Its potential impact can be appreciated by considering these fMRI scans of the brains of an artist, Humphrey Ocean, and a non-artist doing the same thing, copying a face (fig. 1).[1] Before this experiment, conducted at Stanford in 1998 by Robert Solso as part of the Wellcome Foundation's Sciart programme, it would have been difficult to analyse the difference in the mental activity of these two individuals. On the scans these stand out clearly and reveal a surprising contrast. It is not in the artist that the visual cortex at the back of the brain is most active, but in that of the non-artist. The scans also reveal, by what they tell us of activity elsewhere in the brain, why this is so. Evidently, while the visual cortex of the non-artist is trying hard to build up some basic knowledge on which his drawing might be based, that of the artist can immediately feed the information received from the eye forward to other areas, which have already been involved in a similar task. These include the sensory and motor areas in the centre where the movements of pencil or brush involved in their capture have been controlled, and the areas at the front where all our activities are planned and monitored. The scans thus tell us things about the mental activity associated with art-making that we could never otherwise have known. They also tell us things about mental activity generally, because what is true of the artist is true of all of us all the time. Everything we do, we do using neural resources built up by what we have done before. The greater the time and effort we spend on any activity the greater the impact on our brains.

These brain scans reveal not just things about the neural basis of high-level mental activity. They also reveal their own limitations. The information provided by fMRI scans is so coarse-grained as to tell us almost nothing of the

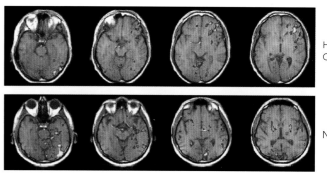

Humphrey Ocean

Novice

1 Two series of brain scans, of an artist (Humphrey Ocean) and of a non-artist, performing the same task of drawing a portrait, showing activity concentrated in the visual area of the non-artist and distributed further forward in the artist. Sciart project, 1998, Wellcome Trust

detailed neural activity on which the making, viewing, commissioning or using of art depends. Neuroarthistory, then, unlike neuroaesthetics, cannot be founded on brain scans. Brain scans help with neuroaesthetics because its core concerns relate to universals, and typically involve asking questions about the localisations of different types of response. These are questions that analysis of a brain scan can answer directly. The core problems of neuroarthistory, by contrast, concern individuals, typically involving asking questions about the preferences and the actions both mental and physical, of particular artists, patrons or viewers as they change in time, and these are questions that at present no amount of analysis of a brain scan can answer – even supposing we were in the unlikely position of being able to put the relevant individual in a scanner. The brain scans of Humphrey Ocean yield little insight into his preferences or his actions. Their importance is above all that, when juxtaposed with scans of a non-artist, they allow us to infer that the neural resources that support his preferences and actions have been built up by his previous history. It is this process that the neuroarthistorian needs to understand. That means understanding the general principles of neural formation, first in the species and then in the individual.

The Brain and Nervous System: Evolution and Function

To understand the formation of the human brain we first have to understand why we have one in the first place. This is best illustrated by considering why animals have brains and plants do not. The reason is simple. A plant, unlike an animal, can survive and transmit its genetic material without moving. Plants do not need brains. Animals do. The significance of this distinction can be brought out by considering the sea squirt. This organism begins life as an animal swimming around the oceans until it finds a spot where it can attach itself, obtain nutrients and reproduce. At this point, no longer needing a brain, it consumes it; which is why it has been unkindly compared to some professors when they get tenure.

All animals, then, need brains and in each species its distinctive properties are the result of millions of years of evolution, the product of a process that began with single-cell organisms in the primordial ooze. The principles governing evolution ensure that for each creature the prime, though certainly not the sole, criterion for the establishment of the properties coded for in its DNA is that they contribute to the transmission of its genetic material. This includes the properties of its brain. Reptiles, early in the evolutionary line, have simpler brains because that is all they need. Later creatures, such as mammals, lead more complicated lives and so need more complex brains. Of the mammals, dolphins and primates have the richest neural resources. The brain of *Homo sapiens sapiens*, the species to which we belong and which emerged only about 100,000 years ago, is the most intricate. As with other creatures, our brains have always served our viscera, the organs essential for our day-to-day survival, helping us with such tasks as the search for food and the avoidance of poisons, the finding and keeping of friends, the detection and deterrence of enemies, the finding and keeping of a mate, and the successful rearing of children, all activities that contribute to the eventual transmission of our genetic material. It was because there were so many threats to that transmission due to the length of time it takes our species to attain adulthood, and because of our physical vulnerability even when fully grown, that our brain acquired its extraordinary complexity, endowing us with properties that decisively distinguish us from other species. Plato taught us to think of these properties as coming from the gods and later Europeans persisted in that flattering view until Darwin showed that they are only refinements on those we inherited from our animal ancestors.

The history of how that inheritance was slowly built up is evident in our brain's structure. Our most remarkable resources are located in its outer layer, the cortex, which, as its surface area increased to help our ancestors deal with more and more difficult tasks, acquired more and more convolutions. In a smooth form the cortex was already present in early mammals, and they also shared the limbic system underneath, containing organs such as the amygdala, crucial for the processing and memory of emotions, the hippocampus vital for other types of memory and the insula which plays an important role in the experience of pain, as well as the striatum crucial for reward. Both cortex and limbic system follow promptings coming from the inner and lower parts in the brain stem, including the mid-brain, which we share with reptiles, and which more directly serve our viscera.

Grasping the overall structure of the brain is one thing. It is much harder to understand the detail of the neural organisation necessary to support its principal activities, the processing of all the information coming in from our senses and the generation of the most appropriate motor response. The level of complexity is staggering, but we can at least now describe it in general terms. Evolution has ensured that the DNA we inherit from our ancestors provides us at birth with about a hundred billion neurons. It also ensures that each of those neurons has on average seven thousand connections with other neurons, and that communication between them is both electrical and chemical. In a typical neuron, communications come in through a multitude of dendritic connections at one end and leave by a simpler axon at the other (fig. 2). So much has been known for decades, but this already complex picture now needs considerable elaboration.

The big revelation of recent years is that this organisation is not constant. Thus, while it used to be thought that the brain each of us is born with remains the same throughout our life, it is now known that it is constantly changing. The transformation is particularly rapid in childhood, but it continues to varying degrees until our death. This is because

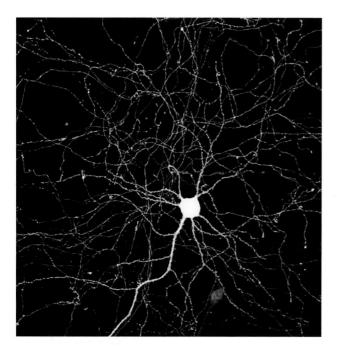

2 Neuron from the hippocampus

the connections between our neurons tend either to multiply or die back, and to become better or less well insulated, depending on how frequently and intensively they are used. We cannot yet monitor this process in detail, but the principles by which it is regulated are clear.

Everything we do requires us to use a particular set of neural connections. Sometimes these are thought of in terms of 'networks', in order to bring out the main lines of communication involved; sometimes, in order to bring out their distributed nature, they are thought of as 'maps'. At other times, in order to bring out some inferred aspect of their organisation, we can talk of 'groupings' or 'layers' or just of specific 'neural resources'. Whichever metaphor we use, the important thing is that the expansion and contraction of these networks is governed by general principles. The more we use a particular network, the more the connections involved will strengthen, most often through the growth of dendrites and the thickening of their fatty insulation, or myelination, with the result that the more often we do something the more likely we are to do it better the next time. Similarly, because the brain is a highly expensive organ to maintain in terms of energy consumption, if we do something less, the

connections involved will weaken and the insulation reduce. This crucial attribute of neural modifiability is known as 'plasticity'. It applies to the neural resources supporting everything we do, whether we are having a sensory experience or making a movement, feeling or thinking, remembering or planning. It is to this property that we owe the regular enhancement and impairment of our capacities that alternately delight and depress us throughout our lives.

The Brain

Plasticity

This plasticity was crucial in enabling members of the new species, *Homo sapiens sapiens*, to leave the tropical African landscape to which they were first adapted and spread over most of the planet, adapting even to a Europe then half-covered by an ice sheet. The plasticity coded for in their DNA ensured that wherever they lived human individuals acquired networks adapted to their survival in that particular ecology. Capacities for conscious reflection and for socialisation, which were also coded for in their DNA, played a part in this process, but both were the more effective because they drew on resources that had been shaped by a process of constant adjustment to the environment that was both automatic and unconscious.

No generation has benefited more from this plasticity than ours. In a world that is more fast-changing than ever, neural plasticity ensures that each of us becomes adapted to survive in our particular social and material environment. Such plasticity presents itself most strikingly when we observe a younger generation, with no training and little effort, easily surpass us in the acquisition of the motor and cognitive skills needed to master a Smartphone. But we get the best sense of the measured process by which our neural networks form slowly in response to use when we remember the painful process of learning a new language or a new musical instrument. The progressive improvement in our competences precisely tracks the increase in the number of the neural connections and the improvement in their insulation. Such growth may result in the actual enlargement of the areas involved, as can now be seen by comparing

the volumes of the brain's sensorimotor areas serving the left hand of a normal right-handed person and of a highly trained violinist.[2]

The neural correlates of sensory and motor activity are easy to establish, because each is located in a distinct area of the brain. Those of what we call 'intellectual' activity are much more difficult to identify because such activity is highly distributed, but the similarly slow process by which we absorb a new idea or theory demonstrates that in this field too speed of mastery is constrained by the laws of neuroscience.

We cannot yet, and may never be able to, observe the process of subtle connection-forming that is the neural correlate of the absorption of an idea, but we can observe a simple parallel to it in an experiment with mice who were learning a new movement.[3] Astonishingly, in all the mice involved some neural growth in the relevant area of the brain was observed within an hour of initiating the task. That was a consequence of their just attempting it. Then, over the following days it became clear that the neural reaction was not uniform. In some individuals the growth died back and they never acquired the necessary skill. Only in some did it stabilise, allowing them to complete the movement. With mice, as with children in a classroom, success at a task depends on the degree of attention with which it is performed, because that is what causes the neural growth required. Even in adult humans, the neural connections that sustain each of our activities, whether mental or physical, are liable to form or fall away throughout our lives depending on the frequency and the degree of attention with which the activity is repeated.

One of the best illustrations of both gain and loss at a neural level in a purely mental domain is provided by London taxi drivers. Brain scans have repeatedly shown that those who have thoroughly learnt the city's geography are distinguished by an increase in the mass of the posterior hippocampus, an area essential for spatial memory. Now a recent experiment has shown that the increase in the mass of the posterior hippocampus – which is probably due not only to the addition of new dendritic connections to existing neurons and to an increase in the insulation of those neurons but also to the growth of new neurons – was directly correlated with success in the necessary two- or three-year training in the so-called 'knowledge'.[4] Those who abandoned the training or were not diligent at it did not experience the enlargement and, if they took the test, failed it. The same experiment also showed how a gain in one area may be offset by a loss in another. Those who passed the 'knowledge' test turned out to be less good than they had been at remembering complex visual shapes, a skill for which the anterior hippocampus is probably vital. Perhaps the average driver retains a good visual memory because he or she navigates by recognising landmarks. A trained taxi driver can rely on spatial memory and this may allow some atrophy of the visual memory.

The Reward System

Essential to the learning both of the mice and of the taxi drivers, not to mention the reader of this Introduction, is the brain's reward system, in which the neurochemical dopamine plays an important part. Dopamine is produced in the mid-brain and its absorption in an area towards the front of the brain, the striatum, and especially the area of the ventral, or lower, striatum known as the nucleus accumbens, is associated with a sense of pleasure or reward. Dopamine is known also to aid the formation of memories in the hippocampus, and to help in the formation of motor memories, certainly in rats and probably in humans.[5] Given that the main purpose of the brain is to help us to survive, it is not surprising that it is adapted not only to reward us when we have an experience or make a movement that is beneficial to us, but also to consolidate the neural resources involved, endowments that are particularly relevant in the context of access to those resources most vital to our survival.

This applies particularly to the adult, but when we are young and inexperienced we depend on guidance from others. In those circumstances much depends on trust, an attitude controlled by another area of the striatum. The dorsal, or upper, striatum is thus able to provide a neurochemical reward that involves dopamine and/or oxytocin reinforcing recommendations from a source in which we have confidence. This is why it is a key centre for the placebo effect, that is, when a medecine that contains no healing agent reduces the symptoms of a disease purely because the patient has been told it will. The dorsal striatum is also a

key centre for interpersonal relations, confidence in which field is associated particularly with a sub-area known as the caudate nucleus. This is borne out by experiments at Aarhus in Denmark showing that it is also activated when a believing Christian addresses God using the Lord's Prayer. It is thus likely that addressing God as 'Our Father' activates the neural resources involved in our relations with our own parents, a correspondence that points to the source of some of the compelling felt benefits of strong religious belief.[6] A related study by the same Danish team also showed how the performance of more personal prayers by members of the same group involved other neural processes, activating the medial prefrontal cortex and temporal parietal junction, both areas associated with the so-called Theory of Mind, that is the awareness that another individual has interests distinct from our own.[7] Evidently, one reason why the Christian religion is so satisfying is because it activates neural resources originally developed to sustain essential interpersonal relations. It is also interesting that these and other areas involved in social cognition, such as the posteromedial cortices, have a principal role in a recently identified default mode network (DMN), a set of areas active in the brain's resting state and concerned with the awareness of autobiography, the self and others. This suggests that the brain's default relation to the world is to treat everything in it, from plants, animals and landscape features to artefacts, such as paintings, sculptures and buildings, as it treats other humans, so explaining the widespread inclination to anthropomorphisation, that is the tendency to approach both natural phenomena and human-made objects as if they shared properties with ourselves.[8]

The Visual System

The neural model of the mind just outlined is helpful to people studying any human behaviour, but it is particularly helpful to art historians, for two reasons. One is that, as a direct consequence of our descent from tree-dwelling creatures, the area of the brain concerned with vision is much larger than those serving the senses of smell and hearing, which are more important to ground-dwelling animals. The other is that the visual part of the brain, being isolated at the back of the skull, is especially accessible to study. Sight is thus

at once the sense most important to us as a species and the one that is best understood. It is also the most relevant to an understanding of art.

This relevance has become increasingly obvious with each new discovery about the visual system. One relates to the principles governing the so-called saccadic movements of the eye. Through such movements, which are spontaneous and outside our conscious control, the fovea, the area rich in colour-sensitive 'cone' cells near the centre of the retina at the back of the eye, can change its fixation (its concentration on a feature in the visual field) four or five times a second. By doing so it is able to build up a much more detailed and informative picture of the world than could be delivered by the rest of the retina, which only contains 'rods', the neurons sensitive to tone that are important for night vision. Eye-tracking devices have shown that the fovea moves rapidly round the visual field, pausing for milliseconds on such significant areas of the body as eyes, mouths or genitals, and such informative attributes of a scene as the edges of forms and spots of colour. Michael Baxandall showed twenty years ago how an understanding of the principles governing such unconscious movements can help in the appreciation of the activities of both artists and viewers.[9] Today a team in Vienna led by Raphael Rosenberg is taking these studies much further.[10]

Another important discovery about the visual system relates to a phenomenon first identified by Gestalt psychologists nearly a hundred years ago, that is the tendency of the brain to break down the visual field by looking for such formal properties as 'proximity', 'similarity', 'grouping', 'closure', 'simplicity' and 'symmetry', before it ever identifies particular objects. The areas of the visual cortex involved in this analysis appear to be those at the very back, where the information carried from the retina by the optic nerve first arrives, areas known as V1, V2 and V3. The tendency to search for such a formal Gestalt is adaptive, in that it speeds up the finding of things that are good and the avoiding of things that are bad. For example, recognising nutritious fruits by their 'similarity' to each other, and mapping their availability by registering their 'grouping' is obviously helpful when foraging, while registering 'closure' and 'continuation' in an outline speeds up the perception of forms and may

give early warning of a shape that is either dangerous, such as that of a predator, or desirable, such as a potential mate. Noting 'symmetry' is also adaptive, since it is a distinguishing attribute of the human face, the object to which it is most vital that we give attention throughout our lives. Psychologists such as Rudolf Arnheim recognised long ago that these propensities were important both in the making of and the response to art.[11] Today we understand much better why this is so because we can recognise their neural basis.

All these perceptual activities noted by Gestalt psychologists are facilitated by the detailed organisation of these areas at the back of the visual cortex. Most important is the arrangement of neurons in spiralling banks, each bank responding to a line of a different orientation, something first noted in the mammalian cortex by Hubel and Wiesel in their landmark discovery of 1959, published more fully in 1962 (fig. 3).[12] Since the perception of bounding lines is essential for the perception not just of so-called Gestalts but of any form, this property is also clearly adaptive. Quite how adaptive it is became clear from the later work of Hubel and Wiesel, who noted that kittens that were exposed to lines of only one orientation acquired a tendency to attend only to those because, while the neurons involved in their perception formed rich connections, those designed to respond to other lines atrophied. As others, such as Keiji Tanaka, working with monkeys, have shown, this tendency is a basic manifestation of one that is much more complex, more essential to our survival and more relevant to the art historian.[13] This is the tendency of the brain, when confronted by a new object, slowly to form networks adapted to its perception, including even retuning individual neurons by changing the form they respond to and reconfiguring the connections between them. The more often and intently we look at an object, the richer and stronger become the networks involved. This has an obvious benefit to the person looking, since the new connections then help us in our search for similar objects, by alerting us to anything that shares similar properties, not just properties of line, but of colour, reflectiveness and so on. It is also professionally beneficial to the art historian, because it means that if we know what objects an individual at any place or time has been looking at with enough frequency or attention to cause such neural formation, we will also know

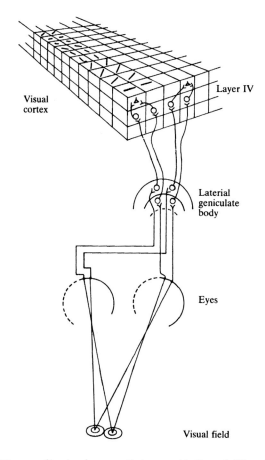

3 Diagram of banks of neurons that respond to lines of different orientation in layer IV of area V1 of the brain, with earlier pathway from the eyes (*Oxford Companion to the Mind*, 1987, 802)

something of the visual preferences that would guide the hands of that individual if he or she is a maker of art, or their choices if they are patrons or users. If we know that many individuals in a particular community, or in a social class or group within it, looked at the same things, we will also know some of the preferences they shared. Baxandall inferred such a process when he talked of a 'period eye', but he was above all interested in conscious mental activity, and so only considered the impact of things people in fifteenth-century Italy had been trained to look at, such as barrels or dance positions.[14] Now that we understand the neurological basis of the 'period eye' we can take his concept much further, acknowledging that passive experiences may be just as important as active, having similar consequences for the shaping of an individual's neural resources without them realising it.

After passing through areas V_1 to V_3, visual information is distributed down two pathways designed by evolution to maximise the speed and efficiency with which it is put to use. A lower, or ventral, pathway, leads to the temporal lobes either side of the head and is primarily concerned with the activity of perception, especially the identification of objects, which is why it has been called the 'what' pathway. By contrast, an upper, or dorsal, pathway leads to the higher parietal lobes and, because these are primarily concerned with the location of objects in space and with action in relation to them, it is often called the 'where' or 'how' pathway. This division is increasingly seen as being too schematic, since there is much feedback both up and down the pathways and between them, something that improves both the information's quality and its utility, but the underlying distinction still holds, and the advantages it brings in terms of the relation of the pathways to the rest of the brain are obvious. In the 'what' pathway the location of the auditory area in the temporal lobe makes it easier for information from the ear to be integrated with that from the eye, while, in the 'where' or 'how' pathway, the fact that the parietal lobe includes the somatosensory and motor areas across the top of the brain makes it easier to adjust hand or arm movements, as in the context of defence or attack.

The internal organisation of these pathways is also daily becoming clearer. Thus, one of the more remarkable recent discoveries in relation to the 'what' pathway is the identification of distinct areas in the temporal lobe, especially in the lateral occipital complex (LOC) and the ventral occipital temporal (VOT) regions, which are each adapted to help us, from birth, in the processing of a different category of visual phenomena.[15] What this means for us is evident from scans of the brains of people looking at the famous illusion in which the same shape can be seen either as a face or a vase. As the individual alternates between seeing a face and seeing a vase, neural activity shifts from one area to another, with other regions being also involved in monitoring the decision.[16] Among the most recognised of such specialised areas are the fusiform face area (FFA) concerned with the processing of faces, and the parhippocampal place area (PPA) concerned with places, including buildings, but others have been identified as responding selectively to such categories as body parts, animals, objects and tools. Given that these are all phenomena of particular importance to humans, it is obvious that it is adaptive for us to enter the world already possessing areas equipped to process them. If initial results are confirmed, this revelation promises to replace the once fashionable assumption that all our knowledge categories are constructed socially and verbally, with the observation that some are constituted biologically and principally visually. Additionally, for the art historian, it might shed light on the genesis of the genres of painting. For example, if the existence of areas in the brain specialised in the processing of objects within those categories is confirmed, it would help to explain the emergence within the European tradition of such subject categories as heads, full-length figures, landscapes, still lifes and flower pieces. Semir Zeki has long argued that painters have always been neuroscientists and such a correspondence would strengthen his case. Certainly, the time in the Early Modern period when these categories begin to appear is one when artists such as Leonardo and Michelangelo were starting to sense the direct influence of the brain on their artistic actions.

An important area in the ventral pathway is V_4, which plays a crucial role in the perception of colour. Colour information is particularly vital for us, as in the context of finding food or a mate, and this is probably why, as Zeki discovered, information on the colour of an object is fed forward to V_4 from areas V_1, V_2 and V_3 even before its form has been recognised. Comparable to the significance of V_4 in the 'what' pathway is that of area V_5 in the 'where' pathway, whose neurons are tuned to movement. This is more important for art historians than one would expect, since the neurons tuned to respond to movement also respond to two types of 'still' images. One is that known as Op art. As Zeki has shown, the reason why an image by Leviant or Vasarély seems to move is because its design is such as to activate V_5 neurons.[17] Even more surprising was the discovery that these neurons are also activated by still images of such things as an athlete in action, a flame or a wave. Evidently, because feedback from the 'perception' pathway identifies these shapes as being those of objects capable of movement, and because such movement might require the viewer to prepare for 'action', the 'action' pathway generates the same response that it would have if

real movement had been observed. Interestingly too for the art historian, unlike with the Op art, the viewer is unaware of this response of the brain. This means that when we look at a statue such as Myron's *Discobolus* (see fig. 47), without us being aware of it, our brain reacts to it, not as it would to a representation of a similar figure in repose, but as it would to such a figure if it were really moving. Thanks to this neural response our brain is prepared to estimate when and where the discus might be thrown. Such preparation for the future by scenario-assessment is a key role of V5 within the 'where' pathway.

The Mirroring System

Discussion of the concerns of area V5 prepares us to consider the implications for art historians of another remarkable discovery about the neural response to movement, that associated with 'mirror neurons'. These were first observed by a group of neuroscientists in Parma, Italy, in the early 1990s in the pre-motor cortex of a macaque monkey. It was already known that the normal role of such pre-motor neurons is to fire a few milliseconds before true 'motor' neurons, so making sure that the neurons involved in that particular action are correctly connected. What surprised the Italian scientists was that these pre-motor neurons also fired when a monkey merely witnessed another monkey perform the relevant action, without the observer monkey making any movement. Even more astonishing was that they fired when the monkey only heard the consequence of that action, that is, the sound of a peanut being cracked. Evidently, by watching the movement the observer monkey was not only becoming neurally prepared to make it itself, but also understood why it was being made. Attention subsequently shifted to analogous phenomena in humans and by 2007 Vittorio Gallese, one of the discovering team, collaborated with David Freedberg to produce an important review of the potential significance of such neurons for the study of the response to art.[18]

By now there is a large literature on the whole phenomenon of 'neural mirroring' in humans, and this in spite of the fact that research in the field is impeded by ethical constraints on the implantation of the electrodes necessary to identify the firing of individual neurons in the human brain. The existence of this obstacle makes the results of experiments recently carried out in Los Angeles, under the rare conditions considered acceptable, particularly significant. The actions chosen for study were ones already known to be affected by mirroring, that is grasping, either 'whole-hand' or 'precision', and facial expression, in this case frowning and smiling. The main conclusions were that: 'A significant proportion of the neurons in supplementary motor area, and hippocampus and environs, responded to both observation and execution of these actions', while: 'A subset of these neurons demonstrated excitation during action-execution, and inhibition [that is deactivation] during action-observation'.[19] This data confirms the existence of neural mirroring in humans and adds to what had already been inferred about them by showing that neural inhibition helped to maintain the distinction between 'observation' and 'action', so ensuring that mirroring did not automatically lead immediately to copying. In this way, learning an action by observing it was separated from executing it at a later date. Certainly, since experiments also show that these neurons can be engaged just by mentally recalling the memory of a movement, it has been concluded that 'during action-execution a memory is formed, and during action-observation this memory is reactivated'.[20]

Understanding the mirroring of smiling and frowning is particularly important because, as the philosopher William James realised more than a century ago, regardless of whether we have a reason to feel happy or angry, we can induce the emotion in ourselves simply by pulling the relevant face. This means that just by mirroring the outward signs of an emotion in someone else we will come to share it. Nor is this the only case in which a form of mirroring can induce in us a response normally associated with a more substantial cause. One of the most remarkable examples of such a response is revealed by experiments in which individuals seem really to experience pain, although they are only witnessing a scene that suggests it is being inflicted on someone else. As brain scans reveal, the sight of pain being apparently inflicted on a loved one's hand activates the observer's own insula, the organ which would have reacted had they experienced the pain themselves.[21] Still other studies have revealed further extensions of the mirroring phenomenon to include

empathy and so-called Theory of Mind through activation of the superior temporal sulcus (STS) and the temporal parietal junction (TPJ), areas whose relevance for social interaction and personal prayer were noted in experiments referred to earlier.[22] Particularly promising is the suggestion that the physical self- and social-awareness of the Mirror Neuron System and the mental self- and social-awareness of the default mode network are linked through areas such as the precuneus.[23] Neural mirroring extends far beyond the motor area and imitation, to include the sharing of emotions and an understanding of their causes.

Context, Cue and Reward

The realisation that these properties of the brain are liable to influence an individual in ways of which he or she is not aware, giving rise to behaviours that are spontaneous, that is, beyond the individual's conscious control, is highly important. So too is a recognition that those behaviours are not necessarily always autonomous, because sometimes they are influenced by factors that are contextual. Good examples are cues that prime the neural networks to respond to particular phenomena. Some cues are internal to the viewer, as Gombrich pointed out when he observed that the hunter is more likely to mistake a tree stump for a rabbit if he is hungry. Others are external. If someone tells us that there is a rabbit around we are more likely to find one. Often the priming will be the result of a powerful experience causing the release of a neurochemical, as for example noradrenaline in the case of fear, or oxytocin in the case of bonding.

Most striking, though, are the experiments that show that responses to art, like those to other high-value human products, such as wine, can be strongly affected by verbal information that is erroneous. This is well illustrated by the way the brain's response to beauty can be drastically modified by verbal cues. The nature of the basic response to an object recognised to be beautiful has been known for some time. Thus it has been shown that a positive reaction to many types of aesthetic experiences, both visual and auditory, is correlated with an intensification of activity in the medial orbital frontal cortex (mOFC), the area in the frontal lobe of the brain between the eyes whose functioning is essen-

tial for many types of judgement. Typically such activation is associated with the anticipation of a reward from a limbic organ, such as the nucleus accumbens, whose role was noted earlier. Ishizu and Zeki's work is only the most recent and refined in its demonstration of the role of mOFC for the experience of beauty in the fields of both art and music.[24] Their conclusions, though, need to be put in the context of another set of experiments performed in Oxford with the participation of the art historian Martin Kemp and designed to find out the extent to which neural responses to authentic and fake or copy Rembrandt portraits are affected by information as to the class to which they belong.[25] One of the significant findings of these experiments was that an increase in the activity of the orbital frontal complex correlated not with the category in which it really fell, but with that to which the viewer was told it belonged. The reward, far from being inherent in the visual experience of a true masterpiece, was more reliably triggered by a label claiming it to be one. Similar results have been found in the field of wine. In experiments in California the activation of the OFC correlated with what the subjects were told about the cost of the wine, not with its real monetary worth, which would normally be taken as an index of quality.[26] If the taster was told that the wine cost $40 there was a strong response from the OFC, even if the bottle was only worth $5. It appears that verbal information from a trusted source is capable of delivering such a neurochemical reward that it can dramatically upgrade the viewer's or drinker's response.

These last findings carry many implications, but perhaps the most significant for the neuroarthistorian is the light they shed on the extent to which an external cue, such as verbal information, can affect the response to art. It is not just that what purports to be an artist's signature on a painting, a label on a frame, or an attribution in an exhibition or an auction house catalogue can radically alter, even determine, our neural response to a work of art. Such is the evident power of words that we now have to consider that the praise of a critic or the description by an art historian can do the same thing. It is no wonder that patrons and collectors have down the ages always made use of optimistic labels and fake signatures. They rightly sensed that such designations could upgrade the responses of viewers.

The Imagination

To some extent, these last experiments are taking us into the world of the imagination. Thus the viewer can be said to be imagining that the fake Rembrandt is real. And this brings us to another remarkable discovery of neuroscience, that when we imagine something we draw directly on the resources of the visual cortex. A simple demonstration provided by scans is that if you ask someone to imagine a small object, only a small region of V1 at the back of the brain is active, while, if you ask them to imagine something large, the activity spreads to a much broader area.[27] Further experiments show the phenomenon to be much more widespread. The same specialised areas involved in perceiving particular object categories, such as the fusiform face area and the parhippocampal place area, are also activated when objects in those categories are only imagined, and a similar correspondence in neural activity was found between perceiving an object in a particular location within the visual field and imagining it there.[28] Another finding from the same study was that the neural activity provoked by imagining something was sometimes weaker than that provoked by its perception, which the researchers explained as probably due to 'imagery . . . being less detailed than veridical perception'.[29] Nor is imagination limited to the visual cortex. Brain scans of someone reading a text about grasping or kicking show activation in the areas of the motor cortex controlling arms and legs.[30] They even show a similar activation when the text describes a metaphor, such as 'grasping an idea' along with other areas uniquely associated with the comprehension of language, so demonstrating the correctness of Lakoff and Johnson's claim in *Meatphors We Live By* that much abstract thought is rooted in lived experience.[31]

These revelations on the working of the imagination have important implications for the shaping of visual preferences, especially in a period such as the Middle Ages when everyone was paying less attention to the world around them and those who could read, like the patrons and many artists, were attending more to books, such as the Bible. Repeatedly reading, or hearing, about something, such as Paradise or Hell, that concerns you greatly although you have never seen it, will strengthen the neural resources involved in imagining it. This means that it is likely that, if you are an artist,

it will be these resources that will guide your hand rather than any shaped by your exposure to a real environment which will have engaged you much less. In the same way in the twentieth century it is likely that those who habitually imagined the transcendental phenomena described in theosophical literature will have experienced a similar effect. In certain places at certain times, if we want to understand which salient neural resources were guiding an individual's hand, it will be more important to know what he or she has been imagining than what he or she has been looking at.

The Brain and Neuroarthistory

This account of some of the findings of the latest neuroscience is necessarily incomplete. It is also provisional. It does, however, allow important general conclusions that are likely to stand the test of time:

that much mental activity occurs below the level of consciousness;

that much of that mental activity depends on processes of neural formation that are shaped by passive experiences;

that such processes of neural formation are governed by principles that are increasingly understood by neuroscientists;

that a knowledge of those principles might provide art historians with a useful additional tool.

Each neuroarthistorian will design their own tools depending on the questions that most interest them. Those offered here were chosen to help me in answering a core set of questions raised by my need to understand the variety of art worldwide: 'Why did this particular person in this particular place at this particular time, make, use, display or otherwise respond to a work of this form and in this material in this particular way?' The principal approach to answering such questions adopted here involves pursuing five axes of enquiry:

identifying an artistic behaviour that has not yet been fully explained, whether this is a new form or subject in painting, a composition or expression in sculpture, a

material or configuration in architecture, a bodily disposition in the working artist or an implicit response on the part of the viewer;

finding out about the material and social environment of the individual or individuals engaged in the behaviour;

establishing which of those individuals' visceral concerns might have been so over-riding that they could have had a salient impact on their neural formation;

relating those saliences of neural formation to the salient aspects of the art-related behaviour under investigation;

exploring how a knowledge of the relationship we have inferred between neural formation and that particular behaviour adds to, or changes, our understanding of it.

In the following chapters I shall pursue a series of studies conducted along these general lines as I consider a wide range of art-related behaviours that have been manifested in the area between the the Urals in the east of Europe and Ireland in the west, Greece in the south and Scandinavia in the north, from prehistory to the present. Repeated use of a similarly structured argument and invocation of the same neuroscientific principles relating to neural plasticity, neural mirroring, the reward system, priming, the imagination and so on, should make it easier to evaluate the studies' merits. Repeated return to the same principles does not mean that at each stage I shall be exploiting the same neuroscientific knowledge. Although that knowledge as a whole is relevant in all places and periods, relating as it does to universal properties of the human brain, the specific circumstances of each new natural and cultural context mean that the relative importance of each of those properties is liable to change. As people's ways of life change so do their experiences, and as their experiences change so, necessarily, do the neural resources on which they depend. The variation in those resources is endless, not just between communities, but between individuals. They even change between periods within an individual's life. A neural approach requires us constantly to ask ourselves which properties of the brain are most at issue in a particular enquiry.

In acknowledgement of the way priorities are liable to be modified with changes of period and place, the survey of European artistic activity presented here is broken down into nine Parts. Each focuses on a different geographical area at a particular time, and each begins with an introduction aimed at identifying the neural properties most engaged in that particular context, before moving on to a series of chapters containing case studies in which their relevance to the art produced and used in that time and place is analysed in detail. These case studies should then be seen as a series of experiments cumulatively testing the applicability of different domains of neuroscientific knowledge to the understanding of different types of art. The whole book is thus a single experiment testing the value of neuroarthistory.

Some readers may feel that the experiments either individually or collectively are gratuitous because in their view the behaviours with which they deal are already adequately explained. Others may agree that the behaviours chosen do require further explanation, but reject those proposed here. The challenge for them is to find others that work better. What is, I believe, beyond question in the light of the provisional knowledge outlined in the preceding pages is that it is today unwise for anyone who seeks to understand any human behaviour to completely shun all reflection on the neural processes on which it depended. It is in the light of this conviction that I present the use of neuroscience not as an alternative to traditional or current art history, but as an additional tool for the solution of problems when other approaches have reached their limits.

Part 1

PREHISTORY

30,000–4,000 BC

Art before Literature

Prehistoric art has never been easy to explain. Prehistory, taken as the period before textual records, is extremely long. It is also marked by extraordinary changes in human behaviour, especially in Europe. When it begins, in the early Palaeolithic, there is little to distinguish our ancestors from other primates. By the time it ends, in the Mesolithic and Neolithic, in many places they are wearing clothes, living in towns and practising animal husbandry and agriculture. Somewhere in between they began to make the visually interesting two-dimensional marks, three-dimensional shapes and permanent buildings that we group together as art. Tracing the process by which our animal ancestors acquired a lifestyle like ours, and understanding art's role in it is difficult. We are good at explaining changes in a behaviour once it exists. We are less confident about explaining how one emerges. From the first millennium BC onwards we feel we know why art forms, such as monumental painting and sculpture and architecture, were exploited, because we know their cultural setting and texts begin to comment on their roles. We do not know what lay behind such early examples of those activities as the paintings of Chauvet, the mammoth houses of Mezhirich or the stone sculptures of Lepenski Vir. Why did those forms of expression appear? Why did they appear where they did and when they did?

As we try to answer those questions we do not even know what our starting point should be. Working from analogies seems sensible, but should we look for those analogies in the conscious behaviours of the descendants of those who made this art, or in the unconscious actions of their animal ancestors? The former approach, on the one hand, relating the art of early humans to the behaviours of their successors, and seeing art as the product of a language-rich culture, is the one most common today. It has the obvious advantage that it allows us immediately to offer explanations for this early art in terms of later belief systems and social practices, complete with verbal commentaries of a type with which we are familiar. The latter approach, on the other hand, relating the art of humans to the behaviours of animals, and seeing it as sharing biological roots, has until now had few supporters, because there has been little knowledge on which it might be founded.

This imbalance in the apparent validity of the two ways of treating prehistoric art is, however, rapidly changing thanks to interconnected developments. Ethologists have shown that the mental life of animals can involve social intelligence, tool-making and the transmission of culture, traits once thought the privilege of humans and deemed to be necessarily dependent on language, and neuroscientists have shown that these capacities can be understood as the product of shared neural resources coded for in our DNA.[1] We thus have a whole new avenue of approach to the human mind, one that sees neuroscience as providing a potential basis on which to construct a new range of explanations for artistic activity.

This leaves us with two viable approaches to understanding prehistoric art, each of which is founded on different premises, the one seeing language as the key and the other neural make-up. There is only one premise on which both agree, the notion that the emergence of artistic activity is somehow directly connected to the distinctive neural resources of *Homo sapiens sapiens*, or 'modern type' humans, the new species that arrived in Europe from Africa about 45,000 years ago. Everyone agrees that the brain of this species, combined with its lighter limbs and bone structure, endowed it with a flexibility and adaptability that enabled it to replace the previous more heavy-boned Neanderthal type and everyone agrees that the emergence of art-making, like the making of more complex and varied tools, is connected to these new resources. What they disagree about is the nature of the connection.

Most scholars assume that the new behaviours are somehow the natural product of the new resources, with the key to the advances in all areas being the use of another dramatically improved tool, language. For them there is no way to explain the achievements of the new human type except in terms of a high level of language use. This, they claim, not only made it possible for our ancestors to discuss problems and exchange solutions, but also allowed them to describe cosmologies and narrate myths, and generally to formulate and share culture. They also assert that the art is the principal evidence for this. Not only is art said to demonstrate the currency of verbally articulated

cosmologies and myths. It is also said that art is necessarily 'symbolic' and that there is nowhere from which humans could have derived the idea of a 'symbolic' activity except language. Indeed, this point of view is so widely accepted that each new piece of early art that is discovered is claimed as evidence of a capacity to symbolise. It is easy to see the appeal of this claim that the role of language was of over-riding importance. At a stroke it does away with the need to provide detailed explanations of the many new behaviours of *Homo sapiens sapiens*. It also flatters us by making our European ancestors the first human group to possess in a fully developed form the attribute said to decisively distinguish humans from animals.

There are, however, difficulties with this view. It assumes that the new achievements depend on a new level of linguistic ability, but no explanation is offered as to why there is no comparable evidence for a high level of language use in the period between the species' emergence in Africa about 100,000 years ago and its arrival in Europe more than 50,000 years later. Equally, no attempt has been made to trace the steps by which the new level was achieved, nor has any explanation been offered for why, if art is a key element in a culture shaped by verbal exchange, surviving examples are so diverse and sporadic in their distribution. The only defence offered aginst this last criticism is the vague assertion that art must once have existed everywhere, what we know today only reflecting the accidents of preservation. This approach thus has obvious weaknesses. One is that it is ultimately based only on assertions. Another is that as an explanation it functions only at a general level. Everybody was smarter, it suggests; so everybody did more interesting things. What it lacks is the capacity to explain how and why the interesting activities developed.

The alternative approach, which also assumes that the emergence of art is a product of the superior endowments of the new species, does not take for granted the role of language, although it considers it. Instead it looks for explanations for the specific properties of the art that has survived in the particular neural resources that were the most important of these endowments. The earliest to develop this argument in an elaborate form was the psychologist G.-H. Luquet nearly a century ago.[2] He believed that art-making began when people saw accidental marks, or naturally occurring shapes, as resembling animals and objects that they knew, and were somehow provoked by the sight of the marks left on cave walls by the paws of bears to elaborate on them. Human mark-making, thus, had its origins in unconscious and involuntary responses. Such an approach, which allows for art to be less a manifestation of culture than a spontaneous response to environmental contingencies, has recently been taken up by Michel Lorblanchet. For him the astonishing variety of prehistoric art both in Europe and worldwide is hardly compatible with the view that art could have spread from one or more centres as a shared cultural practice. He prefers to think that it comes from *le cerveau*, 'the brain'.[3] In 1999 he did not know what specific properties of the brain might be involved, but he certainly sensed them.

So too did the ancient Greeks, who, as we learn from Roman texts, explained the origins of painting, sculpture and architecture in terms of the spontaneous actions of individuals. Thus, Pliny the Elder, when explaining the origin of sculpture, tells how a girl, on the night when her lover departed on a long journey, traced the shadow of his face that a lamp cast on the wall, and how her father, a potter from Sicyon named Butades, somehow preserved it in clay.[4] Similarly, Athenagoras of Athens in the second century BC tells how painting began when one Saurios of Samos traced on the ground the shadow of his horse.[5] The early Greeks, who invented these stories, imagined art being born outside any cultural context. The individuals involved are assumed to have been motivated by a purely private interest in an admired object, a lover and a horse, as they copied its shadow cast in one case by a lamp and in the other by the sun. Their reward is not social or material, but private and emotional – today we would say ultimately neurochemical. Greeks also had a similar account of the spontaneous origins of architecture. The Roman writer Vitruvius, who depended heavily on Greek texts, tells how it was early humans who 'imitating the nests and building practices of swallows made shelters out of mud and twigs'.[6] The Greeks knew nothing of 'mirror neurons', but they were familiar with the imitative actions

they provoked. Humans, they thought, looked enviously at the nests that swallows built for their families and copied them. The authors of these stories believed, like Luquet and Lorblanchet, that human nature by itself – we would say human neural makeup – could, in particular circumstances, generate extraordinary actions, actions that were prototypical of the fields later known as painting, sculpture and architecture.

Today we can back these hunches by considering real examples of similar extraordinary actions on the part of our mammalian relatives. One of the most striking was observed four decades ago by an ethologist who was watching dolphins in a tank.[7] He was smoking, and on one occasion he noticed that when he blew a cloud of smoke into the air, a young female dolphin swam off to its mother, took a suck of milk and, coming back to him, blew it out into the water, so making a cloud just like his (fig. 4). In artistic terms what the dolphin did was quite complex. She copied the shape she had seen, but used both a different medium and a different support, milk instead of smoke suspended in water instead of air. Her actions may seem sophisticated, but they are only the product of specific neural mechanisms in the mammalian brain. The young dolphin's perception of the smoke cloud was made possible by the neural resources supporting shape detection, which had already been tuned by the sight of the clouds of milk that leaked from her own mouth when feeding. The memory of those clouds was then linked to the motor cortex, where she preserved the neural memory of the movements of her mouth that had produced them. This neural memory was re-awakened by her resources for neural mirroring which would have been activated by the movements of the smoking man, whose size and position were similar to those of an older and wiser dolphin, so leading her spontaneously to reproduce his action. The neural resources that had developed over millions of years to improve her ancestors' chances of survival led, because of a chance combination of factors, to the initiation of an action that has many of the properties of art-making, the use of an array of visual and motor resources to create a material shape. There was no training or external inducement involved. The reward system that provoked

4 Man blowing cloud of smoke and young female dolphin blowing cloud of milk in imitation. (Drawing by P. Barrett from description in Taylor and Saayman, 1973, in R. Byrne, *The Thinking Ape: Evolutionary Origins of Intelligence*, Oxford 1995, fig. 6.4)

the behaviour was internal and neurochemical. Although the workings of the brain's neurochemistry are still largely inaccessible, we can be fairly sure that the dolphin would have received a series of rewards, first for seeing the shape, second for recognising it as one she had seen before, third for responding to her inclination to 'mirror' one of her betters and fourth for recreating that 'better's artefact. Evidently, in a species of carnivorous mammal with a life-style and neural capacities close to those of the primates, the act of representation can take place without any of the conscious mental activity, symbolisation, training or social formation with which it is now routinely associated. To the extent that the representation is spontaneous and driven only by the dolphin's internal neural resources we can call it a type of 'neurography'.

There is similar evidence for our closer relatives. Around 1940, Julian Huxley of London's Zoo was so inspired by the sight of the young gorilla, Meng, apparently tracing his shadow on the white wall of his cage, that he suggested

that such an activity might have been at the origin of painting.[8] We cannot know the exact neural mechanisms involved, but again we can attempt their reconstruction. It is, thus, easy to see how the shape-detecting mechanisms in Meng's visual cortex could have been activated by the sharp silhouette of the shadow; how the correspondence of this shape with that of a member of his own species, which inborn neural resources, reinforced by plasticity, had forcefully embedded in his memory, would have charged it with considerable significance; how the bounding line of the silhouette's periphery would have reminded him of lines he had made with his finger, whether, when wet, on a dry surface, or, when dry, on a dusty or dirty one; and how this memory, perhaps associated with the memory of the importance of the tactile grooming essential to the wellbeing of his species, encouraged the activation of his own finger.

These examples of spontaneous image-making by a dolphin and a gorilla have been preserved for us by chance observation. Many thousands more must have occurred unnoticed. The explanations for the origin of human artistic activity proposed by Luquet and Lorblanchet and by the ancient Greeks thus find direct support in the artistic activity of other animals. Such activity can occur without any inducement or social context. All that is necesary is for a visual experience to trigger a motor action that generates a reward, in a sequence that can be elucidated using neuroscientific principles. It is these principles we should bear in mind as we look again at the earliest human artistic activity in Europe.

1

Origins of Two-Dimensional Representation

Animal Neurography in the Chauvet Cave

No examples of early European art are more in need of explanation than the paintings and engravings found in 1994 in the Grotte de Chauvet in the Ardèche in southern France (see figs 5–7, 11–15, 17, 19–21). Not only are they large and impressive, comparable in scale and authority to works such as Michelangelo's Sistine Chapel ceiling or Picasso's *Guernica*, but they are also extraordinarily early, dating, according to Carbon 14 and other tests run in different laboratories, from around 30,000 BC, which is twice as old as the art of Lascaux.[1] So remarkable are they that their discovery requires a radical reappraisal of the assumptions underlying all current views of art's origins.

It had been thought that the earliest images were simple and schematic and that they slowly became more and more lifelike, with the paintings of Lascaux around 14,000 BC being seen as the culmination of this development (see fig. 9). There were always some problems with this account.

For one thing there was no substantial sequence of images, moving from the simple to the more lifelike. Most scholars, though, have not worried about this, seeing the surviving record as just the product of chance. According to them, the early schematic images had been lost, either because they had been made on soft surfaces that have not survived, for example human skin or pieces of wood, or because they were made on rock surfaces that have either not been found or else have been worn away. After all, there is evidence that mineral pigments were collected by humans by the Lower Palaeolithic, and they must have been used for something. Chauvet revealed the absurdity of such prevarication. The paintings were not just large, complex and old, they employed features, such as three-quarter perspective and shading (see fig. 5), that were not found again until Classical Greece. It was, of course, still possible to assume that there was much earlier and more schematic art that had been lost,

5 Bear walking, pigment on rock, *c.*30,000 BC, Chauvet Cave, Vallon Pont d'Arc, Ardèche

but that did not explain Chauvet's remarkable properties. If this art represented the culmination of a slow progress, why did the naturalism it embodied immediately decline, only returning 30,000 years later?

The scholar who came closest to facing up to the challenge presented by Chauvet was Ernst Gombrich, as we can sense from his review of the first publication of the Cave in 1996. There he remarks how 'these early hunters felt free to experiment with frontal view, rudimentary foreshortening, and the device of shading to enhance the impression of rounded forms', before noting that 'the vocabulary they handled with such supreme artistry ... lived on in the formulas, not to say stereotypes, painted or scratched on the walls of such caves millennium after millennium'.[2] As he

recognised, the sophisticated experimental techniques of Chauvet were followed by thousands of years of formulas and stereotypes. The only false note in his analysis is his subsequent throw-away suggestion that their 'complete mastery' was 'presumably based on a tradition extending much further into the past'. Gombrich knew that there was no evidence of such a tradition and, if he had thought about it, he would have realised that it would have been very odd to have the slow build up of a tradition arriving at a moment of experimentation and supreme artistry, only to be followed by a relapse into formulas and stereotypes. Probably the main reason why he imagined an earlier tradition was because he had devoted his life to showing how naturalism in art emerged through a process of 'schema and

24

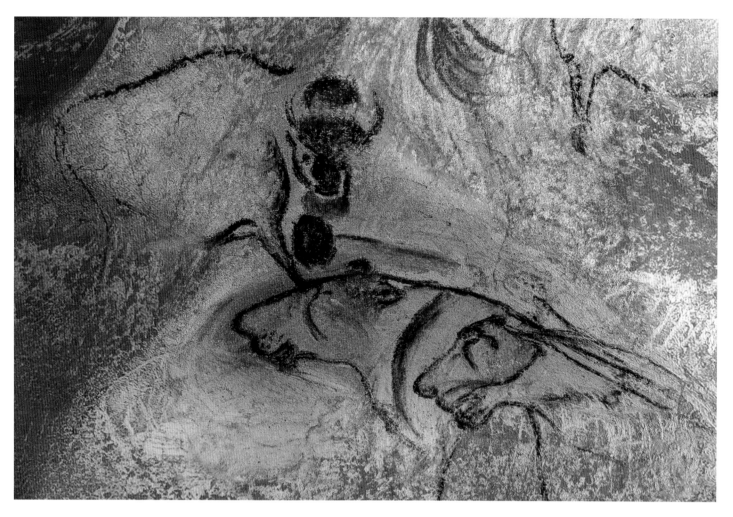

6　Bison and lions, pigment on rock, *c*.30,000 BC, Chauvet Cave, Vallon Pont d'Arc, Ardèche

correction'. The other reason was that he had no other tool to explain what he saw. We are more fortunate. Neuroscience provides such a tool.

What then is the material to which we need to apply it? In terms of subject matter, the latest archaeological publication documents 420 images, of which the major animals are 65 rhinoceros, 71 felines, 66 mammoths, 40 horses, 31 bovids, 20 ibex, 25 cervids, 15 bear, 2 musk ox and 1 owl, not to mention a whole group that are unidentified, as well as 4 or 5 female genitalia and many silhouettes and stencils of hands.[3] A few images are engraved, but most are painted in charcoal and/or ochre. Many of the animals are lifelike and shown in vigorous and alert activity. Some of the rhinoceros seem nervously about to charge, menacingly pre-

senting their horns. Four horses' heads are painted next to each other, each capturing a different equine behaviour. On many heads shading suggests the underlying bone structure, and on bodies the mobility and texture of flesh covered by fur. A bear is shown viewed from above in three-quarter perspective, alert in all its senses (fig. 5). Often there is an extraordinary sense of a moment of viewing recaptured, as in a photograph, for example in the confrontation between a charging bison and a file of lions (fig. 6). One figure may conceal another from the viewer, as would happen in a real encounter, lions lower their shoulders, as they would when hunting, and the positioning of the eyes and ears well conveys an appropriate sensory alertness (fig. 7). The spectator's experience is like that of someone watching a modern

(above) 7 Lionesses hunting, pigment on rock, *c.*30,000 BC, Chauvet Cave, Vallon Pont d'Arc, Ardèche

(below) 8 Lioness hunting, modern photograph, African Lion and Environmental Research Trust, Zambia

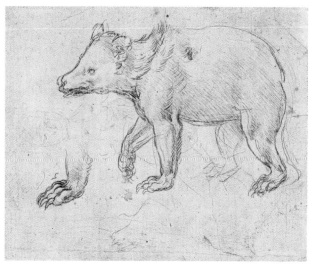

9 Horse, pigment on rock, *c.*14,000 BC, Lascaux Cave, Perigord

10 Leonardo da Vinci, *Bear walking*, early to mid-1480s, metalpoint on pink-light brown prepared paper, 10.3 × 13.4 cm. New York, The Metropolitan Museum of Art, Robert Lehman Collection, 1975, 1975.1.369

wild-life film (fig. 8). In no other cave is the art so natural or so vivid. By comparison, the so-called masterpieces of Lascaux produced more than 15,000 years later look more like paintings of stuffed toys (fig. 9). Even work by the greatest of more recent artists is put in the shade. Compared to the Chauvet drawing of a bear, one by Leonardo da Vinci looks lifeless (fig. 10). There is much to explain.

Neuroscience and Chauvet: Technique

The Mirroring of Bears

A first question to ask is: where did the artists get the idea of making the images in the first place? One answer is that they had seen earlier images, but the few earlier ones that are known look nothing like these, being much more rudimentary, and are hundreds of miles away. We have no evidence that the artists at Chauvet knew them. What they did know were the art-like markings already made by cave bears in the same environment and, as we have seen, scholars like Luquet and Lorblanchet have already argued that such markings were capable of inspiring human artists. Chauvet certainly supports this argument. In the Hilaire Chamber,

engravings of mammoths and a horse are superimposed on prominent marks of bear claws (fig. 11), while elsewhere, next to the point on the cave wall where a bear has accidentally left the mark of a paw covered with clay from the cave's floor, a human has used a pattern of marks similar to shapes made by a hand dipped in ochre to create the silhouette of a painted animal (fig. 12). Such imitative actions might, of course, have been a conscious choice, but neuroscience tells us that the response could have been completely unconscious. If the sight of another hand, or even the sound of a peanut, can activate the mirror neurons in the pre-motor cortex of a primate, it is easy to see how the sight of the marks made by a bear's claw could have activated the premotor cortex of the humans who entered Chauvet and that, in some individuals at least, this would have caused the firing of the relevant motor neurons, leading to the making of a similar mark. A few individuals, it seems, not only gave great attention to these actions of cave bears, but went on to mirror them. The firing of mirror neurons may thus have inspired both of the techniques used in these extremely early two-dimensional representations, engraving and painting. Such mirroring response can only have been encouraged by the natural empathy that human beings would have

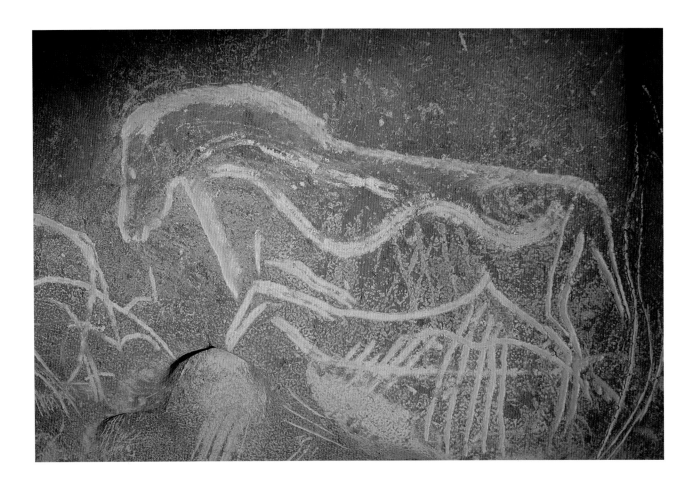

11 Markings of bear claws, with superimposed engravings by humans, *c.*30,000 BC, Chauvet Cave, Vallon Pont d'Arc, Ardèche

12 Marks left by a clay-covered bear's paw with, above, panther marked by dots, 'Panther Panel', *c.*30,000 BC, Chauvet Cave, Vallon Pont d'Arc, Ardèche

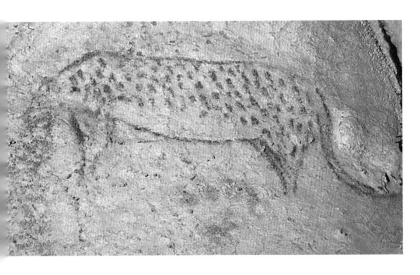

felt with bears, who, like them, also spent much time in caves, were omnivorous, frequently stood erect on two legs and whose claws were enviable equivalents to human tools (fig. 13). Given such empathy, it is easy to see how the same neural apparatus that led a young dolphin to imitate the art-like action of a human might also have led a human to imitate that of a bear.

The principles governing the operation of mirror neurons help us to understand why humans started to make marks on the walls of the cave, and why those marks are of two kinds, one engraved and the other coloured. They also help us to understand the popularity of hand prints. But how are we to understand the fact that there are hand images of two types, the one, dark, being made by pressing a hand covered with paint against the cave wall (fig. 14), and the other, light, made by spitting dark paint around it (fig. 15). Neural plasticity suggests an explanation. Visitors to the cave who brought their hands close to the cave wall would have seen

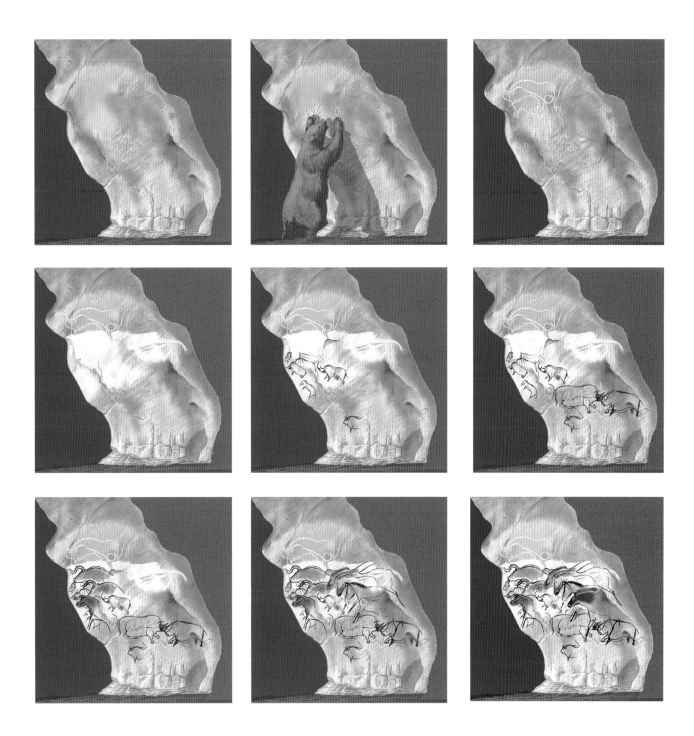

13 Reconstruction of possible chronology of engraving, cleaning and painting activity by bears and humans in one area, *c.*30,000 BC, Chauvet Cave, Vallon Pont d'Arc, Ardèche (Illustration: Gilles Tosello, from J. Clottes, ed., *Return to Chauvet Cave*, London 2003, fig. 111)

the shape of the hand successively in two tonal modes, first as a black shadow cast by the torch, and then, as the hand came between the torch and the wall, as a bright illuminated form. They would have seen this again and again and this would have caused the formation of neural networks that would have strengthened their preference for looking

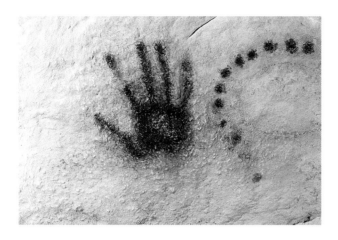

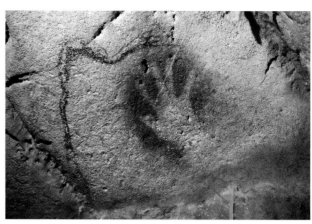

14 Hand print and a semicircle of dots, *c.*30,000 BC, Chauvet Cave, Vallon Pont d'Arc, Ardèche

15 Hand silhouette, *c.*30,000 BC, Chauvet Cave, Vallon Pont d'Arc, Ardèche

at both dark and light hands, so increasing the pleasure in making images of them. Huxley's observation of a young gorilla tracing his shadow on the white wall of his cage shows how shadows may elicit manual activity in a primate, and the notion of a human using blown paint to reproduce a light effect is not far from the young female dolphin's untaught blowing of milk to imitate an effect created by a human blowing smoke. As with the young dolphin, all that was necessary was for the individual involved to remember something of how that particular chance effect had been produced before and repeat it. Such a chance effect could have been created either by a random spitting of paint during the sort of play activity indulged in by other great apes in the wild or by a cough or sneeze, which might easily have accidentally left some silhouette of the hand. Either way, the effect could have been striking and surprising enough for the memory of how it was produced to stay in the brain, where it was ready to be called on when the mirroring networks of the pre-motor cortex, which encourage imitation, stimulated the human's mouth to match the bear's paw mark. The making of the dark prints is easier to explain as individuals would have been used to their hands leaving traces of their touch. This making of positive and negative hand images constitutes an innovation in general behaviour as well as in detailed technology. Both can be seen as the product of our species' distinctive resources, a powerful inborn inclination to imitate beings whose actions

or equipment give them advantages that we desire to share, originally parents, but in this case bears, drawing on the memories of our own motor system.

The Stimulation of Cave Walls

If this particular cave's popularity with cave bears was one of the distinguishing features that made it visually stimulating to humans, another was the exceptional visual interest of its wall surfaces. The limestone caves of southern France come in many forms and Chauvet is among the most splendid, its vast voids filled with all sorts of crystalline concretions and its surfaces stained with many different minerals (fig. 16). It was already filled with forms and colours of great visual appeal long before our ancestors added their paintings and engravings. Those who entered such an environment would have been stimulated by the colours and relief projections illuminated by their moving torches and would have attended to them using neural resources shaped by their most intense previous visual experiences. Their visual neural networks would thus have been formed above all by exposure to those things at which they would have looked with most attention, the large and powerful beasts from whom they were in danger, and the vulnerable creatures on which they themselves preyed. It was the strength of these neural networks that led them to see those creatures in the colours and shapes revealed by the shifting lamplight. This

16 Entrance to the Megaloceros Gallery, Chauvet Cave, Vallon Pont d'Arc, Ardèche

is why in many places at Chauvet, as in many other caves, we can see how a projection or recession, a line or a stain, was the starting point for a representation. We cannot reconstruct the precise sequence of neural events that led to an individual completing the image, often in life-like detail, but we can imagine that the sight of claw marks would have aroused memories of how similar marks had been made by the visitor's own fingernails or tools, while the sight of brilliant washes of colour created by the seepage of ochre down the cave walls would have reminded visitors of effects they might have already achieved in the application of pigment to their own bodies. The memory of what their hands could do when involved in other activities would have caused the motor networks involved in the performance of those activities to fire again. Their hands might, as we sometimes say when hinting at an unconscious neural impulse, have 'itched', encouraging individuals to return to the cave later with their familiar tools, stones and sticks, and pigments, ochre and charcoal, the neural networks controlling their fingers primed to extend or complete the shape embedded in their visual memory. The resultant image is so direct a transcript of reality that we can call it photographic, although, because the transcription is by neurons, we could call the process of its production 'neurography'.

We can reconstruct a little of this process in the context of the painting of a bear seen from above in three-quarter perspective (see fig. 5). The starting point was apparently a fissure in the wall that corresponded with the outline of a bear's forepaw seen from above. Sight of that fissure activated the visual memory of a bear seen from precisely that position, bringing back the image of the whole animal. The process involved is illuminated by the brain scans of individuals when viewing the vase-face illusion, which show how when we think we see a 'face' we recruit one specialised area, the FFA. The only reason we see a face in the simple curved outline is because our brain draws on the memory of faces we have seen earlier to complete the silhouette. In a similar way the line of the accidental fissure would have activated the part of the brain where all earlier images of large quadrupeds were stored, would have found a match with a bear seen from above in three-quarter perspective and so would have given the viewer the imaginative experience that that was what he or she was seeing. That experience could then be turned into a real visual experience by the application of pigment.

Neuroscience and Chauvet: Style

Naturalism

This painting process would have been fuelled by the reward system, as each enhancement of the correspondence between the image and the visual memory was accompanied by the release in the brain of one of the neurotransmitters that drive all the actions that are vital for our survival. The particular chemicals involved in such different activities as competing with a rival, searching for food or pursuing a sexual partner may have been different, but in each context the release is apt to increase until the goal whose attainment it fuelled is achieved. Sometimes, as when dealing with animals that are either dangerous or a potential food, the release may be a response acquired as a consequence of living in a particular environment, in others, as in the case of male exposure to the sight of female genitalia, it is inborn, though susceptible to reinforcement with experience. The images of female genitalia at Chauvet are thus likely to be the product of the same sequence as that proposed for the images of animals. In

each case a process of continuous positive chemical feedback from the manual interaction would have been liable to continue as long as an increase in the resemblance intensified the chemical reaction. The process might stop only when the chemical reaction could not be strengthened further. In each case the point where this occurred might be different but, when the engagement established by the artist's neural networks was particularly intense, the point might be some notional one of 'sufficient' correspondence to the object represented, such as might be established by the completion of a head or the silhouette of a whole body. In this way an unconscious feedback process could lead to the production of a highly naturalistic representation or artwork, without any teaching, guiding or other social stimulation. Or, to put it another way, such an image might be produced completely spontaneously, due only to the interaction of key elements of our neural make-up, especially the motor resources controlling the hand, the perceptual resources supporting vision, and the chemical resources that linked them in pursuit of a particular goal.

Since this explanation for the naturalism of the Chauvet images in terms of the operation of unconscious neural processes is so challenging in its premises, it is worth evaluating it against its principal alternative, which assumes that it would have been impossible to generate images of such quality without the support of a highly self-conscious culture. The latter assumption is not an easy one to refute, principally because the details of how a self-conscious culture might suddenly have produced such art has never been spelt out. All we have is a general assertion that the beginning of the Upper Palaeolithic was marked by a 'big bang', a quantum leap in human achievements by which the new inhabitants of Europe, thanks largely to a rapid expansion of language use, arrived in a short space of time at a level of self-consciousness that somehow anticipated the intellectual attainments of ancient Greece, the Italian Renaissance and Modernism. Strangely, too, if those who propose this view are asked what is the evidence that there was this 'big bang', they are likely first of all to point to the art. Their claim that the art was the product of a newly verbally articulate and self-conscious culture is based on little more than the assumption that without it such images would have been impossible.

Does the evidence support that view? We can compare it with the evidence associated with periods when such quantum leaps really were achieved, ancient Greece and the Italian Renaissance. In both these contexts where there is material evidence of a rapid increase in artistic naturalism over a period of two or three hundred years there is also evidence of powerful social pressures and craft competition associated with rapid urbanisation, not to mention of a dramatic increase in the role of language in the formation of culture. There is no such evidence in the early Upper Palaeolithic. Only in the later Upper Palaeolithic, around 14,000 BC, is there evidence for art production being associated with rapid social change. At that date not only is there robust evidence for high population densities in south-west France and the other areas of Europe in which art is found, but there is also evidence for the sharing of cultural practices in such fields as bodily adornment, to say nothing of painting, engraving and sculpting. In the Chauvet area around 30,000 BC there is none. Not only is there no evidence of a high population density, no habitation sites at all having been found nearby, nor is there any evidence from the cave's undisturbed floor that the cave was much visited. The same is true of what we know of other areas. The impressive earlier small sculptures from southern Germany, and the later body ornaments from Sungir in modern Russia, are isolated phenomena. There is some art from sites such as Aldène, Arcy-sur-Cure, Baume Latrone and Castanet, as well as from Fumane in Italy and Altxerri in Spain, not to mention from the Maros Pankep area of Sulawesi in Indonesia and perhaps Australia, but it is small in quantity, limited in quality and diverse in technique, hardly comparable with Chauvet, and certainly not suggestive of a widespread culture of discussion and imitation.

It is, of course, true that such evidence for similar art might simply have been lost. After all, until the Chauvet Cave was discovered, no one could have guessed at the evidence it contained. Such a total loss of comparable art, though, looks increasingly unlikely. The caves of southern France have been explored in a thoroughly systematic way and they offer optimum environments for the preservation of all types of remains, as the myriad images in hundreds of caves in the region from five, ten and twenty thousand years

later testify. However, the clearest evidence that there was no elaborate culture behind the art of Chauvet is the contrast in character between it and all this later art. If the naturalism, shading and three-quarter perspective of Chauvet were the product of social formation, we should expect to find these features recurring in some at least of that later imagery. This does not happen. Whatever the merits of the most admired examples of later Palaeolithic art, whether from Pech-Merle, Lascaux or Altamira, none shares the remarkable 'photographic' properties of many images from Chauvet. At later periods when naturalism and perspective are found, as in Greece around 400 BC or in Italy in 1400, we find both timid precursor images and confident successors. Before and after 30,000 BC we find neither. Seen in the context of the whole history of art, the imagery of Chauvet is like something captured in a brief moment of stroboscopic illumination.

There is only one aspect of Chauvet that might be thought to undermine this notion that the art-making was driven less by conscious intentions than by reward mechanisms. This is the way that in one area of the cave, now known as the Panel of the Horses, the wall has been scraped bare. Because this seems to anticipate the way a modern artist prepares a canvas it might be taken to indicate a similarly socially framed behaviour, but if that were so we would expect to find evidence of a similar behaviour in many other caves, which is not so. So how might it be explained neurally? There are several places in the cave where images are repeated, as if the artist has been amazed at his or her production and tried to repeat it. This seems to have happened with our bear image (see fig. 5), which, as described, was initially suggested by markings in the rock that corresponded with the outline of the forepaw of a bear seen from above. The presence of a bear muzzle seen from exactly the same angle just in front of the original image and of a more complete image further back makes it look as if someone wanted to see if they could make something similar with less aid from the surface of the cave. Arguably, that would have increased the neurochemical reward, as with a child who for the first time rides a bicycle unaided. If this is so it is possible that one of the image-makers deliberately cleared a section of wall surface so that there was no suggestion from stains, cracks or relief. Since the paintings of aurochs and horses subsequently executed on that surface were certainly based only on the unaided promptings of the artist's neural networks, he or she is indeed likely to have experienced an increase in the neural reward obtained, as, for example, would an individual who first found a particular food without the help of a parent. Since such neurochemical rewards for unaided success are favourable to our survival, they are part of our genetic make-up, reducing the need for rewards that are social. There may, of course, have been some social reward for the cleaning of the wall surface, but if there was it is incumbent on those who propose it to reconstruct the social framework out of which it emerged.

Neuroscience and Chauvet: Subject Matter

Envy as Inspiration

The paintings in and around the Panel of Horses share with others in the cave a sense of wild life captured as if on film, and this offers further powerful resistance to the argument that the imagery is the product of belief systems, language use and social formation. While the almost hieratic friezes of horses at Lascaux (see fig. 9) or the serried bison on the roof bosses at Altamira suggest a community's concentration on and celebration of particular forces within nature, the mobile and mixed dispositions of animals at Chauvet are hardly compatible with any belief system or cosmology. Rather, they offer an image of the chaos of nature in which each creature has its place: horses stand peacefully, rhinoceros threaten, lions stalk and run, bison confront, and so on. No animal is accorded greater respect than the others. As in nature, a wide variety of life-forms inhabit and enjoy equal rights in the same space, each with its own concerns and each distinguished by its own physical attributes and mental resources.

This attunement to each creature's distinctive properties is one of the main keys to an understanding of the neural antecedents of the imagery's emergence. If it does not have its origin in a conscious belief system, a mythology or cosmology, from what unconscious experience could it have originated? The answer lies precisely in the imagery's common theme. We might have expected the animals represented to

17　Long-eared owl viewed from behind, finger marks, *c*.30,000 BC, Chauvet Cave, Vallon Pont d'Arc, Ardèche

be those that excited the greatest fear or desire, the most dangerous predators and/or the most attractive game, but they do not fit these categories. They do all excite one emotion, but it is neither fear nor desire but admiration, even envy, bred of an intense empathy. The animals are those of whom those who represented them were most envious, and it is the attributes of which they were most jealous that are the most prominent. These include not just their weapons and tools, the horns of rhinoceros and bison, the antlers of cervids, the tusks and trunks of mammoth, the strong skin and thick fur of all, but their mental capacities, the slyness, strength and speed of the lion, the persistence and shrewdness of the bear, the sensory alertness of the horse. The admiring envy of physical and mental resources is perhaps best expressed in the engraved owl (fig. 17). It is shown from the back but with the face turned towards the viewer. This brings out the extraordinary flexibility of its neck which gives the bird its remarkable 360-degree visual field, with its prominent eyes

alluding to its remarkable night vision, and its display tufts, which were probably misinterpreted as its ears, suggesting its equally remarkable auditory faculty.

Why should animal-envy have been so potent in this community? Humans had, of course, always lived with animals who possessed physical and mental equipment that was in various ways superior to their own, and the new lighter larger-brained species had already been exposed to them for tens of thousands of years in Africa and beyond, but their arrival *c*.45,000 BC in sub-arctic northern and western Europe made them look at them with a new intensity. Finding themselves in an environment that was so severe that they could not opportunistically vary their diets, but were forced to maximise their consumption of their fellow large mammals, an area in which fire alone could not keep them warm because of their need to spend time outside, their visual attention was inevitably drawn to the many rival life-forms with which they were surrounded and especially to their different resources for dealing with similar problems. Delicate creatures from the tropics, their hairless bodies protected only by thin skins, and armed only with small teeth and fragile nails, they were surrounded by creatures vastly better endowed in all those attributes, and it was with these endowments that they empathised. It is thus probable that it was repeated and intense gazing at these endowments that equipped them with neural resources for the visual perception of animals that were far stronger than those of any of their predecessors or contemporaries elsewhere on the planet. It was these resources that guided their hands as they moved over the walls of the cave, and it was from these resources that they virtually 'printed' their images.

Neuroscience and Chauvet: The Role of the Site

Everything that has been said so far would apply to many of the limestone caves of the early Upper Palaeolithic; so why was similar art not produced in the other caves that shared the same properties and that humans are likely to have visited around the same time? As we have seen, the improved neural apparatus of the new light-boned, big-brained human type, *sapiens sapiens*, would have made all members of this species

who moved into the new hostile environment more likely to indulge in artistic activity, especially if, as at Chauvet, they were confronted with a special combination of cave-bear markings and visually stimulating wall surfaces. But this combination was found in many places in south-west France and nowhere else produced comparable effects. Was there anything special about this particular site that might account for the uniqueness of the response it elicited?

In our search for an answer neuroscience leads us to look for a reason why individuals in this particular area might have spent more time looking at animals than their contemporaries elsewhere, and one unique feature of the cave's environs is likely to have had precisely that effect. The natural rock arch in the landscape immediately below the cave entrance, after which the present town of Vallon Pont d'Arc is named, is one of only a few in the world that bridges a fast-flowing river and its situation, close to the point where the Ardèche enters the Rhone, would have given it a potential role of unusual significance in the context of Ice Age Europe (fig. 18). At this period the severity of the climate would have forced the herds of herbivores, along with the carnivores who preyed on them, to migrate northward in spring and southward in autumn each year in search of food, and the rock bridge is likely to have presented an easy transit over the obstacle of the watercourse which ran from west to east. This would have made the spot a particularly suitable site for occupation by equally predatory humans. Significantly, too, for the archaeologist or art historian wanting to understand the particular neural resources of the artists in the cave, the bridge would twice a year have presented those humans with an unrivalled opportunity to view in safety a procession of the animals whose resources they envied. The principles of neuroscience ensured that some at least of those who witnessed that sight would certainly have acquired neural networks better attuned to the perception of large mammals than anyone living elsewhere.

This explanation for the startling emergence of representational activity in this particular cave is supported by a number of the other features that make the products of that activity remarkable. One of these is the way in which animals are in two cases grouped in tripartite panels around arches, one round the Alcove of the Lions in the Horse Sector and the other around a niche containing a horse in the End Chamber (fig. 19). The latter, which contains the richest collection of animals in the cave, is striking not only for its composition round the arch-like niche but also for the way the mammoths and bison at the right and the rhinoceros at the left seem to be climbing up, as if negotiating a mountainous landscape, while another mammoth stands at the top. The suggestion that the scene recalls one of migration is reinforced by the way it is framed on both sides by a dense and dynamic frieze of animals otherwise unknown in prehistoric art. Another feature of both these panoramas is the way that animals are often shown superimposed on each other but moving in opposed directions. This happens, for example, both in the case of the rhinoceros to the left of the horse niche and the reindeer to the right of the Alcove of the Lions (fig. 20). Seeing an animal moving in one direction might have brought back the memory of a similar movement in the other, something that would have been more likely to occur given the way the neurons in V5 which detect movement in one direction tend to inhibit the activation of neurons detecting movement in the opposite direction. All these puzzling features of the unique frieze over the niche become explicable once we recognise that those who made the images did so only because of the way their neural networks had been configured by repeated exposure to a varied procession of animals migrating over the rock arch. So robust were the networks in the brains of those who had witnessed this spectacle that when they were confronted by a similar, though much smaller, arch in the cave, they found themselves imagining the procession of animals with which that particular form was associated in their visual memory, and their hands itched to re-create it. There were many contingencies contributing to the emergence of representation at Chauvet, but the most decisive was the distinctiveness of the surrounding landscape.

All this helps us to understand why this cave should be the only one filled with such imagery at this early date. It also sheds light on why that imagery is so life-like. We have seen that there were good reasons why humans anywhere in Ice Age Europe would have given unprecedented attention to the animals with which they shared that environment. We have also established that the site of Chauvet offered an

18 Rock arch over river, Vallon Pont d'Arc, Ardèche

unparallelled opportunity to do so. Looking from the area not far from the mouth of the cave towards the arch, their experience would have been like that of someone captive in a cinema, watching endless wildlife films. The expertise in animal behaviour that they would have built up through such purely passive exposure would have been unrivalled. So too would have been the detail and the definition of the pictures embedded in their neural resources. We can now better grasp why the art of Chauvet, unlike all later cave art, does truly resemble a film. Not only is there a rare sense of animals moving in a single direction as in a film of herds migrating in the Serengeti, but also we sometimes, as in the case of the lions to the right of the niche in the End Chamber, find ourselves looking over their shoulders as they

race past us and away, recalling the experience of a viewer in a fixed location watching animals recede into the distance. Nothing like this is found in later caves, where the animals, whether singly or in groups, all seem to be directly in front of us, parallel to what would later be called the picture plane.

Also unlike anything found later is the sense not merely of landscape but of organised composition. In later paintings animals may be arranged singly or in groups, but they cover the wall in a manner that is additive, not integrated. There is nothing later to compare with the sweep of different species moving from right to left, each jostling the other, each with its own momentum, alternately speeding up and slowing down, its drama in counterpoint with the single horse, a still focus underneath in the centre. To find a composition

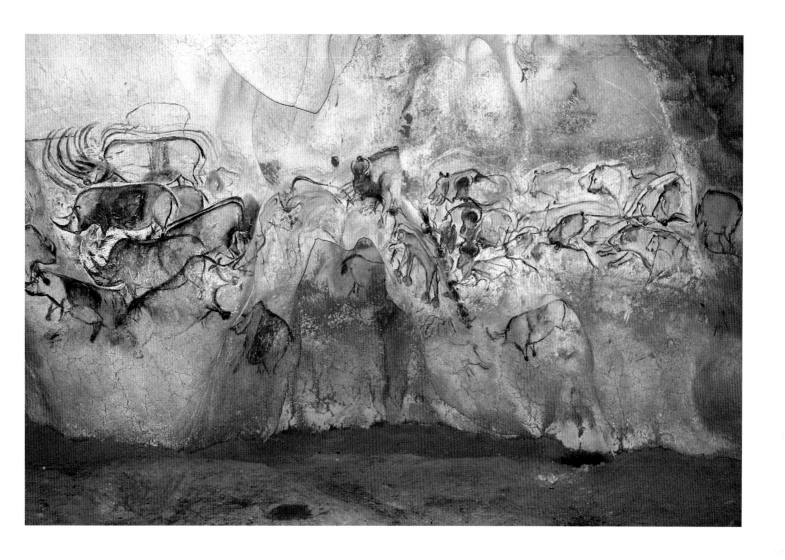

19 Niche with frieze of animals, c.30,000 BC, 'End Chamber', Chauvet Cave, Vallon Pont d'Arc, Ardèche

20 Animals moving in opposite directions, pigment on rock, c.30,000 BC, Chauvet Cave, Vallon Pont d'Arc, Ardèche

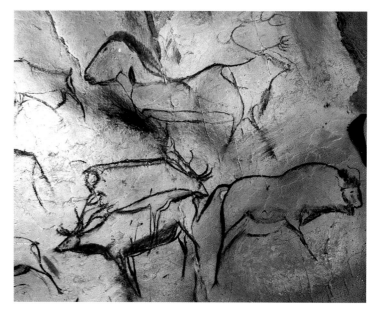

of such rich articulation we again have to turn to Greece around 300 BC and a scene such as the *Battle of Alexander and Darius* (see fig. 54) known today through a later Roman mosaic. By then we can trace the origin and organisation of such compositions to the competitive skill already found in such works of literature as the epics of Homer or the tragedies of Sophocles. At Chauvet the composition owes its integration and complexity only to the repeated witness-

ing of one of the grandest of nature's scenarios, the seasonal migration of many types of animal facing the constraint of a major natural obstacle.

Some Conclusions

On Art

If the argument presented here is accepted, it leads to some conclusions that many will find surprising. One is that the qualities of the paintings at Chauvet are the product not of an assumed verbally articulated culture shared across a wide area of Europe, but of a unique set of contingencies. The members of a new human species, having settled into an inhospitable environment, one far more challenging than those they had occupied before, with their visual networks fundamentally reshaped by the sight of animals migrating over the rock arch and their mirror neurons activated by the sight of the marks made by bear claws and paws, were provoked into adding to the extraordinary visual richness of the cave by their memory of how similar linear and colouristic effects had been achieved by their own hands.

This argument explains the uniqueness of Chauvet. It may also be applicable elsewhere. The much less impressive or substantial art found in other caves of the same period such as Aldène, Arcy sur Cure, Baume Latrone and Castanet, as well as from Fumane in Italy and Altxerri in Spain, may be the product of a similar interaction between the neural resources of the new human species and the European environment, but one that was less productive because of the absence of key elements, such as the viewing possibilities offered by the rock arch, or the intense cave-bear activity. Indeed, it follows from this argument that, since other powerful, though different, conjunctions may have happened at any time, with similar, though again different, consequences for art production, artistic activity is likely to have emerged spontaneously in any number of places at different periods, wherever *Homo sapiens sapiens* lived. A suggestive example are the recently discovered Nerja cave paintings in southern Spain in which neural networks laid down by looking at seals were so activated by the similar forms of stalactites that those who possessed them printed images of the animals on the vertical rocks. But in sites other than Chauvet the resulting images are always more cautious and tentative in their execution probably because they were not the product of such repeated and intense looking.

While one conclusion to draw from this neuroarthistorical argument is that we should expect representational art to have emerged spontaneously many times, another is that we should expect later representations to be less naturalistic, which is exactly what happened. This last point, that the later art is in many ways less effective in capturing the vitality of its subjects, will puzzle those who are used to considering the history of art as a story of progressive improvement brought about by the conscious effort of makers to respond to social criticism by viewers. To someone writing a history of art based on the principles of neuroscience it is not just comprehensible but predictable.

If it was a particularly intense visual exposure to real animals that created the neural networks that guided the hands of the artists at Chauvet, then the progressive increase in the number of painted images that flowed from their hands would have resulted in the formation of different neural networks shaped by different experiences. The networks of later artists would have been shaped less by the alert observation of such subtleties as the way fur moves over skin over muscle over bone on a live creature, and more by self-flattering admiration for the outlines filled in with ochre and carbon and the engraved silhouettes that they had themselves created. The neurochemistry that gave them such pleasure when looking at the first images that they produced made it difficult for them to create such life-like images afterwards. A hand guided mostly by neural networks formed by exposure to art would necessarily produce results that were less naturalistic and more schematic.

We can see this happening even at Chauvet. Those who made the paintings frequently repeat themselves, as already noted in the case of the bear muzzle, and, in consequence, we often find particular representational devices, such as the way a rhinoceros' horn or a lion's brow is drawn, recurring again and again (fig. 21). Often traits become exaggerated, as in the lengthening of the rhinoceros horn, as might be expected from the operation of the neurally based 'peak shift' phenomenon discussed by Vilanayur Ramachandran in 1999.[4]

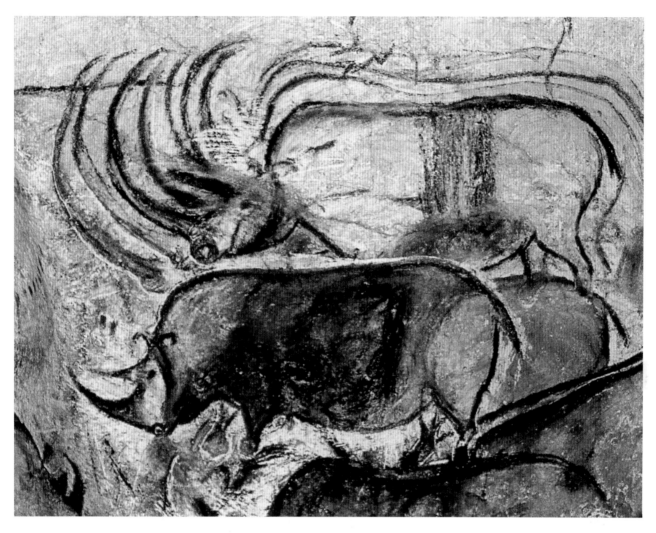

21　Rhinoceros and lions repeated, painting, pigment on rock, *c.*30,000 BC, Chauvet Cave, Vallon Pont d'Arc, Ardèche

Those who painted the first images and who necessarily spent some time looking at them would have been the first to have had their networks reconfigured by such exposure. For those who came after them the process can only have accelerated, though with considerable variation in the neural consequences, as some artists looked more at real animals, while others looked more at painted representations. The more time someone had spent looking at art and the less at live animals, the more their work would have become stilted and formulaic; the more they looked at animals, the more it would have been naturalistic. Often different individuals with the two types of networks might contribute images to the same cave, as seems to have happened at Chauvet. This is

why both here and in later caves there is a great variety in the way representations are made. The stylistic variety of Palaeolithic art and the absence within it of a simple stylistic progression, features which have become increasingly clear over the years, have puzzled, even annoyed, scholars, though not Lorblanchet, who has a more open-minded approach than many. To the scholar who follows the principles of neuroscience, the simultaneous expression of both naturalism and schematisation is no more than one would expect.

Nor is this the last time this happens. The phenomenon is familiar throughout the history of art, for example in Renaissance Italy. Giotto and Michelangelo both produced work of a new freshness and naturalism because they looked more

closely than their predecessors at real human beings, but once their paintings had achieved celebrity and began to attract admiration and imitation, many of the artists who came after them were inclined to look not, like their masters, at live bodies but at those masters' paintings. As a result, the work they produced looked less like a live body and more like a body painted by Giotto or Michelangelo. Others, by contrast, did look more at nature, which is why much of the later European art that was most admired, from seventeenth-century Holland to the French Impressionists, was produced by artists who looked less at the work of other artists and more at the world around them. Still, in their case too, success had its negative consequences, and neuroscience helps us to understand why, again, the admiration that their works attracted ensured that their qualities did not survive their makers.

On Language

The argument advanced here proposes that the first phase of large-scale two-dimensional representation, including the time and place of its emergence and the character of its development, can be largely explained in terms of the neuroscientific principles governing the human visual and motor systems. We have not needed to invoke the role of language, but we should at least reflect on its possible influence. After all, as David Lewis-Williams says, reflecting a common assumption, 'There is no doubt in any researcher's mind that Upper Palaeolithic people had fully modern language'[5] and, if that is so, we should at least consider what its role might have been in the context of the account of European Palaeolithic art just presented.

One way to do so is to look for evidence of language's role in the content of the representations. What do they suggest? After all, a visual representation has something in common with a verbal description; so we should be able to learn something about verbal description in the Palaeolithic from the visual representations from the same period. If we ask ourselves what language we would need in order to produce a verbal equivalent of a Palaeolithic image, the immediate answer is nouns such as 'bison', adjectives such as 'big' and intransitive verbs such as 'runs'. What is missing, not just in the earliest art but in all the tens of thousands

of examples of the many different varieties of later Palaeolithic art, is any clear example of a representation that would require a transitive verb, that is a verb that takes an object, for its description. There is not a single indubitable representation of a noun–verb–object relation, such as a human or an animal doing something to another human or animal. There are no incontrovertible scenes of something attacking, killing or eating something else, or of a woman giving birth to a baby. Nor is there any scene suggesting that 'because this happened that happened', for example, 'because this animal or human appeared this other animal or human ran away'. There is no scene of cause and effect, none in which one thing has 'power' over another, none even of narrative sequence, such as 'this happened after that'. The example most often adduced as an exception to this rule serves, by its weakness, to confirm it. This is the scene in the shaft at Lascaux showing what might be a disembowelled bison in threatening proximity to a recumbent man. If any narrative is intended it is only suggested by juxtaposition. There is indeed in the whole Palaeolithic no direct illustration of cause and effect such as are found in increasing numbers all over the world after 10,000 BC (see figs. 27 and 28). In other words Palaeolithic art provides much evidence for description, none – or almost none – for narrative.

This does not, of course, prove that narrative did not exist. Visual art and verbal language might have been two separate domains with little or no influence on each other. However, since the prevailing view is that the clearest proof of the importance of language is the wealth of representational art, we should expect that art to betray the influence of the domain to whose importance it is supposed to testify. More particularly, since the common view is that the representational art of prehistory demonstrates the existence of such phenomena as shamanism, religion and cosmology, we would expect to see in the art some evidence of the type of language on which such systems always rely. Now, all currently known versions of those systems rely precisely on narrative, on stories of causation, on tales of differentials of power. They all depend on what we call myth. Yet, none of these is evidenced. Again, it could be pleaded that we are not adept at reading the imagery. Perhaps, when animals are shown running one behind the other or standing beside

each other, a narrative or tale of power differential is alluded to but not represented. This certainly happens in later art, that produced after 10,000 BC, and would have been possible in the Palaeolithic, but in that same later art there are also many clear illustrations of subject–verb–object relations, narratives and tales of power differential, as can be seen in paintings from Spain, South Africa and Australia. It would surely be extraordinary if Palaeolithic art depended on story and myth but never illustrated such narratives directly, as did so much later imagery.

This argument, that those who made the first art did not have elaborate language use, finds some support in modern clinical studies. Only recently, in 1998, the psychologist Nicholas Humphrey noted that not only is there a remarkable similarity between the freshness of the art of Chauvet and that of an autistic and virtually languageless patient, Nadia (fig. 22), but that, as Lorna Selfe, who studied her originally, had noted, when Nadia acquired a greater facility with language her artistic talent declined.[6] This led him to argue that the quality of the art of Chauvet is an indication that its makers were similarly deficient in speech use. We associate the complexity of art, as of other cultural products, with articulate language, and they have certainly been so associated for the last ten thousand years, but, if we follow Humphrey, the nature of the earliest art suggests that its quality depended rather on the degree of language's absence.

22 Nadia drawing when about five years old (Lorna Selfe, *Nadia: A Case of Extraordinary Drawing Ability in an Autistic Child*, London 1977, p. 27)

On New Material and Mental Technologies

Besides the presence of art, the other features of the early Upper Palaeolithic that are seen as inconceivable without the elaborate use of language are the rapid advances in material and mental technologies which facilitated a much greater exploitation of the environment. As in the case of art, a neurally based approach has to show what it can also contribute to an understanding of the emergence of these crucial attributes. The explanation for the emergence of artistic activity proposed earlier saw it as the product of the interaction of the complex and flexible neural networks of *Homo sapiens sapiens* and a particularly rich, but particularly stressful, environment. It is possible to extend that explanation to deal with the new problem. One of the most important discoveries of neuroscience is that the operation of mirror neurons is correlative with complex empathy. That is, the stimulation of the pre-motor cortex in the viewer of a movement is associated with an understanding of what that movement means to the viewed, its purpose and value. This finding is of particular help to us as we try to understand the emergence of new material and mental technologies. The more humans looked with admiration at the tools and the intelligent behaviours of their fellow animals, the more they would have understood their value to them. Indeed, members of Damasio's team at USC, in a paper entitled 'Neural Correlates of Admiration and Compassion', after noting that admiration for physical skill in someone else activates not only the brain's default mode network but muscular skeletal networks, conclude that the experience of that emotion produces a sense of

heightened self-awareness that 'incites our own desire to be …skillful.[7] The admiration that we saw as the main driver of visual attention in the artists of Chauvet had consequences that went far beyond the field of art.

The consequences for tool-making are most obvious. As humans gazed at other animals' attributes, without realising it they became aware of the value of their respective properties, the warmness of fur, the hardness of hide, the tenacity of claws, the strength of tusks, the sharpness of horns and the manifold functionalities of different types of teeth. As they observed how mammoth used their tusks, rhinoceros their horns, lions and bears their claws and teeth, bison their horns and reindeer their antlers, they would have empathised with their capacities for piercing and tearing, scraping and cutting, penetrating and levering. With their pre-motor cortices activated to empathise with these activities, they would have been more inclined to adapt the stones and sticks that they had long used as tools to mimic the more specialised functions they observed in the animal world, and to go on to create such composite instruments as harpoons and spear-throwers. Similarly, seeing how spiders spun webs to trap their food and birds wove fibres into nests to protect their young, they would have found their hands doing what birds did with their beaks and arachnids with their legs. In other words, they would have been liable spontaneously to develop textiles, ropes, baskets, traps and nets. Seeing how other mammals were protected against the cold by warm coats they would also have wanted their own, beginning by taking them from the creatures they envied the most, and then imitating birds and insects by cutting and fastening them together. Archaeologists have tended to assume that the improvements in material technology that characterise the early Upper Palaeolithic are, like the art, the product of conscious analysis, verbal exchange and social co-ordination. Such factors may have played some part in the development, although no hard evidence has been adduced that that was so. A better founded – and more intellectually economical – explanation is that suggested by a knowledge of neuroscientific principles. Those improvements were all largely 'spin-offs' that arose naturally as a result of giving exceptional visual attention to the 'technologies' of other animals.

Of those technologies none was more important than those of the senses, that is the acuities of eye and ear and nostril, and the integrating function of the brain, where the inputs from the senses were, as always with animals, turned into motor outputs appropriate to an animal's survival. The focus on the mental techologies of animals is most evident in Chauvet's images of lurking lionesses and prowling bears (see figs 5 and 7), the uniqueness of which it is hard to overstate. Such paintings capture those creatures' sensory alertness and intelligence in a way that is exceptional not just in Palaeolithic art but in all art, and not just in art representing animals but that representing humans too. Look again, not just at the art of the great *animaliers* of the nineteenth century, but at the human imagery of ancient Greece and of the Italian Renaissance, periods at which conscious intelligence was most consciously valued, and we find no face of a philosopher or Father of the Church that captures intelligence as well as these images. The imagery of Chauvet conceals no more sobering insight than this, that intelligence is best captured not by reflection articulated in words, but by intense visual attention. This is because our brain is adapted by evolution to function best when attending to the world visually. Words may be the best vehicle for the communication of knowledge and thought, but the richest verbal products of the mind, whether the poetry of Shakespeare or the theories of Darwin, owe the insights they contain about their subjects above all to intense visual attention.

What applied to material technologies also applied to social ones. As humans observed the behaviours on which other species depended for survival, whether they were prey-animals or predators, whether their expertise was in defence or aggression, they would have found their own already strong sense of the advantages of co-operation, team work, the division of labour and leadership further heightened. They would thus have empathised as much with their mental as with their physical resources, and doing so would have brought them comparable benefits. It would also have yielded further indirect rewards of great importance for the future history of culture, providing the source for many beliefs that later became prevalent. Habitual empathy with the mental resources of other animals is thus likely to be the source of a sense of 'spirit transfer', that is, some sort of

mental exchange with another creature, and it was a consolidation and social exploitation of that sense that eventually encouraged the establishment of such practices as those associated with shamanism and totemism. We may see an early stage in the formation of such practices in the roof of the cave of Altamira around 14,000 BC where rows of bulls suggest a community's sense of affinity with a single animal-type. All this would have happened simply as a consequence of the interaction between the neural networks of the new species and a new environment. For this to happen there would have been no need for language-based reflection, instruction or narrative, although language would certainly have played an increasing role in consolidating the response.

Archaeologists are thus right in seeing the art of Chauvet as being the clearest evidence for the 'big bang', but not for the reasons they suggest. Chauvet is evidence of the 'big bang' not because it testifies to the existence of an elaborate verbal culture but because it provides certain evidence for a type of visual attention in the Upper Palaeolithic that was so intense, and so focused on the resources that enabled other animals to survive, that it sustained humans in the development of new and vital material and mental technologies of their own.

Final Conclusion:
The 'Big Bang', the Eye and the Brain

Such a perspective was anticipated by Ramachandran in an early article on mirror neurons. In it he envisaged 'that the so-called "big bang" occurred only because environmental triggers acted on a brain that had already become big for some other reason and was therefore pre-adapted for those cultural innovations that make us human'.[8] He did not speculate about what those triggers might have been, but the scenario presented in this chapter is consistent with his hypothesis. Implicit in his celebration of the role of mirror neurons is a recognition of the importance of the looking that activates them. This means that it was not language but looking that led to the dramatic changes in behaviours that characterise the Upper Palaeolithic. It was a new intense looking that lay behind the emergence of new physical and mental resources.

Intense looking also lay behind the emergence of representational art. Indeed, the two types of looking were intimately connected. It was empathy that led our ancestors to look at the life-forms with which they were surrounded with such intensity that their neural apparatus was transformed, and it was this transformation of their neural apparatus that led to them seeing and representing animals on the walls of caves and in pieces of ivory and bone. This is why it is not surprising that the range of the fauna represented at Chauvet – or for that matter in the slightly earlier figurines found at Vogelherd and elsewhere in the Swabian Alps of southern Germany – precisely matches that of the animals with which their empathy would have been greatest.

Many were the attributes of their fellow creatures with which the members of these communities empathised, but perhaps one attribute engaged them above all, their capacity for visual attention. They looked intently at animals that were themselves looking intently. They may have desired their horns and claws, their thick skins and warm furs, but most of all they will have found themselves valuing their visual alertness and hunting intelligence, as particularly exemplified in the highly focused lions and bears (see figs 5 and 7). The tools they envied most in the animals they lived with were the neural linkages between their eyes and their brains. It was watching animals who were looking intently that activated their mirror neurons, so teaching them to look intently too, and it was this intense looking that affected the plasticity of their neural networks in such ways that they projected life-like images on the cave walls.

Neuroarthistory thus suggests an explanation for most of the remarkable properties of these images. Other approaches can explain neither style nor subject matter, neither why these works were painted at this date nor why in this particular cave. All other explanations assume that these works owe their quality to their being the result of a long process of artistic development of which the traces have been lost, the reflection of an elaborate belief system of which we have no other evidence than the art, one formulated and shared within a verbally articulate culture, which has left no other trace that substantiates the claim. Such assumptions, which are so established as never to have been questioned, can explain neither why these works are so fresh and visu-

ally engaging nor why later works, which are certainly the result of a long process of tradition-formation, and which, by the Neolithic, are also the product of a verbally articulate culture, do not rival them in these properties. Our brains, like the brains of all animals, are primarily designed to enable us to maximise the benefits of our sensory equipment. Much the most important element of our sensory equipment is our visual apparatus. Our remarkable intelligence is principally expressed in our intelligent looking. It is intelligent looking that produces the greatest early art. It also produces the greatest modern science. Language has a powerful influence on art's history, but it is not as essential as we are used to thinking, either for its miraculous origins or its manifold development. These depend to a surprising extent on neural processes of which we have been unconscious until they were revealed by neuroscience.

2

Origins of Architecture
Home Sweet Mammoth at Mezhirich

Mezhirich, in the Dnepr basin in modern Ukraine, has a position in the history of architecture almost as remarkable as the Grotte de Chauvet on the Ardèche in the history of painting, not because the houses made of mammoth bones that were found there were unique, but because their preservation is exceptional.[1] The four houses, dating from around 15,000 BC, were excavated there in the 1960s and presented to an English-speaking readership in a series of important publications by Olga Soffer. They employ a staggering amount of mammoth bones, Dwelling 1 (see figs 25 and 26) 21,000 kilos of them and Dwelling 4 15,000 kilos. Although the builders must also have used substantial amounts of wood to support the roof, the principal material is mammoth bone, and the amount of it makes it likely that their construction involved the participation of several individuals and that they were occupied for many years, though not necessarily through all the seasons. Their construction certainly required intense engagement by their builders and, even if the reconstructions by the excavators overstate their regularity, it is certain that this engagement involved a complex co-ordination of neural resources, especially those critical components of the sensual and the motor domains, the visual and the manual. It is because the traces of that engagement are so clear, and because these are the earliest surviving buildings that make extensive use of permanent materials, being several thousand years older than the first stone buildings at Göbekli Tepe in Turkey, that it is important to extract the design principles involved and, if possible, reconstruct the neurological processes in which these are based.

The Emergence of Architecture

Architecture is less uniquely human than large-scale two-dimensional representation. Many other creatures make homes that have something of the substance, organisation and complexity of buildings made by humans. Still, in almost all cases their layout is the product of behaviours that are manifested by all members of the species, being the product of neural resources coded for in a shared DNA. The building of a semi-permanent nest by a particular bird and the construction of a mound by termites are examples of such behaviours. In other creatures, in contrast, for whose survival a semi-permanent home is not essential, their distinctive genetic material carries no such coding. *Homo sapiens* and our primate ancestors are such creatures and, still today, there are human populations that only occasionally build a shelter. This, though, is increasingly unusual. Most make constructions that are far more complex and substantial than those found elsewhere in the animal kingdom. It is such complex and substantial structures that in European languages are dignified by the designation architecture, and it is the origin of such structures that is the concern of this chapter. The origin is the more important because substantial permanent architecture is a distinctive feature of Europe from an early date. Stone was used for large-scale temples on Malta from the third millennium BC, for structures like Stonehenge a millennium later and was widely used in the Aegean from the Minoan and Mycenaean periods, before becoming the main building material in Classical Greece.[2]

In looking for the neural roots of this tradition a natural place to start is with the neural plasticity and the neural mirroring we found were important for the origins of representation, and in particular with the empathy with the properties of other life-forms and materials that seemed crucial for the development of material and mental technologies. This we can see at work even behind the first attempts at building among our nearest primate relatives, the chimpanzees and gorillas. They construct beds to sleep on out of branches and put large leaves on their heads during rainstorms. When they do so, they are evidently empathising with and exploiting the properties of the trees on whose limbs they had long rested and under whose canopies they had sought shelter. In this way they came to develop the first furniture and the first roofs, or hats. Similar factors were behind the first European buildings, the huts constructed by Neanderthals near Nice in the Lazaret cave around 100,000 BC and at Terra Amata. They may have relied on rows of branches being leant together and, if these were covered in skins, as has been argued, this is likely to have originated in the mirroring of rival animals. Humans must always have looked enviously at the fur coats of their rivals, imagining themselves with similar protection, and that imagining is likely to have led them to begin to cover themselves with such skins. A similar unconscious neural response is at work when a monkey imitates the jacket of a human by putting a cloth over its shoulders. For humans the result was that they first developed rudimentary clothing, and later went on to drape such skins over timber supports.

Architecture and the Mammoth

The superior resources of *Homo sapiens sapiens* may have at first had little impact on their home-making activities after their arrival in Europe, especially where they had access to caves, as they did in southern Germany and France. In the territories further east, however, the interaction between neural resources and environment had important consequences, especially as the harsh climate became still colder towards 20,000 BC, with the use of mammoth bones in hut constructions becoming increasingly prominent in the large area that stretches from the Czech Republic to Ukraine between 25,000 and 10,000 BC. It would be possible to explain this use of the bones of pachyderms as simply the consequence of the availability of large supplies of that material at a time when the combination of a lowering of temperature and an associated decline in humidity reduced the growth of trees, causing a shortage of timber, but the characteristics of the resultant constructions suggest that something more was going on, something provoked by their going inside the great creatures, standing or crawling under their ribs to extract their organs. Certainly, the new type of hut shares conspicuous design properties with the mammoths themselves and this could indicate that those who made them had, as a result of such exposure, unique neural

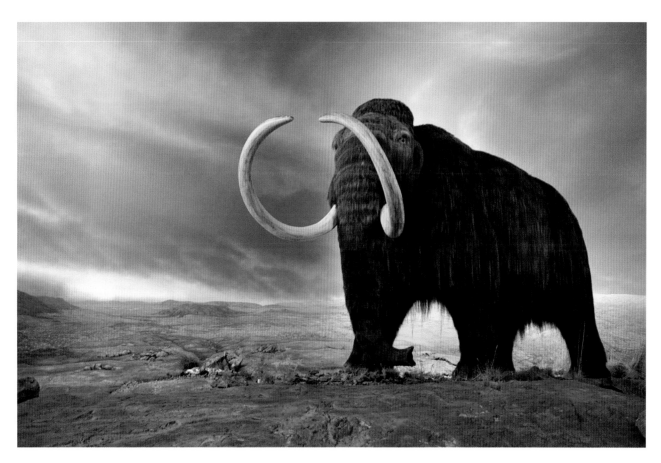

23 Woolly mammoth reconstruction, Royal British Columbia Museum, Victoria, Canada, installed 1979

resources that led them unconsciously to imitate the beasts who were their principal source of food. Neural plasticity and mirroring were the main keys to the formation of these resources. Plasticity meant that looking at mammoths gave them a visual preference for configurations that shared their properties of structure and organisation, while mirroring gave them a special empathy with their solidity and security.

Such looking and empathising apparently intensified over time. Two of the earliest sites occupied by *Homo sapiens sapiens* with substantial remains of huts from around 25,000 BC are Dolni Vestonice and Pavlov in the Czech Republic. These are close together, in a location that was particularly favourable to hunting migrating mammoths. One factor that encouraged the construction of more permanent dwellings was, without doubt, simply the bountifulness of the supply of much-needed meat and tool-making materials, which was assured by the predictable migrations of great herds

of large animals, this circumstance being reinforced by the cold temperature, which allowed the meat to be preserved. Once significant accumulations of food and tool-making materials had been built up in a particular place, there was every reason to stay by them and that meant building more durable homes. But there may have been another factor. The hunters could have been unconsciously encouraged by their association with the great beasts to build dwellings that not only employed the bones of mammoth but that also shared that animal's general robustness (fig. 23). If this was so, the impact on their neural networks of the intense visual attention that they gave to the mammoths and their neurally based empathy with the animals' general properties are likely to have played a part in shaping these building activities.

The special relationship between human and mammoth in Eastern Europe, which was the product of a distinctive Ice Age ecology, was unique on the planet and continued

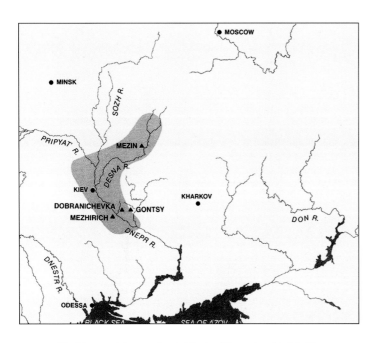

24 Mammoth hunter sites in Ukraine (Illustration: Patricia Wynne, from Mikhail I. Gladkih, Ninelj L. Kornietz and Olga Soffer, 'Mammoth-Bone Dwellings on the Russian Plane', *Scienitific American* 251, no. 5 (Nov. 1984), 138)

could be understood as mirroring the social relationships found within the herds of pachyderms. Near Mezin, for example, some distance north of Kiev, the huts are arranged in a row; elsewhere, as at Dobranichevka, much further to the south, they are in a rough circle, while at other sites again they are arranged in a rectangle. Such variety might be just a consequence of chance, but their dispositions may also have been taken over from the elephant herds. These vary their group behaviours to respond to different pressures and needs, and the builders of the settlements may have given visual attention to and empathised with them, so picking up on the different benefits they offered.

Mezhirich

We can apply similar principles when trying to understand the design of the individual buildings at Mezhirich. These too are highly varied and exceptionally complex. Dwelling 1, which uses the largest amount of bone, is perhaps the best understood, as the reconstruction shows (figs 25 and 26). The base of the wall on the inside was made of skulls and these are arranged in the orientation they would have had on the live animal, that is with the holes for the tusks pointing down, and with the flat foreheads towards the interior. The outside of the wall, instead, was made up of mandibles, or lower jaws, also placed as they would have been in the live animal, that is with the chin down, but the most surprising feature of their disposition is the way they were apparently piled one above the other in stacks, so generating a herringbone pattern. Above these tiers of mandibles, as the roof curved towards the centre, there was a ring made up of other large bones, such as scapulas (shoulder blades), femurs and tibias (long bones from legs) and small tusks. The tusks had the advantage of following the roof's curvature, and this trait

for fifteen thousand years, until the melting of the ice cap transformed the climate, leading, soon after 10,000 BC, to the mammoths' extinction. There is no better expression of the fruitfulness of this relationship than the series of settlements established during this period over a wide area north of the Black Sea in modern Ukraine (fig. 24). The most elaborate of these are characterised by great storage pits for meat and piles of bones for tools. But their most remarkable feature are the associated dwellings, which are more permanent and more complex than any that would be built in Europe for more than five thousand years.

One of the features of these settlements is the sense of order in their arrangement, and the variety within that sense of order, which may reflect their makers' awareness of the mammoths' exceptional social resources. All elephants display habits such as intense care for the young, long-term attachments and group co-operation, which they share with humans but are rare in other species; so those humans who studied the behaviour of their favourite food-animal will have unconsciously reinforced their own inclinations in these respects. If this indeed happened, the groups of houses

(facing page, top) 25 Dwelling 1, Mezhirich, Ukraine, c.15,000 BC. Reconstruction viewed from rear, Natural History Museum, Kiev

(facing page, bottom) 26 Dwelling 1, Mezhirich, Ukraine c.15,000 BC. Reconstruction of front view (Illustration: Patricia Wynne, from Mikhail I. Gladkih, Ninelj L. Kornietz and Olga Soffer, 'Mammoth-Bone Dwellings on the Russian Plane', *Scientific American* 251, no. 5 [Nov. 1984], 137)

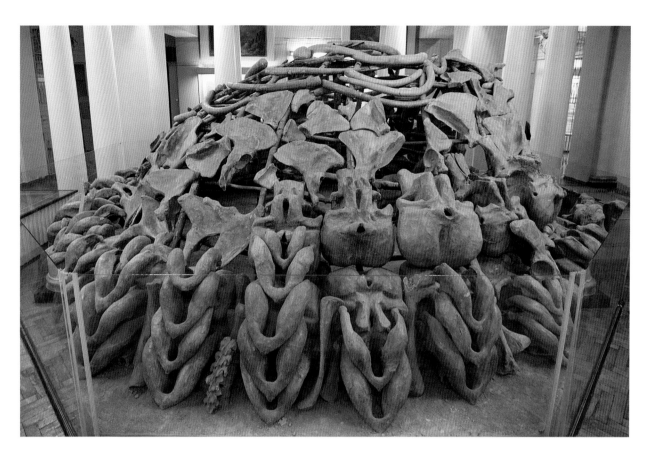

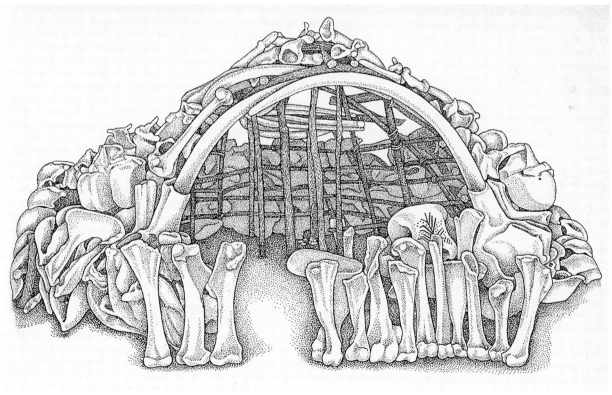

was exploited most forcefully at the entrance, which was framed by curving tusks from one or more older animals that rose from their original position in skulls, which were here inverted, to meet in something like an arch. All these features suggest architectural forms that became familiar thousands of years later, but the closest such anticipation was found in the row of leg long-bones that formed a sort of fence, nearly a colonnade, in front of the entrance. Everywhere there is a strong sense of pattern, a repetition of elements in such a way as to create what we would call a geometrical design, and patterning was also exploited in the painted decoration of a mammoth skull, this time the right way up and looking outwards, which confronted anyone who entered.

In trying to develop a framework for understanding this extraordinary configuration it is helpful to compare it with the other contemporary structures from the same site. In Dwelling 2, for example, the base of the wall was again composed principally of skulls, the right way up and facing in, but the upper part was built predominantly using femurs and tibias, arranged vertically. Dwelling 3 is too fragmentary for detailed study, but Dwelling 4, as reconstructed, presents a more complete and coherent picture. One way of understanding it is as a mixture of the techniques of Dwellings 1 and 2, since its outer walls combine mandibles and long-bones, but detailed analysis shows that its design, like that of the other two, should be treated as having its own character. The outer wall can thus be seen as made up of a series of different patterns. At one point, for instance, there are two tiers of mandibles, stacked with the chin down, as in Dwelling 1, but next to them are more stacked the other way up, while on the other side of the two tiers rises a stack of vertebrae, so reconstituting a spinal column. This pattern of vertical elements is then repeated in the section made up of vertical long-bones. Taken together the wall thus presents a series of coherent variations on the basic theme of similar units set in a repetitive pattern.

There are several approaches that we can take to interpreting the 'architecture' of these three dwellings. One is to understand each as the result of a high level of planning and social co-ordination, and as the expression of an elaborate belief system, perhaps embracing both society and the supernatural. A second is to see it as nothing more than the product of a combination of the need for a practical solution to a structural problem and the opportunistic exploitation of a readily available resource. A third is to recognise it as the latter, but inflected by the predictable unconscious responses to the situation and to materials to which the latest neuroscience gives us access.

Each person can make his or her own decision about these choices. The excavators and later scholars from the area tend to favour the first type of explanation, probably primarily because it enhances the significance of the site as a place where a new level of culture appears, and secondarily because that was, until recently, the only way of explaining such systematic ordering. Some would probably favour the second approach, pointing out that the variation not just between all three buildings, but internally within Dwelling 4 is so great as to make the first possibility highly unlikely. About this they would surely be right, but they are unable to explain the extraordinary level of ordering found in all structures, which is why logic requires us to turn to the third possibility. The level of idiosyncrasy in the different designs, particularly taking into consideration the fact that the arrangements of the bones at the other sites in the area are equally varied, makes it highly unlikely that there is any coherent socially constructed or verbally shared intention to them. Certainly, the challenge for anyone who thinks there is such a shared intention is to try to reconstruct what it may have been, but that has not been attempted. Of course, the challenge for someone adopting a neuroarthistorical approach is the same. What we have to reconstruct is the particular type of unconscious neural activity that might have led to these intriguing bone homes acquiring their specific different characters.

A first step is to reconstruct the neurally based attitudes to mammoths and their bodies that a member of one of these communities might have had as they started to make opportunistic use of their bones as a building material. After all, it is probably a fairly safe supposition that their attitudes to the body parts of the living creatures would have influenced their attitudes to the bones inside them after death. It is thus likely that they would have associated individual mammoth heads with alertness and defensiveness and a row of heads with the assurance of the herd's security. If this was so, it is not impossible that placing a row of the heads of the

animals that they had killed – and whose resources they thus controlled – around the interior of a dwelling could have enhanced their own sense of security, while placing a single skull at the entrance of Dwelling 1 could have projected a particular alertness and defensiveness in that vulnerable area. Similarly, it is surely likely that they would have been impressed by the stability and immovability of mammoth legs, that is as long as they were vertical under the live creature; so that when, after the creature's collapse, they extracted the leg bones these would still have carried those associations, associations that could be exploited for their own benefit by using them in rows, either within the walls of the dwellings, as in Dwelling 4, or, more pointedly, in the fence-like structure outside the entrance of Dwelling 1. These associations are, of course, likely to have been shared at one level by all members of the community, but there will have been variations in the associations felt by individuals, based on their particular experiences, and, in applying this neural approach, these variations should be borne in mind, especially when trying to understand the differences in the way the bones are used in different buildings. After all, during the building process these will have been carried by one or two individuals, and it will have been their neural equipment, or that of a dominant individual who might have directed them, that will have influenced their choices of which bones to pick up, where to place them within the building, and in which orientation (e.g. with the same orientation as they would have had in the living animal, an inversion of that and so on). The arrangement of the bones is thus likely to have been influenced by the whole range of the varied unconscious memories and the hopes and fears possessed by those involved in the construction.

These factors may have influenced the positioning and the orientation of the bones, but they can hardly have determined the patterns of their arrangement, which are such a prominent feature of these buildings. To understand these we have to consider other sets of neurally based inclinations. Why, for example, did they often place bones in parallel rows or build up vertical stacks of repeated units? One set of potential influences could have been the neural processes first recognised by Gestalt psychologists, the inclination to look for arrangements that are 'grouped', 'symmetrical' or

tending to 'closure'.[3] The brain's properties evidently cause the eye always to look for similarities, such as those between bone types, and also to pay particular attention when those similar objects are disposed in such a way as to constitute a configuration. Those who were placing the bones would have been affected to some degree by such inborn neurally based preferences.

They would also, however, have been influenced by preferences that were acquired as a result of neural plasticity, for example, preferences that resulted from looking repeatedly at mammoth skeletons. Stripping meat from the skeletons would, thus, have revealed the patterns of the mammoth's bone structure, its rows of ribs, its sequence of vertebrae and so on, and the visual attention that members of the community gave to these patterns would have been likely to lead to them developing a preference for such repetitions. There were many reasons for giving visual attention to skeletons, including the fact that mammoths were their principal source of nutrition and tool-making materials, but one of particular importance in this context has already been noted, their envy of the mammoth's stability, security and warmth, the reason why these people are likely to have wanted homes like mammoths in the first place. If they came to feel that the repetitive patterns of the mammoth's skeleton, that is the architecture of the body that was its 'home' in life, was one of its key properties, that would inevitably have encouraged them to transfer that property to their own homes. In other words, what they dreamed of was a home that was less like a traditional hut and more like a mammoth.

Given the richness and complexity of the relationship that the humans in this region would have had with mammoths, it is also worth considering other possible neurally based reactions that may have influenced them. One feature that is particularly prominent in Dwelling 4 at Mezhirich, but present elsewhere to different degrees, is the grouping together of bone types into categories, such as skulls, mandibles, tusks and long-bones, and it may be helpful to relate this grouping not just to the general preference for grouping noticed earlier, but to the faculty of categorisation inherent in the organisation of the brain's inferotemporal cortex. There is in fact a mounting body of evidence that there are separate adjoining areas of the cortex concerned

with such different categories as faces, body parts, places and phenomena of the natural world such as plants and animals, many with sub-categories such as four-legged. We do not yet know where bones would be categorised, but the important point is that the brain is designed to categorise automatically the phenomena to which it is exposed and – as a consequence of the principles governing neural plasticity – constantly to improve its categorisation of those things to which it is exposed most frequently. It seems too that, having looked at an object from different angles, and having built up neural networks that relate to those different views, we eventually develop small groups of neurons that respond to the object from whatever angle it is viewed, often called 'view invariant'.[4] These automatic mechanisms would have ensured that the inhabitants of this area of Eastern Europe would have had highly developed neural equipment for the categorisation of mammoth bones, and it could be argued that the better their brains equipped them mentally to place similar bones together in one area of the cortex, the more likely it would have been for their hands, under the control of their brains, to place them together physically in a building. Such matching of physical with mental categorisation would help to explain why in Dwelling 4 tiers of normally oriented mandibles are found next to those that are inverted, since what this suggests is that they are being placed together not because they look alike, which they do not, but because the neural response to them was 'view invariant'.

One last neural resource that it may be worth mentioning as having possibly influenced the design of Dwelling 4 is the equipment that gives us a preference for symmetry. In one area of the wall, a mammoth skull is flanked by 'identical sequences of two scapulas and a pelvis that form mirror-symmetrical reflections of each other'.[5] It has often been suggested that the human preference for symmetry about a vertical axis is rooted in the evolutionary advantage of having a preference for engaging with the healthy human body, particularly the face, in which symmetry is most emphatic, and it may be relevant that in this case the arrangement develops the symmetry around a skull. There is even the possibility that the similarity between a mammoth scapula and a mammoth ear proved the starting point of the positioning. Placing scapulas either side of the skull would have increased the visual similarity with the mammoth/human face and, once the similarity between ear and scapula had been exploited, there may have been a further visual pleasure in pairing the scapulas, since that would have again recalled the symmetry of ears either side of it. Equally intriguing is the fact that each side of the symmetrical arrangement terminates in a pelvis. Since the pelvis marks the mammoth's rear, as the face marks its front, it is possible that each half of the composition, running as it does from skull to pelvis, can be seen as a recapitulation of the mammoth's whole body.

So, we return to our original question of how to understand the genesis of these extraordinary buildings. It is difficult to imagine a socially constructed, or conscious, intention that would explain their properties. It is equally difficult to see them just as the outcome of opportunism and chance. The degree of variety both within and between buildings is incompatible with the former explanation, and the degree of design co-ordination and control is incompatible with the latter. In contrast, the neurological approach proposed here has the advantage that it allows us to explain all these attributes. The regularities and coherences are explained by the regularity of the principles that would have governed the neural processes of all members of the community brought up in that particular environment. The degree of variation is explained by the differences in the experiences and consequent neural formation of the community's individual members. As with the two-dimensional representations at Chauvet, the unique properties of the buildings at Mezhirich are best understood not as necessary stages in the continuous development of an art form but as the product of a unique set of contingencies. Most crucial in both cases was the interaction between the neural resources of *Homo sapiens sapiens* and a particular natural environment.

Having been at pains to distinguish the neurological approach adopted here from the others, it is important that they should not be seen as mutually incompatible. It is thus likely that the 'building' behaviours outlined here are only spin-offs of a lifestyle in which opportunism and chance played a predominant role. All that neuroscience does is bring out some of the mental operations that inflected that lifestyle. Equally, although the coherence manifested by the buildings may not have had its origin in a socially co-ordi-

nated and verbally expressed intention, it could well have contributed to the emergence of social co-ordination and to the formulation of such verbally expressed intentions. Indeed, at the same time as freeing us from the need to invoke a culture of conversation and instruction, a neural approach provides a mental context out of which conversations and instructions might have emerged. Although each of the neurally based propensities just discussed could have influenced the choices and actions of individuals at a purely unconscious level, the design features they called into being may have elicited such strong reactions in community members as to contribute to the emergence of a co-ordinated social response, and that response may have found expression in words. In this sense, although the layout of the buildings described may have been largely the product of the unconscious mental processes of individuals, their impact on other individuals may have been such as to accelerate the growth of a social consciousness, a consciousness that might subsequently have been expressed verbally.

It is thus by provoking such an unconscious response that these buildings may have helped in the conscious formation of what we have come to call culture. So, for example, the empathy between mammoth and house might have led to someone actually giving voice to the notion that the latter should embody the properties found in the former, or, once an individual or group had constructed a building that was different from those of other individuals or groups, they might have felt obliged to explain that difference, not just by invoking a preference but by justifying it with reference to a social relation or a belief. Indeed, this is probably the way culture did develop. Traditionally archaeologists, who could not conceive of the mental activity of *Homo sapiens* except as articulated in words, have tended to think that belief systems were formed by sequences of thoughts, verbal formulations and exchanges, which then influenced physical actions. Now, the new understanding of the complexity of unconscious mental activity made possible by a knowledge of the latest neuroscience allows us to see such activity as constituting the first stage in the formation of culture, the products that resulted from it as the second stage, and verbal formulations relating to them as the third. In the first stage people have unconscious perceptions and awarenesses, such as the empathy, grouping, Gestalt recognition, categorisation, symmetry preferences and so on discussed earlier. In the second those unconscious perceptions and awarenesses find material expression in physical actions, as in the construction of these houses. It would only be at the third stage that people might use words to express criticisms and justifications and so contribute to the emergence of shared belief systems.

The Emergence of Architectural Theory

It is certain that by the time a truly monumental architecture emerged, that is, one built not of bones but of stones, social co-ordination and verbal expression would have been around for a long time. But, if the argument advanced here has any substance, the unconscious, neurally driven processes that were critical earlier would have continued to influence the design of architecture, and we can consider what that influence might have been. For example, the anthropomorphism, that is the correspondence to the human form, of Greek and much later European architecture might be as much a product of unconscious neural formation as the mammothomorphism proposed here. After all, as is argued in a later chapter, the ancient Greeks looked at humans with the same level of visual attention that Palaeolithic Europeans looked at animals. In this sense, this chapter deals as much with the origins of architectural theory as it does with the origins of architecture. And it is remarkable that the Roman writer on architectural theory, Vitruvius, not only reconstructs a 'prehistory' of architecture, but describes it in terms similar to those used here. As he says in *De architectura* II: 1, early humans probably got the idea of making simple structures out of wattle and daub by looking at swallows and imitating the way they built their nests, and, when he comes to the Greeks he is clear that both the general properties of temples (III: 1) and the design of columns (IV: 1) should be adapted from the human body. These observations thus help to explain why Palaeolithic buildings have much in common with those of the great architectural tradition inaugurated by the Greeks. Both acquired the salient attributes of the particular mammalian body to which their makers gave most attention, in one case that of an elephant and in the other that of a human.

3

Origins of Abstraction

Humans as Tools and the Formation of Culture at Lepenski Vir

For the Palaeolithic we concentrated on understanding the origin of the unique properties of two restricted types of art, the two-dimensional representations of Chauvet and the buildings of Mezhirich. Here, for the Mesolithic and Neolithic we will be concerned with understanding the origin of the defining properties of two broader phenomena, the subject matter and style of a whole new type of painting and engraving found in a relatively wide area, and the relation between a new type of sculpture, new house type and a new settlement layout at a single site, Lepenski Vir in modern Serbia.

From the Animal to the Human and from Naturalism to Schematisation in Painting

The Mesolithic, loosely the period that begins with the warming of the climate around 10,000 BC, saw broad

changes in artistic expression. This is most obvious in painting. In terms of subject, the animals, which had been preeminent in the Palaeolithic, become smaller, while humans, who had been extremely rare, become more common and more dominant. In terms of style, the heavy modelling used earlier for both animals and human females, is abandoned in favour of outlines that are relatively thin and schematic.

This last change has long presented a problem for researchers. The study of the art of ancient Greece and the Italian Renaissance has habituated us to the idea that an increase in naturalism typically reflects an increase in the exploitation of conscious intelligence, but in the Mesolithic, and the Neolithic too, the relationship appears reversed. Changes in behaviour that seem to make much greater demands on human intelligence are associated with an increase in schematisation. The most decisive of the changes in behaviour was the transition from a lifestyle that exploited opportun-

istic hunting and gathering to one that depended increasingly on careful planning in the context of the emergence of herding and the beginnings of agriculture. Even where hunting was concerned, there was a pronounced shift from relatively simple tools, such as stones and spears, to more complex technologies, such as bows and arrows, nets and lines. Why then, at a time when humans were more and more in control of their environment, did they represent themselves as thin and stick-like? If during the Palaeolithic they represented the animals they most respected, and women too, with full-bodied naturalism, why did they afterwards shrink both males and females to linear schemata? How could this happen, when in later art, whether that of ancient Egypt, Mesopotamia or Greece or later Europe, full-bodied representation seems to be an expression of admiration for all that humans can do, both physically and mentally? One way to find an answer to these questions is to find out what the men and women of the Mesolithic were looking at with particular visual attention, with what they were empathising, and what they were mirroring.

That requires us first to consider the big change in the natural environment caused by climatic warming and the retreat of the glaciers. This transformed human lifestyles, opening up possibilities that had not existed before. With warmth came humidity, causing larger trees to grow. In their shelter the great herds of big herbivores were replaced by smaller forest-dwelling animals, such as deer and boar, and these were joined in the air by a multitude of birds. This brought a change in hunting practices. Instead of groups pursuing large and dangerous beasts with spears, we find a new stress on the individual and on technical skill. Animals were killed from a safe distance using bows and arrows, birds were captured with nooses and other traps, fish were caught with harpoons and lines, traps and nets. Everywhere humans had a new relation to their surroundings. During the Upper Palaeolithic they had looked with envy at the superior physical and mental equipment of their rivals, the powerful predators, and with admiration at the similar attributes of the impressive game they hunted. In the Mesolithic, not only had the powerful predators and the largest prey been killed or moved away, but also new weapons gave humans an absolute advantage over the new types of game. As their relation to other animals became increasingly one of superiority, humans would have felt more confident and safe. They looked at different things and felt differently about them. The animals they looked at would have been less ones that intimidated them with their bulk and their powerful natural weapons than those that impressed them with their speed and ability to avoid capture (fig. 27). Most significantly, the animal they now admired most was their own species, and the attribute they would have most respected its new weapons and tools.

The impact of these changes is clearest in southern Europe and especially eastern Spain. There a whole group of paintings in different rock shelters, which can only be approximately dated to the late Mesolithic and early Neolithic around 5000 BC, share various properties. In Palaeolithic art, animals were often large and shown either by themselves or in short rows. Now we find whole scenes in which one or more humans are seen hunting smaller game such as deer, ibex and boar. The individual figures of men, women and animals are often in rapid movement and are small, only ten to twenty centimetres high (some four to eight inches). Their equipment has great importance. Bows and arrows were the objects of the greatest visual attention and this seems to have affected the artists' neural resources, with profound consequences for their visual preferences. The impact of this exposure is clearest in their approach to the human figure, as in the scene of fighting archers from Morella la Vieja (fig. 28). These are now often shown with linear bodies, arms and legs. Sometimes the legs are spread to give the impression of running. Sometimes they form a curve, resembling the bow held in the hunter's arms. The artist has not simply been influenced by the bow's formal properties, but has so empathised with its capacity to store and release energy that this has been transferred to the person who uses it. This was also appropriate, since the new type of hunting of smaller game would have involved more active pursuit.

The repeated sight of the bow-wielding running hunter would have had its own neural consequences. Similarities in form and energy between weapon and limbs would have meant that the bow and the arms and legs of the hunter would all have activated the same neural resources, making it easy for one to be inflected with the properties of the other. The sight of the hunter's arrows would have had a similar effect on

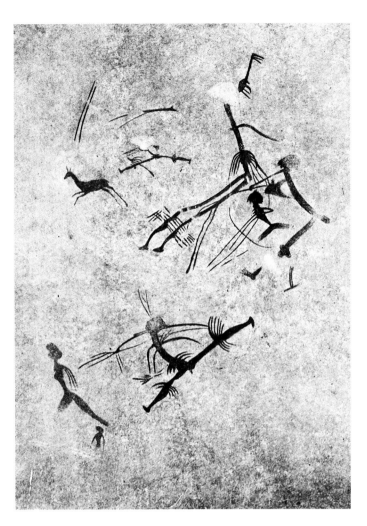

27 Hunting scene, *c.*5000 BC, Cerro Felío, near Alacón, Teruel, Spain (watercolour from *Encyclopedia of World Art*, New York 1959–87, XI, pl. 288)

28 Archers fighting, *c.*5000 BC, painting, Cueva del Roure, Morella la Vieja, Castellón de la Plana, Spain (watercolour from *Encyclopedia of World Art*, New York 1959–87, XI, pl. 286)

the artist. Attached to his waist they would have been liable to be grouped by the brain's networks with his hair streaming behind him. Once embedded in their target they would have been grouped with the animal's legs. There was even apparently a further assimilation between the combination of bow and arrows and the antlers of deer. Thus, sometimes, the antler, instead of being shown as it was, a branching form, was represented more as a long curving bow-like line with a row of parallel lines extending from it at right angles. So much had life become focused not on meat but on the technology used to acquire it, that the 'technology' at the disposal of animals was also experienced and seen differently.

For the first, and certainly not for the last time in this enquiry, the attention attracted by tools and technology had so much impact on the formation of the viewer's visual cortex that the experience completely transformed artistic style. It is possible to see this in terms of a shift in style from one that is more naturalistic to one that is more abstract, but this is to miss the point. We should talk rather of a shift from a style shaped by a particularly intense neural exposure to large animals to one shaped by a more intense exposure to small and delicate artefacts. Mesolithic, and Neolithic art too, looks different from Palaeolithic art principally because those who made it looked intently at different things.

The new salience of tools and other artefacts in the Mesolithic probably lies behind another shift in the content of art, from animals to configurations of parallel lines and grids. Bows and arrows were only the most glamourous element in the Mesolithic and Neolithic arsenal of equipment. Equally, if not more essential, were nets for catching fish and small game, baskets for carrying, mats to sit on and textiles for clothing. The Mesolithic and Neolithic home or settlement would have been full of the plant and animal fibres, the grasses and twigs, needed to make such artefacts, as well as of the artefacts themselves, and exposure to these would also have affected visual preferences. Because of the similarity in the properties of weapons and fibre artefacts, something particularly clear in the case of the bow and arrow, which combined wood and fibre, a preference for the properties of one artefact type could easily be reinforced by exposure to those of another. The experience of looking at all these linear forms would have certainly strengthened a preference for objects – or representational art – which shared similar properties. In addition, an exposure to grids, mats, nets and textiles would have provoked its own distinctive set of preferences for configurations made up of parallel and crossing lines. Such forms are found both in their own right and as attributes of other configurations in many places in Europe. These range from the parallel grooves found on many of the rocky outcrops of sandstone in a site such as the Forest of Fontainebleau to patterns on animal bodies, as in the horses from the cave at Gouy in Normandy, and many artefact types. The most striking example is perhaps the paddle from Tybrind Vig, Denmark, where a symmetrical pattern of lines has been set into the surface of the wood by filling grooves with brown paste (fig. 29).

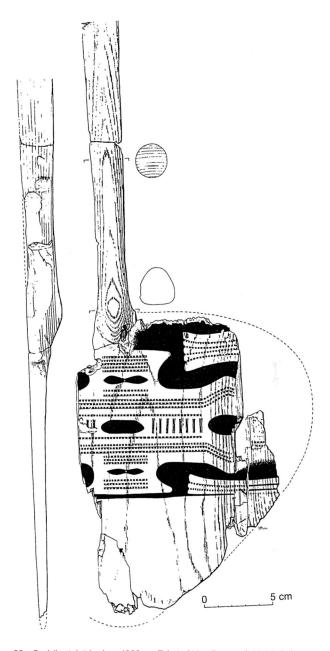

29 Paddle, inlaid ash, c.4000 BC, Tybrind Vig, Denmark (J. M. Coles and A. J. Lawson, eds, *European Wetlands in Prehistory*, Oxford 1987, 279, fig. 165)

Lepenski Vir and the Emergence of Monumental Stone Sculpture and Planned Architecture

Sometimes we know that people throughout Europe shared similar neurally based preferences, such as those based on an exposure to linear tools and textiles. In other cases, as with the paintings at Chauvet or the mammoth houses of Ukraine, we have to recognise that people living at a particular place at a particular time have acquired neurally based preferences that were special. This appears to have been the case at Lepenski Vir, on the river Danube in modern Serbia. The site has a complicated stratigraphy and history, having been first excavated by Dragovan Srejović in the 1960s, before being moved

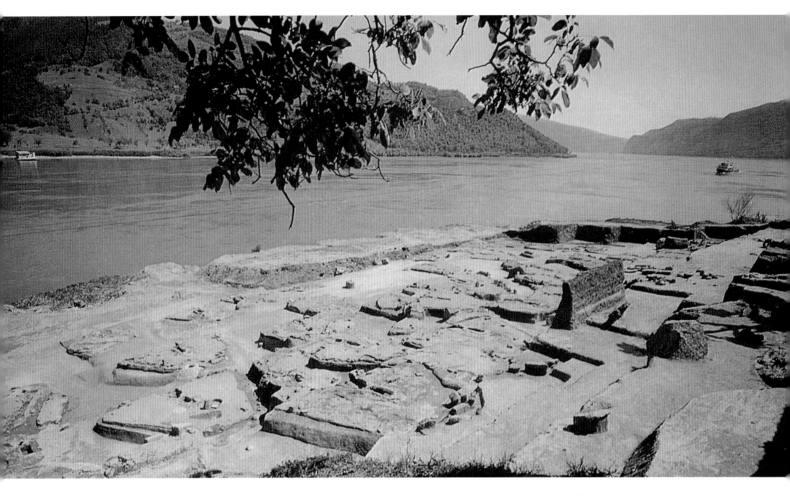

30 General view of Danube valley with Lepenski Vir settlement site before flooding, Serbia (D. Srejović, *Lepenski Vir*, London 1972, pl. III)

up-hill to avoid rising water levels, and recently subjected to new analysis, especially by Dusan Borić, who has excavated the adjoining site of Vlasac.[1] Although there are conflicts over the interpretation of data, there is general agreement that the most important activity took place between 6500 and 5900 BC. The settlement itself takes its name from a great whirlpool in the Danube caused by accidents of underwater geology at a point in the river gorge known as the Iron Gates. It lies on the river's south bank on a narrow shelf of flat land surrounded by a horseshoe of sloping mountains (fig. 30). The location is advantageous, partly because the ecology is sheltered, allowing plants to grow that would not have survived elsewhere in the surrounding area, but above all because the whirlpool was a place where large fish, such as carp and sturgeon, gathered to feed.[2] Several features of the

site make it unique in the history of art. Most remarkable are the richly carved yellow and red sandstone boulders which had been dragged from the bank of the Boljetinka river ten kilometres (about six miles) away (see fig. 31). Some from the older layers of the settlement have elaborate wave patterns, but others from the later phases have been given faces which combine fishy eyes and mouths with human noses and other features. These are the earliest monumental stone sculptures in Europe and among the earliest found anywhere on the planet. Also exceptional is the architecture of the houses (see fig. 33). Whereas elsewhere in the Mesolithic houses were either rounded or rectangular, far from consistent in plan or construction, and variously oriented, these embody many forms of regularity. They were built on platforms covered with a hard and smooth cement-like surface. These conform

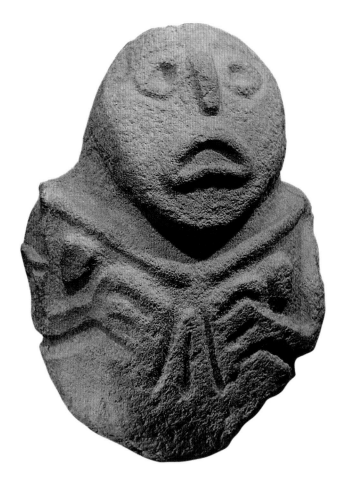

(left) 31 Carved stone from house XLIV, Lepenski Vir, 6500–5900 BC, Serbia (D. Srejović, *Lepenski Vir*, London 1972, pl. V)

(above) 32 Carp feeding on surface

to a particular pattern, a fan shape covering an angle of about 60 degrees, and there is a great similarity in their internal arrangements. Usually there is a long rectangular hearth towards the front, a slab-like table behind and something resembling an altar in between, often associated with one of the carved boulders just described. Finally, the platforms are so co-ordinated that collectively they form an ordered pattern (see fig. 35).

If we ask ourselves what the inhabitants might have been looking at with such intensity that it gave them neurally based visual preferences for this array of new forms, several possibilities emerge. As far as the sculptures are concerned, a common feature of both the flat and the vertical carved boulders is a fondness for irregular and repetitive curving lines and these have much in common with the patterns made on the surface of the water of the Danube, especially here in the vicinity of the Lepenski Vir whirlpool. The inhabitants would have spent much time looking at

those patterns, as they searched for the fish that constituted fifty per cent of their diet. Many of the carved boulders also have heads or faces on them, one feature of which is a turned-down mouth (fig. 31). Such mouths are virtually unknown in anthropomorphic art in any period, but bear a close resemblance to those of fish, such as carp and sturgeon (fig. 32). Equally fish-like are the eyes, many of which bulge more than is normal with humans. When such faces are combined with wavy lines, as in sculptures 5 and 43 in Srejović's book, the effect is closely similar to that created by a fish when it raises its head up out of the water, something that would also have been a familiar sight.

At the same time, many of the boulders are clearly anthropomorphic, that is, they resemble human faces and bodies. For example, many have vertical noses as elements in a configuration that resembles a human face and one of the sculpted boulders in house XLIV has what look like arms and possible genitalia, male or female. It is not difficult to reconstruct the type of intense visual experience that might have led them to assimilate the faces of men and fish. A fish raising its head out of the water, as it might voluntarily when feeding, or involuntarily when being caught and killed, easily reminds the viewer of a human being, and the inhabitants of this settlement are more likely than most to have sensed the assimilation. For one thing, the Danube

fish most desirable as food would have been large carp, and a carp can grow up to five feet long, suggesting an almost human bulk. For another, people such as those who often looked intently at fish would have looked at humans with neural resources tuned to dealing with fish, and so would have been inclined to see fish-like characteristics in their fellow community members. Indeed, knowing that they all ate so much fish that they were largely made of fish would have increased the likelihood of such an identification.

In this comparison the most important missing element are the boulders from which these sculptures are made. There are many stones lying around on the banks of the Danube, and people who were used also to seeing the bodies of both dead fish and live humans in similar positions will have possessed neural resources that would have helped them to mistake the stones sometimes for one and sometimes for the other, sometimes for both. This would have been most likely to happen when a boulder poked out of the mud and sand of the river-bank looking like the head of a fish or a human rising out of the river. The assimilation of boulder, fish and human may also have been most intense after a community member's death. Then, their body lying on the ground would have had something in common both with the boulder and the fish. In those circumstances people may easily have sensed that the stone was like a petrified fish or human or both, and that sense may have been reassuring. At the very least, since the sight of a large fish looking up out of the water will always have given pleasure, as might the sight of a similarly upward-looking human face in daily life, such as that of a baby or child, the activation of the neural resources involved in such a perception could easily have led to the release in the brain of pleasure-giving dopamine. If such sensations were repeated and shared by many in the community, people may have started to get similarly pleasurable feelings just from looking at the stones. The fact that the boulders involved did not come from the immediate environment might be thought to militate against this suggestion, but their distinctive colouring, mixing yellow with red patches, supports it. The most common fish remains from Lepenski Vir are carp, the name of whose genus, *kyprinus*, refers to their copper colour, while red is a colour associated with human skin (see fig. 36). The colour of the stones from the bank of the Boljetinka would thus have been particularly likely to provoke such neural and neurochemical responses.

It is then these responses that probably caused people to bring the stones to the settlement, recalling the similar action of an Australopithecine ancestor three million years earlier in South Africa. One of the most remarkable objects to come from an early hominid site is the large round red pebble from Makapansgat,[3] which was apparently also carried there from some distance away. The pebble is remarkable because, although entirely natural, it bears a striking resemblance to a human or, rather, a human baby face. It was probably the warm feelings that that resemblance elicited that led a member of the genus Australopithecus to bring it to the site he or she occupied. The boulders from the Boljetinka valley can never have borne such a striking resemblance to either a fish or a human, but their colour and size may well have activated the neural networks of the inhabitants of the river bank at Lepenski Vir so positively as to have led to them bringing them home. Furthermore, since it was possibly their capacity to evoke the same responses as the face of a carp or a human that caused them to be brought to the settlement, it is quite possible that this also encouraged those who carried them to touch them and to shape them with stone tools in ways that intensified that response. At any point in this process the response may have given rise to verbal commentary, to individual or communal decisions and then to shared beliefs. These conscious expressions, though, would have been secondary to the neural activity provoked when resources shaped by an intense exposure to carp were also exposed to sandstone boulders lying by a river. This is why the inhabitants of Lepenski Vir were the only human beings then living on the planet to have had the inclination to make such sculptures.

Some stones only bear carved lines like flowing water and, since the water of the river would often have had the same colour as the boulders, it is possible that the boulders also activated neural resources shaped by such an exposure. The boulders may thus have evoked both 'carpness' and 'waterness', something not so strange if the river, as is quite likely, seemed to those who lived beside the great whirlpool to be alive.

We can sense the way the villagers felt towards these stones from considering the positions that they typically had within the houses (see fig. 33). Each had a long rectangular fire pit

just inside the entrance and on its main axis, and in many just behind the pit was one of the boulders, either one with a linear pattern recalling water or one carved to resemble the head of a fish or human. Behind that again, towards the rear, there was often a flat limestone slab. It is easy to imagine that after the fish/meat had been cooked a portion might have been placed in the hollow of the carved boulder, where it would have served as an offering either to the river or to the fish or to both, before the remainder was consumed around the slab/table. Such an arrangement would have served to diminish the anxieties associated with taking the big fish from the river. As humans became more and more capable of dominating and exploiting nature, first during the Palaeolithic and then during the Mesolithic, they are likely to have become increasingly anxious about the implications of that relationship. For people fishing in a great river such as the Danube the anxieties would always have been particularly intense. The fact that the river was capable of inundating the village would have made people fear it, and the proximity of the whirlpool can only have enhanced the sense that the river had a life of its own. As the river seemed alternately to give and to take, it would have evoked the same response as a person who behaved in a similar way, making the villagers wonder whether their behaviour had upset either the river or the fish. In those circumstances, having in their homes something that represented either the river or a fish, or both, as they prepared their meals, would have been reassuring. By making offerings to the effigy as they consumed the fish, they could feel better themselves. The real fish could be cooked in the presence of the river/fish stone, and an offering from it placed in the depression on it, before the remainder was consumed behind. The whole sequence would have increased their neurochemical wellbeing. Bringing a stone that seemed to stand for the river or fish into the house would have produced some neurochemical pleasure, modifying its shape so that its stand-in function was more apparent would have intensified this and, finally, placing the stones in the places they did and presenting them with offerings would have maximised the benefit from the previous actions, especially when, as Borić has suggested, they also relate to bodies buried close by. The sequence can be discussed in purely anthropological terms, by analogy with practices else-where, but its uniqueness means that it is best understood neurologically. The colour of the stones and their origins on a river bank could have started to produce a response in the visual cortex that was something like that of a real river or fish. Carving would have intensified that response. Both reactions would have prepared for a neurochemical pay-off when the boulders were incorporated into the household, almost as another guest. The entire series of responses would have been a consequence of an intense visual interest in the real river and real fish driven by concerns that were visceral.

Other aspects of Lepenski Vir that could have been powerfully influenced by consciously or unconsciously formed visual preferences are the plan and overall design of the houses and their floor construction (fig. 33). The most remarkable aspects of the houses were their shape, essentially a sixty-degree arc of a circle, as noted before; their roof structure of radiating poles; and their geometric regularity. All three aspects may be related to the visual properties of what was probably one of the community's most important tools, a fishtrap (fig. 34). Although none survives from Lepenski Vir, a number have been found at other Mesolithic sites and they all have the same properties. Two types are most familiar. One is a long continuous cone. The other has parallel sides and ends in a steep cone that approximates to an isosceles triangle, its geometry maximising strength and minimising waste. The latter type has the most impressive regularity and, consisting as it does of a bunch of reeds held together by others, it has a similar construction to the huts. The binding reeds may even, like the front of the huts, have the shape of a segment of a circle. The importance of such traps in the life of the community could have been enough to explain why their forms are evoked in the houses. However, if we follow the argument just proposed, that the fishermen were making the fish feel as much at home as possible, it could be argued that such a conscious or unconscious desire to do so may have led them to make the huts look like fish traps. It has also been suggested that the shape of the houses is inspired by the silhouette of the mountain of Treskavac on the opposite bank of the Danube and, while it is hard to see why a vertical rock should have been taken as a model for a building plan, it is not impossible that the similarity between this crag, which the inhabitants would have seen every day,

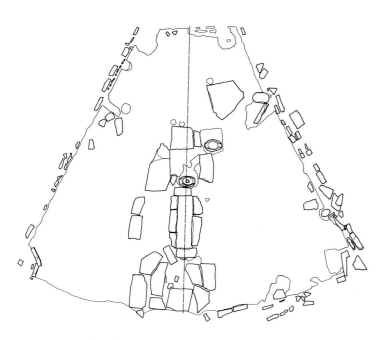

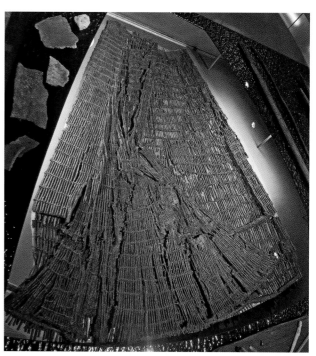

33 Plan of house XXXVII, Lepenski Vir, 6500–5900 BC, Serbia
(D. Srejović, *Lepenski Vir*, London 1972, fig. 8)

34 Fish trap from Bergschehoek, Netherlands, *c.*4200 BC, National
Museum of Antiquities, Leiden

and the equally familiar fish trap would have strengthened the preference for that configuration.

What, though, could be the origin of the cement floors? One of their most remarkable features is that 'The floor is not of an overall even thickness: at the edges it is only one or two centimetres thick, whereas by the hearth, at the stone blocks and slabs, it is as much as 25cm'.[4] As the excavator noted, this is because the cement was poured as a liquid after all the stones had been set in place. The floor began life as a pool that, like modern cement, would have taken time to set. Since the inhabitants of the village would each year have seen either their village, or at least the land below it, flooded, and would often have noticed how the pools of silt that would have been left behind dried out, that experience could have inspired them to reproduce the effect, which they may have felt was some kind of gift from the river. The origin of the idea of adding the lime that gave the floors their hardness is not so clear but, given that it was apparently made by burning the local limestone, it might have been discovered by accident, when people observed what hap-

pened when water became accidentally mixed with stone that had been burned in one of the hearths. Whatever the inspiration for the specific mixture, it is hard to avoid the conclusion that their pleasure in the liquid, pool-like, floors derived in some way from the pleasure they took in observing the behaviour of water or silt. Certainly, since the floor was apparently poured round the stones that were carved to look like either water or fish it can be seen as enhancing the sense that the hut was an extension of an aquatic ecology, the environment of their principal food. Like both those sculptures and the trap-like structure of the house, the floor could have contributed to the neurochemical pleasure of its occupants. They would have felt good because they felt that the fish they were eating were really at home.

Everything that has been argued so far is something that each individual member of the community might have felt. It helps to explain why the formula used in the houses might have given them pleasure, but it does not explain why it is a 'formula'. Indeed, this formulaic character of the housing is in clear contrast to the earlier mammoth dwellings of

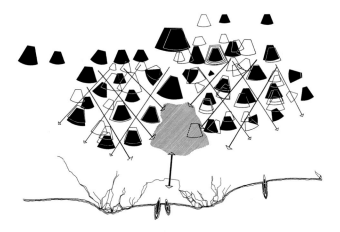

35 Settlement plan, Lepenski Vir, 6500–5900 BC, Serbia (D. Srejović, *Lepenski Vir*, London 1972, fig. 12)

36 Carp scales

Mezhirich. There I argued that the variations between the houses suggested that each was the product of a variety of neural activity. At Lepenski Vir the similarity in the design, the layout, the construction and the orientation of almost all the houses makes it clear that these were the result either of instruction or agreement, or a mixture of the two (fig. 35). This is not surprising. The mammoth hunters are likely always to have been more opportunistic than the fishermen, if only because the behaviour of their prey was difficult to predict. There may have been a leader in every hunt but, because of the hazards of the chase, there was no advantage in having a set of rules for its management. For the fishermen on the banks of the Danube, the situation was much more governed by regularity. The behaviour of the river would have varied fairly consistently according to the time of year, and the behaviour of the fish would have been even more predictable, especially in the vicinity of the whirlpool, with some fishing sites being much more productive than others. Any individual who understood those predictabilities will have attracted imitators and followers. If matters were discussed, he or she would have been listened to. And since all members of the community needed a supply of fish, there would always have been a need to ensure that each had equal access to it. That would have meant that the placing of nets and traps would probably have been subjected to some regulation, either communal and voluntary or imposed and enforced. Since a knowledge that such matters were regu-

lated would have meant that all members of the community would have felt happier, it is likely that they would also have felt happier if house design was also regulated, especially if, as argued here, such regulation was felt to be crucial to the humans' relation to their fish food.

A similar explanation can be developed for the final unique feature of Lepenski Vir, the fact that not only does each individual house follow a formula, but that there is also a formula for the relation between them. Several millennia passed before another settlement of such geometric regularity is found, with all houses showing the same orientation and with the spacing between them being so arranged that paths were established giving everyone equally direct access to the bank of the river. Clearly, such a coherent scheme must also reflect compliance with an overall plan, which must have resulted either from mutual agreement or from general acceptance of an imposed rule. But what is the scheme's source?

One possibility is that it was inspired by the fish traps themselves, which may have been laid out in the river in one or more rows, all oriented in relation to its flow. If people felt that their houses derived from traps, it would have been easy for the relations between the traps to influence the layout of the village. Another possibility is that the layout was influenced by something else to which they would have given much visual attention, fish scales, especially those of carp (fig. 36). Besides colour, the principal visual attributes

of carp scales are their rounded form and their disposition in rows, and these two attributes, associated as they were with the sight of the most reliable element in their food supply, must have laid down neural pathways that would have associated rows of rounded forms with a positive neurochemistry. The fact that the convex outlines of the house facades were associated with smooth, sometimes shiny, grey cement floors would only have increased the likelihood that village layout and fish scales might have been experienced through the same neural pathways. Indeed, the experience of looking down on the village from the slope above would have been similar to that of looking down on a fish lying on the ground.

The nature of the social processes that lay behind the conformity demonstrated by the similar house plans with their co-ordinated layout is necessarily impossible for us to determine today. We shall never know how much collaboration or coercion was involved. What is certain, though, is that the fact that everyone in the community would have shared similar experiences would necessarily have reduced any strains involved. This is one of the main benefits of adopting a neural approach. Given that the principles governing neural plasticity would have ensured, first, that similar visual experiences would have caused the formation of similar neural resources in the visual cortex of all members of the community and, second, that those visual experiences would have been associated with similar emotional responses, we can be sure that everyone in the community would have been likely to have held similar unconscious preferences. This meant that if they were deciding together how to lay out either a house or the entire village they would have found it easy to agree with each other, and, if they were under any sort of sway by a dominant individual or team, they would have been more prepared to accept it.

This neural approach thus has implicit consequences for our evaluation of the relative importance of two factors often invoked in discussions of culture, the role of words and the role of power differentials. The more that similar experiences led to the formation of similar preferences, the less it would have been necessary either to develop elaborate verbal arguments in their favour or forcibly to impose them. In a community in which a sharing of experiences led to a sharing of neural resources, any suggestion made by one individual would be likely to be agreed with by the others. Power in a community naturally went to those whose proposals were coherent with the neural formation of its members. Power, in other words, was given as much as taken. Neuroscience thus adds a critical new dimension to the study of the emergence of cultural and social institutions.

A neural approach also has implications for our understanding of the relation between one community and others in the surrounding area. I have argued that the main reason why people in this particular settlement adopted particular architectural and sculptural practices was not because they had been persuaded to but because, owing to the similarity of their experiences, they seemed right to them. If this was so, there would have been much less likelihood that the patterns they developed would be adopted by others. For one thing, in other communities which grew up in other locations, where the unique environment of Lepenski Vir was not replicated, people would have had no neural affinity for that community's way of doing things. For another, there would have been no battery of verbally formulated arguments with which to persuade them. This might seem irrelevant to our consideration of the art of Lepenski Vir, but it is highly relevant when we try to answer the question of why it is unique, only finding echoes in a few neighbouring sites, such as Vlasac.

According to one of the most common views of the history of culture, once an impressive practice such as the architecture and sculpture of Lepenski Vir appears, it is likely to be soon imitated by others, for two reasons. One would be that it seemed attractive to other communities, the other that its merits could be easily communicated to others by words. From such a social-constructionist perspective it may seem surprising that none of the startling innovations made in this community on the Danube seems to have been taken up beyond a narrow radius. From a neuroarthistorical perspective, it would have been surprising if they had been. One of the principles of neuroarthistory is that, since much of the mental formation that sustains innovations is unconscious and specific to a particular environment, we would not expect innovations to be readily adopted outside the environments in which they emerge. Since everything that is unique about the art and architecture of Lepenski

Vir can be related to its unique site opposite the whirlpool that gives the modern site its name and gave the ancient community its food, it had little relevance elsewhere. The art at Lepenski Vir, like that at Chauvet and Mezhirich, is largely the spontaneous product of a unique relationship between the neural make-up of *Homo sapiens sapiens* and a particular environment at a particular time. This is not to deny any role of language and other cultural practices in the formation of behaviours at the site. Language must certainly have played an increasingly prominent part in the shaping of culture. The problem is that we have no way of reconstructing that part. The situation with neuroscience is different. Recognising that all forms of artistic expression are dependent on the properties of the individual's visual brain, and that those properties can to some extent be reconstructed in the light of neuroscientific knowedge, allows us to go some way towards explaining what the role of those properties might have been in the formation of culture.

Part 2

ANCIENT GREECE
800–100 BC

Art and Literate Culture

Artistic activity in the Aegean area had increased greatly by the second millennium BC, but in terms of quantity it was nothing compared to what is found in the first. How are we to approach the art produced after 800 BC, which is among the most admired in the world? In the case of prehistoric art the benefit of turning to neuroscience is obvious. At a time before written records, a knowledge of the way the brain is formed and operates provides otherwise unavailable access to people's minds. What, though, is the value of neuroscience in the context of a culture such as that of ancient Greece with its rich legacy of texts? Does the high degree of self-consciousness to which these writings testify reduce the need to study the process of unconscious mental formation? Given that from ancient Greece until today verbal articulation and self-consciousness have remained conspicuous features of European culture, the answer we give to this question will have important implications.

Everything hinges on how we view texts and self-conscious utterances. If we think that in such a self-conscious culture actions in the domain of art are the product of thought, and the stuff of thought is words, then a discussion of unconscious mental formation may appear irrelevant. This point of view might also seem to be encouraged by the Greek language itself, in which the word for 'thought', *logos*, derives from *legein*, 'to speak'. But it is not sustained by the texts the Greeks themselves wrote. We have already seen how Greek stories of the origins of painting, sculpture and architecture present them as the products not of thought but of instinctive responses to visual experiences. Even Plato plays down the importance of rational thought. He presented his theory of knowledge of things both abstract and concrete as a 'theory of ideas', as one based on vision, the Greek for 'to know' being cognate with the Latin *videre*, 'to see', arguing that such visual 'ideas' enter the mind at birth where they become the subject of the highest mental activity, contemplation. Indeed, one of Plato's main preoccupations was a hostility to words driven by his desire to expose the weaknesses of the sophists and rhetoricians who had become adept at using them to control the minds of the youthful. A principal purpose of his elaborate verbal artefacts, the dialogues, was at once to diminish our trust in words and enhance our interest in vision as the basis for knowledge. He even, with his account of how ideas enter our brains from the divine mind in a purely passive process, gives prominence to the notion of unconscious mental formation. In doing so he shows us how we should treat words. For Plato their relation to thought is epiphenomenal. Far from being thought's substance, they are only its symptoms. Instead of taking words at face value we should try to work out what was the mental formation that underlies them.

What we need to understand is the unconscious mental activity that precedes thought's conscious expression. That means that we should engage with Classical (and later) texts in the same way that we engaged with prehistoric art. Just as there we first identified what was new in the art and then sought to reconstruct its neural correlates, so we have to do the same with what is new in the thought contained in Greek texts. In the case of prehistoric art, we attempted to reconstruct the neural correlates of innovation by identifying what was new in the social and material environment to which those who made and viewed the art were exposed. Now we have to look for our explanations for the distinctive innovations that interest us in Greek thought in the distinctiveness of their exposures too, remembering that the most important of those exposures are likely to have been visual.

One set of texts whose novelty calls out for explanation are the Greek accounts of human creation. These differ sharply not only from the Mesopotamian account familiar from the Bible, but also from virtually all others around the globe. The Mesopotamian story of humans being shaped from clay and Mesoamerican stories of an origin in maize flour both relate birth to moulding processes that were habitual in those cultures. These materials' most important common properties are their plasticity when moist and rigidity when dry. A corollary of that rigidity is that once broken the artefact is, like the body after death, useless. In such stories birth and death are understood in terms of two of the most familiar experiences of the material reality of daily life, moulding and breaking. The Mesopotamian account has its echo in the Prometheus story, but other Greek stories relating to creation are based on different familiar experiences.

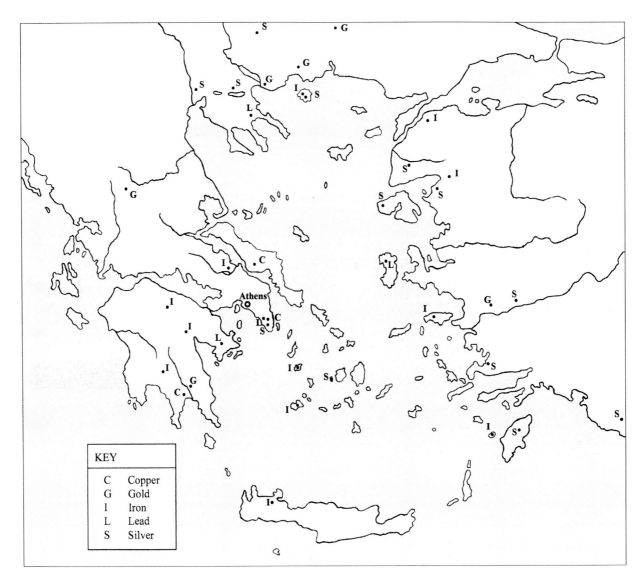

37 Map of Greece and Aegean, showing minerals

KEY

C	Copper
G	Gold
I	Iron
L	Lead
S	Silver

The contrast is evident in two of the more suggestive narratives. One tells how Deucalion and Pyrrha repopulated the earth after a punitive flood by throwing stones over their shoulder, one of which became Hellen, father of the ancestors of the different Greek, or Hellenic, tribes. The other rehearses the sorry tale of how the gods created five successive generations, four of which were in some sense metallic, the first being golden, the second silver, the third of bronze with a spirit of steel, with the last, which came after a brief race of heroes, being of iron. The unusual neural appeal of these stories

of stone and metal origins is apparent in the properties that distinguish these materials from clay and flour, their hardness and their workability. While other peoples empathised with materials that started out soft and ended up broken, the Greeks empathised with ones that were hard and which, if broken, could be reshaped. Strikingly too, while Mesopotamians and Mesoamericans acquired their empathy with clay and flour from exposure to the relatively intimate craft processes familiar from the workshop and the kitchen, the Greeks acquired theirs for stone and metal from a different type of experience. The

38 View of Athens with Acropolis

traditions of working these materials the Greeks inherited from others, but for them they had an exceptional salience because of their daily exposure to a landscape rich in rocks and minerals, and to military equipment that exploited these natural resources with unprecedented intensity. It is their exposure to that landscape and that equipment that we have to understand if we are to share their empathy with stone and metal.

At the base of that exposure was the overwhelming prominence of rocks in the fabric of their land. The reason for that prominence is apparent if we compare the silhouette of the peninsula where most Greeks lived with those of the other land masses projecting into the Mediterranean (fig. 37). Spain, Italy and so-called Asia Minor are all fairly regular in shape, with smooth and continuous coastlines reflecting a relatively undisturbed geology. Greece, by contrast, has a most complicated

configuration in both plan and elevation, with many projections, such as the Peloponnese and Attica, and as many deep indentations, such as the Gulf of Corinth and the Saronic Gulf, reflecting an extraordinary interlocking of mountains and sea, a property it shares with the west coast of Asia Minor, which was also occupied by Greeks. This fractured silhouette was the product of a tormented geology which, by the first millennium BC, had created a relief of steep massifs often framing narrow valleys, a terrain that continued to be modified through erosion by wind and water. This last process had a dramatic impact on the peninsula, leaving large bare masses of rock, such as the Athenian Acropolis (fig. 38) or Acrocorinth, rising above fertile plains. There are many places on the planet where mountains rise from plains, but there are few where the mountains are so naked and so obviously display to the eye their stony resources of limestone and marble along

(above) 39 Scheme of phalanx, 5th century BC

(right) 40 Tower, Aigosthena, Attica, third quarter of 4th century BC

with their embedded veins of iron, lead and silver ore. There is none where such an ecology is surrounded by the navigable waters of a temperate inland sea, such as the Mediterranean. There was thus no region that was so well placed to take advantage of the opportunities in the domains of agriculture and warfare, craft and trade that emerged after a period of great instability at the start of the first millennium BC.

It was the strains associated with the rapid economic growth that resulted from this exceptional conjunction that caused those rocks to take on their extraordinary importance. As communities outgrew their land resources they enviously eyed those of their neighbours, even as their neighbours eyed theirs. In these circumstances a fence of wood or a wall of stone could offer a basic protection, but even more critical was a body of warriors that shared the properties of such built defences, but was equally effective in aggression. To create such a body, males were required to exercise as individuals, to train to move togther in a rigid formation and to dress in heavy bronze armour, so becoming a hoplite, from *hopla*, 'arms'. That this formation was called a *phalanx*, cognate with English 'plank', shows that it was intended to have the properties of a solid block of wood, and a similar attitude led people to see it as a wall made up of separate stones (fig. 39). This vision is most forcefully expressed in Homer's *Iliad*, where Achilles, the greatest Greek warrior, is described as marshalling his

men, the Myrmidons, like someone 'building a wall out of tight-fitting stones' (*Iliad* XVI, 211–15), while elsewhere the formation is compared to a tower (XIII, 151 and 2). At the time the *Iliad* was composed in the eighth century BC neither the phalanx nor the wall was particularly well ordered but, as competition between cities further intensified by the fifth and fourth centuries, both embodied to an extraordinary degree the regularity and rigidity that the text celebrated (fig. 40). Such mental images responded to visceral anxieties. Greek warriors empathised with stones in walls, because such stones possessed the attributes they needed if they were to play their part in the phalanx. They needed to be hard and they also needed to be shapeable, so that a commander could fit them together. The importance of this last attribute is brought out both by Homer's positive comparison of Myrmidons to close-fitting stones and his negative comparison of the greatest Trojan warrior, Hector, to 'a destructively rolling boulder' that 'descends from the brow of a crag . . . until it arrives at the plain and rolls no more' (*Iliad* XII, 126–42). All good warriors should be as hard as stones, but only the best are shaped and arranged so that they fit together perfectly.

More properties desired in warriors are brought out by other Greek stories. One told of how warriors sprouted from the ground after Kadmos had sown rows of snakes' teeth. Snakes' teeth inherently possessed even more of the properties desired in the soldiers who made up the phalanx,

41 Warriors arming with crab and scorpion emblems on their shields, calyx krater, painted by Euphronios, c.525 BC, Attic. Rome, National Etruscan Museum – Villa Giulia

since they are hard and sharp and grow in parallel rows, the one behind ready to move spontaneously to replace one in front. Another tale related Achilles's Myrmidons to ants, *murmekes*, known for their capacity for orderly and organised work and warfare, their bodies protected by armour-like exoskeletons. Such stories are the conscious social expressions of neurally based empathies that were felt daily by individuals. Some were expressed in visual art. About 525 BC in Athens, Euphronios painted a scene of warriors arming themselves and decorated the shield of one with a scorpion and of another with a crab (fig. 41). The viewer instantly and unconsciously shares the warriors' wishes that their weapons should be as deadly as the claws and sting, and their armour as protective as the

exoskeletons of the aggressive arthropods, one terrestrial and the other marine, evoking the principal elements of the Attic defence force. If the members of the community at Chauvet envied and gave intense visual attention to the properties of other large animals, the members of Greek communities had a similar relation to the properties of smaller creatures such as snakes, ants, scorpions and crabs, as well as with the inanimate substances of wood and stone.

Many languages share conceptual metaphors drawn from commonalities of lived experience, for example, notions of life as a journey or marriage as a container, as George Lakoff and Mark Johnson showed in 1980 in *Metaphors We Live By*.[1] In a context such as ancient Greece, where contingencies of landscape and lifestyle ensured that

experiences were unlike those of other peoples, conceptual metaphors more private to the language developed. This is why it was easy for Greeks to feel that they were, metaphorically, stone and metal. Lakoff and Johnson began by thinking of metaphors as arising when a 'source' domain in lived experience, for example, in this case, that of raw materials, was mapped onto a 'target' domain, such as warfare, which was in need of conceptualisation. Lakoff's work led him in the 1980s to think of the relationships he was describing in embodied terms and to develop a collaboration with the computer scientist Jerry Feldman on the Neural Theory of Language.[2] Since 2000 his emphasis on the neurological element has only become more important, with source and target domains increasingly described in terms of neural 'groups' or 'circuits'.[3] Viewed from this perspective, a 'source' domain such as Greek raw materials and a target domain such as Greek warfare could each be conceived of as a neural 'group', and the process of one being mapped onto the other understood as involving the growth of linking networks. Breaking the process down, we might infer that giving repeated attention to different features of the social and material environment would have caused the formation of ever more robust neural groupings for dealing with them, so leading to the emergence of two different groups, one dealing with the human element of the defensive apparatus, warriors, and the other with its inorganic element, fences and walls, each being substantially based in different areas of the cortex. Although they would have originally developed separately, desire for the one to possess the properties of the other would have caused more and more connections to form between them. Looking at warriors made of flesh and blood, while wishing that they possessed the hardness and sharpness of shaped wood and stone objects, caused neural connections to grow between the networks dealing with the two categories of phenomena. It was this experience that caused shaped wood and stone to become metaphors for warriors.

The neural formation that resulted in the establishment of these metaphors can be further illuminated by reference to neural plasticity and neural mirroring. Greek valley floors were strewn with boulders that, like the one that was Hector's prototype, had made a downward rush from a distant summit. Often they would have been man-sized and, being made of white or beige weathered limestone or marble, were also human-coloured. As such, they would often have activated the neural resources with which all of us are equipped at birth and which ensure that we seek protection from older humans. Exploring infants and children, who would have been the most susceptible to such instinctive responses, must often have felt towards boulders as they felt towards their parents. This would have made it easier for them, once grown up, to treat rocks as human-like. In the context of first millennium BC Greece, where the properties that stone possessed inherently were those desired in adult males, this inclination would have been greatly reinforced. Just how far the Greek warrior's empathy with stones went is evident from the story of Amphion, whose lyre-playing caused stones to move and form themselves into the wall of the Boeotian city of Thebes. Warriors who felt themselves to be stonelike, and who were used to having their movements controlled by music in training and on the battlefield (see fig. 71), naturally imagined stones responding to music in the same way.

Perhaps the most striking example of how distinctive Greek concerns led to the formation both of unusual separate neural groupings and of unusual connections between them is provided by the female poet, Sappho, writing around 600 BC. In verses celebrating the simple power of sexual love, she taunts her male contemporaries with the unnaturalness of their visual interests: 'some say the most beautiful thing in the world is an army of horsemen, some say an army of foot soldiers, some a fleet of warships . . . but I say it is one's beloved' (Sappho 38, 1–3). Both her observation and her implicitly neural analysis are acute. Her male contemporaries, she says, get the same emotional pleasure from looking at military formations that ordinary people get from the person they love. The release of dopamine in the nucleus accumbens prompted in most people by a visceral interest in sexual contact becomes prompted, in the Greek male, by another visceral interest, that in physical survival. Neural resources that should be serving the selection of the best lover serve instead the selection of the best military configuration, one of cavalry, of infantry or of ships. In noting 'some say this'

and 'some say that' Sappho may also be drawing attention to the way neurally based preferences for different types of formation vary in correlation with the different priorities of different classes or groups. Those, like the aristocracy, who relied more on horses, would have acquired neural networks most engaged with the cavalry; those, such as the newly important middle classes whose fighting role was as hoplites, would have acquired networks related to the infantry; and those, such as traders and sailors, who depended more on ships, networks connected with the fleet. Noteworthy is the common element in the desirable object, the repetition of units within a formation, whether in an army or a fleet. In the case of the fleet, by the fifth century such repetition had become a feature even of one unit, a single ship, as in the multiplication of banks of oars and of oarsmen in the trireme (fig. 42).

Sappho is likely to have realised that, increasingly, the most important common element of the defence system of all Greek states was the infantry, more particularly the phalanx, whose association with sexual desirability is shown by its illustration on a vessel such as an aryballos in Berlin by the Macmillan Painter, used to contain the perfumed oil with which young men anointed themselves after exercise (fig. 43). This, indeed, we might almost have predicted on the basis of the laws of neurology. The sight of a phalanx of armed warriors provoked such pleasure deep in the centre of the Greek brain that it became an

42 Trireme, c.410 BC, marble relief, 40 × 51cm. Acropolis Museum, Athens

object of almost sexual fixation. While males elsewhere in the world had sexual fantasies about human partners, usually of the opposite sex, Greek males fantasised about military formations, which is why they could enhance their attractiveness to other males by anointing themselves with an oil that, when dispensed from such a flask, became essence of phalanx.

43 Confrontation between the front ranks of two phalanxes, detail of a scented-oil bottle by the Macmillan Painter, mid-7th century BC, Corinthian. Staatliche Museen, Berlin

4

The Greek Statue

No category of Greek art is more admired today than the life-size statue, made of marble or bronze. None is more clearly illuminated by what we know about the unconscious formation of Greek culture. This is because the principal subject of these stone and metal representations was the naked male athlete and warrior, precisely the human type in whom the mineral properties of strength and workability were most desired, as noted in the Introduction to Part II.

Men of Stone and Metal

When the Greeks started to make such statues around 600 BC the myths of stone and metal origins were already well established, and the underlying feelings of which those myths were an expression of even longer standing. It was those uniquely Greek feelings that gave rise to this uniquely Greek art form. When the Egyptians had made statues of pharaohs and other officials in stone, and occasionally in bronze, usually in a funerary context, it was above all to maximise their permanence. Individual Greeks had long visited Egypt, but when they were invited first as soldiers and then as traders, by the Pharaoh Psammeticus I (ruled 664–610 BC) and were confronted by such statues, they would have felt that the Egyptians were shown as they felt themselves to be. They would immediately have been attracted to adopt the practice. This would have happened the more easily because, as Herodotus tells us (*Histories* II, 152), one of the reasons Psammeticus invited the Greek soldiers in the first place was because their body armour made them seem to be literally made of bronze, metal men. The Greeks would probably have liked the fact that their mineral nature was recognised, and would have exploited it, feeling, as they began to make large statues of themselves in limestone, marble and bronze,

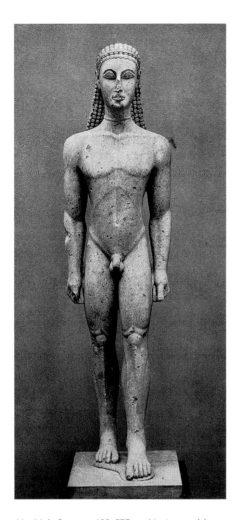

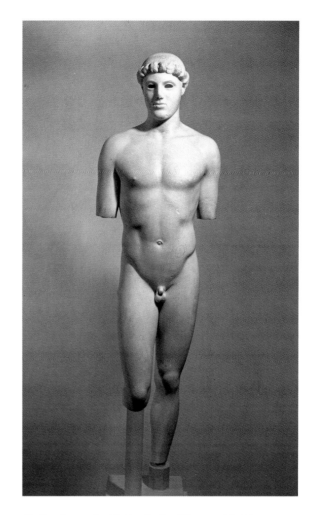

44　Male figure, c.600–575 BC, Naxian marble, h. 194.6 cm, Attica. The Metropolitan Museum of Art, New York

45　Youth, so-called 'Kritian Boy', c.480 BC, marble, 86 cm. Acropolis Museum, Athens

that they were only expressing their nature (fig. 44). As their origin myths reveal, flesh and blood Greeks really wished that they were made of stone or metal, and in their statues they could realise that aspiration. This does not mean that there is a causal connection between the myths as such and the statues. The value of the myths is, rather, that they give us insight into unconscious, neurally embedded, sensibilities. It was these sensibilities, rather than the myths in which they were articulated verbally, that shaped visual expression, and they did so because these sensibilities were possessed by everybody in the community, both patrons and sculptors. It was their common desire for men to share properties with metal and stone that brought into being the unprecedented Greek

series of life-size stone and metal statues that filled their cemeteries and shrines. Most were of males, many of warriors or prize-winning athletes, the figures in whom stone and mineral properties were most desired, but others were of the females needed to produce such men, their mothers, sisters and daughters.

If the Greeks' sense of themselves as stone men explains why they started to replicate the figures they encountered in Egypt with their own, it does not explain why such statues soon acquired properties of lifelikeness unknown either in Egypt or anywhere else, becoming ever more accurate in their anatomical detail (fig. 45). The Egyptians had been making lifelike stone and occasionally metal statues for mil-

lennia, but they never manifested these traits. The Greeks themselves liked to explain the changes in the series in terms of more or less conscious innovations by individual sculptors, each of whom sought to make up for some defect in the work of his predecessors, and a similar story is told in textbooks today, but this account is highly questionable. There is no parallel to the trend anywhere else in the world at any time. In Egypt, Mesopotamia or Mesoamerica, where supreme pieces of sculpture were also produced, there is always some degree of lifelikeness, but this varies from time to time, under the influence of many factors. What we need to know is which factors might have been behind the consistent increase in naturalism that is uniquely Greek.

Greek Naturalism and Neurography

When proposing an answer we have one helpful precedent, the lifelikeness of the paintings of Chauvet. I argued that the only possible explanation for the extraordinary naturalism of the images, including such features as the modelling of surface and three-quarter perspective not known again until Greece, was the intense and repeated visual attention that the artists had previously given to the animals that were their subjects. The product of 'neurography' – the hand that made them being passively guided by visual neural networks shaped by exceptionally intense prior exposure to their subjects – they demonstrate how naturalism can emerge in the absence of any conscious intention. Invoking this precedent does not mean that there is no merit in the stories told by the ancient Greeks and modern textbooks, only that the role of conscious effort in the sequence may have been much smaller than has always been thought. How, then, might the balance between the conscious and the unconscious in the account of this development be differently drawn up? This is a question we need to answer in relation to Greek art, but our answer will have consequences for our understanding of the art of many other traditions, because what is thought to have happened in Greece is seen as prototypical for much of the later development of European art, with an increase in naturalism traditionally always being seen as necessarily the product of conscious reflection on the part of the artist.

What we have to do, now that we understand the principles of neural plasticity, is to reassess the extent to which purely passive exposure may often have been a more important factor than conscious reflection. Might not the factor that caused the extraordinary naturalism of Greek statues have been the same as that which caused the extraordinary naturalism of the Chauvet paintings, exceptional visual attention to the object represented? In the French cave, the objects were large mammals; in Greece, naked human males. The main difference in the naturalism concerned is that the direction of change is different. At Chauvet it is the earliest images that are the most naturalistic because the neural resources of their makers had only ever been exposed to real animals; with every image that they made, those neural networks became modified by exposure to representations, resulting in a progressive decline in naturalism. In Greece the trend was reversed. To judge by surviving artefacts, sculptors began by looking at existing representations of the body, whether ones in their own tradition or ones from the traditions of their Levantine and Egyptian neighbours. It was only as athletic and military competition between states and individuals caused them to give real naked males more frequent and intense attention that the neural networks involved in the perception of the body became richer and richer, leading to the making of more and more naturalistic images.

The process by which, as military and athletic training became more and more important in the life of communities, the opportunities to view the naked male body increased can be well followed at Athens, where the progressive increase in anatomical accuracy is best documented by a large series of statues, mostly in marble, but some in bronze. A critical influence on the trend was the ruler Peisistratos. It was he who established the Panathenaic Games in 566 BC in emulation of the existing Great Games at Olympia and Delphi, and who, by excluding all but Athenians from many contests, ensured that they were a particular focus for his own community. The prestige of all the different Games not only increased general interest in athletic activities but also brought big improvements in the facilities for observing them. Large audiences came to witness the athletic competitions at all centres and, to accommodate them,

large structures were built, most prominently the U-shaped stadia surrounded by rising banks of seating, which still survive in upgraded form at Olympia, Delphi and Athens. Such stadium architecture must have been as decisive for the formation of people's neural networks as was the rock arch at Chauvet. Both settings ensured that the communities concerned enjoyed unparalleled visual exposures to a particular phenomenon, animal migration in one case and human athletic competition in the other. It was because of the consequences of such exposure for the neural networks of the members of those communities that the art which they produced possessed its unparalleled naturalism.

Action, Mirroring and Empathy

This general interest in the male body was heightened dramatically at the end of the sixth and the beginning of the fifth century. During the sixth century, statues were erected principally in order to foster admiration for their subjects, be they soldiers, athletes or simply citizens. What raised the stakes was a series of major historical events. One was the attempted assassination in 514 BC of the sons of Peisistratos by a pair of lovers, Harmodius and Aristogeiton. Because this was carried out at the Panathenaic Games, it possessed an athletic aura, making it easy for it to be presented as exemplary and commemorated in a sculptural group (see fig. 46) erected in the Athenian Agora, or marketplace, following the democratic reforms by Kleisthenes in 507 BC. Other events were the military successes of the Greeks against the Persians following their invasions of 490 and 480–479 BC. These victories, often won by small numbers of Greeks over much larger Persian armies, threw the virtues of the Greek hoplite into new relief. Nowhere was this more true than at Athens after the Battle of Marathon in 490 BC, when a small phalanx of its citizens had routed a great Persian host. The pleasure long taken in the sight of an effective male anatomy was now infused with an extra pride and self-satisfaction. To a distant admiration succeeded identification and empathy, and the sculptures created in this new climate reflected the influence of what amounted to a new neural dimension to the experiences of making and viewing.

A key to that new dimension was the impact of training on the neural formation of young men. The need for uniformity of movement both in the hoplites in a phalanx (see fig. 39) and the oarsmen in a trireme (see fig. 42) meant that young men spent much more time imitating the movements of their elders than would have been the case in other cultures and this not only greatly reinforced their mirroring resources, it also had telling implications for their response to art. Recent experiments have shown that the mirroring resources of individuals who are highly trained in specialist movements are most likely to be activated by looking at representations of other individuals making exactly the same movements.[1] In the experiments the specialised movements were those of ballet dancers and capoeira performers and the representations were on film, but the results can be extrapolated to apply to Greek warriors and athletes and their representations in sculpture and painting. What the modern experiment suggests is that young Greeks who had begun their athletic or military training and who then gazed at images of their role models in appropriate poses in sanctuaries, cemeteries and other public settings would have found themselves mirroring them. This may sometimes have led to them moving their limbs in similar ways. Even when it did not have that effect, it would have reinforced their training by, without them knowing it, reactivating the relevant pre-motor neurons.

One of the first works that illustrates the new response was the statue group commemorating the heroism of Harmodius and Aristogeiton made by Kritios and Nesiotes and erected in the Athenian Agora in 477/6 BC to replace that made thirty years earlier and carried off as booty by the Persians in 480 BC (fig. 46). As a dramatic reconstruction of the episode the new group, now known only from a Roman copy, captured the movements of the two figures as they raised their arms against the tyrants. Unlike the frontal standing figures typical of the sixth century, which, like deity images, invited mainly admiration and honour, these invited their male viewers to empathise with and emulate them. This we might have inferred, or indeed sensed, but some aspects of the response can be further illuminated by neuroscience. A surprising revelation of brain scans is that neurons in area V5 that are normally distinctively activated by the perception of something that really moves can in fact be activated by some types of completely

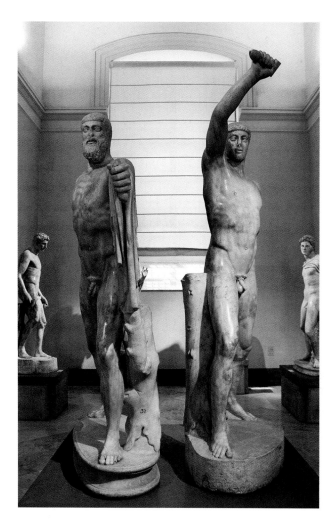

46 *Harmodius and Aristogeiton,* Roman marble copies of bronze originals by Kritios and Nesiotes, *c.*477 BC. National Archaeological Museum, Naples

of this – and that period of crisis would have heightened all forms of bodily awareness – it could have been a decisive spur to the patronage of works that had such a dynamic effect. Activation of neurons in V_5 would have generated a sense that the figures were about to move, and that sense may in turn have prompted some response from mirror neurons, causing the viewer's limbs to 'itch' to move in similar ways. The sculptors could not know this but they, like other viewers, might have felt it. Certainly, in the pair of tyrannicides, the way the lower-body movements of the younger man copy those of the older emphasises the importance of imitation in this culture. The group thus brought the lessons of the gymnasium into the Agora and transmitted tyrannicidal skills and inclinations to succeeding generations of young Athenians.

A similar response will have been evoked by the metope panels of the slightly later Temple of Zeus at Olympia (472–456 BC) showing the Labours of Hercules in high relief. This was especially likely considering that the temple was rebuilt to celebrate the Greek victory over the Persians, that Hercules was seen as a role model for Greek warriors and that the majority of those who gave the building intense attention would have been participants in and observers of the Great Games. Neuroscience suggests that everyone who went to Olympia would have come with their resources for neural mirroring ready primed and that this would have greatly increased the likelihood that their bodies would have been engaged both by live athletes and by sculptural representations of the body, whether free-standing or in relief.

Other sculptures created in the decades after the end of the Persian Wars in a similar neural climate were Myron's *Discobolos* of *c.*460–450 BC and Polykleitos's *Doryphoros* of *c.*440 BC. The way the *Discobolos* (fig. 47) affects viewers was well captured in Leni Riefenstahl's film of the Berlin Olympics (1936), *Triumph of the Will,* where, in the initial sequence, the *Discobolos* metamorphoses into a live discus-thrower. Riefenstahl cleverly uses the impact of the Greek sculpture on the viewer as a model for the impact her paymasters hoped her film would have on the millions of Germans who watched it in cinemas. Just as the modern discus-thrower mirrors the ancient statue, so the cinema audiences should mirror the Olympic athletes. The movements of the legs and arms of the *Doryphoros* (fig. 48) are less obvious, but they too

'still' images. Subjects that have this effect include, besides waves and flames, human bodies that, because they include an element such as a raised arm or leg, suggest the likelihood of movement. Since such motions can have implications for an individual's personal security, as when a threatening movement of a particular type from a particular direction prepares the body of the viewer to take evasive action, such a neural response engages the viewer much more powerfully than would an image of a figure with arms at the sides. This means that the new, more active, statues would have engaged viewers much more directly than would their sixth-century predecessors. If those who commissioned the works sensed any

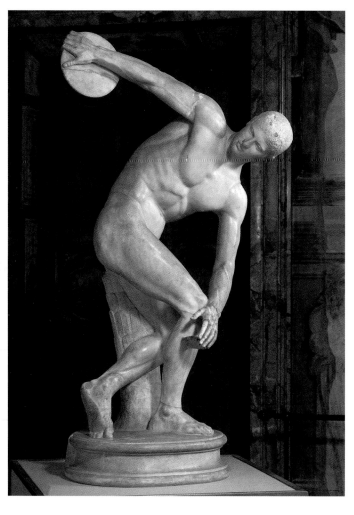

47 *Discobolos*, Roman marble copy after bronze original by Myron,
*c.*460–450 BC. National Archaeological Museum, Rome

48 *Doryphoros*, Roman marble copy after bronze original by
Polykleitos, *c.*440 BC. National Archaeological Museum, Naples

would probably have been enough to activate neurons in V5
and so provoke some neural mirroring.

The sculptures that would have had the greatest effect,
though, were those conceived by Pheidias for the Parthenon,
the temple of Athena Parthenos erected on the Athenian
Acropolis in 445–431 BC. There were several reasons for this.
The triumph of the Athenian phalanx over a vast Persian
army at Marathon had been perhaps the most signal tes-
timony to the effectiveness of disciplined young warriors.
Even more than that of Zeus at Olympia, the Temple of
Athena Parthenos at Athens was a victory monument. And it
was paid for out of what was effectively the defence budget
that the treasury had amassed to fund the ongoing war

against the Persian enemy. All who approached the Parthe-
non would have had the heroic actions of Athenian hoplites
in their mind. If they were men they would have hoped to
rival them. Their resources for neural mirroring would thus
have been activated by all its imagery of figures in motion,
not just the metopes that showed warfare on foot, Greeks
fighting Persians, Lapiths fighting Centaurs and Gods fight-
ing Giants, and the great frieze of cavalrymen, shown both
on foot and astride their steeds, but the pediments, especially
that in which Athens and Poseidon compete for precedence
in Attica. Of no individuals would this have been more true
than the sculptors themselves, from Pheidias down, who had
the most intense engagement with the imagery. Not only

did they know best why they were paid to carve those particular subjects, but they also knew that they were expected to be as similarly effective as infantrymen or cavalrymen, and must often have taken their own bodies and those of others in their workshop as their models.

Pride in recent military achievements had other, equally subtle, influences on sculpture. The Greeks had always admired the hoplite's armour as much as his body, and that admiration had always had some effect on the way the naked body was represented (fig. 49). Sculptors could never carve a warrior's body without imagining the torso clothed in a cuirasse, the leg encased in a greave and the head covered in a helmet. In the sixth century, when all surface anatomy was more schematic and harder, the conflict that this caused between neural resources shaped by contrasting exposures to flesh and metal was easily resolved. In the fifth century, as flesh became more palpably soft, this was not so easy. The solution of Polykleitos when making the *Doryphoros* was to combine a surface having much in common with that of a naked body with a volumetric organisation that suggested a bronze casing. In a similar manner, Myron made the pectoral muscles of the *Discobolos* resemble the disc, or circular weapon in his hand, and we sense the same identification of weapon and muscle in a tomb relief from Megara commemorating Pollis, 'who died, not a coward, but [fighting] in the line of battle', where the curve of his pectoral muscles echoes that of the shield that protects them (fig. 50). To the extent that the brain of a fifth-century BC sculptor took pleasure in the sight both of the naked and of the armed body, he was equipped to create statues that elicited the same double pleasure from viewers, evocative descendants of the 'bronze men' seen by the seventh-century BC Egyptians. The history of art, even in a period of so-called naturalism, is never so much the history of what the artist sees as it is the history of what he or she has in her head.

Quadrangular Men

To discover the roots of another trait of fifth-century BC statuary we have to look even deeper into the heads of contemporary Greeks. I began by noting that the origin of the Greek habit of making life-size stone statues of warriors and athletes lay in their desire for them to share the properties of stone blocks in a wall and this had its corollaries. For stones in a wall to fit well together they have to be uniform and cuboid in shape, and it was the challenge involved in endowing men with those properties that probably led Simonides around 500 BC to complain that: 'It is difficult for a good man to come into being. Square [*tetragonos*, literally 'quadrangular'] in hands and feet and mind, wrought without blame' (Simonides 5, 1 and 2). The inspiration for Simonides's conception of a quadrangular man is likely to be the notion of a man able to function like a block in a wall, and the same notion probably underlies Pliny's statement (*Natural History*, XXXIV, 55) that Polycleitos's *Doryphoros* not only embodied a system of proportions characterised as a *Rule* or *Canon*, as the title of the book that he wrote about his masterpiece suggests, but was also *quadriangulus*, a Latin word Pliny employed probably to translate the Greek *tetragonos*. The statue not only looks natural, and is made up of volumes that evoke armour, as already noted. It is also geometrical in its general properties and the torso possesses a character of squareness.

This concern with rectangularity probably also explains the prominence at the same period of the rectangular posts crowned by heads which were called herms and which are also described as *tetragonos*. We no longer have the three examples set up in the Stoa of the Herms in the Athenian Agora to commemorate the generals who were responsible for a minor victory over the Persians at Eïon in Thrace in 475 BC, but we do know the verses that were inscribed on them. One told of the heroism of their achievement. Another said that the herms were there to commemorate the generals' virtue ('manliness', Greek *arete*) and to encourage succeeding generations to develop similar qualities. The last told how just as Homer made Mnestheus of Athens an outstanding marshal (*kosmetor*) of the Greeks, so too is it right to call these men orderers (*kosmetai*) of war and of manliness (as recorded in 336 BC by Aeschines in *Against Ctesiphon*, 184). A row of heads atop rectangular posts was apparently seen as the best way of representing both the generals' manly 'virtue' and their skill in the co-ordination of forces. Their rectangular shape and their almost certainly regular align-

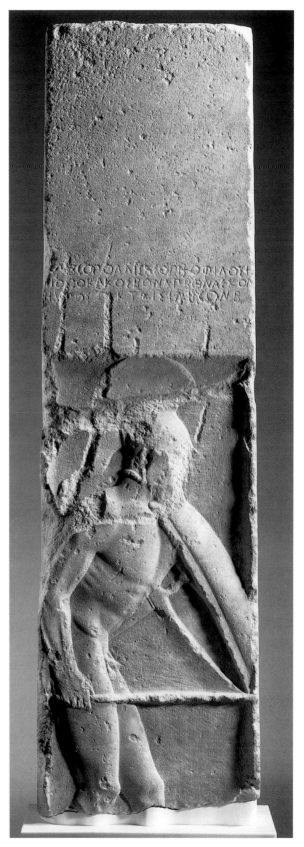

(above) 49 Ancient Greek armour: helmet, bronze, 7th century BC; muscle breastplate and pair of greaves, bronze, 5th century BC. Private collection

(right) 50 Pollis as warrior, tomb relief from Megara, inscribed: 'I Pollis, the beloved son of Asopitos, speak, having died not a coward [but fighting] in the line of battle'. c.480 BC, marble, 153 × 45 × 15cm. J. Paul Getty Museum, Los Angeles

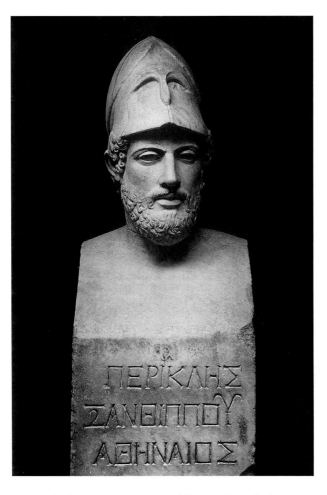

51 Pericles, herm portrait, Roman marble copy after mid-5th century BC, original by Kresilas. Vatican Museum

52 Grave stele of Thraseas and Euandria, early 4th century BC, marble, 160 × 91 × 30 cm, Attic, Pergamon Museum, Berlin

ment would have made them particularly effective in that role. A similar thinking probably underlies the most famous herm portrait, that of Pericles (fig. 51), the general who led Athens at the peak of its power and who commissioned the Parthenon. The helmeted head on a rectangular post captures the essence of what was expected of a military man.

From Mirroring to Empathy

Motion is one thing, emotion another, and, having acquired the ability to represent the former, Greek sculptors went on to explore the latter. As long as statues were intended above all to express the physical capacities required in a warrior

or athlete, their faces are impassive. Indeed, they are at their most inexpressive at the period when they burst into movement after the Persian Wars, giving rise to the term Severe Style, and it is not going too far to say that many fifth-century BC statues like the so-called *Kritian Boy* (see fig. 45) give an impression of real stolidity. They are just doing their duty. Only in fourth-century BC Athens, after defeat by the Spartans had lessened the need to manifest a stiff upper lip, as the loss of Empire did in Britain in the 'swinging sixties', did sculpted faces become more animated. This first occurs on monumental tomb reliefs, where facial and body gestures increasingly suggest sadness and where the originally low-relief figures acquire ever greater depth (fig. 52). Like the previous enhancement of physical naturalism, this devel-

opment would have been neurally driven, often depending on the reshaping of the same resources. During the fifth century BC, individuals whose direct and indirect experiences of warfare and athletics became more intense commissioned more and more naturalistic statues from sculptors who shared their heightened sensibility to the body's physical resources, and as succeeding generations looked at such statues more and more intently they would have been more and more inclined to mirror them. As long as attention was focused on warfare, such mirroring would have involved moving the body while keeping the face 'straight', inexpressive, because emotions have a negative effect on a warrior's performance. Once defeat had diminished the glamour of warfare and public service generally, and as people invested increasing economic resources in private expressions of grief at the departure of loved ones, a new type of mirroring brought a steady increase in the expression of vulnerability and loss. The circle of mirroring that had once revolved round placing the depersonalised body in the service of the state now revolved round the family and the personalised face. Inborn neural resources of empathy ensured that the feelings of those who commissioned the tomb reliefs were transmitted first to the sculptors who executed them and then to those who contemplated them; so further enhancing their value to their patrons.

By the late fourth century BC the awareness of such inborn human inclinations had risen to such a level that Aristotle, who had inherited an interest in physical endowments from his doctor father, could discuss it directly, noting in the *Poetics* that 'imitation is an instinct in men from childhood and in this they differ from other creatures, being the most imitative and learning the first lessons by imitation, and everybody enjoying imitation' (*Poetics* 1448b). He also goes on to stress the special importance of transmitting emotion, observing that the dramatist should co-operate with the movements of the actor: 'because he agitates others who is himself agitated, and he excites others to anger who is himself most truly enraged' (*Poetics*, xvii). Through a combination of self-awareness and acute observation of others, Aristotle understood the importance of neural mirroring, although he knew nothing of the mechanisms involved. Nor was he alone. A sculpture such as Praxiteles's *Hermes*

53 Praxiteles (?), *Hermes with infant Dionysos*, c.340 BC, Parian marble, 370 cm with base. Archaeological Museum, Olympia

from Olympia, of c.340 BC, reveals a similar awareness (fig. 53). When Praxiteles showed Hermes tempting the infant Dionysus, god of wine, with a bunch of grapes he well knew that by putting a slight smile on Hermes's face and a hint of annoyance on that of Dionysus, he was ensuring that viewers would empathise with the feelings of both. He could not have done this so successfully had he not himself experienced such empathy when creating the group.

Probably the best evidence, however, for the importance of empathy in the fourth century BC is provided by stories

told about both Praxiteles and his contemporary the painter Apelles. Both are said to have used famous professional courtesans, Phryne and Campaspe, as models for representations of the goddess of love, Aphrodite, and the erotic impact of the resulting works on viewers was legendary. If each had not empathised profoundly with their female subjects' talents for seduction, they could never have achieved such an effect. One story, though, places empathy itself centre stage (Pliny, *Natural History*, XXXV, 79–97). This tells how, when the great Alexander, Aristotle's pupil, saw the painting that he had commissioned Apelles to make of Campaspe, at the time when she was his favourite, he recognised from the power of the image that the artist's love for her was even greater than his, and so decided to give her to him. There are other stories about Praxiteles and Apelles, Phryne and Campaspe and Alexander and we can never know how they relate to the truth, but the fact that many of them involve empathy means that the mid-fourth century BC was a period when it was widely experienced and recognised.

Mirroring and Empathy Exploited

Once the phenomenon of emotional empathy had been widely experienced, and been recognised by Aristotle as part of our biological make-up, it was available to be exploited by artists and their patrons, as in the *Battle of Alexander and Darius* (fig. 54), probably of *c*.300 BC. If the mosaic from Pompeii is a copy of the painting made by Philoxenos of Eretria for the court of one of Alexander's immediate successors, Cassander (king of Macedon, 305–297 BC), it would have had a powerful effect on its beholders. No one would have had any difficulty identifying with the figure of the disciplined and cool Alexander, on the left, who continued the

54 *Battle of Alexander and Darius*, mosaic, *c*.100 BC, 582 × 313 cm, possibly after an original painting by Philoxenos of Eretria, *c*.300 BC. National Archaeological Museum, Naples

type of military exemplar established in the fifth century BC. Widely different would have been their engagement with the most prominent figure in the composition, the terrified King Darius. As they gazed on his distraught face and beseeching arm gesture, they would have shared in full the Persian ruler's horror at the scale of his downfall. They too would have experienced defeat. If the painting was made to shore up Cassander's highly insecure position, it can only have served to intimidate his rivals and their supporters.

A much fuller exploitation of empathy had to await a moment when insecurity extended beyond the individual to engulf a whole community. This was the period in the third and second centuries BC when the state of Pergamon, which dominated a large part of Asia Minor, was threatened by marauding bands of Gauls. The state's ruler, Attalus, confronted and defeated them and seized the opportunity his victory gave him to declare himself king with the title of *Soter*, Saviour. He also erected at least one monument commemorating his victory, something repeated by his successors not just at Pergamon but at Athens and elsewhere. While the exact dating of the surviving marble copies of the figures involved remains in dispute, there is general agreement that they relate more or less directly to original Attalid dedications. All would have had a similar effect on viewers. Victors may or may not have been represented, but the images of the conquered, which do survive in copies, all engage viewers in their fate. No one even now can contemplate the *Gaul killing Himself* (fig. 55) – having probably already despatched his wife – without sympathy. Few can see the figures of the *Dying Trumpeter* without feeling the hopelessness of his effort to raise himself. Even the large recumbent or prostrate figures of a *Gaul*, a *Giant* and a *Persian*, now in Naples, are designed to elicit as much pity as revulsion, with their bleeding wounds and their hair matted with sweat. There can be no doubt why these figures are designed to have this effect. By being drawn into an identification with these victim-figures the viewer comes to share the respect they must feel for the superior forces that have humbled them. More significantly, they also come to share the figures' guilt.

Any uncertainty on this point is resolved by the frieze of the great Altar of Zeus, dedicated on the acropolis of Pergamon by Attalus's successor, Eumenes II. This presents the

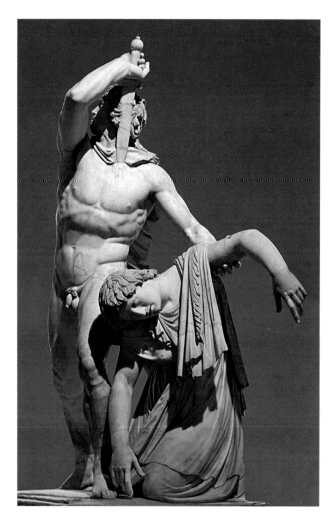

55 *Gaul killing Himself and his Wife* (*Ludovisi Gaul*), 2nd-century Roman marble after Greek bronze original, *c.*230–220 BC, marble, h. 211 cm. Museo Nazionale di Roma, Palazzo Altemps, 8608

gods' defence of Olympus against the assault of the Giants (literally *Gigantes*, 'Ge, or earth, born') as a prototype for the Attalid defence of Pergamon against the attack of the Gauls, and it is with these personifications of anarchy that the viewer is required to identify as he or she looks up at the long relief of larger than life figures (fig. 56). It would have been difficult for any mother not to identify with Ge (Earth) as she witnesses her son, Alcyoneus, the leader of the rebellion against higher authority, dying as Athena tears him from the soil that gave him birth, and it would have been hard for any man who had once felt inclined to rebel not to feel some commonality with him. The sculptors well understood

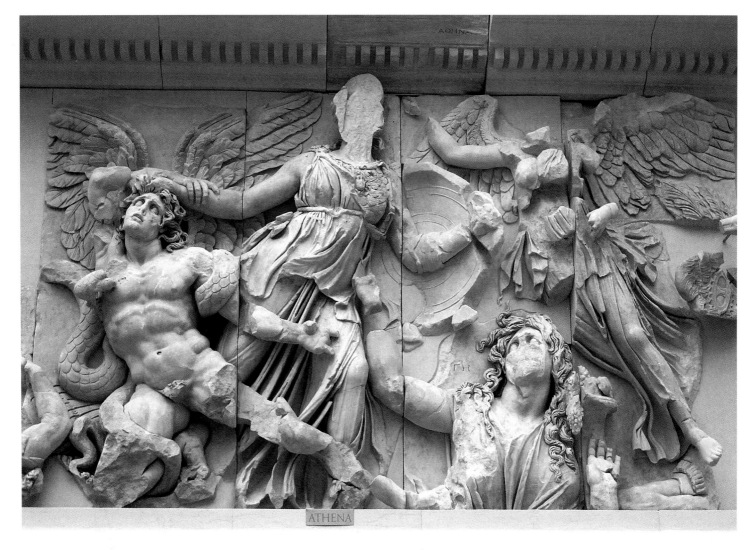

56 Athena, *Ge and Alcyoneus*, detail of Battle of Gods and Giants on the Altar of Zeus, *c*.170 BC, marble, 35.6 × 33.4 m. Pergamon Museum, Berlin

that the more emphasis there was on the suffering of the giants the more they would arouse empathy in the viewer and the more they aroused empathy the more they would contaminate the viewer with their culpability.

That the Attalids sensed the effectiveness of these works in distancing them from their subjects is suggested by a number of other works that can be more or less directly connected with late third- and early second-century Pergamon and which exploit a similar viewer response. The *Laocoön* group (fig. 57) is connected to the Zeus Altar not just by its scale and style. Even more striking is the correspondence between Laocoön's pose and that of Alcyoneus. The Roman sculp-

ture that we know today was appropriately commissioned to evoke sympathy for the Trojan priest, Laocoön, in his unjustified suffering for his heroic attempt to warn his people, the ancestors of the Romans, of the dangers of the Greek Wooden Horse. But it clearly derives from a Pergamene original, and no one in Graecophile Pergamon could have had an interest in such a subject.[2] It is more likely that the sculpture the Attalids commissioned, and which provided the

(facing page) 57 *Laocoön and his Sons*, 1st-century *c*.170 BC adaptation of Greek original, *c*.200–*c*.170 BC, marble, h. 240 cm. Museo Pio-Clementino, Vatican 1059, 1064 and 1067

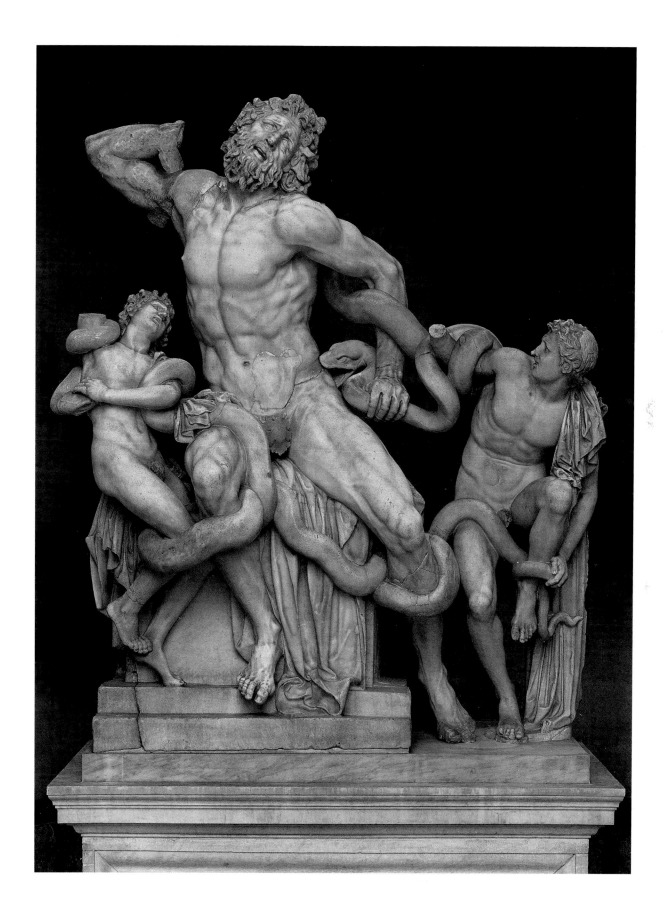

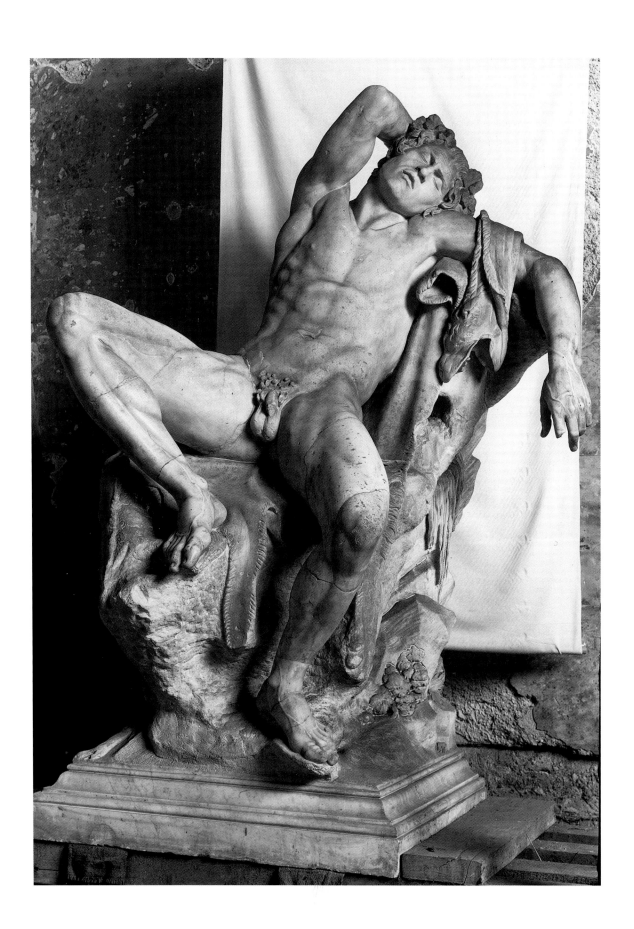

models for the figures on the Altar relief, illustrated another story about the Trojan priest, his deserved punishment for debauchery enacted on the altar he was supposed to serve. Prominently displayed, such an image would have naturally joined the Gaul monuments as a warning of foreign failings, while its evocation of sensuality and suffering would have engaged the empathy of all men who might have been similarly tempted to sin or sacrilege.

The original of the *Barberini Faun* (fig. 58), with its hint of careless abandon after indulgences signalled by distended veins, would have served a similar goal, as would other groups associated with Pergamon, that showing Marsyas being flayed for challenging Apollo's refined lute with his bestial pipes, or the centaur ridden by Eros, whose hands bound behind his back warn of the costs of enslavement to Love. Each of these images is extraordinary in its portrayal of the deserved suffering of an inferior being. Laocoön suffers for a specific sexual crime, the Barberini faun probably for a general laxity of mores, the centaur for his surrender to unbridled passion, Marsyas for arrogance and bad taste. All, like the Gauls, pay the price for their lack of self-control. Each was probably originally commissioned by the Attalids in a similar spirit to the large frieze of the Altar of Zeus, where the upstart giants are shown being punished by the gods for their arrogant assault on Olympus. All would have served as reminders of the moral distance between rulers and ruled. Viewers of all these works, finding themselves empathising with the manifest weaknesses of their protagonists, would have been reminded of their own.

Such statues are exemplary as Greek statues always had been, but in new and different ways. The neural response anticipated in Pergamon in 150 BC was not that expected in mainland Greece in 550 BC. Then, several hundred years of competition to survive in narrow valleys surrounded by mineral-rich mountains had equipped people with neural resources that gave them an unconscious positive empathy with life-size and lifelike marble statues of naked young men. Those sculptures showed men as they wanted to be. In second-century BC Pergamon, four hundred years of history, which had brought first motion and then emotion to the fore, had culminated in a situation in which the patronage of art served to sensitise viewers not to their strengths but to their weaknesses. Earlier the most effective statues were those that reinforced people's sense of being stone-like. Now they were those that reminded them they were not just made of flesh but driven by their viscera.

(facing page) 58 *Barberini Faun*, probably early 2nd century BC, Pergamene marble, 215 cm. Glyptothek, Munich

5

The Greek Temple

Doric and Ionic

Another artefact type that is as uniquely and characteristically Greek as the life-size and lifelike statue is the Greek column, and there is even a close connection between the two forms. This is not obvious to us but might have been sensed by any Greek, as Euripides reveals in his *Iphigeneia in Tauris*. At the beginning of the play Iphigeneia comes out of her house and recounts a disturbing dream of the previous night. In it she saw her ancestral home collapsing until 'only one column was left . . . and from its capital golden hair streamed, and it took on a human voice' which she recognises as her brother's. This vision she interprets as meaning that 'my brother Orestes is dead . . . since the columns of a house are sons' (*Iphigeneia in Tauris* 47–57). It would be possible to see this interpretation simply as a literary trope, but like most such tropes in Greek literature its neural foundations lay in real experience.

The Greek Column and the Greek Brain

The ancestral home of Iphigeneia and Orestes, the children of Agamemnon, was the palace of Mycenae, whose most striking feature would always have been the great gate above which two lions flank a single standing column (fig. 59), and it is this which evidently inspired the comparison in Euripides. We do not know who made the identification but for any visitor from Athens, who would have had Orestes at the front of his mind remembering his trial on the Athenian Areopagus, it would not have been difficult to see the column as representing the great hero. That the column on the Lion Gate was experienced in this way would then explain the unprecedented features of the design of the Portico of the Maidens, once misidentified as Caryatids, on the second most important shrine on the Athenian Acropolis, the Erechtheum (421–405 BC; fig. 60 and see fig. 64),

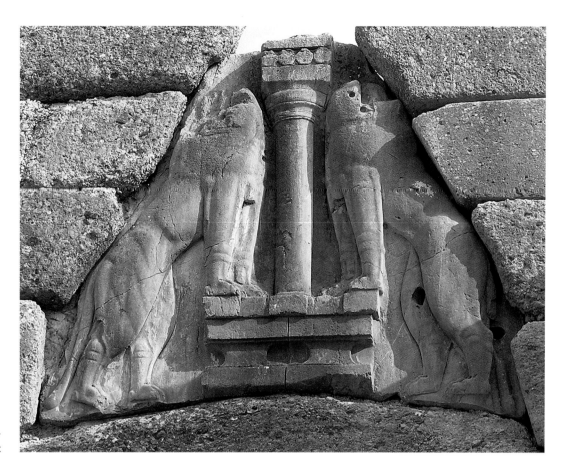

59 Lion Gate, Mycenae,
c.1300–1250 BC

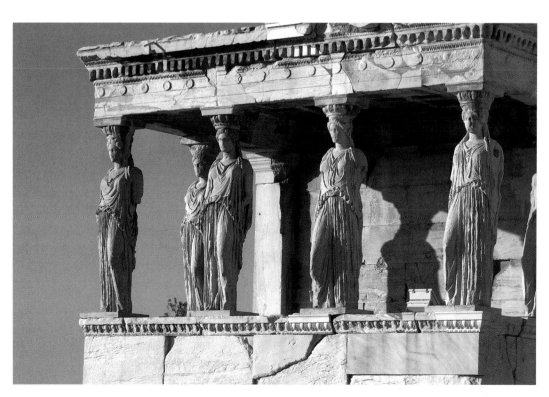

60 Porch of the Maidens,
421–405 BC, Erechtheum, Acropolis,
Athens

built on the site of the palace of the Mycenaean-period king, Erechtheus, whose shrine it included. Its flat roof and the row of discs on the architrave are without precedent in contemporary architecture and require explanation. They were apparently suggested by the row of discs representing the ends of beams supporting a flat roof on the architrave above the Lion Gate's single column. The maidens who replace the columns below would then be a direct expression of the feelings related in Iphigeneia's dream, the whole porch being intended as a reconstruction of the Mycenaean palace and the marble maidens representing Erechtheus's daughters in conscious emulation of the column at Mycenae experienced as representing Agamemnon's son.[1] When Euripides's play was performed in the Theatre of Dionysus below the Acropolis in about 414 BC, the audience, being familiar with the women who replaced Ionic columns on the Erechtheum, would have found it easy to see the simpler Doric columns of the Parthenon as representing their sons and brothers, descendants of a race that went back to the daughters of Erechtheus. After all, to produce men like stone columns one needed to breed from women with similar properties.

The abiding memory of the assimilation of columns and people in fifth-century BC Athens survives in the story, probably invented around 400 BC and transmitted by Vitruvius, that Doric columns derive from the bodies of men, Ionic from those of matrons. This particular derivation is certainly wrong, but the underlying idea that the forms of Greek architecture were influenced by what they were looking at is correct.[2] What we have to discover is what those things were.

The Greek Temple

The first question is: what is the derivation of the unique temple type that is common to the traditions of both so-called Doric and so-called Ionic, but unknown elsewhere in the world? In the form of a long rectangular building with a porch at one end and surrounded by columns, this was established around 600 BC and achieved its fullest development in the Parthenon in Athens (447–431 BC; figs 61–3). As a stone structure this type displaced a variety of predecessors made of more temporary materials, some of which had rings

of wooden posts, and made use of terracotta panels in their upper parts. In the following decades of the sixth century on the Greek mainland and in the colonies in Sicily and southern Italy, the plan-type rapidly took on a standardised layout, most frequently with six columns on the front, the whole raised on a platform ringed by three rows of steps. This unique configuration is universal in the Greek world and if we ask ourselves what object in that world might have attracted so much attention that looking at it could have caused the formation of neural networks carrying a preference for it, there is only one obvious candidate, the phalanx (see fig. 39). As described earlier, by 600 BC it had established itself as the most essential piece of human defence technology and it is thus hardly surprising if it also influenced divine defence technology. One of the main reasons why the Greeks built elaborate houses for their gods was because they looked to them for protection, and their confidence in the gods' ability to provide this would certainly have been increased by enhancing the phalanx-like attributes of their residences. Homer in the eighth century BC had already compared great warriors to trees, with Pirithous and Leonteos being described as 'tall oaks' standing before the gates of the Greek camp (*Iliad* XII, 132), and Iphigeneia's speech comparing columns to men shows the survival of a similar idea in the late fifth century BC. Given the assimilation of trees to defensive heroes in the Homeric brain, putting up posts in front of a deity's house would have already provided some reassurance, and putting up posts all round would have increased it. Besides, given the additional association of warriors with stone as a material, turning the posts into stone columns would have maximised the psychological impact. This was especially true of the forms we now call Doric.

Doric Details

If it was looking at – and imagining – the phalanx that gave the Greeks a preference for rectangular temples ringed with stone columns, what experience gave them the preferences for the properties that decisively differentiate the mainland Doric versions of those columns from the plant-like shapes found in Egypt and the Levant, their sharpness, angularity and hardness, as exemplified in the Parthenon (fig. 63)? It

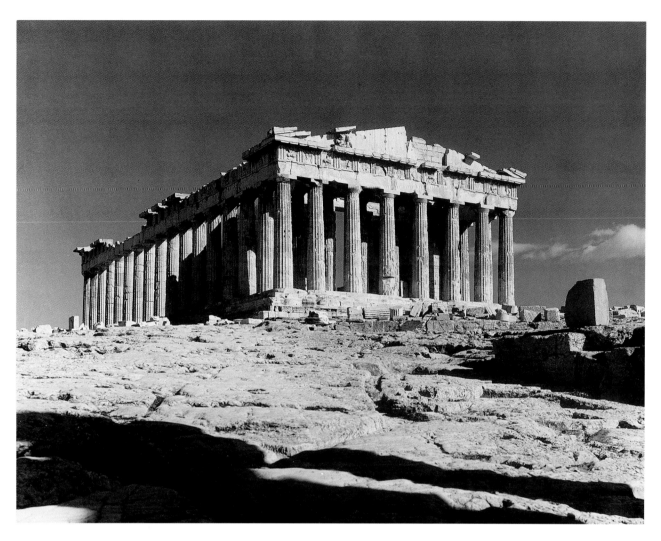

61 Parthenon, 447–432 BC, Acropolis, Athens

clearly was not looking at trees or naked bodies. Instead, it is likely to have been looking at the equipment that made the naked body an effective part of a fighting machine (see fig. 49). The hard-edged bronze cuirasses and greaves, the shield and helmet with which the body was protected, and the sharp iron swords and spears with which it could be armed, all shared precisely the properties that distinguish Doric columns and entablatures. The correspondence is closest in the case of the columns, where the arris between the concave flutes recalls the edge of a sword or spear where it would often be flanked by hollow ground faces. In a similar way the early Doric capital shares roundness and convexity with a shield of the same period, and the way architectural

62 Plan of the Parthenon, 447–432 BC, Acropolis, Athens

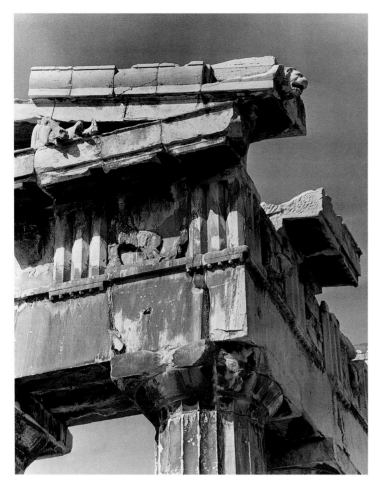

63 Parthenon, entablature details, 447–432 BC, Acropolis, Athens

who turned to the temple for protection they can only have enhanced its power to intimidate potential enemies. Many of the distinctive attributes of the Doric temple, like those of the visibly well-trained phalanx from which they derive, would have been reassuring to the community to which the temple belonged and threatening to its enemies.

It is thus not surprising that, as warfare became more and more important during the sixth and fifth centuries BC, the expressively threatening power of the Doric temple constantly increased. The disciplined uniformity of rows of columns and capitals became more insistent, mouldings ever harder and sharper. Most intimidating and militaristic was the Parthenon. Not only were its metopes decorated with scenes of fighting and its frieze with a procession of cavalry, but Pheidias's gigantic cult statue of Athena inside had scenes of fighting on the inside of the shield and even round the soles of the goddess's shoes. The Parthenon was also the first large Doric building to be constructed of a material that could only be worked with high-technology tools, marble. This allowed its forms to be even more spare and hard, evoking ever more closely the aesthetic of the armourer. Paid for out of the defence budget of the Delian League, commissioned by Pericles, the general who was the head of the militarised Athenian state, and home to the heavily armed statue of the warrior goddess Athena, the Parthenon was a building whose structure and ornament were both calculated to generate a neurochemistry of reassurance in Athenian citizens and a neurochemistry of intimidation in their rivals, especially the Spartans.

Ionic Details

Given the correspondence between the deep round folds of the Erechtheum's Ionic columns and the folds in the dresses of the maidens in its porch (see fig. 60), it is easy to see how the idea that the Ionic column had a feminine inspiration became current from around 400 BC, but this can hardly be its true origin, since Ionic has many properties, such as the geometry of its capital and mechanical regularity of its base, that cannot be related to a feminine aesthetic (fig. 64). Where do they come from? To answer that question we have to go back to the time and place of the order's emergence, 150 years

elements were seen in terms of objects possessing properties that were desirable in military terms is evident in the name given it by the Greeks, *ekhinos* (*echinus* in Latin), from the sea urchin, famed for its hard convex protective shell. When it comes to the temple's upper elements, the architrave, the frieze of metopes and triglyphs, and the underside of the cornice liberally decorated with the heads of pegs or nails, it is not their specific forms that relate to arms and armour but their general properties of angularity and hardness, and above all the sharpness of their edges. Still other associations are brought out by the profile of the cornice on which the water spouts often had the form of lion's heads. Homer regularly compared his warriors to lions, and given that the lion spouts suggested an analogy between their roar and the sound of rushing water, in the eyes and ears of those

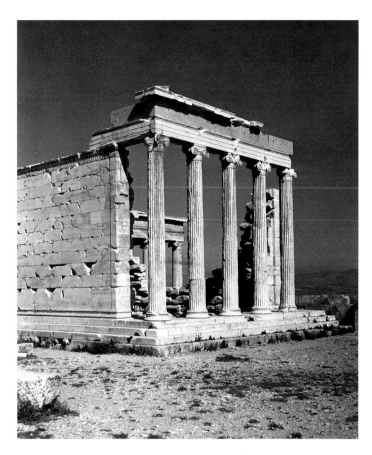

64 Erechtheum, 421–405 BC, Ionic portico, Acropolis, Athens

before the Erechtheum, on the islands of the Aegean and the coastal cities of Asia Minor. What might the designers of temples in this maritime context have been looking at with such attention that it equipped them with neural resources that led them to design columnar structures that differed strikingly from their mainland predecessors? A hint is provided by Sappho's remark that while some thought an infantry formation the most beautiful thing, others thought it was a fleet of ships. There is no question that ships would have been particularly appealing to the inhabitants of the islands and the Asiatic coast, and it is telling that the area where Ionic was most popular was as much united by an emphasis on sea power as the Doric areas were by a concern with power based on the land. Indeed, Samos, the site of the first great Ionic building, the Temple of Hera of about 560 BC (fig. 65 and see fig. 68), was at that time the greatest naval power in the Aegean, a thalassocracy dependent on a great fleet.[3]

The correspondence between Ionic temple and ship is not as close as that between Doric temple and phalanx, and Ionic temples are also phalanx-like in their configuration, but there are similarities in general configuration between a ship with its multiple rows of oars and a temple with its multiple rows of columns, and there are some features of Ionic that evoke a ship more than a phalanx. One is the single column introduced in the centre of the rear facade of the Samos temple. By breaking the symmetry of the temple's plan, it disrupts the order necessary in the phalanx, but can be seen as directly recalling a key part of a ship, the sternpost. In a similar vein, if the assimilation of Doric temple and phalanx explains why Doric structures have large steps all round, as if to allow the columns to move in any direction, the placing of steps only at one end on the Ionic suggests that it, like a ship, had only one 'business' end. The beak on a Greek war vessel not only occupied a similar position in the ship's plan to the steps on the Ionic temple, but also had the same sloping form.

What of the other main differences from Doric, the capital and base? The Ionic capital derives ultimately from the leaf-based forms popular in western Asia, where people gazed lovingly on the trees that nourished them. So what had the Greek inhabitants of the Aegean been looking at with such intensity that they changed soft leaves into a new more rigid and mechanical shape already found in the earliest surviving capitals from Ephesus, c.550 BC, in modern Turkey (fig. 66)? Vitruvius (*De architectura*, III: 5, 7) called the main element, swelling in the centre and ending either side in tight spirals, a *pulvinus*, in English a 'cushion' or 'bolster', suggesting a stuffed textile, and one such object was a rolled up sail (fig. 67).

65 Plan of the Temple of Hera, c.560 BC, Samos

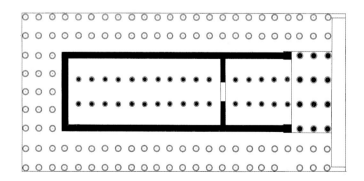

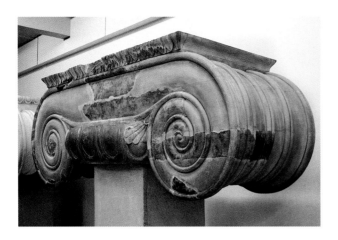

66 Ionic capital from the Temple of Artemis, *c.*550 BC, Ephesus. British Museum, London

67 Ship with mast and sail, detail of *Odysseus passing Scylla and Charybdis*, red-figure vase, *c.*520 BC. British Museum, London

Strengthened at the edges by a cord, when rolled up it too would, like the *pulvinus*, have been narrow in the centre and fatter at the ends, while the ends themselves would indeed have presented the appearance of tightly rolled spirals. If the round moulding on the faces of those spirals recalls the cord that strengthened the edge of the sail, the similar rounded mouldings on an Ionic capital, which are often spaced regularly across the 'bolster's' side elevations, recall similar cord reinforcements repeated across its surface. While the inhabitants of western Asia, who depended on palms and fruit trees, saw leaves at the top of their tree-like columns, the inhabitants of the Aegean, who depended on sailing ships for both trade and defence, would naturally tend to see columns as masts and the element with which they were crowned as a sail, rolled up as it would have been in port.

What of the Ionic base, which also has its origin in western Asia? In contrast to the rounded and often organic forms found on such bases as those in the ninth century BC palace at Tell Tayinat in modern Turkey, the Ionic forms – the simple round *torus* and the concave *scotia* or *trochilus* flanked by rectangular fillets – are relatively plain. What did the Ionian brain see in such forms to get a positive feeling from them? The answer is probably pulleys and ropes. This is supported by the names of the mouldings themselves. In Greek *toros* regularly means 'knot' and *trokhilos* is the Greek word for 'pulley', from *trekhein*, 'to run', a place for a rope to run in. No Ionic bases are more like pulleys than the earliest ones

from Samos, *c.*550 BC, with their convex and concave profiles marked by hollows that seem made to receive ropes (fig. 68). The technology of their production points in the same direction. These massive stone bases were made by turning on a lathe, a giant version of the instrument that would have been needed to produce the best wooden pulleys. Even the

68 Column base, Temple of Hera, *c.*550 BC, Samos

so-called Attic base with its splayed form running down to a fillet looks like one half of a pulley, or the flanged end of a drum on which the ropes of rigging and anchor might have been wound, as on the modern bollard. Most *torus* mouldings were smooth but one form, used prominently on the Erechtheum, was decorated with a pattern resembling the plaiting of fibres. Such a moulding would have given intense pleasure to a community all of whom would have been familiar with the way a rope might be strengthened by braiding.

It is either a happy chance or a silent confirmation of the suggested neural associations of the forms of Doric and Ionic that two nearly contemporary Athenian buildings at Delphi carried explicit associations with land and sea warfare. The Athenian Treasury at that site, outside which were displayed the spoils from the land Battle of Marathon in 490 BC, was Doric, so setting off the triumph of the Athenian phalanx, while the Athenian Stoa nearby, the first Ionic structure commissioned by the city, was erected specifically to house and display the ropes and other ornaments taken from the Persian ships defeated at the Battle of Salamis in 480 BC, in evident celebration of the superiority of the Attic navy.

The Greek Temple and Greek Warfare

In stressing that the Doric order was developed by people for whom the phalanx was the most important instrument of war and Ionic by people for whom it was the trireme, there is no suggestion that these were mutually exclusive cerebral obsessions. The common preoccupation with warfare was of universal and over-riding importance, as is suggested by the detailed forms of both building types and the names by which they were identified. We can thus compare the name *echinus*, 'sea urchin', for the element at the top of the Doric shaft, with that of dentils, 'little teeth', for a moulding on the Ionic architrave. A more modern name for an Ionic detail, and one which brings us even closer to the phalanx, is the 'egg and dart'. The word 'dart' refers to a pointed shape, which by the Roman period did indeed often take on the form of an arrow or spear. That, however, was only the final stage of a series of transformations that went back to a moulding that was originally a series of down-turned leaves separated by shoots. The process by which the down-turned leaves were slowly transformed by generations of sculptors is a perfect example of how changes in visual experience produce changes in the shaping activity of the hand. During the sixth century BC the pointed shoots began acquiring ridges and a curved profile that gives them a threatening sharpness, recalling a lion's claw, and, in some versions, the soft leaves have hardened into convex rounded forms with metallic borders, a tendency that continued in the fifth century BC. The most likely explanation for these transformations of innocent vegetation is that people who looked at the early leaf mouldings had the phalanx so much on their minds that they saw in the leaf pattern something like the series of shields and spears described by Homer (see p. 100). Themselves trained as soldiers in the phalanx, the carvers unconsciously modified the leaves so that they looked enough like a row of spears and shields to give them a similar pleasure. The fact that in some places there was a tendency to make the sharp elements look more like lions' claws should not disturb us. When the Greeks looked at warriors, in their imaginations, as we know from Homer, they saw them as lions, their weapons being like the claws and teeth of felines. To make the same element look both more like a row of spears and a row of claws did not constitute a conflict. Rather, it reinforced the desired effect. The way both tendencies worked together is well illustrated by the Siphnian Treasury at Delphi (fig. 69). There a 'leaf and dart' moulding finds itself juxtaposed both with one of the best portrayals of a phalanx front with its alternation of spears and shields and with a celebration of the destructive power of the lion's claw. When contemporaries looked at such an image the networks in their brains would have helped them to sense what the building's designers had in theirs.

The use of the word 'sense' brings out the advantage of a neural approach to the architectural ornaments that I have been reviewing here. For one thing, it enables us to understand why the forms only ever evoke, never represent. All that was necessary was for the forms of a temple to have enough elements in common with weaponry to trigger a release of dopamine in the nucleus accumbens of members of the population that built it and a release of noradrenaline in their enemies' amygdalas. Those effects were best achieved

69 Battle of Gods (left) and Giants (right), detail of north frieze of the Treasury of the Siphnians, before 525 BC, Delphi

by subliminal suggestion. Carving of an actual row of spears and shields would have risked frightening even the community who paid for it. The tact involved is familiar in such banal areas as women's dress. For a woman to wear a blouse with a leopardskin pattern and to have long nails is effective, for her to have a hat in the shape of a leopard's mask or nails sharpened to become real claws would be counter-productive. The same applies to all the other assimilations proposed. Forms that have just enough properties in common with a particular phenomenon to trigger a desired neurological response represent an optimum solution. Forms that look exactly like the phenomenon are not. Columns that actually looked like warriors or mouldings that really looked like sea urchins or teeth would have been off-putting.

For the forms I have been discussing to be effective it is clear that they have to be indeterminate, and that reminds us how dangerous is our habit of defining them in terms of names. An *echinus* is not a sea urchin and a *trochilus* is not a pulley. They are only forms that activate networks that have been shaped by visual exposure to sea urchins and pulleys among many other objects. If we want to understand their power we have to react to them not in rational verbal terms but visually and viscerally, reconstructing how they would have been responded to by their intended viewers. To do that we have to imagine a past world where hopes and fears for the individual's, the family's or the community's survival jostled one another. Iphigeneia's speech is a window onto such a world, where the meaning of architectural forms can

only be hinted at indirectly through the interpretation of the imagery of a dream.

At least in the case of architecture, which was a communal expression, we have some certainty when reconstructing the shared interests that would have had a dominant role in guiding the aesthetic choices of a particular building's patron, designer or users. If the social and material circumstances of a community were such that people gave particular attention to the apparatus of craft activities and land warfare, it is their influence that would be likely to be dominant. If they were such that people gave attention to the apparatus of trade and of naval warfare, the dominance would be there. If, as was the case at Athens, whose citizens were active in many fields, attention was given to all these, then all would have a role, greatly enriching the unconscious mental activity involved in design. The Parthenon, with its outer Doric colonnade and its inner Ionic columns, draws on networks formed by attention to activities both civil and military, both maritime and terrestrial, and it packs an exceptional punch because all those networks – and many more – worked together in ways that could never have been articulated in words. Greek art owes its power less to its makers' prior conscious reflection than to the intensity of their prior visual engagements. Thinking and talking can shape thought and direct attention. They cannot guide the draughter's pen or sculptor's chisel. This is best done by robust visual neural networks shaped by intense exposure.

6

Greek Art and Mathematics

There is perhaps no trait of Greek culture that is so widely celebrated as the omnipresent interest in mathematics. Whether we are talking of cosmology or education, music or philosophy, architectural or sculptural proportions, mathematics, in the form of both arithmetic and geometry, are everywhere. What can a knowledge of neuroscience contribute to an understanding of the unconscious mental formation behind this Greek interest?

Neuroarthistory suggests an answer, since the interest is manifested in art long before there is any evidence of a Greek concern with either philosophy or mathematics as such. Indeed, the latter's prominence in pottery of the ninth and eighth centuries BC has led to a whole style being categorised as 'Geometric' (fig. 70). This acquired its designation because its products are characterised by many attributes that are shared with the type of diagrams that later became the basis of the mathematical discipline of

'geometry'. Without it being spelt out, the suggestion is that somehow the spirit that was to shape that intellectual discipline already informs these early craft products. Prominent attributes are circles, triangles, rhomboids and other configurations with parallel lines. These are most obvious in the scenes of warriors. Spears are insistently parallel and circular shields repeated at regular intervals. Bodies are often triangular, arms and legs straight, with muscles indicated by standardised curves. These are the soldiers described by Homer at the same period as 'forming a fence, spear against spear, shield against shield, helmet against helmet, man against man' (*Iliad* XII, 130–36). Their properties are those that make an armed man an effective member of a well-

(facing page) 70 Amphora with scenes of charioteers and footsoldiers, late 8th century BC, Attic. Antikensammlung, Staatliche Museen zu Berlin, Preussicher Kulturbesitz

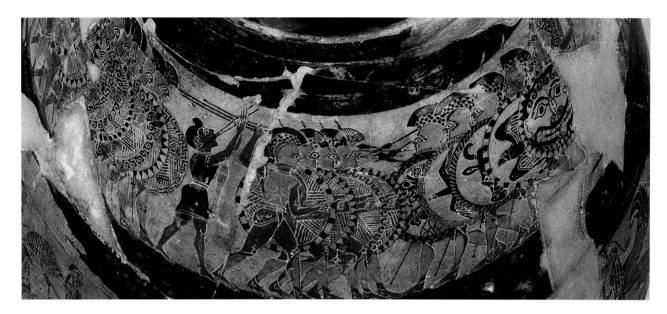

71 Flute player and armed warriors, detail of oinochoe (the Chigi Vase), third quarter of 7th century BC, Corinthian. Villa Giulia, Rome

drilled phalanx. If there is an origin to this style it is in the regularity that Greeks recognised as critical for success on the battlefield, what we might call an aesthetics of warfare. It would be more appropriate to characterise the style not as 'Geometric' but as 'Military'.

Geometric Style or Military Style?

It was not only in the visual field that regularity was associated with warfare. The same was true of the aural. Throughout Greek history, music is seen as providing a key to military order. Its role is celebrated even in early literature. Hesiod in the late eighth century BC tells how the personification Harmonia (Fitting together) is the antidote to the destructive power of her sisters, Panic and Fear, as daughters of Ares and Aphrodite, 'who drive in disorder the dense phalanxes of men' (*Theogony* 933–7), while another account made Harmonia the bride of Kadmos, King of Thebes, who sowed the rows of dragons' teeth that spontaneously turned into the perfect formation of warriors. On the real battlefield, harmony or 'fitting together' was encouraged by instrumental music. Flute players are shown as the key to a regular phalanx on the Chigi Vase (fig. 71) in the seventh century

BC, and in the late fifth Thucydides credits the major Spartan victory over the Athenians at Mantinea to flute players who were placed among the soldiers 'so that they should advance marching and in time and so that the formation would not break up' (*Histories* V, 70).

The Chigi Vase is only one of many produced in Corinth and Athens in the seventh and sixth centuries BC that give prominence to a correlation between regularity, visual and auditory, and military subjects. It is most evident in those drinking vessels known as shield cups because their concave shape evokes the weapon most associated with military honour, an accoutrement the hoplite should never abandon (fig. 72). We can see that shields were uppermost in the minds of the makers, purchasers and users of such cups because they are often ringed by bands of regularly spaced shield-bearing warriors whether on foot or on horseback. On larger vessels these may be joined by men driving chariots with shield-like wheels, and rows of aggressive animals, large felines and bulls, similarly spaced and aligned. The men who commissioned such vases to drink from at feasts after military training still had war on their minds even as they relaxed. Flasks that contained the perfumed oil with which they anointed themselves between exercise and feast could contain even more distilled expressions of a military aesthetic, as does the

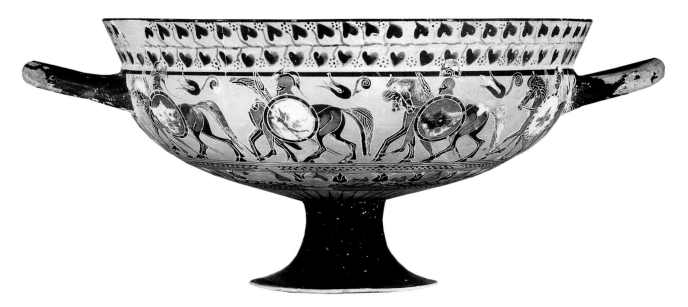

72 Cup with shield-bearing cavalrymen, second quarter of 6th century BC, Attic. British Museum, London

aryballos by the Macmillan Painter, with its ranks of warriors as rigid as mechanical robots (see fig. 43).

It is possible to understand these trends without reference to unconscious neural activity. Many of their aspects, such as the choice of subject and compositional type, may have been the product of decisions expressed in words. Where a neural approach helps is in providing a better appreciation of the unconscious mental processes that preceded such conscious decisions. This applies particularly when the process began with an experience that was purely visual. Thus, it was looking at formations of armed men, combined with a desire for such formations to have properties of regularity, that first caused the laying down of neural networks that were particularly alert to and so encouraged a search for those properties. This would have affected all in the community, and especially all males. Anyone who possessed such networks would then be predisposed, if they were a craftsperson, to embody those properties in the products they made and, if they were a patron, to look for them in those they acquired. Such was the importance of the visceral concerns behind these networks that they were not only activated by portrayals of explicitly military and militarily related activities. They could affect all forms of ornamental expression, for example the flowers that adorn the upper fields of vases or the triangular forms that adorn their bases. In the same way, if looking at shields endowed people with networks that gave them a preference for circular shapes, that preference could be activated and strengthened by the sight of anything else round, such as a chariot wheel. We can call such preferences 'geometric' because they anticipate shapes exploited by the later discipline, but in terms of their origin and cultural context they are military.

Pythagorean Mathematics

Firmer evidence for the connection between mathematics and the military comes from texts by authors who later came to be thought of as the founders of what we call Greek philosophy, but whose initial concerns were more practical, relating to the understanding of nature and the universe and the guidance of behaviour. Most influential was Pythagoras, who moved from Samos to southern Italy around 500 BC.[1] Although we know his ideas only from later sources, he seems to have described the order of the heavenly bodies in terms of a *kosmos*, or battle order held together by *harmonia*, and to have encouraged his followers to become *mathematikoi* by following *mathemata*, that is 'things learnt

or that have to be learned'. We know more about one of his later followers, Archytas of Tarentum in southern Italy (late fifth to mid-fourth century BC). Besides writing important works on topics such as mathematics and harmonics, he was famous for being seven times elected as the *strategos* or general of his city. Most influential, though, was his recognition that in education four disciplines have primacy because of their mathematical basis: arithmetic, called by him logistic, geometry, astronomy and music. Transmitted to the Middle Ages as the quadrivium, or 'four ways', these disciplines came to constitute the core of European higher education. More relevant to us here is the fact that Archytas's ideas were taken up by his contemporary, Plato, who adapted them for the curriculum of the 'guardians' in the state he describes in the *Republic*. Whatever the additional benefits of these mathematical disciplines as aids to the teaching of higher truths, Plato is clear that the primary benefits they bring are in the conduct of war: arithmetic for marshalling the troops, geometry for arranging formations, music for gymnastics and astronomy for picking the seasons for campaigning (*Republic* 400–04 and 522–7). Each of the mathematical sciences is justified in terms of its military utility and, at the beginning of the *Timaeus*, which is presented as the *Republic*'s sequel, this is expressly brought out, when Socrates tells how he wants to see how effectively his imagined state would perform in a war situation (*Timaeus* 19B). Such evaluation on the battlefield was crucial because the decisive element in the context of Socrates's thought and Plato's writing was despair at Athens's defeat by Sparta. This was the visceral drive behind the vision Plato inherited from his teacher, and, when looking for a safeguard against such a disaster happening again, it was to Pythagorean mathematics that he turned. From Geometric vases to Plato's *Republic*, the military value of mathematics was fundamental.

Convergent Perspective

The extent to which the Greeks anticipated the mathematical system of one-point perspective as formulated by Brunelleschi and Alberti in the Renaissance is still uncertain, but there is strong evidence that they came close.[2] Minor

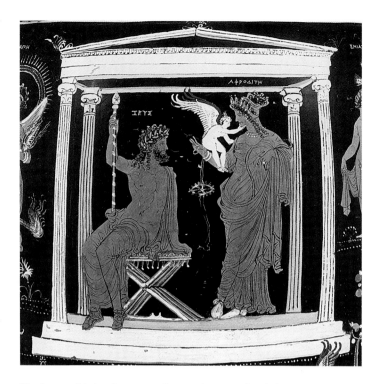

73 Zeus and Aphrodite in an architectural setting, detail of red-figure loutrophoros, c.330 BC, South Italian. J.Paul Getty Museum, Los Angeles

examples of some convergence are found in Greek painted pottery of the fifth and fourth centuries BC (fig. 73), and by the Roman period many wall paintings deriving from Greek originals exploit converging orthogonals more or less systematically (fig. 74). It is thus unquestionable that the Greeks possessed something like the system of geometric construction that since the Renaissance has been known as linear perspective. What is less clear is the process by which it emerged. A traditional view would have it that the Greeks were interested in representational truth and that perspective was consciously developed as a system to achieve that, but there is no direct evidence to support this claim. Can neuroscience offer an alternative explanation by reference to processes of unconscious neural formation? In other words, can neuroscience suggest a category of experience that would have encouraged a taste for lines converging on a point?

If we ask ourselves what that experience might have been an answer is suggested by the early first century BC Roman Lucretius, one of the first people in Antiquity to describe per-

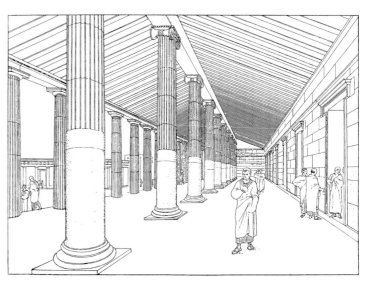

74 Wall painting in a *cubiculum* (bedroom) from the Villa of P. Fannius Synistor, *c.*40–30 BC, from Boscoreale, Naples. The Metropolitan Museum of Art, New York, Rogers Fund, 1903 (03.14.13a–g)

75 Interior of the Stoa, 2nd century BC, Priene, reconstruction

spective at all coherently. He compares its effect to the experience of looking along a colonnade, in which the receding lines appear to come together in a cone (*De Rerum Natura* IV, 429). The same experience could have inspired Euclid's account in the *Optics* around 300 BC. In his formulation: 'The further parts of planes below the eye appear higher. The further parts of those above the eye appear lower. Of those things that extend forward, those on the right bend to the left and those on the left to the right' (*Optics*, Theorems 10–12). A colonnade having a floor and a ceiling does indeed have planes above and below the eye, while the lines linking a row of capitals and bases on one side and those marking the parallel courses of masonry on the wall opposite could indeed be said to bend to the right and to the left (fig. 75). Euclid's exposition sounds less like a theory of vision that could be used as the basis for a theory of true representation than an account of the way we experience a particular architectural space.

What these observations by Lucretius and Euclid bring out is the salience of a visual experience unknown before the Greeks. The portico, whether as a free-standing *stoa* or as one element in a more substantial building, such as a temple, was a prominent feature of the Greek environment, being found everywhere in both marketplaces and sacred sites. Such porticoes, like most Greek structures, were full of orthogonals. In other cultures such colonnades were rarer and less public. In Egypt, for instance, they were principally associated with mortuary temples that were only visited occasionally. They also lacked the receding lines. Egyptian columns did not usually have bases, as did Ionic ones, and their curving leaf capitals hardly created alignments. Besides, Egyptian masonry, being made of sandstone and often intended to be covered with hieroglyphs or scenes, lacked visible joints between the courses. Greek masonry on the other hand was typically made out of hard limestone and marble, with clearly visible lines separating the courses, and often with mouldings articulating its overall structure. Such masonry was unknown in other cultures, but had already become a typical feature of Greek architecture in the sixth century BC, its popularity

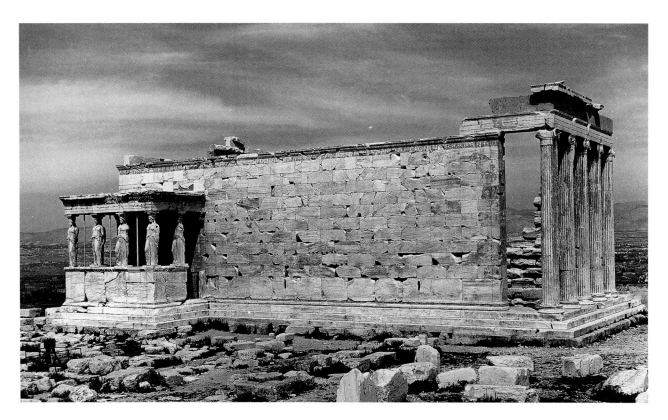

76 Erechtheum, 421–407 BC, Acropolis, Athens

being probably encouraged by a military aesthetic that saw rows of well-trained men in the phalanx as sharing properties with rows of well-cut stones in a wall.

Greek architecture, then, offered many examples both of interior spaces with axes receding into depth and of walls made of clearly separated courses of masonry. Daily exposure to spaces with this combination of attributes would have had a direct impact on the neural resources of viewers, especially on the banks of neurons in the early visual system that are tuned to respond to lines of a different orientation, the response strengthening with increased exposure (see fig. 3). People who found themselves looking along receding walls and colonnades would have been exposed to more lines of different orientation, some below the eyes, some at the same level, some above, than people earlier or elsewhere on the planet, and the result would have been that all the banks of neurons involved in the perception of such lines would have been strengthened. Significantly too, since such lines, when receding, were always experienced as tending to

meet, they would also have acquired a preference for such convergence. In an artist those neural networks would have encouraged the making of compositions using such lines, in patrons they would have encouraged their commissioning, and in users in general they would have encouraged a preference for looking at them.

The process would have been incremental. As more and more such structures were built, more and more people would have experienced more and more convergence. As the experience was repeated the associated preference would have intensified. This would have been especially the case in Athens. After the Persian Wars many new stoas and temples were built particularly on the Acropolis and in the Agora, and architecture acquired a greater prominence in the environment than it had in any other city (fig. 76). The period that saw an increase in the experience of colonnaded interiors also saw other changes in the visual field of the normal citizen. Furnishings, which in Egypt or Mesopotamia had been the prerogative of the powerful, now became more widely

distributed in the population and, with the increase in the number of tables, chairs, beds and chests, people would have seen more and more receding cuboid volumes. Because of the loss of such contemporary monumental paintings as those in the Painted Stoa (the Stoa Poikile) we cannot fully monitor the process by which convergent perspective emerged, but there is enough evidence to demonstrate its increasing manifestation. Vitruvius, in the first century BC, when discussing the representation of architecture, describes the use of receding orthogonals as constituting *scaenographia*, 'scene painting', and credits its invention to the fifth-century BC Athenian scene painter Agatharchus (*De architectura*, VII: Preface, 11). He is probably being anachronistic when he credits the fully convergent perspective of his own day to Agatharchus, but he is probably right to attribute to him some exploitation of receding lines, as his generation will have been the first to have had an exposure that nurtured a preference for them.

This neuroscientific explanation of the origin of perspective representation in ancient Greece does not deny a role for conscious mental activity in the eventual formulation of its rules. When Vitruvius talks of lines converging *ad circinis centrum*, 'toward the point of the compass' (I: 2, 2), he is suggesting that by his period at least there was a recognition that the convergence of receding orthogonals could be grasped using geometrical procedures, and this could not have happened as a result of neural tuning alone. Instead, it is likely that the phenomenon of convergence was at some stage noted by someone already interested in geometry. Ever since Pythagoras, geometry had been an instrument used consciously as an aid in the understanding of form and, once such geometry had been applied to optics by Euclid, Archimedes and others, it would have been a small step to reduce the convergence of receding orthogonals to the formulation found in Vitruvius. As in many areas of Greek culture, an experience that was unconscious led first to conscious reflection and then to formal regulation. Until recently we have only known about the last two stages. Now, thanks to the discoveries of neuroscience, we can understand the first.

Part 3

ROME
100 BC–AD 300

Art, the Material Environment
and Material Power

By the time Octavian, the future emperor Augustus, defeated Anthony and Cleopatra at Actium in 31 BC, Rome had, from its base in Latium, conquered most of the territories ruled by the Greeks in the eastern Mediterranean, had displaced the Phoenician colony of Carthage as the dominant force in North Africa and the western Mediterranean and was expanding its authority over large areas of what we now call Europe. No earlier state outside Asia had gained control of such human and material resources and none was so well equipped militarily and politically to maintain it. The mental situation of the beneficiaries of this control was thus a complete contrast to that of the Greeks at the time their culture was formed. While the Greeks, even after their victory over the Persians, were constantly adjusting to the constraints imposed by geographical and historical circumstances, the Romans, after Augustus's inauguration of what became known as the Empire, were free to bend human and natural resources to their will. For many this sense that Rome was associated with power was enhanced by their realisation that the city's name closely resembled *Rhome*, the Greek word for 'force' or 'bodily strength', the real response to such homophony being due to the extent to which similar sounds use the same pathways in the auditory cortex. The wealth and efficient administration on which Rome's power depended diminished drastically in the third and fourth centuries AD, but the self-confidence and mental flexibility it had already brought into being persisted, providing a much needed cushion against the trauma of imperial decay.

Roman Identity and the Environment

The Romans' sense of power may also have been reinforced unconsciously by their immediate physical environment, which presented a great contrast with that of Greece. The rocks of Greece are the product of a process in which slow sedimentation under cool seas was followed by folding. As such they are frequently seen to be layered and fractured. Those around Rome are the product, direct or indirect, of relatively recent and violent volcanic activity (fig. 77).[1] Most of the visible rocks, such

77 Map of volcanic activity around Rome showing craters with lakes

as basaltino, peperino and tufa, reveal the impact of heat, being made up of either lava flow or fallen ash. Others, like travertine, represent the deposits of hot springs. The process of deposition from hot springs could still be observed in several places in Latium, including Tibur, Tivoli, from where travertine takes its name, Lapis Tiburtina. Lava flow and ash fall could only be seen taking place intermittently at more distant active volcanoes, such as Vesuvius, Stromboli and Etna, but in 104 BC flames shot up at Volsini Volcano on Lake Bolsena to the north of Rome, and constant similar manifestations gave their name to the Phlegraean, or Flaming, Fields to the south, near Naples. In contrast to the situation in Greece, all the processes involved heat, were dynamic and resulted in the extrusion and deposition of stone in continuous masses.

Ancient Greeks and Romans knew nothing of modern geology, but if some form of empathy with the environment is a fundamental, neurologically determined, human trait, and if Lakoff and Johnson are right that the 'metaphors we live by' derive from our experience, we can see how the two environments might have evoked widely different unconscious responses. Thus, while the Greek landscape encouraged a feeling for the linear, the measured and the refined, that surrounding Rome encouraged a feeling of flow, of energy, of heat, of transformation. Both the cooling of lava and the precipitation of travertine

involved the solidification of flowing liquids. Fluidity was also prominently manifested in the River Tiber, which ran through the centre of Rome and was much more powerful than the often barely visible rivers of Athens, especially in winter when it was liable to flood. Flow was as much associated with massiveness and violence in Rome's river, as it was in her rocks.

We cannot know the extent to which these properties transmitted themselves to those who lived with them, but there are suggestive correlations between the contrast in the environments of Athens and Rome in this comparison of Greek and Latin oratory by Quintilian (*c.*AD 35–*c.*100, the first teacher of rhetoric officially appointed by the Emperor):

We cannot be so elegant;	**let us be more forceful.**
They win in terms of refinement;	**let us excel in weight.**
Their sense of propriety is more sure;	**let us surpass them in our copiousness.**
Even the lesser talents of the	**we are usually driven by larger sails;**
Greeks have their harbours;	**so let them be filled with a stronger wind.**

Institutio oratoria XII: 2, 36–40 [author's arrangement]

Many other Latin writers of the period pick up on the notion of volume and flow. Quintilian's older contemporary Petronius writes of the flowing vigour of Roman style and says of the orator's education: 'Then let Roman authors flow round him, and, unimpeded by the Greek language, let them, swelling, change his taste' (*Satyricon* 5). Again, a few decades later, L. Annaeus Florus puts Quintilian's recommendations into practice in a political context, comparing the spread of Rome's power through Italy to a forest fire and the rage of Julius Caesar to both a flood and a fire. In AD 155 Aristides Quintilianus claimed that the way Rome's buildings covered its hills could only be compared to a snowfall. Many other factors contribute to the shaping of this imagery, but one of those factors was Hellenistic literary theory, which also took its imagery from the local environment, as when the Alexandrian critc Callimachus, familiar with the Nile, said of a large book that it was like a big dirty Assyrian river and compared it unfavourably with the small springs that

were the source of his own poetry. We would be unwise to exclude the influence of an unconscious empathy with the forces that made Rome's natural environment unique.

Certainly, whether or not they felt that they were like a force of nature, Romans found it easier than anyone before them to impose their will on their surroundings. Wealthy citizens turned plains into mountains and mountains into plains. Emperors built aqueducts to bring vast quantities of cool water to the centre of the hot city and erected gigantic bath buildings where water was heated for pools of different temperatures. Visitors to the Baths of Caracalla (212–16) found themselves in a new world nearly a half a kilometre square where the familiar laws of nature no longer applied. The painted vaults far above were supported by the shifting curves of walls and colonnades clothed in marbles from all round the Mediterranean. The gardens were full of exotic plants, and a personnel of barbers and philosophers, masseurs and librarians could offer almost any pleasure or stimulation that mind or body might crave. Rome's power to transform people as well as their material surroundings had already been noted by Juvenal (*c.*100 AD) when he told how, at a Roman's bidding, a hungry Greek could turn himself into 'a grammarian, rhetorician, geometer, painter, trainer, soothsayer, rope dancer, physician, magician; if you ask him to go to heaven he will' (*Satires* III, 78). Whatever the Roman wishes, the Greek becomes.

Roman Identity and Magic

Juvenal cleverly makes the Greek's last transformation into that of a magician and so reminds us that there was an enormous expansion of both belief in and the practising of magic during the Roman Empire, as we know from Pliny the Elder (AD 23–79) writing fifty years earlier. At the beginning of Book XXX of his encyclopaedia of knowledge, the *Natural History*, he remarks that magic has had enormous influence 'in every country and in nearly every age', being deeply enmeshed 'in medicine, religion

and astrology'(XXX, 1, 1 and 2, 5). As he implies, these are all fields that people enter because they desire something, whether health, life after death or knowledge of the future, which magic helps them obtain. However, although magic is universal, as Pliny noticed, it is not, as he also noted, always equally popular, flourishing particularly in his own days under Nero (*Natural History* XXX, 2, 5).

Pliny was right about the rise of magic in the Roman Empire, and there were many reasons for the trend, the arrival of practitioners from the east being one of them. But perhaps the most important reason was the fact that it was becoming easier than ever before to change your circumstances in material terms. For the rich, personal wealth, and for the poor, the emperor's generosity, meant that everyone regularly experienced transformations of their environments which would have been inconceivable earlier. Entering a hot bath in the middle of winter or a cold one in summer represented the fulfilment of personal wishes, and repeated experience of such fulfilment laid down neural networks that made people more susceptible to believing in the fulfilment of wishes in other more personal domains. In this way both magic rituals and material tranformations were able to cause the development of particular neural networks that could then be exploited in the field of religion. Habituation to the belief that a person's circumstances could be transformed for the better, whether it was by binding a lover through a spell or bringing running water to the home, laid down neural resources that were then available to support the expansion of so-called 'mystery' cults, which offered the prospect of fulfilling personal wishes for 'life after death' or 'eternal bliss', and which all saw exponential growth under the Empire. For people who were used to the idea that magic could realise their private dreams and that exceptional resources could bring about unprecedented improvements in their material environment, the rewards that such religions offered were entirely believable. The transformation that Roman power brought in all fields laid down neural pathways that were then available to facilitate the expansion of both traditional magic and the magic of religion.[2]

Pliny's recognition that magic was particularly popular in his own day is telling, but understanding that it is found everywhere at almost all times is more significant for the historian of culture as it constitutes the beginning of a theory of magic, which is elaborated by his indication that in different areas of life it serves a common function. Much later, in the nineteenth century, under the influence of the generalising theories of Charles Darwin, such an all-encompassing view was developed more consciously by the founder of cultural anthropology, Edward Tylor. In *Primitive Culture* (1871) he argued that all magic is based on an omnipresent, though erroneous, association of ideas.[3] This approach was then taken up by J. G. Frazer who, in *The Golden Bough*, developed the first systematic theory of the phenomenon.[4] Frazer, who had studied magic cross-culturally and throughout history, came to the conclusion that it everywhere displayed common traits. The major category of magic he saw as Sympathetic, being governed by a Law of Sympathy, and this he analysed further into two sub-divisions, the Homoeopathic, based on the Law of Similarity, and the Contagious, based on the Law of Contact.[5] Although Frazer, like both Pliny and Tylor, thought that all magic was fraudulent, he dignified it with a singular intellectual coherence. The laws he referred to he called 'Laws of Thought', a designation that has important implications for how we view them. Such universal trans-historical laws must be rooted in human biology, that is, in the brain. Indeed, although he does not state it, there can be little doubt that Frazer's concept of 'sympathy' drew strength from the recently invented concept of *Einfühlung* or Empathy, whose neurological basis had been studied by writers from Friedrich and his son Robert Vischer to Theodor Lipps.[6] Frazer was not looking for neurological explanations for his laws, but today it is possible to provide them by invoking the principles of neuroscience.

No principle is more important for magic than that underlying the response identified by Frazer as 'sympathy', our capacity to identify ourselves or someone else with an object. It is such identification or empathy that causes us, if that object is given our name, or the name of a friend or enemy, to feel that what is done to it is also done to the individual named. Giving a personal name to an object establishes a link in our brain between our perception of that person and our perception of that object. It is because

these rules apply universally that one of the most common forms of magic involves taking an object or image, giving it a name and then tying it up or breaking it. In this way magic allows a person to feel that they are achieving a goal, such as binding a lover or destroying an enemy, that cannot easily be attained by another means. This is what Frazer meant by a Law of Sympathy, on one hand. The Law of Contact, on the other, would be operating if the magic involved, for example, doing something to a hair taken from a particular individual's head. Knowing that it comes from that individual's head establishes a neural link between the hair and the individual, with the result that an action done to the former will be experienced as affecting the latter.

We can explore more of the neural basis for magic by considering the knot-related sorcery discussed by Pliny in his *Natural History*, XXVIII, 17. There we learn that twining the fingers or putting ones arms around one or both knees can prevent a nearby woman from giving birth, while someone who crosses and uncrosses their legs at a meeting can make it impossible for the parties involved to come to an agreement. Such actions were felt to obstruct or otherwise influence outcomes because anyone who was familiar with knots, or, indeed, with any form of binding, would know that they constrain and reduce movement in the thing to which the knot or binding is attached. In that person's brain, the area in the temporal lobe where the forms of knots and bindings are categorised would be neurally linked to the other areas of the brain where all the hopes and fears associated with the consequences of binding are experienced. Since the sight of someone putting their arms around their knees and removing them, or of someone crossing and uncrossing their legs, could activate those same hopes and fears, such actions could be exploited for magical purposes either to heighten or resolve anxieties. Similar neural processes underlie Pliny's recommendation in the same passage that the stable symmetrical entwinings of the reef knot, the so-called Knot of Hercules, should be used both in the bandage of a wound and in a girdle worn every day. Such bindings, which evoke stability because the more you pull on them the stronger they become, and which evoke a sense of control because they are simple and are easily undone

78 *Nero and Agrippina*, showing Knot of Hercules on belt of emperor, *c.*65 AD, marble, Roman. Aphrodisias Museum, Turkey

by the wearer, are experienced neurally as profoundly reassuring, which explains their prominence on the belts of the statues of emperors, such as Nero, as well as in wedding jewelry (fig. 78). A kindred form is the emblem representing the shaking of right hands, known as the *dextrarum iunctio*. This was a reassuring image of union and could resolve anxieties, as in a coin of the emperor Nerva, where the emblem reassures all who saw it in circulation that a 'concord of the armies' had prevented chaos in the aftermath of the assassination of Domitian (fig. 79).

The neural basis is even clearer for another piece of Roman magic, the practice of *damnatio memoriae*. This punishment for a crime against the state voted by the Senate involved the erasing of names, the replacing of heads on

79 Gold *aureus* coin showing the head of Emperor Nerva (ruled 96–8 AD; obverse) and clasped hands, *dextrarum iunctio*, with inscription CONCORDIA EXERCITVM, 'Concord of the armies' (reverse), Rome. British Museum, London, R.6663

statues and the removal of figures from reliefs. First invoked against the ambitious Sejanus in 31 AD, it was subsequently applied in different degrees to fallen emperors such as Caligula, Nero and Domitian. What made the punishment effective was the neural response to the sight of such damage. As neuroscience has shown, when we see someone close to us appearing to have a nail driven into their hand, our own insula, a key centre for empathy and the experience of pain, is activated just as it would be if the injury happened to us.[7] If those who viewed the damage consequent on *damnatio memoriae* were supporters of the person involved, they would have felt real pain, just as, if they were his enemies, they would have felt real pleasure. It may be objected that *damnatio memoriae* is not technically magic as commonly understood, but it is one of the advantages of neuroscience that it reveals how actions that we are used to placing in separate cultural categories should in fact be grouped together because they rely on similar processes. Pliny had implied this when he saw magic as having a role in medicine, religion and astrology. The unifying element in the practices in all these domains is that they are intended to bring about a desired change in someone's circumstances which is otherwise outside their control, its basis being in the properties of our nervous system.

Roman Identity and the Imagination

One of the faculties on which transformation in all these worlds, the material environment, ritual magic and mystery religions, relied was the imagination. You need imagination to visualise a new layout for your villa. You need imagination to conceptualise the goal you want to reach with your magic practice. You also need it to visualise life after death or eternal bliss. Imagination was thus a faculty that was more important in the Roman world than it ever had been before, which is why it is not surprising that it was also one in which people could get training, as recommended by Pliny the Elder's younger contemporary, Quintilian. As he says in his handbook, the *Institutio oratoria*, the orator needs to develop his imagination so that he can use it to help him win cases as, for example, by persuading judges that a victim's injuries were worse than they were by describing someone who has only been beaten as murdered. To do so the orator has to develop his capacity to imagine the murder that never happened using what the Greeks call *phantasiai* and Romans *visiones*, of which he provides vivid examples still relevant today: 'When our mind is unoccupied or filled with empty hopes or day-dreaming we are beset by these images I am talking about: we travel, voyage, fight, address public meetings, enjoy wealth beyond our means; and we seem not to dream these things but to actually do them' (VI: 2, 27and 28). Being able to imagine things that are not true in this way is an ability essential to the orator.

Quintilian had no idea what the neural resources were that sustained the fantasies he is describing, but today we know that the neural networks we use when we imagine something are the same as those we would use if we were really seeing or hearing it.[8] The only difference is that, instead of the relevant areas of the visual and auditory cortex being fed by sensory inputs from the environment through the eyes and ears, they are fed by words that we hear or read, by stories we make up or by memories. Quintilian's account of the murder that never happened is a good example of the faculty's power, illustrating as it does how the more we live in the imagination the more we are detached from the experience of reality. During the Roman Empire this was to happen more and more

frequently. With the decay of the real environment, as shrinking incomes meant that public services declined and damaged buildings and roads and ruptured aqueducts were increasingly left unrepaired, the neural resources that had earlier been formed through sensory exposure to the world became progressively weaker, while those needed to sustain an inner life, *visiones*, 'visions', rather than *visus*, 'sights', expanded to an unprecedented degree. Indeed, since dreaming of foreign travel, imagining the possession of wealth and believing in the afterlife shared an engagement with the unreal, each would have sustained the other, so strengthening the neural resources involved. At the same time the networks that had earlier so effectively inhibited such activity, such as the connections to the areas in the orbital frontal cortex that are equipped to evaluate correspondence with reality, necessarily atrophied and fell away. Previously such evaluations had been based on information coming from the senses, and it was the convergence of information from different senses that secured the certainty whose symptom was the neurochemical boost that laid down memories that would guide future behaviour. Now, as the Empire advanced, such evaluations were increasingly based on verbal inputs that, although they were erroneous, were still capable of generating the chemical boost, as we know from experimental subjects today whose reward systems can be activated by false verbal information on the authorship of a painting or the price of a wine.[9] The result would have been that people increasingly accepted as true what their predecessors would have recognised as false.

One way to measure the decline in earlier critical faculties is by noting the rise in literary fiction, in which completely improbable things happen. A compelling example is the *Metamorphosis* of Apuleius (*c*.124–after 170), better known as *The Golden Ass*. This tells how, when a magic spell goes wrong, the hero turns into an ass and only returns to human form after many adventures when he becomes an adherent of the cult of Isis. The story is thus about both the failure of magic and the success of one of the new mystery religions. As such it parallels the Christian Gospel stories of Christ's death and resurrection, which in some ways belong to the same genre and require similar imaginative leaps. Such leaps were often encouraged by verbal outputs. These might take many forms: a literary fiction like *The Golden Ass* designed to entertain, a school exercise by a young orator designed to show how persuasive he could be, a real speech by an adult orator celebrating the powers of an increasingly powerless emperor, a religious text promising eternal life, or just the spell of a magician claiming to eliminate a rival in a sexual relationship. In each case what was imagined brought a greater neurochemical boost than what was known to be true because what the words described or promised was simply more attractive than what the listener might otherwise have believed to be the case.

Of no context was this truer than daily life. People who every day, from the late second century onwards, experienced through their senses a world that was rapidly degrading in material terms, whether at the level of the supply of grain and water, or the provision of leisure amenities, or trust in military security, were easily tempted by the benefits of living in a world of the imagination, whether that world was shaped by the words of orators, of politicians, of priests or of magicians, or by a religious ritual. With time, and especially with the decay in the social and material environment, people chose to live in a world of the imagination by using neural resources shaped by rhetorical training, by reading fiction and religious texts and by participation in magical practices and sacred liturgies. For the first two hundred years of the Empire the role of the Roman imagination was principally to inspire people in the transformation of material reality to suit their dreams. In the last two hundred the imagination allowed them to disregard the material world and live in a mental world shaped by words and rituals. This change could not have happened without fundamental adaptations taking place in the neural makeup of all its inhabitants, rich and poor, free and enslaved.

7

Roman Shapes, Roman Magic and Roman Imagination

Roman sculpture and painting are influential in the history of European art but their impact is hardly comparable to that of Roman architecture. In terms of forms, the extensive use of the arch, the vault and the dome are complete innovations. In terms of materials, the same is true of concrete. What can neuroarthistory contribute to their explanation? Most accounts credit these developments to a combination of Roman practicality and Roman pleasure in the visual expression of power, and these, like other currently available explanations noted in this book, are not to be discounted. The latest neuroscience does, however, allow us to consider the influence of less conscious factors.

Roman Architecture and Roman Landscape

Take the dome, for example. There is no more authoritative expression of Roman taste than that of the Pantheon (*c.*118–*c.*128) with its diameter of 150 feet (about 48 metres) and large central opening (fig. 80). It is the grandest of a series of similar structures, beginning with the circular bath building known as the Temple of Mercury (first century BC) at Baiae on the Bay of Naples and including the central space of Nero's Golden House (the Domus Aurea, *c.*65 AD). Was there anything in the Roman environment that people might have looked at with such attention as to encourage the use of such forms? One answer could be volcanoes. It is easy to forget how unusual is the landscape around Rome. There is no other major city anywhere in the world that is surrounded within a radius of a hundred kilometres by numerous extinct volcanoes, several of which have left

115

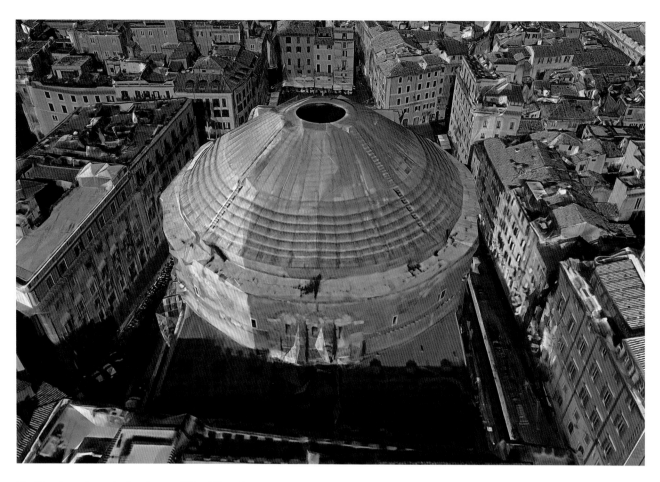

80　View from above the Pantheon, *c.*118–*c.*128 AD, Rome

craters filled with circular lakes (see fig. 77). These volcanoes would always have been the most striking feature of the topography of Latium, the site of whose legendary first capital, Alba Longa, the predecessor to Rome below it on the plain, was on top of one of them, overlooking the crater lake of Lago Albano (fig. 81). Although they are not often mentioned in ancient texts, these extinct volcanoes would have attracted frequent and intense attention, and that would have given their viewers unique visual preferences. These may have been first manifested in the Temple of Mercury, which was one of several circular structures with openings at the top that were built in the Phlegraean Fields within sight of the cone of Vesuvius, which was also known to produce flames. Given the prominence of volcanoes in the environment of both Baiae and Rome, it is easy to see how the visual preferences they shaped could have given individuals

in those locations, including architects, patrons and users, a taste for circular structures covered with roofs that diminished upwards culminating in a round opening.

Some will think it unlikely that neural resources shaped by looking at landscape might be employed to look at buildings, but such a proclivity was certainly facilitated by the brain's organisation. Both landscape and buildings are processed in the parhippocampal place area (PPA) because, presumably, it was easy for an area that had developed originally to deal with natural space also to deal with the human-made features with which it came to be filled. Examples would be wooden buildings, which could be easily processed by neurons that had long responded to forests, and stone structures that could be easily processed by neurons that had long responded to rocks. This meant that in an area like Latium, where volcanoes inherently possessed properties of regu-

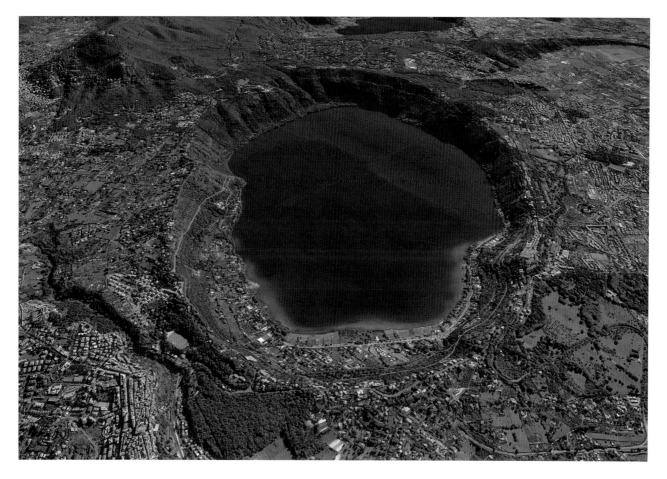

81 Lago Albano, Lazio, crater with lake

larity and symmetry that were more normally attributes of buildings, it was easy for both to be processed by the same resources. Such neural responses made it more likely that one would influence the other.

There is even a remarkable text that demonstrates the extent of the exchange between the two domains of landscape and architecture. In a first-century poem by Calpurnius Siculus, a countryman who is trying to communicate to an equally rustic friend the impression he had of the wooden amphitheatre that Nero had in 57 AD erected in Rome tells how: 'just as this valley comes together in an open plain and the bending sides with their sloping woods form a concave curve between the mountains, so there the curving sides enclose a sandy plain and bind the central oval with the twin masses' (*Eclogues*, 7, 23ff). Such a description would apply better to the truly mountainous Colosseum dedicated by Titus twenty-

three years later in 80 AD and even more to the great series of bath buildings running from those of Nero to those of Constantine, whose mountainous vaults and domes created roofscapes that more and more resembled the surrounding terrain. The conception of any of them may have been influenced by precisely the sense of the similarity between landscape and architecture evoked by Calpurnius Siculus.

One way of testing this suggestion about there being a potential link between the landscape surrounding Rome and its architecture is to do the same in the case of Athens, comparing the two buildings most emblematic of each city, the Pantheon and the Parthenon. Clearly, the greater uniqueness both of the landscape around Rome and of the domed space of the Pantheon makes the claim more plausible in the Roman context. The Parthenon, as a peristyle temple with a ridged roof, is not unique to Athens and, equally clearly, the

117

(above) 82 Mt Hymettos, Attica

(right, top) 83 View from above the Acropolis, Athens, towards Mt Hymettos

(right, bottom) 84 View from above the Pantheon (a), Rome, towards Monte Albano (b)

mountains around Athens are not much different from those elsewhere in Greece. There is, however, still sufficient similarity between the angular ridged roof of the Parthenon (see fig. 61), covered with tiles of marble from nearby Mt Pentelikon chiselled by metal tools, and the ridges of the equally nearby Mt Hymettos (fig. 82), chiselled by wind and water, to allow the suggestion that there is a similar correlation to that between the Pantheon and Monte Albano. Monte Albano and Mt Hymettos had, indeed, a similar prominence in people's experience, being the nearest mountains to the respective cities, both being about twenty kilometres (some twelve miles) from their centres, as we can verify from images taken from space (figs 83 and 84). The important point here, though, is not that there is necessarily a connection between these particular mountains and these particular buildings, only that there is a general connection between the angular ridged geology of Greece and the angular ridged temple type on the one hand and, on the other, between the more rounded geology of Latium and the more rounded forms of

Roman architecture. If so, both correspondences would be the product of preferences shaped by a passive exposure to the natural environment.

So much for the dome. What about the vault and the arch? Are there other elements unique to the Roman environment that could have encouraged a preference for such forms, already evident in the market at Ferentinum south of the capital in 100 BC (fig. 85)? One salient attribute of the lava that spilled, and the ash that was vomited up from the volcanoes of Latium, was the tendency for their masses to fracture as they cooled so that they often broke up into

85 Market hall, Ferentinum, Lazio, c.100 BC

86 Volcanic rock formation, Bomarzo, Lazio

outcrops formed of cliffs possessing an almost architectural geometry. In an example from Bomarzo, north of Rome, we can see how on the left a vertical line is as sharp as the corner of a built wall, how next to it the cliff curves away like a vault and how on the right the surface is hollowed out like an incipient half-dome or apse (fig. 86). The resulting visual effects are far different from those characteristic of the sedimentary limestones of Greece. All around Rome, and in the city itself, such rock masses would have been an omnipresent feature. If exposure to volcanoes, their craters filled with lakes, encouraged the construction of domes crowned by oculi, it is not difficult to see how exposure to lava outcrops with their volumes characterised by combinations of straight lines and curves might have also contributed to predisposing people towards the construction of walls and vaults combining similar forms.

This argument also finds support in the nature of the material that played a crucial role in the construction of such vaults and walls, concrete. The Greeks had often made use of lime, usually prepared by burning limestone, in the mortar they used to strengthen the joints between stones, but the Romans from the second century BC began to employ it in massive quantities, taking advantage of both the particular chemical properties of the volcanic dust today known as *pozzolana*, named after Puteoli in the Phlegraean Fields, and the ready availability of porous volcanic tufa, which could easily be broken up and added to the lime mixture to lighten it. Originally used for footings, and for the walls and vaults of ports and markets, by the first century AD concrete was increasingly used for the domes I have just mentioned, from the 'Temple of Mercury' to Nero's Golden House (64–9), to the Pantheon, before being exploited even more systematically in the grand series of imperial Thermae or bath buildings.

The functional, economic and creative advantages of the new cheap and flexible material are well known but, given the rapidity with which the material became established, which is astonishing in the light of the general conservatism of architectural traditions, it is worth considering the role that passive exposure to the environment may have had in heightening its appeal and influencing the manner of its use. The appropriateness of doing so is suggested by the symmetrical correlation between landscape and technology in building materials in the environments of Athens and Rome. Just as the layered strata of the sedimentary rocks of Attica are mirrored in the coursed masonry that became typical of the area, so the masses of lava and volcanic ash that cover the landscape of Latium anticipate the undifferentiated masses

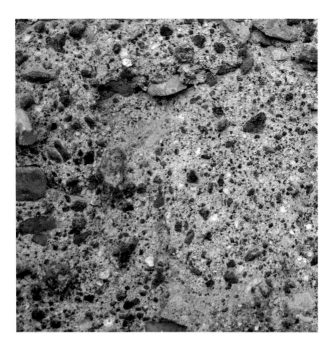

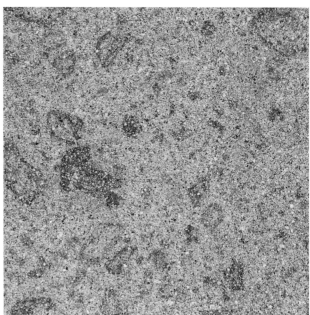

87 Roman concrete, *pozzolana*, Hadrian's Villa, *c*.125, Tivoli

88 *Peperino*, volcanic rock

of concrete that become characteristic of the buildings of Rome. There is even a precise correspondence between the make-up of the natural and human-made substances, both of which were solidified liquid mixtures. The volcanic masses frequently contained lumps of rocks embedded in the compacted dust and cooled liquid (fig. 87). And so too does concrete, where we regularly find the once liquid substance to be full of the fist-sized *caementa*, or 'cut up', volcanic rock from which 'cement' takes its name (fig. 88). Roman builders must have discovered the chemical properties of the miraculous volcanic powder *pozzolana* largely by chance, probably when laying foundations. But as they started to build above ground they would have looked at it with neural resources habituated to the appearance of *peperino*, the volcanic rock, which they were used to cutting into blocks for walls. Sensing the similarity between the two materials, they would have been encouraged to increase the similarity between them by adding lumps of rock to the fluid. Over time, the new material allowed architects to design buildings that increasingly evoked the silhouette and the volumes of Latium's landscape. It also made it possible for those buildings to be increasingly covered with heaving slabs of volcanic materials like those

that enveloped the surrounding hills. The use of Roman concrete is one of many cases in this book that illustrates how a purely passive visual exposure to a particular environment can play a surprisingly active role in the history of art.

Angular Greeks and Rounded Romans

One last feature of the Roman structural vocabulary that needs explanation is the semi-circular arch, a form used only occasionally by the Greeks. Was there something semi-circular to which Romans were exposed, and which carried such strong positive associations that it might have given them a strong preference for a form avoided in other architectures? One such object, which was both prominent in people's daily visual experience and positively charged, was the Roman toga, the dress of male citizens. Not only was it roughly semi-circular in shape, in striking contrast to the rectangular Greek tunic, the *pallium*, the dress of slaves, but the distinction in the geometries of the two items of dress was often alluded to (fig. 89). We thus read that the normally toga-clad Roman citizens in Greece put on 'rectangular' clothes to

escape the anti-Roman violence of the Mithridatic war in the early first century BC (Athenaeus, *Deipnosophists*, V, 213), while Dionysius of Halicarnassus later in the same century insists that the toga is 'not rectangular but round' (*Roman Antiquities*, III, 61). The negative associations of the rectangular pallium and the positive associations of the rounded toga are also brought out later in the first century AD by Petronius's reference to a witch 'dressed in a square pallium' (*Satyricon*, 135) and Quintilian's praise for a 'round and well-cut toga' (*Institutio oratoria*, I: 11, 3) and they were hardly diminished by the Philhellene Hadrian's occasional wearing of a pallium. Indeed, the negative associations of the pallium only acquired greater prominence as the Empire advanced, as slaves who were freed put off the Greek garment and put on the Roman. So important was the toga for the national identity that Virgil could characterise the Romans simply as the *gens togata*, the 'togaed race' (*Aeneid* I, 282). There is also the intriguing possibility that the contrast in geometry of the two garments was somehow related to contrasting visions of the perfect man. For Simonides, quoted by Plato as we saw, the good man is 'rectangular', 'wrought without blame'. For Cicero in the mid-first century BC, repeating a Stoic idea, the happiest man is like a sphere, having no angles to which a 'blemish of vice' might adhere (*Paradoxa Stoicorum*, 2), an idea taken up a few years later by Horace, who tells how the wise man is 'smooth and round, so that nothing external can attach to the polished surface' (*Satires*, II: 7, 86–7). Even Ausonius at the end of the Empire repeats the notion. It was not only Roman clothes that were round.

The importance of the distinction in dress between Greek rectangularity and Roman roundness allows us to consider the possibility that this particular distinction might have been exploited both unconsciously and consciously in the field of architecture. Rectangularity is certainly a salient property of all Greek architecture, while Roman architecture prominently exploits the curve in both plan and elevation. There is a similar contrast in ornamental elements. While all niches in Greek buildings are rectangular in both plan and elevation, the Romans regularly employ recesses that are curved in both dimensions. And again, while all Greek pediments are triangular, Romans often use ones that are segments of circles. The correlation with the distinction in the geometry of dress

89 Greek tunic and Roman toga

is startling. Angular and rounded forms in architecture may have carried the same associations as they did in clothing.

This suggestion is borne out by the three building types in which combinations of the two forms feature particularly. Thus a prominent early use of the curved niche was in the Tomb of the Freedmen of Livia, which once stood on Rome's Via Appia: it is framed by two niches that are rectangular (fig. 90). The combination giving precedence to the rounded form may reflect the fact that many of the tomb's occupants would have been slaves, who had exchanged the rectangular pallium for the rounded toga. Much more common is the combination of such forms in the theatre, a setting in which a Greek-type play, known as a *fabula palliata*, might alternate with Roman-type *fabula togata*. Here alternation became habitual. At the top of the seating at Taormina in Sicily, round niches with rounded tops alternate with rectangular niches crowned by triangular pediments (fig. 91), and similar alternations are often found both on the front of the stage and in the *scaenae frons* behind, as, for example, at Sabratha in Libya. Such alternations become one of the more remarkable innovations in Roman architecture, and their association with a Greek and Roman dualism is confirmed by their use in a third building type, the library. Pairings of Greek and Latin libraries were common in the Roman world, being prominent in the Augustan Temple of Apollo on the Palatine Hill in Rome, in the two buildings either side of the great spiral column in Trajan's Forum and in Hadrian's great library at Athens. Only two, though, have preserved their ornamental forms, that in the Basilica of Plotina, Nimes, once known as the Temple of Diana (fig. 92),

90 Tomb of the Freedmen
of Livia, early 1st century AD,
Rome (after Giovanni Battista
Piranesi, *Columbarium of the
Freedmen of Livia Drusilla*,
etching and engraving,
1756, reprinted in *Opere di
Giovanni Battista Piranesi,
Francesco Piranesi e d'altri*
[Paris 1835–9], book III, fol.
XXVI)

91 Upper terrace of the
Roman theatre at Taormina,
early 2nd century AD, Sicily

92 Library of the Basilica of Plotina, the so-called Temple of Diana, showing pedimented scroll cases, *c*.130 AD, Nimes, France

and that of Celsus in Ephesus, both of around 120 AD. Both are distinguished by their combination of triangular and segmental pediments. At Nimes small ones alternate over the niches for scrolls on the interior. At Ephesus two large segmental pediments frame a central one that is triangular. The segmental pediments stand out particularly at Ephesus because elsewhere in the Greek east rounded Roman architectural forms of all types were generally avoided. Here they probably reflect the pride that Celsus's family felt in his having been the first Greek to rise to the rank of Roman consul, with the central triangular pediment still giving cultural precedence to Greece.

The alternation of forms in such libraries refers primarily to an acknowledged dualism of literary traditions, but it also resonates with a hidden dualism in the form of the letters in which the two literatures were expressed, a dualism that is evident in the two sets of inscriptions in Greek and Roman capitals that are another feature of the Library of Celsus. This dualism has in fact remarkable properties in common with the other dualisms of Greek and Roman landscape, Greek and Roman dress and especially of Greek and Roman archi-

tectural forms. While there are many variations in the letter forms of the two linguistic traditions, going back to their Phoenician origins, as in architecture, the overall trends are clear. The standard forms of the Greek letters Γ, Δ, Π and Σ (Gamma, Delta, Pi and Sigma) all feature angles as prominently as their Latin equivalents, C, D, P and S, do curves. It is also striking that three Greek letters, A, Δ, and Λ (Alpha, Delta and Lamda), share the triangular form of the Greek triangular pediment, while the Latin C and D share the broad curve of the Roman segmental variant. Nor is it artificial to relate architectural forms to letters. Just as Calpurnius Siculus described one building in terms of landscape forms, so Pliny the Younger describes another in terms of a letter, noting that a portico in one of his villas has the shape of the letter D (*Epistulae*, II, 17). We cannot know for certain what caused this differentiation between Greek and Roman letters, but since the trend to rounder forms manifests itself already in the alphabets of Greek colonies in Italy and in that of the Etruscans, it is likely that it was a shared exposure to a new landscape that had the greatest influence on the original formation of preferences in that field. Those preferences will then have been

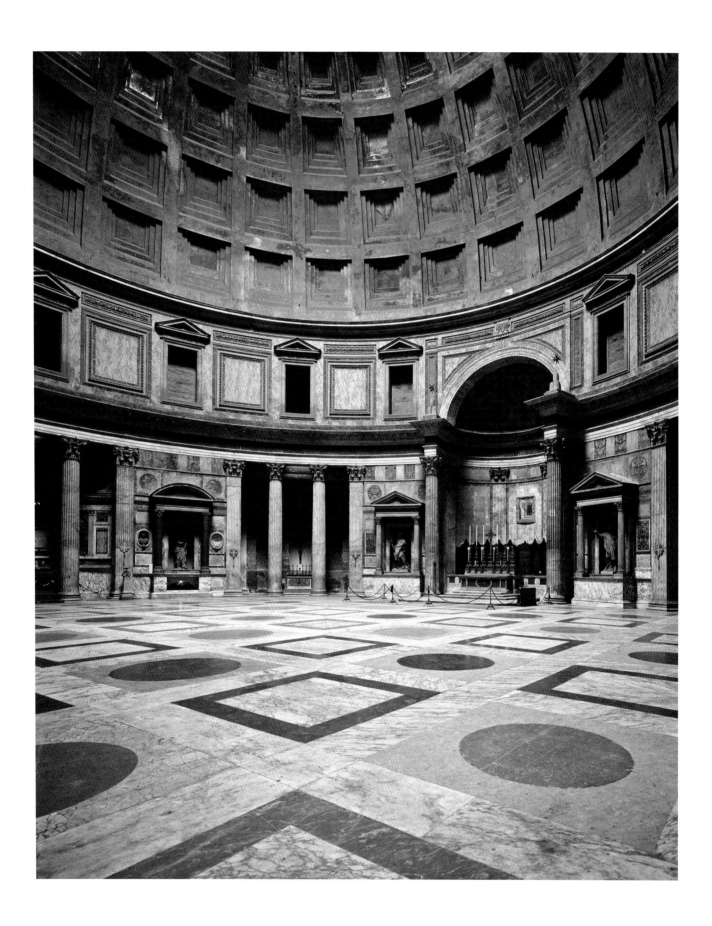

reinforced by exposures in other domains, such as dress and architecture. As a result, the uniquely Roman visual exposure endowed them with neural networks that gave curved forms a positive reference in any context.

This exceptionally close relation between the forms of landscape, architecture and letters that I suggest existed in both Greek and Roman worlds is comprehensible in terms of the general plasticity of the visual cortex, but it is also likely to have been facilitated by that cortex's organisation. The area of the brain concerned with the perception of letters, the visual word form area (VWFA), nicknamed the 'Letterbox' by Stanislas Dehaene, is located next to the PPA, where both landscape and architecture are processed.[1] This makes it more likely that connections might develop between the two areas, causing skills developed in one to be transferred to the other, which has been confirmed by the discovery that the acquisition of literacy improves discrimination between forms in all surrounding areas.[2] The recognition that landscape and architecture would not just have been processed by the same area of the Roman brain, as happened elsewhere, but by the same networks does more than help explain how the first might have influenced the second. It also helps us to understand why, as noted earlier, the relation between landscape and architecture was all-embracing, covering everything from materials to types of form, plan and elevation. Probably never again would the experience of landscape have such an overwhelming impact on architecture.

The exceptional integration of neural networks that I have reconstructed in ancient Rome implies that there would have been a greater than usual community of response to architectural forms. This gives us a better idea of what the formal properties of a building such as the Pantheon might have meant to patrons, designers and users (fig. 93 and see fig. 80), especially if we reconsider them in the light of the interests of its patron, Hadrian. One of his principal goals was to promote unity within the Empire, as he did both by travelling through many of its provinces and by evoking different sites in Greece and Egypt in his great villa at Tivoli. No concern was more central to his agenda than the desire to treat Greek and Roman cultures with equal respect. This was why he some-

times wore the toga at dinner and sometimes the pallium (*Historia Augusta*, Hadrian, 22), why he built extensively in both Athens and Rome and why he constructed paired libraries of Greek and Latin texts in both cities, as well as directly or indirectly inspiring the building of such libraries at Nimes and Ephesus. This may also be the key to his conception of the Pantheon, where many of the structure's distinguishing features, from the combination of a rectangular trabeated porch with a circular domed main space, to the double alternation of both triangular and segmental pediments in the internal elevation and of curved and rectangular niches in plan can all be seen as reassuringly monumental expressions of Hadrian's dualistic vision. The alternation of squares and circles in the Pantheon's paving may be understood in the same light too. All these design features may have been the result of conscious choices, but not necessarily. If people's neural networks were so configured by experience that angular and rounded forms were generally associated with the two traditions, and some forms such as the pediment types specifically so, these connections would have been felt unconsciously, especially by individuals who shared the emperor's vision and passions, who might already have been sensitised to such pairings as those found in the Knot of Hercules and the *dextrarum iunctio*. Viewers today do not experience the Pantheon in this way. Our neural resources are tuned to other interests by our admiration for Rome. What strike us are its size, richness, colour and miraculous top-lighting. Roman neural resources were different. Many will have entered the Pantheon with anxieties about the Empire's cultural diversity and hopes that the Emperor could resolve them. With their neural networks primed to find reassurance in the bilateral symmetries of knots and handshakes in other areas of their lives, they might have welcomed this new emblematic combination.

Roman Architecture and Magic

If the Pantheon was capable of persuading viewers that Greek and Roman cultures were entwined like two threads, it was effectively casting a spell over them, and the possibility that its elements had this power encourages the search for other examples of architectural magic. If the pairing of

(facing page) 93 Interior of the Pantheon, c.125 AD, Rome

94 Arch of Titus, c.80–85 AD, detail with Composite capital, Rome

pediments and niches in Roman imperial architecture parallelled the working of the Knot of Hercules and the *dextrarum iunctio*, may not other innovative combinations parallel the working of the *damnatio memoriae*?

An example of such innovation is the column capital known since the sixteenth century as Composite (fig. 94). It was the sixteenth-century architectural theorist Sebastiano Serlio who gave it this name in Book IV of his treatise (1537), but he took his cue from the humanist Leon Battista Alberti a century earlier. Alberti had seen it as a combination of previously separate Greek forms and had called it Italic, understanding it as a clear celebration of Rome's power over Greece.[3] Alberti's recognition of the capital as an addition to the canonical types named in Antiquity by Vitruvius and Pliny the Elder is remarkable. His reaction is a testimony to the power of visual forms in themselves, without verbal commentary, to mean something precise and important to the viewer. Alberti had been cued to see the combination of

the circular echinus of Doric, the volutes of Ionic and the leaves of Corinthian as an emblem of power by noticing its use on triumphal arches, from that of Titus onwards. He could not have known, as we do, that the same form was used on several other contemporary buildings expressive of Roman power, from the Colosseum, begun by Titus's father, Vespasian (r. 69–79 AD), the founder of the Flavian dynasty, to the Palace of Titus's younger brother, Domitian, on the Palatine. Nor, probably, did he know that Vespasian presented himself as above all truly Italian, in contrast to Nero, his corrupt Graecophile predecessor. Alberti thus lacked the knowledge to prove that his hunch was right, and that the Composite capital almost certainly really did demonstrate the power of Italy/Rome over Greece.

The effectiveness of the capital as an emblem of triumph can, of course, be understood without reference to neuroscience, but neuroscience helps us to appreciate the subversive source of its power. Most people in ancient Rome, and espe-

cially those to whom these monuments were particularly addressed, would have possessed neural networks that by habituation were specifically adapted to the perception of the more or less canonical forms of Doric, Ionic and Corinthian, and they would, through familiarity with their names, have associated each with a different Greek community. The more they were habituated to the three separate identities, the more their neural networks would have been confused by a capital in which they were mixed. All new capitals – and many were invented during the Empire – called for special efforts on the part of viewers' neural resources concerned with the categorisation of architectural forms, but a new capital that put together elements that had till then been absolutely distinct – almost biologically so because of their association with different races, as in the case of Doric and Ionic – would have imposed a particular strain. We can imagine a neurological situation similar to that which Semir Zeki found when he scanned the brains of people looking at objects with unnatural colours.[4] When the subject was shown a red strawberry, brain activity was evident in the hippocampus because the memory was involved, that being the prototypical colour of that form. An image of a blue strawberry, in contrast, activated the middle frontal cortex, a monitoring centre concerned with dealing with uncertainty. For the inhabitants of ancient Rome, where the varieties of capitals were as familiar as varieties of soft fruit today, the neurological situation may have been similar. While the sight of another Doric, Ionic or Corinthian capital would have activated the memory centre in the hippocampus, the sight of a new capital that combined elements of all three might have engaged the middle frontal cortex. Uncertainty would have been caused not by 'unnatural' colour but by 'unnatural' form. This would have meant not only that the object areas in the temporal lobes would have been specially taxed, but also that because the capital combined mutually incompatible forms, other resources would have been co-opted as the viewer tried to understand how the mixture came about.

Those resources would have been activated by the cue of the context in which the capitals were used. Given that the Arch of Titus was built to celebrate Roman triumph over the Jews, and that the Colosseum was built at the same time so that the population of Rome could witness all the animals and peoples who were in the emperor's power being killed for their amusement, viewers of the capitals displayed in those structures would have had Roman 'triumph' and 'control' in their minds, that is to say, their neural resources would have been primed to understand the relation between the parts of the new capital in those terms. In the case of the Colosseum they would have been helped by the pattern of the distribution of capitals on the building. On the exterior, the three orders, Doric, Ionic and Corinthian, one above the other, would have been seen as clearly distinct types, as distinct as the animals and peoples who were led to their deaths inside. In the interior, by contrast, the mixture of the three exterior forms in the Composite, 'Italian' or 'Roman' capitals of the crowning colonnade would have mirrored the mangled body parts which would have littered the building's floor. No conscious mental effort was needed. The normal working processes of the brain would have encouraged a recognition that the capital was yet another expression of Roman might and as such would have stimulated production and absorption of the feel-good chemicals necessary to strengthen gratitude to the emperor who had made it all possible.

That, at least, would have been the response that unconscious neural activity would have been liable to induce in a Roman citizen or someone who otherwise enjoyed the benefits of Roman power. The response of someone who felt oppressed by Rome, especially a Greek, whether freedman or slave, would have been far different. In them the area of the brain most likely to be activated was the insula and the neurochemicals released would have been those associated with the pain of being a victim. The responses of Romans and Greeks to the Composite capital would thus have been analogous to those of the witnesses to an ancient *damnatio memoriae* or the modern toppling of the statue of a totalitarian ruler. All relied on the same neural mechanisms as some of the most common practices of 'sympathetic' magic.

If the magic of the Composite/Roman, or Italic, capital may have been intentionally 'hurtful' to Greeks and reassuring for Romans in the aftermath of its introduction under the Italian-oriented Flavian dynasty founded by Vespasian, the magic involved in the alternation of Greek and Roman forms in the Pantheon may have been understood as 'medicinal'. The even-handedness of the combination of

triangular and segmental pediments on the aedicules showed how under Hadrian both traditions were equally valued. It is thus not just affirmative, but performative, magically uniting two cultural traditions that were frequently at odds, serving somewhat like the *dextrarum iunctio* which marked the Concordia, or reconciliation of divisions in the army on the coins of Hadrian's predecessor, Nerva (see fig. 79). For most people in the Empire, and especially for Hadrian, the integration of Greek and Roman cultures without damage to their separate identities was much to be desired, but difficult to realise. The combination of Greek and Roman elements in the Pantheon could be seen as magically bringing it about.

The magic of the overall conception of the building, however, could be seen, like the mixture of forms in the Composite capital, as slightly sinister. Although there is some equality in the alternation of the aedicules, these delicate forms are all upstaged by the grand axial niche that is curved in both plan and elevation, just as the rectangular trabeated Greek temple facade is upstaged by the larger typically Roman round and domed main space. On seeing the combination, a Greek might have felt pain in his insula while a Roman or Italian might have experienced a boost of dopamine in their nucleus accumbens. Such reactions would have been particularly likely, given that the increasing currency of magic in the daily environment at this time would have meant that viewers were becoming neurally predisposed to respond to such material manipulations.

The Rise of the Imagination and the Decline of Naturalism

If one vital set of neural resources underlying artistic innovation in the Roman world owed their formation to the new importance of magic, another owed their formation to the new importance of the imagination, especially as cultivated within a rhetorical education. This is clear from a comparison of the writings of Quintilian and the many earlier writings on rhetoric, including those of Aristotle and Cicero. None of these laid such stress on the importance of orators developing and exercising their visual imaginations as did Quintilian. Nor does Quintilian represent the peak of this phenome-

non. During the second and third centuries these skills only became more important, as rhetoric became the core of the intellectual movement known as the Second Sophistic. It was then that the development of these skills became particularly important for the history of art, as a description of a work of art, often called an *ekphrasis* – as exemplified by those of Philostratus the Elder in the late second century, of Philostratus the Younger in the early third and Callistratus in the fourth – became a principal field for the display of rhetorical flair. That the use of the visual imagination intensified in this period is evident in the way the character of such descriptions do not change in parallel with trends in contemporary art but in opposition to them. Even as art became less naturalistic, as we see from a comparison of two paintings of a similar subject from the first century BC and fourth AD (figs 95 and 96), accounts of it became more vivid.[5] Even as paintings and sculptures contain less and less visual information about the subject represented, in the texts each successive writer seems to see more in the works of art he describes than his predecessor. One possible explanation is that the decline in lifelikeness in art actually stimulated literary creativity, as writers enjoyed imagining what they could no longer see. Another explanation is that the wealthy patrons, who were themselves often students of oratory, tended to commission or purchase less and less realistic art because that offered them a more rewarding field to display their imaginative ability. In either case it looks as if the general trend away from naturalistic detail was sustained by an increasing use of the imagination, itself the direct result of rhetorical training.

Not that an improvement of the imaginative faculty was the only neurally based reason why painting and sculpture became less naturalistic and three-dimensional and more flat and schematic over the second, third and fourth centuries. The main cause was a change in the concerns of patrons. As wealthy Romans became less interested in the physiques of athletes and heroes and the real pleasures offered by the natural world, they found themselves more and more interested in commissioning and collecting copies of famous works. One result of this trend was that the artists they employed inevitably looked less and less at any form of nature and more at art. This necessarily reduced the complexity of their neural formation and, in a pattern first detected

95 Lady playing cithara, c.40 BC, wall painting from Villa of P. Fannius Synistor at Boscoreale, Naples. The Metropolitan Museum of Art, New York, Rogers Fund

96 Personification of Rome, 'Roma Barberini', wall painting, 4th century AD, Museo Nazionale, Rome

at Chauvet, their art became more schematic. Not that the pattern was uniform. Those artists who, because of their own or their patron's interests, looked intently at the best earlier art were most likely to maintain the richness of their neural resources and preserve the ability to make complex images. Most, though, looked more and more at the growing majority of more schematic works, with predictable consequences. Their neural networks inevitably became stored with less and less rich visual information, and that ensured that the works produced under the guidance of those networks became increasingly simple and flat. This placed new demands on the viewer. Only one equipped with the neural resources of a highly trained imagination could give back to statues and paintings the liveliness they had lost.

Fortunately, we know that the neural resources involved were surprisingly well understood at the time, because their working is described in a major product of the Second Sophistic, the *Life of Apollonius of Tyana*, the biography of a contemporary of Quintilian in the late first century who spent some time in India, written by the most celebrated member of the Philostratus family, Flavius Philostratus, born around 170. In this work the author presents his subject's explanation for people seeing images in clouds. Apollonius, he tells us (2.22), noted that they cannot be

> made by the gods for their amusement . . . rather these shapes are without meaning and carried through the heavens without any divine intervention and it is we who, having an inborn mimetic faculty, turn them into forms and make them. . . . The mimetic art has two sides; one consists of imitation using the hand and the mind, that is painting, the other consists of making images with the mind alone . . .

Even more remarkable is the elaboration of this commentary in which he explains how a visual attribute such as colour does not need to be represented to be perceived. Having noted that we find the work of early artists completely satisfying, although their use of colour is very restricted, he goes on to observe (2.22):

> even if we were to draw one of these Indians with a white line he would still seem to be black; since his flattish nose,

straight locks, prominent chin and the cast of his eye would turn what we were looking at black. . . . Whence I would say that those who look at works of painting also need a mimetic faculty. For no one would appreciate a painting of a horse or bull unless they had formed a mental image of the animal represented.

This is important not only because it is the first clear analysis of the role of the brain in vision, but also because it emphasises the importance of the history of the neural formation of the individual for the way he or she experiences the world. We will only see a flattened Indian nose painted in white as black if we have already seen a real Indian face. And the text has a further significance for the history of art. The assertion that we can find early art satisfying, although its use of colour is unrealistic, implies that viewers might also find a similar satisfaction when faced with the less realistic art of their own day. Viewed from this perspective, the realism that had once cost artists much time and patrons much money is simply unnecessary. Even a schematic presentation will be found realistic by viewers who possess a vivid 'mimetic faculty'. Whether this remarkable observation is that of Apollonius in the first century or of Flavius Philostratus in the early third, in its implication that realism is not needed in art it can be seen as preparing the way for the continuous decline in naturalism in the later Roman Empire. Indeed, given that the mental mimetic faculty of the viewer must have a higher status than the manual faculty of the artist, the opinion should probably be seen as encouraging the trend, predisposing a reader of the *Life* to prefer a schematic presentation to one that was lifelike.

A last insight into the increasing role of the imagination in the response to art is provided by the descriptions of a class of objects that have much in common with Apollonius's clouds, possessing as they do no inherent representational properties. These are the marble slabs that were regularly used to cover the internal walls and floors of Roman buildings. From the first century to the fourth, these slabs always have the same inherent visual properties of veining and coloration that they bring from the quarry, but this does not mean they were experienced in the same way, as writers seem to have seen more and more in them

through time. Pliny the Elder is the most objective in his vocabulary, talking only of 'stains' and 'colours', except when offering anecdotes on the responses of primitive peoples or when making a philological gloss. Statius, on the other hand, writing in a more poetic and rhetorical mode only a few years later in the first century, is prepared to see more: 'Here is the Libyan, here the Phrygian stone; here the hard stones of the Spartans shine green; here is the curved onyx and the veined rock which is the same colour as the sea' (*Silvae*, I: 2, 148ff). Indeed, elsewhere he goes further, saying of the green stone of Sparta that it 'imitates in rock the soft grass' (II: 2, 91). In the immediately following centuries there is a shortage of descriptions of marble, but we can reconstruct a trend of increasingly imaginative response by turning to the fifth-century Sidonius Apollinaris and his comments on a new church in Lyons, which he sees almost as a landscape: 'Marble diversified with a varied gleam covers the floor, the vault and the windows; in a multi-coloured design a verdant grassy encrustation leads a curving line of sapphire coloured stones across the leek-green glass . . . and the field in the middle is clothed with a stony forest of widely spaced columns' (*Epistulae* II, 10, 13–15, 20 and 21). Now the stones are no longer identified by their provenance, but are chiefly characterised by metaphors from the world of vegetation, allowing the church's nave to become a field and the colonnades a wood. In the writer's imagination the hard stone and rigid geometry of the building have acquired the softness and life of nature. Framed in a letter that is a sophisticated literary exercise, the text demonstrates the extent to which in the Late Empire the development of the imaginative faculty had been stimulated by a rhetorical education. That the comparison between architecture and landscape picks up a theme that we discovered at the beginning of this chapter also reminds us how deeply the inclination to such experiences was embedded in the Roman mind, largely because, as we saw, in Latium the relationship between buildings, their forms and materials, and the natural environment was exceptionally close.

Part 4

EUROPE

300–1200

Art and Spiritual Power

Between 313 and 410 a sequence of events took place that had profound consequences for the neural formation of all the inhabitants of the Roman Empire and which would, in the following centuries, have similar consequences for almost all the inhabitants of what we now call Europe. In 312 the Emperor Constantine (*c.*274–337) is said in at least one account to have had a vision that if he added the *chi rho* monogram of Christ to his standards he would defeat his rival, Maxentius, in battle (see fig. 105). Having done so, the next year he issued an edict at Milan ending the persecution of the Christian religion. He also began a series of actions in its active support, first handing over the Lateran Palace to the Bishop of Rome, so laying the foundations for the future papacy. By the 380s, a successor, the Emperor Theodosius, cemented Christianity's position, issuing the edicts that made it the sole state religion, and prohibited all pagan cult practices, even in private. Finally, in 410, came the Sack of the city of Rome by the Goths, a material disaster celebrated by St Augustine as marking the demise of the City of Man and the rise of the City of God.

Christianisation and Neural Homogenisation

Many factors lay behind this profound shift, but a major one was the way the new faith made up for the deficiencies in people's daily experience that were consequent on the Empire's decline. Fourth-century emperors knew that they were less and less able to provide the same level of material pleasures to their subjects as their predecessors, and those subjects were all too conscious that the aqueducts bringing water to Rome and other cities were in disrepair, that grain imports were less and less reliable and that the supply of animals for the games in the Empire's amphitheatres was dwindling. In this situation both emperor and subjects had a mutual interest in shifting attention from the material to the spiritual world.[1] If there was not the volume of water to fill the baths, there was always enough for ritual in the baptisteries; if there was a shortage of bread on the table at home, it was always available in small quantities at the altar in church; if there was a shortage of blood in the amphitheatre it too could be provided in church, both in

the Eucharist and in readings about the passion of Christ and the sacrifice of matyrs; while, if wellbeing could not be assured in this world, it could at least be promised and looked forward to in the next. In other words, the centuries-old expectations of water, bread, bloody spectacle and a good life, which were so long established as to be neurally embedded in the population, could now be satisfied in new ways, with the vital materials, water and bread, being provided in token quantities, bloody spectacle being provided in readings and rituals, and a good life being imagined in the future. Hence the complicity between Constantine and the majority of his subjects in the shift from secular and pagan values to ones that were spiritual and Christian.

That shift had abiding consequences. One was the cultural homogenisation of Europe. In 300 there was a great variety in the behaviours and in the social and material environments of the populations who lived within the Roman Empire. There was also a vast difference between all of these and those of the peoples who occupied the territory to the north, from the Black Sea to the Atlantic. By 1200 this was no longer so. After the imposition of Christianity on the Empire had largely unified culture within its original borders, the faith's subsequent spread northwards – which was accelerated by rulers who recognised the corollary benefits of being able to claim succession to the divinely approved Old Testament kings of Israel – disseminated that same culture throughout the continent, bringing towns and monumental architecture to areas previously occupied by villages, and with them a level of literacy. At least in the religious context, a babel of languages was replaced by Latin in the west and Greek in the east. By the early second millennium we can talk of the first continent-wide European culture. Of the new neural resources associated with this culture none were more important than those needed to support its most important constituent, the new religion.

The extent to which this was true can be appreciated best if we think of the implications for people's neural formation of sharing a common creed, that is, consciously assenting to the limited set of propositions on which the faith was founded. Of these the most authoritative was that

approved in the presence of Constantine at the Council of Nicaea in 325, and still the basis of Catholic belief. In a few sentences it swept away all preceding views of humanity's place in the world, replacing them with a series of simple statements: that God the Father had created everything visible and invisible; that Jesus Christ, who was consubstantial with his father, had descended to earth and become flesh for our salvation; that he had suffered, had risen on the third day and ascended into heaven; that he would come again to judge the living and the dead and that he had prepared for his followers a kingdom that had no end; that the Holy Spirit (or Ghost) existed, a comforter who spoke in the prophets; that there is one baptism for the remission of sins; and that there is one Catholic Church. Since the Nicene Creed became an integral part of the liturgy, and participation in that liturgy was enforceable by law, these beliefs became the foundation of everybody's lives.

Christianisation: Experience replaced by Belief

Just how dramatic were the neural implications of subscribing to a Christian view is evident if we think how at odds it was with what had been either known or believed earlier. Not only did it not correspond to what anyone but an adherent of the new faith had thought to be true, it bore no relation to experience. During the Roman Empire, while the educated were likely to subscribe to one of the Greek nature-based philosophies, being more attracted to Plato or Aristotle, Stoics or Epicureans, most of the others, apart from those who followed one of the growing number of more or less private religions, unreflectively followed conventional practice in such fields as religion, and in daily life followed what passed for common sense. In most cases Christianity was the opposite of common sense. God was manifested as a trinity consisting of a divine father in heaven, a son who came to earth as a man and a holy spirit. Christ not only performed miracles, turning water into wine and multiplying loaves and fishes, but also told his disciples that baptism in water could wash away their sins, that the wine they were

drinking at his last supper was his blood and the bread they were eating was his body. He died as a human being and ascended into heaven to be with his father, having told his followers that in the future the last would be first and the first last, and that he would return to judge them, sending the bad to Hell and taking the good to a Paradise. This last was presented in the book of Revelation as a heavenly version of the earthly Jerusalem, a city with jewelled stone walls that descended from the sky. Acceptance of the truth of Christ's message thus required some degree of abandonment of the neural networks that had sustained mental activity for centuries, networks shaped by exposure to daily experience and to books containing knowledge that was relatively tried and tested against the evidence of the senses. The networks required by the new faith were different in character.

Christianisation and Neural Specialisation

Architectural Metaphor

Some of these networks can be separated out. One was the network or set of networks required to imagine the buildings that became the most important structures in people's minds, not just the Heavenly Jerusalem of the New Testament but structures in the Old, the Tabernacle of Moses, the Temple of Solomon and the visionary Temple of Ezekiel. Another was a set that was called into being by the Bible's many architectural metaphors. These are already a feature of the Old Testament, as in the description of the two columns in front of Solomon's Temple as Iachin ('he shall establish') and Boaz ('in him is strength') and the prophetic reference at Isaiah 28: 16 to the Messiah as the precious cornerstone of the Temple. More important were the metaphors used by St Paul the Apostle in his letters, such as his comparison of the Church as an institution to a building founded on the Apostles at Ephesians 2: 20 or his comparison of apostles to columns at Galatians 2: 9. The new concentration on the Bible as text combined with the psychological importance of such reassuring metaphors meant that architectural imagery took on an importance it had never had before. For earlier Greeks and

Romans the buildings most important to people were real ones, and their properties physical. For Christians from the fourth century onwards, the most important were those they imagined, and their most important properties psychological.

It may seem odd that so many people were ready to abandon a more common-sense view of the world for one that was based on wishful thinking about the afterlife, but the shift was encouraged by general changes in daily experience. The neural networks that had sustained the previous common-sense view needed repeated exposure to reality for their maintenance. Once the decline of the Roman Empire from the third century onwards brought the collapse of transport and defence systems, and with that the degradation of the social and material environment, it was inevitable that people would give them less and less frequent and less and less intense attention, so causing the decay of the neural networks necessary for their enjoyment. At the same time, the more people gave attention to the life to come, whether just by participation in the liturgy or by becoming a priest, monk or hermit, members of a new spiritual elite, the more they found themselves acquiring new resources.

Some of these constituted enhancements of networks already nourished by developments in the second and third centuries, such as those fostered by the reading of fiction and the rhetorical training of the imagination. It was the strengthening of these that prepared the way for Christianity's acceptance by members of the educated class, such as St Augustine and St Jerome (c.342–420), who played a crucial role in its propagation. Their particular awareness of the neural benefits of repeated and intense study, a foundation of intellectual life for a thousand years, also helped them when framing such instruction as the catechism preceding baptism and when fostering the habits of meditation, prayer and spiritual engagement generally, all of which constituted a form of Cognitive Behavioural Therapy by which structured mental activity could bring predictable changes to inner life.

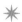

Spatial Memory

We can get some idea of the neural consequences of such training in the imagination of architecture by analogy with the neural consequences of the training of modern taxi drivers in the knowledge of London noted in the Introduction.[2] The Christian did not need to acquire a knowledge of the street plan of a particular city, but did need to understand the meanings of the topography of the baptistery and the church, as well as of the Holy Land and Jerusalem, and to appreciate the relation between them, as expressed in the parallel between the experience of the catechumen and that of Christ. He or she needed to know that the journey of the living from the outside world to the baptistery and from church entrance to altar, like the journey of the dead from church to cemetery, and the hoped-for final ascent to Heaven, recapitulated Christ's journeys, first through the Holy Land from Bethlehem to Jerusalem, and then within Jerusalem from Gethsemane to Golgotha, from Golgotha to the Tomb and finally from Ascension to Heaven. This knowledge of various forms of religion-related topography was as vital for the Christian who wanted to improve his or her chances of admission to the Heavenly Jerusalem as a knowledge of London's street plan is essential for a London taxi driver who wants the financially valuable qualification of an operator's licence. Its acquisition would thus probably have had a comparable impact on the spatial memory in the posterior hippocampus. The extent to which the Christian's need of topographic knowledge was unique is brought out by comparing it with the needs in the same field of practitioners of the pre-Christian religion most widespread in Europe, that involving worship of the Olympian deities. This required no more than the sponsoring and witnessing of sacrifices at any relevant altar. Other practices, such as Judaism, Mithraism or the other Mystery religions made some call on spatial memory, but the demands were far less complex than those of the new religion. The practice of Christianity thus required the formation of specific new neural pathways in the posterior hippocampus, and recognising this helps us to understand the process by which those practices became ever more deeply embedded in the Christian brain.

Applying the same basic neuroscientific principle, that the more an action is repeated and performed with attention the more the neural resources that support it will be reinforced, we can ask which other pathways would have become differentially consolidated in early Christians. One set were those associated with the rituals that were performed in the buildings we have just been considering, rituals such as Baptism and the Eucharist. We can approach an enquiry into their neural foundations by considering one of the features they share, the earlier noted dimension of magic, that is the belief that the performance of a ritual act and the uttering of particular words increased the likelihood that an individual might obtain a desired goal.

In terms of Frazer's categories of Sympathetic magic, for instance, we can note that one reason why believers found Baptism effective was because it combined both the Homoeopathic and the Contagious. It was Homoeopathic because confidence that it helped in 'washing away sins' (Acts, 22: 16) was founded in people's neural habituation to the use of water in many forms of cleaning. It was Contagious because the belief that being anointed with oil made one a permanent member of the Church was based on their familiarity with the way oil, unlike water, leaves traces on the body that are difficult to remove. Indeed we can go further. Repeated observation of the effects of washing lays down ever more robust neural resources supporting an ever more robust conviction that it works, and the same is true of the repeated experience of being touched by oil. Feeling water on one's body makes one feel clean, and feeling oil on one's body makes one feel that one is being affected by something that will not rub off. It is because the neural networks involved in these feelings were so robust that the rituals in which they were reactivated were effective.

Another aspect of Christian rituals that exploited existing neural networks was the belief that one material can be transformed into another, as happens most strikingly at Communion, when wine becomes blood and bread becomes flesh. This belief was facilitated by the neural structures that we all possess which ensure that objects that are similar in appearance can easily be felt to share similar properties. Thus the appearance and texture of wine are sufficiently similar to blood, and those of bread sufficiently similar to those of flesh, for it to be believable that the one changes into the other. The magic of Communion is facilitated because wine has visual and tactile properties in common with blood, bread with flesh. The magic of the baptismal ritual works because water is used for washing, and that of anointing with oil works because medicines were regularly applied suspended in that liquid. In each case, because of the way the brain has been structured by evolution, the neural pathways associated with the perception of the different substances were either close or linked, with materials being grouped together by categories in separate areas in the temporal lobes. A substance is thus first recognised as a liquid and only then identified as wine or blood, water or oil, on the basis of colour, texture or odour.[3] The more similar one material is to another the easier it is for the two to be assimilated. It is only because wine and blood, being liquids that are similar in colour, are processed by the same neural networks until the moment when they are sorted into one category or another, that the magic transformation at the centre of the ritual is believable.

The effectiveness of Christian rituals was also reinforced by the building up of neural networks supporting susceptibility to metaphor, an attitude essential for the acceptance of such transformations. Both the Old and New Testaments of the Christian Bible, which achieved canonical status in the fourth century, are full of metaphors, as when Christ at different times says he is the 'way', the 'light of the world', the 'bread of life', the 'good shepherd', the 'vine' and so on. Listening to, reading and meditating on those texts will have encouraged the habit of metaphorical interpretation, so strengthening the neural resources involved. Significantly, too, since metaphor was generally essential to Christianity, those resources will have been primed each time an individual engaged in a Christian practice, such as entering a church or opening a Bible. Such priming would have made it more likely that Christ would really be experienced as the 'way', the 'light of the world', the 'bread of life', the 'good shepherd', the 'vine'. The same applies to the metaphorical interpretation of movement.

For the Christian, whose neural resources were primed to interpret actions metaphorically, the movements made at Baptism, descending into a basin and then climbing out of it, could really be experienced by the catechumen as suggesting first being 'buried' with Christ, as St Paul said at Romans 6: 4, and then sharing in his Resurrection. Or it might apply to the passive response to the action of the priest, as in anointing with oil. Being anointed turned the catechumen into another 'christ', the Greek translation of the Hebrew Messiah, 'the anointed one'. In the context of religious instruction and ritual, the default networks, those most continuously activated, would often have been those supporting different types of metaphorical experience. Only after departure from the church and return to normal daily life would the default system become the one concerned with the experience of reality.

Desire and the First Choice Brand

In this process a crucial role is played by desire. If one desires the water of baptism to be cleansing, or its benefits to be permanently attached by anointing with oil, one is more likely to experience those rewards. If one would like Christ to be the way, the light, bread, the good shepherd or the vine, one is more likely to experience him in those roles. If one wishes wine to become blood or bread flesh one is more likely to taste them as such. Desire was certainly a shared drive behind all these experiences because a principal shared emotion among Christians was the desire for salvation and entry into Paradise. The capacity of desire to change people's experience is probably illuminated by a modern experiment designed to establish the role of the affective as opposed to the rational element in decision-making in the context of 'brand preference'.[4] A principal finding was that while, in general, presentation of different brands of beer and coffee provoked activity in brain areas associated with analytical processes, only the sight of a product already identified as an individual's 'first choice brand' caused activation of areas of the ventromedial prefrontal cortex (vmPFC), which is particularly associated with an emotional decision. It was, moreover, only the first-choice brand that caused such activation, not

a second- or third-choice brand. In other words, the emotionally based attachment to a favourite brand was made on a 'winner takes all' basis. Considering that the influence of imperial patronage turned Christianity into the most heavily marketed religion, and that through its emphasis on feelings such as love and hope, it was also the most emotionally driven, it may not be inappropriate to apply this last experiment's findings to the Early Christian experience. If marketing made Christianity, in the field of religion, the first-choice brand, the decision to believe in the effectiveness of its practices may have been driven more by emotion than analysis and so also made on a 'winner takes all' basis. This had implications for the experience of ritual, because the neural pathways of desire opened up and consolidated by recognition of the first-choice brand would have made it easier for a Christian to believe that something could become something it was not, wine become blood, poverty wealth and death life, and this would have led during a lifetime to the formation of a further set of new pathways supporting such belief.

Christianisation and the Power of Words

Crucial to the instilling of these beliefs was the use of words. This was most obvious in the verbal commentaries that accompanied the Church's rituals. The words of the priest, which partly repeated those of Christ in the case of the Eucharist, or, in the case of Baptism, those of St John the Baptist or St Paul, played an important part in convincing the believer that the transformation had really taken place. This would have been particularly likely to be true if the caudate nucleus, with its association with trust, was activated, as in the Aarhus experiment.[5] A climate of trust is certainly evoked by the Christian habit of addressing as 'father' not just God but the pope and all priests. Because the invocation of a 'father' would probably have activated the neural networks passing through the caudate nucleus on which people relied when young, everything said by the person so invoked would be more likely to be believed. Other experiments specifically illustrating the power of words from a respected source to

affect the response to a physical experience are those from Oxford and California that showed that attaching a falsely optimistic name to a painting or a falsely inflated cost to a wine could upgrade people's experience of such objects by generating a big increase in the reward from the nucleus accumbens.[6] Analogy suggests that the verbal element in a ritual such as Baptism or the Eucharist could also have had a powerful effect on how the materials involved in it were experienced. The mechanism that causes someone today to have a £40 response to a £5 vintage may have helped worshippers fifteen hundred years ago to experience water as wine. It could certainly have caused them to get a neurochemical boost that was sufficient to make them want to repeat the experience, as happens today with drug-takers.

Nor were these the only contexts in which words could be used to heighten the worshipper's reward. Inscriptions or *tituli* had an important role in shaping the worshipper's or pilgrim's experience. Indeed, they could directly influence the choice of a place of burial, both in catacombs and in the floors of churches. A carved or painted inscription bearing the name of someone whose martyrdom meant that they were more likely to enter heaven enhanced the value of a site as a place of pilgrimage or burial in the same way that the designation 'Rembrandt' today increases the sense of the value of a painting or a high price increases the sense of the value of a wine. The power of such names was crucial to the viewer's unconscious mental experience, and was exploited on a large scale through the circulation of relics. Simply attaching an authoritative name to an object such as a bone, a flask of oil or even an empty box would have brought all who saw it a predictable neurochemical enhancement of response. It did not need to be authentic. Much of the magic of the Christian experience depended on the power of words to generate such rewards.

8

Europe 300–750

Christian Imagination, Christian Magic and Christian Intellect

The person who initiated and shaped the process by which Christianity came to dominate first the Roman Empire and then the rest of Europe was Constantine and it was his patronage and that of his advisers that revealed the religion's capacity for transforming artistic culture. His first decisive step, soon after his victory at the Milvian Bridge near Rome in AD 312, was to commission the Basilica of the Saviour, now S. Giovanni in Laterano. The adoption of the aisled plan, which was traditional for Roman basilicas, buildings whose most significant function was as halls of justice, had important implications for the responses of those who used it. Our neural make-up is such that when we enter a building whose forms we associate with a particular use, our neural resources are primed, preparing us to behave appropriately and creating particular expectations. The basilican plan thus did more than meet the fuctional needs of accommodating a congregation. With Christ's altar replacing the judgement seat of the emperor or his representative, the layout achieved two goals that were important for Constantine, for the Church and for the congregation. By priming the neural networks of users with its evocation of legal authority, it strengthened the expectation, already implicit in the use of such legal terms as 'commandment', 'testament' and 'covenant', that the rituals that took place there had a contractual status. This strengthened confidence in the promises made by Christ in the past and by the priests in the present. It also reminded the worshipper that the ultimate decision as to whether someone would be admitted to Paradise would be made by Christ when he returned to sit in judgement. The way the basilican plan primed people to experience what went on in a church in terms of legal certainties helped it to become the standard plan for major churches.

One of these was the even grander church erected over the tomb of St Peter (*c.330*; fig. 97). The building had a special importance as a fulfilment of Christ's text 'You are Peter [Greek for 'stone'] and on this rock I will build my Church', and both its form and its decoration are infused with metaphorical thought. The arch separating the nave from the transept carried a mosaic showing a military standard circled by the victor's laurel with the Latin inscription: 'Because with you as leader the world has risen triumphant to the stars the victorious Constantine has established for you this hall'. This arch was called a 'triumphal arch' in the eighth century and was probably thought of as such from the beginning, that meaning being brought out by the use of Composite capitals on the eight columns at the end of the church's aisles that supported it, as well as the four nearby that terminated the transept, making a total of twelve (fig. 98). As we saw in the last chapter, Composite was probably invented as an earlier piece of architectural magic expressing Italian/Roman triumph and had been used as such on all triumphal arches from Titus until that of Constantine, dedicated in 315/16, which abandons it for Corinthian. Its absence from the Arch of Constantine combined with its prominence in St Peter's makes it likely that the emperor had consciously transferred the form to Christ, both because it was to him that he owed his own victory on the battle-field and because it reinforced the idea of Christ's triumph over death expressed in the crowning inscription's phrase, 'the world has risen triumphant'.

The architectural metaphor experienced by those who saw the arch at the end of the nave of St Peter's as a triumphal arch was unique to the context of the Empire's capital, where people were familiar with real arches celebrating military triumphs, but architectural metaphors in general had a much wider circulation from the time of St Paul. In his Epistle to the Galatians 1: 7–10, Paul notes first that Peter is the apostle to the Jews and he to the Gentiles, before going on to say that James, Cephas (that is Peter) and John are 'columns' who gave the hand of friendship to him and Barnabas, while in Ephesians 2: 14–22 he returns to the same issue of the tension between Jews and Gentiles, noting that enmity once stood 'like a wall' between the two communities, but now 'you' – that is, the Gentiles of Ephesus – are 'fellow citizens with God's people', the Jews,

> members of God's household. You are built upon the foundations of the apostles and the prophets, with Jesus Christ himself as the corner, or key, stone, in whom the whole building is bonded together and grows into a holy temple to the Lord. In him you too are being built with all the rest into a spiritual dwelling for God [translation slightly adapted].

Paul was aware that the greatest problems for the new religion were instability and division, and he knew that for his audience there was no better expression of solidity, stability and integration than a building. This was why Paul repeatedly resorted to architectural metaphors, preparing the way for Constantine to exploit those same metaphors when turning to Christianity to combat the instability and the division of his secular world. The emperor and his advisers thus sensed that Paul's architectural imagery could play a key role in achieving this goal, especially if it was combined with imagery from the Book of Revelation 21: 12–14, where we learn that the Heavenly Jerusalem has twelve foundation stones, each bearing the name of an apostle. This was why twelve Composite columns were placed in St Peter's transept, where they make combined allusion to the architectural visions of the two earliest Christian writers, St Paul

97 Groundplan of Old St Peter's, *c.330*, Rome

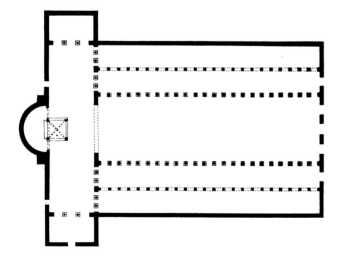

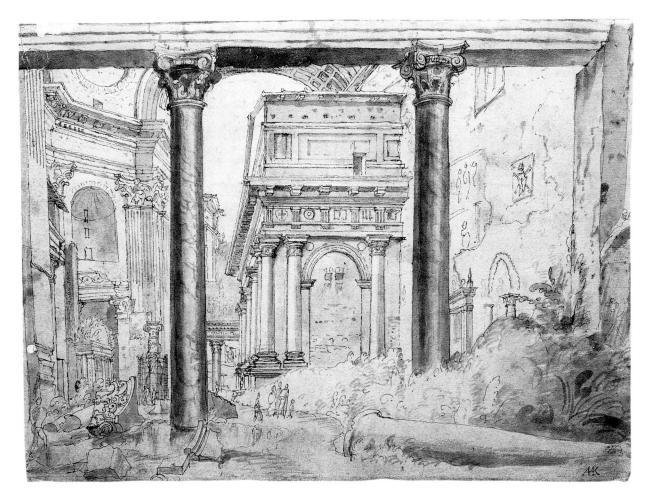

98 Old St Peter's, *c*.330, Rome, transept showing Composite capitals, drawing by Maarten van Heemskerck. National Museum, Stockholm

and St John the Divine, in an assimilation of two things that were fervently hoped for by many, a stable unified Church in this world and a home in Paradise in the next.

A similar combination of the imagery of Paul's Epistles and St John's Revelation was probably also found in Old St Peter's apse mosaic. This was destroyed in the thirteenth century, but its replacement at that time had so much in common with a series of compositions in different media dating from the mid-fourth century onwards, that it is likely that all derive from an original mosaic there showing the so-called *traditio legis*, the 'handing down of the Law'. To judge from the derivative compositions, this showed Christ in an environment identified, by two palm trees and four rivers, as the Paradise of Revelation, with Peter on one side, to whom he is giving the Law, and Paul on the other. That the two

saints were intended, following Paul, to represent Jews and Gentiles was confirmed by the scene below in which two rows of sheep (bringing to mind Christ's injunction to Peter to 'feed my sheep') issue from two buildings, one to the left representing Bethlehem, scene of the first Gentile adoration of Christ, and the other to the right Jerusalem, capital of the Jews, converging on the four rivers in the centre. A scene of Christians joining Peter and Paul in a heavenly Paradise was an appropriate sequel to the inscription on the preceding arch announcing that 'the world has risen triumphant to the stars'. It both expressed Constantine's hopes for a unified empire and fulfilled the individual worshipper's aspiration for a celestial afterlife.

Viewed in the context of the twelve Composite columns in the transept, it could also be seen as an illustration of

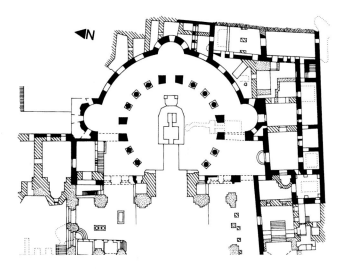

99 Groundplan of the Anastasis rotunda (Church of the Holy Sepulchre), c.340, Jerusalem

the benefits offered by the Church as an institution that was founded, as Paul envisaged, on twelve strong apostles. Indeed, so reassuring was this last mental image that Constantine repeatedly exploited it in both words and actions. At the Council of Nicaea (325) he gave a speech in which he imagined the Church as a facade with twelve marble columns carrying a pediment[1] and, in the following years, he or his son, Constantius, commissioned several buildings, of which one was St Peter's, that gave real expression to the architectural metaphor. The most important was the Anastasis rotunda, later known as the Holy Sepulchre, built over Christ's tomb in Jerusalem, which was supported by twelve columns in four sets of three (fig. 99). Since the structure could be said literally to be founded on Christ, it was an appropriate place to fulfil Paul's vision of a Church that had him as the cornerstone. Constantine also cleverly adapted the same scheme in the church of the Holy Apostles in his new capital, Constantinople, in which he himself was buried. There, as Eusebius relates, the emperor's sarcophagus was ringed with twelve piers inscribed with the names of the twelve Apostles, in a more material extension of the assimilation of the unifying role of Christ and the emperor, already suggested in St Peter's triumphal arch.[2]

Each of these three structures erected by Constantine in the three cities most important for both Empire and Church,

Rome, Jerusalem and Constantinople, uses architectural elements familiar from earlier pagan buildings, but they all display properties that differentiate them fundamentally from their predecessors. While there is a significant echo of the Greek comparison of warriors with columns in the similar comparison of apostles, it is important to realise the difference in the neural resources that drive them. In the earlier Greek case the assimilation was shaped by the exceptionally powerful neural resources in the visual cortex built up by looking at soldiers with an intensity driven by fear for physical survival. In the later Roman case it was shaped by equally powerful neural resources in the visual cortex, though by then they were formed only by imagining the metaphorical architecture described in texts and doing so with an intensity driven by fervent hopes of a life beyond death. This difference in the neural resources of typical viewers explains one of the fundamental differences between the resulting architectures. Because all in ancient Greece looked at real phalanxes and all real phalanxes followed the same template, the buildings that resulted from such exposures were closely similar. In the Christian world, by contrast, because each person when reading or listening to a text constructed his or her own imaginary building out of architectural elements that he or she had seen in all sorts of real structures, the buildings that result are widely different. The unpredictability of the outcome of this last process helps to explain the phenomenon noted by Richard Krautheimer seventy-five years ago, that many medieval buildings of which texts say they 'copy' a famous monument, such as the Holy Sepulchre, look different not just from the claimed model but from each other.[3] Throughout the Middle Ages both architects and patrons relied more on their imaginations than did their predecessors in Antiquity. The same applied to the numerous buildings of many different types that explicitly evoke the Heavenly Jerusalem. Because there was only a sketchy text to read and no real heavenly Jerusalem to look at and copy, the celestial city had each time to be imagined anew by both patron and architect.

The impression given by this discussion is of a programme of construction that was well planned and carefully implemented, but there is one aspect of these early buildings that disturbs that picture. This is the way in which, in many

ecclesiastical buildings of the fourth and fifth centuries, architecural forms are mixed and even jumbled in a way that would have been inconceivable in a pagan temple. It is already apparent in the mixtures of columns and capitals in the nave of St Peter's and is striking in the sixth-century church of S. Lorenzo fuori le Mura in Rome, where a mixture of capitals and shafts is surmounted by an equally miscellaneous series of sections of entablature taken from several different buildings (fig. 100). All this was constructed at a time when there were many disused buildings, especially temples, which could easily have been robbed to produce much more coherent assemblages.

Indeed, it was probably the association of pagan temples with such coherence that made it important to avoid it. In paganism it had always been necessary to pick perfect sacrificial animals with which to please the gods, and the same applied to the choice of forms in the temples erected in their honour. Perfection was thus part of their magic and one of the reasons why in Rome at least, no temple was adapted to Christian use until the Pantheon in 609. It was this that made it necessary to break that magic by systematically jumbling their elements when re-used. In this there is a similarity with the explanation proposed for the origin of the Composite capital: the mixing of elements in the Composite capital broke the power of Greek culture. Similarly, the jumbled colonnades of early churches broke the power of pagan religion. The breaking of objects had long been a central part of magic rituals in which an individual or institution's power was broken, and now it was applied on a monumental scale. Such breaking worked in all these contexts because of its impact on the neural resources of viewers. Just as looking at the Composite capital inflicted pain on the insula of those who loved Greek culture and brought pleasure by activating the striatum of those who loved Rome, looking at church colonnades made out of jumbled temples evoked pain in those who loved paganism and pleasure in those who were devoted to Christianity.

Not that this was the only neural response in play. In a number of cases what looks at first to be a confusion can be seen in fact to be highly ordered. An example is the sequence of entablature sections in the same S. Lorenzo. These are arranged in such a way that they become more

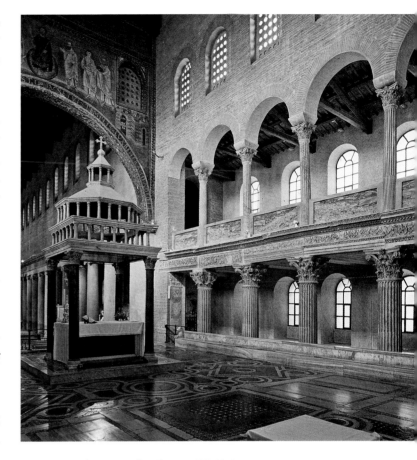

100 Interior of S. Lorenzo fuori le Mura, 579–90, Rome

ornamented, and in particular more organically alive, as one moves towards the original altar. There is no way of knowing for certain what the response of the Christian worshipper would have been to such an arrangement but, because of the way the neophyte was prepared for the experience of the liturgy by instruction in biblical texts, we can suggest several possible unconscious reactions. Given St Paul's reference at Ephesians 2: 20 to the Church 'growing' together in Christ, people might have felt the building itself coming alive like the institution. And, given that catechumens were taught that in Baptism they metaphorically first died and then came alive again, they might have felt that the way old fragments were brought back to life in a new building reflected that process. Specifically, the use of capitals decorated with military trophies next to the church's original altar seems, like the Composite capitals in a similar position in St Peter's, to evoke a metaphorical victory over death.

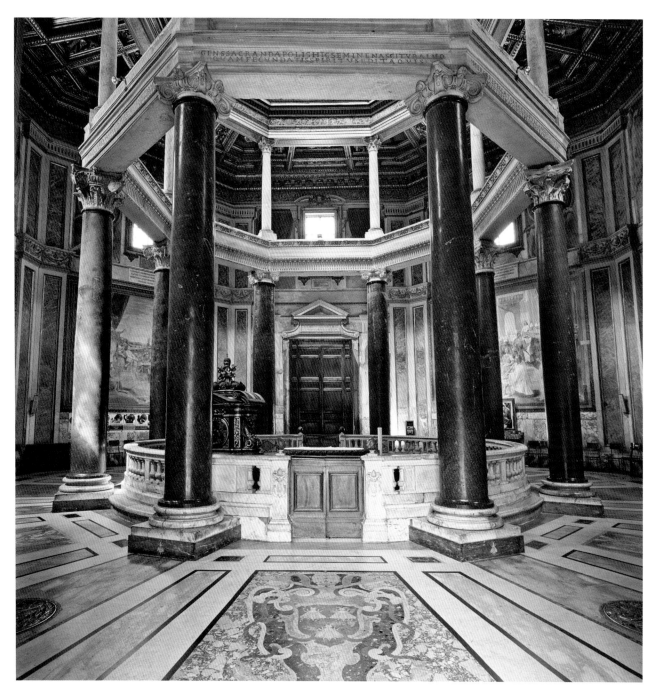

101 Interior of the Lateran Baptistery, c.435, Rome

The closest we can get to documenting such a relation between an organised variation of forms and a sense of spiritual change in a Christian structure is at the Lateran Baptistery (432–40; fig. 101). There the octagonal lower entablature is supported by eight columns bearing capitals of three different types, which, again, seem at first disordered. It is only when we look twice that we see that they are carefully laid out, with four Ionic capitals on the entry axis, followed by a pair of Corinthian to the east and a pair of Composite to the west. The meaning of this arrangement is then brought

out by verses inscribed on the entablatures above, which offer a commentary on the baptismal rite. Evidently, at entry the neophyte only saw the simplest capitals, the Ionic, then during the ritual turned first towards the Corinthian pair before being finally confronted by the Composite. These last, being towards the west (the orientation of the altar of the adjoining basilica), suggested a triumphant end to the spiritual journey. The definitive value of the baptised's experience is announced in the final inscription: 'You who have been reborn in this fountain hope for the Kingdom of Heaven; those who have been born only once cannot attain the happy life.' Prior instruction would have prepared the individual to empathise with the progressive increase in the ornamentation of the capitals and so better experience the transformation involved in the baptismal experience of rebirth.[4]

102 *Judgement and Freeing of Susannah*, 3rd century, paintings from the Catacombs of Priscilla, Rome

Painting and Sculpture: Imagination and Schematisation

One of the main features of art after Constantine is the continuation of the decline in naturalistic detail and three-dimensionality that we noted in the earlier Empire (see p. 128), and much of it can be attributed to the same factors. Others, though, were new and related to the shift in subject matter. Artists of earlier generations, who were called to represent figures from the secular and pagan worlds, knew that the physical bodies of those figures were attributes important to their identities. For those charged with portraying biblical figures and saints, this was no longer the case. Besides, while even a second-rate earlier artist would have been conscious of the naturalistic attainments of a Praxiteles or an Apelles, the new Christian artists, knowing that their subjects had never been treated by such masters, were less likely to have works by them in their minds as they painted and carved. Instead the images they were likely to have in their heads were other more recent representations of Christian stories and subjects. That would have meant initially such modest art as the paintings from the Catacombs and such sarcophagi as those showing Christ as the Good Shepherd (fig. 102). The neural networks formed by exposure to these works, which were already more schematic

than contemporary work for pagan patrons, would have carried even less detailed information on visual appearance, so causing a further reduction in the naturalism of the works made under their guidance.

The factor that had the greatest influence, however, on the trend to ever flatter and more schematic images was the new role of two mental activities, imagination and meditation. Fourth-, fifth- or sixth-century Christians, who were constantly invited by texts and liturgy to imagine sacred figures whom they had never seen, necessarily visualised them not as living three-dimensional bodies but as they knew them from their relatively schematic representations in paintings and mosaics. As they adored such images or prayed in front of them they would have received particularly strong impressions on their neural networks. If they were artists, when they themselves made new images guided by networks shaped in this way, those images would have inevitably emerged as even more flat and schematic, and if they were worshippers they would have been pleased by the way such works corresponded with their prototypes (fig. 103).

To these general factors encouraging the formation of neural networks that were poor in three-dimensional information we can add others that are more specific. One was the circumstance that, because of the danger of idolatry, which was associated with paganism, there were few statues of Christian figures. Furthermore, those that did exist were

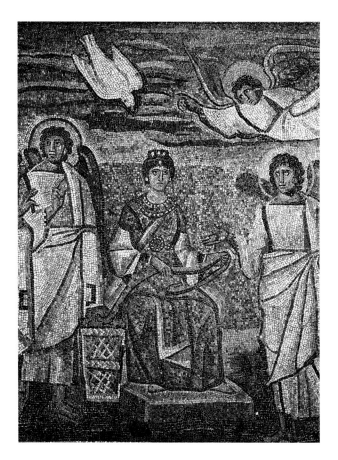

103 *Annunciation*, 5th century, mosaic, Sta Maria Maggiore, Rome

The cumulative consequences of these new neural exposures are most evident in the distinctive properties of the monumental art of Italy and the frescoes, mosaics and icons of Byzantium, but they can be felt everywhere in all types of art. By drawing attention to the neural processes involved, the intention is not to replace or question existing explanations for stylistic developments, which emphasise the conscious decisions associated with particular political agendas or religious attitudes. All that the preceding paragraphs do is draw attention to the likely consequences of those decisions for the unconscious mental formations of all those involved.

This argument expands on the reasons why art became more flat and schematic, but it does not explain why there was so little resistance to this process. After all, at least some of the people who were familiar with the naturalistic art of Antiquity, especially among those who were privileged and wealthy enough to challenge conventional processes, should have been disappointed by flat and schematic images and have demanded more depth and detail. That this did indeed happen is suggested by the periodic revivals of those features, but that it did not happen more often can also be explained by following up another argument presented in the last chapter, that about a rhetorical education and how it encouraged viewers to see things that were not there (pp. 113, 114).

What gave that argument a new relevance in the context of Christian art was the enhanced role that the imagination played in everybody's lives. Under the pagan Empire, where the predominant intellectual frameworks were those developed to support the Greek search for truth, the imagination was a marginal, even a dangerous, faculty. The uneducated, who had no need to distinguish between their mental faculties, could employ it freely, as they always did. The educated were sceptical of it, valuing it only as a resource cultivated as an aid to persuasion within a rhetorical education. Christianity's establishment changed all that. Universal acceptance of a faith that was based on rejecting the physical world in favour of a spiritual vision meant that now no one could survive without a highly developed imagination. One could even claim that training in the use of the imagination in the context of a rhetorical education contributed directly to the rise of the new religion.

small, while the far more frequent two-dimensional representations in painting and mosaic, which were freer from the potential charge of idolatry, were often of a large scale, sometimes several times life-size. Looking less at sculptures and more at powerful images in two dimensions had neural consequences that inevitably accelerated the trend to flatness. And this trend was also encouraged by the way an increasing use of painted and mosaic images as objects of prayer and adoration favoured the selection of a frontal pose. In a frontal pose it is necessarily more difficult to bring out depth. Indeed, a flat frontal image of Christ, Mary or other sacred figure who fixes the worshipper with an unwavering gaze is a highly effective object of spiritual contemplation, and the more intense the worshipper's engagement the more potent the impact on his or her neural resources. When these resources were those of a patron or an artist, they could have a critical influence on the direction of artistic development.

Such training certainly continued to influence the development of art, as we can see from the way rhetorical descriptions of marble slabs made even greater demands on the imagination than they had under paganism.[5] Sixth-century descriptions of the coloured marbles lining the interior of Haghia Sophia in Constantinople go much further than the writings of Sidonius Apollinaris in the fifth. Procopius in his biography of Haghia Sophia's patron, the Emperor Justinian, tells how 'one might imagine one has chanced on a meadow in full bloom. For one would surely marvel at the purple hue of some and the green of others, at those on which the crimson blooms, at those which flash with white' (*De aedificiis*, I, 59 and 60), and the orator Paul the Silentiary provides an even more remarkable record of contemporary response to the marble surfaces in one of two poetic eulogies (*Descriptio ambonis*, 224–35) composed on the occasion of the completion of a restoration of the church's dome in 562. Most elaborate is an account of the ambo or pulpit in front of the altar. In his description, the structure, now lost, is transformed:

And as an island rises amid the waves of the sea, adorned with cornfields, and vineyards, and blooming meadows, and wooded heights while the travellers who sail by are gladdened by it and are soothed of the anxieties and exertions; so in the midst of the boundless temple of the sea rises upright the tower-like ambo of stone adorned with its meadows of marble . . . Thus, like an isthmus beaten by the waves on either side, does this space stretch out, and it leads the priest who descends from the lofty crags of this vantage point to the shrine of the holy table. The entire path is fenced on both sides with the fresh green stone of Thessaly, whose abundant meadows delight the eye. . . . When to soothe your sorrows, you cast your eyes there, you might see snake-like coils twining over the fair marble in beauteous wavy paths . . .[6]

We could take this reverie on the landscape properties of the island pulpit and the evocation of the psychological reassurance it offered merely as rhetorical display, demonstrating how divorced from daily experience both oratory and art had become, but we would be wrong to do so. Rather, it illustrates how, for a contemporary, seeing the ambo in terms of a landscape that evoked positive emotions was natural and appropriate because it still depended on the activation of neural resources shaped by daily experience. The pleasure associated with the sight of a rocky peninsula projecting into the sea would have been habitual for many of the traders and sailors who lived in Constantinople, a city that was itself a peninsula, gladdening the hearts of many as they returned home. Besides, when it was claimed that the church's pulpit-peninsula evoked a similar pleasure, it in effect became the key to a religious experience, the reassuring anticipation of the possibility of entry into Paradise offered by the Gospel message pronounced from its summit. An administrator or soldier, a merchant or mariner who, following his return from a voyage, entered Haghia Sophia to thank God for his return and pray that he might one day enter Paradise might well have experienced the pulpit, both visually and emotionally, in exactly the way the writer describes it.

Other aspects of the marble decoration of Haghia Sophia are spelt out in another contemporary text: 'the floor . . . made visitors marvel, for it appeared like the sea or the flowing waters of a river thanks to the great variety of its marble. The four linear strips of the church he [Justinian] called the four rivers that flow out of Paradise and he decreed that people excommunicated for their sins should stand on them one by one' (*Narratio de S. Sophia*, 26).[7] For the whole community the four strips represented the rivers of Paradise and, for the excommunicated, the idea of being washed in them brought hope of rejoining the community of the blessed. The watery references of the floor of Haghia Sophia are not an isolated phenomenon. In Venice, the wavy slabs of Proconessian marble under the central dome of St Mark's (eleventh century onwards) have traditionally been called a *mare* or 'sea' and the vault above them has images of the rivers of Paradise. The recurrence of this maritime reference in the port city on the Adriatic reminds us once again that the rules governing neural formation mean that the metaphors to which we are most disposed neurally are those that relate to our lived experience.

We could say that the marble slabs in Haghia Sophia owed their extraordinary properties to the designer's understanding of the brains of those who worshipped there. In these brains, in terms of Lakoff's neural theory of meta-

the narthex to the nave (fig. 104). These have been selected and split in such a way as to suggest the silhouette of a figure with its hands raised in the gesture of prayer. Any doubt as to whether these veined patterns were intended to be seen as pictures of humans is disposed of by the tiny, almost invisible holes drilled in the marble in the places where the eyes should be. These slabs would have served to activate at least two of the neural groupings with which many of the sixth-century inhabitants of Constantinople would have been endowed, that which enabled them to 'see things' in slabs of marble and that which sustained their belief in the effectiveness of personal prayer. Both were driven by hope. In the one case, hope that the interior of the church would give a vision of Paradise and, in the other, hope that performance of a ritual would bring access to the ultimate Paradise closer. It was the convergence of these two hopes that would have led to the establishment of neural connections between the two groupings, predisposing those endowed in this way to experience a neurochemical reward once they were activated together.

Magic: Homoeopathic and Contagious

Hope is one of the keys to magic, magic usually being, as we saw earlier, a means of convincing someone that they will realise a particularly vital desire, whether it is for their own advantage or someone else's disadvantage. Often words are an essential element, as in a spell. More frequent is some sort of physical action. A good example would be the procedure that Justinian recommended for those who had been excommunicated and desired re-admission to the Church. When he suggested they should stand on the strips representing the rivers of Paradise in the floor of Haghia Sophia, he certainly intended that they should feel the contact to be beneficial, the 'marble' water having a power similar to the real water used in Baptism, which could wash away sins. Thus the efficacy of the action involves a combination of Frazer's two sub-types of Sympathetic magic, the Homoeopathic and the Contagious. The requirement of standing on the strips exemplifies the power of contagion, the implication of their cleansing properties that of homoeopathy.

104 Entrance from narthex into Haghia Sophia, Istanbul, 532–7, showing figures in split marble slabs above door

phor,[8] three groupings were connected: first, the primary grouping which was built up by daily exposure to water; second, that which was built up by rhetorical training to assimilate elaborate metaphors; and third, that sustaining a belief in the effectiveness of ritual built up by the Christian experience. It was the connections between the last two that was the key to the worshipper's experience, and we can sense how these might have been primed by entry into the building if we consider the slabs over the doors leading from

Probably the best illustration of the importance of contagious magic in Christendom between the first and the thirteenth centuries was the prevalence of a desire for contact with something sacred – a site, a figure, an object – that might help an individual to atttain some vital goal, whether it was a cure for an illness in this world or salvation in the next. The neural groupings involved affected both people's behaviour during their life and the way in which they disposed of their bodies after death. Many, when alive, made pilgrimages to sites such as Rome and Jerusalem, where holy figures had lived and died, and brought back containers of holy substances, like the phials containing sacred oil preserved today at Monza Cathedral in northern Italy. Others ensured that their bodies were buried near the places where either the saints themselves lay or where relics directly associated with them were preserved. This need to realise magic 'contact' had major consequences for the history of art. One was the number of churches constructed on such pilgrimage and burial sites. Another was the large scale of such buildings, which had to accommodate hundreds if not thousands of believers. A third was the complication of their layout, caused by the need to allow devotees to circulate and get as close as possible to the holiest places and relics.

Fourth-century structures in the Holy Land and in Italy, such as the Anastasis rotunda built over Christ's tomb in Jerusalem (see fig. 99) and the great Roman basilicas, such as those of the Lateran, St Peter (see fig. 98) and St Paul, are only the earliest and most prominent of such structures. Over the following centuries, thousands of churches owed their layout, their scale and their magnificence to their need to do more than house a local congregation. They had to attract, accommodate and impress large numbers of the faithful, who often came from afar to be as close as possible to someone who might respond favourably to their prayers and help them to enter Paradise. They came because they possessed neural resources primed to be sensible to the magic of contagion, that is, resources that responded to a claim for the presence of a saint at a particular site by activating the reward centre in the mOFC. It was the way that such a claim could intensify the worshipper's response, in the same way that today a claim in relation to a wine vintage intensifies that of the wine lover, or one in relation to the attribution

of a painting intensifies that of an art lover, that caused the competition in the acquisition of relics. In the early years a mere inscription, or *titulus*, as in the Catacombs of Rome, would have been enough to activate the reward centre, but as competition between sacred sites intensified, other factors, such as the elaboration of the tomb or reliquary and of the chapel housing it, became more important. This visual elaboration engaged many other neural networks, such as those processing colour, value of materials and quality of the work, all of which might enhance the viewer's attention.

Other factors, related more to homoeopathy than contagion, which would have enhanced mOFC response, would have been the use of a design that either recalled one of those magically powerful structures mentioned earlier, such as the Anastasis in Jerusalem or St Peter's in Rome, or shared properties of material, colour or layout with a structure approved by God, whether a real building from the Old Testament, such as the Tabernacle and Ark of the Covenant made under Moses or the Temple erected by Solomon, or the visionary structure from the New Testament, the Heavenly Jerusalem. Only because the neural groupings that computed the relative effectiveness of such magic by resemblance were so widespread in the population was great care taken to make such assimilation visible, whether by a plan type or by a decorative element, as we will see in the next chapter.

The Power of the Cross

Of the many examples of the magic of homoeopathy in Early Christianity none is more important than the use of the cross as an instrument of salvation. Its potential importance was already recognised by St Paul who, in I Corinthians 1: 18, calls the Gospel 'the preaching of the cross', but it was Constantine who took the lead in establishing the cross's magic role. Having used it in some form as an emblem on his standards in the rout of Maxentius at the Milvian Bridge, as commemorated on coins (fig. 105), he went on to erect a gigantic statue of himself holding a cross, in his rival's great new basilica off the Roman Forum. He also seems to have believed that the cross could work its magic when incorporated in building plans, because he not only added a new apse on an axis at right angles to that originally intended for

105 Roman *nummus* with laureate head of Constantine (obverse) and *labarum* with shaft piercing serpent (reverse), AD 327, copper alloy, d. 18 mm. British Museum, London, 1890,0804.11

the Basilica, so endowing it with a 'cross' plan, but went on to add a cross-axial transept to the otherwise convention-ally basilican plans of the two great churches of the Lateran and of St Peter (see fig. 97), so introducing the cruciform plan that came to play a major role in Christian architecture. It is revealing that Constantine also banned the traditional use of the cross for executions. To maximise its positive sig-nificance, the cross had to be disconnected from criminal-ity. Freed from that association the form could acquire an enhanced status in rituals, as soon noted by Augustine:

> If this cross be not traced upon the foreheads of the faith-ful, or over the water from which we are to be born anew [e.g. at baptism], or over the oil with which we are anointed [e.g. at confirmation], or over the sacrifice with which we are fed [e.g. at communion], then none of these acts is accomplished according to the rite [*Tractatus in Evangelium Johannis*, 118, 5].

The cross as a sign could work magic, but that magic was greatly enhanced by the attention given under Constantine to the cross as a physical object. First, the emperor's mother, Helena, in 325/6 went on a pilgrimage to Jerusalem and soon excavated what she claimed was the original Cross on which Christ had died. This had an immediate effect on her son, inspiring him to begin major churches. The most

important was that built over the site of the excavation, the Anastasis ('Resurrection') rotunda. Also significant was the basilica of Sta Croce in Gerusalemme in Rome, erected to house a major part of the Cross that had been brought to the city so that it could there work its magic by contagion. Then, in the early fifth century, the Emperor Theodosius II gave the original Jerusalem Cross a jewelled casing. This early and prominent addition of rare and valuable ornaments to a relic not only made it an object of visual concentration but also, like the label on a wine bottle or the golden frame on a painting, achieved the, in neural terms, critical goal of strengthening the response of the brain's reward centre. That goal was then reinforced by such later grand representations of the jewelled Cross as those in the apses of Sta Pudenziana in Rome (after 400; fig. 106) and S. Apollinare in Classe, Ravenna (532–6). Such was the magic of the cross that every time it was reproduced, whether in such a monumental public context or in a more intimate personal setting, as on a tomb slab or ring bezel, it strengthened the viewer or user's hope for resurrection and salvation.

This effect was predictable for anyone who at once under-stood the significance of Christ's death on the Cross and also possessed a neural grouping for processing magic effects such as would allow the form to be instrumentalised. It would have been enhanced if the cross's shape also activated neural resources formed as a result of some more personal visceral engagement in an individual's daily life, as when something that shared formal properties with the cross was also associ-ated with hope and confidence. This helps to explain why, for instance, in the first to the third centuries, when fear of attracting persecution limited people's use of the cross as such, Christians in the Roman catacombs preferred to use the emblem of an anchor with crossbar, the anchor being a natural emblem of hope for Mediterranean seafarers, as St Paul notes in Hebrews 6: 19: we have 'hope as an anchor for the soul'. The particular form of an anchor with a crossbar gave even greater reassurance (fig. 107). Such an anchor acti-vated two neural networks, one shaped by daily exposure to real anchors and relating to survival in this world, and the other shaped by exposure to the cross in a religious context and relating to survival in the next. Constantine's idea of attaching a *chi rho* form of cross to the military standard, the

(above) 106 Christ and the Apostles, with jewelled Cross, apse mosaic, after 400, Sta Pudenziana, Rome

(right) 107 Tombstone with dove, anchor and crosses, 3rd century, Catacombs of Priscilla, Rome

labarum, can be seen to have similar roots, depending as it did on the experience he shared with his soldiers of looking often and with intense attention at military standards in which a cloth was hung from a horizontal bar attached to a vertical pole (see fig. 105). All military standards brought hope of victory in battle and a standard that explicitly combined its cross shape with the *chi rho* would have upgraded that hope into one of victory over death. In the same way

108 Sarcophagus with trophy surmounted by monogram of Christ framed by scenes of the Passion, mid-4th century. Museo Pio Cristiano, Vatican City

the assimilation of the cross surmounted by a monogram to a military trophy, as on a mid-fourth century sarcophagus in the Vatican (fig. 108), can be understood as a consequence of a frequent and intense exposure to real monumental trophies, erected to mark victories on the battlefield.

With the expansion of Christianity northwards the response to the cross was inflected by neural networks formed by different exposures, such as those to different types of tree. Venantius Fortunatus, the sixth-century bishop of Poitiers, for example, describes the Cross as a tree bearing a remarkable fruit, a vine, an image that would have been highly reassuring in a relatively warm environment where fruit trees and vines brought promise of sweet nourishment.[9] In Britain, still further to the north, in contrast, where fruit trees were rarer, and where Christianity only with difficulty displaced tree worship, the experience of the Cross had other dimensions, as we find in the great Anglo-Saxon poem, *The Dream of the Rood*. The dream begins with a vision of the Rood, or Cross, as a jewelled relic before the wood becomes a Christ-like tree having a wound in its side and suffering when the nails are knocked into it. This wound brings the tree to life so that it can tell how it was uprooted from the forest before being re-erected as the gallows-tree of victory on which Christ the hero died, how it was cut down and buried and then dug up again before being encased in gold and gems. For people who had only recently worshipped trees, the assimilation between Christ and the tree and the sense that the

jewelled relic in Jerusalem, the cross of victory, was like one of their own sacred trees would have been profoundly reassuring, while its resemblance to their own gallows gave it a further resonance. For people who possessed neural networks shaped by both exposures, the experience of the cross was particularly meaningful.

It was an awareness that many in his community shared such habituations that encouraged Oswald, the recently converted king of two territories in northern England, to evoke Constantine in his own way, on the night before the decisive Battle of Heavenfield (633/4), by erecting a cross of timber. When Oswald won, his hitherto heathen nobles joined him in the new faith, so preparing for the establishment of a new Christian kingdom of Northumbria, destined to be celebrated for both its learning and its art. One of the greatest examples of the latter was the eighth-century stone cross, now at Ruthwell (fig. 109). Inscribed with several lines from *The Dream of the Rood*, it keeps alive the assimilation of cross and tree.

Individuals throughout Christendom shared neural resources giving the cross reassuring properties, but in each region at different periods those resources were influenced by others shaped, in turn, by their local experiences. This enhanced the cross's efficacy, enabling it to work homoeopathically by its evocation of the positive associations not just of the instrument of Christ's sacrifice but of an anchor, a military standard, a military trophy, a fruit tree, a forest tree and a sacred column. In each case it was people's engagement with a particular object that shared visual properties with the Cross that caused the two forms to be associated. This positive association played a vital role in strengthening the cross's ability to reduce visceral fears.

The Seal of Solomon

One of the most powerful magic designs in the Jewish world was the Seal of Solomon. Its magic was embodied in its baffling geometry, either a hexagram, like the design now known as the Star of David, consisting of two superimposed triangles, or a five-pointed pentagram, which allows the lines of the triangles to run on endlessly. Sometimes, as in the fourth-century synagogue at Capernaum, in order to

(left) 109 The Ruthwell Cross, 8th century (restored 1823), stone, inscribed with runic lines from *The Dream of the Rood*, Ruthwell Church, Dumfriesshire, Scotland

(above) 110 Rope Seal of Solomon, detail of entablature, synagogue, 4th or 5th century, Capernaum

make the design even more baffling, the lines are treated as interlocking or string-like, adding to the design the security of a knot (fig. 110). It is possible that one function of the Capernaum relief is to defend that lavish structure by recalling the example of Solomon, the builder of the first, and divinely approved, Temple to God. Solomon was certainly invoked for similar reasons when the first grand churches were built under Constantine, as we know from the panegyric of Eusebius, the bishop of Caesarea, on the completion of the cathedral of Tyre up the Levantine coast, the first

explicit verbal commentary on a Christian building.[10] Eusebius went on to become bishop of Constantinople (339–41) and was probably responsible for the construction of the first church there, with the unusual dedication of Haghia Sophia, 'Holy Wisdom'. Its siting next to the imperial palace encouraged people to associate wisdom with the Emperor and to see him specifically as the successor to the 'most wise' Solomon, who built his own palace next door to the Lord's Temple. That this church was explicitly identified with Solomon we know from Justinian's declaration in 537, when entering the building which he constructed to replace its damaged predecessor: 'Solomon, I have surpassed you.' That this was not a rhetorical claim after the fact is indicated by the building's underlying geometry of two interlaced triangles. Justinian chose two mathematicians, Anthemius of Tralles and Isidore of Miletus, as its architects probably because they best knew how to strengthen his intellectual credentials by such cleverness.

The Solomonic character of Justinian's Haghia Sophia is also confirmed indirectly by the building with which it competes most directly, the now lost St Polyeuctus (c.525). This had been constructed by a noble lady, Anicia Juliana, who saw herself as Justinian's rival claimant to the imperial throne, and in its great inscription, recorded before the building's destruction, she claimed that she had 'surpassed the wisdom of renowned Solomon, raising a Temple to receive God'.[11] One way she had done this was by including references not just to Solomon's Temple but, through its hundred-cubit square plan, to its visionary successor, described at Ezekiel 41, which became the model for the Heavenly Jerusalem of Revelation. The building's mathematical properties were certainly intended as expressions of Anicia's own Solomonic wisdom and we have direct evidence of her interest in possessing Sophia and expressing it in her building activities from the frontispiece to a manuscript commissioned to thank her for helping to rebuild a section of Constantinople after its destruction in an earthquake (fig. 111). A complex illumination shows her as Sophia surrounded by scenes of building and framed by two rotated squares of knotted ropes which are in turn framed by a knotted circle, the perfect Seal of Solomon, an insoluble riddle. Given Anicia's ostentatious claim to wisdom, it is hardly surprising that Justinian in his

111 Anicia Juliana as Sophia (Wisdom) flanked by Greatness of Soul and Prudence, 6th century, paint on parchment, in Dioscorides, *De materia medica*. Östereichisches Nationalbibliothek, Vienna, cod. Vindobonensis med gr 1, fol. 6v

own rebuilding of the church dedicated to Wisdom went to great pains to surpass both Solomon's and hers.

As this account reveals, one of the main advantages to a ruler of constructing a church dedicated to Solomonic wisdom was that it strengthened their claim to an authority recognised by God. This is why others followed Justinian. One was a Lombard prince, Arechis II, who, around 760, erected the church of Sta Sophia in Benevento, Italy. An early document claims that its 'exemplar' was the church of the same dedication in Constantinople and, since it was, most unusually, laid out round a ring of six columns, it renders the geometry of the two interlaced triangles of the Seal of Solomon that underlay that structure even more visible.

Someone who visited Italy at the time and who might have heard about this building was the Northumbrian

scholar Alcuin (c.735–804), and it may have been this project that inspired him to persuade Aelbehrt, the Archbishop of York, the city where he ran a famous school, himself to build a church with a similar dedication, to Alma Sophia in 780.[12] Although there were kings of Northumbria at the time, there is no evidence to associate the church with a royal residence, and it may have been intended above all to strengthen the position of the archbishop, who was only the second to hold that position. We know nothing else about the church, but it is important as a link to one of the most important buildings of the first millennium, the palace chapel at Aachen. Two years after the dedication of Alma Sophia in York, Charlemagne invited Alcuin to his new capital to establish a school and generally raise the intellectual level of his whole domain. Soon afterwards the chapel was begun, an octagon founded on two rotated squares (see figs 115 and 116). When it was completed, as much the most refined and geometrical post-Roman building north of the Alps, Alcuin celebrated it as the 'temple of the most wise Solomon'.[13] With the combination of the building and the school, Alcuin transformed his patron's image, associating the barely literate ruler with the highest intellectual attainments. Never before had the resources of the brain been given such a high political profile.

9

Art and the Mind in Christian and Pagan Northern Europe

700-1100

There is an intriguing resonance between the linear geometry of the Solomonic designs associated with both Justinian and Anicia Juliana and the refined art of Northumbria as exemplified by a manuscript such as the Lindisfarne Gospels (figs 112–14). Both emphasise a combination of linearity, complication and precision in a way that is unprecedented and when the two traditions, the Byzantine Solomonic and the Northumbrian, met in Charlemagne's court the conjunction proved exceptionally fruitful. Much of the art that emerges in the Carolingian world of the late eighth and the ninth centuries, as in pages from manuscripts such as the Ebbo Gospels or the Utrecht Psalter, has a vitality of line that had never been seen before in Europe. In their complexity and animation these illustrations could almost be said to share the properties of neural networks, including the firing of neurons. How did they? One answer could be that the culture that Alcuin brought to Aachen was the most cerebral

there had ever been. It was not more intelligent than, say, Greek culture, but it was more cerebral. While the Greeks were always conscious of their bodies and their engagement through their senses with the external world, the monks of Ireland and Britain, who created the culture that Alcuin took to Aachen, paid little attention either to their bodies or their sensual engagement with the world, concentrating on an inner involvement with sacred texts.

Looking at Letters: The Lindisfarne Gospels

The over-riding priority of this involvement is evident in many of the manuscripts produced in Ireland and Northumbria in the seventh and eighth centuries, the Lindisfarne Gospels and the Book of Kells being the most elaborate. While most medieval manuscripts are famed for their figural

112a and b Carpet page and initial at beginning of the Gospel of Matthew, paint on parchment, in Gospels, executed in Lindisfarne by Bishop Eadfrith, 'Lindisfarne Gospels', c.700. British Library, London, Cotton MS Nero D.IV, fols 26v–27

scenes and the lavishness of their decorated borders, these are distinguished chiefly for the precision and complexity of their largely abstract full-page patterns, usually built round either an initial letter or a cross. Although the origin and meaning of these designs remain elusive, we can say with certainty that the neural resources that created them were principally shaped by concentration on the designs themselves. If any other experience of the world informs the designs, it is that of metalwork or needlework with their Celtic and Germanic roots. From metalwork come the sharp lines, the small size of the constitutive units and the enamel-like colours. From needlework come the intertwining of the lines and their continuity. But the overall aesthetic is self-referential. The qualities that absorbed the draughters were precision and complexity, qualities that we can define as being more purely cerebral than those found in almost any other works of art. Typically in the history of art the way that artists improve their productions is by strengthening their neural resources by looking either at the thing in the outside world that they are representing (a figure, a landscape, a flower) or at other art that they admire. In the case of these works, we feel that it is the intensity with which the artists concentrated above all on the manuscripts themselves that strengthened their neural resources, and it is this that enabled them to produce illuminations of an unprecedented complexity and refinement.

113a and b Carpet page and initial at beginning of the Gospel of John, paint on parchment, in Gospels executed in Lindisfarne by Bishop Eadfrith, 'Lindisfarne Gospels', *c.*700. British Library, London, Cotton MS Nero D.IV, fols 210v–211r

Where did the drive to do so come from? One answer is from the habit of intense contemplation on the 'word', which distinguishes Insular (that is, of the British Isles) Christianity. In Byzantium, the area of Europe with the liveliest and most elaborate artistic patronage at the time, the persistence of a tradition of monumental painting going back to ancient Greece meant that concentration was on large-scale figural art, frescoes and mosaics, as well as the icons of Christ, the Virgin and saints that were the supreme expression of Orthodox faith. In Rome, the situation was similar, but the resources available for patronage more limited. Elsewhere on the European continent, invasions catastrophically disrupted

economic and cultural life, and patronage of either monumental painting or manuscripts was minimal.

The situation in the British Isles was different, in large part because of the unique situation of Ireland. That island had never been conquered by the Romans and so had never known literacy, nor had it been Christianised before missionaries arrived in the sixth century. This made their impact on the population of illiterate pagans dramatic. The communities of monks that formed as a result focused with exceptional intensity on the mental and material culture of the new religion. Discovering through a new book-based faith two whole new worlds, that of the Latin language

and that of writing, they gave to each much more attention than did their contemporaries elsewhere. In order to make Latin easier to read, they for the first time inserted spaces between words and accents to mark stress, and they also developed a new clear version of Late Antique uncial script. The texts they read and wrote they digested with a fervour that combined the Jewish tradition of meditation on texts and the Classical tradition of their analysis. Each reinforced the other. Perhaps for the first time in human history the shaping of culture was chiefly in the hands of literary scholars, individuals possessed of unusual powers of concentration on the acts of reading and writing. The more their understanding of texts gave them confidence, the more deeply they immersed themselves in them. Looking at the letters of the texts on which they worked with exceptional attention, the monks would have had their neural networks shaped by the letters' abstract forms, and it was those networks that guided them in their ornamentation. Recent experiments have shown how, in general, reading enhances the neural resources involved in the perception of form not just in the visual word form area, but in associated areas in the temporal lobe, and, with the excitement of a new-found literacy, the enhancement would probably have been particularly conspicuous.[1]

The Lindisfarne Gospels are a supreme product of this new engagement with words. Recognised by most as entirely the conception and production of a single hand, Eadfrith, the Bishop of Lindisfarne in 698–721, each aspect of the manuscript manifests an unusual coherence and strength. These have their origins in the intellectual effort of Eadfrith, as he sought to give maximum expression to the biblical text, but it is the character of the distinctive neural formation generated by that effort that endows the manuscript with its visual authority. As Eadfrith concentrated on shaping each letter, he was strengthening his interest in and preference for vigorously fluid curves and forcefully sharp angles, and it was these neurally embedded preferences that guided him in the design and execution of the initials, the canon tables, the carpet pages and the portraits, their underlying architecture of curves and angles being often reinforced by the use of geometrical instruments. If the most robust neural resources, on the one hand, were those attuned to curves, as in the *chi*

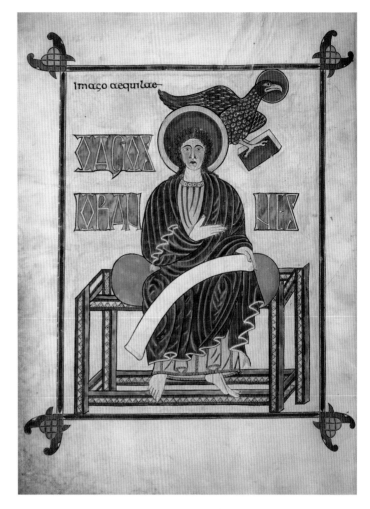

114 Portrait of St John, paint on parchment, in Gospels executed in Lindisfarne by Bishop Eadfrith, 'Lindisfarne Gospels', *c*.700. British Library, London, Cotton MS Nero D.IV, fol. 209v

rho at the beginning of Matthew, then the same curves could spread like eddies in water from the major to all minor forms (see fig. 112). They were also liable to recur, as they do in Matthew, in adjoining sheets, the 'Incipits' ('beginnings' or 'openings') and the carpet pages. If, on the other hand, as in the case of the *In Principio* at the start of John (fig. 113), angular forms predominated in the initial letters, then it was the same angularity that dominated in the organisation of the borders and the preceding carpet page, the whole being reinforced by the black lines whose salience was evoked by the explicit reference to writing in the whole phrase *In principio erat verbum*, 'In the beginning was the word'. The pre-

dominant influence of exposure to lettering is also apparent in the emphasis on flatness in both curved and angular forms and the avoidance of any suggestion of relief. That last feature is particularly evident in those subjects where an emphasis on three dimensions had been frequent earlier, that is, in the author portraits and canon tables. The influence of text on image is most striking in the portrait of John in the opening before the carpet page and 'incipit' (fig. 114). Its symmetrical frontality, which distinguishes it from the other portraits, derives from the parallel verticals of the 'I'(n) and the 'P'(rincipio) of the 'incipit' of the following text, which find another assertive echo in the equally unprecedented verticals of the legs of his seat. They also recur in the lettering, 'HO HAGIOS IOHANNES', behind him, which is more geometrical than that on the other portraits. Eadfrith had certainly also directed his intense Christian scholar's eye at other objects – probably earlier manuscripts, both the continental products brought back from Rome by Benedict Biscop and Insular works, not only those produced locally but also those brought from Ireland and Scotland by the missionaries who founded Northumbrian Christianity, as well as Insular metalwork with the refined enamelled geometry of the Ardagh Chalice. We can sense the traces of the distinct neural preferences shaped by all those visual experiences. However, their influence on his mental conception and the movements of his hand was not as strong as that of the manuscript on which he was working, because that experience had been both more intense and more frequent. The only object to which he gave greater attention was the Cross, which, as we saw, had a particular prominence in Northumbria because of all the stone crosses set up in succession to the wooden cross erected at Heavenfield in 634 on the occasion of Christianity's victory over paganism. This is why the Cross, and the properties of its parts, become the theme of all the carpet pages.

Bede and Levels of Interpretation

Such intense study of texts not only resulted in the production of great art. It also inspired the production of great scholarship, and no one produced greater scholarship than Eadfrith's contemporary, Bede (673–735). Bede is a central figure in this neuroarthistory for two reasons. One is his role as the scholar-educator who was the role model for Alcuin. Bede was the teacher of Alcuin's teacher, Ecgbert, and the person who was the model for him in his love of Sophia. The other reason is Bede's significance as someone who gave more attention to buildings than any earlier Christian writer, even if the structures were only imagined, as in his *De Tabernaculo* (c.721–5)[2] and *De Templo Salomonis* (c.729–31).[3]

Both books begin with explanations for why it is vital to give biblical texts such attention. At the start of *De Tabernaculo* Bede quotes Paul on the Old Testament at I Corinthians 10: 11: 'All these things were done as an example for us'; in the beginning of *De Templo* he quotes Romans 15: 4: 'whatever was written in former days was written for our instruction so that by steadfastness and the encouragement of the scriptures we might have hope', repeating that 'to secure the hope of heavenly goods we must have patience, and contemplate the consolation of the scriptures', before insisting that our engagement with them must involve 'frequent meditation'.[4] Bede makes a similar point in a more personal message to *De Templo*'s dedicatee, Acca, telling him that he had sent this 'little work ... recently written in the allegorical style on the construction of the temple of God' with the thought that: 'If you read it attentively, then the more you find the mysteries of Christ and the Church contained in its ancient pages and the more liberally you see there the gifts of God bestowed upon us in this present time and promised us in the future, the more' you will be able to bear 'the favourable and unfavourable vicissitudes of perishable things.'[5] St John the Divine, he adds, had enjoyed comparable benefits when imprisoned on the island of Patmos, where, being only able to contemplate 'the unfathomable mysteries of the heavenly mansions', that is, the Heavenly Jerusalem, he 'was privileged to enjoy the sight and conversation of angelic friends'.[6] Bede wants his readers to really concentrate on the texts and expects them to benefit psychologically from doing so. We might say today that he hoped that the experience would affect them neurally.

One of the desired neural consequences of the recommended intense reading was that the areas of the cortex that were concerned with processing the information he gives on the Temple and its allegorical significance would

become connected with other areas, such as the limbic regions involved in experiencing the emotions, and the mOFC with its links to the reward centre of the striatum. To encourage the formation of such connections Bede used several devices cleverly to activate neural resources which he knew that his readers already possessed, and which, once activated, would intensify their engagement with the text. An example is the phrase 'angelic friends'. This is one among many references to angels that he introduced to draw people into his writings. He himself knew, and recorded in his *Historia Ecclesiastica Gentis Anglorum* (*Ecclesiastical History of the English People*), the story of how Gregory the Great, when seeing English – that is, Angle – slaves in Rome, had exclaimed that they would be 'not Angles but angels if they were Christians'.[7] He also knew that the assimilation this implies would not only encourage the English to be devout Christians, but would also help them to think of themselves less as inhabitants of a muddy island and more as made of angelic material, properly at home in heaven. The desire to allude to angels probably explains why he chose to define his history as Gentis Anglorum ('of the English people') rather than in terms of some other racial or geographical designation. It is also why he begins the first paragraph of *De Templo* by saying of the building: 'To this house belong the chosen angels, whose likeness is promised to us in the life to come' and ends it by saying of the Temple as figure: 'In some respects it describes the unclouded happiness of the angels in heaven, in others the invincible patience of mankind on earth, in others the help of the angels bestowed on mankind, and in others again it will show the struggles of mankind rewarded by the angels' (*De Templo* 1.1). The repeated reference to angels is odd, but makes sense in neurological terms. Bede knew that, whether or not his readers knew the story of the assimilation between Angles and angels that he told in the more or less contemporary *Ecclesiastical History*, they would be likely, whether consciously or unconsciously, because of assonance, to experience the reference to angels as an indirect reference to themselves. The reassurance this would have given them would have led to the formation of neural connections that would have decisively increased their engagement with the text. It may be asked what difference it makes to describe the impact

in neural terms instead of just saying that Bede had raised their consciousness by wordplay. The answer is that describing it in terms of a change at a neural level brings out how deeply embedded the assimilation could become, coming to constitute, in effect, an aspect of his readers' identity, and being consequently linked to their concerns about life and death. Indeed, it is because national identity is always apt to be neurally embedded and linked to visceral concerns that throughout history it has been exploited for political and military reasons, as it now is in sport. Bede's reasons, though, were religious. He exploited the concept of identity through the *angeli/angli* assimilation because by doing so he could help to resolve his readers' anxieties about the likelihood of their obtaining eternal life in Paradise.

Bede well knew these neurally embedded concerns of his contemporaries because he shared them, and another that he exploited out of self-knowledge was the insecurity many would have felt, as recently converted pagans, about the robustness of their Christian identity. This he mitigated by two clever ploys. One was direct, to insist repeatedly that the mission to the Gentiles (that is, those ignorant of the Lord's message) had always been more important than that to the Jews (who had already received it). Thus, at the beginning of *De Templo* he points out that, while the Tabernacle was a purely Jewish structure, the Temple of Solomon had been largely built by non-Jews from Phoenicia, and goes on to insist that St Paul, the leader of the mission to the Gentiles, was more important than St Peter, the apostle to the Jews. The other ploy was indirect and involved pointing out, as he does at *De Templo* 11.2, that while the key object of the Jews, the tablets of the Law, were stone, the key object of the Christians, the Cross, was of wood. Bede, like the author of *The Dream of the Rood*, knew that, because tree worship was deeply neurally embedded in his audience, drawing attention to the Cross's woodenness would enhance his countrymen's sympathy for the new faith. By adapting his presentation of the new religion so that it could be easily linked to neural groupings already possessed by his audience, Bede thus accelerated and consolidated conversion. Thinking of such phenomena as racial identity and local material preferences in physical neural terms is helpful because it brings out how deep-seated they were and how little susceptible to change,

that being his main reason for exploiting them. Bede knew that by connecting the new neural resources that he wanted to foster in his readers with those they already had, he could more rapidly consolidate them.

So, what were the resources Bede wanted to encourage? We learn something about them when reading *De Tabernaculo* 25 and 26. There he explains that the great table before the altar 'has four feet because the words of the celestial oracle are customarily taken in either a historical, or an allegorical, or a tropological (that is moral), or even an anagogical sense'. These interpretative frameworks go back through Augustine to Origen in the early third century, who combined Judaic and Platonic traditions to create three levels of biblical interpretation, the literal, the moral and spiritual.[8] Bede now uses them as the basis for his own triple interpretation of the Temple. He begins *De Tabernaculo* with the statement that 'The house of God which king Solomon built in Jerusalem was made as a figure of the holy universal Church which, from the first of the elect to the last to be born at the end of the world, is daily being built through the grace of the king of peace, its redeemer.'[9] This assertion that a historical building was a 'figure' of the Church from its beginning to the end of time he then enriches with two parallel claims, that it is also a figure of Christ's body, since Christ's claim that he could rebuild the Temple in three days referred to his death and resurrection, and of our bodies too, as Paul says at I Corinthians 3: 16: 'You are God's temple'. Nor does Bede lose contact with architectural materiality in this imagery, for Christ was imagined as the cornerstone in the foundation of the Church (Isaiah 28: 16) and Christians as living stones, as Paul says at Ephesians 2: 20. Bede then goes on carefully to differentiate the Temple from the Tabernacle. The Tabernacle was constructed by Jews for Jews, as a figure of the purely Jewish community of the Old Testament. The Temple, in contrast, having been constructed for Solomon both by Jews and by non-Jewish workers sent by the non-Jewish king, Hiram, was a figure of the Christian Church, in which Jewish proselytes are joined by Gentiles.

The architecture of the Temple Bede then breaks down into its parts. Its major spaces represent the history of the Church. The portico, which was in front of the Temple, was 'a figure of the faithful of old', that is, the patriarchs and the prophets; the Temple itself was 'a figure of those who came into the world after the time of the Lord's incarnation'; and the inner house, that is, the Holy of Holies, prefigured the future, 'the joys of the heavenly kingdom' (*De Templo* 11.3). Each architectural element also develops into a figure: the door from the portico into the Temple is Christ himself (10.9); the windows are the holy teachers and spiritual people of the Church, which are splayed toward the interior because rays of heavenly contemplation cause the heart to expand (7.1). Metaphors are, indeed, everywhere, as in the interpretation of the Temple's dimensions – its length standing for the long endurance of the Church, its breadth for the charity of her wide bosom, and its height for the hope of a future reward (6.1). But the most recurrent imagery relates to the Church's composition and history. Thus the two cherubim either side of the Ark represent at once both the Jews and Gentiles and Old and New Testaments, and so do the two columns, Iachin and Boaz, that flank the entrance. The latter then receive a more elaborate interpretation, which develops the identification made in *De Tabernaculo* between the pillars holding up curtains in the court and holy figures, where it is said 'the pillars upon which these hangings are suspended on high are the holy teachers' (27.9–10). This Bede expands so that the tops of the two columns are the 'hearts of faithful teachers' (*De Templo* 18.8) and the two capitals above them are the two Testaments (18.8), while the chains that adorn the capitals represent the variety of spiritual virtues in the saints, with their intertwining suggesting the many different characters among the elect who 'reveal the miracle of their interconnection' (18.9).

Bede's elaborate meditation on the Temple of Solomon is not evidence of an interest in real buildings. In his *Ecclesiastical History* he often mentions buildings but never reflects on their meaning. In *De Templo* he is only following in a long tradition of biblical interpretation. Still, by developing this tradition much further in the context of biblical descriptions of buildings than any of his predecessors, he came to have a profound effect on built architecture, due to Northumbrian Christianity's role in shaping the culture and patronage of the court of Charlemagne.

Charlemagne and Alcuin

The quantity and quality of the late eighth-century artistic patronage associated with the court of Charles, king of the Franks, later known as Charlemagne (ruled 768–814), stands out in contrast to the low level of activity in the field in the previous three centuries. Its scale reflected the ruler's new wealth, especially following the expansion of his control both in Italy, where he largely absorbed Lombard territories, and in Germany, where he subdued the Saxons. Ruler of most of Western Europe, Charlemagne was able to think of himself in far different terms from his Merovingian and Carolingian predecessors. What were those terms? In other words, what were the neural resources that shaped his enterprise?

One answer is the resources that supported his sense of being heir to the Roman emperors, resources that linked his consciousness of self with the attributes of a past world characterised by administrative order, literary production, intellectual attainment and artistic magnificence. His sense of walking in the footsteps of emperors grew with his conquests both inside and outside the ancient imperial frontiers, and was strengthened by his campaigns in Italy, which brought him face to face with the most impressive material expressions of Roman power. But it was probably the illegitimate seizure of imperial authority by a woman, Irene, the widow of the emperor in Constantinople, that encouraged him to claim the imperial title for himself, as he did when he allowed himself to be crowned Emperor by the Pope in St Peter's on Christmas Day 800. The emperors that he and his contemporaries would have had most in mind as models were the Christian emperors, especially Constantine and Justinian, and among their actions that he was most inclined to imitate, because they justified his own expenditures, were those in the field of art and architecture, an emulation in which he was joined by many members of his court.

Imitation was evidently taken seriously, as we can see in the ivory reliefs produced in his reign, which are of such high quality as to be almost indistinguishable from their Late Antique exemplars. Their accuracy and refinement reveal them as the product of the demands of extremely visually alert patrons and of the response those demands evoked from craftworkers who could only have achieved such results by looking so intently at the works they were copying that they acquired neural resources comparable in subtlety to those of their makers. We can also see a high level of imitation in Charlemagne's greatest building, his palace chapel, now Aachen Cathedral (fig. 115). Its architect, Odo of Metz, and his masons must have either visited and personally examined the church of S. Vitale in Ravenna, or else looked closely at detailed drawings of it, to have been able to conceive and execute such a sophisticated combination of columns and capitals, entablatures and arches, as is manifest in the octagonal chapel's elevation. The neural networks that sustained the craftworkers in their imitation, like those involved in the production of the ivories, combined both the visual networks that gave the eye its edge and the sensorimotor networks that gave the hand its deftness.

Those networks associated with Aachen's other Classical Roman aspect, the physical appropriation of materials, were different. This appropriation came about following Pope Hadrian's positive response to Charlemagne's letter requesting permission to take 'mosaic, marbles, and other materials from floors and walls' from both Ravenna and Rome. As a result, substantial monumental remains, including marble slabs and architectural elements such as columns, were brought from Italy to Germany, where nothing similar had been seen before. This movement of materials called on several different neural networks already possessed by the people involved. One was that involved in magic and more particularly the contagious magic described earlier in the context of the movement of relics. In this case, contagious magic allowed the authority identified with Rome, and through Ravenna with Constantinople, Rome's successor capital, to be transported to a city destined for a similar role. The fact that the magic involved in this unprecedented movement of monumental remains over a long distance is closely similar to that involved in the by-then habitual movement of relics suggests that its operation was facilitated by the same neural networks. We can put it in traditional language, saying that people were used to the idea that power can be attached to, and so be transported by, objects, and we can also update that language by talking about objects having 'agency', but such descriptions are impressionistic and allusive. To think of the transfer in terms of the specific brain

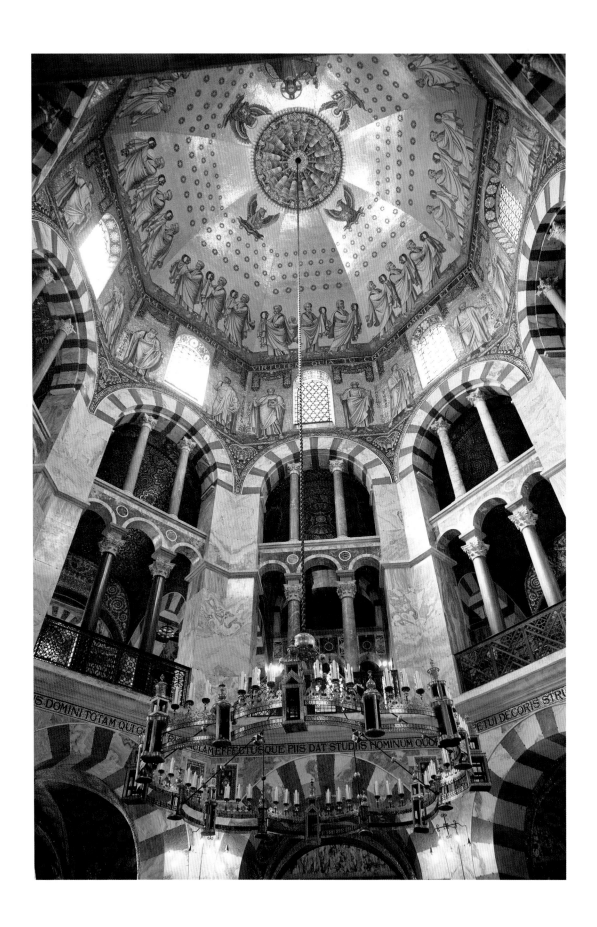

mechanisms involved brings a new clarity. For example, it helps us to understand why such behaviour happens more in some places and communities than in others, reminding us that much of our mental activity can be analysed in terms of the use of particular pathways, and that repeated use of a particular pathway facilitates and indeed encourages its use for the same, or an analogous, purpose in the future.

This applies to art historians today. If we do not indulge in a particular mental activity we will never develop the neural connections needed to support it, as we can appreciate if we consider another aspect of the patronage of Charlemagne and members of his court and reflect on why it has never been fully acknowledged. That aspect is their artistic emulation not of Classical emperors but of Old Testament leaders. This has been neglected by art historians because they, being concerned above all with material 'art' and relying heavily on their visual cortex, have tended to see the clear visual resemblance between Carolingian and Classical art as the principal key to its meaning. Because it does not look like ancient Jewish art, they do not relate it to that tradition, although it is above all to that tradition that it is related by contemporary texts.

The most authoritative opinion on this point is that of Alcuin himself. In a letter of 798 addressed to Charlemagne (referred to in the last chapter), he expresses the hope that he will soon see the king 'in the Jerusalem of the desired fatherland . . . where the artful Temple of the most wise Solomon is being erected with God's help',[10] while a slightly later writer, Notger, known as the Stammerer (*c*.840–912), from St Gall in modern Switzerland, goes further, asserting that the chapel was 'built after the model of the most wise Solomon'.[11] To resolve any uncertainty about the closeness of the Old Testament connection, Odo of Metz, the chapel's architect, was identified with Solomon's architect, King Hiram of Tyre, and Einhard, Charlemagne's biographer, was identified with Bezaleel, the famous craftsman who worked for Moses.[12] Moreover, Charles's marble throne on the upper gallery has six steps, matching the biblical description of Solomon's at II Chronicles 9: 17, while the two columns that flank it may

116 Groundplan of Palace Chapel, now Cathedral, *c*.790–805, Aachen

also be Solomonic. Each contained the relics of an apostle, Peter and Jude, and since one was the apostle to the Jews and the other to the Gentiles, the reference could be directly to Bede's interpretation of the two columns, Iachin and Boaz, as representing those two communities.

What, though, does Notger mean when he describes the whole building as 'after the model' of Solomon? An answer is suggested by features of the Chapel that were noted decades ago. The building's dimensions correspond with those of the Dome of the Rock in Jerusalem, the dedication inscription occupies a similar position, giving similar prominence to the founder's name, and the plan is also based on rotating two squares (fig. 116). Reasons for the correspondence between the chapel and an Islamic structure of a hundred years earlier are not immediately obvious, but they can be reconstructed. The Dome of the Rock (see figs 127 and 128) was built on the site occupied by the Jewish Temple from the time of Solomon until the first century AD, and was evidently intended as the Temple's rebuilding. So much is indicated by its relation to the Anastasis (see fig. 99), the structure erected over Christ's tomb a few hundred yards away, from which it takes such features as the dimension of its central rotunda and the alternating piers and niches of its exterior. The Anastasis had always been seen as a New Temple, built over Christ's burial place, that being the appropriate site for

(facing page) 115 Interior of Palace Chapel, now Cathedral, *c*.790–805, Aachen

165

the construction of a replacement for the old Temple, since Christ's challenge in relation to the Jewish Temple at John 2: 19 – 'Destroy this sanctuary and in three days I will raise it up' – was taken as an anticipation of his death and resurrection. It was because Muslims knew that the Anastasis was seen by Christians as the New Temple that they took it as their model when building a shrine where that of Solomon had once stood.[13] It was because Christians knew this that the monk Bernhard around 870, in his pilgrim's itinerary, after describing his reception in a great hospital for pilgrims constructed by Charlemagne, goes on to describe the Dome of the Rock as the 'Templum Salomonis', a designation maintained by the Crusaders after 1099.[14] Charlemagne was evidently heavily invested in Jerusalem and would have had all the contacts needed to allow him to erect a chapel in his new Jerusalem at Aachen that was built 'after the model of the most wise Solomon'. The relationship of the Aachen chapel to the Dome of the Rock was of a different kind from its relationship with S. Vitale. While it looks like S. Vitale, which is never mentioned as a model, it does not look like the Dome of the Rock/Temple of Solomon, which is mentioned and from which it adopts siginificant attributes. The reason for the disjunction is that the neural resources in the visual cortex that were involved in generating the design were shaped by two distinct experiences. The designer (probably, Odo's mason) had actually seen S. Vitale, or a drawing of it, but could only imagine Jerusalem's Temple of Solomon on the basis of verbally transmitted description.

Recognising that the Dome of the Rock was thought of as a new Temple of Solomon explains why it was appropriate for Alcuin, in his desire to project Charlemagne as the successor to the Old Testament ruler renowned for his wisdom, to take it as a model. But Alcuin wanted Charlemagne and his court to manifest a deeper real wisdom and, to enable them to do so, he seems to have turned to the teacher of his teacher, Bede. De Templo – and De Tabernaculo – would have been well known to him and, as we saw above, those texts were full of suggestions for ways in which wisdom could be embedded in a building. Most typical was the use of allegorical and especially numerological properties: in the case of the Aachen chapel, the first is exemplified by a comment of a teacher of Irish origin, Sedulius Scotus

(mid-ninth century), that the *aula* ('hall') of the just king cannot be stable unless it is supported by the eight columns of the virtues.[15] Since Charlemagne's chapel is called an *aula* in its dedicatory inscription, the reference is probably to the way his throne in the gallery was there supported on eight piers. Indeed it is an intriguing possibility that these are the 'pillars which have been set up in the wonderfully beautiful church which your wisdom has prescribed' which Alcuin, in a letter to Charlemagne, reports that he discussed with a woman, perhaps Charlemagne's queen.[16] At all events, Sedulius's thought is similar to Bede's observations in *De Templo* that the quadrangular posts of the door of the Temple could represent either the four books of the Gospels or 'the four cardinal virtues, prudence, fortitude, temperance and justice on whose firm foundation, as it were, every edifice of good actions rests (*De Templo* 16.4). It may also be intended to recall Proverbs 9: 1: 'Wisdom hath builded her house, she hath hewn out her seven pillars'.

Number symbolism is also apparent in a group of buildings sponsored by Charlemagne and erected by another member of his court, and a good friend of Alcuin, Angilbert. Angilbert himself tells us that his complex at Centula in northern France included three churches because the Trinity was the basis of the Christian faith and that the church of the Virgin, which excavations revealed to have been twelve-sided, contained twelve altars each dedicated to an apostle.[17] A twelfth-century account tells us also that the trinitarian symbolism went much further, for the three churches were laid out round a triangular court, the whole complex being served by three hundred monks and the main church having three altars covered by three canopies from which hung three crowns; there were also thirty reliquaries and three lecterns.[18] Trinitarian symbolism was also found at Corbie, not far from Centula, where there were three churches 'in which the confession of the Trinity could find unified expression'.[19] This was probably at the request of its abbot, Adalard, a cousin of Charlemagne and a friend of both Angilbert and Alcuin, who in 822 founded a daughter house at Corvey in Germany which is said to have revealed the same divine mystery in its triangular plan.[20] A similar approach also underlay the work of Benedict, a church reformer associated with the court and another correspondent of Alcuin.

117 *Ark of the Covenant*, apse mosaic, c.806, Chapel of the Saviour, Germigny-des-Prés, near Orléans

According to Benedict's biographer, the monastery that he built at Aniane in southern France also contained a reference to the Trinity in a triple structure under the main altar.[21] This last object can be connected with another key interest of Bede, Old Testament furnishings, having been modelled, we are told, on the altar installed by Moses in the Tabernacle, as were many other of the church's ornaments, which were explicitly reconstructions of those of the ancient Jews, including a seven-branched candlestick and seven lamps said to be made with 'salomonic wisdom', seven representing the seven gifts of the Holy Spirit.[22]

Even more directly linked to Bede in its Solomonic references is the chapel that Theodulf, Bishop of Orleans (another, though more independent, contact of Alcuin), erected at Germigny-des-Prés, near Orleans, around 806. This is said in texts to have been modelled on the Aachen chapel but, since it is square rather than octagonal, the reference cannot be to a correspondence in form. Probably, it applies to their common derivation from Solomon's Temple: the stucco reliefs of palms recall the palms in the Temple which are discussed at length by Bede, while the mosaic in the apse showing cherubim and the Ark of the Covenant relates even more precisely to his commentary (fig. 117). Bede tells us that there were four cherubim in the Temple, two smaller ones on the original Ark itself and two larger ones made for Solomon above them, and that is what we find at Germigny. Bede also specifies that the outer wings of the larger pair touched the walls because those walls represent the two communities of the Jews and the Gentiles (*De Templo*, 13.5), and that their inner ones meet because the two Testaments, although they were addressed to these two different communities, are in agreement. This could not be

167

expressed in the wings of the larger cherubim at Germigny because of their position in the apse, but it does match the configuration of the wings of the smaller two on the Ark, two of which meet in the centre and two of which stretch out to the sides. It thus looks as if the decorations of Germigny are directly inspired by Bede's *De Templo* and it is difficult to see who but Alcuin could have transmitted knowledge of it.

The notion that the decoration at Germigny has a programmatic background is supported by the relation between the apse mosaic and the text of the so-called *Libri Carolini*. These are writings purporting to be from the hand of Charlemagne himself but today generally thought to have been composed by Theodulf. Composed in 790–92, they represent a response to resolutions that the Eastern Church had formulated in the context of the Iconoclast controversy. The *Libri* criticised both the extreme hostility to images of the Council of Constantinople of 754 and the encouragement of the adoration of images promulgated at the Second Council of Nicaea in 787. Their purpose was to justify the limited use of art in a Christian context but to forbid its worship. One way to do this was through comments on the use of art by Moses, specifically on the Ark and the representations of cherubim. Such works, the *Libri* tell us, were made neither for 'adoration' nor as a 'memorial of things past', but as 'a most holy prefiguration of future mysteries'.[23] Since the text refers to two pairs of cherubim, as pictured in the apse mosaic, it is appropriate to see it as a justification of that work as a 'prefiguration of future mysteries' and, since it also echoes Bede, it appears to understand prefiguration in his terms.

Once we recognise that the use of art and architecture inspired by the Old Testament at Germigny was understood allegorically, and that it reflects programmatic policy emanating from Charlemagne's court, we can see all the parallel examples elsewhere listed earlier in a similar light. Charlemagne needed an artistic policy that avoided the extremes of polemic sponsored by the Eastern Emperors. By claiming, through the *Libri Carolini*, that art should be about mystical signification, and by simultaneously encouraging the patronage of a whole group of works endowed with such signification both by their susceptibility to numerological

interpretation and by their Old Testament references, he could resolve the issue in relation to Iconoclasm that he had with the Eastern Church. He could also, at the same time, resolve another issue that was recurrent in the Christian Church, that of the dangerousness of art as an expression of materialism. As long as economic and social conditions in western Europe inhibited such expression, as they had done in the sixth, seventh and earlier eighth centuries, the issue was dormant. Once Charlemagne found himself with a need to build and with the resources to do so, he realised that he required a robust defence of his expenditure. For this we can infer that Alcuin recommended that he turn to Bede, and he did. What was new about the buildings and decorations at Aachen, Aniane, Centula, Corbie, Corvey and Germigny-des-Prés was not so much their undoubted material magnificence but the mystic significance with which that was justified.

Rabanus Maurus and Mystic Signification

The theory underlying these separate innovations was soon made explicit in a major book by Rabanus Maurus (*c.*780–856). Rabanus, who had been a favourite student of Alcuin at Tours around 800 and received from him his nickname, Maurus, the Dark, spent much of his life at the monastery of Fulda in Hesse. This had been founded in 744 as the spearhead of the Anglo-Saxon Boniface's mission to the Saxons and, following his murder by the Frisians in 754, it became his burial place. Boniface was increasingly seen as the 'apostle to the Germans' and, under Charlemagne, in acknowledgement of the similarity between his role and that of St Peter, the abbey church at Fulda was rebuilt in imitation of the latter's church in Rome. Rabanus advised Fulda's abbot Eigil on the design of a chapel of St Michael (820–22) and when he became Eigil's successor he equipped the church with furnishings similar to those noted earlier, a shrine like the Ark of Moses decorated with cherubim and a bronze candelabrum. He also wrote much, but his greatest work was a massive new encyclopaedia, *De Universo*, composed in the 840s when he was archbishop of Mainz and dedicated to Charlemagne's grandson, Louis the German.

The book builds on the *Natural History* of Pliny the Elder, a materialist encyclopaedia of the works of nature and of humanity, and the *Etymologies* of Isidore, Bishop of Seville, by adding a further dimension. As Rabanus puts it in the dedication to Louis, to the 'remarks on the nature of things [Pliny], and on the properties of words [Isidore] I have added others on the mystical signification of things'.[24] His main concern is to supplement historical explanations with mystical ones, histories with allegories.[25] He would have acquired his knowledge of layers of signification from Alcuin and through him from Bede, but he applies them much more widely. The best example of his approach is the way he takes Bede's comments on the two columns in front of Solomon's Temple, Iachin and Boaz, and applies them to columns in general. Rabanus begins his treatment of columns by repeating what his predecessors had said, Pliny about physical columns (Doric and so on) and Isidore about their etymologies (*columna*, for example, being related to *collum*, Latin for 'neck'), before going on:

> The bases, however, can be mystically understood as the books of the divine Testaments on which rests all the doctrine of the holy preachers. For the columns are the apostles and the teachers of the Gospel. These persons are prefigured in the two columns which we read that Hiram put up when building the Temple of the Lord. . . . These are the columns about which Paul says: James, Cephas, and John, who seemed to be columns, gave Barnabas and me the hand of friendship so that we could go among the Gentiles and they among the Jews [Galatians 2:9]. By these words he seems to expound the mystery of the material columns, both what they apparently represented and why there were two. For they stand for the apostles and all the spiritual doctors, raised up toward the heavens and strong in faith and works and meditation. And they are two because by their preaching they introduce both Gentiles and Circumcised into the Church; for the columns stood in the portico before the doors of the Temple. . . . For the door of the Temple is the Lord: because no one comes to the Father except through him [John 14] . . . The tops of the columns are the minds of the teachers of the faithful, by whose thoughts dedicated to God all their works and

words are guided, just as the limbs are guided by the head. But the two capitals which are placed on the tops of these columns are the two Testaments, by the meditation on the observance of which the holy doctors are ruled, both in their whole mind and in their body.[26]

Rabanus thus goes significantly beyond his masters. While Bede had only interpreted the buildings described in the Bible allegorically because Paul and others had made clear that the sacred texts should be meditated on in that way, Rabanus takes his interpretations and applies them to real buildings. From now on every base in a church can be one of the Testaments, every column in a church an apostle or church father, every door to a church Christ. Anyone who picks up his ideas is encouraged to take the few architectural metaphors familiar from the biblical texts, connect them together and, using the neural networks that doing so brings into being, look at all real buildings in similar terms. In this way Bede's purely internal and mental meditation on the biblical text becomes applied to a new engagement with the external world. Neural networks developed by the use of the imagination now become connected to the visual networks on which the individual relies in everyday life.

Indeed, they acquire further connections to the networks involved in self-awareness and empathy. The reason why 'bases' are 'Testaments' is not just because they are visually below columns representing apostles, but because being under them they contribute to their stability and strength, as feet do in a person. In order for the viewer to appreciate the 'mystical signification' of architectural elements, he or she is encouraged to empathise with their physical properties and relationships. This point is brought out by the way in which Rabanus expands Bede's commentary on the tops of the columns: 'The tops of the columns . . . are the minds of the teachers, by whose thoughts dedicated to God all their works and words are guided, just as the limbs are guided by the head'.[27] The reader will not fully understand why the tops of the columns are the minds of teachers unless he or she is aware of how his or her own body is ruled by the head.

In this case we can be fairly clear about some of the sets of neural resources that Rabanus calls on. Fundamental are those that underlie the reader's proprioception, that is his or

her sense of his or her own body, which is acquired as the individual slowly accumulates experience during his or her life. Another set are those underlying the awareness of the way a building's structure functions, acquired as a result of handling, and observing the handling of, bricks, stones and timbers. Still other resources are those supporting movement through space and the negotiation of entrances, slowly built up as the individual learns first to walk and then to navigate through ever more complex spatial sequences. By the successive activation of these and other neural resources in his readers, Rabanus teaches them to experience fully the metaphorical references of buildings. While an Early Christian writer like Origen or Eusebius may use a metaphorical interpretation as a didactic literary device in the context of a particular biblical text or building, Rabanus wants his reader to be able to experience all architecture in terms of mystic signification.

By changing the way people experienced buildings, Rabanus changed the way they were designed. In this he was not starting but consolidating a trend. Since the institutionalisation of Christianity under Constantine, many buildings had been designed to express some property of the faith, and people had become used to seeing them as such, but there had been no consistent theoretical basis for this approach to buildings. Rabanus was also not just consolidating a trend in thought, he was also consolidating neural resources. By encouraging people to experience their environment in terms of *mystica significatio* he was inviting them to look at every building in terms not of its material and its surface appearance, but of what its structure and organisation might suggest about religion. Seeing a built church as a figure of 'The Church' meant consolidating the connections between neural assemblages that had previously been linked only intermittently and therefore weakly. Where people would have previously tended to see churches as just serving basic functional requirements, as many early churches did, or as celebrating victory over paganism, as many of the more elaborate columnar basilicas did, or as representing the Heavenly Jerusalem, as a few of the most important churches did, now they were encouraged to see them all as having properties that metaphorically expressed properties of the Church as an institution.

118 Text with Lamb of God and Symbols of the Evangelists, from Rabanus Maurus, *In honorem sanctae Crucis [De laudibus sanctae Crucis]*, written in Mainz 822–47, parchment, 36.5 × 28 cm. Bibliothèque Nationale de France, Paris, Département des Manuscrits, Latin 2422

Rabanus's personal encouragement of a new richness of response to the visual experience of Christian art is evidenced in two other works, one literary and one architectural, for which he was directly responsible. One is *De Laudibus Sanctae Crucis*, a book dedicated to Charlemagne's son, Louis the Pious, before 814 (fig. 118). This work, which develops the picture poems of Publilius Optatianus Porfirius from the fourth century, consists of an extraordinary series of visual meditations on the Cross accompanied by elaborate commentaries.[28] The meditations are made up of grids of letters out of which emerge shapes both geometrical and pictorial in which the letters form further patterns of meaning. Allegories are everywhere, as when the shield in the hand of the emperor becomes the protecting shield of Faith. So too is number symbolism, as when the eight Beatitudes are represented by octagons. The link to the Insular tradition is manifest in the similarity between the whole series and the carpet pages of the Lindisfarne Gospels of a

hundred years earlier. Both are elaborations on the Cross, but in Rabanus's work the labyrinths of colours and shapes of Lindisfarne are replaced by organised configurations of letters and other meaningful forms. References beyond the page that were implicit in the work of Eadfrith are explicit in that of Rabanus.

Also explicit are the demands on the reader-viewer's brain. Each feature of the drawings – the geometry, the lettering, the pictures – requires the activation of another neural grouping. In the normal life of most individuals around the globe at most periods, each of those features would be encountered in a distinct context and the neural resources required for a response to them would not be linked. Rabanus assumes that his reader-viewer is prepared to respond to all three at the same time. This is a lot to ask today, when people can find looking at *De Laudibus* dizzying. In his time Rabanus could anticipate a different response because his readers inhabited a world in which it was becoming habitual to see something like a church not just as an assemblage of masonry, requiring the same set of neural resources to experience as a house, but as a numerical and geometrical configuration, in which an octagonal plan could be seen as representing the Beatitudes, individual stones as the Church's members and columns as the Apostles. The manuscript's readers-viewers, in whose brains the neural resources needed to respond to each of these aspects of the building had already become linked as a result of such a habituation, would have found it much easier than we do to respond to the drawings' separate layers.

A similar richness of assumed response is implicit in the chapel of St Michael erected at Fulda (figs 119 and 120). Although put up under Abbot Eigil, the latter's biographer, Candidus, tells us that Rabanus was responsible for the *tituli* or inscriptions commenting on its different altars, and it is likely that he developed the conception of the whole building. This is explained by Candidus and is unlike that of any earlier building in the richness of its meaning and in the way that it is integrated in its structure. Although the upper part of the church was later rebuilt, it retains the ninth-century layout and the crypt is unchanged; so we can still experience the single column supporting the vault of the crypt and the eight columns above rising to a dome with a central

119 Interior of St Michael, Fulda, 820–22 and later

120 Crypt of St Michael, Fulda, 820–22 and later

keystone. This allows us to understand how, as Candidus tells us, the whole 'prefigures Christ and the Church, that is a Church built of living stones, that is constructed of holy men'; how the column in the crypt represents Christ, who is 'the foundation, a column remaining unshattered by virtue of his perpetual majesty; on whom the whole building grows into a temple sacred to the Lord'; how the stone at the top represents God who is the beginning and ending of all our actions; how the eight columns represent the eight Beatitudes 'because those who follow these recommendations of Christ are deservedly thought to be supports of the Church'; and how 'The circle of the church, being endless, can appropriately be seen to signify a compendium of inner life, that is the divine sacraments, a kingdom of perpetual majesty, and the hope of eternal life, as well as the abiding rewards with which the just are deservedly crowned for eternity'.[29] This is no interpretation after the fact, such as Bede offered for the Tabernacle and the Temple. Instead, the whole design, the chronology of its construction from basement Christ column to divine keystone, and the structural relationships of Christ column to upper church, Beatitude columns to walling, whole edifice to keystone, is calculated to bring out the value of the architectural metaphors exploited in their teachings by Christ and St Paul. Unless worshippers empathise with the structural principles inherent in the church's construction, they will not fully understand their roles as living stones in a Church founded on Christ, and the importance for the fulfilment of that role of their following the Beatitudes. Nor will they understand either God's role as beginning and ending of everything or the reality of eternity.

Irminsul and Cross:
The Pagan Roots of Rabanus's Mystic Signification

It is tempting to see Rabanus's approach to the interpretation of architecture as expressed in both the rotunda of St Michael and *De Universo* as simply a natural development of a tradition within the Christian Church that had led from St Paul to Bede, but this is to underestimate the importance of another powerful influence, local pagan thought. This is

clear in the most remarkable feature of St Michael, the single Christ column at the centre of the crypt (see fig. 120). There is no precedent for such a column in Christianity, but it can be directly related to the tree columns that had long been worshipped by Germans and especially Saxons.[30] The most famous of these was the Irminsul that stood on the hill of the Eresburg about 150 kilometres (some 93 miles) north-east of Fulda until it was demolished by Charlemagne in 772 as part of his campaign of Christianisation, and there is an implicit allusion to that event in Candidus's contrasting characterisation of the Christ column in the crypt as *inconcussa*, 'unshattered'.[31] A slightly later description of the Irminsul as 'a universal column, supporting everything'[32] also shows that in Saxon cosmology it anticipated the Christ column in the crypt of the chapel of St Michael out of which we are told 'the whole building grows into a temple'. An even closer relationship is implied by Rabanus's claim, in the prologue to *De Laudibus Sanctae Crucis*, that the Cross is 'a heavenly column [*columna coelestis*] on which is built Christ's home'.[33] To see the Cross as a column supporting the heavens is new in Christian literature, crediting it with a function similar to that traditional in the Irminsul. The analogy between Cross and pagan sacred tree had already been made by the Anglo-Saxons and formed part of their general attempt to adapt pagan practices to a Christian purpose, something they continued after they arrived in what is now Germany, as we learn from the story of St Boniface destroying Donar's (or Thor's) Oak near modern Fritzlar, half way between Fulda and the Eresburg. This act had miraculous consequences. When the tree fell, it broke into four pieces of wood, which, probably because they were seen to represent the four Evangelists, were then used by Boniface to build a church, so materialising the allegory by which the Evangelists were essential to the formation of the Church as an institution. If the Oak was also seen as an anticipation of the tree on which Christ died, it would explain why the first action of Sturm, the German monk sent by Boniface to set up the Abbey of Fulda in 744, was to raise a great Cross. Sturm's ability subtly to negotiate the Irminsul–Cross relationship may then be the reason why a few decades later, in the aftermath of the Irminsul's destruction, he was also asked by Charlemagne to take charge of the Eresburg where it had stood. Rabanus in

his prologue to *De Laudibus* specifically mentions his difficulties with local pagans; so it was a clever idea, when communicating with people who had only recently abandoned the earlier religion, to suggest that the Cross had a similar structural role to their Irminsul, supporting now not the material universe but Christ's heavenly abode, the Paradise where Christians hoped to join him.

Just how important it was for people to see the Fulda Christ-column as descended from the Irminsul is clear from the character of its capital. This is not tall and Corinthian-like, as capitals of important columns always were, but low and Ionic-like. The reason for this strange choice is provided by a series of contemporary and later monuments that all use a similar form. Their most striking example from the general area of Saxony is in the relief of the Deposition carved in the early twelfth century on one of the natural rock pillars known as the Externsteine (fig. 121). This shows Christ being taken down from a gigantic cross, with, on the right, a relief of a bent-over tree whose short arms rise from and terminate in forms much like the Fulda capital, being Ionic-like volutes.[34] Such volutes had their origin in the branching tree or axial pillar as shown on the front of a Roman image of the god Sucellus in the Geneva Museum.[35] The spiral form found at Fulda and on the Externsteine was probably inspired by the way buds, most vividly those of forest ferns, can be seen to unfurl as if by magic. Whether rolled up or uncurled they were evidently a defining feature of the Irminsul, which meant that people whose visual neural resources were habituated to getting a neurochemical reward from exposure to such volute forms on the column that supported their universe would have derived a similar reward when exposed to the same form on a Christ column, with direct benefit to the faith of viewers. The Externsteine relief may even take the Christ–Irminsul analogy a step further. A bent-over Irminsul may only indicate that it has been conquered, but the parallel between its configuration and that of Christ's body is perhaps more suggestive of empathy. The Irminsul may thus share Christ's pain, rather as the tree in *The Dream of the Rood* shares Christ's wounds. Whether in seventh-century England or twelfth-century Germany, it was felt that assimilating Christ to a pre-Christian sacred object in which the relevant local

121 *Descent from the Cross*, detail showing Irminsul, relief carving, 12th century, Externsteine, North Rhine-Westphalia

population had already invested much faith could only increase their trust in him. This is why the Irminsul and Cross could safely be shown together, as when elsewhere in Saxony, at Elstertrebniz, the two emblems were carved either side of a twelfth-century tympanum.[36]

A recognition that Ionic-like volutes were associated with the Irminsul also sheds light on another sacred structure in the Saxon territory, the crypt of St Wigbert at Quedlinburg (*c.*930; fig. 122). Here, unusually, a single square pier stands at the centre of the apse flanked by four round columns, two either side. Since the central pier has a higher base and rises above the flanking columns, it is clearly the most important support, and its Ionic-like volutes, resembling those of the single column at Fulda, identify it too as an Irminsul–Christ column. This allows us to interpret the round columns either side, in the spirit of Rabanus's *De Universo*, as 'figuring' the four Evangelists. Given that traditionally columns were nobler than piers, it may seem surprising that the Irminsul–Christ support is square, but the choice of form

122 Crypt of St Wigbert, Quedlinburg, *c*.930

is probably explained by the desire to represent Christ by a *lapis angularis*, an 'angular' or 'corner' stone, following Isaiah 28: 16 and Ephesians 2: 20. Placed in the centre of the apse, this column, which combines the volutes of the Irminsul with the 'angularity' of Christ, can be seen as appropriately uniting the building's two side walls, which would now represent not so much ancient Jews and Gentiles, following St Paul in this Ephesians passage, as modern Christians and pagans, following Bede and Rabanus. This interpretation of the choice of supports at Quedlinburg is sustained by their similarity to those of the entrance to the lost chapter house at St Pantaleon, Cologne, also *c*.930. There too a pair of columns is placed either side of a single square pier, making it susceptible to a similar interpretation, while the fact that the pier is placed in the middle of a doorway suggests that it combines references to the two most important New Testament architectural figurings of Christ, both 'corner stone' and 'door'.

Further evidence for the assimilation of Christ columns and Irminsuls in this area of northern Germany comes from Hildesheim, where there is a direct link to St Pantaleon in Cologne, since it was a monk from that house who, in 996, was appointed the first abbot of the great new monastery of St Michael, founded by the ambitious Bishop Bernward, a member of the Ottonian Imperial family. Bernward was a bishop in the mould of the Fulda abbots, intensely conscious of the value of the arts, especially of architecture and metalwork, and St Michael's was a focus of his attention. There he erected an enormous bronze column, always known as a Christussaüle (Christ column), behind the altar,[37] while in front of it stood another column known as an Irminsaüle.[38] Since another Irminsaüle was later installed in the town's cathedral, and even purported to be the Irminsul itself, having been brought there by Louis the Pious, the continuity of function from pagan column to Christian is certain. The Irminsul evidently had such a central role in the

world-view of local Saxons, and the neural resources that sustained that view were so established, that it was helpful to the transmission of the message of the new religion to present Christ as its successor.

The free-standing Christ and Irminsul columns are elements in a much larger scheme of architectural allegory at St Michael's. Intended by Bernward to house his tomb, the church was equipped with twelve columnar supports representing the Apostles, in imitation of the Anastasis/Church of the Holy Sepulchre in Jerusalem. However, since two of their original capitals are inscribed with the names of saints, they probably represent these too, following Rabanus's claim that columns represent 'the apostles and doctors of the Church'. The interior scheme, with one Christussaüle behind the altar and six apostles supporting each of its two side walls, is also prefigured on the exterior of the south wall of the nave, which as an exceptional case constituted the church's main facade towards the town (fig. 123). This has an unusual organisation, with at its centre a single shallow pilaster made of sandstone blocks on a high base, which must represent Christ, flanked either side by six shallower pilasters without bases representing the Apostles. The position of Christ at the centre of the wall and his representation through an angular form mean that here again, as at Quedlinburg, he can be seen as a *lapis angularis* in whom the two walls either side come together. Bernward evidently followed Rabanus's *De Universo* in believing that Paul's architectural metaphor at Ephesians 2: 14 in relation to Jews and Gentiles, that Christ 'is the peace between us, and has made the two into one', could be given material expression in a real building.

All these interventions demonstrate how architectural thought responded to local circumstances. Paul had been inspired by intercommunitarian tensions in the church at Ephesus to introduce the notion of the unifying role of Christ, one that would help the new religion to resolve divisions throughout the Roman Empire. Bede, recognising that the English Church was made up of converted pagans, had taken it up. There was a similar situation in Germany east of the Rhine. Alcuin, and even more his pupil, Rabanus, knew that the Saxons would be more likely to accept Christianity if its presentation could be accommodated to their particular neural resources. That was why Rabanus introduced the

123 Entrance facade, St Michael, 1001–33, Hildesheim

Christ column in the basement of St Michael's at Fulda, and why others introduced them first at Cologne and Quedlinburg and then at Hildesheim. By placing an Irminsaüle and a Christussaüle one behind the other, Bernward made clear that he was as interested in converted pagans, that is Gentiles, as he was in those who had long been Christians, the equivalent of the Jews. Bernward, like Rabanus, following Bede, Boniface and Alcuin, understood that mystic signification could be a powerful weapon for winning over reluctant local heathens and he showed how that could be done in buildings. That understanding had local roots. Following Boniface, the Apostolus Germaniae, Rabanus, later known as the Praeceptor Germaniae, had shown in his *De Universo*, dedicated to Louis the German, how his religion could best be served by employing an architecture that acknowledged his particular community's neurally embedded needs. Bernward, a leading member of that community, understood that too. The major expansion of mystic signification in architecture in the Carolingian and Ottonian periods, which had a profound influence on the formation of a new Christian style of architecture in the twelfth century, was rooted in paganism.

These examples of artistic patronage materialise architectural metaphors in reassuring ways because they activate neural networks laid down by lived experience, but they also have a 'magic' dimension in that they could be experienced as actually contributing to changing the situation.

An obvious example is the chopping down of the Irminsul under Charlemagne. On the one hand, the sympathetic magic involved in that act depends on worshippers of the Irminsul feeling pain, that is having their insulas activated, at the sight of damage being inflicted on something dear to them. On the other, the erecting of the stone Christ column in Fulda has the opposite effect. The fact that it cannot be cut down and is in fact *inconcussa* (unshattered), as Candidus describes it, guarantees the permanence of what it represents. Magic's currency at this period is well illustrated by the way, according to Eigil, that King Pepin, Charlemagne's father, demonstrated that he had abandoned his once negative view of Fulda's first abbot, Sturm. In the *Life* of his predecessor, Eigil tells how Pepin took 'a thread from his cloak' and 'let it fall to the ground' saying 'Lo, as witness of perfect forgiveness, I cast this thread from my cloak on the ground that all may see that my former enmity against you is annulled'.[39] Viewers would have understood that the thread represented the king's hostility to Sturm and, seeing it dropped on the ground, would have felt that he had abandoned that negative emotion. A positive example of contagious magic from the same source is the story of how Sturm when travelling by himself marked a cross on his forehead each night to protect himself from predatory animals. The contemporary installation of relics in churches can be understood in the same light. Rabanus's programme of acquiring relics of saints from Rome for Fulda through an intermediary, Deusdona, as described by Rudolf of Fulda in his *Miracula sanctorum in ecclesias Fuldenses translatorum*, was exemplary, as was his use of eloquent inscriptions on the altars and shrines in which they were contained. This energetic collection of Roman relics brought to Fulda not only the power of the saints but also the authority of the eternal city.[40] That the witness of a saint could validate an utterance was demonstrated by legislation requiring that all oaths be sworn either in church or on relics.[41] The general expansion of the use of relics in the Carolingian period and the following centuries thus constitutes a powerful illustration of the magic of contagion. It would also have contributed to the strengthening of the neural networks on which such magic relies, steadily increasing the need for access to such holy objects, and so influencing the development of architecture. It was the rapid increase in the need for access to relics that inspired the expansion of ambulatories at the east ends of abbeys and cathedrals, which was one of the most important architectural developments of the eleventh, twelfth and thirteenth centuries.

The Abbey of St Denis

New Neural Resources, New Problems and New Solutions

An abbey that was to have much greater influence on the history of architecture than any erected in Germany between 800 and 1100 was that of St Denis outside Paris as rebuilt under Abbot Suger (1081–1151; see figs 124–6, 132 and 133). Being the burial place of the early Christian martyr St Denis, one of France's patron saints, and, later, of most French kings, the church had long attracted interest, having been rebuilt on a grand scale by Charlemagne. Suger, though, had compelling reasons to rebuild it again. As the principal adviser first to Louis VI (ruled 1108–37) and then to Louis VII (ruled 1137–80), becoming the latter's regent during the king's absence on a Crusade, Suger saw both a need to enhance his abbey's position and an opportunity to do so.[1]

St Denis and Abbot Suger

In a period when many grand new abbey churches were being constructed, which made his own look increasingly small and outdated, rebuilding was a strategic option, but it was not obvious what form the new edifice should take. Before he became a counsellor to kings, Suger had travelled widely in Western Europe, had had contacts with many leading ecclesiastical figures and seen many churches both ancient and new. Many factors weighed with him as he sought to develop his institution in ways that would serve both the Church and the French monarchy. Like his Byzantine, Lombard, Anglo-Saxon, Carolingian and Ottonian predecessors, he wanted a building that would offer a reassuring anticipation of the Heavenly Jerusalem and be an expression of divine approval for the French monarchy, comparable to that accorded to the kings of Israel. There was also, in the light of the contem-

porary Investiture controversy opposing Pope and Emperor, urgency to confirm the authority of the Church as an institution. Besides, Suger wanted his building to mark the new status and military strength of the French monarchy by materially surpassing the buildings of its rivals, not only those of the German emperors and the dukes of Normandy, but of the recently established kings of Sicily and of Jerusalem, which had been reconquered from the Muslims in 1099. And at the same time he needed to protect its splendour from charges of material display, such as those then being levelled at other Benedictine monasteries by Bernard of Clairvaux (1090–1153), the founder of the new austere Cistercian order. What Suger, far more than Charlemagne, needed for his splendid new material building was a cloak of spirituality.

Suger's Brain

In preparing to fulfil these needs he could draw on exceptional neural resources. Besides those he shared with his post-Carolingian predecessors, both those that enabled them to conceive of an architecture inspired by Old and New Testament textual descriptions and those that enabled them to render such an architecture easily susceptible to mystic interpretation, he had built up new and more personal neural resources shaped by his own visual and imaginative experiences. Suger had seen religious buildings such as St Etienne, Caen, the Cathedral of Mainz, the Abbey of Cluny and St Peter's, Rome, and on the basis of hearsay accounts he could imagine more distant churches such as the abbey of Monreale in Sicily, Haghia Sophia in Constantinople and the Holy Sepulchre in Jerusalem, then being rebuilt by the Crusaders. He had also seen impressive secular structures, both castles and the new stone fortifications of cities. The resources shaped by such visual and imaginative experiences were to be invaluable as he set about conceiving his new buildings, just as other resources, shaped by his education and later involvement in the life of the Church would prove vital as he set about defending them from verbal attack, using inscriptions and manuscript commentary. Other individuals may have shared such resources to some degree, but none would have developed the connections needed to integrate

them that he would have acquired from the variety of the discussions and negotiations in which he had been engaged.

It would never have been possible to locate those resources by brain scans, but we can infer that they would have included both the resources in the parhippocampal place area (PPA) built up by looking at real structures and by imagining buildings described in sacred texts, and those involved in mirroring, especially in empathising with the potential viewer, whether admiring or critical. As Suger attempted their integration he would certainly have made intensive use of the frontal cortex, both the prefrontal area where plans are formed and the medial orbital frontal area where pleasure, especially visual pleasure, is evaluated.

The context in which the integration of those resources in Suger's brain is best expressed is the church of St Denis itself, but it is in the three texts that he wrote about the building, the *Ordinatio* (c.1140), the *Libellus Alter de Consecratione Ecclesiae Sancti Dionysii* (after 1144) and the *Liber de Rebus in Administratione sua Gestis* (c.1150), that their layering is most explicitly presented.[2] Indeed, his decision to compose the three separate texts in itself reveals his awareness of 'layering', not just in his artistic patronage but in the genres of commentary and in the expectation of audiences. Although there is much overlap in their contents, the differences between them show how each relates to a different literary model and was addressed to a different constituency. No individual had approached the presentation of a single building, still less one they had themselves commissioned and whose construction they had supervised, through such a varied set of frames, each of which was to some extent supported by a different layer of neural resources.

One layer relates to the history of architecture and art. Thus, in the discussion of the church's new facade, Suger reveals an appreciation of its earlier history, referring to the buildings of Dagobert and Charlemagne, and he shows an understanding of stylistic sequence in his reference to the commissioning of a mosaic 'contrary to modern custom' over an old bronze door on the left of the facade[3] and in his clear identification of his own work as *opus modernum*,[4] while he later makes clear that the church's great altar frontal had been given by Charles the Bald[5] and two candlesticks that he himself placed on the altar were the gift of his own king

Louis VI.[6] Another layer relates to the history of religion, as when he refers to the blood on David's hands and the wealth of Solomon.[7] Another relates to number symbolism. Thus in his account of the triple entrance of his new facade and its dedication by three members of the Church hierarchy, as in his reference to completion of his choir in three years and three months, he would have been understood, like his Carolingian predecessors, to celebrate the Trinity.[8] Another layer relates to precious stones. There are several lists of them and their presentation shows how the neural layer with which they were processed was linked to others. The stones on the new altar are related to biblical typology[9] because they match the list of the stones on Aaron's breastplate in Ezekiel 28: 13, which is in turn taken from Exodus 28:17–21, while the reference to their properties draws attention to their functions in the domain of magic.[10] Nor are these layers always separated. In several passages Suger brings out the importance of the links between them, as when he notes how one can move from one level of interpretation to another. One of these links enables the viewer to rise from the visual enjoyment of jewels to a meditation on the virtues they represent, 'transferring that which is material to that which is immaterial'.[11] He calls this approach 'anagogical', that is, 'leading upward', because it facilitates movement from a position intermediate between the shit of the earth and the purity of heaven: 'The dull mind rises to truth through that which is material/And, in seeing this light, is resurrected from its former submersion'.[12] Another link that he refers to shortly afterwards is that of 'appropriateness', the idea that a particular behaviour is fitting in a particular context. This notion he invokes most tellingly when defending himself against critics who say that for the service of God you need no ornaments, only inner qualities such as a saintly mind and a pure heart. He disagrees, insisting that ornaments are appropriate to the high significance of the Holy Sacrifice.[13]

Suger's Brain and Suger's Building

Both the differentiation of the neural layers in Suger's brain and the extent of the links between them emerge most clearly in the building itself, where the integration of plan, elevation,

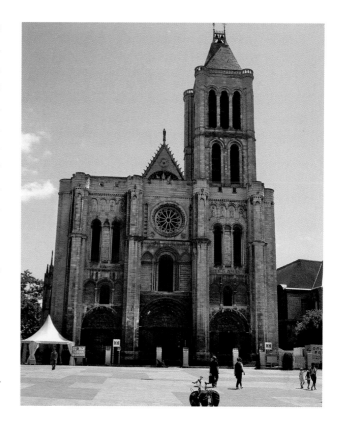

124 West facade of the Abbey Church of St Denis, c.1135–40

spatial organisation, lighting, metalwork, glass and stone sculpture depend on the integration of the parts of his brain with which he conceived them. In formulating his conception he may have been helped by others, among them his great contemporary, Hugh of St Victor, who probably enhanced his knowledge of the writings of Augustine and of Dionysius the Pseudo-Areopagite, but Suger could only exploit that enhancement because it could be fed into pathways he already possessed. The integration of these layers, links and pathways in Suger's brain is the secret of his building's success.

In no area would this integration have been more apparent than in the architecture itself, whose many innovative features would have been liable to elicit a strong response from any viewer, whether king or peasant, monk or pilgrim. Suger himself claims that the crenellations of the facade were there for beauty and defence, but it is likely that they would also have suggested arrival before the walls of the Heavenly Jerusalem (fig. 124).[14] The three portals would have suggested the Trinity, while the Lamb at the apex of the

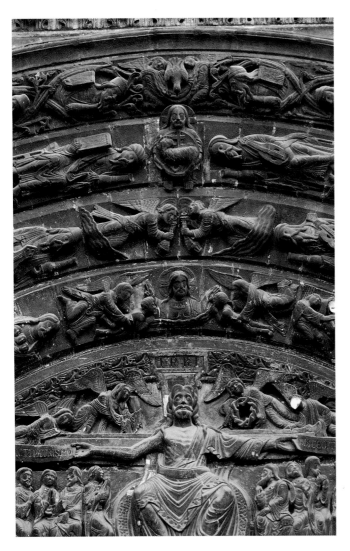

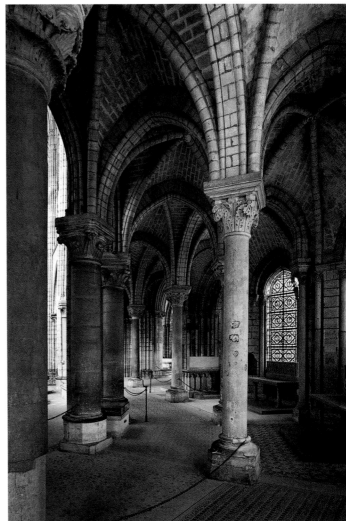

125 Central portal, west facade of the Abbey Church of St Denis, c.1135–40

126 Ambulatory of the choir, Abbey Church of St Denis, c.1140–44

central doorway would have suggested how the two sides of the church, understood to represent Jews and Gentiles, Laity and Clergy, came together in Christ (fig. 125). That the whole building was intended to be interpreted in this way is explicitly stated in Suger's own description of the two rows of columns around the ambulatory (fig. 126):

> The inner ones expressing the number of the twelve apostle, and the same number in the outer aisle, signifying the prophets, all rose up to support the lofty structure, which is as the apostle says, spiritually edifying: 'Already', he says, 'you are not guests or stranger; but you are fellow citizens of the saints and servants of God, built upon the foundations of the apostles and the prophets with Jesus Christ as your crowning corner stone, he who joins both walls and in whom the whole edifice, whether spiritual or material, grows to become a temple dedicated to the Lord.'[15]

Suger is principally addressing the meaning of the columns, but he is also talking of the building's walls, and, although the original choir vaulting was replaced in the thirteenth century, there can be little doubt that the ribs of the original apse vault would, as in many later churches, have converged on a keystone, perhaps carved with a symbol of Christ.

Protecting Christian Buildings

The Pointed Arch

It has often been wondered why Suger never comments on the feature of the building that was perhaps most original and influential, the use of the pointed arch. The form had already been employed in Burgundy, and especially in the third great rebuilding of the Abbey of Cluny (Cluny III) after 1088 (see fig. 130), but it was probably its use at St Denis after 1140 that provided the model for its employment in a whole series of great buildings, first in northern France and then throughout Europe, where almost everywhere it replaced the round arch that had been ubiquitous since Roman times. Explanations for its introduction have ranged from Raphael's suggestion that it was inspired by German forests to nineteenth-century arguments that it was either a better structural solution or more spiritually elevating, and such factors may have contributed to its appeal. None, though, explains the rapidity of the form's adoption or the weight of its authority.[16] The only explanation that does so, if indirectly, is that suggested by Sir Christopher Wren's claim that the form was of Saracen origin. This is because it reminds us that the sudden rise to dominance of the pointed arch in Islamic architecture in the eighth century constitutes a sriking precedent for its equally sudden triumph in Christian Gothic four hundred years later. It is also telling that in both contexts its introduction can be traced to a single structure.

The building from which the pointed arch was disseminated through Islamic architecture, in the same way that it was later disseminated through Christian from St Denis, was probably Islam's very first monumental stone structure, the Dome of the Rock, erected in Jerusalem on the rectangular platform known as the Haram Al Sharif in 688–92 by the Umayyad Caliph Abd al-Malik. As we have seen, whatever its other associations, this structure was primarily intended to be the successor to the Jewish Temple, being designed to imitate and surpass the Anastasis, the New Temple built over Christ's body, a few hundred yards away (see fig. 99). In its plan and formal vocabulary it clearly recalled its model, but in other ways it was decisively differentiated, most strikingly in its geometrical properties. One difference was the three-degree rotation out of perfect symmetry of the two squares

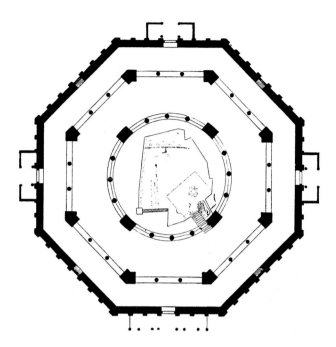

127 Groundplan of the Dome of the Rock, completed 691, Jerusalem (Georg Dehio and Gustav von Bezold, *Kirchliche Baukunst des Abendlandes*, 1887–1901, pl. 10)

underlying the Dome's octagonal layout (fig. 127). Given that a scheme of interlocking squares had been essential to the perfection of the plans of many Roman and Early Christian octagonal structures, its decisive rupture in their first Islamic successor is potentially extremely significant. More visible is the decisive rupture with tradition in the building's interior elevation. There the round-arch form used in all those prestigious earlier structures is still employed in the Dome's outer arcade, but is replaced in the inner arcade by ones that are pointed (fig. 128). That the change is significant is clear from the subsequent history of the pointed arch. It was probably used again in a building of comparable importance, the neighbouring Al Aqsa Mosque completed in 705 (at that stage only the second mosque after Mecca), and again in one almost as important and early, the Great Mosque at Damascus (706–15), but the pointed arch's significance for the new religion comes out most strongly in the way it was taken up in thousands more Islamic buildings over the following centuries. There is curiously little discussion in the scholarly literature on the introduction of the pointed arch in the Dome of the Rock and its subsequent dissemination. Most

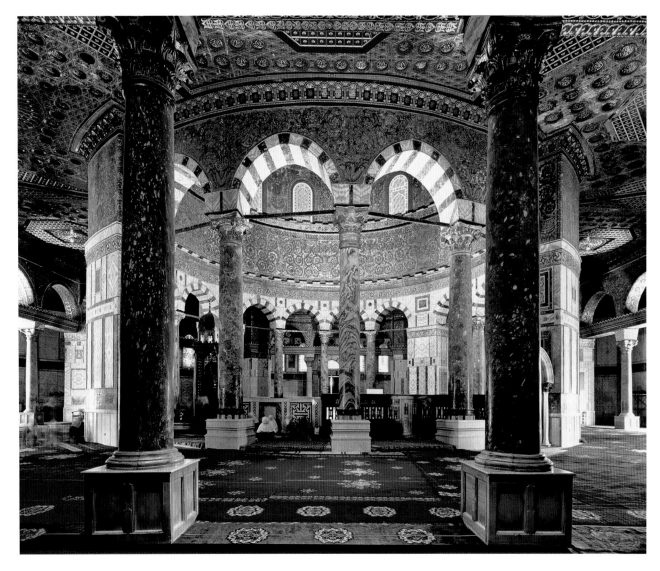

128 Interior arcades of the Dome of the Rock, completed 691, Jerusalem

often it is just presented as an existing local form that comes to a new prominence. Even those who think that it must be emblematic of Islam never explain why it was chosen above other arch forms that were available, such as the catenary or horseshoe. There is even less discussion of the asymmetry of the interlocking squares. Neuroarthistory cannot demonstrate why these features were introduced in the building, but it can provide a framework for a potential explanation.

One way of describing the common element between the striking modifications of the geometry of both plan and inner elevation is to say that they involve breaking with an existing practice, by the twisting of a square in one case and the fracturing of a round arch in the other. Now, twisting and breaking are both features of many magic rituals designed to disempower an individual or institution, as when a doll representing an 'enemy' is broken or has its head twisted off, and such 'sympathetic' magic works because, as noted earlier, once our brain associates an object with a particular individual or institution, whatever is done to it is experienced as being done to that individual or institution.[17] We also saw how there may have been an element of magic not only in the invention of the Composite or Roman order, which

forced together Greek orders that were previously distinct, and in the transfer of that order as an emblem of victory from Rome to Christ, but also in the jumbling of capitals and columns in the naves of Christian churches, which shattered the formal perfection essential in a pagan temple. This last type of magic enabled Christians to meet two needs, both to exploit the authority of the pagan forms and to 'break' their power. The needs of Muslims were similar. They wanted to get the benefits of associating themselves with the forms linked with both the dominant preceding political 'authority', the Byzantine Empire, and the preceding religion of 'the book', Christianity. That is, they wanted to capitalise on the existing neural links between those forms and the feeling of wellbeing that they generated in the mOFCs of those they wanted to convert. However, they also needed their religion to be distanced from both traditions. Breaking the geometries that were important shared attributes was one way to achieve that goal. Most people would not have noticed the twisting of the squares in plan, but many magic rituals are purely private and only enacted for the psychological benefit of the invested individuals. It would have been enough that the twisting gave reassurance to Abd al-Malik and those around him, as they took the bold and risky step of erecting a magnificent building with no models in the materially modest religious and secular traditions of the Arab world on a doubly holy spot. The impact of the magic involved in the pointing of the arches would have been more public and general. That rupture of the round-arch form would not only have reassured Muslims but would also have dismayed the Christians, whose attribute it had long been, perhaps causing them to feel pain in their insulas. The opposition in the feelings of the two communities may also have been heightened by the existence in each of an awareness of the texts in the Jewish scriptures that talk of the breaking of bows, for example those in Hosea which twice talk of God 'breaking the bow' of Israel (1: 5 and 2: 18). Since the Latin word for arch is taken from the word for bow, it was easy to see the breaking of an arch as equivalent to the breaking of a bow, an action emblematic of the taking away of military strength. Indeed, if the text of Hosea played a role in this development, it could have been because Hosea envisaged God breaking the bow of the Jews specifically as

an expression of his anger at their failings. The Muslims must have seen their own victorious entry into Jerusalem as a sign that God preferred them to both Jews and Christians, just as Jews and Christians both experienced their successive expulsions from the city as God's just punishment. Whether or not such texts contributed to the psychological effectiveness of these architectural innovations, through them the Muslims could be seen to have succeded in having it both ways. By keeping the general forms of Classical and Christian architecture they benefited from their positive associations, but by destroying their geometry they distanced themselves from those that were negative.

What might this explanation of the origin and the popularity of the pointed arch in the Muslim world contribute to an understanding of its introduction and spread within Christianity? For a start, there is certainly the possibility of a direct connection between the two buildings from which it was disseminated, the Dome of the Rock and St Denis. The conquest of Jerusalem by the Crusaders in 1099 had forced them to engage directly with the beautiful building at the centre of the Haram Al Sharif, which was soon converted for Christian use, becoming the Templum Domini, and we know that they responded positively to its pointed arches, because that form was now adopted for the arches and vaults of the rebuilt Holy Sepulchre church, completed in 1148, where they conspicuously replaced the rounded forms of the previous Anastasis rotunda. It may seem surprising that the Christians took over a Muslim form so enthusiastically, but it was not the first time that Christian art had been influenced by the practices of their rivals. One of the principal drives behind the rise of iconoclasm in the Byzantine Empire in the eighth century had been the extraordinary success of an iconophobic Islam. Indeed, one explanation given for God's support for Islam's advance was precisely that Muslims had been more rigorous in their adherence to the Mosaic prohibition of images.[18] If unease about their own practices encouraged eastern Christians to adopt a ban on images from the Muslims, the same anxiety may lie behind the western Crusaders' adoption of the pointed arch, both in the Holy Land and in France. There was certainly much Christian guilt around in early twelfth-century France, especially in relation to architecture. St Bernard was only the

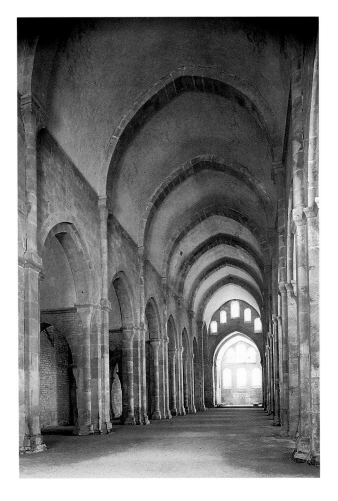

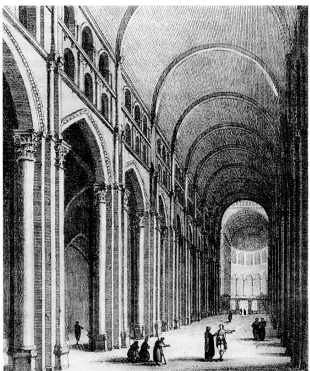

(left) 129 Interior of Fontenay Abbey church, begun c.1139

(right) 130 Interior of the third Cluny Abbey church (Cluny III), 1088–1130, in an 18th-century print

most prominent among those who indicted the builders of the grand new monasteries, especially those associated with the Benedictines, pointing an accusatory finger at 'the vast height of your churches, the immoderate length, their superfluous breadth'.[19] Bernard does not refer to the style of these structures, but one of their features was their increasing imitation of Classical pagan buildings, incorporating fluted pilasters and Corinthian columns, forms that were conspicuously shunned by the new monasteries of his own Cistercian order, which from the beginning adopted the pointed arch (fig. 129). Since Suger's writings were, among other things, intended to protect his architectural activity from criticism, it would not be surprising if Suger adopted pointed arches for the same reason, allowing them, like his inscriptions, to address visitors to his church directly. The breaking of the round arch in the rebuilt royal abbey would have affected viewers in the same way it had when it was introduced in

the Dome of the Rock, and for the same neural reasons. It would have magically cleansed the building of the taint of paganism and materialism.

The notion that the introduction of the pointed arch was a response to the criticism of grand monastic churches is supported by its most prominent use in the West before St Denis, that is in the nave arcade of Cluny III, begun in 1088 as the most magnificent church in Christendom (fig. 130). In this area of the abbey most visible to worshippers, the rejection of the round arch is compatible with the view that the form provided the extravagant project with a built-in protection against charges of a return to Roman materialism. At the same time, if the nave vault was rounded, as shown in the above print, that would weaken the argument that the pointed arch was introduced for structural reasons. The introduction of the form in Cluny III also fits with a derivation from Islam. Not only was the project's opulence

largely made possible by a huge gift of Islamic gold coins from Alfonso VI, the king of Leon, who was reconquering Spain from Muslim dynasties and who was a great admirer of their culture, but the 'lobing' of the arches of the church's galleries is derived straight from Spanish Muslim architecture.[20] The Cluny connection also supports an Islamic link at St Denis. Cluny's abbot from 1122 to 1156, Peter the Venerable, went to Spain around 1140 in order to study with Islamic scholars and translated the Quran into Latin. Although he was highly critical of the rival religion, the fact that he saw it essentially as a Christian heresy made it easier for him to learn from it, and he may well have shared his views with his contemporary, Suger, the head of France's next most important abbey. In fact, the peak of Suger's building operations at St Denis coincided with Peter's most intense research into Islam.

It may thus have been the general use of the pointed arch in Islamic architecture that recommended it to Christians, but there is also an intriguing possibility that it was the Dome of the Rock itself that drew their attention to the form's advantage. That this was so in Suger's case is suggested by one of his more original conceptions, the idea that in the choir of St Denis the outer ring of smaller columns represents Jewish prophets and the inner ring the Christian Apostles. The use of successive rows of columns to represent successive phases of religious revelation has no precedent in Christianity, but can be seen to echo the message proposed for the Dome of the Rock, that the outer ring of round arches in some sense represented previous traditions, especially that of Christianity, while the inner ring of pointed ones represented the new religion of Islam. It would not have been hard for the Crusaders, who would have realised that Muslims viewed Christians much as Christians viewed the Jews, that is as predecessors who had strayed from the correct path, first to penetrate the meaning of the Dome of the Rock's architecture and then to turn it to their own advantage. Once they had rebaptised that structure the Templum Domini, they could claim the pointed arch as their own. If they indeed looked at the Dome of the Rock in this way, it could explain both Suger's introduction of the pointed arch and his use of two rings of columns expressly to represent two religions, Judaism and Christianity.

The Knotted Column

The pointed arch may not be the only piece of architectural magic to have been transmitted to Christendom by the conquest of Jerusalem. A remarkable innovation of the Crusader architects was their invention of an extraordinary variety of knotted columns, many of which were re-used by their Muslim successors in buildings around the Dome of the Rock (fig. 131). Knotted forms in built architecture are absent from the Christian tradition but have a long ancestry in Islam, beginning with the great knotted window of the Umayyad palace of *c*.740 at Khirbet al Mafjar in the Jordan valley. It is highly likely that this was a magic object, since its underlying geometry was that of a six-pointed star, known, as we have seen, as the Seal of Solomon, and both this under-

131 Knotted columns, Golden Gate, 12th century, Jerusalem

lying geometry and its surface decoration of continuous rope forms confound the viewer by making it difficult to understand and impossible to break down. As such it offers the palace's builder a magic protection, like the reef knots worn on the belts of Roman emperors, but one far more complex. This window cleverly introduced into the palace both the general power of magic and the particular power of Solomon, and the twelfth-century knotted columns of the Temple area at Jerusalem appear to combine the same merits. They are all associated with the place where the Old Testament king's original Temple once stood and most are in pairs, making it likely that they refer to the two great pillars, Iachin and Boaz, that stood in front of his temple. Indeed, the two most impressive knotted columns to survive in Western Europe, the thirteenth-century specimens preserved at Würzburg Cathedral, are specifically identified as Iachin and Boaz by contemporary inscriptions on their capitals. They are also easy to connect with Jerusalem, since the predecessor of the bishop who probably commissioned them had visited the Holy Land on pilgrimage.[21]

If we ask why the knotted columns were created, there is no precise answer in the Solomonic tradition, but there is in that of magic. The Crusaders who reconquered Jerusalem in 1099 were rightly worried about losing it again. To assuage their concerns they may well have sought reassurance in architectural magic, beyond that suggested by the pointed arch. Iachin, 'he shall establish', and Boaz, 'in him is strength', were talismans of the stability and strength of Solomon's kingdom, attributes not securely possessed by its Crusader successor. The particular magic of knotted columns can be appreciated by considering them in the context of Hittite magic of two thousand years earlier, which exemplifies with unusual clarity practices that were widespread. One spell is against sorcery:

> The Old Woman goes forth and assembles in front of the Sun three pieces of bitumen, [holds] a bronze dagger (in readiness), and also kindles a fire. She ... speaks as follows: 'whatever words the sorcerer spoke, whatever he tied together, whatever he wove, whatever he made in whatever place, these things he did not (properly) know, the sorcerer. He built up sorcery like a pillar, twined it

together like a string. I am thwarting him. I have pushed over these words of sorcery like a pillar, I have untwined them like a string.' The Old Woman pushes the pieces of bitumen over, breaks them and puts them into the fire.[22]

The Old Woman's client is evidently persuaded that his or her problem is solved by witnessing first the creation of a special artefact with which the problem is identified and then its destruction. Pillars are first pushed over and burnt and then a string is untwined. That knotting was still an important part of magic, especially in the Arab world, we know from the last *sura* (chapter) of the Quran (cxiii, 4), where there is a warning against 'those who puff on knots'. For people who were worried about the security offered by the fibre knots usually used in magic, knotted stone columns must have offered enormous reassurance. Since several knotted columns are still visible at entrances to the Haram al Sharif, where they were re-used by Muslim builders, it seems that they too hoped to exploit their magic for similar ends. Even now, looking at them causes stress in our neural resources, because the networks we have developed to deal with stone have no connection with those we have developed to deal with ropes and knots. Since we know from drawings that such columns were also used on the tomb of one of the last kings of Crusader Jerusalem, Baldwin I (r. 1100–18), they may have been a proud invention of that ruler's sculptors. They may have reassured him in life, but they could not protect his kingdom after his death. Elsewhere knotted columns are rarely found. There are a number on Italian Romanesque churches but none of the magic complexity of those in Jerusalem. Probably the reason for their being concentrated in the Crusader kingdom is because their target public, an Islamic community who were heirs to the long tradition of Middle Eastern magic and whose main art form was textiles, were particularly sensitive to their power. They certainly possessed neural resources habituated to both magic and the twining of fibres.

The Ribbed Vault

Knotted forms as such have no role in Suger's new architecture but ribbed vaults (fig. 132), which like knots show 'criss-crossing', do, and they may also owe that role to their

132 Narthex of the Abbey Church of St Denis, c.1135–40

property of a magic spell. What this magic was intended to achieve was much discussed in the early twelfth century and we have commentaries on the rite by two highly influential theologians. One was Hugh of St Victor, probably one of Suger's advisers, who wrote that, since the two walls of the church represent the double pairing of Jews and Gentiles and Laity and Clergy, the diagonal cross marked on the floor of the church shows how 'faith began with the Jews and later went over to the Gentiles'.[23] Honorius of Autun, his contemporary, went further, saying that the two lines actually represent the Jews and Gentiles, who, had they kept going straight, would have persisted in error but who had in fact come together in Christ, who is the cornerstone or keystone.[24] Both the ritual itself and these interpretations go back to chapter two of Paul's Letter to the Ephesians, which we have found played an important role in architectural metaphor from Origen. In that passage Paul seeks to reconcile Jews and pagans by pointing out that the two communities, which were once far apart, had been brought together by Christ as 'the chief corner stone; in whom all the building fitly framed together groweth unto an holy temple in the Lord' (2: 21). The dedication ritual gave material expression to Paul's thought, and the commentaries of Hugh and Honorius bring out its meaning. Usefully, too, the two texts suggest that the ritual does not just commemorate reconciliation but somehow reinforces it.

In Paul's time the division that disturbed the Church at Ephesus was between Jews and Gentiles, but by the twelfth century in Western Europe it was that between laity and clergy, which is why that opposition is specifically invoked by Hugh of St Victor. The relationship between these two bodies, which had been vexed for some time, came to a head in the Investiture Controversy, a dispute about whether the right to appoint bishops belonged to Church or State. Most dangerous had been the violent confrontation between the Pope Paschal II and the Emperor Henry IV around 1100. Even before that, earlier churches, such as S. Miniato, Florence, taking their cue from the dedication rite, had employed an X-shaped arrangement of capitals round the main altar representing Christ to resolve the tensions that this dispute had brought to the surface.[25] The rib vault, which allowed diagonal lines actually to meet in a keystone, made their

capacity to elicit an unconscious, neurally driven response. The ritual of church dedication at this period involved the priest making two lines on the floor, one from the left-hand side at the east end to the right-hand side at the west and the other from the right-hand side at the east to the left-hand side at the west, so creating a diagonal cross. This sounds like magic, and even more like magic is the fact that the lines were to be made in ashes and that in them should be inscribed letters of the alphabet, effectively giving them the

resolution even more visible. For congregations disturbed by the dispute between clergy and laity the permanent new vault form was a more effective form of magic than the cross temporarily marked on the church floor at the moment of dedication. Only through diagonal ribs meeting in an aerial keystone, a *lapis angularis*, a *caput anguli*, could the reconciliation promised by the temporary cross of ashes on the floor be seen to acquire durability.

Uniting a Divided Church: From Jews and Gentiles to Clergy and Laity

Rib vaults were not at first associated with the pointed arch. Round-arched ribs had supported vaulting in several eleventh-century churches. It is only at St Denis that the rib is combined with the pointed arch, both in the narthex and in the choir aisles and probably in the lost high vault of the choir. From St Denis the combination spread to a whole series of cathedrals around Paris and then to Britain and other countries. The usual explanation for this dissemination sees it as due to the new style's combination of two principal qualities, a superior structural logic and a compatibility with new ways of thinking emanating from the School of Paris. Both may be relevant, but neither is likely to have been of such over-riding significance as to justify such a general change. When explaining a shift that is as total and universal as this, it is wise to look for factors that would have been more widespread in the population and more viscerally compelling, factors such as those we posited influencing the formation of the Doric and Ionic temple types, that is, ones of which there is no explicit trace but which can be understood using a neural model of the mind. Given the prevalence of an association of the round arch ultimately with Rome and paganism, everyone would have felt better if the power of that association could be removed by breaking it. Similarly, if the two walls of the church were associated with Jews and Gentiles and Laity and Clergy, everybody would have felt better if they could be more visibly linked by ribs, both transverse and diagonal. The transverse ribs would have assured viewers that the walls were directly linked, while the diagonal ribs would have assured them that that linking also

involved a role for Christ as *lapis angularis*. When they were combined, people's wellbeing would only have been compounded, since, once integrated in a ribbed vault, a pointed arch allowed the meeting of the separate walls to be made visible in the angular ridge running down the length of the building. This crucial idea, too, was probably first expressed at St Denis, although it may have been already found in the barrel vaults of Cluny's transept. Certainly, the first place where Christ is shown in the keystone of an arch is at the summit of the main portal of St Denis, where he appears as an element of the Trinity (see fig. 125). That this image at the centre of the abbey's facade was already seen as indicating how the two walls of the church meet in Christ is supported by the architecture of the opposite end of the building, the central chapel of the apse (fig. 133). This terminates not, as in other churches, in a window set in a curved wall, but in a central pier flanked by two windows that meet at an angle. The notion that this unusual configuration was designed to express the meeting of two walls representing two traditions could be seen to be confirmed by the subjects of the two windows either side of that pier, the Tree of Jesse and the life of the Virgin. These were appropriate representations of the dualism of Old and the New Testaments, Jews and Gentiles, and appropriate framing for a pier representing Christ.

A Living Church

Suger's Tree of Jesse window is a great celebration of growth and growth is one of the religious metaphors to which Suger gives new life throughout the building, taking his cue from the Pauline text about how the church 'grows together' in Christ. Suger knew what growth meant. He had had the same experience of the natural world as his contemporaries and he had closely engaged with great trees when he had entered the forests of Vexin looking for the timbers he needed for the abbey's roof.[26] His love of such growing is evident in the new sculptural decoration of his new building,

(facing page) 133 Interior of the apse of the Abbey Church of St Denis, c.1140–44, with stained-glass windows showing Tree of Jesse (left) and Life of Virgin (right), 12th century and later

which, in so far as it survives, avoids the figures of humans, animals and monsters familiar elsewhere and attacked by St Bernard, in favour of luxuriating leaves. These Suger could see as expressing the growth that Christ had talked of at John 15: 5: 'I am the vine, you are the branches', and to which St Paul referred in Ephesians.

Abbot Suger also found other ways of bringing the church to life. The most remarkable monumental sculptures at St Denis were the large-scale figures attached to columns flanking the main portal, of which only fragments and an eighteenth-century engraving survive. Like the building's other innovations, they were probably intended to charge it with mystical signification. Taking up the assimilation of sacred figures to columns found in texts that go back through Rabanus Maurus to Paul's Letter to the Galatians, for the first time they make it visible. So effective was the introduction of the column-figure as a way of making a stone church spiritually alive that it was taken up in many later buildings, culminating in the Ste Chapelle and its imitators, where the attaching of apostle figures to interior supports turned the structure into a clearer anticipation of the Heavenly Jerusalem than had been possible earlier.

At St Denis, the abbot and his masons constructed a building whose architecture would have powerfully affected the neural equipment of those who saw it, especially those who had psychological needs, in a way that no previous structure could. To his contemporaries the neurally embedded anxieties that it would have helped to relieve were, besides the ever-present uncertainties about entry into Paradise, those about the morality of large and expensive buildings, about the appropriateness of the use of Roman forms and about the relation between clerics, such as Suger, and laymen, such as the king whose chancellor he was. To the extent that later generations shared those anxieties they would have shared that relief. To any believer, the combination of supporting columns, pointed arches, opposed walls meeting both at the top of the building in keystones at the centre of cross-vaults, and at its end in an angular division between two windows, would always have offered unconscious reassurance of the stability of a Church that in spite of its divisions could be experienced as united in Christ. That was the magic of the building's combination of forms.

That at least is the claim made here, and if St Denis were the only building to possess all these attributes it would only be a claim, and it could just be argued that all we have at St Denis is a mixture of existing forms that were liked and known by Suger and his masons. But it is not the only building with these properties. In the decades that followed its completion, all its new features were, in various combinations, taken up in a series of major and minor buildings, first in the area around St Denis, as in the cathedrals of Laôn, Paris and Chartres, and then in England and elsewhere. Again it could be argued that this was simply because they were liked and carried positive association from their prestigious source, but this would not explain the rapidity of their spread and the coherence with which they were employed. Besides, far and away the clearest evidence that the combination had an element of magic is the way the round arch was abandoned in favour of the pointed. That this has nothing to do with its assumed structural advantages in high buildings is clear from the fact that the patrons who were foremost in its dissemination outside the great cathedrals were precisely the leaders of those ecclesiastical orders who expressly shunned height on moral grounds. The reason why first the Cistercians, in the twelfth century, and then the Franciscans and Dominicans in the thirteenth, repeatedly rejected the round arch in favour of the pointed can have nothing to do with its structural advantages. Indeed, the Franciscans also generally avoided vaults. It would make much more sense to relate their use of the pointed arch to the over-riding importance of the agenda these orders shared, the desire to shun worldliness. For such institutions, faced with the need to build large new buildings while avoiding any charge of magnificence, the pointed arch was a talisman of probity, breaking the power of the rounded arch which carried worldly associations that went back to ancient Rome. Their need was similar to that of the Muslims. They too had no interest in high buildings, but had used the pointed arch for four hundred years. For Christians, as for Muslims, the appeal of the pointed arch was not rational and structural but unconscious and magical. Its magic worked because everyone who entered a building in which the ancient rounded form had been broken would have felt that it had been purified.

Confirmation that the introduction of the pointed arch had nothing to do with its assumed structural advantages is also provided by the circumstances of its abandonment. The great buildings that were constructed using the round arch in the fifteenth and sixteenth centuries, churches such as St Peter's in Rome or St Eustache in Paris, were just as high and made as great a use of vaulting as the twelfth-century buildings in which the pointed arch was introduced. Their designers and patrons, like their ancient Roman predecessors, found that the round arch imposed no constraints on their projects. Their preference for the round arch was rooted in their desire to revive precisely the link with Classical Antiquity that the break in the arch had so judiciously severed.

Part 5

WESTERN EUROPE

1200–1600

The concerns about the afterlife that preoccupied people throughout Europe for six hundred years after the victory of Christianity did not go away in the second millennium, but they were no longer as over-riding. One reason was that with the passing of the years after Christ's death, his prophecy of 'Yet a little time and I will be with you' was taken less and less literally. This was especially true after the turning of the millennium in 1000, widely anticipated as a date for the end of the world. With the Last Judgement less imminent, people relaxed. More and more individuals expected to spend longer in this world, and they started to look at it with an interest not shown since pagan Rome.

Nature in general and humanity in particular were valued as they had not been since Antiquity, with Christians seeing both as God's handiwork.[1] Most instrumental in promoting a love of animals and plants were the life and teachings of St Francis (1181–1226), while the new emphasis on humanity is evident in the celebration of the Virgin Mary, to whom many cathedrals, from Notre Dame in Paris to Sta Maria del Fiore in Florence were dedicated for the first time. Nature and the Virgin also became frequent themes both of sacred hymns and secular poetry.[2] A particularly telling expression of this new interest in reality was a revival of the study of vision under the influence of Arab texts. Most influential were the writings of an English Franciscan, Roger Bacon (c.1214–94). People became more conscious of the importance of looking.

A more widespread engagement with the material world was also encouraged by social and political change. As the Normans and the Magyars, the last of the peoples from the margins who ravaged Europe, settled into new areas, a more stable context for life was established. The strengthening of the feudal system brought many constraints, but the military control that it facilitated created a sense of security and a climate more sympathetic to economic expansion. Three-field crop rotation improved food production and towns grew, thanks to the improvements in communication and transport associated with better maintenance of roads and more efficient riverine and coastal shipping. The quantity of artefacts on which such activities as warfare and agriculture, trade and craft production all depended increased rapidly and, as competition intensified, so did

their quality. In markets everywhere consumers and merchants acquired new skills of visual discrimination. Early on, an important role in this was played by the great commercial fairs, such as those of Champagne, but by the fourteenth and fifteenth century trading was most intense in the cities of Italy and Flanders, where textile production brought the most rapid growth, accelerated by its association with the development of banking.

Changes in visual interest followed. The focus on bright and strong jewel-like colours, which biblical texts had made a dominant concern since the fourth century, was increasingly affected by social and economic factors, such as the price of pigments. Importantly too, the need to evaluate competitively artefacts of cloth, wood and metal caused people to give new analytical visual attention to such properties as form, texture and shine, with direct consequences for their neural resources.[3] Among the artefacts that attracted visual interest none was more important than the dress and military equipment of kings and princes and their court elites, especially the coats of arms and banners which often played a major role in articulating identities and expressing order, both on and off the battlefield. Not that the neural consequences of the visual exposures these imply were uniform. As always, these depended on the urgency of the attention involved. The neural formation consequent on exposure to costume and weaponry we can expect to have been most critical during periods when warfare was constant. The Hundred Years War, in which France and England confronted each other during the fourteenth and fifteenth centuries, was one such period.

Such conflicts brought out the importance of another cultural trend that resulted from economic growth. As towns and townsmen became richer, rulers relied less on the manpower of their feudal dependents and more and more on the taxation of citizens. Faced with this new situation, they and those around them found new ways to motivate individuals and communities to support them, one of the most effective of which was by the use of cultural and political affiliation to foster both cohesion and exclusion. Most important for the formation of a sense of national identity was language. This was first

apparent in the flourishing of Tuscan literature, thanks to the efforts of Dante, Petrarch and Boccaccio, but as the fourteenth century progressed there were similar manifestations in England, France, Scotland and elsewhere.

By the end of the fifteenth century the Portuguese, too, buoyed by their success as traders round Africa, confidently asserted their difference from the other states within the Spanish peninsula.

French and English Gothic

1150-1550

The main driver behind Suger's work at St Denis was the need to defend a magnificent project from accusations of materialism by charging it with mystical signification. It was the same need that caused it to be imitated, first in the Ile de France, then more widely in northern France and England and finally everywhere in Western Europe and the Crusader Kingdom. The single most important key to the mystic signification of the new buildings was the vitalism that they transmitted, the sense that they were not, like the buildings of previous generations, just masses of masonry, but somehow alive and growing. To achieve this effect both patrons and masons needed to look afresh at plants and trees, and this became possible as a decline in the fear of the wild allowed people to engage with all of nature with a new sympathy. It was such looking that lay behind a number of the new architecture's striking attributes, from the foliage and flower forms that are omnipresent on capitals on all types of

supports – whether as budding crockets or fully developed leaves – to the tree-like vertical mouldings that rise through the inner elevations. Each ecclesiastical building could now be experienced as an expression of the Living Church.

French Gothic

Early

It is also significant that, thanks to the way that the rising mouldings intersected in the ribs of vaults and met in key-stones, it was a Living Church in which the increasing tensions between the principal constituents of that church, the clergy and laity, could be resolved by organic integration. Indeed, this last advantage may explain why the new style was first adopted where those tensions were most obvious, in the cathedrals of French cities including Laôn, Paris,

134 West facade of Laôn Cathedral showing statues of bulls in top level, *c.*1160 and 13th century

Chartres and Amiens, where bishops and townspeople were often literally at war.

As striking as the common features of these buildings were their differences. At Laôn, for example, as construction continued from the 1160s to the 1240s under different masters, circular forms came to play a dominant role in fenestration, becoming the most prominent attribute of the new structure. Four large rose windows were placed on the transept facades, the west facade and the east end, and the two transept windows are themselves made up of eight smaller roses round one large one, while, even more remarkably, round windows also figure in the cloister (fig. 134). There is no obvious reason for the repetition of the circular form, but it may relate to a much more clearly unique feature of the building, the large statues of oxen that stand proudly at the top of its towers in commemoration of their heroic role in the church's construction. Laôn is exceptional among the cathedrals of northern France in being sited on top of a significant eminence.

This meant that stone could not, as elsewhere, be brought close by water, but had to be dragged uphill on oxcarts. No individuals would have been more conscious of this than the building's masons. They would have given the wheels of the carts unprecedented attention, with necessary consequences for their visual preferences. The extent of those consequences is probably also evident in distinguishing features of both parts and the totality of the cathedral's plan as completed. Thus, not only do the four diagonal aedicules that crown the towers create a rare radial effect, but also the construction, first of longer than usual transepts having symmetrical twin tower facades resembling that of the west front, and then of a long choir whose square end most unusually matched the termination of the other arms, completes a layout more wheel-like than any found elsewhere.

In this connection it is interesting that Chartres, as constructed after 1194 – the only other cathedral that, because it too was on a hill higher than 100 metres (some 305 feet) above sea level, would have required the intensive use of wagons – also has an exceptional number of wheel-like features. These include, besides three great rose windows on the west and two transept facades, a row of round windows crowning the clerestorey that runs round nave and choir. Even the flying buttresses of the nave are designed to resemble the quadrants of spoked wheels.

Rayonnant

An exposure to spoked wheels may also have contributed to the formation of the next phase of Gothic, that known as Rayonnant, 'radiating', from the radiating 'bar' tracery of the rose windows of the new cathedral of Rheims (begun 1211; fig. 135). Rheims is at the centre of the Champagne, a region famous in the twelfth and thirteenth centuries for its trade fairs, which saw merchants converge on different centres over long distances. These fairs brought major improvements to road networks and so may have hastened an ongoing trend in wheel technology. Early wheels, especially those of heavy carts, were solid and flat, being built up out of planks, but, as soon as travel and economic conditions improved, as with the expansion of the Champagne fairs, these would have been replaced by lighter forms that

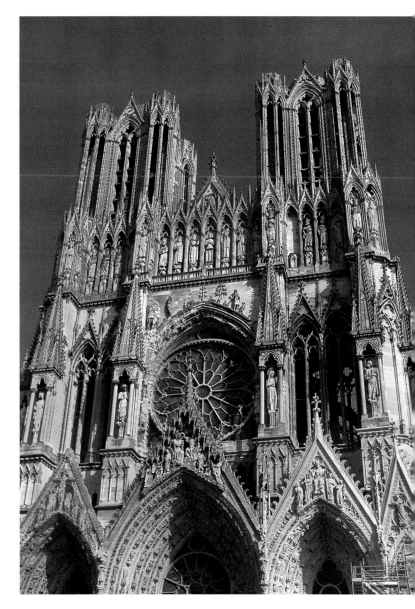

135 West facade of Rheims Cathedral, 1211–75

were spoked. There is thus a possibility that an increasing visual exposure to a new 'spoke' technology was one of the many factors behind the abandonment of the so-called 'plate' tracery characteristic of the cathedrals of Chartres, Laôn, Paris and elsewhere in favour of 'bar' tracery emanating from Rheims. This would probably have been reinforced by exposure to the other material artefacts on which the fairs depended, the poles and ropes that supported traders' booths and the small components of the trestles and

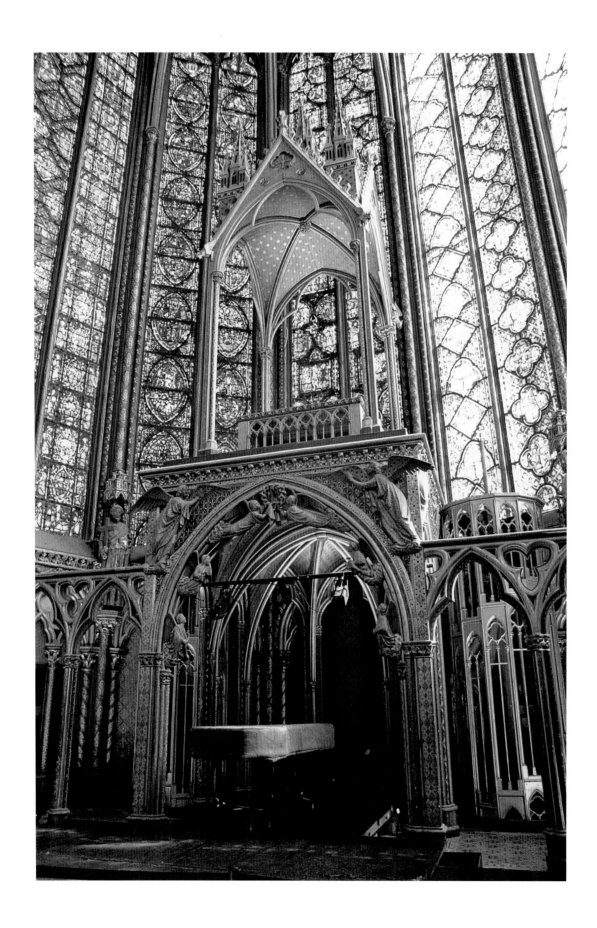

other furniture they contained. Whatever the details of the change, there can be little doubt that the emergence of a new and lighter type of Gothic was encouraged by the formation of neural networks increasingly exposed to the sight of artefacts made of ever thinner elements, especially rods of wood and bars of metal.

The most brilliant exploitation of the new lighter forms was found in the Sainte Chapelle, Paris, consecrated in 1248 (fig. 136). The chapel was founded by the devout king Louis IX, St Louis, to house shrines containing several relics of Christ's passion, principally the Crown of Thorns, soon joined by a fragment of the Cross and the tip of the lance that pierced his side. It has long been thought that the designer who conceived the chapel's prinicipal features, lofty proportions, slender supports and large stained-glass windows, had in mind a metal reliquary set with precious stones.[1] Today we can put it slightly differently. Rephrasing the same point in neural terms, we can agree that the neural resources that guided the designer and patron in their choices would have been primarily shaped by looking at such shrines, but can add that they may also have been shaped by looking at or just imagining the relics contained in this particular example. The Crown of Thorns was made up of twisted stems of wood and the lance to which the metal point was once attached would have been a rod of the same material. It is likely that these were the objects that were uppermost in the minds of the chapel's royal patron, the artisans who built it and the faithful who visited it. Perhaps that is why the building's miraculously thin supports have something in common with a ring of lances, and the tracery of the windows has something in common with the Crown of Thorns. Such a creative role for the Crown is also suggested by its striking sculpted representation near the Chapelle's east end. Placed at the centre of the structure that once supported the original reliquary, the Crown's forms seem to be taken up in the lobes and cusps of the framing labyrinth of bars. And there is a similar resonance between the thorn twigs of the Crown and the unusually organic curves of the round mouldings

(facing page) 136 Interior of the Sainte Chapelle, 1239–48, showing support for the reliquary of the Crown of Thorns with a carving of the Crown at the apex of the central arch, Paris

over the seats of Louis IX and his queen either side of the chapel nearby. It is almost as if the royal couple sit under crowns made of the same stuff as Christ's.

English Gothic

Early Gothic in England shares the vitalism found in France, and probably for the same reason. In England too there was much criticism of the expenditure on new church buildings, as in the texts of the Cistercian Aelred of Rievaulx (c.1109–1167)[2] and Alexander Neckam (1157–1217),[3] and an easy way to ward it off was to encourage viewers to experience them not as piles of materials but as representing a living institution. The more magnificent the structure, the more this was necessary, which is possibly why the first English building to employ the pointed arches, ribs and vitalistic imagery developed at St Denis was the reconstruction of the choir of Canterbury Cathedral, complete with a shrine to the murdered St Thomas à Becket, begun in 1174. The four piers of the eastern crossing were described by a contemporary chronicler, Gervase, as meeting in a keystone, and the fact that that keystone carries a sculpture of Christ the Lamb suggests that the building directly takes up Suger's notion of a Living Church growing together in Christ.[4] Given the tensions between Church and State, the spot where an archbishop had been murdered at the behest of a king was one where a confirmation of the unity of the Church was particularly desirable.

One of the ways in which the architecture of the new east end of Canterbury was made to express vitality was the use of Purbeck marble for the supporting columns. The frequently greenish colour of the marble evoked growth, and its shine is a property easily associated with young life and the organic. Certainly, the contrast with the limestone used in French buildings, whose comparative dullness would have associated it more with age and the inorganic, means that the series of great English churches, including the cathedrals of Lincoln and Salisbury and culminating in Westminster Abbey (1245), in which the use of such marble was combined with pointed arches and rib vaults, were all much more evocative of a 'living' church than their contempo-

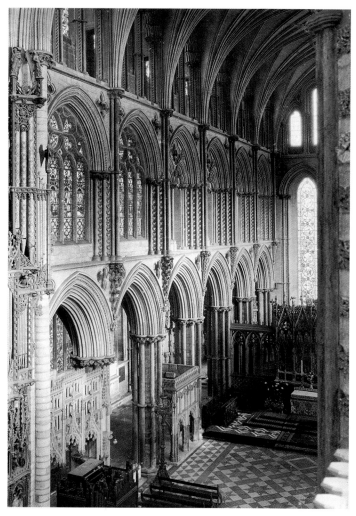

137 Lincoln Cathedral, nave arcade, detail, thirteenth century

138 Interior of the retrochoir of Ely Cathedral, 1234–52

rary French equivalents. But the most assertive element in the vitalism of English Gothic was the luxuriance of the leaf forms with which not just these Purbeck columns and shafts but all architectural elements were associated. Lincoln Cathedral (fig. 137) offers many examples, including its extraordinary crocketted piers of about 1200.[5] The need to introduce such living forms may have been particularly urgent at this site in order to counter the materialistic and secular values of the preceding Romanesque structure, whose 'triumphal arch'-like west facade reminded visitors that Lincoln had once been a Roman *colonia*. Whatever their origin the cathedral's vitalistic properties were repeatedly celebrated by writers. Gerald of Wales tells how it is made

not of 'lifeless material' (*insensibili materiali*) but 'living stones' (*vivis lapidibus*)[6] and Henry of Avranches in a more poetic elaboration describes it as a work 'not of art but of nature' (*non esse videtur ab arte / Quin a natura*).[7]

One feature that makes all these buildings seem more alive than those in France is the multiplication of small shafts, which seem to sprout, bud and unfurl leaves as we look at them. While in cathedrals such as Chartres and Rheims a few massive and masonic mouldings rise through their full height with sparse stiff crockets on their capitals, in the cathedrals of Lincoln and Wells, as well as in the choir of the abbey, now the cathedral, of Ely (fig. 138), we find a series of horizontal layers, out of each of which, almost as in a plant nursery,

139 Coppiced (top) and pollarded (bottom) trees

as the simpler stronger verticals of French Gothic did from those of French forests.

The English preference for clusters of colonettes that were shaped by real visual experience may also have been reinforced by the visual imagination's response to the language of spiritual metaphor. Wooden rods figured significantly in biblical texts, so that to the twelfth- and thirteenth-century churchman the sprouting shafts of grey-green Purbeck would have chimed with the mental images they had formed from reading about the flowering rod of Aaron, about Mary as a branch from the stem of Jesse and Christ as a vine of which the Apostles were branches, which figure prominently in English texts of the period. All will have gained authority from the memory of the uniquely Anglo-Saxon repeated assimilation of Christ's Cross to a 'rood', etymologically cognate with rod.

grow numbers of slender shafts. We cannot know what different exposures may lie behind the contrasting visions of the Living Church, but they may partly reflect differences in the woodland cultures of the two countries. France had at the time, and still has, many large and mature forests, making it easy to relate the long strong supports found in French buildings to the sight of tall trees. In England, by contrast, which had been largely deforested even in the Neolithic period, such timber was rare. This meant that it is likely that people were forced to increase the supply of wood available for harvest by coppicing and pollarding. When a tree is coppiced (cut at the base), several smaller trunks replace a single large one, and when it is pollarded (cut higher up), even more smaller rods appear (fig. 139). Both processes resulted in the production of a wealth of small timber, which could then be used for the construction of everything from the spokes of wheels to the wattle walls of houses, as well as for fuel. They would also have exposed viewers to different visual experiences. Instead of tall single trunks, people would have seen clusters of small vertical branches rising either, with coppicing, from the ground or, with pollarding, from higher up, generating an effect much like what we see in the choirs of Ely (see fig. 138) or Lincoln. The horizontal layering and the multiplication of shafts of English Gothic may thus derive from the properties of English woodlands, just

Asymmetrical Contrasts: English Decorated versus French Rayonnant and English Perpendicular versus French Flamboyant

If the progressive divergence between the architectures of France and England during the thirteenth century calls for comment, what happened subsequently in the fourteenth and fifteenth centuries absolutely demands an explanation. At first, after 1300, in France the Rayonnant mode continues, with rigorous geometries, repeated verticals and restrained leaf patterns, while in England vegetation becomes ever more riotous and there is an outburst of double curves, often in three dimensions, in the so-called Decorated style. Then, after 1350, this pattern rapidly reverses. In England, Decorated is replaced by Perpendicular which is characterised by rigid grids of vertical mullions and horizontal transoms, purely geometrical mouldings and angular tracery, and this at exactly the moment that in France the austere parallel verticals of Rayonnant begin to be replaced by the exuberant double curves known as Flamboyant. Both the symmetrical contrasts and their sudden reversal are particularly surprising in a period when the social and economic contexts in the two countries were remarkably similar. Both are equally affected by the great plague of the Black Death

around 1350 and, during the Hundred Years War that follows, their relationship is marked by much exchange, both voluntary and involuntary.

The context for this inversion is rarely discussed. Where the styles are analysed separately they tend to be treated as somehow logical and natural developments within national and regional traditions both intellectual and masonic. For example, both Decorated and Perpendicular can be shown to have some roots in St Stephen's Chapel, Westminster (after 1292), where lierne ribs and traceried wall panelling were first introduced. Identifying such masonic filiations and finding parallels in contemporary intellectual life sheds important light on aspects of the new developments, but such observations hardly provide explanations for changes of such an all-encompassing nature.[8] Can a neuroarthistorical framework do more? For example, can the differences be related to differences in the things the inhabitants of the two countries were either looking at or imagining with such visceral interest that their neural resources would have been powerfully affected?

English Decorated

Of the buildings labelled Decorated some, such as the cathedrals of Exeter and Lichfield, offer just more exuberant versions of the colonnette-rich styles of the thirteenth century. Others, such as parts of Ely, are characterised by an even greater luxuriance of foliage and above all by the use of more complex curves. The richest varieties of such forms are found in Ely's Lady Chapel (fig. 140) and in the octagonal crossing constructed after the collapse of the church's central tower, but they also feature in many other buildings from the late thirteenth until the mid-fourteenth century.

One transformation of people's visual and imaginative experiences at this time was brought on by a change in weather patterns. It is well known that the climate of Europe warmed in the late first millenium and continued to improve until the early fourteenth century, before worsening disastrously (fig. 141).[9] One of the clearest testimonies to the warming was the increase in vine planting in England, which was so dramatic that it caused the winegrowers of Bordeaux to request their then lord, the king of England, to

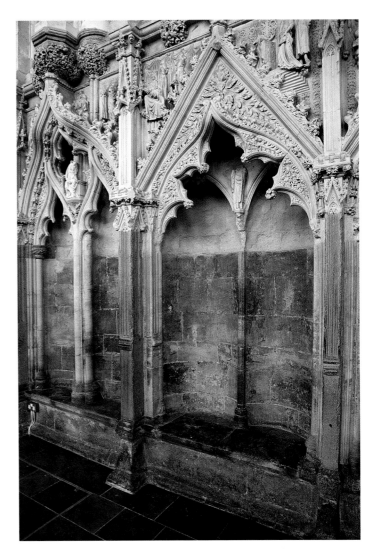

140 Ely Cathedral Lady Chapel, begun 1321 (detail)

surpress English production.[10] The peak of this trend coincided with the unusual run of warm dry summers between 1284 and 1310, whose psychological impact was such that, as the climatologist H. H. Lamb has observed: 'The first decade of the new century was a time when many had the confidence to start new vineyards in England'.[11] Those plans give us a precious glimpse into the preoccupations of the contemporary brain, revealing that many in England at the time imagined a new and burgeoning vine culture. If one of the reasons for the spread of vineyards was Christ's claim, 'I am the vine and ye are the branches', then there may have been a particularly close connection between the flourishing

Estimated course of the temperatures prevailing in central England since AD 800. Probable fifty-year averages: (a) for the whole year; (b) for the high summer months, July and August; (c) for the winter months, December, January and February. The shaded area indicates the range of apparent uncertainty of the derived values.

141 Climate chart (H. H. Lamb, *Climate, History and the Modern World*, 2nd ed., London and New York 1995, fig. 30)

142 Map of medieval vineyards (H. H. Lamb, *Climate, History and the Modern World*, 2nd ed, London and New York 1995, fig. 65)

LEGEND

- Vineyard, usually 1–2 acres or size not known.
- ◣ Vineyard, 5–10 acres.
- ■ Vineyard, over 10 acres.
- ○ Denotes evidence of continuous operation for 30–100 years.
- ◯ Denotes evidence of continuous operation for over 100 years.

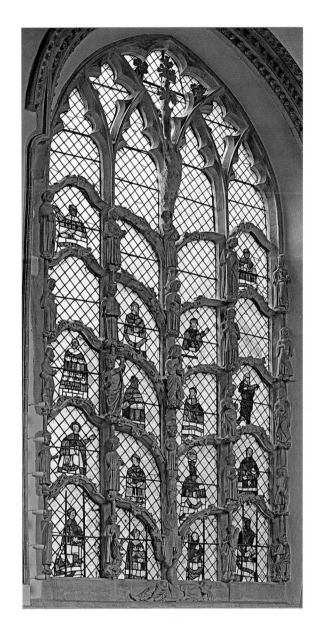

143 Tree of Jesse Window, 1330s, Abbey Church, Dorchester

of the plant and the spread of leaf ornament in churches. It is probably also not fortuitous that there is some correspondence between the locations of the best examples of Decorated work and those of known vineyards (fig. 142). One of the best documented, which finally failed in 1469, was that of Ely.[12] Others were at Dorchester Abbey, where the tracery of one window is itself carved into a highly organic Tree of Jesse (fig. 143); at Tewkesbury, where from 1321 vaults of an unprecedented elaboration were introduced; and at Wells

which, between 1310 and 1319, acquired a vault of similar elaboration. If, after the hot summers of the late thirteenth century, vineyards, and organic growth generally, filled the English imagination and even became a feature of visual experience, it is easy to see how the formal properties of tendrils and branches could have influenced the neural networks of both patrons and craftworkers, so nurturing new visual preferences.

Climate may also have contributed to Decorated's demise. If dreams of vines and lush vegetation were encouraged by the warm weather around 1300, they were snuffed out by the rapid cooling of the following decades, beginning with 'the extraordinary run of wet summers, and mostly wet springs and autumns, between 1313 or 1314 and 1317'.[13] In the following decade the decline continued, with terrible consequences for the harvest, and deadly implications for the population, which, weakened by malnourishment, was decimated in 1348 by the Black Death or bubonic plague. It has sometimes been suggested that the population loss caused by the plague had some role in the abandonment of the labour-intensive Decorated style and the rise of the much more austere Perpendicular, but that would explain only the simplification, not its new formal vocabulary of linear spareness and rectangularity.

English Perpendicular

What was it that gave these forms their attraction to contemporaries? One factor may have been a fundamental change in agriculture partly connected with the change in climate, namely the rise of sheep rearing. Wool's importance to the English economy had been increasing for some time, but it acquired a predominant status only after 1350. This was partly because grain cultivation was made more difficult by the combination of a reduction in the supply of labour following the Black Death and the deterioration of the climate. It was also because the continental demand for high-quality English wool increased rapidly with the expansion of cloth production in Italy and Flanders. Both trends led to a shift away from the raising of crops and into sheep farming, with dramatic consequences for the environment, as furrows were replaced by enclosures, giving prominence to a new class of

artefacts. These were sheepfolds, which in southern England would have been composed of fences, hurdles and gates, all made out of simple rods, tied and woven together (fig. 144). Some connection between the expansion of the sheep industry and the spread of the Perpendicular style is certain, for many of the churches exploiting the new forms were financed directly or indirectly by the wool trade. Indeed, no group would have loved hurdles more than those who paid for the great parish churches of East Anglia, the Cotswolds and the West Country, with their endless rows of mullioned and transomed windows, their outside walls often gridded with stone and flint 'flushwork' panelling and their roofs ringed by fence-like parapets. And it is worth reflecting that the associated preferences would only have been strengthened by members of the same communities looking with delight at the rectangular frames of the looms on which English wool was now with increasing frequency woven into high-value domestic products.

Exposure to sheepfolds and looms may have influenced taste but hardly explains all the new features of so-called Perpendicular with its grid of vertical mullions and horizontal transoms, its depressed arches and its foliage-free capitals. Was there another class of artefacts, exposure to which might have generated visual preferences capable, from the

144 Wattle pen full of sheep, *The Luttrell Psalter*, written in Lincolnshire c.1325–35, paint on parchment. British Library, London, MS Add. 42130, fol. 163v

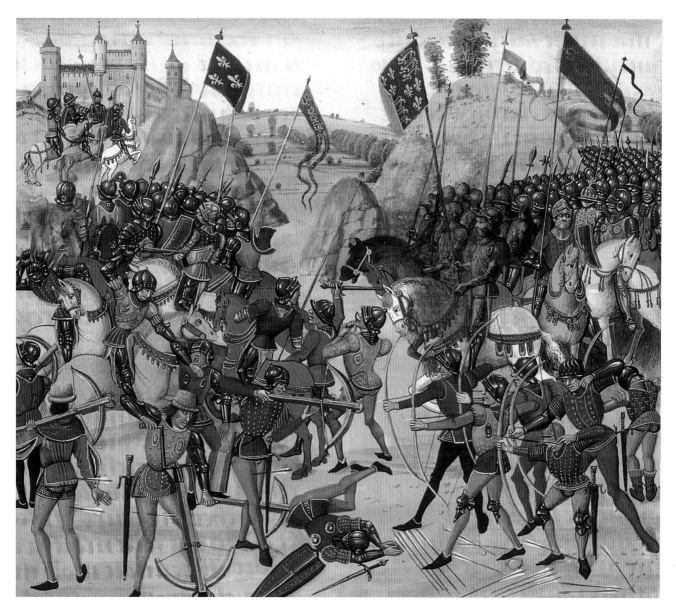

145 Battle of Crécy (1346), *Chroniques* of Jean Froissart, 1470–75, illuminated manuscript. Bibliothèque National de France, Paris, Français 2643, fol. 165v

mid-fourteenth century onwards, of begetting such formal configurations as the choir of Gloucester Cathedral (see figs 146 and 147), the naves of Winchester and Canterbury Cathedrals, and such royal chapels as St George's at Windsor (see fig. 154) and that of King's College at Cambridge? One class stands out above all others, the longbow and arrows that took on a new and decisive role in English battles. Victory came first against the Scots at the Battle of Halidon Hill (1333), where the front ranks of the enemy 'Were so

grievously wounded in the face and blinded by the host of English archery that ... they were helpless and quickly began to turn away their faces from the arrow flights and to fall'.[14] After that came the more astonishing triumphs over the much wealthier French at Crécy (1346), Poitiers (1358) and Agincourt (1415). They were credited above all to a weapon that came to be seen as distinctively English, as we see from representations of the battles in manuscripts (fig. 145). Such was its impact that for most of the fourteenth

century and much of the fifteenth, whatever the glamour of the French knight and his equipment, or the effectiveness of other weapons (the continental crossbow and pike and, increasingly, firearms), the most feared instrument of war, when in the hands of an English archer trained to loose several arrows a minute, was the longbow. This simple and unornamented length of yew, curved against the tension of the string, with its accompaniment of straight arrows which had feathers to guide them and steel tips to penetrate protection and kill, was a combination of mysterious power. This instrument, which only developed out of the smaller, weaker, shortbow in the years after 1300, was to prove the key to the great victories of the Hundred Years War fought by Edward III and his successors as they sought to enforce their claim to the French throne.

Everyone knew this. Young men were enlisted as archers and the national psyche was mobilised through the revolutionary use of the English language, which now began to displace French in critical areas of the national life, becoming a vehicle in new forms of expression.[15] One was that of the despatches that were sent back by the king from battlefields such as Crécy and Agincourt and read out in villages across the country. Another was a new class of military poem, such as those of Laurence Minot (*c.*1300–1352). These repeatedly frame the war in nationalist terms as a conflict between the French 'lily' and the English 'leopard' and praise the power of the English bow to defeat French steel: 'With bent bowes thai war ful bolde/ for to fell of the Frankisch men'.[16] So important was the power of the bow for the national military identity that it was also credited with a mythical prehistory at the court of King Arthur, as in the alliterative *Morte d'Arthur*: 'The English archers let fly eagerly,/ And their arrows struck harm through the hardest steel'.[17] At the same time its strategic significance in the present was brought out by the warning put into the mouth of Henry V by the contemporary chronicler Wavrin, that 'the French would cut off three fingers of the right hand of all the archers that should be taken prisoners'.[18] But nothing made Englishmen everywhere more conscious of the importance of archers than the efficient countrywide system for procuring their weapons. These were produced not only centrally, at the Tower of London armouries, but in villages throughout the land. In

the four years 1341, 1346, 1356 and 1359, requests totalled 18,280 bows and 47,650 sheaves of arrows (or 1,143,600 individual shafts).[19] Under Henry V there were similar orders for the collection of the arrows' business ends, including two for 400,000 arrow heads and two for 1,190,000 feathers, the latter with the specification that six be picked from each goose.[20] Since all these materials were paid for by the king, the system worked well to redistribute monies raised by taxes to remote communities. With all this it would have been hard to escape being caught up in the excitement about the supremely English weapon.

The first place where we might expect this attention to the bow to have had an impact on architecture is the Abbey, now Cathedral, of Gloucester. After the death in 1327 of Edward II, his son, Edward III, the leader of England's military expansion, ordered an elaborate tomb for him in the choir of the Abbey and, although the monument was still in the Decorated style, the reconstruction first of the interior of the south transept (from 1331) and then of the whole choir (from 1335) was in a totally different mode. The Romanesque walls were covered with a grid of thin verticals and horizontals and a vast East Window (1349; fig. 146) was endowed with the system of mullions and transoms that would be employed thousands of times in the following two centuries. This window was in many ways the most important feature of the reconstruction. Triumphant in scale, as the largest not just in England but in Europe, it was also directly connected with the scenes of the bow's victories, its glass bearing the arms of leading participants in the battles of Halidon Hill, Calais and above all Crécy. It has been thought of as a vast war memorial and is today often called the Crécy window, having been perhaps paid for by Baron Bradeston, himself a commander at that battle. Unusually too, the window is not flat but canted at either end, making it the first example of a uniquely English type of fenestration, the so-called 'bow' window. The horizontally curved mouldings in the Gloucester choir's side walls have their immediate inspiration in the Romanesque arches behind, but they also resemble longbows in shape (fig. 147). Indeed, since they anticipate the depressed arches that

(facing page) 146 Crécy window, 1349, in the choir of Gloucester Cathedral

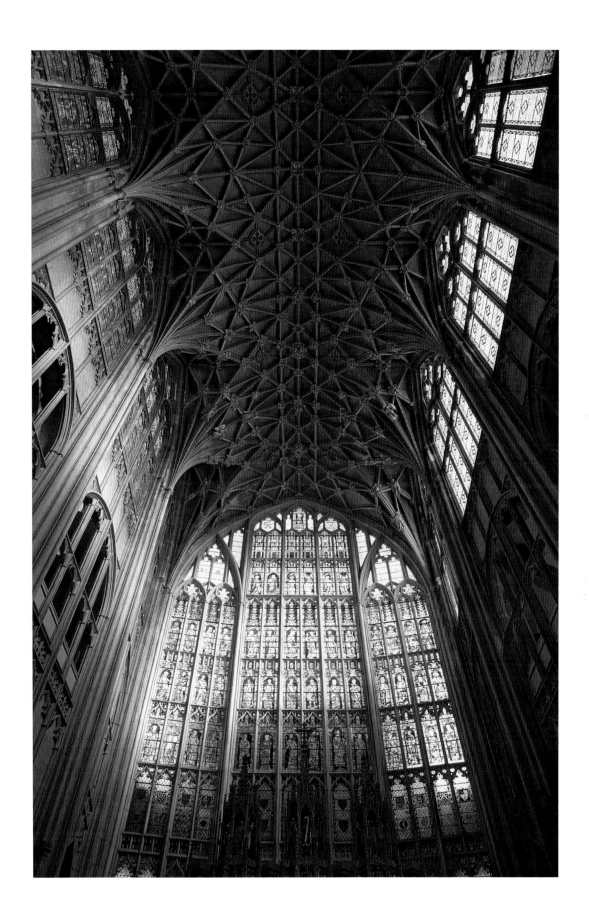

147 Interior of the choir, 1351–67, Gloucester Cathedral

148 Cast-iron railings, 1864, Giardino Garibaldi, Palermo

became popular in the next decades, it is an intriguing possibility that the longbow played its part in encouraging the change to that new form, which eventually became famous as the 'four-centred' or 'Tudor' arch. Arches and bows were much closer in the medieval mind than they are now, since the primary reference of the word for 'arch', *arcus* in Latin, was to the archer's bow, 'bow' being its English translation, as in the designation of the Church of St Mary-le-Bow. This identity between the word for arch and the word for bow would have made it easy for the bow's rise to prominence to influence arch design. Certainly, the depressed Perpendicular

arch has much in common with a longbow, especially at the moment before the arrow is released. The pressure of the archer's hand causes the bow to bend from a middle point where it is thickest and the pull of the string causes the bend to increase at the thinner extremities, generating a shape that has much in common with a four-centred arch.

Closely associated with the bow was the arrow, and this too had properties that may have contributed to the formation of the new style. Thin and straight, with an iron point at one end and angled feather 'flights' at the other, and always carried in a bunch, the arrow may have played an important role in encouraging windows in which mullions crowned by cuspings were marshalled in rows between horizontal transoms. This may seem far-fetched but, if we want to know what an architectural screen inspired by bows and arrows might look like, we can study the cast-iron railings (1864) of the Giardino Garibaldi in Palermo (fig. 148). There a row of vertical arrows lined up under a series of horizontal bows creates an effect remarkably similar to the Gloucester stonework. The main difference is that in the railings the allusion to the use of bow and arrow in hunting is explicit and conscious, while the neural processes that led to the design of the Gloucester screen walls are likely to have been com-

pletely unconscious. Its appeal depended on the pleasure that it created being unwittingly shared by all involved in the building – its patrons, its designers and its users. Even more suggestive of a connection between archery and architecture, though, are Gloucester's extraordinary pair of strainer arches, each of which looks exactly like a bow loosing an arrow upwards (fig. 149). Such an orientation is particularly appropriate given that English bowmen owed their deadliness to their firing their arrows from massed formations, upwards, in an arc, so that at Halidon Hill they created a storm that 'blinded' the Scots and at Crécy the shafts 'fell as thick as snow'.[21] If the designers of the strainer arches felt this resonance it is even possible that archery inspired another of the building's unique features, the extraordinary proliferation of short so-called lierne ribs in the vault above. While at Tewkesbury and elsewhere liernes are ornamental additions to organised vault patterns, at Gloucester their almost chaotic expansion to cover the whole vault surface makes them resemble an arrow-storm.

A structure of similar importance to the Gloucester choir was the new roof added to the Great Hall of the Palace of Westminster (1395–9; fig. 150) under Richard II, Edward III's successor and the son of his heir, the warrior Black Prince, the victor at Crécy and Poitiers. The largest wooden roof in Europe, it elaborates on a new type of construction called hammer-beam, exploiting a combination of curved members and parallel vertical linear elements to allow the opening up of a vast uninterrupted space for court ceremonial and feasting. Besides celebrating bow-like arches and arrow-like verticals, it introduces two opposed rows of angels on the horizontal beams, who confront each other like two aerial armies. These angels, which may relate to the unusual ranks of angels who surround the Virgin on the Wilton Diptych, also commissioned by Richard II at the same period, are probably the first of the hundreds of angels incorporated in similar positions in hammer-beam roofs during the fifteenth century, at least one of which at South Creake in Norfolk was a celebration of the victory at Agincourt and decorated with the coat of arms of the Black Prince (fig. 151). The prominence of the feathers on the wings of both the angels in the Diptych and those in the Westminster roof raises the possibility that they reflect the interest in feathers fostered

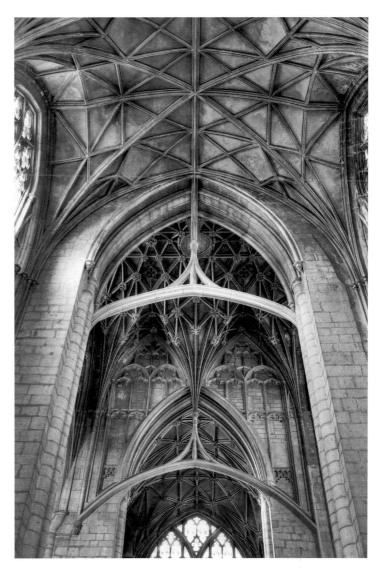

149 Strainer arches in the choir, 1351–67, Gloucester Cathedral

by their use in the flights of arrows. Considering the effort involved in assembling 1,190,000 goose feathers, that interest must have been widespread, even more so than the many church roofs in which everywhere feathered angels confront each other as if in battle.

Essential to the context for a national love of the bow and the hammer-beam roof was the more widespread prominence of wooden artefacts in the material environment of fourteenth- and fifteenth-century England. They formed part of a repertoire of wooden monuments unparalleled in Europe. Among these were such unique structures as the

150 Angel roof, constructed 1395–9, Westminster Hall, London

151 Angel roof, second quarter of 15th century, Our Lady St Mary, South Creake, Norfolk

great octagon of Ely and the spire of Old St Paul's, claimed to have been 520 feet (about 158 metres) high at the time of its destruction in 1561, and the temporary hall 200 feet (some 61 metres) in diameter built at Windsor to house a reconstruction of Arthur's Round Table as part of Edward III's morale-building effort.[22] The series eventually culminated in the great wooden Palace of Nonsuch, intended by Henry VIII to astonish his continental rivals, Francis I and the Emperor Charles V, at a time when they were seeking to enhance their reputations by their patronage of such stone structures as their palaces at Chambord and Granada, built in emulation of ancient Rome. Nowhere else in Europe was timber so associated with the neurochemistry of pride, power and pleasure.

One last distinctive element of Perpendicular was the fan vault, and its emergence too may have been influenced by visual preferences fostered by another artefact type linking woodwork and war, one of particular importance to the English. The basic principle of the fan vault is that each unit has the form of a half, or occasionally a whole, conoid. These are either treated as discrete units rising to a completely flat ceiling, as in its first use in the cloister of Gloucester (after 1351; fig. 152), skilfully blended into each other as in the vault belatedly added to the chapel of King's College, Cambridge, by Henry VII, or further elaborated into pendants, as in the same Henry's chapel at Westminster. Although the ancestry of the fan vault in the increasingly rich rib vaults of the thirteenth and early fourteenth century is unquestionable, its new properties, both structural and decorative, suggest another source. Most striking is the way the clearly separable ribs found in all earlier vaults are replaced by shallow mouldings that meet in lobed tracery, becoming part of a surface that curves continually in two dimensions. This is an unprecedented feature in the field of stone architecture, but has clear parallels in the textile architecture of tents, which provide a possible source for the fan vault's conoid form, this being precisely the shape taken on – albeit in an inverted position – by fabric falling from a central pole. Tents were, indeed, another field in which the English were exceptionally strong. Edward I (1239–1307) had had twenty-five tent-makers, a staff unknown in other courts.[23] He needed tents for his many military expeditions and so did his warrior grandson Edward III. It is easy to guess how those expe-

ditions may have influenced architectural tastes. On their *chevauchées* in France, Edward III and members of his court and their heirs would have spent much of their time sleeping in tents, often gazing up at their roofs. With their neural resources shaped by such an exposure they would have had a particular pleasure in seeing such forms above them when they got home. The tent was one of many artefact types that Europeans had adopted from their Muslim opponents during the Crusades and this eastern origin is evident in the dependence of fourteenth- and fifteenth-century representations of tents on thirteenth-century scenes of Arabs playing chess in the *Book of Games* of Alfonso X. A principal feature that European tents adopted from their models was the lobed decoration of their roofs, which means that the large lobes, unknown in masonry vaults, which are found in the Gloucester cloister, point to the same source. This suggestion is supported by an illustration from a manuscript of *Le Chevalier errant*, where not only do several tents have patterns on their inverted conoid roofs like those on the cones at Gloucester, but also, being arranged in rows, they echo the cloister walk (fig. 153). If the design of the Gloucester cloister recalls the tented communities found on campaigns, it may, like the design of the choir, reflect the unconscious, or just possibly conscious, choice of either patron or architect, or both, in the aftermath of Crécy. The assimilation between the cloister and a tent may have been facilitated by another of its new features. Gloucester's cloister has a flat roof covered in lead and since that material (unlike the earlier tiles and slates) was laid in sheets, like a cloth, this would have made it easier for the architect to think in textile terms. The cloister thus had an exterior covering of cloth-like lead sheets and an interior covering of tent-like vaults.

This also applies to another building celebrating the same forms that was erected after many campaigns in France had consolidated the taste for tent-like vaults, the Chapel of St George, begun at Windsor by Edward IV in 1475 (fig. 154). Conceived in the same year that Edward exacted a vast payment from Louis XI at the Treaty of Picquigny, its principal goal was to provide a worthy home for the knights of the order of the Garter founded by Edward III in 1348 after his triumph at Crécy. Besides its great fan-type vaults, the Chapel has several other unusual traits. One is its combina-

152 Cloister, after 1351, Gloucester Cathedral

tion of lowness and horizontality, which are exceptional for such an important structure. Another is the introduction of semi-circular terminations to its transept. The origin of these features can be inferred from a comparison of the Chapel with a splendid tent designed a few decades later as a possible setting in which Henry VIII might display himself as the rival to Francis I and Charles V at the Field of the Cloth of Gold in 1520 (fig. 155). This shares all the properties noted in the Chapel, including a roof-line animated by large heraldic beasts. That those properties of the chapel were exceptional in stone architecture but normal in chivalric tents makes it highly likely that that world is their source, with the possibility that by this time there is some reverse influence from the building on the tent.

(above) 153 Workshop of the Master of the City of Women, tented encampment, illumination on parchment, in a manuscript of Thomas III de Saluces, *Le Chevalier errant*, written in Paris in 1394. Bibliothèque Nationale de France, Paris, Français 12559, fol. 162

(below left) 154 Exterior of St George's Chapel, begun 1475 as seat of Order of Garter, Windsor Castle, Berkshire

(below right) 155 Design for a tent for the Field of the Cloth of Gold, before June 1520. British Library, London, BL Cotton Augustus III, fols 18–19

The period between 1340 and 1520, when Perpendicular was dominant and the fan vault the most favoured covering, embraced both the Hundred Years War and the Wars of the Roses. At a time when battle and its material accoutrements figured exceptionally prominently in the lives of everyone in England, it is not surprising if exposure to them should have an unprecedented influence on the visual preferences of patrons, designers, viewers and users. We may also sense the impact of that experience in the extraordinary rise in the popularity of crenellations on church buildings, especially towers, including that of Gloucester Cathedral begun in 1450.

French Flamboyant

If the architecture of England during the fourteenth and fifteenth centuries shows an ever greater fondness for parallel straight lines and simple geometry, that of France moves steadily in the opposite direction, exploiting ever greater curvilinearity and geometrical complexity. Flamboyant does not have such a decisive launch as Perpendicular at Gloucester, but by 1500 in structures such as the transept of Beauvais Cathedral (fig. 156) it is so coherent and assertive that it too calls for an explanation in terms of shared experiences.

What might the French have been looking at to give them such a different taste? One starting point is suggested by the name, *flamboyant*, 'flaming'. This was given to the style in the nineteenth century because the continuous double curves often found in its tracery suggested nothing so much as fire and flames. French architectural historians saw the strongest vertical element in Flamboyant tracery as a *soufflet*, or 'bellows', and the asymmetrical flanking elements as *mouchettes* or 'snuffers'. Considering that inflammable wooden bows and arrows had such a role in French humiliation during the Hundred Years War, that evocation might have provided the French with unconscious pleasure, but it is hardly likely to have inspired a new style.

A better guide to the meaning of such forms may be the response of the English architectural historian, Francis Bond, to the same forms. He saw the soufflet as a dagger and the mouchette as a falchion or battle axe.[24] Certainly, weapons were what were most needed by the vanquished of Crécy and

Poitiers, the French king John II, held a prisoner in London in 1356–60, and his son, Jean, Duc de Berry, who replaced him as a hostage in London in 1360–67, but above all his oldest son and heir, the future Charles V (ruled 1364–80), who was left in charge of the country. France had a population four times the size of England's and was much wealthier. Its armies were also bigger than those of England and better equipped. The contrast between the helmeted continental crossbowman and the lightly clad English archer with his simple weapon of prehistoric origins was emblematic (see fig. 145). Given this puzzling situation it is not surprising that Charles V resorted to magic, as when he had Thomas de Pisan cast a spell to rid the country of its invaders:

> Under a proper constellation five hollow human figures were made of lead, named for the king of England and four captains; they were labelled with astrological characters and names and filled with earth from the middle and the four corners of France. At the right astrological moment they were buried in the places the earth came from, face downwards and with their hands behind their backs, with incantations for the annihilation of the persons they represented and the expulsion of the English and their adherents: 'and within a few months all the said companies had fled from the realm'.[25]

Magic was also given a new authority when texts by astrologers such as the same Thomas took pride of place in a new royal library founded in the Louvre chateau in 1368. There they formed part of a new armoury of knowledge to be deployed in a war in which Charles, in imitation of the English kings, now saw language as a principal weapon. Many original French works were commissioned, as were many new translations of Latin texts. Another step, of both material and psychological importance, was that already taken by Charles's father in 1360, the establishment of a strong national currency, the stable gold franc.

Charles V's franc gave a new prominence to the *fleur de lys* on both obverse and reverse, and Charles also drew a new attention to another national symbol, the battle banner, the

(facing page) 156 South transept facade, Beauvais Cathedral, designed by Martin Chambiges, begun 1499

(left) 157 Charlemagne receiving a standard from St Peter, mosaic, c.800, later over-restored, Triclinium of Pope Leo III, Lateran Palace, Rome

(above) 158 Battle of Roosebeke (1382), illumination on parchment, in a manuscript of Jean Froissart, *Chroniques*, c.1412–15. Pierpont Morgan Library, New York, Purchased through the Lewis Cass Ledyard Fund, 1938, Morgan M.804 Chroniques, fol. 338r

Oriflamme. Both emblems were written about by scholars at his court, especially Raoul de Presles who elaborated on earlier accounts to make them both gifts from God on the occasion of Clovis's conversion and victory at the Battle of Tolbiac (496), so charging both with sympathetic magic.[26] All texts exalted their authority, with different stories making the *fleur de lys* originate in a flaming lance in the hand of either Clovis or Charlemagne.[27] Etymologically, Oriflamme seems to derive from the Latin and French for 'gold' and 'flame' and, from illustrations in manuscripts and descriptions, it appears to have been an elongated rectangle, bearing golden, flame-like decorations and ending in two to five fluttering, equally flame-like, triangles. The separate existence of the two emblems is not clear until the time of Suger, but they are anticipated in a mosaic of around 800 in S. Giovanni

in Laterano, Rome, where Charlemagne is shown receiving from St Peter a lance with a *fleur de lys*-like point from which flutters a banner (fig. 157).[28] Charles V enhanced the power of the *fleur de lys* by changing the design on his own shield, replacing the so-called *semis* display of many small flowers with three strong, aggressively pointed shapes. This is how it is shown on the surcoat of his son Charles VI in a manuscript illumination of the Battle of Rosebeke (Roosebeke or Westrozebeke, 1382; fig. 158). There it is prominently accompanied by the Oriflamme because it was the unfurling of that banner that had dissipated the fog by which the Flemish enemy had been concealed. This was evidently due to the heat of the flames implicit in the banner's name and perhaps expressed in its flickering sihouette. These divinely appointed emblems continued to be of great psychological

importance even, as we can tell from the text of Noel de Fribois, in 1459. In order to make people conscious of the condition of France, he imagines her as 'all dishevelled, torn, squandered, wasted and undone', but to rebuild national morale he urges 'good, true, Frenchmen of the kingdom' to think of the *fleur de lys*.[29] The French are thus likely to have contemplated the *fleur de lys* and the Oriflamme with the same pleasure as the English did their longbow and arrows, with similar consequences for their neural networks. Their curves would have become as attractive to the French as the straight line to the English.

Formation of an unconscious preference for double curves would have been encouraged by the conscious use of the *fleur de lys* in tracery. The idea for this may well have come from Jean, Duc de Berry, who would have seen Decorated tracery while a hostage in London and who may well have developed a taste for its forms, especially when they suggested lily shapes.[30] This experience may then have provided the inspiration for the tracery that he installed in the palace at Poitiers in 1388 after the city was retaken from the English (fig. 159). The three great tracery *fleur de lys* on the end wall triumphantly celebrate France's restoration after the shame of the Poitiers defeat, their expressive potential being enhanced by their unusual placement above three great fireplaces, where they also evoke flames such as might destroy the enemy's wooden weapons. Equally significant is the tracery in the windows of the residential part of the palace. This gives prominence only to the lily's central element, the *soufflet*, which may well derive its expressive authority from the identification of the central bud of the lily with the point of a spear, as anticipated in the Lateran mosaic. If this was so it would have allowed the French to get as much of a military frisson from their tracery as their enemy did from theirs. It would also explain why the duke used the same form prominently in the chapel of his palace at Riom in the Auvergne (*c.*1395–1403; fig. 160), and why it was taken up in the fifteenth-century completion of the chapel that Charles V had begun at his great Château de Vincennes, where it is linked with clear *fleur de lys* in the crowning balustrade (fig. 162). Confirmation that these usages of Flamboyant forms are associated with royal policy is found in the buildings of Jean de la Grange, first in the chapel he installed in Amiens

159 Fireplaces and windows in the Great Hall, 1380s, Palace of Jean, Duc de Berry, Poitiers

Cathedral while bishop there in 1373–5, and then in the church of St Martial which he erected in Avignon in 1380 following his elevation to a cardinalcy attached to the papal court. La Grange was a close councillor of Charles V and later an agent of the Duc de Berry, filling his own tomb in St Martial with statues of the French royal family to celebrate this association.[31]

Following these co-ordinated initiatives of the Duc de Berry and Cardinal de la Grange, the triple form of the *fleur de lys* gained in visibility. In the window onto the street of

160 South window, 1390s, Sainte-Chapelle, Riom, Auvergne

161 Detail of interior gallery, Abbey Church, Mont St Michel, Normandy, rebuilt after 1446 as intended seat of the Order of St Michael

the great chapel of the palace built by the merchant Jacques Coeur at Bourges (1443–51), it proclaims his loyalty to the French royal house, while at Mont St Michel (fig. 161), rebuilt from 1446, it witnesses the Mont's resistance to an English siege and recalls Louis XI's plan to make the church the home of a new national Order of St Michael. Louis also associated *fleur de lys* tracery with explicitly national propaganda in the stained glass he presented to the Lady Chapel of the Cathedral at Evreux in 1467–9. But the greatest celebration of the *fleur de lys* was in a series of grand facades, each of which couples a balustrade made up of a row of *fleur de lys* with a rose window composed of shapes that should probably be understood as replications of its central element,

the spear point/bud. Besides the new front that Charles VIII (ruled 1483–98) gave to the Sainte-Chapelle in Paris (*c.*1490), these include the transepts of the cathedrals of both Beauvais (1499; see fig. 156) and Senlis (1521–34). The balustrade at Beauvais (fig. 163) is particularly revealing because it exploits separately both the whole *fleur de lys* and its central more weapon-like element, thus confirming the authority of both. Within this series the prominent early use of the *fleur de lys* form in St Maclou, Rouen, begun in 1432, may seem puzzling, since the English were then briefly in control of the city, but, given that the English king also claimed the emblem, its introduction could hardly have been frowned on. The principal patrons, the Dufour family, who were

162 Detail of south side, Sainte-Chapelle, begun 1379, Château de Vincennes

highly opportunistic, may also have been correctly anticipat-
ing the return of French power.[32]

Another element that may have contributed to the French
taste for forms that came to be called *flamboyant* was provided
by the way flames and the destiny of France were linked
through the burning of Joan of Arc at Rouen in 1431. When
the French saw their heroine dying in flames they may well
have remembered the instrument that enabled the Maid to
raise the siege of Orleans in 1429. It was fire that came to
Joan's aid when she led the attack on the most threaten-
ing English siege bastion, and it was fire that consumed the
English camp, *divino nutie*, 'with divine approval', as the con-
temporary writer T. Basin declared in his *Histoire de Charles*

163 Balustrade, south transept, Beauvais Cathedral, begun 1499

VII.[33] With good reason it was decided, as Basin relates, to give thanks every year afterwards for the 'divine aid'. The symbolic significance of this turning point in the hundred-year conflict was further brought out by his next comment: 'From this time onward the somewhat blunted tip of the English arrows could no longer penetrate'.[34] His emphasis on the role of fire in French victory reminds us of what was said earlier about the psychological appeal of a 'flaming' architecture to a community that feared wooden weapons above all. Whether or not this increased the attraction of the new style, the symmetry Basin sees between French flames and English arrows resonates well with the symmetry we have proposed between Flamboyant and Perpendicular.

French Firepower

The *fleur de lys*, the Oriflamme and flames all played their part in French resurgence, but a more decisive role in the ejection of the invaders was taken by gunpowder and the new technology of firearms. After the English abandonment of Paris in 1436, Harfleur fell thanks to 'amazing mortars in large numbers',[35] and that success was repeated elsewhere.[36] Soon, Charles VIII was so well equipped that he was able to march, mostly unimpeded, up and down the Italian peninsula. The proudest beneficiary, though, of French firepower was Francis I (ruled 1515–47), who probably celebrated it in his most famous emblem, the salamander (fig. 164). This lizard's dark skin with yellow spots led people to think that it thrived in fires and Francis, when still a prince, took it as his emblem on a famous medal of 1504.[37] There the salamander

165　Gateway to Arsenal, Compiègne, 1623

164　Salamander emblem of Fancis I, detail of stained-glass window, early sixteenth century, Sainte-Chapelle, Château de Vincennes

is shown couched in flames and surrounded by an inscription meaning: 'I am nourished by the good fire and I extinguish the bad', and later the salamander figures prominently on many of Francis' buildings. Often, as on the facade of the French church in Rome, S. Luigi dei Francesi (begun 1518), it is shown in a new guise, with flames actually issuing from its mouth, and it has been well argued that this is an allusion to the monarch's fondness for artillery, to which indeed he owed his famous early Italian victory of Marignano (1515), as shown in reliefs on his tomb in the Abbey of St Denis.[38]

On those reliefs the rows of canon look much like a row of horizontal columns, and the neural networks formed by exposure to the one cylindrical form must often have been activated by the other. Whether or not Francis was in the

habit of seeing canons when he saw columns, the designer of the lost gate of the Royal Arsenal of Paris (1584), which served as the model for that at Compiègne (1623), must have done so, since what look from a distance like Classical columns turn out on inspection to be the vertical barrels of guns (fig. 165). If Francis himself could see canons as columns, perhaps he could also see columns as canons? If so, his love of artillery may lie behind his passion for that cylindrical architectural form, which culminated in the use of columns in the central bays of his courtyard at the Louvre (1546). Contemporaries elsewhere in Europe who had a similar experience of the power of artillery may have had a similar unconscious response. In which case the adoption of Classical columns across the continent may have been accelerated by the fact that for many they activated the same visual neural networks and neurochemistry as canon.

12

Italy 1300-1600
Cities and Styles

For Italy from the fourteenth to sixteenth centuries there already exists a neural approach to the explanation of stylistic difference in the concept of the 'period eye'.[1] When Michael Baxandall published the idea in 1972 he became the first person to seek to develop a framework for the study of art that was based on a knowledge of the brain, and his discussion of such variation in terms of variations in the 'human equipment for visual perception' directly anticipates the approach adopted here. The only difference, and a crucial one, was his emphasis on the way such variations were the result of training and involved a conscious effort on the part of the individual involved. Still, his approach – which was natural considering that the study of the Renaissance focused particularly on the role of education in the shaping of a new self-consciousness – did present scholars with a vital new set of tools. If you wanted to know why a patron had commissioned a particular type of art you only had to ask yourself what had been particular to his education. One reason this seemed a sensible method to pursue was because, if you were to have asked the patron himself, he might have given the same answer, or at least would have been likely to assent to yours.

Neuroarthistory and the 'Period Eye'

Neuroarthistory, as outlined in the present volume, accepts and includes such an approach, but, following Elisabeth de Bièvre's example in her book *Dutch Art and Urban Cultures, 1200–1700*, supplements Baxandall's study of neural formation that is the result of active and conscious mental activity with a consideration of neural formation that is the result of exposures that are passive and non-conscious. Since the most important of such exposures for an individual's neural

formation were often those driven by visceral concerns, it is about these that we are asking, not about their education.

An example of the way this approach changes our understanding of culture is provided by the way it changes our view of the movement that we call the Renaissance, or 'rebirth', putting the emphasis not on its intellectual achievement but on its visceral origins. Viewed from this perspective the Italian Renaissance owes its urgency and power, which are as much its distinguishing attributes as is book learning, to the same patriotic and nationalist drives as the architectural trends of Perpendicular and Flamboyant, which manifested themselves at exactly the same period in northern Europe.[2] Indeed, in the field of architecture, the visceral origins of the Renaissance are clearly apparent, since it was the 1402 attack on Florence by the Visconti duke of Milan, as the representative of the German emperor, that inspired Brunelleschi to develop a new Florentine style. The recent ostentatious Visconti sponsorship of a gigantic new cathedral in Milan (1386) in the alien northern style that we now call Gothic made it pressingly desirable to shun the pointed arches and rib vaults then being used in Florence's own Duomo (begun 1296) and look again, intensely and repeatedly, at the pre-Gothic buildings known as Tuscan Romanesque.[3] It was an intense visual engagement with the cylindrical columns and Classical capitals, the pediments and entablatures, the round arches and domes of the Florentine Baptistery and other structures that shaped the neural resources that guided his hand as he designed such structures as the Innocenti Hospital or the churches of S. Lorenzo and S. Spirito. Brunelleschi's architectural style was as 'nationalistic' as the styles of contemporary England and France, its conception having been driven by similar forces.

The situation with Italian Renaissance painting and sculpture was not as clear-cut. Those arts had started to change earlier, under the influence of pressures less violent than the arrival of a Visconti army at the gates of Florence. The basic drive, though, was similar in nature – a desire, in the face of French cultural and political domination, to recover an Italian pride lost since the Fall of Rome in 410. We can feel that desire in Giotto's paintings and the sculptures of the Pisanos, as we can feel it in the writings of Dante, Petrarch and Boccaccio. Indeed, it is most obvious in the works of the last three, because they signally avoided the French language then becoming fashionable in Italy in favour of the local Tuscan dialect, which was closer to the language of the ancient Romans.

This nationalistic consciousness that was driving the new trend in Italian art is evident in the early fifteenth century in the writings of the artist Cennino Cennini, who tells of how Giotto changed painting from Greek (that is Byzantine) to Latin,[4] and in Raphael's letter a hundred years later claiming that Bramante had brought architecture back to the level of the ancient Romans after its degradation under the Goths.[5] It is most clearly expressed, though, in the *Lives of the Artists* (1568) by Giorgio Vasari, where it acquires a distinctive local emphasis through the celebration of those from his native Tuscany, especially Leonardo and Michelangelo. Vasari also crucially defines the Tuscan artistic achievement in terms of its pre-eminence in *disegno*, 'drawing', a point of view that provoked the Venetians Paolo Pino and Lodovico Dolce to play down *disegno* in favour of the broader effects of *colore* achieved by their countrymen, especially Titian. The critical writer Pietro Aretino, in Dolce's *A Dialogue on Painting* (1557), further focuses the opposition when he says that painting consists in the imitation of nature using 'lines' and 'colours'.[6] People sensed that Florentine painting concentrated on the former and Venetian on the latter. What they were unaware of was that in both cases the preference had its origin in passive neural exposure to the environment.

Florence and *Disegno*

The extent to which this was true in the case of Florence is well illustrated by the rise of one-point perspective. This appears quite suddenly in that city in the decades after 1400, and soon becomes a feature of much of the painting and sculpture produced there (see figs 168 and 170). Why? Or, more pointedly, why did a device first found in Greece reappear in Florence in the fifteenth century rather than in another place at another time? In answering that question we may begin by reminding ourselves how its first appearance in ancient Greece was explained. The argument then was built on an understanding of the principles governing neural

plasticity. As the Greeks built more and more rectangular buildings with walls constructed in coursed stone masonry, they were exposed to more and more receding orthogonals, and as a result acquired an ever greater preference for configurations in which receding lines were convergent (see figs 73–6). The same principles help to explain the decline of perspective under the Roman Empire. As wall surfaces came to consist more and more of concrete, faced at different times with 'irregular' *opus incertum*, 'net-like' opus *reticulatum*, brickwork and figured marble slabs, and as more curved lines were used in plan and curved surfaces in elevation, there was little to nourish a neurally based preference for convergence. Paintings using one-point perspective continued to be made because both painters and viewers were neurally prepared to expect it by their exposure to the work of earlier Greek masters, but with time perspective became increasingly vestigial, especially after the end of the Roman Empire and the interruption of tradition (see figs 102 and 103).

A good way of testing this explanation for the first emergence of convergent perspective is to ask where and when, applying the same principles, we would expect one-point perspective to reappear. If we do so, our answer must be where, as economic life in Western Europe recovered, many rectangular buildings were once again constructed in coursed-stone masonry. We can exclude most places. Rome was full of ruins. Siena had much new construction in stone, but masonry was not obviously coursed; besides, most streets and the main piazza were curved. Venice had many new buildings, but these were mostly faced in brick and veined marble, and the city's main artery, the Grand Canal, was serpentine. Cities in northern Italy, such as Milan or Bologna, and those in the Low Countries, such as Ghent or Bruges, were full of new rectangular buildings, but these were usually built of brick. Their weak receding orthogonals generated an emergent preference for converging effects in local painters, but no full convergence.

In only one city, Florence, were enough of the conditions we found in Greece recreated to shape a similar preference for convergence, and not as part of a slow general trend. In Florence the reasons for their re-emergence were essentially political. During the thirteenth century the German Emperor Frederick II made extensive use of the coursed

166 Masonry on the side facade of the Palazzo Vecchio (originally Palazzo della Signoria), begun 1297, Florence

stone masonry that the Romans had used for fortifications in the castles that were the prime expression of his role as heir to Roman authority. This provoked the Florentines, in their resistance to him as a foreign overlord, to employ a similar masonry in their Palazzo della Signoria (later the Palazzo Vecchio) of 1297 (fig. 166). There it served as an expression of their independence as heirs to a Roman tradition that was not Imperial but Republican. It was because of the positive associations of coursed stone masonry as an emblem of their Republicanism that they then went on to adopt it for more and more buildings during the great boom of the fourteenth century. They began with those along the streets leading from the main Piazza della Signoria, and continued with more and more buildings, especially those in high-profile locations. The result was unintended but decisive. As the fourteenth century advanced, the Florentines

acquired neural resources that were more and more differentiated from those found in other populations, not just in Italy, but throughout the world, resources that gave them an increasing preference for configurations in which receding orthogonals were convergent. In Brunelleschi, born in the city in 1378, the preference would have become over-riding.

Of course, it is one thing to have an over-riding preference. It is quite another to use that as the basis for the formulation of a new system of representation, as Brunelleschi did. What empowered him to take that step were other elements in his neural formation, elements that resulted from those conscious and active mental processes studied by Baxandall. These included both his general intellectual training as a lawyer's son, relatively well educated in mathematics, and his particular personal interest in architecture, which was an extension of his activity as a goldsmith and sculptor, stimulated in part by his ambition to complete the dome of the city's new cathedral. It was the degree of interconnection in Brunelleschi's neural resources between those passively formed by visual exposure and those actively formed by education that enabled him successfully to articulate the rules that were soon presented in texts by two other Florentines, first Alberti in his *De pictura* (1436) and then Filarete in his *Trattato* on architecture (*c*.1460).

The circulation of these texts was critical for the wider dissemination of the practice of linear perspective, but more important for its initial establishment in Florence was the fact that all Brunelleschi's fellow citizens of his generation, having shared a similar passive formation, shared similar visual preferences. This applied to the Florentine artists who first took up his system, Donatello, Ghiberti and Luca della Robbia, and it also applied to the most prominent patron of the work that exploited perspective, the banker Cosimo de' Medici. Someone it did not apply to was Masaccio (1401–28), the painter generally agreed to have played the principal role in applying the system. He did not grow up in Florence, and so would not have benefited from that exposure, but his birthplace, S. Giovanni in Valdarno, fifty kilometres up river, was in some ways just as propitious (fig. 167). Founded in 1396, the same period as the Palazzo della Signoria, it was a contemporary expression of the same values. One of several grid-plan cities built to defend Florence against threatening enemies,

167 Plan of the town of S. Giovanni in Valdarno, Tuscany, founded 1299

it was also much the biggest. It thus had a groundplan containing more and larger, and more regular, rectangular streets and piazzas than any other town, including Florence, and, although it had few buildings in expensive coursed stone masonry, because of its layout it offered a surfeit of receding orthogonals. This means that when Masaccio arrived in Florence, his neural resources would have been primed to respond to the numerous smaller scale receding orthogonals offered by its street facades. Reinforced in this way they facilitated his exploitation of Brunelleschian perspective in the frescoes of the *Life of St Peter* in the Brancacci Chapel in the Carmine and the *Trinità* in Sta Maria Novella, where we can sense the city's impact on him in the scene of *St Peter healing the Sick with his Shadow* (fig. 168) with its celebration of both coursed stone masonry and receding orthogonals.

Perspective is only one aspect of a much broader local preference for the linear, which can be seen to have roots in other aspects of Florentine architecture. Because of accidents of geography and geology the city had better access to a wider variety of stone than any other city of Italy, and its inhabitants thus made greater use of these materials. The quarries that yielded the relatively cheap stones of which most of the city was constructed, the coarse brown *macigno* and the more fine-grained grey *pietra serena*, were close by in the surrounding hills. The finer marbles were easily brought up the Arno river, green from neighbouring Prato and white from Carrara on the coast. Lavish exploitation of these resources meant that Florentines were everywhere exposed

(left, top) 168 Masaccio, *St Peter healing the Sick with his Shadow*, c.1424–5, fresco, Brancacci Chapel, Sta Maria del Carmine, Florence

(left) 169 Marble panelling, south side of Florence Cathedral, begun 1296

(above) 170 Sandro Botticelli, *St Augustine in his Study*, c.1480, fresco, Ognissanti, Florence

to lines, the lines that outlined buildings and sculptures and the lines that constituted the main ornaments of the marble panelling that covered the most prominent buildings, the Baptistery, S. Miniato al Monte and the Cathedral above all (fig. 169). Looking at the forceful sculptures of Arnolfo di Cambio, the clear, expressive, silhouettes of Giotto's painted figures and the refined fretwork of marble inlay and relief of the Campanile gave artists and patrons of fourteenth-century Florence a taste for ever stronger linear configurations,

and this was consolidated as people were exposed to more and more works of art reflecting those influences. Out of this neural formation emerge the sculptures of Verrocchio, the paintings of Botticelli (fig. 170) and the architecture of the San Gallos in the fifteenth century and the works of Michelangelo, Bronzino and Vasari himself in the sixteenth.

Venice and *Colore*

It is easier to identify the principal factors behind the visual preferences of Venetians than those of members of other communities, partly because one element of the environment, water, was so predominant, and partly because there was a chance correspondence between the visual properties of water and the artefacts to which Venetians had privileged access from their position on the Adriatic. Water was not only omnipresent, filling most of the spaces between the buildings, it also had an even more visceral importance for them than for other communities (fig. 171). It provided them

with a natural protection from attack and a natural opening for long-distance travel and trade, especially with the East. To which it can be added that by mirroring shifting skies and unstable weather the water reflected and animated the Venetians' hopes and fears for success in such maritime enterprises. Besides, eastern travel brought them into contact with Byzantium, with which they had had close contact since the eleventh century, with its buildings covered with veined marble and glass mosaics, and eastern trade brought familiarity with shiny oriental silks and cotton damask, named after Damascus. Neural networks already tuned to shifting colours and reflections became ever richer, sustaining sensibilities and discriminations that were ever more sophisticated.

The conclusions that follow are not new. Recent writers have stressed the importance of factors such as the particular opportunities for trade, the differential availability of materials, the dependence of the city's life on water and weather. Paul Hills has discussed Venice's watery aesthetic[7] and Deborah Howard has detailed the influence on the city of the art of the Middle East.[8] What neuroscience can

171 View of the Grand Canal at evening, Venice

offer is a greater understanding of the organic process by which a nexus of factors – political, economic and environmental – contributed to the formation of distinctive neural resources that then led to the production of a distinctive art. Thus, the original impulse behind the introduction of glass mosaics to the city was predominantly political. The Byzantine emperors had always sought to keep a foothold at the top of the Adriatic and, when St Mark's was rebuilt in the eleventh century, by employing Byzantine artists Venetians could present themselves as their heirs. Similarly, it was political and economic opportunism that caused Venetians to take a leading role in the Sack of Byzantium in 1204 and bring back as booty many of its treasures, especially marble slabs, metalwork and textiles. But it was prior environmental exposure that endowed Venetians with neural resources ensuring that such objects gave them pleasures greater than they would have given to others, and it was to be those neural resources that would increasingly shape Venetian taste in the following centuries, in a process that only accelerated as commercial preoccupations continually sharpened their eyes.

After 1100 the expansion of craft production and trade meant that the visual neural resources of the members of most European urban communities were increasingly shaped by their exposures to different types of goods, and this was particularly true of Venice, where the number of high-quality artefacts was exceptional and the choice wide. The increasing frequency and intensity of visual engagement meant that the neural networks of thirteenth-century Venetians would have been more affected by what they looked at than those of their predecessors would have been, and the same was even more true of those of their fourteenth- and fifteenth-century successors. As glass mosaics covered more and more of both the interior and the exterior of St Mark's, and as more and more sheets of veined marble were brought back from the ruined Roman cities of the eastern Mediterranean to adorn not just St Mark's (fig. 172) but many of the city's palaces, the neural resources of the citizens of the lagoon nurtured ever stronger tastes for reflections, unstable colours and wavy patterns. Those tastes affected the choice of all types of artefacts, both those in which they traded and those they produced. Glassware, silks and other shiny fabrics were among the luxury goods

172 Marble panelling, Treasury, 13th century, St Mark's, Venice

that most appealed to Venetians, and the more intently and frequently they looked at them, the more the taste for the visual properties of such objects increased. Glass production expanded rapidly, especially after 1291, when it was excluded from the city proper and concentrated in Murano (fig. 173). So too did the production of luxury fabrics.[9] Both trends intensified after the Fall of Constantinople (Byzantium) to the Turks in 1453, which brought a new wave of immigrant merchants and craftworkers, while technical developments internal to the Venetian industry also had knock-on effects. For example, the invention of more transparent *cristallo* glass

173 Glass bowl decorated with fish-scale pattern, 1475–1500, Murano glass, 7.1 × 22.2 cm. The Metropolitan Museum of Art, New York, Gift of Julia A. Berwind, 1953 (53.225.101)

174 Giovanni Bellini, *Doge Leonardo Loredan*, 1501–2, oil on panel, 61.6 × 45.1 cm. National Gallery, London

175 Titian, *Assumption of the Virgin*, 1516, oil on panel, 690 × 360 cm. Basilica of Sta Maria Gloriosa dei Frari, Venice

by the glass-maker Barovieri around 1450 encouraged the more widespread use of glass, as in windows, which necessarily increased the taste for transparent reflective surfaces (see fig. 171). At the same time, the development of new dyes for the textile industry encouraged a special interest in colours, so that by the late fifteenth century these were sold not as elsewhere by apothecaries, but by specialist *vendecolori*, so heightening an interest in colour throughout the community.[10] The unique Venetian concentrations on transparency and colour in the years before 1500 led to the formation of neurally based preferences that were unique. These had profound implications for the development of art. They ensured that Venetians took more pleasure than did people from other cities, such as Florence, in the new technique of oil painting, recently developed in Flanders, with

its ability to capture reflective surfaces, and this allowed new and fruitful collaborations between painters and patrons, of which the use of the medium by Giovanni Bellini (*c.*1430–1516) to capture the refulgent brocades of the costume of Doge Loredan (1501; fig. 174) is exemplary.

Bellini was born in Venice, unlike Giorgione and Titian, who both came from the countryside, Giorgione (1477/8–1510) from the plain and Titian (*c.*1488–1576) from the hills, but both were young enough when they arrived in the city to be intensely engaged by the Venetian environment and to sense its affinity for the oil technique. Most innovative was their response to clouds and humidity in the atmosphere generally, as we see in Giorgione's *Tempesta* (1506–8) and many paintings of Titan, including his *Assumption* in the Frari (1518; fig. 175) and the Ancona Altarpiece (1520).

Titian's clouds and mists are full of shifting forms and when he and other Venetian artists sought to capture their softness on paper they found powdered chalk best suited to their purposes, rarely giving the hard line of pen and ink the importance it had in Florence.

Verona and Clarity

One of the artists who was closest to Titian was Paolo Veronese (1528–1588). He shared Titian's interest in colour and fondness for chalk drawings, but his paintings have a different tone, being lighter, brighter and more limpid in atmosphere (fig. 176). These qualities can all be traced to his birthplace, Verona, and are indeed shared by earlier artists from that city, far different from Venice in its architecture and atmosphere. Situated where the Adige river issues from the rocky massif of the Alps, Verona under the Romans had acquired an imposing architectural fabric of white limestone and marble, a set of buildings that were the most eye-catching ancient structures in Italy outside Rome. One reason for their survival and excellent preservation was that, unlike many buildings in the city on the Tiber, they relied in their structure and ornamentation on the use not of imported materials that tempted the looters, but local stone. Thus, while in Rome fluted marble columns had largely been moved inside churches, leaving few such supports outside, in Verona many structures with straight and spiral fluted columns accompanied by their apparatus of entablatures and pediments were still available as objects of attention for everyone (fig. 177). To be brought up in Verona was thus to have your neural networks critically shaped by exposure to white stone and richly carved details within the city and great outcrops of exposed rock outside.

It was these exposures that shaped the style of artists such as Liberale da Verona, Falconetto and Francisco Morone before it shaped that of Veronese. In Liberale's miniature of *St Martin and the Beggar* (Siena Cathedral; 1460s), the horse, and even the clouds, seem to be made of the same material as the rocks behind, while both the body and shroud of Christ in his Munich *Pietà* of about 1490 share similar crystalline properties. Again, Liberale's *Dido's Suicide* (National

176 Paolo Veronese, *Mystic Marriage of St Catherine*, c.1575, oil on canvas, 337 × 241 cm. Gallerie dell'Accademia, Venice

Gallery, London; early sixteenth century) has similar properties with the *Augustus and the Sibyl* (Verona; 1509–17) of his pupil Falconetto, illustrating how living in proximity to an ancient Roman theatre on what was effectively a Roman stage encouraged the imagination of Roman scenes of remarkable authenticity.

No artist, though, gives a clearer demonstration of the abiding influence of the city's environment on its inhabitants than the painter who bears its name. Like that of his architect compatriot, Michele Sanmicheli, Veronese's head

177 Arco dei Gavi, 1st century AD, Verona

Mantua and Mists

An artist who grew up in a city close to Venice, Padua, and worked briefly in Verona before moving to the Gonzaga court in Mantua was Andrea Mantegna (*c.*1431–1506). A highly demanding subject for a neuroarthistorical enquiry, his art was profoundly shaped by contrasting exposures in the fields both of art and nature. Brought up in a university city, rich in Classical antiquities and antiquarians, and married to a Venetian, the sister of Giovanni and Gentile Bellini, his early art reflects both influences or, as the neuroarthistorian would say, is the product of both exposures. Since Verona shares with Padua a Roman past it is not surprising that the great altarpiece that Mantegna painted for the church of S. Zeno in that city in the mid-1450s reflects this impressive heritage. Nor is it surprising that when Mantegna moved on to Mantua the works that issue from his brush bear witness to new visual experiences. The atmosphere of his new home, as he represents it in the background of the *Death of the Virgin* (fig. 178), was profoundly affected by the humidity generated by its surrounding shallow lakes, which made Mantua even more susceptible to mist than the

178 View of Mantua in the background of Andrea Mantegna, *Death of the Virgin*, *c.*1462, tempera on panel, 54.5 × 42 cm. Museo Nacional del Prado, Madrid

was still full of the fluted white marble columns of his birthplace, even when working in Venice, where other colours, materials and forms were salient. Hence the prominence of such forms in both Veronese's *Mystic Marriage of St Catherine* altarpiece (see fig. 176) and Sanmicheli's Palazzo Grimani on the Grand Canal. The childhood memories of the distinctive architecture of their native city were so strong in the brains of both painter and architect that their influence on the designs coming from their hands was much greater than that of the more glamorous buildings of their new working environment. Verona's general location where a rocky valley issues from mountains into a plain also plays a role in the formation of their styles. Its site has much in common with that of Florence and it is not surprising if this also encouraged a 'Florentine' linearity of style.

rest of the Po valley. Condensation could be so thick that in 1509 a favourite Gonzaga daughter, Leonora, on leaving the city with her entourage for her marriage to the Duke of Urbino, immediately lost her way in the fog.[11]

The same conditions could also affect an artist's style. If one was looking for evidence of such an impact on Mantegna one could point to the difference between the clouds in the predella of the S. Zeno Altarpiece and those in his *St Sebastian* (fig. 179), usually dated to about 1459 just as he entered the Gonzaga service. The first are petrified like those in Liberale's *St Martin*, the latter soft and vaporous. His vision of a horseman in the cloud in the *St Sebastian* was almost certainly the product of Apocalyptic fears provoked by the recent Fall of Constantinople, but more relevant to this enquiry is the way the cloud may relate to Mantegna's new natural environment. Being habituated, since his youth in Padua, to looking at images in Roman white stone reliefs, he would have found it easy to see them in Mantua's clouds. The vaporous environment of Mantua also inspired others to see apparitions in the heavens and one was Mantegna's contemporary, the devout Gonzaga relative, Beata Osanna Andreasi. Among her most famous visions were those of Christ and an angel, which were captured in 1519 in a painting by Francesco Buonsignori commissioned by Isabella d'Este, the wife of Mantua's then ruler, Francesco Gonzaga. The dependence of the visions on the local humidity is evident from the way both figures not only stand on clouds but also seem to be made of nebulous material. Mantegna himself had already painted a similar secular vision for Isabella, *Minerva expelling the Vices* (1502; fig. 180). There, the Virtues are seen riding on the clouds on the right while, on the left, the clouds themselves become transformed into faces, perhaps as winds aiding the cleansing work of Pallas below, while in a similar fashion the neighbouring rocks seem to dissolve into forms that are cloud-like. Not only were mists and clouds a predominant influence on the neural networks of people in Mantua, but they also had such an effect on their perceptual habits that they became the vehicles of powerful fantasies.

179 Andrea Mantegna, *St Sebastian*, c.1459, tempera on panel, 68 × 30 cm. Kunsthistorisches Museum, Vienna

180 Andrea Mantegna, *Minerva expelling the Vices from the Garden of Virtue*, 1502, oil on canvas, 159 × 192 cm. Musée du Louvre, Paris, RF1975-8

Clouds also seem to have acquired positive associations with the 'heavenly', a notion that would have been highly attractive to the city's rulers. Evidence that the Gonzagas had in the fifteenth century started to take pride in their vaporous environment is provided by Mantegna's witty introduction of a puff of cloud at the centre of the oculus of the Camera degli Sposi (*c.*1470) in the Palazzo Ducale, with its great dynastic celebration below.

These positive associations acquired by clouds in Mantua are confirmed by their role in the paintings of Giulio Romano (1499–1546), who was invited to the city by Franc-esco's heir, his son, Federico II (1500–1540). As in the case of Mantegna, once Giulio arrived from Rome, where he had been brought up surrounded by a different atmosphere and a different architecture, clouds immediately, and for the first time, take on a powerful and positive role. In his most ambitious work, the Palazzo del Te (1524–34), they fill the ceilings. This is most clear in the Sala di Psiche (Psyche) where, in contrast to the clear blue aether of the Loggia of the same subject in the Villa Farnesina back in Rome, on which Giulio had been working with his teacher Raphael a few years earlier, the skies are now full of billowing masses

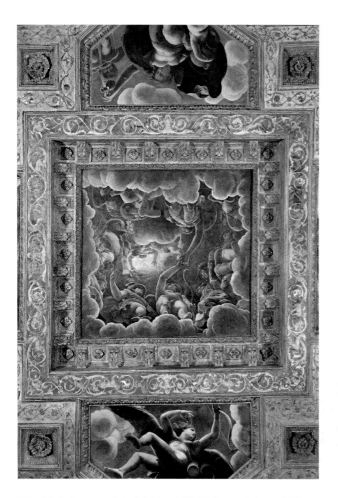

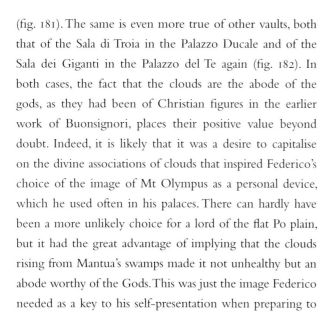

181 Giulio Romano, Sala di Psiche, 1520–22, fresco. Palazzo del Te, Mantua

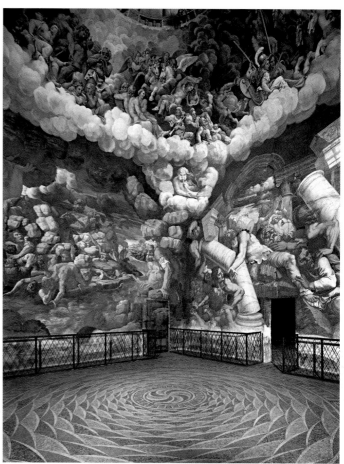

182 Giulio Romano, Sala dei Giganti, 1520–22, fresco. Palazzo del Te, Mantua

(fig. 181). The same is even more true of other vaults, both that of the Sala di Troia in the Palazzo Ducale and of the Sala dei Giganti in the Palazzo del Te again (fig. 182). In both cases, the fact that the clouds are the abode of the gods, as they had been of Christian figures in the earlier work of Buonsignori, places their positive value beyond doubt. Indeed, it is likely that it was a desire to capitalise on the divine associations of clouds that inspired Federico's choice of the image of Mt Olympus as a personal device, which he used often in his palaces. There can hardly have been a more unlikely choice for a lord of the flat Po plain, but it had the great advantage of implying that the clouds rising from Mantua's swamps made it not unhealthy but an abode worthy of the Gods. This was just the image Federico needed as a key to his self-presentation when preparing to

receive his feudal superior, the Emperor Charles V, in 1530. The mists and clouds of Lombard Mantua not only reconfigured the neural networks of those who spent time there but also affected those networks in such a way as to allow artists and patrons to create a new order in which the mobility and indeterminacy of clouds made them emblems of a power that was transcendent.

Giulio's interest in clouds and mists also affected his approach to architecture. If the mists that all too often wreathed the Gonzaga palaces were tokens of a divine presence, what better than to cover those same buildings with a permanent cloud-like cloak? Nothing in Giulio's, or indeed anyone else's, earlier work prepares for such extraordinary phenomena as the rusticated vaulting of the Cortile della Cavalerizza or the fur-like coating on the columns in the

183 Columns designed by Giulio Romano, 1524–34, in the vestibule of the west entrance of Palazzo del Te, Mantua

entrance of the Palazzo del Te (fig. 183), nothing, that is, except the top left of Mantegna's *Minerva expelling the Vices*, where stone crags dissolve and join the clouds in their crusade. It is possible that Giulio's introduction of what should probably be called not rustication but 'cloudification' was the result of a purely conscious decision, but few artistic decisions are purely conscious and in this case we can reconstruct the neural formation that would have unconsciously prepared for this brilliant invention. Giulio, unlike virtually all contemporary artists, was born in Rome, as his name indicates, and so had been brought up surrounded by the crumbling, and largely white, travertine ruins of the ancient city, some of them like the great Porta Maggiore making extensive use of rough, unfinished stonework. Looking at such works with admiration would have endowed him with unique neural

resources, giving him a preference for rough white shapes. When he arrived in Mantua these resources would have been immediately activated by its fogs, helping him to experience them as a travertine-like covering on the city's predominantly red-brick structures. It would then have been these resources that unconsciously guided his pen as he designed Federico's rustication-clad buildings, something particularly natural, considering that when the rustication was applied in the form of moist white plaster, as it usually was, it would even have shared with fog some physical properties.

That water vapours acquired uniquely positive associations in Mantua is confirmed by another work made for Federico in connection with the visit of Charles V, Correggio's painting of *Jupiter and Io* (1533; fig. 184). The cloud into which Jupiter turns himself so that he can consummate his

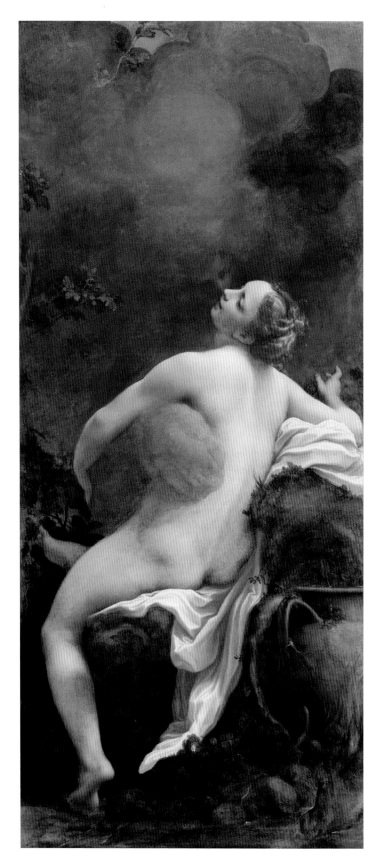

(left) 184 Antonio Allegri da Correggio, *Jupiter and Io*, 1533, oil on canvas, 163.5 × 70.5 cm. Kunsthistorisches Museum, Vienna

(above) 185 Antonio Allegri da Correggio, *Vision of St John the Evangelist*, 1520–22, fresco, 969 × 889 cm. S. Giovanni Evangelista, Parma

passion for Io is extraordinarily realistic and the way the god's face emerges from the vaporous substance recalls the cloud faces in Mantegna's *Minerva expelling the Vices* (see fig. 180). Since the painting was commissioned by the Gonzaga duke in the same years that he was installing the cloudy columns in the entrance of the Palazzo del Te, built as a love nest where he could consummate his own passion for his mistress, both rusticated column and cloud-god are products of the same world. Both are expressions of Federigo's own identity as a sex-mad cloud-god living in a foggy Olympus.

Correggio would have found it much easier than Giulio to empathise with his patron's needs because he came from

another city nearby in the valley of the river Po which would have been plagued, like Mantua, by Lombard fogs. He would early have acquired neural networks that were adapted to the perception of vapours and softness. It was these that empowered him to make his extraordinary image of Jupiter as a cloud, but their influence is even more manifest in two of his earlier inventions in nearby Parma, the *Vision of St John* in the dome of S. Giovanni Evangelista (1520–22; fig. 185) and the *Assumption of the Virgin* in that of the cathedral (1522–30). In both, sacred figured are shown at home in a cloudscape, an image of heaven that would have many imitators in other climes in the following centuries.

Part 6

EARLY MODERN EUROPE

EUROPE

1500–1700

New Artists and New Viewers

The formation of new neural resources as a result of a new interest in the physical world was the most obvious phenomenon in a neuroarthistory of European art of the fourteenth, fifteenth and sixteenth centuries because, as we have seen, those new resources had the most direct impact on the appearance of art. An understanding of those resources helps us to answer such questions as why individual patrons living in particular places commissioned particular works of art and why individual artists living in particular places found it natural to make works that met their requirements. There were, however, other neural resources formed at the period whose influence on artistic production was less direct but whose impact on the quality of the best of the new art was decisive. These were new neural resources formed as a result of the new intensity both of the artist's inner life and of the viewer's responses.

The new inner life of the artist had deep roots. Those capacities for introspection that had been encouraged by the rise of Christianity were not lost when people started to look afresh at the external world. Instead, they were redirected away from the transcendental and the spiritual towards the material and the biological. The relation between Augustine's *Confessions* (*c*.400) and Benvenuto Cellini's *Autobiography* (written 1558–62 but not published until 1728) is emblematic. Each is a remarkable document of self-awareness. Augustine's *Confessions* is the product of a moment when the mind of someone still possessing a wealth of Classical wisdom becomes focused on issues of personal belief and religious experience. Cellini's *Autobiography* is the product of a moment when the mind of someone possessing a wealth of inner life nurtured by Christianity becomes focused on engaging with the material world through such activities as art-making, love-making and fighting. The amount of Cellini's reflection and the degree of his self-awareness in each area has no precedence in either pagan Antiquity or the Christian Middle Ages. No one earlier had described so clearly what it feels like to be an artist, a seducer, a killer. No one before had provided such a precise accountancy of the flashes of inspiration, the sudden emotions and the persistent drives that successively shaped those dimensions of his personality.

Cellini (1500–1571) owed some of his new self-consciousness to his interest in playing the role of courtier, one for which there were now handbooks. Most famous and influential was the *Libro del corteggiano* (*The Book of the Courtier*; 1528) written by Baldassare Castiglione.[1] This provided guidance in all the skills needed for success in a courtly environment, stressing the equal importance not just of manners and codes of conduct, but of ability in fighting and literature, expertise in music and in the visual arts, and indeed most of the attainments celebrated since Classical Antiquity. Translated into all the major languages of Europe and circulating in more than a hundred editions, it had an enormous impact, persuading several generations of elites of the need to train themselves in a wide range of activities. As the experiments noted in our Introduction demonstrate, this would have involved the laying down of many different neural resources in the motor and sensory areas of the brain, their richness depending on the particular engagement of the person involved. To the extent that individuals held such neural resources in common we can say that they shared in a common culture.

The *Book of the Courtier* was one of a growing number of books dealing with art that were addressed to the general reader. Together they indicate a new level of conscious interest in art on the part of the educated viewer. This interest, though, is parallelled by the growth of a new and less conscious interest in things visual. That was provoked by the emergence of a new type of visual experience as a consequence of the rapid expansion of the new trans-oceanic navigation. The journeys of Columbus to the Americas beginning in 1492, of Vasco da Gama to Africa and India beginning in 1497 and of Magellan around the world in 1519–22 dramatically increased the range of both artefacts and natural products arriving in Europe and ensured that with each passing year people were exposed to more strange goods, and more strange plants and animals and their derivatives, than they had ever been before. The repeated and intense visual inspection that this provoked made the neural resources involved become ever richer. One set of resources were those engaged just by looking. Another set were those involved in categorising what was looked at. With time, and habituation to the novel, both neural reactions were to weaken, but during the sixteenth and seventeenth centuries they ensured that viewer response had an unprecedented predominance in people's experience.

13

Self-Awareness and the Early Modern Artist

In the case of Benvenuto Cellini, the new awareness was related to many areas of his life, which is why he felt motivated to present such a complete autobiography. With other important self-aware figures, such as Alberti, Leonardo or Michelangelo, the insights relate more exclusively to art. But, while an interest in art is a factor that unites them, the nature of their insights relates to the particularities of their personal experience.

Alberti and Leonardo as 'Natural' Children

For both Leon Battista Alberti and Leonardo da Vinci, for example, one factor heightening their self-awareness was their illegitimacy. While a legitimate child would always tend to define itself in terms of social conventions and ancestry – as did Michelangelo, for instance – a 'natural' child, who

was liable to be excluded from many of society's privileges and securities, would always feel a greater need to define itself in terms that were less social and more biological. This trend was reinforced by another, which was an indirect consequence of illegitimacy. Coming from relatively privileged Florentine families but lacking inheritance rights, Alberti and Leonardo became much more opportunity-conscious, and that meant having to be more physically mobile and mentally flexible in their pursuit of financial support.

The process of adjustment could begin early. Already as a child, Alberti (1404–72), who was born in exile in Genoa, moved first to Venice and then pursued qualifications at the universities of Padua and Bologna, before gaining a position at the papal court in Rome and then designing buildings for patrons both in the papal city and at Ferrara, Rimini, Mantua and Florence, in each case adapting them to local traditions.[1] While a legitimate member of a Florentine family

of his father's class could have expected for the rest of his life to rely on neural resources and contacts built up in childhood, Leon Battista, in order to thrive in each new setting, had to develop new neural resources encompassing such diverse areas as dialect, manners and visual taste. Leonardo (1452–1519) was not born in exile, and so was not as rootless as Alberti, but he too moved from Florence to Milan in search of better patronage from Lodovico Sforza, and when his patron was forced out by the French, went on to Venice and Rome, spending more time in Milan and Florence again before ending his life in France. Both Alberti and Leonardo were restless in their acquisition of new abilities and sensibilities, acquiring expertise in many fields, each of which required the development of new neural resources. This could have been exhausting and confusing, but both avoided that. They economised on these resources by building connections between them through the formulation of underlying principles. These provided the basis for the ambitious theories on which they based their practice, and the ability to move back and forward between the different areas, and within each to move backward and forward between the specific and the general, enabled both to achieve unrivalled distinction in three major visual arts normally treated as separate worlds – painting, sculpture and architecture. None of this would have been possible if they had not also developed neural resources of exceptional richness relating to self-consciousness. Living with such resources gave them unique personal insights.

Alberti

Alberti wrote influential books on subjects as diverse as Italian grammar, ethics and mathematics, not to mention painting, sculpture and architecture, and it is easy to take this achievement for granted as a product of his wide learning, but it is helpful to think of what acquiring such learning implied at a neural level, constantly requiring, as it did, the formation of new connections. He could not have excelled in these separate fields without building up separate neural resources to deal with each of them. Alberti could also not have rethought each of them without using the resources

that he had acquired to deal with one to engage with another. Often he used resources built up to deal with an established field to endow a new one with a stronger theoretical base. Thus he used the neural resources accumulated when studying geometry to add new mathematical dimensions to his theoretical treatments of sculpture in *De statua*, of painting in *De pictura*, of architecture in *De re aedificatoria* and of cartography in the *Descriptio urbis Romae*. In a similar way he used resources built up when studying rhetoric to effect a fundamental reformulation of the principles that should govern painting, and those built up by the study of ethics to do the same for architecture. His recognition of the general validity of key ideas, such as *ratio* (rational explanation), or classificatory categories such as *genus* and *species* (genus and species), most of them extracted from his studies of Classical texts, provided him with neural substrates for a clearer treatment of all fields. This clarity turned out to be of great importance for the neural formation of other individuals, especially those who came after him and read his texts. It made it much easier for them not only to follow his argument but also to build up their own neural resources in each area and so raise the level of their own achievements. This process began during his lifetime, as his writings circulated in manuscript, but accelerated after his death as printing allowed the ever wider dissemination of his ideas. Indeed, we may credit much of the strength of the so-called High Renaissance art produced in all media after 1500 to the influence of these texts.

Some fruits of Alberti's personal neural formation could be easily shared in this way. Others could not be so easily transmitted because they originated in personal experience. These were the insights into the neural that came to Alberti in the form of sudden aperçus. One of these is contained in his account of the origin of sculpture at the beginning of *De statua*. There he describes how people:

probably occasionally observed in a tree-trunk or clod of earth and other inanimate objects certain outlines in which, with slight alterations, something very similar to the real faces of Nature was represented. They began, therefore, by diligently observing and studying such things, to try to see whether they could not add, take

away, or otherwise supply whatever seemed lacking to effect and complete the likeness. So by correcting and refining the lines and surfaces as the particular object required, they achieved their intention and at the same time experienced pleasure in doing so.[2]

The notion that humans are capable of 'seeing things' in the natural environment was not new, having been treated by both Aristotle and Philostratus, but Alberti is the first to use it, in combination with the notion of inner reward, as the basis for an account of the origin of art, almost certainly drawing on his own personal experience. Probably he himself, when attempting to make a sculpture out of clay for the first time, had noticed that he began by seeing the thing he wanted to represent in the unformed raw material before his eyes, that he then set out to achieve his goal by a process of adding and taking away material, and that when he had obtained the desired result he had felt real pleasure. We may take all this for granted, but we should not. Everything Alberti says here is new. He was simply the first person to have reflected on the separate phases of the creative process, the first to notice that they involved different activities, activities that we can now recognise as having different salient neural correlates. Each phase requires the engagement of many areas of the brain, but in the planning phase the orbital frontal cortex would be salient; in the execution phase, the sensorimotor area; and in the final contemplation phase, the visual cortex and the reward centres. The correspondence between Alberti's scenario for the origin of sculpture based on his own introspection and that proposed earlier for the art of Chauvet based on the latest knowledge of neuroscience is striking. Like his recommendation that painters should improve their compositions by looking at them through half-closed eyes,[3] it demonstrates how the skills of self-awareness developed during a millennium of Christian soul-searching could, when people eventually opened their eyes to the world, yield revolutionary insights into the psychology of perception and creation.

Another such insight, which must have a similar source, is his recommendation that painters introduce into their compostions faces of well-known people because 'the face that is well known draws the eyes of all spectators'.[4] Only through

a heightened awareness of his own responses could he have extracted this principle, which is based on the fact that our brains are always trying to help us find things at which we have looked before.

In other cases, the starting point for an insight may be a comment in an ancient text that acquires a new freshness in Alberti's formulation. Thus Aristotle's observation that the poet should co-operate with the movements of the actor 'because he agitates others who is himself agitated, and he excites others to anger who is himself most truly enraged' (*Poetics* 1455a) is expanded into the claim that a painted scene will move spectators when the people in the picture outwardly demonstrate their own feelings as clearly as possible: 'Nature provides – and there is nothing to be found so rapacious of her like than she – that we mourn with the mourners, laugh with those who laugh, and grieve with the grief-stricken.'[5] We are left with the feeling that Alberti's recommendation on the importance of making painted figures expressive is based on his own observation of how people in real life are moved by each other, something we now know to be based in universal, neurally based, tendencies for 'mirroring'.

Leonardo

Leonardo would have benefited from the same layering and integration of neural resources that I have proposed for Alberti, and these allowed him many new insights. For example, his acquisition of robust networks for dealing with geometry, reinforced by his friendship with the mathematician Luca Pacioli, allowed him to see similarities in the mathematics underlying the painter's lines of perspective and the musician's musical intervals, while the links between his expertise in painting and music allowed him better to understand the importance of expressiveness in all the arts.

Another fruit of Leonardo's ability to make comparisons between the arts was his recognition that although, in general, painting was superior to poetry,[6] there was one area in which the painter could learn from the poet. As he says: 'poets . . . are unrelenting in their pursuit of fine literature

and think nothing of erasing some of their verses in order to improve on them'.[7] Painters should do something similar, working out the detailed movements of their figures before they attempt to make them beautiful. He then goes on to use the example of his own exploitation of the imperfect shapes of clouds and stains when refining his compositions and in this way helps us to understand how the stain-like layerings of successive sketches with which he blots the pages of his manuscripts were essential preparation for the perfect design solutions for which his finished paintings became famous. Leonardo realised that excellence was not the product of conscious intention alone but of a process in which the artist was passively responding to shapes, looking for the best solution among multiple possibilities. By this means the poet's habit of correction, which we can recognise as being, like all skills, the product of neural formation, can also be acquired by the painter. The positive impact of the practice on the painter's art is demonstrated by the superiority of Leonardo's compositions to those of his predecessors and rivals.[8]

If these observations demonstrate the positive side of unconscious mental activity, another illustrates one that Leonardo finds negative, the tendency of bad artists to represent themselves in their art. Some artists 'in all their figures seem to have portrayed themselves from the life, and in them we may recognise the attitudes and manners of the maker' so that 'if the master is devout his figures are the same, with their necks bent, and if the master is a good for nothing his figures seem laziness itself'.[9] Leonardo's explanation of the phenomenon is that 'the very soul which rules and governs each body directs our judgement before it is our own . . . and this judgement is powerful enough to move the arm of the painter and makes him repeat himself and it seems to this soul that this is the true way of representing a man'.[10] His notion is that in a bad artist the individual's 'soul' takes control of the faculty of judgement and makes the artist like only figures that resemble himself. This, he says, is wrong because 'good Judgement is born of good understanding and good understanding is born of rationality – drawn from good rules – and good rules are the daughters of good experience'.[11] A good artist will not allow his soul to control his judgement, but will build it up

for himself, relying on repeated looking. What Leonardo did not realise is that the phenomenon of artists representing figures that look like themselves probably has the same source. The phenomenon certainly exists, as Gombrich noted,[12] but it can hardly be a product of some inborn soul. Instead, it too has a neural basis, being also the product of neural plasticity. Seeing oneself in a mirror, however primitive, will always be liable to give one an unconscious preference for people who look similar to oneself, and the effect will be intensified if mirror neurons cause one to empathise with oneself. Leonardo did not know about this mirroring phenomenon, but he did understand the way that neurally based preferences move the artist's hand, as we see from his reference to judgement being powerful enough to move the painter's arm.

Leonardo's sense of the physical reality of the nervous system owed much to his anatomical researches. These were pursued intermittently throughout his life, in Milan in 1485–9, in Florence in the late 1490s, in Milan again, when he was able to collaborate with the anatomist Marcantonio della Torre until the latter's death from plague in 1511, and for a few more years in Rome, until he was prevented from continuing the activity by Pope Leo X. These researches gave Leonardo an access to the mind that had been unavailable earlier. Alberti, for example, could only talk vaguely of *animus* (originally 'breath') and *ingenium* (mental ability). Leonardo, by contrast, could talk of the mind in physical terms, acknowledging the roles of both the brain and the whole distributed nervous system:

The soul seems to reside in the judgement, and the judgement would seem to be seated in that part where all the senses meet; and this is called the Common Sense. . . . Feeling passes through the perforated cords and is conveyed to this common sense. These cords diverge with infinite ramifications into the skin which encloses the members of the body and the viscera. The perforated cords convey volition and sensation to the subordinate limbs.[13]

No aspect of that system interested Leonardo more than the visual. He could observe the optic chiasm in the lateral geniculate nucleus, where the nerves from the two eyes meet and divide again before arriving at the visual cortex at the

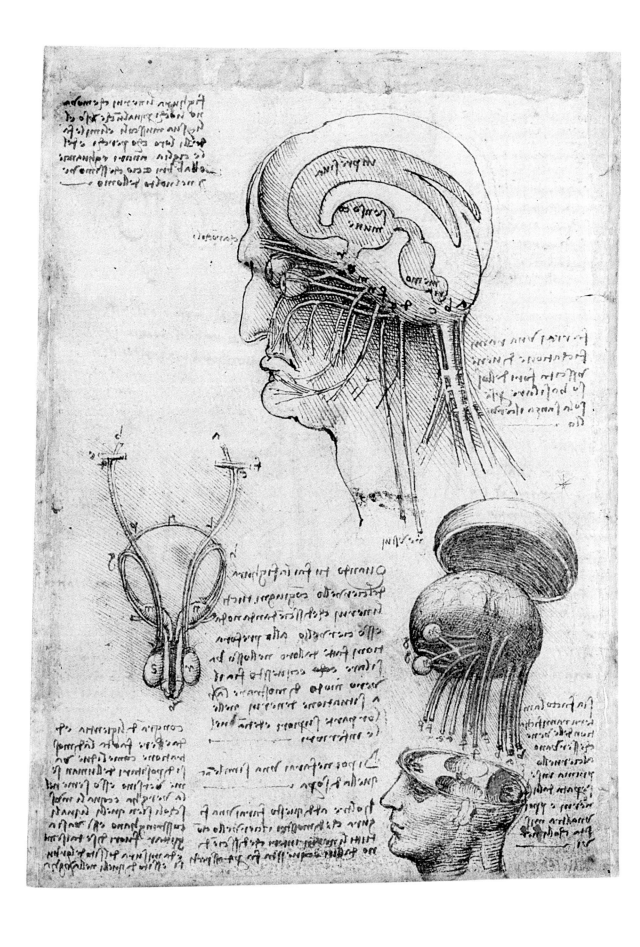

back of the brain. He could not identify precisely the visual cortex as such, but he notes that 'here we must have regard to the mass of that portion of the brain which is given up to the sense of sight and nothing else'.[14] He could even explain the importance of sight in terms of visceral imperatives, noting that 'by the means of sight' animals 'find food with which to nourish themselves' and 'through sight' they can 'appreciate the beauty of all created things, more especially those that arouse love'.[15] His recognition that the eye is 'the highest sense and the prince of the others'[16] also sustained his view that conveying knowledge visually was more effective than through words, a perception that clearly differentiates him from Alberti. The earlier humanist, who had learned much from ancient texts, made little or no use of illustrations in his treatises, but for Leonardo they were the most trusted means of communication. He knew that he had acquired his knowledge of humans and the natural world by the use of his own eyes and he expected anyone using his notebooks to do the same.[17]

A Neural Key to the Appeal of Leonardo's Mona Lisa

An area of knowledge that Leonardo was particularly anxious to develop using anatomy and observation was that of facial expression, as noted in a page from 1490–92: 'Represent all the causes of motion which the skin, flesh and muscles of the face possess, and see if these muscles receive their motion from nerves which come from the brain or not. And do this first for the horse which has large muscles and clearly evident parts.'[18] Just how much progress he was able to achieve emerges in a drawing of the head and brain made in 1506–8, originally part of the Windsor manuscript B on anatomy and now in Weimar (fig. 186). While in a schematic diagram of about 1490 he had labelled the parts of the brain according to the categories canonical in the Middle Ages, the new drawing is much more analytical. Rejecting tradition, he introduces a new *imprensiva*, or 'grasping' faculty where sensations from the different senses are gath-

(facing page) 186 Leonardo da Vinci, *Brain and Human Nervous System*, 1506–8, ink on parchment, 19.2 × 13.5 cm. Schloss Museum, Weimar

ered before being transmitted to the *senso commune*, and goes on to add important new observations of his own on the role of the nerves in controlling expressive movement. As the note at the top left tells us, the sheet 'shows the nerves that move the eyes in all directions, including the muscles involved, and does the same for the eyelids and brows, as well as for the nose, cheeks and any other part of the human face that moves'.[19] Leonardo has here brilliantly risen to his own earlier challenge. Not only does he show many tiny nerves buried in such expressive parts of the face as the lips and cheeks, but he also shows how these are linked to the brain by larger fibres passing through holes in the skull. The skin is in direct communication with the seat of consciousness. No one before had linked the most superficial area of the body to the deepest life of the mind.

The benefits for his art were immediate because the drawing reveals Leonardo's preoccupations at the time he was involved with the *Mona Lisa*. He began the portrait in 1503 and went on working on it until his death in 1517 (fig. 187). We cannot know exactly when the anatomical discovery recorded in the Weimar sheet affected his work on the painting, but its impact is likely to have been decisive. From the moment he noted those nerves, his approach to her face would have been transformed. Where earlier, like other artists, he would have just seen skin, now he would have imagined the thousands of tiny fibres with which the flesh beneath was irrigated. He would also have known that those fibres were linked to the brain. This is why the face possesses such animation, not just physical but mental. Indeed, if Vasari is correct in saying that the sitter was listening to music as she posed, then the subtle suggestiveness of that animation may also owe something to Leonardo's perception of the way she was moved by higher aesthetic sensibilities. If so they are sensibilities we can now share.

Neuroscience, then, does not just shed light on the genesis of the *Mona Lisa*, it also illuminates our experience of the painting as we stand in front of it today. The evolution of the nervous system has ensured that we respond to the human face more intensely than to any other visual experience. That response is essential to the quality of our most vital relationships, whether as children or parents, friends or lovers, and the key to its complexity is the face's animation.

245

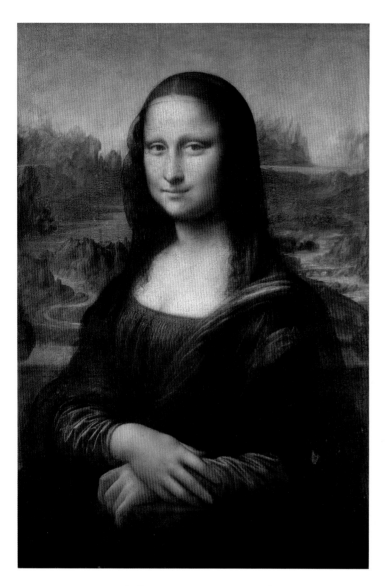

187 Leonardo da Vinci, *Mona Lisa*, 1503–17, oil on poplar, 77 × 53 cm. Musée du Louvre, Paris

Because Leonardo was both the first and the last artist to appreciate the precise neural resources on which the face's animation depends, the *Mona Lisa* is arguably the only portrait to capture it, so eliciting an unconscious response from the similar neural resources shared by the viewer. Our sense of the *Mona Lisa*'s exceptional expressiveness we owe not to aura or hype, but to Leonardo's capacity to transmit to us the fruit of his anatomical investigations. The superior quality of our relationship to her image is dependent on Leonardo's superior knowledge of neuroscience.

Michelangelo

If Leonardo transmitted to a whole generation an urgent interest in the arts of the eye the only one to whom he transmitted his deep interest in anatomy was Michelangelo (1475–1564). The latter's engagement with dissection was brief, but it was intense. It also had a greater impact on his neural make-up than it did on Leonardo's, for two reasons. One was his youth at the time. When, in 1492, he was given access to corpses by the Prior of S. Spirito in Florence, he was still only in his late teens and so highly self-conscious. This would have made the experience particularly formative. Dissecting the bodies of others at an age when he was only discovering his own heightened his awareness not only of the mechanics of the body, but of the relation between that mechanics and the workings of head and heart. This awareness informs all his art, both his later drawings of the male nude from the life and his sculptures and paintings. But the sensitivity to his own being that it gave him comes out most compellingly in his sonnets.[20] In some he concentrates on his sense of his physical body, as in the early poem V where he describes what it was like to work for long periods on the Sistine Ceiling lying on his back:

> I've grown a goitre by dwelling in this den
> . . .
> Which drives the belly close beneath the chin:
> My beard turns up to heaven; my nape falls in,
> Fixed on my spine: my breast-bone visibly
> Grows like a harp: a rich embroidery
> Bedews my face from brush-drops thick and thin.
> My loins into my paunch like levers grind:
> My buttock like a crupper bears my weight;
> My feet unguided wander to and fro;

Later, in poems addressed to Vittoria Colonna he talks sometimes more of ideas, as in XIV: 'When that which is divine in us doth try/ To shape a face, both brain and hand unite/ To give, from a mere model frail and slight,/ Life to the stone by Art's free energy' and sometimes more of feelings, as in XVIII: 'A heart of sulphur, flesh of tow,/ Bones of dry wood, a soul without a guide/ To curb the fiery will, the ruffling pride/ Of fierce desires that from the passions flow'. No one

earlier had written so acutely about the body's role in these different emotions.

The other reason why Michelangelo was more affected by dissection than Leonardo was because of his greater prior involvement with the art of stone carving. Although first trained as a painter, in the early 1490s Michelangelo turned his attention to sculpture. This meant that from the first moment he manipulated the anatomist's scalpel he would have felt the correspondence between its powers and those of the sculptor's chisel, as he would also have felt the similarity of role between the corpse he was working on and raw marble. As an active draughtsman, he would also have felt the probing sensitivity of the pen, especially when he was trying to understand his subject's anatomy (fig. 188). The neural memory of the act of dissection would thus have stayed with him always, adding a new dimension to his work. Just as Leonardo on the basis of his anatomical experiences found himself imagining the nerves in the lips of the *Mona Lisa*, so Michelangelo could not conceive his Adam on the Sistine Ceiling without imagining his bones. Throughout his life, as the instruments of the draughtsman, the painter and the scuptor alternated in his hands, so the scalpel's power would have been been transferred not just to the chisel and the pen, but to the chalk and the brush. His abiding memory of the knife's revelation meant that the research into a person's physical and mental make-up that he had once carried out using the instruments of the anatomist he could now pursue using those of the artist. Whatever the medium he was working in, that memory was always liable to give an extra charge to the movements of his hand. The continued activation of neural networks formed during his first engagement with dissection also ensured that through-out his life Michelangelo always remembered how investigation necessarily brought destruction. That memory would have been most alive when he was using a chisel that shared the scalpel's penetrative force. Unconsciously remembering how probing the mysteries of human make-up necessarily involved the progressive destruction of the once intact cadaver, he would have been encouraged in a parallel consumption of the marble block. This might go so far as to render a sculpture's completion impossible, as we see in a whole series of works from the early *St Matthew* (1506) to

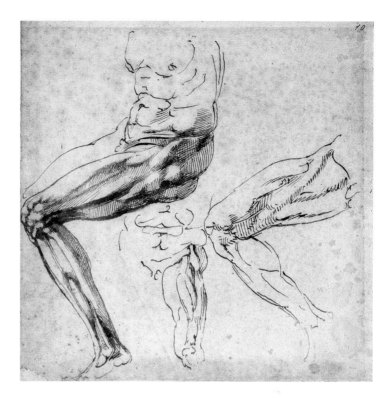

188 Michelangelo Buonarroti, *Studies of Legs*, showing bones, c.1520, ink on paper, 26 × 26 cm. Casa Buonarroti, Florence

the last *Pietà*s. Recognising the role of the neural training of the anatomist in the formation of Michelangelo's artistic personality thus adds a new dimension to our appreciation of two vital aspects of his 'genius', the pleasure he took in a penetrating physical enquiry into human nature and his sense of the value of the *non finito*, the 'unfinished'.

This early intense experience of anatomy also sheds light on more prosaic, but no less essential, aspects of Michelangelo's art. One of these is his recurrent interest in, and feeling for the properties of, the dead body. Understandably, this is first manifested in the *Christ on the Cross* in wood that he made for the Prior of the Ospedale di S. Spirito in recompense for his privileged access to cadavers, and is palpable in the capture of the weight and substance of Christ's corpse in his unparallelled series of *Pietà*s beginning with that made for St Peter's (1498–9) and culminating in those made at the end of his life. The other is more surprising and more personal, the link he felt between dissection and a raw self-awareness. This is first revealed in the Ceiling of the Sistine

Chapel (1508–12), when he turns the severed head of Holophernes into a self-portrait, but it receives its most painful expression in the *Last Judgement* on the Chapel's end wall (1535–41), where he uses his own image as the face attached to the flayed skin of St Bartholomew. He could not represent a situation in which a dead body was connected with a knife without identifying with the body's owner.

In this case Michelangelo's awareness of his resources for neural mirroring is only communicated to us indirectly through his works. In another it is hinted at in his words. People have long been intrigued by the artist's statement recorded by Vasari, that he 'imbibed sculpture with the milk' of his wetnurse whose husband and father were both stonemasons associated with the neighbouring quarries at Settignano. The significance of this experience for the artist was explained by Michelangelo himself to his biographer, Condivi. It was no wonder that the chisel had given him so much gratification, he noted, 'for it is known that the nurse's milk is so powerful in us that often, by altering the temperature of the body, which has one propensity, it may introduce another, quite different from the natural one'.[21] Michelangelo evidently felt that his experience of the quarry as an infant had an abiding effect on his make-up and an understanding of mirror neurons provides a possible explanation for that sensation. Neural mirroring is an adaptation essential for our survival, and the way we spontaneously learn many movements from the time we open our eyes. The baby lying in the cradle or on the ground is able to mirror neurally the movements of her or his parents or surrogate parents long before she or he can actually make them. This means that where a parent or surrogate parent possesses special skills, for example those of a musician, a painter or a sculptor, the infant begins to acquire those too. It is easy to see how this helps to explain the precocious talents of such painter's children as Raphael or Picasso. It also helps us to understand how Michelangelo, just by watching his wetnurse's husband work with stone, would have acquired some of the skills of a sculptor while still at the breast. That, though, is not as remarkable as the fact that somehow Michelangelo felt that to have been the case. This we have to credit to his general self-awareness, and in particular to his sensibility to the uniquely powerful resources for neural mirroring that affect all his art. Michelangelo's early interest in the coarse hand of the young *David* (see fig. 194) and his late reflection on the source of his talent may both have their origins in neural resources acquired from an infancy on the edge of a quarry.

There were other resources, too, of which his self-awareness made him conscious. Most important were those that guided his hand when he was making the drawings on which his productions in all the arts were based. One place where he alludes to them is in his statement that 'one should keep one's compasses in the eyes, not in the hands'.[22] The 'compasses' that he was referring to were, of course, not in the eyes, but in visual neural networks whose calibrations had been refined by the most intense and repeated looking. By comparing them to geometrical instruments he adroitly brought out the extent to which such experiences laid down neural resources whose robustness was almost physically palpable. A similar sense of the almost physical robustness of neural resources built up by experience is implied in his observation in a late letter: 'It is an established fact that the members of architecture resemble the members of a man. Whoever neither has been nor is a master at figures, and especially at anatomy, cannot really understand architecture'.[23] Michelangelo felt that an intelligent relation to architecture depended on an intense prior exposure to the human figure.[24] That certainly was the case with him, as he had had a long experience of the figure – including anatomy – before his abortive project for a grand facade for the church of S. Lorenzo, Florence (1516–20) and his successful work on the adjoining New Sacristy and Library. As he then laboured over his drawings of architectural members, he must have felt how the neural resources guiding his pen and chalk lines had been formed by this earlier concentration on human limbs. Certainly, his sensitivity to their promptings not only influenced the general tone of his designs but became the source of some of his most important contributions to the history of architecture.

The influence on general tone is apparent in S. Lorenzo's facade in the exceptional prominence Michelangelo gives to curves, as in the segmental pediments over the doors, while the influence on the invention of new forms is palpable in the window type that he introduced in 1517 on the palace of his Medici patrons nearby. Its principal new feature is the

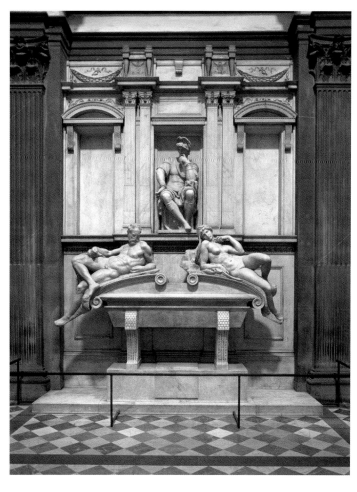

189 Michelangelo Buonarroti, Tomb of Giuliano de' Medici, Duke of Nemours, 1520s, New Sacristy, S. Lorenzo, Florence

pair of large brackets supporting the cill. We know that these evoked the human body to contemporaries because Vasari calls the window *inginocchiata*, 'kneeling'.[25] Designed immediately after Michelangelo stopped working on the *Moses* (1513–16) for the Julius Tomb, the brackets recall that figure's highly expressive knees, giving the impression that the neural resources built up by working on the statue guided the design of the architectural detail. If so, the artist may even unknowingly be attributing to the Medici family the qualities of energy and authority for which Moses, described by his follower and biographer Ascanio Condivi in his account of the tomb as the 'leader and captain of the Jews', was famed.[26] This connection would then help to explain why Michelangelo seems also to have had calves and knees on his

mind when he invented another influential form, a baluster swelling at the top and tapering downward, in the New Sacristy, begun in 1521 to house the tombs of several members of the Medici family, including that of the patron of the 'kneeling' windows, Lorenzo, Duke of Urbino, and Giuliano, Duke of Nemours (fig. 189). The form goes straight back to the lower half of the fifteenth-century baluster-type which was vertically symmetrical around a central element and still used by Michelangelo in the Chapel of Leo X in the Castel Sant'Angelo (1514). Here, though, deprived of its balancing upper twin, it acquires a new vitality. This is brought out by the pairing of such balusters in the upper parts of the Medici tombs. There, reprising the anthropomorphic resonance of the *finestra inginocchiata*, they echo the calves of the statues of the two military *capitani*, Lorenzo and Giuliano, seated below. As Michelangelo was moving backward and forward between the act of drawing the figures, with which he was familiar, and drawing the architecture, which was a new challenge, he could not prevent the neural resources built up in one field affecting the other.

A Neural Key to Michelangelo's terribilità

This process is revealingly documented in a drawing in the Casa Buonarroti that also adds another dimension to our understanding of Michelangelo's creative processes (fig. 190). The main purpose of the sheet was to help him design the Sacristy's columnar elements, but this routine project is interrupted on one of the bases by the emergence of the profile of a head. This startling invention might just have been the result of neural networks adapted to the representation of the figure becoming dominant over those adapted to the representation of architecture, but the particular character of the face indicates that another property of the nervous system is involved, neurochemistry. The face's combination of turban and aquiline nose identify it as Turkish and Muslim, one that in the aftermath of the Fall of Constantinople (1453) at a time when Turkish vessels were harrying the coast of Italy would certainly have evoked fear, which makes it look as if a crucial role in the genesis of the form was played by Michelangelo's amygdala. A prime function of that organ is to help us deal with a risky situation by ensuring the production

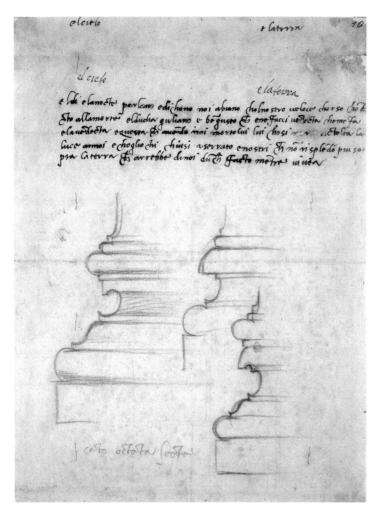

(left) 190 Michelangelo Buonarroti, drawing of profiles of pillars for the New Sacristy, S. Lorenzo, Florence, 1520s, red chalk on paper, 28.3 × 21.4 cm. Casa Buonarroti, Florence

(above) 191 Michelangelo Buonarroti, egg and dart and frieze of masks, 1520s, New Sacristy, S. Lorenzo, Florence

and absorption of noradrenaline, which among other things primes our neural resources to look for signs of danger. We are familiar with the impact of such priming on our perceptual system when we walk in woods at night. We see what we fear, and so did Michelangelo. The resemblance between a torus moulding and a turban made him imagine a Turk, and that vision led him to add an 'oriental' hooked nose below the turban and an angular tooth-like element further down, so turning what should have been an innocent *cavetto* into a greedy mouth, the whole assemblage of architectural details being brought to threatening life by the insertion of an eye. The great Michelangelo's conscious decision to design a banal architectural detail has been derailed by the brain's fear centre.

It is probable that this would not have happened had his amygdala not been activated by other circumstances, as we learn from Michelangelo's comments in lines on the same sheet. These elaborate on the meaning of the Sacristy's sculptures, telling how Duke Giuliano has closed the eyes of the statues of Night and Day to take vengeance on them for having ended his life. The use of the concept of vendetta in the context of this artistic commentary reminds us that the Medici had for more than a century been involved in a much more sinister vendetta with Florentine Republican forces, one in which Michelangelo had been involved on both sides. In 1504 he wanted his *David* to intimidate the Medicean party. Now he was involved in a range of projects around their church of S. Lorenzo all of which were intended to intimidate the family's enemies. If Michelangelo's sensibility to the mutual fear implied in these few lines of text already provoked the production and absorption of noradrenaline, it is easy to see how that neurochemical response may have been reinforced by fear of Turkish attack. In the 1520s his brain may have been frequently awash with noradrenaline.

Such a process would certainly contribute to an understanding of a surprising feature of the Sacristy's interior, the row of masks inserted as a frieze behind the tombs (fig. 191). That row is evidently the product of a process exactly analo-

gous to that which elicited the face from the column base. Although no drawing illustrating the process has survived, there can be little doubt that once again a routine design activity has been distorted by the presence of fearfulness in Michelangelo's mind. At the same time that he feared the Medici, he knew that they feared their Republican enemies and were anxious to evoke fear in them. This was why, as Michelangelo started to draw a standard moulding combining an egg-and-dart and tooth-like dentils, he found himself inventing a doppelganger of nightmarish quality, in which aggressive faces, their mouths filled with large teeth, alternate with arrowheads equipped with threateningly angular points and barbs. As with the Casa Buonarroti drawing, it is difficult to explain the way an innocent moulding becomes terrifyingly anthropomorphic without reference to the function of the amygdala. We can understand the unconscious genesis of the frieze. What is more difficult to explain is why Michelangelo consciously decided to introduce it into a building that is otherwise calm. Perhaps he wanted both to please the Medici by expressing their power and at the same time reanimate their enemies, of which he was one, by reminding them of that power's sinister edge.

This was not the first time that Michelangelo had both served and criticised his employers. His relation with his most powerful patron, Pope Julius II, had also been riven with tensions, with fear already activating his amygdala. Indeed, his behaviour towards Julius, in which 'fight and flight' responses alternated, suggests a classic noradrenaline-driven reaction. He told Condivi that when during the painting of the Sistine Ceiling Julius had threatened to throw him off the scaffolding, he had muttered under his breath that it was not he who would be thrown, implying that the roles would be reversed and he would throw the pope. Michelangelo feared Julius, but he also began to mirror him. Indeed, his identification with Julius helped him to charge the figures in the ceiling with unusual force. To his contemporaries he even seemed to mirror God, which is one reason why he came to be called *divino*. With this background it is not surprising that Julius's successor, Leo X, found Michelangelo 'frightening' and the feeling was surely mutual. Michelangelo's relationship with his patrons was such that by the 1520s even as he feared them, they feared him. This was why he

192 Michelangelo Buonarroti, drawing of fortificatons for Florence, late 1520s, red chalk and pen on paper, 56.2 × 40.7 cm. Casa Buonarroti, Florence

acquired a reputation for *terribilità*, 'terrifyingness', one that would only become stronger with time.

Michelangelo's reputation helps to explain his role following the 1527 invasion of Italy by Charles V, when the new Medici pope, Clement VII, was imprisoned and the Medici faction was ejected from Florence. In this new stage of the vendetta, the Republican Michelangelo found himself appointed the city's Procuratore delle Fortificationi and immediately set about designing for it a new set of bastions (fig. 192). It has long been realised that these were intended not just to be effective physically but also to intimidate the Medici and their supporters, and we can now recognise that

193 Michelangelo Buonarroti, inner facade of the Porta Pia, 1564, Rome

their combination of curved and angular forms forcefully develops the aggression of the frieze of masks and arrowheads. An expressive weapon originally intended to intimidate the Medici's enemies was now turned on them and their supporters.

Nor was this the last occasion on which Michelangelo was called on to materialise *terribilitá*. One of his last commissions before his death in 1564 was for the inner face of Rome's new Porta Pia (*c.*1561), the gate at the end of the Via Pia, laid out by Pope Pius IV in the hope of encouraging cardinals to build their summer residences inside rather than outside the city's walls. Both the Porta's architectural forms and the grotesque face with which it was ornamented were well chosen to persuade the cardinals of the dangers that awaited them in the countryside beyond (fig. 193). Michelangelo knew well how to frighten people because he had often been frightened himself.

Cellini

Because of their unique involvement with the body, the neural formation of sculptors in the fifteenth and sixteenth centuries was liable to give rise to a level of self-awareness unknown to the practitioners of any of the other arts, not just the visual but the musical and even the literary. This is why sculptors produced the most extensive personal writings, from Ghiberti's *Commentaries* in the mid-fifteenth century, to the *Poems* and *Letters* of Michelangelo, the *Memoriale* by Baccio Bandinelli and a recantation by Bartolomeo Ammanati in the sixteenth. In no other artistic field can these works be matched. None of them, though, rivals the far more extensive and more personal account of his life written shortly before his death by the goldsmith turned sculptor Benvenuto Cellini (1500–1571). So remarkable is this work that it is often considered the first autobiography in the modern sense.

That Cellini's autobiography depends on his experiences as a craftsman is not obvious. Only a few sections are focused on his most celebrated products, the exquisite gold, silver and enamel *Salt Cellar* (1543; see fig. 198) and the monumental bronze *Perseus* (1545; fig. 195). But the parallel between many passages and the more fragmented texts of Michelangelo suggests that both derive from a common source in a particular type of bodily self-awareness that has its origins in their similar experiences as sculptors. Their widely different expressions of the travails of sexual love, for example, both evoke an intensely visceral experience. In the writings of both the connection between life and art is close, in Cellini's case exceptionally so. Thus the combination of heightened bodily awareness and unusual honesty that gives authority to his descriptions of what he felt in his 'hottest' moments, as when shooting the Constable of Bourbon from the Castel Sant'Angelo, murdering a male rival in the street or raping a female model in the studio, also empowers a work such as his great *Perseus*. Cellini even seems to endow his violent hero with some of his own neural resources. He cannot have modelled the hand of Perseus twisted in the locks of Medusa without remembering how, as he tells us in the autobiography, he had dragged a girl round his studio by her hair until her injuries made her unusable as a model. He knew too well what it was like to desire a sexually attractive woman, such as Andromeda is shown to be on the relief on the statue's base, and he also knew what it was like to wield a sword like the one with which Perseus severed the monster's head. Cellini understood the corollaries of such experiences. He had often enjoyed the embrace of female flesh and relished the sight of blood flowing from the body of a

194 Michelangelo Buonarroti, *David*, c.1501–4, h. 409 cm. Galleria dell'Accademia, Florence

195 Benvenuto Cellini, *Perseus*, 1545, bronze, h. 320 cm, Piazza della Signoria, Florence

wounded enemy. Michelangelo had given the hand of his *David* across the Piazza della Signoria the neural resources he had acquired by mirroring a rough mason and had equipped the head and body with those that sustained his own patriotism (fig. 194). Those with which Cellini endowed his *Perseus* were ones shaped by his more private passions. Both can thus be seen as examples of the neurally based phenomenon of artists 'portraying themselves' noted by Leonardo.

The Painter's Body Image

As sculptors, it was easy for Cellini, the murderer, to identify with and represent himself in *Perseus*, just as it was easy for Michelangelo, the anatomist, to feel that his chisel was like a scalpel. How did painters feel about themselves? What was their body image? Since the body image of the painter that emerges in the sixteenth century is new not just in Europe

253

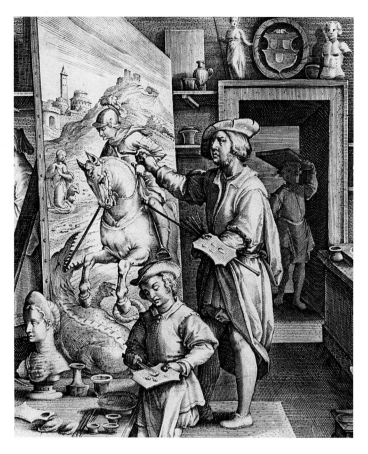

196 J. B. Collaert after Johannes Stradanus, *Color Olivi: van Eyck in his Studio*, c.1590, engraving. Warburg Institute, London

197 George Gower, *Self-Portrait*, 1579, oil on panel, 56.4 × 49.6 cm. Private collection

but in the world, and soon becomes canonical, these are questions of great importance. The key to answering them is suggested by the body image that the new one replaced. When painters had been shown in the Middle Ages, they were typically seen seated like a Christian scholar at a desk, working at a page of manuscript or a small panel. If they were not themselves monks they certainly identified with them. With whom did painters identify in the sixteenth century? Who was the model for the erect figure holding a long brush in his right hand and a palette loaded with paint in his left, standing at a distance from a panel or canvas resting at an angle on a wooden stand (fig. 196)?

Who could painters have been looking at with such intensity that their body language became their own? An obvious answer is those members of the class above them, the class that the best among them were then aspiring to

join, that of knights. Even if a particular painter did not share such an aspiration, he would always have looked at someone who had a sword and a coat of arms, the defining attributes of social superiority and of privilege, with a particular interest and attention. The principles governing neural mirroring justify the proposition that those who looked at knights with admiration or envy would have been inclined to adopt their body language and material attributes, and the body language and material attributes of the artist from the sixteenth century onwards are compatible with such an inclination. Not only is the brush in the right hand of a standing artist much like a sword, and the palette in his left like a shield, but what the English call an easel (from the Dutch *ezel*, donkey) was called in Italian *cavaletto* and in French *chevalet*, a 'small horse', so bringing in the last essential piece of a knight's equipment.

Two images from the sixteenth century support this notion. One is the engraving of around 1590 by the Netherlandish artist Jan Stradanus purporting to show Jan van Eyck in his studio experimenting with oil paint – a technical innovation with which the new pose certainly has some connection (fig. 196). The artist stands before a panel on an easel, a long brush in his right hand and a palette in his left, and two features are particularly evocative of 'knightliness'. One is the subject of the painting, St George, a knight on horseback. Since there is no external or internal reason for this choice, it is tempting to see it as above all the product of an empathy between the artist and his subject. That empathy might only have its source in a sense of the similarity between the bodily dispositions of artist and knight, but it might also have been encouraged by the personal affinities of both Stradanus and van Eyck. Stradanus was conscious of his own family's faded aristocratic past, while we know the status of van Eyck's family from the coat of arms on his tombstone. Indeed, that status may be directly alluded to by the print's other reference to knightliness, the shield shown on the wall behind the painter. What is certain is that the painter/knight identification is also suggested both by the similarity of form between that shield and the palette in the artist's left hand and by the correspondence between the shield's 'charges' and the palette's blobs of paint. That the implied assimilation of painter and knight was more widely felt at this period is confirmed by a work from another environment from ten years earlier, the 1579 self-portrait by the English court painter George Gower (fig. 197). Here his palette is shown immediately below the coat of arms he had inherited from his father, and it is displayed at a similar angle. That we are expected to sense a meaning in this visual echo is evident from the nearby emblem and inscription. The emblem shows the artist's dividers on a pair of scales outweighing the family's coat of arms, while the text vaunts his acquired skill at the 'pencil's trade' against his inherited status with its associations with swordsmanship.

These images confirm the suggested assimilation between painter and knight, and by bringing out its visceral neural correlates they also give us fresh insight into the painter's secret inner life. The painter – most likely a man – who felt his brush to be like a sword would have been reinforced psychologically, gaining the confidence and pride of the knight. He might even have felt that the soft instrument in his hand had an almost deadly power. For those artists, such as Titian, Rubens and van Dyck, who were indeed knighted for their skills with the brush, and whose works contributed to the making or breaking of individuals and institutions, such a feeling would have been well founded. It comes close to surfacing in Velázquez's self-portrait in *Las Meninas* (see fig. 205) of *c*.1656, where the breast of the imperious painter bears the cross of the knightly order of Santiago to which he was admitted three years later.

14

Self-Awareness and the Early Modern Viewer

During the sixteenth and seventeenth centuries it was not just the power of the artist that was enhanced, it was the power of the art object, and not just the objects created by the new types of artist, but those in many other categories. If the power of the artist was transformed by the new neural resources they possessed as makers of art, that of the object was transformed by the new neural resources of viewers. These we know much about because they were so powerful that they forced themselves on people's consciousness and became an important subject of discussion.

The Awareness of Wonder

Cellini himself comments on them. A vivid vignette in the autobiography describes the reaction in 1543 of Francis I to the wondrous salt cellar that he had commissioned (fig. 198).

When the monarch first saw it, we are told that 'he uttered a vocal expression [*voce*] of astonishment [*stupor*] and couldn't sate himself with looking'.[1] The emphasis on the inarticulate *voce* and the captivated gaze is new in the language of art appreciation and draws attention to the non-conscious and essentially physiological nature of the response. Its inappropriateness in a monarch is indicated by the use of the word *stupore*, deriving from *stipes*, 'post' or 'log' and cognate with 'stupid', suggesting a paralysis that was both physical and mental. The properties of the salt cellar that gave rise to this condition were indeed remarkable. A composition of golden nudes was integrated with an enamel ground representing Earth and Water, the two elements that were the ultimate source of the pepper and salt whose consumption it was designed to celebrate. This grouping was complemented by representations of numerous life-forms and artefacts, the ensemble being mounted on a base of ebony and ivory. The

198 Benvenuto Cellini, *Salt Cellar*, 1543, enamel and gold on ebony and ivory base, 26 × 33.5 cm. Kunsthistorisches Museum, Vienna, 881

whole made manifest the exploitation of the world's different resources, including pepper, ivory and ebony from the newly accessible tropics. Its execution drew on a bewildering expertise that was also highly innovative.

Francis was one of the first generation to be powerfully impressed by the new breed of great artists described in the previous section. Before Cellini, he had invited Leonardo to his court, and legend had it that the master died in his arms. Francis was also one of the first generation to be exposed to the new products of nature and of art brought back to Europe following the opening up of the oceans by Vasco da Gama and Columbus. The salt cellar was intended to demonstrate his leadership not only in the appreciation of newly heightened artistic talent but also in the recognition of the significance of new discoveries in the realm of nature. He was not disappointed.

The role of vision in energising these new sensibilities may have been brought to the monarch's attention by Leonardo himself. After all, Leonardo was one of the first to acknowledge the extraordinary power of sight to affect the body, as when he tells his reader that 'beauty will stimulate love in you, and will make your senses envious, as if they wished to emulate the eye – as if the mouth would wish to

suck it into the body'.[2] No one previously had described so clearly how the sight of beauty affects the body's sensory and motor systems.

Others shared his new awareness. The poet Ariosto, in the *Orlando Furioso*, published in 1532, also describes the physiological consequences of looking at beauty, though in slightly different terms. When the Count of Holland is warned that the sight of a beautiful woman will make him 'arch his eyebrows and tighten his lips with astonishment',[3] there is a clear allusion to a mechanism linking the eye and the muscles of the face. The contemporary recognition of the mechanism's universality is confirmed by other texts, in which astonishment is again the issue. Vicino Orsini, for instance, when planning the Sacro Bosco below his Palazzo at Bomarzo after 1550, presented the whole experience of the garden as beginning and ending with wonder. At the entrance he placed two sphinxes, one bearing on its base an inscription: 'Who does not pass through this place with raised eybrows and tight lips fails to admire the seven structures of the world', and the other posing the question whether 'so many wonders [*meraviglie*] are made for deception or art' (fig. 199).[4] What those wonders were is spelt out in another inscription at the conclusion of the visit, one that

199 Left-hand sphinx at the entrance to Bosco Sacro, Bomarzo, after 1552 with inscription: 'Who does not pass through this place with raised eyebrows and tight lips fails to admire the seven structures of the world'.

200 Giambologna, *Appennino*, 1579–80, mixed media including lava and brick, h. 10 m. Villa Demidoff-Pratolino, Vaglia

returns to the theme of wonder in a worldwide context: 'you who wander through the world, desirous of seeing marvels high and stupendous, come here where there are horrendous faces, elephants, lions, whales and bears'. The list of marvellous animals well brings out the fascination with nature provoked by the discoveries of recent voyages.

Vicino's garden made an excellent theatre of wonder because within its confines natural wonders could be mixed with those that were human-made and this was soon achieved on a much grander scale in the garden that Grand Duke Francesco de' Medici planned for his villa at Pratolino,

north of Florence (1569–81), one of whose few remaining monuments is Giambologna's (Jean Boulogne) colossal statue *Appennino* (fig. 200). The garden's rationale is spelled out in detail in the printed guide (1586), written by Francesco's court philosopher Francesco de' Vieri:

Such artificial products are a marvel [*maraviglia*] and an amazement [*stupore*] because their cause cannot immediately be found and because they are made with such excellence that they surpass common usage. Whence it can be inferred that marvel or amazement is nothing but a great

desire to know the cause of certain effects that happen. Our response to this desire to know is that we are all occupied with consideration and investigation of that cause, and as long as we fail to find it we raise our eyebrow and tighten our lips. The arching of the eyebrows means that the cause is known to God, who is over the heavens above, and the tightening of our lips means the cause is concealed there and that we cannot explain it to someone else.[5]

These observations add to our understanding of wonderment in the late sixteenth century in a number of ways.

First, de' Vieri insists that wonder exists only as long as we cannot explain what we are looking at: 'Marvellous and stupendous are all those things of which the causes are unknown and this can happen either because they are unknown at first or because the reasons are hidden as long as we are in this world.'[6] The distinction between mysteries that are temporary and those that are permanent is important because it means that the frontier of the wonderful is continuously moving. As he says, at first people were amazed by eclipses, earthquakes and tsunamis but in time, by analysis and logic, Aristotle and the Peripatetics came to understand such phenomena; so they no longer caused astonishment. Some mysteries, however, can never be explained, such as why the lodestone moves iron, or why the stingray causes paralysis. These have always astonished and always will. De' Vieri is too absolute in the distinction he draws, but he uses it to make the perceptive observation that: 'Manmade objects cause amazement of the first category, that is they amaze either because we cannot understand how they are made, or because they are made with such skill that they transcend the familiar'.[7] Again, the suggestion is that objects in this category only amaze for a limited period. As soon as we understand the processes of their manufacture, and the skills used to make them become so well known as to seem normal, they lose their power to amaze, as is perhaps true of the *Appennino*.

De' Vieri's recognition that wonder is liable to be a transitory response is acute and prescient. When he notes that an artistic product only impresses as long as the secret of its making is obscure, and a natural phenomenon only impresses as long as its origin is not understood, he implicitly acknowledges that the age of wonder, of which the Grand Duke's garden was a splendid product, would be of limited duration. It began because of the conjunction of two exceptional factors. First, the new type of super-artists empowered by the self-awareness discussed in the last chapter produced works that were so remarkable that one of them, Michelangelo, was called 'divine'. And, second, the opening up of the oceans by Vasco da Gama, Columbus and their successors brought to Europe a cascade of exotic artefacts, ranging from feather coats from the Americas to porcelains from China, and exotic products of nature, from live animals and their parts to seeds such as white pepper, fruit such as pineapples and leaves such as tobacco. Wonder at the inexplicable and the new had always existed. What changed in sixteenth-century Europe was the frequency with which it was evoked. People experienced wonder so repeatedly that the response became habitual, with the result that the neural resources on which it relied could become well established. That was why it was noted, commented on and exploited as it never had been earlier. And that, of course, is why, as de' Vieri would have seen, it could not last long. Not only did people become familiar with the phenomena that evoked wonder, and with their causes, they also became so familiar with wonder itself that as the seventeenth century advanced they ceased to remark it.

The court philosopher de' Vieri was not alone in commenting analytically on wonder. Francis Bacon in *The Advancement of Learning* (1605) calls wonder 'the seed of knowledge',[8] recognising that wonder provokes the enquiry that will bring it to an end, and Descartes in *The Passions of the Soul* (1645) draws attention to the same turning point, reflecting that:

> When our first encounter with some object surprises us and we find it novel, or very different from what we formerly knew or from what we supposed it ought to be, this causes us to wonder and to be astonished at it. Since all this may happen before we know whether or not the object is beneficial to us, I regard wonder as the first of all the passions.[9]

And Bacon and Descartes were, of course, only the first of a new cohort of thinkers, including Galileo, Leibniz and Newton, who, by their ability to explain the inexplicable, progressively diminished the number of wonders.

Display

The Wunderkammer and the Chamber of Curiosities

This diminution, though, happened only after the emergence of a whole new institution, the *Wunderkammer* or 'Wonder Room'. An early example was that built up by Ferdinand II (1529–1595), Archduke of Austria, and it was appropriately to this lover of wonder that one of Francis I's successors, Charles IX, gave Cellini's wonderful salt cellar. In Ferdinand's collection at Schloss Ambras outside Innsbruck it joined many other objects with similar powers over their viewers. These included, besides many European paintings, a Chinese scroll and a Japanese lacquer bowl. Most 'wonderful', though, were the objects built round the parts of rare new plants and animals, cups made out of rhinoceros horn and coconut, an inkwell with a coral centrepiece and a far more elaborate structure crammed with rare ornaments, including coral, mother of pearl and lapis lazuli (fig. 201). Objects such as these transformed the viewer's active and conscious admiration into helpless astonishment. That was why they were collected by the powerful and displayed to their rivals.

Slightly different from the collections formed by great rulers, such as Ferdinand and his successor Rudolph II, and by their competitors lower down the pecking order such as the Pastons of Oxnead Hall in Norfolk, were those formed by their more scholarly protégés. These, like that made by John Tradescant on behalf of the Duke of Buckingham, or by Olaus Worm, who was close to the Danish royal court, are perhaps more appropriately called 'chambers of curiosities', a designation that draws attention not to the first stage of astonishment, but to the second stage of enquiry which, as de'Vieri, Bacon and Descartes realised, would bring that astonishment to an end. One way in which that happened is suggested by the fate of the Tradescant collection. First acquired by Elias Ashmole, it was then given, together with the latter's personal collection of natural curiosities and artefacts, including Greek sculptures and the great American Indian dress item Powhattan's mantle, to Oxford University. By the time the eponymous Ashmolean was eventually opened as Europe's first public museum in 1683 many of the objects it housed had already lost their mystery.[10]

201 Coral cabinet, *c.*1600, pearls, mother of pearl, coral, plaster, mirror glass, glass, gold braid, velvet, bronze, lapis lazuli, gilding and wood, 66 × 55 × 56.2 cm. Chamber of Art and Curiosities, Schloss Ambras, Innsbruck

Finally, one of the most remarkable of de'Vieri's observations is that the wonder response is not just a property of a period, it is also the attribute of a social class, being a human trait most manifested in noblemen: 'man, and especially one who is noble, possesses among his other properties, that of being subject to marvelling'.[11] The tone here is far from Cellini's observation of royal *stupore*, which showed how his art could humble kings. It was because, presented in that way, the response was subversive of the social order, that de'Vieri reframed it. By crediting noblemen above all with this disposition, he could testify to the loftiness of their minds and to their 'desire to know the cause of certain effects which happen'. Such a view provides one more element to the context in which wonder was exploited by princes and aristocrats in the late sixteenth and early seventeenth centuries.

Another, equally essential, element in that context was never discussed. This was the way wonder was more associated with the country than the town, and not the countryside tamed and made productive by agriculture and animal husbandry, but the wild nature of forests and lakes exploited by the nobility for hunting. This was because the animals with whom the nobles were brought into contact by that particular rural activity were different from the domesticated breeds familiar to farmers and peasants. While the behaviour of domesticated animals was heavily regulated by humans, that of the animals with which the nobles kept company, whether their own horses and dogs, or the deer, boar and wild birds they hunted, was free and highly expressive. Such game animals are highly social, like their hunters. They also habitually display traits of dominance and subservience through the sounds they make and their body language, and they use their attributes – their teeth, manes, antlers, tusks and feathers – to attract the attention of prospective mates and to impress rivals. Spending time in the company of such creatures, the mechanisms for neural mirroring would have caused noble men and women, whether they knew it or not, to empathise with them, something not surprising considering that their behaviours were already similar to those of the animals. Indeed, hunting was itself a conspicuous example of such a behaviour, with all the opportunities it offered for the display of different types of control, both over horses and dogs, and over the animals hunted.

The systematic study of animal display and its parallels in humans had to wait till Charles Darwin, but it is noteworthy that his researches brought him close to de'Vieri. Darwin had become convinced that the omnipresence of astonishment in the natural world provided some of the best evidence that the study of animals was a key to the understanding of human behaviour. That was why the first query in the questionnaire that he published in *The Expression of the Emotions in Man and Animals* (1872), having first requested answers to it from correspondents worldwide, was: 'Is astonishment expressed by the eyes and mouth being opened wide and by the eyebrows being raised?'[12] Darwin's identification of the traits is different from de'Vieri's, being based on his own observations. So too is his explanation for its origin, being not theological but biological and functional. He sees the raised eyebrows as associated with a wider opening of the eyes to improve vision, and the opening of the mouth as associated with an intake of breath to prepare for action. Still, the search for an explanation is similar, and de'Vieri's suggestion that the tightening of the mouth is associated with speechlessness has something of the flavour of Darwin.

Darwin was convinced that the facial expression of emotions, such as that of astonishment, was the product of natural selection, because it made it easier to resolve conflicts through non-destructive display. He knew that such behaviours were inborn and neurally based, although he had no knowledge of the way the coding for the neural networks that support them is carried by each creature's DNA. He was, however, right about their function, which is why, when looking for the reason for the rise of display in the sixteenth and seventeenth centuries, it is helpful to follow his argument, looking for parallels to the phenomenon that he had observed in the natural world. Display among wild animals is particularly associated with periods of instability, as when herds break up or move territory, when mating is a priority for the young, or when, as a dominant male weakens with age, succession is an issue. After 1500, Europe went through just such a period of instability. Rapid economic growth had already challenged existing hierarchies, with bankers, merchants and lawyers attaining wealth and status that had previously only been available to landed nobility. Now the uncertainties associated with this trend were dramatically increased by events such as the shift in world trade that followed the Fall of Constantinople to the Turks in 1453 and the increase in contacts with Africa, Asia and the Americas made possible by new navigational skills. They were also further complicated by the tensions generated first by the Protestant Reformation and then the Catholic reaction against it, the Counter-Reformation. In a situation when so many patterns of relationship were fractured, and when the monarchs who had previously been the keystones in a relatively stable social order could be abjured, as was Philip II of Spain in the northern provinces of the Netherlands (1581), or assassinated, as was Henry IV in France (1610), or executed, as was Charles I in England (1649), it became

less and less clear where power resided. War was one way to bring back clarity to the situation. Display was the other.

Display among the powerful had always taken its cue from the animal world. Hunting had always provided a theatre for rivalry and was now presented as such. Throughout Europe, castles and country houses were built with viewing terraces on their roofs and pavilions constructed in their grounds for similar purposes. Often the men and women watching the hunt from these structures would at the same time have been themselves involved in a 'chase', whether for sexual partners, for friends or for allies. In such a frame of mind they would necessarily have recognised the similarity of their activities to those of the animals they were watching, the deer posing with their antlers, the boar revealing their tusks, the horses cavorting with their manes and the dogs exhibiting through their mouths, body profiles and tails the behaviours of dominance and subordination. The same would have been true when members of this group of nobles visited the growing number of court menageries. There too they would have received lessons in display, not only from the menageries' owners but also from their contents. Since the animals they housed, such as the felines (lions, tigers and leopards) and the large pachyderms (elephants and rhinoceros), were the product of millions of years of selection for the display of striking claws, horns, tusks, skins and furs, exposure to them had the same effect as exposure to animals in the hunt. The aristocracy of Europe inevitably empathised with such creatures, especially with their use of display. Exposure to menageries, like exposure to hunting, would have led to mirroring of the animals concerned, and that would have led to imitation. The same neural resources that caused artists unconsciously to imitate knights in their deportment would have also caused nobles to imitate animals in their display behaviours.

We can sense this happening already in two paintings commissioned by the Emperor Charles V. Their importance to the patron is evident in their scale, since they are among the first large-scale full-length portraits. This gives a particular interest to the way the most powerful man in Europe is shown to share significant properties with the animal by whom he is accompanied. In the painting of 1532 by Jakob Seissenegger, Charles is shown on foot, beside a large hunting dog (fig. 202). Dressed in a doublet of the same

202 Jakob Seissenegger, *Charles V with Dog*, 1532, oil on canvas, 231 × 149 cm. Kunsthistorisches Museum, Vienna, GG A114

colour as the hound's coat, the emperor's legs echo the animal's in disposition. Both look in the same general direction and Charles can be seen to share the dog's alertness and readiness. In the Titian painting, by contrast, made in 1545, after the Emperor's great victory over the Protestant armies at Mühlberg, what they share is physical promptness, the horse prancing forward and the emperor excitedly urging him on (fig. 203). Charles would have sensed how such expressive

203 Titian, *Charles V at Mühlberg*, 1548, oil on canvas, 332 × 279 cm. Museo Nacional del Prado, Madrid, P00410

pairings would reinforce the viewer's awareness of the qualities that made him supreme as a leader.

One reason why Charles V understood such artistic 'horsepower' was because he had himself recently experienced a significant confrontation with a monumental equestrian figure. In 1539 Pope Paul III had ordered the great Roman bronze statue of Marcus Aurelius on horseback to be brought from the Lateran and installed by Michelangelo on a pedestal at the centre of the Capitoline piazza so as to create a worthy setting for the reception of Charles V on his return from victory over the Turks in Tunis. The gesture was probably intended by the Pope as at once a compliment and an intimidation. What it became was an inspiration, suggesting to the Emperor that he might himself be portrayed in paint in a similar role to even greater effect, with the energies of both horse and rider much more fully expressed.

Others followed his lead. Charles's contemporary, Cosimo de' Medici, commissioned a bronze equestrian statue of himself, and by the seventeenth century many rulers commissioned portraits of themselves on horseback, both sculpted and painted. The extent to which such imagery was influenced by animal behaviour is illustrated by the many paintings of rulers that not only show them riding horses with prominent forelocks, manes and tails but that, like Velázquez's *Count Duke Olivares* and van Dyck's *Charles I*, credit the rider's hair with the same substance and configuration as that of his steed. A conscious or unconscious assimilation of the attributes of horse and rider may also lie behind the, at first, mocking designation of Charles I's supporters as Cavaliers, since what chiefly distinguished them from their Roundhead rivals was their free-flowing hair. It may also sustain the growing use of hair-pieces and extensions in the seventeenth century, culminating in the exuberant use of wigs, or periwigs. It is easy to see how the French king Louis XIV, the leader in this trend, as in many others, who particularly favoured such equestrian portraits, both painted and sculptured, and loved both hunting and warfare, might have been tempted by his desire to emulate his charger's coiffure to go one step further by artificially supplementing his natural growth (fig. 204). Other reasons have been adduced for his use of wigs, such as his regret at the loss of the hair that was his glory as a boy, and these should not be discounted. All that the suggested emulation of his horse does is provide an additional and perhaps crucial unconscious neurally driven motive. One reason why it would have been easier for Louis than for other monarchs to emulate his horse in this way was his frequent dressing up to take on other roles in ballets and masques. Indeed, it was the assimilation of his mass of hair to the rays of the sun god Apollo that inspired his performance in that guise on stage.

Two of the characteristics of the periwig as worn by Louis XIV that differentiated it from a horse's mane or tail were its substance and resistance, and these became characteristic attributes in other new fashion trends at the period. Until then European dress had been typically soft and enveloping, from the Greek tunic and Roman toga to the shifts and jackets, stockings and cloaks of the Middle Ages, but from the sixteenth century onwards clothing manifests new traits,

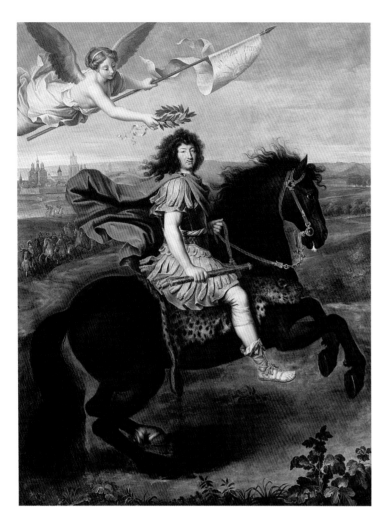

204 Pierre Mignard, *Louis XIV crowned by Fame*, 1673, oil on canvas, 305 × 234 cm. Galleria Sabauda, Turin

the wings of butterflies and the exoskeletons of insects – and that it was precisely these body parts which were most likely to find their way into the *Wunderkammer*, it is easy to see how humans anxious to catch attention and attract respect might exploit similar characteristics. England's Elizabeth I was one of the first rulers to exploit display, reinforcing her authority by frequently 'progressing' through her realm, and her sensibility to this particular principle behind its use in nature probably explains why she was both an early user of a stiff wig and favoured an impression of stiffness in both her costume and her pose in portraits.

The Power of Art Collections and their Limits

All the forms of display just described were outshone by the art collections formed at this time. In Antiquity, art had been collected by wealthy Romans and put on public display by the emperor, in the Middle Ages both churches and monarchies had accumulated significant treasuries, and in fifteenth-century Italy popes, princes and merchants, inspired by ancient example, had started to move beyond the commissioning of frescoes and altarpieces in churches, acquiring art for display in their own residences. Nothing, though, prepared for the investment in artistic patronage of the late sixteenth and the seventeenth centuries. This embraced not only paintings, sculptures and tapestries but also fireplaces and furniture, which now all vied for attention not just in the palaces of prelates, princes and nobility but in the more modest homes of merchants and, in the socially mobile new country of the United Provinces of the Netherlands, of shopkeepers and craftworkers. The collections of the Archduke Ferdinand, his nephew Rudolph II, Maria de' Medici, the Earl of Arundel, Charles I of England and Philip IV of Spain surpassed anything found before.

The extent to which such collections were fuelled by alertness to the power of the wonder response is clear from the intellectual context of their formation. Both the Archduke Ferdinand and Rudolph II's art collections were only extensions of collections of 'wonderful' objects of all kinds, while Maria de' Medici was the daughter of the Grand Duke Francesco who commissioned both the Villa at Pratolino

such as the use of the hardening and enlargement found in the codpieces and full-bellied doublets worn by men, or the farthingales or hoopskirts and bumrolls worn by women. Hardness was an even clearer property of the new headgear, such as the hats, often with high crowns and/or wide brims, worn by both sexes, while in the ruffs and cuffs, often highly starched, also worn by both, this could become rigidity. In women's jewelry and men's daggers and swords these properties were even more condensed. Given that a comparative rigidity is also a general attribute of display features in the animal kingdom – in the tusks, horns, antlers, teeth and claws of mammals, in the beaks, crests and tails of birds, in the carapaces of reptiles, the fins and tails of fishes, even in

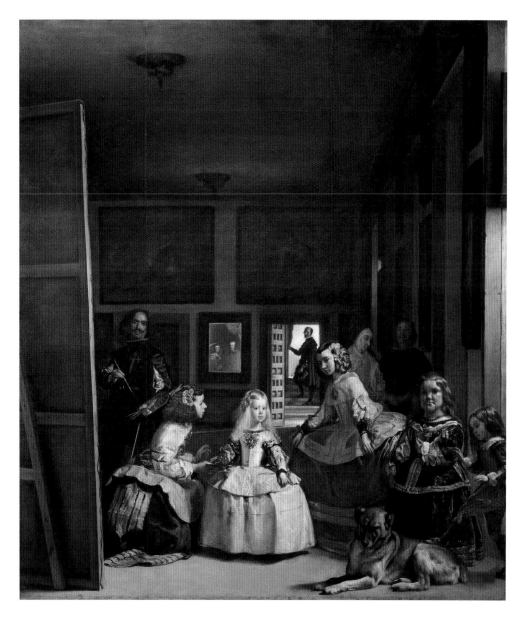

205 Velázquez, *Las Meninas*, 1656, oil on canvas, 318 × 276 cm. Museo Nacional del Prado, Madrid, P01174

and its guidebook, and the Duke of Buckingham sponsored the Tradescant collection.

A particular link to the wonder response is provided by the mirror, French *mirroir*, from the Latin 'to gaze or wonder at'. It was during the seventeenth century that the mirror ceased to be a hand-held aid to preparing the hair and the face for public display and became a substantial item of furniture, in which people could gaze at their fuller reflections. Mirrors were found alongside art collections in the palaces of rival princes. Sometimes court painters elaborated on the juxtaposition, as did Velázquez in his ingenious image of the Spanish royal family, *Las Meninas* (1656; fig. 205). There, besides his astonishing self-portrait, we find representations of marvellous works from the royal art collections, two dwarfs (prodigies of nature) and in the centre a great mirror, in which is captured the likeness of Philip IV and his queen. There could not be a better example of de' Vieri's 'artificial products' which 'are a marvel and an amazement because

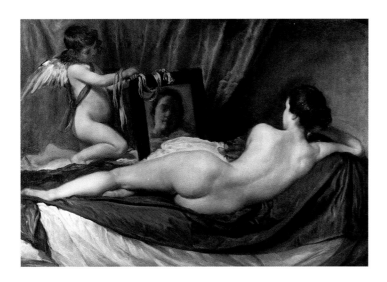

206 Velázquez, *Toilet of Venus (Rokeby Venus)*, 1647–51, oil on canvas, 122.5 × 177 cm. National Gallery, London, Presented by the National Art Collections Fund, 1906, NG2057

their cause cannot immediately be found and because they are made with such excellence that they surpass common usage.' The same is true of Velázquez's so-called *Rokeby Venus* (1647–51; fig. 206), where we look over the curving shoulders of a naked woman to be confronted by her face reflected in a looking-glass. In both paintings, the artist reflects on wonderment. It is no accident that the images we see in the two mirrors, the king and queen in *Las Meninas* and the beautiful face of a naked woman in the *Rokeby Venus*, are typical objects for the astonished gaze in nature. The appearance of the dominant male and female may turn heads in any herd, and a sudden confrontation with a beautiful sexually mature female may stop any male in his tracks. These paintings are not just about looking: they are about the type of stare which millions of years of natural selection has made an instinctive reaction to such sights, because looking at such subjects long enough to learn may improve our chances of surviving and transmitting our genetic material. Before the dominant pair we must be careful not to compete, and before a beautiful female the male must assess his chances of union. That had always been true, but art had rarely addressed the issue. Only in this age of heightened awareness of the importance of the response to the visual did it occupy such prominence in the mind of artist and viewer. This is why the age of the

Wunderkammer is also the age of the ruler portrait and of the nude and semi-nude woman. No one sensed this more than Velázquez. Hence his repeated combination in the same image of the baton-bearing male and the rearing stallion.

In all this Velázquez was reacting to the extreme instability of the Spanish monarchy. Although Philip was known as the 'planet king' because he ruled an empire that was larger than any the world had seen, the base of his kingship was hopelessly fragmented. His principal title was King of Castile, but he was also King of Aragon, of Naples and of Sicily. As he endeavoured to fulfil his manifold responsibilities he depended heavily on advisers, many of them rivals, to some of whom, such as the Count Duke Olivares, he accorded a status that matched his own. He spent half his life trying to win back the control of the Northern Provinces lost by his grandfather Philip II, and in 1640 he was forced to surrender the crown of Portugal. It was to provide an image of control to counter this picture of collapse that Velázquez produced his many portraits showing the king, his son and his generals in apparent mastery of rearing horses. Velázquez also advised the king as he set about acquiring more than four thousand paintings, the largest collection Europe had seen, installing many of them in the Palace of Buen Retiro, where we see some of them in the background of *Las Meninas*.

Not surprisingly, the faith that Philip IV and Velázquez put in the greatest group of equestrian portraits the world had seen, and the greatest collection of paintings, was not vindicated. Philip's failure, though, was still not as conspicuous as that of his predecessors in the fields of both portraiture and patronage. Maria de' Medici, the daughter of the builder of Pratolino and widow of the French king Henry IV, built up an unrivalled display of paintings and tapestries at her new Palais de Luxembourg, not to mention a great fountain in the garden, but died in exile in Cologne. Charles I of England also commissioned extraordinary portraits, both on and off horse, and spent a fortune on acquiring the collection of the dukedom of Mantua when that title was extinguished, but ended his life on the scaffold. For none of these rulers did the display of art ultimately have the power they imagined. Frederick August I of Saxony (1670–1733) had visited Versailles in the 1680s and when, having inherited the title of Elector in 1694, in 1697 he aspired to the

Polish crown, he decided to strengthen this questionable claim by imitating Louis XIV in his art patronage at his seat in Dresden. Still, in spite of his success as a collector, he ended up as a vassal of the Russian emperor, Peter the Great. Perhaps the only ruler truly successfully to exploit the power of art rather later was the German wife of Peter's grandson, the Empress Catherine the Great (ruled 1762–96), who bought the important collection of Sir Robert Walpole (regarded as England's first Prime Minister) in 1779 along with others and installed them together with a host of different treasures in The Hermitage in St Petersburg.

Taking all these fields together, the greatest seventeenth-century art patron was Louis XIV. Like Philip IV a great hunter and horseman, he and his advisers commissioned numerous painted and sculpted portraits of the king in apparent control of powerful steeds and he filled his palaces, especially the vast new structure at Versailles, begun in 1661, with these and every conceivable type of art and furnishing, including the mirrors that lined his amazing Galerie des Glaces. Versailles's gardens had many more wonders than Pratolino. Louis also drew attention to a phenomenon akin to empathy in the *Mémoires* he wrote for his son in 1662. There, after saying that entertainments, *divertissements*, were good because they gave everyone and not just himself pleasure, he went on to note how: 'all our subjects are delighted to see that we love what they love, or what they have most succeeded at. By this we attach their mind [*esprit*] and their heart [*coeur*] sometimes more powerfully than by rewards and benefits'.[13] Neural empathy with royal pleasures, he rightly saw, can attach subjects to their ruler better than gratitude for the receipt of favours. And, of course, Louis could not have made this claim if he did not himself feel empathy with those subjects. In the same text he also shows a wider empathy as he writes not only of the pleasure that the audience derives from such a performance but of the value of presenting foreigners with a favourable impression of magnificence, of power, of wealth and of grandeur. It was his particular sensibility to viewer-response that caused him to spend so lavishly on all the arts, especially at rural Versailles where the absence of other distractions meant that not only every performance but also every building, painting, sculpture, every decoration, every garden feature, had the maximum impact. As someone who was used to performing and who much of his life sought to impress by his personal displays in such arts as dancing and horsemanship, Louis had an exceptional appreciation of the principles governing the viewer's response.

THE EIGHTEENTH CENTURY

Art, the Brain and the *Camera Obscura*

At some moments in the history of art the problem for the historian is: what is the source of this or that innovation? More often, though, it is the equally important problem: why is there here such a strong sense of continuity? The latter is certainly more relevant in the case of much art of the late seventeenth and early eighteenth century. In most parts of Europe the proportion of paintings, sculptures and buildings that have much in common with those produced in previous decades is high. This is true of the vast bulk of altarpieces and portraits, statues and tombs, church facades and palaces, whether they are produced in Spain or Poland, Sicily or Sweden, or anywhere in between. As to the explanation for this continuity of traditions, a large part consists, as so often, in the high degree of continuity in the political, social, economic and religious life that such art served, and in the associated pressures on art-related behaviours familiar to the historian.

Other elements in the answer were, however, new and can be illuminated by neuroscience. One was the growing influence of teaching institutions such as the art academies, both public and private, which were established in key centres, such as Florence 1563, Bologna 1582, Rome 1588, Haarlem 1600, Milan 1620, Paris 1648 or Nuremburg 1678. Another was the parallel rise in the number of printed treatises on the arts. Still another was the emergence, fostered by both these devlopments, of a canon of the most admired artists and the most admired works of art, best illustrated by Roger de Piles's *L'Abrégé de la vie des peintres* (1699) with its lists ranking the painters of different traditions. All these trends were conducive to standardisation, as more and more young artists across Europe were trained in similar ways.

Most important was training in looking, with all its necessary consequences for neural formation. Groups of students in an academy, who all looked at the same live model or antique statue, acquired similar neural resources. So too did artists in their separate studios scattered through Europe, who often looked at and copied illustrations from the same textbooks, for example the perspective constructions in the treatise by Abraham Bosse (1645), or the facial expressions in Charles Le Brun's *Méthode pour apprendre à dessiner les passions* (1698), as well as paintings

and reproductive prints. The more artists looked at the same images, the more they ended up with similar neural networks.

These habits were then reinforced by two more general trends that involved a larger section of the population. One depended on changes in the technology of glass production. The knowledge of how to make glass, long kept a secret in Murano, had since the sixteenth century been disseminated from Altare near Genoa. This allowed significant new developments north of the Alps. One was George Ravenscroft's 1674 patenting of a new process involving lead, which allowed the production of clearer, harder, glass that could be used for lenses, so causing a rapid expansion in the use of optical instruments ranging from spectacles to the microscope, the telescope and the *camera obscura*, a box that allowed a scene to be projected on its back wall. Another was the discovery in France in 1688 of a process for making plate glass, ideal for use in mirrors, such as those lining Louis XIV's Galerie des Glaces. By 1700, the activity of looking, whether in the domestic environment through glazed windows or at mirrors, or in special contexts through microscopes and telescopes and at images projected on the back plane of a *camera obscura*, had acquired a new status, so heightening the importance of visual attention generally.

The other trend was that provoked by the new emphasis on experience and experiment, associated originally with philosophy and its offshoot, the emerging field of science. At the beginning of the seventeenth century Francis Bacon had stressed the importance of 'experience and observation' and as the century advanced these activities took on a new salience. This is evident in the writings of an ardent follower of Bacon, the medical doctor Thomas Browne (1605–1682). We sense the urgency of his looking in his *Religio Medici* (1643), one of the most widely read and translated books of the period, where he draws on his anatomical investigations to conclude that the soul has no material basis: 'because in the brain, which we term the seat of reason, there is not anything of moment more than I can discover in the crany [skull] of a beast'.[1] Browne's attitude to looking was also influenced by recent visual technologies, as he wrote in *The Garden of Cyrus* (1658),

where he compares the retina at the back of the eye 'to the paper, or wall in the dark chamber' of the *camera obscura*.[2] Feeling that the image projected on the retina is like one captured in a scientific instrument gives it a new authority, and this was further enhanced by new discoveries about the brain behind it. Critical were the revolutionary investigations of Thomas Willis (1621–1675), the Sedleian Professor of Natural Philosophy at Oxford in 1660 and the next year an early member of the Royal Society. Willis accomplished for the brain what William Harvey, another doctor, had accomplished first for the heart and circulatory system in *An Anatomical Study of the Motion of the Heart and of the Blood in Animals* (1628) and then for embryology in his *Essays on the Generation of Animals* (1651), presenting the body in terms of quasi-mechanical operations. Willis's great *Cerebri Anatome* (*Anatomy of the Brain*; 1664) was a landmark in several ways. It was the first book to use the term 'neurology'. It also achieved a new level of clarity of presentation by exploiting a technique for preserving and making visible the brain's organisation developed by his friend, the mathematician and architect Christopher Wren, and applied by Wren in the book's illustrations. Just as important, though, was its argument about the way the brain's material properties shed light on higher mental activities:

> For as the animal spirits, for the various acts of Imagination and Memory, ought to be moved within certain and distinct limited and bounded places, and those motions to be often iterated or repeated through the same tracts or paths: for that reason, these manifold convolutions and infoldings of the brain are required for these divers manners of ordination of the animal spirits, to wit that in these Cells or Store-houses severally placed, might be kept the species of sensible things, and as occasion serves be taken from thence.[3]

Willis's emphasis on the different functons of the 'bounded places' of the brain and on the role of 'repetition' in the formation of pathways anticipates today's neuroscience, just as his notion of the 'species of sensible things' being kept in separate store-houses anticipates the discovery that different categories of phenomena are processed in

different areas of the temporal lobe. Equally modern is his recognition that each person's brain is individual, reflecting their experiences, a point that is central to his *De Anima Brutorum Quae Hominis Vitalis et Sensitiva est: Exercitationes Duo* (1672), where he could draw on his anatomical studies of the brains of people whose mental problems he had known in life. All of which helps us appreciate the role of Willis in shaping the fundamental rethinking of the basis of knowledge by one of his pupils at Oxford, the medical doctor who became one of the most influential of philosophers, John Locke (1632–1704).[4] We can be sure of Locke's familiarity with Willis's ideas because his notes from Willis's lectures provide us with our first access to them. It is thus of great importance that it is in those pages that we meet the origin of one of Locke's most important ideas, the notion of the mind as a blank sheet:

> Imagination is caused by an impression from some external object that moves the spirits inwards and excites other spirits in the medulla oblongata into an expansive movement. These latter spirits are then variously circulated through the cerebral orbits forming different ideas. When a similar movement is repeated in these orbits memory is evoked as the cerebrum in infants is a tabula rasa. Phantasy arises from the convergence of various objects, as the spirits move in different ways. When imagination is evoked the expansion of the spirits is repeated and the paths and orbits of the spirits are varied.[5]

It is the view of the brain that Willis puts forward here that authorises Locke's principal revolutionary argument in *An Essay concerning Human Understanding* (1690), that ideas and aptitudes which were traditionally thought innate are only acquired by experience and by practice: 'We are born with faculties and powers capable almost of anything . . . but it is only the exercise of these powers which gives us ability and skill in anything' and 'as it is in the body, so is it in the mind: practice makes it what it is'.[6] This property of what we would now call the plasticity of the mind Locke explicates, as if combining Browne's view of the retina as the sheet at the back of a *camera obscura* and Willis's characterisation of the infant's brain as a *tabula rasa*,

by arguing that we should treat the human mind as a 'white paper, void of all characters without any ideas', and insisting that we should recognise that all our knowledge derives from experience, that is 'sensation', and from the inward 'reflection' that then follows.[7] This notion he develops by telling how, while 'imprinting' is much helped by 'attention and repetition', there is also always the risk that memories fade away: 'The pictures drawn in our minds are laid in fading colours and, if not sometimes refreshed, vanish and disappear', an observation that leads him to speculate 'whether the temper of the brain makes this difference, that in some it retains the characters drawn on it like marble, in others like freestone, and in others little better than sand'.[8] Locke's references to the material properties of the brain, which were certainly informed by his studies with Willis, perceptively anticipate the findings of neuroscience. They also probably reflect, in their use of metaphors from the world of art to illuminate the material nature of the mind, the impact on Locke's neural resources of his exposure to the resurgence of everything from grand art patronage to printing at the end of the Commonwealth and the wave of construction, sculpting and painting that followed the Great Fire of London in 1666. Locke's notion of the primacy of experience resonated with much European scientific thinking of the preceding century, and when the *Essay* was translated into French in 1695 his idea of the mind as a blank sheet began to become familiar to the educated all over Europe. It must have heightened the general new sensitivity to experience and made people more attentive to the way such experience formed their knowledge.

Particularly telling is that both Browne and Locke compare the mind to a sheet of paper, given that it was on such sheets that works of art were, with increasing frequency, first conceived in the shape of drawings. They were not directly contributing to this trend, but they were bringing to consciousness and so intensifying neural sensibilities that were already nourished by people's exposure to new materials and technologies. One of the artists thus affected was Jonathan Richardson (1666–1745), whose private collection of drawings on paper was exceptional in both size and quality. Richardson was so deeply influenced by Locke's approach that he was inspired by it to write a treatise on art criticism that came to have a profound impact on the neural exposure of generations of wealthy compatriots. The chief tenet of his *Discourse on the Dignity, Certainty, Pleasure and Advantage of the Science of the Connoisseur* (1719) is that connoisseurship, the ability to identify good art from bad and originals from copies, is truly a new science, one that has to be built up by each of us through the accumulation of personal experiences. To illustrate the importance of this he explains, following Locke's line of argument, how we, as individuals, never remain the same: 'Every man therefore is perpetually varying from himself according as the ideas happen to be which arise, and pass along in his mind'.[9] 'Every man differs from every other man in the number and degrees of his persuasions',[10] which is why 'The brain of a Chinese, a French Man, a West Indian, an Italian, a Lap-lander, an English-Man, etc are stored with ideas strangely different'.[11] This is what makes exposure to good paintings important: 'If our nobility, and gentry were lovers of painting and connoisseurs, a much greater treasure of pictures, drawings and antiques would be brought in, which would contribute abundantly to the raising and meliorating our taste'.[12] To which he adds that not only does each individual have a different store but also that even in the individual that store is constantly changing. This is because everything we see affects us. It is on this basis that he argues: 'By conversing with the Works of the Best Masters our Imaginations are impregnated with Great and Beautiful Images'[13] and that such study of great art turns us into connoisseurs.

On this basis he sent his son, Jonathan Richardson the Younger, to do something he had been unable to do, go on a tour to Italy to examine and make notes on works of art, a project that resulted in their joint publication of *An Account of Some of the Statues, Bas-Reliefs, Drawings, and Pictures in Italy* (1722).[14] This work became a bible for the young Englishmen who, inspired by Richardson, now began to visit Italy in growing numbers. People from all over Europe had been visiting cities such as Rome for centuries and, to the extent that they had looked at art with attention, they would have been affected by the experience. This new group of English visitors, however, believing that the blank sheet of their minds was really

being marked by what they looked at, would have looked both more selectively and more intently, with important consequences both for their neural formation and for their subsequent behaviour as collectors. Their conscious decisions guided by Richardson's advice certainly had potent implications for the shaping of their unconscious preferences, and so for the history of art. As he anticipated, their experiences affected their taste in all areas of their life because, as he observed: 'A connoisseur has this further advantage' that he sees not only beauties in art but 'in nature' and the 'common things' of daily life.[15] But it was the impact of their experiences on their taste in art that was to have the greatest impact. It raised their standards first in the acquisition of foreign 'old masters' and then, as the eighteenth century advanced, in the patronage of living British artists.

15

Eighteenth-Century England and the Grand Tour: The Patron

What you look at is what you want

A striking innovation of the early eighteenth century was the transformation of garden design in England. During the sixteenth and seventeenth centuries throughout Europe, the most important parts of the most important gardens had been arranged in geometrical configurations, with grids of rectangles and triangles being arranged along straight axes. There were often natural areas, such as the Italian *bosco*, 'wood', or the informal areas planned by Le Nôtre at Versailles, but these had typically been areas of transition to the surrounding countryside. Then, in England in the decades after 1700, and especially after 1720, such areas of informality take on a new importance. They were brought closer to the house, their properties given a new emphasis and they became liable to be enriched with small structures evocative of the distant and the past. Outstandingly early examples were at the home of the poet Alexander Pope on the Thames west of London, at Rousham House in Oxfordshire

and at Stowe in Buckinghamshire. Even in the eighteenth century the phenomenon generated an elaborate literature, and soon writers were talking of the 'landscape garden' or the 'picturesque garden'. The literature and the designations tell us much about the conscious thought behind the trend. They do not, however, fully account for the extraordinary expansion of the new garden-type, which in England swept away the earlier tradition that remained dominant on the continent for most of the century. However, they do suggest some of the elements in the visual experience of the practitioners and patrons of the new style that might have affected their neural resources in such ways as to endow them with visual preferences predisposing them to favour it.

Gardens as Paintings

One element is already alluded to by the terms 'landscape' and 'picturesque'. The Dutch term *landschap*, from which the English 'landscape' derives, first gained currency as a word for a painted representation, and it is to such representations that the English 'picturesque' refers. There are, indeed, explicit references to garden views as pictorial compositions as early as 1709, when John Vanburgh recommends retaining the ruins of the old manor of Woodstock, Oxfordshire, in the grounds of Blenheim Palace because it would 'make One of the Most Agreeable Objects that the best Landskip painters can invent',[1] and Joseph Addison tells us in 1712 that with some effort, 'a Man might make a pretty landscape of his own possessions',[2] while Pope writes: 'All gardening is landscape-painting. Just like a landscape hung up.'[3] As the decades passed, more and more visitors compare the new gardens to paintings. Most compelling are the comparisons invoked by the patrons. Henry Hoare II (1705–1785) at Stourhead, Wiltshire, compares the view of his Pantheon to a Gaspard Dughet, and Richard Payne Knight (1750–1824) at Downton Castle, Herefordshire, finds similarities to the work of Titian, Rubens, Rembrandt, Claude, Poussin, Salvator Rosa, Ruisdael, Ostade, Waterlo, Hobbema, Teniers and van de Velde.[4] The same theme is taken up in commentaries by the growing number of garden visitors, and an anonymous poet praises the greatest of all landscape gardeners, Capability Brown (1716–1783), as an 'artist' who

> Gilds every scene with beauty and delight;
> At Blenheim, Croome and Caversham we trace
> Salvator's Wildness, Claud's enlivening grace,
> Cascades and Lakes as fine as Risdale drew
> While Nature's vary'd in each charming view.
> To paint his works would Pusin's Powers require.[5]

It is easy to see the trend to treat gardens as 'picturesque landscapes' as driven by conscious intentions and there is no doubt that both patrons and designers deliberately pursued such effects. What is at issue is the reason for a development so at odds with previous English tradition and contemporary continental practice. Might the origin of such unprecedented visual preferences lie in unprecedented visual neural resources? To answer that question we have to ask what was truly new in the neural resources of the people involved, both patrons and viewers.

The Impact of Art Collecting

One dimension to our answer is suggested by the Lockean argument inherent in Jonathan Richardson's comment that 'By conversing with the Works of the Best Masters our Imaginations are impregnated with Great and Beautiful Images'.[6] The exceptional and rapid growth of English art collecting did indeed ensure that the imaginations of the English were exceptionally impregnated. Influential collections of internationally recognised works had been built up in England in the seventeenth century by figures such as Charles I and the Earl of Arundel, but the majority of paintings in Britain before 1700 were portraits, often by local artists. This situation changed dramatically in the eighteenth century. Following their victories over the Dutch and the French and the increase in their colonial possessions, the English had new opportunities for economic expansion and felt a new confidence. Inspired by the writings of the Richardsons, more and more individuals went on a 'grand tour', emulating that of the younger Richardson. In this way they began to acquire the skills of the connoisseur and soon they were applying them to the purchase of works of art, especially paintings from Italy, France and the Netherlands. These they then hung in their country houses, many of which were now expanded or rebuilt. A direct consequence of their looking at their new acquisitions was that they developed neural resources unknown previously either in England or elsewhere.

On the continent most people still collected work by local artists and continued to follow the critical conventions with which these had long been associated. English collectors, by contrast, made aware by the Richardsons of the importance of selecting original works by the best masters from the major national 'schools', engaged with art with a new passion and cultivated rare talents for discrimination. Through their travels they also gained a new sense of the relation between paintings and the contexts in which they were made. They

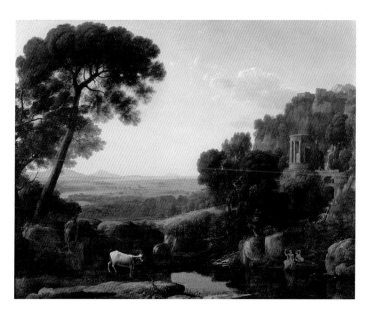

207 Claude Lorrain, *Argus guarding Io* (with round temple at Tivoli in background), 1644, oil on canvas, 101 × 123 cm. Norfolk, Holkham Hall

to anything that had similar properties to the irregular compositions of their paintings.

Another element besides the increased exposure to particular categories of landscape paintings was the increase in exposure to a particular category of real landscape. Those who followed Richardson's recommendation to travel south to Italy would have learned to look with delight at that country's distinctive landscapes in which ruins and other picturesque structures were scattered on hills and valleys, often in woods or near water. They might then have acquired paintings, drawings or prints of them, like this Claude featuring a view of the round temple at Tivoli (fig. 207). No wonder that when they returned home it was to views like those which they had seen from their carriage windows and had preserved in the portfolios of the works on paper which they had purchased that they were most attracted.

came to appreciate how most of the paintings by Dutch, Flemish and French artists related to their native landscapes, while those of the more travelled painters from those traditions were influenced by the landscape of Italy, as were also, of course, the works made by Italian artists. As a result, although they started from a much less sophisticated base, a new breed of English collectors came increasingly to pride themselves on their 'eyes', or as we would say 'brains', in a way that few collectors from other countries could.

The neural resources so acquired would not only have changed the way they looked at paintings. They would have changed the way they looked at everything, and especially the views they saw from the windows of the reception rooms of their country houses where the paintings hung. As their eyes moved to and fro between a Claude or a Poussin, or other Italianate painting, and the window, they would have tended to search in the view of the surrounding landscape for the same irregular compositions, the same picturesque structures that they found in the adjoining canvas or panel. The pleasure they had earlier taken in the rigid parterres and stiff avenues with which they had previously been confronted outside their windows would have been much diminished. Instead, they would have responded positively

Travel, Collecting and William Kent's 'shared' Eye

It could be argued, though, that these new elements in these English tourists' mental formation, an interest in collecting 'old masters' and in Italian landscape, would have had little impact on garden design if it had not been for one individual who brought them together. William Kent (1685–1748) was a young coach-painter who was picked up by supporters in his native Yorkshire and sent to Italy, where he spent ten years from 1709 to 1719. He first visited Florence and then spent several years in Rome studying painting before meeting wealthy English patrons, most notably Sir Thomas Coke (1697–1759), with whom he travelled in the Veneto in 1714, and Lord Burlington, who visited the Veneto himself in 1719. Kent thus had his neural resources shaped by intensive exposure to Palladio's buildings in that area and, since his greatest patron, Burlington, acquired a large collection of Palladio's drawings, some in 1719 in Italy and more in 1720 on his return to England, he was exposed to those too. Kent himself also collected paintings, though on a small scale. His visual resources were thus shaped by the same exposures as some of the most significant of his potential patrons, and when he returned to England he was able to call on these

208 William Kent, exterior of Holkham Hall, 1734–65, Norfolk

resources when designing not only buildings and furnishings but gardens too. All bore the traces of the preferences he had built up.

Among the most important of these gardens were those for Chiswick House (1727–30), Burlington's villa to the west of London on the Thames, and Holkham Hall (1734–65; fig. 208), the country house in Norfolk of Thomas Coke, who became Earl of Leicester in 1744. They also included those at Rousham (1738–41) for General Dormer and at Stowe (1730–48) in Buckinghamshire for another general, Viscount Cobham (1669–1749). Neither of the last two had made a conventional grand tour, but both had travelled on the continent in the course of their military careers, looking at unfamiliar landscapes with a soldier's eye, with inevitable consequences for their neural formation. In each of these contexts, to an unprecedented extent the conscious aspirations of patron and designer were sustained by 'shared' neural resources adapted to their implementation. Their conscious decisions were, on the one hand, to construct houses in the tradition of an earlier visitor to Italy, Arundel's protégé, Inigo Jones, with columnar porticoes following Palladian models, and, on the other, to recall Italy in their surrounding countryside. The success of such combinations depended on the extent to which the neural resources of both patrons and designers had been shaped by similar intense exposures both to Palladian buildings and to Italian landscapes, whether real or painted.

One of the great expressions of such a combination was Holkham Hall. There the range and quality of the collections reflect the influence of Jonathan Richardson and we are reminded of that link today by two other paintings in the house, Richardson's portraits of the patron and his wife. But the chief product of that influence was the collaboration between Coke and Kent, which resulted in a remarkable union between the house with its symmetrical pediment and columns, reflecting long exposure to Palladian designs, and the surrounding gardens, with their evocation of Italian countryside. This union is best expressed in the Landscape Room (fig. 209). On its walls still hangs a distinguished group of pictures by Claude (see fig. 207), Gaspar Dughet and others in which landscape is a principal common element. The adjoining view is plain, but other windows take in a hill covered in woods, including a grove of Mediterranean ilex, in which a range of Classical monuments including an obelisk, a temple and an arch are alternately concealed and revealed much as Kent envisaged in a drawing (fig. 210).

In the case of garden design in England, we can see how an initial privileged exposure to the Italian countryside and to Italian, French and Netherlandish landscape paintings would have first primed the neural resources of patrons like Burlington and Coke and an artist such as Kent, before the wider establishment of the fashion for making a grand tour and for acquiring a collection of paintings had a similar effect on a larger group, all of whom would have had some awareness of Locke's idea that the mind was a blank sheet. Indeed, as art collections became more important during the eighteenth century and gardens more admired, and as wealthy individuals started to tour country houses to view both, there were further inevitable consequences for their neural formation.

209 Landscape Room showing Claude painting (fig. 207) top left, Holkham Hall, Norfolk

210 William Kent, drawing for garden of Holkham Hall, after 1734, pencil, pen and ink and wash. Holkham Hall, Norfolk

The viewing of paintings had an ever greater impact on the viewing of landscape, the most extreme result of this process being the introduction of the 'Claude glass'. This was a darkened convex mirror which endowed any scene reflected in it with the tonalities of an 'old master' canvas covered in yellowing varnish. With its aid any view in nature could be given the properties of a masterpiece of painting.

As people's sensibility to the relation between the two categories of experience became more and more heightened, more and more books specifically addressed the relationship. One of the last and the most perceptive was *An Analytical Inquiry into the Principles of Taste*, by the wealthy patron Richard Payne Knight (1805). For Payne Knight the

277

senses were the source of immediate and typically short-lived responses, particularly characteristic of the young. The responses of the intellect, in contrast, were progressively heightened through life by the slow accumulation of experiences and associations. As he says at the beginning of Part II, 'The faculty of improved or artificial perception ... continues to improve through the subsequent stages of our lives'.[7] He then goes on, as if in acknowledgement of the way that neural plasticity can lead to the formation of stable networks, to note that this is why a musician can tune an instrument after he has lost his hearing and a vintner, whose organs of taste have been blunted by age, can retain the discrimination of his palate: 'All refinement of taste, therefore, in the liberal arts, arises, in the first instance, from this faculty of improved perception'.[8] Such 'improved perception' can then be invoked when confronting what he sees as an essential problem, the need to develop a new architecture appropriate to the countryside. The only reason architecture is so geometrical is because it has never 'completely emancipated itself from the regular confines of the street and the square'. For a context of 'forests, lawns and mountains', something is required that shares their irregular properties.[9] To generate such a design we should look at the compositions of artists such as Claude. 'The best style of architecture for irregular and picturesque houses, which can now be adopted, is that mixed style, which characterises the buildings of Claude and the Poussins'.[10] To complement picturesque gardens one needs picturesque buildings, such as his own Downton Castle, which was clearly intended to harmonise with the wild landscape of the adjoining gorge.

Asymmetrical Architecture and the Animal

Payne Knight feels that people's taste for the irregular can be improved by looking at countryside and landscape paintings, but he may have overlooked another more specific element in the visual field of eighteenth-century Englishmen and women. This is one that suggested itself to me in response to a challenge by a colleague when I was first talking about using neuroscience to answer art-historical questions. Around 2005 Stefan Muthesius said that he

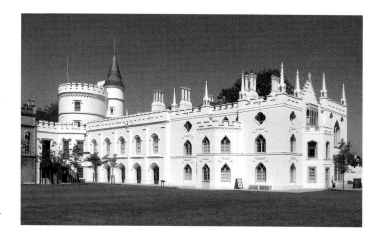

211 Strawberry Hill, Twickenham, designed by Horace Walpole, 1749–76

would be convinced by my argument if I could produce a neural explanation for the appearance of asymmetrical compositions in eighteenth-century English architecture. He was aware that in virtually all other architectural traditions anyone constructing an expensive building tried to make it symmetrical, an inclination now thought to be almost certainly guided by the same inborn resources that give us a preference for a regular human body. Not until eighteenth-century England, with buildings such as Strawberry Hill (fig. 211), as conceived by Horace Walpole, do we find architects deliberately designing buildings that were asymmetrical, a practice that continued through the nineteenth century, especially for country houses. Muthesius's problem was thus real and it became mine.

In looking for a solution I asked myself whether there had been a class of objects that eighteenth-century English aristocrats might have looked at with such frequency and intensity as to change their preferences in this direction. An answer that suggested itself was animals, specifically horses and, to a lesser extent, dogs. The particular English passion for horses goes back to the import of three Arabian horses in the late seventeenth and early eighteenth centuries. It is to these three animals that all thoroughbred horses throughout the world trace their ancestry, and because they and their descendants possessed qualities that made them particularly adapted to racing and to hunting, activities that took on an unprecedented importance in eighteenth-cen-

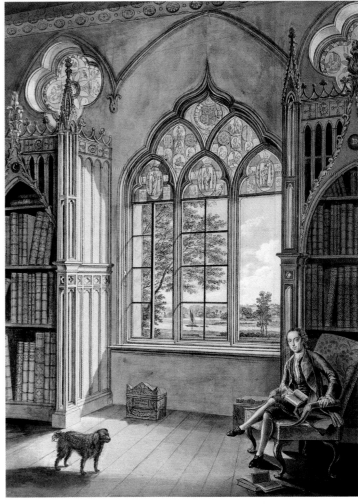

(above) 212 George Stubbs, *Mambrino*, 1790, oil on canvas, 88 × 117 cm. Private collection

(right) 213 Johann Heinrich Müntz, *Horace Walpole in his Library*, 1755–9, pen and ink and wash, 50.8 × 38.1 cm. Private collection

tury England, they attracted enormous interest. The most prominent visual testimony to this are the thousands of paintings of horses made for wealthy patrons, beginning with the work of John Wooton (*c*.1682–1764) and culminating in the great works of George Stubbs (1724–1806; fig. 212). Both artists also made imposing paintings of dogs, both hounds for hunting and domestic pets. Always the animals were shown in profile, the traditional position for evaluating a quadruped, making them highly asymmetrical, with a head usually raised at one side and a tail often down at the other. Given that horses and dogs were objects highly valued by their owners, equally distinguished in their pedigree, and that the builders of country houses gave them great visual attention, often commissioning asymmetrical portraits of them for their collections, we can be certain

that, as the century advanced, more and more people would have had neural networks giving them a strong preference for configurations that shared their properties. This would certainly have been the case with Horace Walpole and Richard Payne Knight, both of whom were particularly attached to their dogs. We can sense the importance of the relationship in the portrait of Walpole with his pet in Strawberry Hill's Library (fig. 213).

16

Eighteenth-Century England and the Grand Tour: The Artist

What you look at is what you make: Canaletto and Guardi

In the collections of Venice's Museo Correr there are two *camera obscura*s (fig. 214). One bears the name of Giovanni Antonio Canal, that is, Canaletto (1697–1768) and the other that of Francesco Guardi (1712–1793). It is unlikely that either ever belonged to one of the two great *vedutisti*, but we know that they along with Canaletto's nephew, Bernardo Bellotto (1722–1780), and his rival, Michele Marieschi (1710–1743), all used the device. Zanetti the Elder drew Marieschi around 1740 with the instrument displayed behind him, the sun's rays suggesting that it is receiving an image, and Zanetti the Younger tells us that 'Canal taught the correct way of using the *camera ottica*'.[1] What they all sought was to capture, first in their drawings and then in their paintings, something of the accuracy of the image that the *camera*'s lens projected, whether that was on ground glass, paper or some other surface. Each was trying to obtain an image that we would today call photographic. In this sense, all these artists looked at Venice in the same way, which is why there are many similarities among their works. Yet these very similarities only serve to throw into relief their great differences. The still geometry, even lighting and smooth finish often characteristic of Canaletto is far from the mobile curves, the tonal variety and flickering brushwork of his younger contemporary, Guardi. What light can neuroscience shed on the striking similarities and the equally striking differences in their work?

Looking through the *Camera Obscura*

It is most easy to account for the similarities. The neurally based preferences that both were trying to satisfy were those of their patrons, most prominent and most demanding among whom were wealthy British *milordi*. What the latter were looking for were works that captured as fully as pos-

214 Camera obscura (inscribed 'A. CANAL'), 18th century, wood, mirror and frosted glass. Museo Correr, Venice, , inv. Cl. XIX n. 0313

Canaletto

The artist who met their requirements most fully was Canaletto, and it was his works that came to set the standard for his successors, not just his nephew Bellotto but Marieschi and Guardi too. One reason why Canaletto and others were conscious of the requirements of their patrons was because they were probably spelled out to them by British middlemen, especially Owen McSwiney and Joseph Smith (*c.* 1674–1770). Smith had lived in Venice since about 1700, was in the habit of entertaining in his residence many of the young grand tourists and eventually became the British Consul (1744–60). More significantly, having discovered Canaletto, he bought many of his works for himself and negotiated the sale of many more to his fellow countrymen, becoming the principal link between the artist and his market. It has thus been argued that it was he who caused Canaletto to brighten his paintings by telling the artist that his northern clients wanted scenes filled with sunlight, and it is likely that it was also he who transmitted to him the need for accuracy which led him to call on the resources of the *camera*.

Indeed, there may be a connection between the two developments, since the *camera* needs strong light to produce a clear image. Certainly, Canaletto would have been more than usually disposed to respond to such observations, given his original training by his father as a scene-painter, which was also Marieschi's background. Success in that field depends to an unusual extent on the painter being aware of how his work looks to the theatre-goer. Besides, given that the Greek name for perspective, *scenographia*, suggests that it was developed partly to meet the needs of those who frequented the theatre in Antiquity, it would have been understandable if Canaletto sought to strengthen his talent for perspective illusion by exploiting the *camera*'s ability to capture such effects. The precise nature of his use of the *camera* is still disputed, but it is likely that the remarkable properties of the rigorous series of drawings of Venetian buildings contained in a sketchbook now in the Accademia in Venice, usually dated to the 1730s, are evidence of its use (fig. 215).[2] And, since many of his most important paintings are based on these drawings, such use may have played a significant part in his satisfaction of his clients' demands.

sible the visual experiences they themselves had enjoyed. Of course, there had long been a call for city views, especially in Italy, and painters like the originally Dutch Gaspar van Wittel, known as Gaspare Vanvitelli (1652/3–1736), and Luca Carlevarijs (1663–1730) from Udine, had been responding to it with panoramas of scale and great charm. The new clientele, though, were much more exacting, for reasons outlined in the last chapter. Under the influence of Locke and Richardson they not only looked with an unprecedented intensity, but were also more highly sensitised to the impact that such looking had on the blank sheets in their heads, which they hoped, following Locke's metaphor, would be as retentive as 'marble', not 'sand'. They were thus themselves more deeply affected by their exposure to Venice's cityscape than any previous travellers and demanded material representations of it that in accuracy and clarity rivalled the images impressed on their own minds.

215 Canaletto, *Campo San Giovanni e Paolo, Venice*, 1730s, four drawings. Gallerie dell'Accademia, Venice

The use of the *camera obscura* may also have contributed directly to the emergence of those properties that distinguish his work from that of his rivals, especially from that of Guardi, that is, their clarity, linearity and angularity. These are properties that are inherent in architecture. In the pages of the Accademia sketchbook, which is devoted almost exclusively to Venetian buildings, they are omnipresent. There is none of the shading frequently found in other types of drawing, and the only references to tone and colour are contained in annotations. Canaletto's decision to make such an intense study of architecture was certainly conscious, but he will not have been conscious, except subliminally, of its consequences for his neural formation. Looking so intently, and so frequently, at the angular linear dispositions of architectural elements would have progressively strengthened the networks carrying preferences for such attributes, and it is these which will have guided his brush as he made not just the major paintings based on those drawings but many others.

The Accademia drawings are only the most striking token of Canaletto's distinctive interests. His concern with architecture must go back to his artistic origins. Unlike the majority of artists, for whom painting the figure was the central activity, as a scene-painter he would have been responsible only for painting the background to figural action, a background that would usually have been architectural. It was expertise in this field that led to his involvement in the execution of two large paintings of the tombs of great Englishmen

commissioned by McSwiney for the Duke of Richmond. In both, the architecture and foliage was said to have been painted by Canaletto and Giovanni Battista Cimaroli, and the figures in one by Giovanni Battista Piazzetta and the other by Giambattista Pittoni. In fact, in both works, Canaletto's responsibility is likely to have been the architecture. This interest of Canaletto the scene-painter in architecture would only have been strengthened by its resonance with the interests of patrons with even clearer preferences than those of the Duke of Richmond, that is other British visitors who, for reasons noted in the last chapter, had a more direct interest in the city in the lagoon. Like the gentry and nobility of other nations, the British revelled in the pleasures and rituals embodied in the city's human life, but, unlike them, they also shared a specific interest in the architectural tradition out of which Palladio's buildings had emerged. Since clarity, linearity and angularity were primary attributes of the Palladian buildings that were then becoming an increasingly prominent element in the English environment, visitors would have already possessed neurally based preferences for those properties when they arrived, and it was these that influenced them when choosing between, say, a 'Carlevarijs', a 'Marieschi' and a 'Canaletto'. The 'Canaletto' would have appealed as simply the most architectural, at least in that artist's mature period.

Canaletto's early works, though, reflect different interests that are more generically Venetian. The first large group of

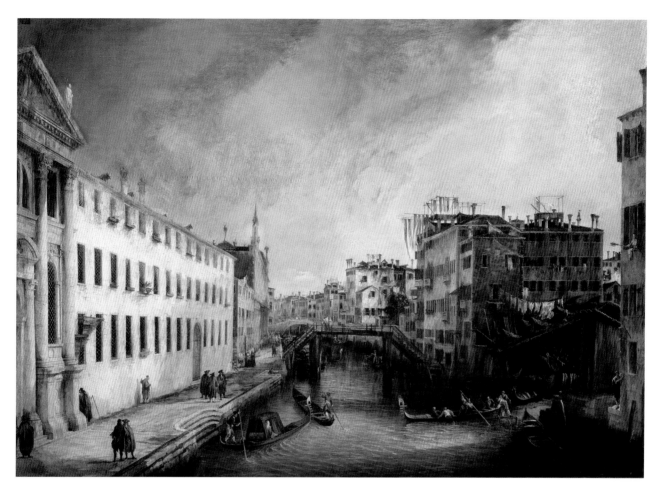

216 Canaletto, *Rio dei Mendicanti, looking South*, 1723/4, oil on canvas, 143 × 200 cm. Ca' Rezzonico-Museo del Settecento, Venice

views are dateable by building work and other interventions to around 1723. All have a dark tonality, with small figures scattered in the fore- and middle-ground and sombre, dramatic skies. Even the most architectural of them with the most rigorous perspective, the *Piazza San Marco* in the Thyssen Collection, has little of the linearity to be found later. Only in one, the *Rio dei Mendicanti, looking South* (fig. 216), do we get some insight into the way Canaletto's neural resources were going to influence his art. Two areas demonstrate a marked polarisation in his style. Thus, while in most of his early paintings, the water generally lacks animation, here in the foreground on the left, where a gondola is leaving the quay, a series of curling ripples almost become waves. If we ask ourselves for an explanation for the phenomenon in terms of then current theory or practice, none

presents itself. Rather, it seems to have arisen only as a visual echo of the landing-stage's curved steps. That the ripples are not raised by the wind is demonstrated by the stiff row of textiles hanging from rods on the roofs on the other side of the Rio, where their pattern of rigid rectangles echoes both the adjoining series of chimneys and the windows in the emphatically cuboid building below. Such echoes between the elements of a composition are found throughout the history of art and reflect the inbuilt human preference for 'groupings of similar shapes' noted a hundred years ago by the Gestalt psychologists and now illuminated by an understanding of the role of areas V2 and V3 in early visual processing. In this case, though, there is an added neurological interest to the echoing, as it cues us into a trait of importance for much of Canaletto's future development, the susceptibil-

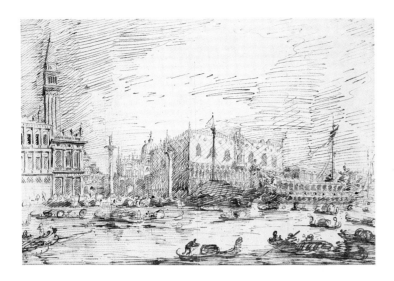

217 Canaletto, *The Bacino di San Marco, Venice, on Ascension Day*, 1729, pen and ink over free and ruled pencil, 21.3 × 31.7 cm. Royal Collection, London, RCIN 907451

ity of his neural networks to the impact of the salient properties of particular subject matter.

This produces changes in his style that are best illustrated by comparing drawings from a series that once belonged to Consul Smith, now in the Royal Collection. In them the modifications of technique can be directly related to the subject represented and the adjustments can be quantified and computed. In the *Bacino di San Marco, Venice, on Ascension Day* (fig. 217), a first glance suggests an overall coherence to the pen lines, with water and sky, for example, being treated in a similar mixture of regular and iregular strokes, but a closer look reveals a clear contrast between the area immediately below the horizon line and that immediately above it. Below, where boats and people, gondoliers and awnings, predominate, the surface resolves into a chaos of curves, while in the architecture above, vertical and horizontal lines are brought into a geometrical relationship by diagonal hatching. A similar contrast is found in a different view from the same year, *The Bacino looking West from San Biagio*, but in a later view of the same general scene of about 1735–40 the contrast has been resolved. The geometry of the architecture is similar, only better organised, and a similar order is now to be found on the water, where the surface is captured in parallel horizontal lines, and boats, almost free of people, are

blocked out in heavy diagonal shading. Foreground figures on the quay are also similarly blocked out, only now with curved lines articulating their more cylindrical volumes. In the sky, too, the chaotic hatching earlier used to capture shifting clouds has been replaced by equally uniform lines, only slightly lighter and more fluent. The process of ordering and harmonisation of touch is taken even further in *The Molo from the Bacino* of about 1740–45. There repetitions of vertical, horizontal and diagonal lines abound, and each object and building acquires a new mass and solidity.

The fact that the ordering is most thorough in this particular composition, with its worked-up border of carefully ruled lines, alerts us to the underlying cause of the trend in this direction, the increasing attention given by Canaletto to things possessing linear and angular clarity, above all buildings. It would, of course, be possible to claim that Canaletto took a series of conscious decisions to move in this direction, but that is hardly likely, given that there is no model, or parallel, for such thinking. It is more likely that a decision that was conscious, to concentrate more and more on architecture and to use tracings from the *camera obscura* as aids, exposed him to more and more such lines, so causing him to develop an increasing preference for them. This is why there is a parallel development in his paintings. Thus, in *San Cristoforo, San Michele and Murano from the Fondamenta Nuove* of 1722 (now in the Dallas Museum of Art), diagonals dominate not only both the foreground and the sky, but also the group of buildings, which are barely sketched as a picturesque assemblage of forms defined by tones, while in *The Entrance to the Grand Canal, looking West, with Santa Maria della Salute*, of about 1729, although the boats and figures in the foreground seem all to be going in different directions at different angles to the picture plane, the buildings on the right form a well-drilled series of rectangular facades, their vertical elements emphatically mirrored in the water below, at the same time that much of both the water and the sky above is marshalled into equally emphatic horizontals. The *Bacino di San Marco* (c.1738/9; fig. 218) goes even further. Not only is the sweep of buildings, from the piazzetta on the left to the Island of San Giorgio on the right, articulated as a frieze punctuated by vertical campaniles, but the boats in the middle- and foreground are instruments in a similar music,

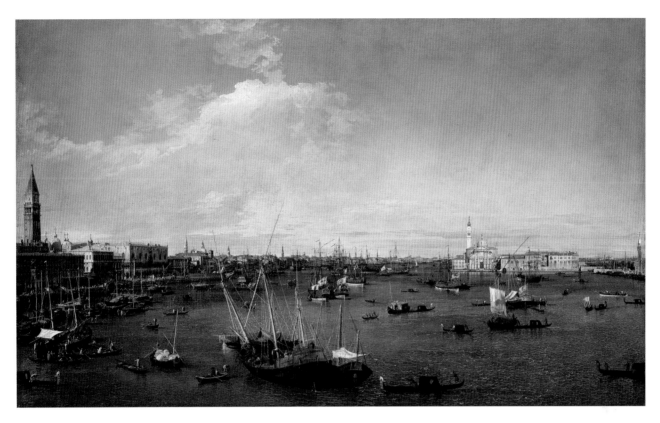

218 Canaletto, *Bacino di San Marco, Venice*, c.1738, oil on canvas, 124.5 × 204.5 cm. Museum of Fine Arts, Boston, Abbott Lawrence Fund, Seth K. Sweetser Fund, and Charles Edward French Fund, 39.290

to the extent that the group of vessels that are the main focus near the centre come together as a virtuoso performance, in which masts and rigging create a composition of straight hard lines that, although departing from the vertical to varying degrees, all pick up the same theme. The extraordinary harmony of this view of the Bacino is well brought out by a comparison between it and the rather similar view by Marieschi from the same years. In the latter work rich internal reverberations are replaced by the meaningless dissonances of chance. Instead of a unified effect we have many abrupt contrasts not just of shape but of colour and tone too.

Boats are not the only elements that Canaletto infuses with an aesthetic shaped by architecture. Even more striking is what happens to his figures. In the *Piazza San Marco: Looking West from the North End of the Piazzetta*, signed and dated 1744 (fig. 219), the numerous figures resemble the multitude of columns with which they are surrounded, being described by J. G. Links as 'puppets rather than people'.[3]

Here we can see the combined impact of two neural phenomena. Neural plasticity means that repeated intense exposure to architecture made Canaletto prefer highly structured forms, while the particular assimilation of figures to columns may well be the product of the Gestalt psychologists' 'grouping', that is the tendency of the brain to look for similar forms within the field of view. In this case such a tendency could have led to the perceptual system grouping figures with columns, making the former look more like the latter to increase the neurochemical reward. The overriding impact of exposure to architecture, though, is the predominant factor shaping Canaletto's tastes, as we can see in the late *Grand Canal looking South East* painted for Sigismund Streit between 1758 and 1762. Of this work Michael Levey noted that: 'Canaletto has compelled the untidy reality of the assembled bobbing gondolas and other boats at the right here, as well as the bustling activity of rolling barrels or bales along the adjoining quay, to be frozen into deliberate, intri-

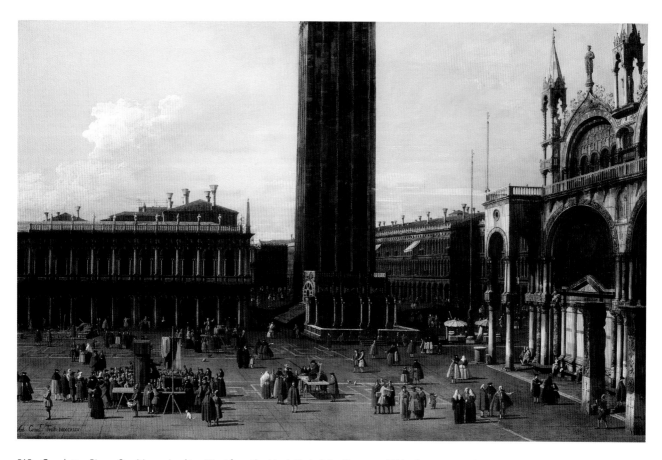

219 Canaletto, *Piazza San Marco: Looking West from the North End of the Piazzetta*, 1744, oil on canvas, 77.5 × 119.5 cm. Royal Collection

cate patterns'.[4] The unified effects produced by Canaletto in this and many other paintings of the 1730s and 1740s can be seen to depend on his transposition of properties inherent in Venetian architecture to all other elements in the composition. He can never have intended such an effect consciously, but his conscious decision under the influence of the middlemen, McSwiney and Smith, and of individual patrons, to concentrate on architecture, and to exploit linear tracings from a *camera obscura* for its representation, led to his developing neurally based preferences in that direction that were unprecedented in European art.

Just how unprecedented they were emerges from a comparison between his style and that of his sixteenth-century Venetian predecessors discussed in Chapter 12. There could hardly be a more abrupt contrast between the two visual expressions, although both are the product of a neural response to the same environment. The concerns of the

sixteenth-century painters were different from his, and the same was true of those of their patrons. As argued earlier, the distinguishing traits of those concerns, fondness for oil paint, loose brushwork, an interest in reflections, and rich colouring, were the product of neural exposure to water, coloured marble, mosaics, glass and silk, to all of which artists and patrons then gave great attention because of their associations with the city's triumphal political and commercial success. By the eighteenth century both territories and markets had been lost and success had been succeeded by relative failure. No one looked at the Venetian environment in the same way, not the Venetians and certainly not the English aristocrats, whose prime interests, besides social pleasures, were in the architectural sources for their own Palladian tastes, and in the sunshine they lacked. Many painters become great by empathising with the visual preferences of their patrons and Canaletto did so to an extraordinary degree. It is important

220 Antonio and Francesco Guardi, *Departure of Tobias*, 1749–50, oil on canvas, 80 × 91 cm. Chiesa dell'Angelo S. Raffaele, Venice

to say 'become' because it takes time for neural plasticity to facilitate the formation of the neural connections on which the visual power of Canaletto's mature paintings depend. In a painting such as *San Cristoforo, San Michele and Murano from the Fondamenta Nuove*, of about 1722, we can still find much of the loose brushwork, reflections and rich colouring of the Venetian painters of earlier centuries, not just because he had been looking at the same material and social environment as they, but because he had also been looking at the work they had produced, both in the sixteenth century and the seventeenth. The neural preferences of the young Canaletto, like those of many artists when they set out, were formed by an intense exposure not to his physical environment but to the art of those he sought to rival.

Guardi

This was particularly true of the other artist with whom we are concerned here, Francesco Guardi, since he, like his brother Antonio, thirteen years his senior, began his career as a painter of figure subjects, especially altarpieces, and as a copyist. It is thus no surprise that his early work has something in common with the whole Venetian tradition from Titian to Piazzetta, and also with Giambattista Tiepolo (1696–1770), who in 1719 had married his sister. Typical is the *Departure of Tobias* (fig. 220), painted by Antonio and Francesco for the church of S. Raffaele. A particular feature of the painting is the agitation, not just of the figures, but of the dog, the vegetation and the sky. If the contribution of the

221　Francesco Guardi, *Doge of Venice carried by Gondoliers following his Election*, c.1770, oil on canvas, 67 × 100 cm. Musée de Grenoble

Canal family to the *vedutisti* tradition has its origins in their training as painters of scenes for which actors would provide the figures, that of the Guardi family is characterised by the role of Antonio, Francesco's older brother and mentor, as a painter of figures inserted into views by Michele Marieschi. If the Canal family concentrated on architecture, the Guardi family concentrated on figures. The Canal family were specialists in the still, the Guardi family in the moving. Their focus on figures and their properties gave them interests that extended to other things that moved, including clouds in the sky and waves in the water.

These, then, became the interests that differentiated the views of Francesco Guardi from those of Canaletto at the point when the former, probably sensing a gap in the market during Canaletto's absence in England, started to imitate, sometimes to copy, the scenes that had made the latter

famous. They are apparent in works painted in the 1750s based on Canaletto prints and paintings, including the *Doge of Venice carried by Gondoliers following his Election*, c.1770 (fig. 221), where the agitated figures in the Piazza and the flapping awnings above upstage the masonry masses of the Doge's Palace, the Loggetta and the Procuratie Nuove, in a way they never do in Canaletto's treatments of the subject. Francesco was already neurally equipped to give those mobile elements more attention, and that attention would have strengthened his neural equipment, leading him to paint works like *The Giudecca Canal and the Zattere* in which the architecture recedes to the sides, leaving the shipping, the figures, the coloured clouds, as well as the water in which they are reflected, to dominate the scene. Again, in the *Molo and the Riva degli Schiavoni from the Bacino di San Marco* of about 1765 (now in the Metropolitan Museum, New York), shimmering light

222 Francesco Guardi, *Regatta on the Grand Canal, c.*1775–7, oil on canvas, 61 × 91 cm. Gulbenkian Museum–The Calouste Gulbenkian Foundation, Lisbon

effects in water and sky set off the movements of the gondolas and sailing boats and their energetic crews, in strong contrast to Canaletto's slightly closer view in the Royal Collection of *c.*1733–4, where the boats and their occupants take their more stable rhythms from the buildings on the waterfront. The same is true if we compare Canaletto's *Regatta on the Grand Canal* in the Royal Collection of a similar early date with Guardi's presentation of the same theme from the same position of about 1777 (fig. 222). Although the boats and their rowers are more prominent in the Canaletto, they have acquired the monumentality and regularity of the series of palaces that line the Grand Canal. In the Guardi, by contrast, the palaces seem almost to bob up and down like boats. Another difference, which is especially surprising, since Guardi has copied many shipping details directly from the Canaletto, is the introduction of a number of gondolas which seem to fly like birds propelled by agile gondoliers, pulling the viewer's eye far down the waterway.

Probably nothing is more revealing of the distinctive neural resources that Guardi had acquired by his work as a *vedutista* than these lively figures, which give many of his later works their distinctive animation. We have a feeling that he particularly loves gondoliers because he empathises with them, taking his cue for the way he dips his brush and flicks his paint from their elegant movements as they flick the water of the Grand Canal with their oars.

THE NINETEENTH CENTURY

Art, Industry and Neurology

The combined impact of the French political Revolution and the British Industrial Revolution meant that the years around 1800 brought social and economic changes more dramatic than those associated with any earlier turn of the century. Their impact was also more long-lasting and far-reaching. Over the following ten decades and beyond they affected the daily experience of almost everyone in Europe. The consequences for the neural formation of the individual were enormous, whether or not he or she was a direct beneficiary of the revolutions. It was not necessary to enjoy the new rights envisaged in Revolutionary France in order for them to change people's thinking about their relationship to society. Just imagining those rights was enough to cause the formation of neural resources facilitating a previously undreamt of range of personal choices. Similarly, it was not necessary to be a worker in a steam-powered factory, such as the cotton mill installed by Richard Arkwright in the Albion works, London, in 1787, or to use a train pulled by a steam engine, as first demonstrated by Robert Trevithick in 1801, to appreciate their potential influence on both production and consumption. It would have been impossible to grasp the implications of these two revolutions using the same neural networks that had enabled people to deal with the relatively stable social and economic norms that had prevailed earlier. New rights and new opportunities could only be appreciated by forming more complex networks. In the social field more complex networks were needed to relate different classes to differing interests, expectations and rights. In the economic field, too, more complex networks were required to calibrate different notions of labour, different notions of markets, and different technologies.

The formation of such networks was encouraged by the dissemination of new models of the mind. One model was that associated with the emerging phenomenon of Romanticism. This placed a new emphasis on possibilities for individual expression and on the importance of emotional drives. Another, which resonated with this view, was that associated with a new interest in the brain. How this interest enlarged mental space is best illustrated by Charles Darwin's grandfather, the doctor Erasmus Darwin

(1731–1802). In his visionary poem, *The Temple of Nature* (1802), he offers a history of life from the most primitive organism to humans. A central role is played by the nervous system:

Next the long nerves unite their silver train,
And young Sensation permeates the brain;
Through each new sense the keen emotions dart,
Flush the young cheek, and swell the throbbing heart.
From pain and pleasure quick Volitions rise,
Lift the strong arm, or point the inquiring eyes;
With Reason's light bewilder'd Man direct,
And right and wrong with balance nice detect.
Last in thick swarms Associations spring,
Thoughts join to thoughts, to motions motions cling;
Whence in long trains of catenation flow
Imagined joy, and voluntary woe.

(lines 269–80)

Erasmus Darwin went further than his contemporaries in his description of the manifold role of the nervous system in sustaining all human physical, emotional and intellectual activities, but many shared a similar sense of the importance of their neural make-up.

Following the work of Willis, such sensibilities had been growing during the eighteenth century but only in the nineteenth do we find a full neural self-consciousness. There are hints in the art of the sculptor Franz Xaver Messerschmidt (1736–1783), who used his own face to articulate sixty-four 'canonical grimaces', and in the writings of one of his subjects, a Viennese contemporary, the doctor Franz-Anton Mesmer (1734–1815), known for his ideas on 'animal magnetism'. Related ideas emerge in the 'physiognomic' theory of the Swiss Johann Kaspar Lavater (1741–1801). A fully neural – and also completely erroneous – theory only appears, however, in the work of the first true neuroanatomist, the German doctor Franz Joseph Gall (1758–1828). Gall developed the theory of phrenology based on the notion that the brain has different areas devoted to different faculties, such as love, and that their enlargement, being visible on the surface of the skull, indicates their relative importance in the individual's life. A more objective analysis had to wait

for the discoveries made possible by more sophisticated microscopes with new compound lenses. It was these that allowed the Frenchman René Dutrochet in 1824 to draw nerve cells in slugs and the German Gabriel Valentin in the 1830s to describe those in the human cerebellum. Precision of knowledge further improved with Hermann von Helmholtz's measurement of the speed of electric transmission in the nervous system in 1849, and the 1865 publication by another German, O. F. C. Deiters, of the first detailed drawing of a nerve cell from the spinal cord, clearly differentiating the single large axon from the many smaller fibres, or dendrites. In the same decade, in 1861, the Frenchman Paul Broca was able, by anatomising patients with speech defects, to localise and eventually give his name to the main area involved in speech production. Work with staining then allowed first the Italian Camillo Golgi and then the Spaniard S. Ramon y Cajal, from the 1870s onwards, to reveal further the brain's almost infinite physical complexity. By the century's end a neural model of the mind sustained the notions of *Einfühlung* (empathy) developed by Friedrich Theodor Vischer (1807–1887) and of the 'Unconscious' formulated by Sigmund Freud

(1856–1939). It also allowed the wider population to accept that many maladies were 'nervous'.

The gradual emergence and dissemination of an ever more refined awareness of the workings of the brain had an added impact on thinking because they resonated with developments in the new technology of photography. Thomas Browne's comparison of the retina to the screen of a camera obscura and Locke's of the mind to a blank sheet were both rooted in a neural empathy with inanimate materials. This empathy greatly intensified as inventors like the Englishman William Henry Fox Talbot and the Frenchman L.-J.-M. Daguerre showed how such materials could be in some sense brought to life. As lenses improved, and the light-sensitive substances on which the images they captured were projected became more stable, there was a growing tendency for individuals to feel, either consciously or unconsciously, that the relation between the eye and the brain had much in common with that between the camera lens and the film or plate. This was particularly likely to be true for artists, some of whom felt that they were in competition with the new technology, while others exploited it.

Nineteenth-Century England

Constable and Turner

In any context there are two obvious ways to open up a neuroarthistorical enquiry. One is to identify an artistic phenomenon that seems poorly understood and then look for some new element in the social and physical environment that might have had such a significant impact on people's unconscious neural formation as to contribute to its emergence. Sometimes, as in the case of the difference between the architectural styles of late medieval France and England, this means talking of the neural formation of a whole group. Sometimes, as in the case of the pre-eminence of Leonardo's art, we are dealing with that of the individual. Another way to open up enquiry is to identify a new element in the social and physical environment that was so conspicuous that it would have been likely to cause specific changes in people's unconscious neural formation and then look for the consequences of such formation in artistic patronage and production. This is what we did for early eighteenth-century England, when we first

identified a powerful new combination of influences in the writings of Locke and Richardson, and then looked for evidence of their impact, and in late eighteenth-century Venice, where we first noted the existence of *camera obscura*s bearing the names of Canaletto and Guardi and then looked for evidence that their use might have affected their art. The heuristic value of this more deductive approach is illustrated by the fact that the features we traced to these new influences were not in themselves striking enough to call for an explanation.

Constable and Turner and a shared Interest in the Vaporous

The same is true of certain features of the art of John Constable (1776–1837) and Joseph Mallord William Turner (1775–1851). We simply note them and take them for granted

223　John Constable, *Clouds*, 1822, oil on paper laid on cardboard, 30 × 48.8 cm. National Gallery of Victoria, Melbourne, Felton Bequest, 1938 (455-4)

224　Joseph Mallord William Turner, *Venice with the Salute*, c.1840–45, oil on canvas, 62.2 × 92.7 cm. Tate Britain, London, Accepted by the nation as part of the Turner Bequest 1856, N05487

as emblematic aspects of their achievements. Their salience may only emerge if we start by asking ourselves what were the most striking new elements in their environment, and go on to ask whether these elements had an effect on their art. Applying this approach to Turner and Constable we can begin by noting that, as two English artists who came to maturity around 1800, they were among the first in the world to have been exposed to the Industrial Revolution, and we can go on to ask which of its visual manifestations was most likely to have affected them. One answer to that question presents itself straight away, smoke and steam. Not only were they highly visible products of the Industrial Revolution but also, because of their association with economic growth, material improvement and wealth, they would have been salient, carrying powerful positive associations. This we can put in neural terms. We can say that it was much more likely that the networks of the visual cortices of these two artists would have been exposed to those phenomena than were those of their predecessors in England or contemporaries elsewhere, and that this would have led to them acquiring neural resources specifically adapted to their perception. We can also say that, given their positive associations, the firing of the neurons involved would probably have been associated with some activation of the reward system, for example with the uptake of 'feel-good' neurochemicals in

the nucleus accumbens. This allows us to develop a hypothesis about particular features of their art. Since those same neurons would also have fired when they were exposed to any other phenomenon that shared their formal traits, we can argue that exposure to smoke and steam would have been likely to lead to an increased interest in mist, fog and clouds.

On this basis we can look at their work to see whether they do indeed have an exceptional interest in such vaporous substances, and what we find is that it was true of both of them. Constable was the first artist to have made many studies of clouds as such (fig. 223) and Turner was the first to have made mists his principal theme (fig. 224). Their shared interest in such vapours was remarkable, and its novelty in the English tradition the more striking because, although clouds and mists had for millennia been prominent in the British visual environment, they had never been an important subject in British art. This point is especially important because it brings out one of the ways in which turning to neuroscience is productive. It is not sufficient for a particular feature to be prominent in the environment for it to affect the formation of neural networks. It has to be salient in people's experience. There have to be reasons why it attracts frequent and intense attention. Mists and clouds had no special place in earlier English art because earlier there was no reason for them to attract special attention. In this

there was a clear contrast with the earlier situations in both Venice and the United Provinces of the northern Netherlands, where they did, because water, and its vaporous manifestations, were proportionally much more important for the economies of those two communities which were based on maritime trade. It was because this circumstance caused the Venetians in the fifteenth and sixteenth centuries and the Dutch in the sixteenth and seventeenth to develop neural resources attuned to those phenomena that vaporous skies play an exceptional role in their art in those periods.[1] What happened in early nineteenth-century England represented a continuation of that tradition, with a scientific interest in the impact of weather on maritime trade causing people to take a new interest in clouds, but there was now a new factor, an interest not just in the natural phenomena themselves, but in manufactured phenomena that shared their properties, steam and smoke.

Since this is a prominent example of the way new manufactured phenomena can change people's view of those that are natural, this development is particularly worth studying. In many cases earlier I have argued that neural exposure to an element in the natural environment caused the formation of neural resources that shaped people's view of the human-made. Now the situation is reversed. Not that the new smoke and steam did not have their origins in a specifically local nature. Accidents of geology meant that the high-quality coal on which the Industrial Revolution depended was readily available under British soil. Accidents of erosion meant that on north-east coasts coal seams were exposed in cliffs, from where their contents could easily be shipped to London to provide heating and cooking as the city grew during the sixteenth and seventeenth centuries. Such exploitation increased during the eighteenth century, especially as improvements in pumping technology made it possible to open up deeper mines inland. The most important of these improvements was the introduction of steam power, made possible by the work of James Watt and Robert Trevithick, and these benefits were further compounded when the combined power of coal and steam was harnessed to other machines, which could transport first minerals, such as coal and iron, and then people, by both land and sea. By 1800 everyone in England was beginning to benefit from these developments, either directly or indirectly, and most would have felt pleasure at the sight of smoke and steam. Even the smell came to carry positive associations, especially after it was discovered that coal could produce gas and gas could provide lighting, as William Murdoch demonstrated in his own house in 1792.[2] The spread of public gas lighting after 1800 made cities more secure, while its use in factories facilitated 24-hour working. Even those who knew no more of the benefits of coal than its value for domestic cooking and heating would have felt an unconscious pride in the innumerable advantages it brought. London may have been called with ever increasing justification 'The Smoke' and in English cities generally mists may have turned ever more regularly into poisonous smog, but smoke and steam generally had connotations that were essentially good. George Cruikshank may have noted the destructive aspects of these developments in his 1829 print *London going out of Town – or the March of Bricks and Mortar* (fig. 225), but he cannot stop us seeing the smoke that engulfs the sky above and the polluting lime dust which is made to look more like steam or gas emitted by the land below as principal indices of what passed for progress.

The signpost at the top right of the Cruikshank print reads 'Hampstead' and it was on that hill above the London fog in 1821 and 1822 that Constable made his revolutionary series of paintings of clouds (see fig. 223). His conscious rationale is limpidly presented in a contemporary letter:

I have done a good deal of skying – I am determined to conquer all difficulties and that most arduous one among the rest, & now talking of skies – . . . That Landscape painter who does not make his skies a very material part of his composition – neglects to avail himself of one of his greatest aids. Sir Joshua Reynolds, speaking of the 'Landscape' of Titian & Salvator & Claude – says '*Even their skies seem to sympathise with the Subject*' . . . It will be difficult to name a class of Landscape, in which the sky is not the '*key note*' – the *standard of 'Scale'*, and the chief '*Organ of sentiment*' . . . The sky is the '*source of light*' in nature – and governs every thing. Even our common observations on the weather of every day, are suggested by it but it does not occur to us.[3]

225 George Cruikshank, *London going out of Town – or the March of Bricks and Mortar*, 1829, etching. 27.6 × 37.4 cm. Lewis Walpole Library, Yale University

These are highly intelligent observations and, together with what we know of the artist's familiarity with the scientific studies of clouds by his contemporaries, Luke Howard and Thomas Forster, they help to explain the rigour and intensity of the cloud studies. Most revealing, though, is Constable's final phrase: 'but it does not occur to us'. In this acknowledgement of the extent to which our relationship to the sky is unconscious he allows for the fact that the ultimate source of his own interest in clouds did not occur to him either. That is only suggested by the Cruikshank print. It was exposure to London smoke and smog following Constable's arrival from his Essex river valley that would have laid down the neural networks with which he later engaged with clouds as a painter. We may not like the notion of such passive exposure having an active role in the shaping of his talent, but he himself alludes to such passive neural formation

in one of his more evocative pronouncements: 'The sound of water escaping from mill dams, willows, old rotten planks, slimy posts and brickwork, I love such things . . . these scenes made me a painter'.[4] Besides revealing the intensity of his sensory response to his surroundings, this text, through the phrase 'these scenes made me a painter', gives us a strong sense that Constable felt that in his relationship with nature it was the environment that was active on him rather than the reverse.

If in Constable the importance of his exposure to vaporous phenomena is best expressed by a single group of works, the cloud studies, in Turner it is expressed by a much more consistent engagement. This goes beyond the conscious concern with smoke and steam expressed in such portrayals of steam vessels as *The Fighting Temeraire* and *Rain, Steam and Speed: The Great Western Railway* (1844; fig. 226) and extends to an

226 Joseph Mallord William Turner, *Rain, Steam, and Speed: The Great Western Railway*, 1844, oil on canvas, 91 × 121.8 cm. National Gallery, London, Turner Bequest, 1856, NG538

227 John Constable, *Barges on the Stour, with Dedham Church in the Distance*, 1834–5, oil sketch, 92.1 × 123.2 cm. Victoria & Albert Museum, London, Given by Isabel Constable 325-1888

interest in all things vaporous. A highly revealing anecdote about him is the story told by the doctor, Robert Graves, of sitting next to a man on a stagecoach crossing the Alps, who turned out to be the artist and who was busy making rapid sketches of clouds.[5] So recurrent was Turner's interest in all forms of vapours that he made a number of images that consist of little else, from *Snow Storm: Hannibal and his Army crossing the Alps* (1812) to *Sunrise with Sea Monsters* (1845). But perhaps the works that best bring out the way his neural networks were activated by the merest hint of vapour are the interiors of Petworth House, Sussex, where the haze that fills the palatial rooms may well be smoke from the coal that the third Earl of Egremont had brought to Petworth on a specially built canal.

Constable and Turner: Differences in Exposures, Differences in Art

If the new interest in vapours that characterises the work of Constable and Turner can be related to a neural response that was common to both artists – to the visual manifestations of the Industrial Revolution – the differences in

those interests can be related to differences in their neural formation that depended on histories that were more personal. Constable, for example, was more interested in water vapours, Turner in smoke, and this reflected the difference in their home backgrounds. Constable's was rural. He was the son of a miller, brought up on a river on the Essex/Suffolk border. Turner's was urban. He was the son of a barber who lived and worked in the centre of London, next door to Covent Garden Market. Constable's early exposure was thus to mists free of particulate pollution, Turner's to the smokiest atmosphere anywhere in the world. Constable's interest in mists lasted throughout his life, from his sketches of Dedham Vale (fig. 227) to his many attempts to capture a rainbow. Turner's greater interest in smoke is apparent not only from the paintings of steamboats and steam locomotives noted earlier but from those he made to record the burning of the Houses of Parliament, a scene from near his birthplace (fig. 228). The fact that some of their interests were common to both while others were unique to each does not mean that there is no relation between the interests that united and divided them. It was because the common element in their home background was an exposure to vapours more intense than that of their contemporaries that

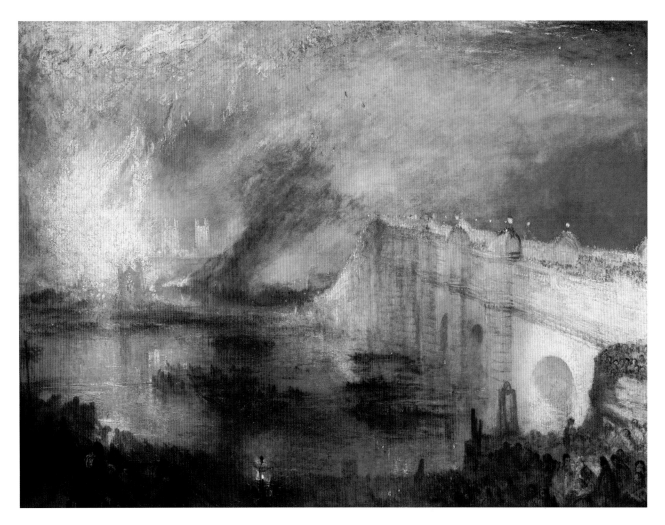

228 Joseph Mallord William Turner, *The Burning of the Houses of Lords and Commons, October 16, 1834*, 1834/35, oil on canvas, 92.1 × 123.2 cm. Philadelphia Museum of Art, The John Howard McFadden Collection, 1928, M1928-1-41

they were well equipped neurally to respond to the vapours of the Industrial Revolution. Neither the Stour valley nor Thames-valley Covent Garden were part of that revolution but the vapours, particulate and otherwise, that were salient features of those environments were a perfect starting point for an interest in mist and clouds, steam and smoke. That is why these elements figure more prominently in their work than in that of contemporaries brought up in less vapour-filled environments.

Turner and Ruskin:
The Formation of the Artist's Brain

One of the reasons why the work of Constable and Turner reflects, almost literally, their visual experiences is because they came from an English culture deeply imbued with a Lockean notion of the mind as a blank page, a notion whose importance is stressed by Turner's younger contemporary and great admirer, John Ruskin, writing in the 1840s:

> The first great mistake people make in the matter [of looking], is the supposition that they must see a thing if it is before their eyes. They forget the great truth told them by Locke, book ii, chap. 9, §3.– 'This is certain, that

whatever alterations are made in the body, if they not reach the mind, whatever impressions are made on the outward parts, if they are not taken note of within, there is no perception. Fire may burn our bodies, with no other effect than it does a billet, unless the motion be continued to the brain. . . . How often may a man observe in himself, that while his mind is intently employed in the contemplation of some subjects and cautiously surveying some ideas that are there, it takes no notice of impressions of sounding bodies, made upon the organ of hearing, with the same attention that uses to be for the producing the ideas of sound.'[6]

As Ruskin goes on, what is true of the ear is much more true of the eye. The eye is always active as a 'bodily organ', but we rarely give attention to what it sees: 'And thus, unless the minds of men are particularly directed to the impressions of sight, objects pass perpetually before the eyes without conveying any attention to the brain at all; and so pass actually unseen, not merely unnoticed, but in the full, clear sense of the word, unseen.' Some people do not see things properly because they have other concerns, some because their sensations are naturally blunt and, in the latter case, if they are distracted as well 'their faculties of perception, weak originally, die of disuse'.[7] Ruskin could not know how well his observations would tally with the discoveries of neuroscience.

Later, Ruskin develops the point about intense looking, noting that it is above all early exposures, just such as we pointed out for Constable and Turner, that are most important for the formation of the artist's visual preferences. Indeed, one of his remarkable claims is that 'all great painters, of whatever school, have been great only in their rendering of what they had seen and felt from early childhood . . . The Madonna of Raffaelle was born on the Urbino mountains, Ghirlandajo's is a Florentine, Bellini's a Venetian', a specific point that he immediately generalises into the fearless assertion:

> that it is impossible that it should ever be otherwise, and that no man ever painted or will paint well anything but what he has early and long seen, early and long felt, and early and long loved. . . . Whatever is to be truly great and affecting must have on it the strong stamp of the native

land . . . if we are now to do anything great, good, awful, religious, it must be got out of our own little island, and out of these our times, railroads and all; if a British painter . . . cannot make historical characters out of the British House of Peers, he cannot paint history; if he cannot make a Madonna out of a British girl of the nineteenth century, he cannot paint one at all.[8]

This might all seem like a jingoistic rant, but it is founded on the rational conviction that you will not see something truly unless you have looked at it often with love and attention, because, following Locke and anticipating recent neuroscience, such intense looking is necessary to have an impact on the brain. Neuroscience also confirms that the plasticity that defines the degree of that impact is greatest in the young.

Ruskin then goes on to observe that, while this is certainly true of figure painting, it is less true of landscape. This is because landscape is, in its fundamentals, less variable, whether through space or time, falling into similar types: 'so that feelings educated in Cumberland, may find their food in Switzerland, and impressions first received among the rocks of Cornwall, be recalled upon the precipices of Genoa'.[9] His idea is that if a landscape is sufficiently similar to one that a person has got to know deeply, in this case a mountainous one or a rocky one, it can be experienced in the same way. In terms of modern neuroscience, we would say that neural networks formed by exposure to one particular type of landscape will also help in the perception of another, providing it is sufficiently similar.

The critic then turns to Turner and asks himself what scenery will have most deeply affected him, indeed affected him so deeply that its influence can be traced throughout all his works. His conclusion is that it is that of Yorkshire: 'Of all his drawings, I think, those of the Yorkshire series have the most heart in them, the most affectionate, simple, unwearied finishing of the truth'. His affection for Yorkshire can be traced not only in the drawings themselves,

> but in the peculiar feeling of the painter for rounded forms of hills; not but that he is right in this on general principles, for I doubt not that, with his peculiar feeling for beauty of line, his hills would have been rounded still, even if he had studied first among the peaks of Cadore

[the environment of Titian's youth]; but rounded to the same extent and with the same delight in their roundness, they would not have been. It is, I believe, to those broad wooded steeps and swells of the Yorkshire downs that we in part owe the singular massiveness that prevails in Turner's mountain drawing, and gives it one of its chief elements of grandeur.[10]

This profound influence is constructive when he is treating other mountains, but when it comes to the representation of the landscape of a place like Florence it leads to failure. This is a result of the effort needed 'to force the freedom and breadth of line which he learned to love on English downs and Highland moors, out of a country dotted by campaniles and square convents, bristled with cypresses, partitioned by walls and gone up and down by steps'.[11] Neural networks adapted to the perception of rounded landscape forms are ill-equipped to deal with an environment characterised by angular landscape features and cuboid buildings.

These assumptions, which recall our own observations on the role of the environment in shaping the different visual preferences of Romans and Greeks, help Ruskin to explain why Turner is excellent at painting France, which is close in character to England, but less good at Switzerland and Italy, which are not. In France he can capitalise on his English history of intense looking at leafy trees. As soon as he has to represent pines, Ruskin notes, the result may be so bad as to be pitiful. The same is true of the Alpine rose, the chestnut, the olive tree and the vine. This does not mean that Turner's tendency to allow memories of Britain to tinge his representations of the landscapes of other countries is a bad thing, rather the reverse: 'I adduce these evidences of Turner's nationality . . . not as proofs of weakness, but of power; not so much of want of perception in foreign lands, as strong hold on his own will; for I am sure that no artist who has not this hold upon his own will will ever get good out of any other.'[12] Turner's apparent failings are only a proof that he had been robustly formed by exposure to his homeland.

This is a point Ruskin returns to again and again, and happily caricatures as when he notes that the rocks of Turner's *Jason* could have come from a quarry in Warwickshire, that in the *Fifth Plague* the pyramids of Egypt look like brick kilns and the fire on the ground looks like burning manure, that the landscape of the *Rape of Proserpina* looks more like the setting for the actions of 'men with spiky hats and carabines', and that the trees of Palestrina look more like an avenue at Hampton Court.[13] The more the artist has looked with love at England, the more English elements will keep cropping up in his portrayals of other climes.

Venice is, according to Ruskin, the only foreign setting in which his hero consistently thrives and, as he suggests towards the end of *Modern Painters* in his comparison of Venice and London at the start of 'The Two Boyhoods', those of Giorgione and Turner, this is because those two great maritime cities, for all their differences, had much in common. Again, though, as with our earlier comparison of Constable and Turner, it is the differences in the backgrounds of the two artists that explains their distinctive contributions, as he makes clear when crediting the strength of many of Turner's great paintings to his upbringing off Covent Garden with its market and its location only yards from the Thames. Throughout his life, the artist

attaches himself with the faithfullest child-love to everything that bears an image of the place he was born in. No matter how ugly it is, – has it anything about it like Maiden Lane, or like Thames' shore? If so it shall be painted for their sake. Hence to the very close of life, Turner could endure ugliness which no one else, of the same sensibility, would have borne for an instant. Dead brick walls, blank square windows, old clothes, market-womanly types of humanity – anything fishy and muddy, like Billingsgate or Hungerford Market, had great attraction for him; black barges, patched sails, and every possible condition of fog.[14]

This attachment to the scenes of his youth has, according to Ruskin, some surprising consequences. Turner's neurally embedded visual memories of London were so vivid that, as he notes, they crop up like 'flashbacks' in the most unlikely places. Thus, one particularly common sight for the boy brought up near Covent Garden was litter and his paintings are often full of it. Ruskin even notes that the last words the artist ever spoke to him about one of his works consisted of an exclamation about the St Gothard Pass referring to

229 Joseph Mallord William Turner, *Mt St Gothard*, 1806–7, watercolour, 18.4 × 26 cm. Tate Britain, London

'that litter of stones which I endeavoured to represent' (fig. 229).[15] Subject after subject is infected by those early memories, the oranges of *The Golden Apples of the Hesperides* and *The Meuse: Orange Merchantmen going to Pieces on the Bar* are those he had seen in the market, and ships like those in *The Death of Nelson* and *The Fighting Temeraire* are based on those he had seen below London Bridge. For Ruskin, Turner's intense looking at London was as important a source for the strength of his later representations of people, objects and water elsewhere as his intense experience of the Yorkshire hills was for his representation of any landscape. In both cases the power of his work came from the intensity of his early experiences. And in his recognition that such influence was something of which Turner himself was quite unconscious, Ruskin brings out one of this book's main arguments, that most artists are completely unaware of the neural formation on which the excellence of their work depends.

Ruskin's observations help to explain the power and freshness of Turner's art in general. They also help to explain why much other art lacks these properties. As he says, to be a great British artist in his time one has to look intensely, because, first, 'unless the minds of men are particularly directed to the impressions of sight, objects pass perpetually before the eyes without conveying any attention to the brain at all', and, second, the artist has to look at what makes Britain modern because one's material has to 'be got out of our own little island, and out of these our times, railroads and all'. Ruskin knew that most artists were not looking as intently as they should, nor, indeed, were they looking at modern Britain. Instead, their most intense attention was directed at traditional paintings and at scenes that evoked the past. He also knew that a principal reason for these trends was the presence of a similar neural neglect in the brains of the purchasers of art, who also tended to allow objects to pass their eyes without affecting their brains, preferring to concentrate rather on imagery in which they could escape the present. Ruskin did not understand the precise mechanisms involved, but he did know that the principal reason for the weakness of much Victorian painting lay in deficiencies in both artists and patrons, deficiencies that we now know to have been neurally based.

18

Nineteenth-Century France

Monet, Cézanne and Courbet

Claude Monet (1840–1926) and Paul Cézanne (1839–1906) were two artists who, like Constable and Turner, mainly focused on landscape. Also, like the English artists, they were born only a year apart. Unlike them, though, they came from opposite ends of their country, France, and spent their first twenty-odd years in environments with few features in common, Monet mostly on the coast of Normandy, and Cézanne in Aix-en-Provence. They only met when they both moved to Paris in the 1860s. Their fame they achieved from the 1870s as leading members of the group called the Impressionists. The similarities and differences in their careers make them *prima facie* suitable subjects for neuroarthistory, and there is a hint of neural awareness in their eventual adoption of the designation Impressionist, a term that suggests that they themselves thought of their art as distinguished by the extent that it was the product of 'impressions' made on them by the world.

Through their self-awareness as individuals and because of the powerful reactions, both negative and positive, that their work has always aroused, an enormous amount is known about the Impressionists. In particular, because much of their lives was social, we often know about the minutiae both of their personal relationships and their physical movements. Many of the letters that they and their friends wrote have been preserved, their aphorisms noted and their conversations recorded. Their conscious intellectual life has been explored in great depth and its role in the genesis of each of their works has been studied in detail. In these circumstances it might be thought that there is little that neuroarthistory can add. Given the depth of our knowledge of their conscious ideas, can a reconstruction of their unconscious experience contribute anything new to the explanation of their distinctive achievements?

Taine: 'Milieu' and the 'Original Sensation'

That the answer might be 'Yes' is suggested by the writings of a contemporary commentator on art, who was almost as influential an intellectual presence in the French art world as Ruskin was in the English, Hippolyte Taine (1828–1893).[1] Taine is a relevant voice to listen to because he adopted some of the English critic's most important ideas on unconscious mental formation and, inspired by new discoveries about the brain, took them much further. He also burst onto the artistic scene in Paris in the mid-1860s at exactly the same time as did the individuals who later became the Impressionists, and is known to have had a profound impact on one of their defenders, Émile Zola, who had been a friend of Cézanne since childhood. It is thus not surprising that Taine may well have inspired not just the title of the work from which the movement took its name, but core aspects of the artistic agenda of two of its leaders. Whether or not these last two claims can be substantiated, he is certainly important for one reason, if for no other. At a time when, for the members of this group, an artist's mental formation was a major issue, Taine alerts us to the currency of the notion that such mental formation could be largely unconscious.

Taine was a man of enormous ambition and wide interests. He came first in the *concours* for France's premier institution, the École Normale Supérieure, but in 1851 was failed for his *agrégation en philosophie* for manifesting 'an exaggerated expenditure of talent'. Still, he went on to write on travel, literature and philosophy and, after some political difficulties, in 1864 he was appointed to teach aesthetics and the history of art at the École des Beaux-Arts, as the successor of Viollet-le-Duc. His annual cycles of lectures at that institution he then went on to publish, first in separate volumes during the 1860s and, later, as a multi-volume *Philosophie de l'art* in 1881. Although Taine was critical of Ruskin, largely because of the English writer's admiration for the Christian Middle Ages and his interest in naturalism, his respect for and familiarity with English culture made it easy for him to build on Ruskin's ideas. There is, indeed, much in common between these influential figures, but Taine was more of a teacher and, as the title of his collected lectures suggests, inclined to be more systematic. He was also more scientific,

as he says at the beginning of his first volume on Italian art. His approach to art is, he tells us, like a botanist's approach to plants.[2] This means that he will apply to art the botanist's notion that plants are distributed according to zones of temperature and humidity. As he sums up: 'The products of the human spirit, like those of living nature, can only be explained in terms of their milieu',[3] and when he goes on to insist that milieu in both cases works by 'natural selection',[4] he makes it clear that one of the projects he is trying to rival is Darwin's *Origin of Species*, which had appeared five years earlier, in 1859. The provinces of European art were evidently going to be Taine's Galapagos.

Milieu consists of two elements, the physical environment, which is constant, and the moral environment, which changes over time, and for Taine it is the former that is most important for the quality of a work of art or a school. This is because true artists do not become great through study but by having 'an original sensation. One character of the object has struck them, and the effect of this shock is a strong and characteristic impression'.[5] This is because the talented artist has perceptions that are 'delicate and quick', 'and this sensation, so alive and so personal' does not stay inactive; 'the whole nervous thinking machine as a consequence receives a perturbation ... Involuntarily the artist expresses his internal sensation'. Driven by 'an impulse the active brain has rethought and transformed the object'. As a result, 'both in the bold sketch and in the aggressive caricature, with poetic temperaments you notice the dominance of the involuntary impression'.[6]

This idea that the artist's eye is shaped by exposure to the environment informs much of Taine's writing, but he exploits it with particular effectiveness when discussing the difference between the arts of northern and southern Europe: 'The education of the eye in Flanders and Holland has been quite particular. The area is a humid delta, like that of the Po.' Its cities, 'in their rivers, their canals, their sea and their atmosphere, resemble Venice. Here as at Venice, nature has made man a colourist'. By contrast: 'In a dry part of the country it is line which predominates and which first attracts the attention: mountains stand out against the sky with tiered architectures of a grand and noble style and all objects rise with sharp edges in the limpid air.' The Nether-

lands is a country of tones, 'and the tones are full and rich'. A dry and dull country, by contrast, such as southern France or the mountainous part of Italy, leaves the eye with only the sensation of a chequerboard of grey and yellow. 'To tell the truth, a town of the Midi, a landscape of Provence or Tuscany, is only a simple drawing', a remark that reminds us of our earlier observation on the role of the local landscape in nourishing Florentine *disegno*.[7] In a humid country like Holland, the earth is green and many lively touches break up the uniformity of the fields, dark brown soil, red bricks and tiles, white and pink paint on the houses.[8] 'In Italy a tone remains constant'; so if you return to a painting of a particular subject after a month, you will find the palette you need unchanged. 'In Flanders it varies by necessity with the variations of light and of ambient vapour'.[9] Again and again we are told that artists who live in a particular environment paint in a particular way.

Taine's simple principle has its roots in a conception of artistic activity that is at odds with previous ideas on creativity and the artist. The roles of instruction and conscious personal effort are played down, to be replaced by notions of how an 'original sensation' ensures that the artist receives 'a strong impression', all due to the operation of 'the whole nervous thinking machine', the 'active brain'. This essentially passive nature of the brain's response is brought out by the use of expressions such as 'unthinking' and 'involuntary'. What shapes Taine's approach is a new scientific view of humanity's relation to the environment. The artist's hand is guided not by a conscious mind but by a largely unconscious brain, its operation being understood in terms of the largely passive response of the nervous system to its surroundings. We are almost in the world of neurography, where we began.

In the case of most writers such references would be a reflection of popular knowledge. Not in Taine's. In 1870 he published a thousand-page two-volume work *De l'intelligence* (*On the Intelligence*).[10] This he presents as a study of *connaissance*, or as we would say now 'cognition', and the core of the study is an analysis of the nervous system. It amounts to a prodigious synthesis of data that had only recently been published in French, German and English, and reflects a wide range of conversations as well as a familiarity with experiments and medical and psychological case-studies. His knowledge cannot match that which is available in the twenty-first century, but the overall picture he gives of the brain goes far beyond the poetic vision of Erasmus Darwin and corresponds to a remarkable degree with that current today. Taine understands that the brain is an extraordinary complex of nerve cells linked by filaments. These filaments, he tells us, can be as small as a hundredth of a millimetre. The whole cortex, he thinks, contains 500 million cells and, with on average four filaments to a cell, two billion fibres, a number that would have sounded high at the time, although dwarfed by modern estimates.[11] He knew that there were nerves coming from the senses, and others that went out to the muscles. Taine understood, although he got the details wrong, that the brain is organised into areas with separate functions. He realised not only that each of the senses is served by a separate 'ascendant' neural system, but that all are linked by 'transverse' networks. This not only permits each sense to draw on the others, but also allows for many sorts of mental associations to be formed.[12] From this knowledge he went on to draw important conclusions, one of the most highly significant of which was the recognition that most mental activity occurs below the level of consciousness.

More importantly, Taine understood the basis for the impressionability of Locke's blank sheet, recognising that the physical neural structure of the brain was not fixed, as most people, including most neuroscientists, were to think for the next century, but that it was constantly being shaped by experiences. He even correctly identified the two factors that principally promoted its shaping. The impact of an experience, he says, is proportional to the intensity of the attention with which it is associated and the frequency of its repetition.[13] He also recognised one of the physiological factors contributing to this effect, one demonstrated only recently, that the 'more a nervous filament has conducted, the more it becomes a better conductor', a rule that depends, as was noted in the Introduction, on increasing use causing an improvement in the nerve's myelination, or insulation with a fatty coating of glial cells.[14] As a result of these processes, over time the repetition of an experience actually leads to 'a modification of the structure' of a group of cells and fibres.[15] All this is astonishingly prescient. The

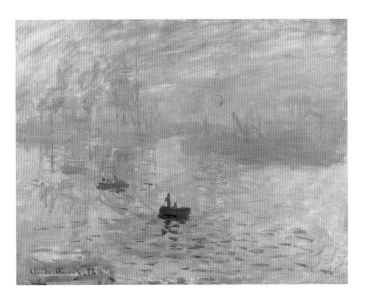

230 Claude Monet, *Impression, Sunrise*, 1872, oil on canvas,
48 × 63 cm. Musée Marmottan Monet, Paris

principles he is describing are precisely those now known to underlie 'neural plasticity'. He was thus not wrong in his claims about the extent to which neural formation is largely passive. People exposed to different environments really do acquire different neural resources.

Knowing what Taine was teaching about art at the École des Beaux-Arts and what he was publishing, both on that topic and on the mind in general between 1865 and 1870, we are now in a better position to understand why Monet might, in 1872, have given the work that became the emblem of a whole movement the title *Impression, Sunrise* (fig. 230). There is no direct evidence that the Impressionists knew Taine's ideas at the time, but it is significant that in 1865, as Zola was preparing to embark on a series of reviews of exhibitions containing works by both the Provencal and the Norman artist, he sounds much like Taine: 'A work of art is a corner of nature seen through a temperament'.[16] Zola was certainly a great admirer of Taine, using his ideas as the basis for his theory of 'screens' on which his notion of realism was founded, and one thing he said about Taine is that everyone was talking about his ideas. It would certainly have been hard to avoid them, as they were disseminated between 1865 and 1870. Monet's personal interest in Taine is shown by his possessing at his death the 1881 *Philosophie de*

l'art, although we do not know when he acquired it. In the end, though, the question of whether or not Monet and/ or Cézanne were directly influenced by Taine is less important than whether neuroscience, either of the nineteenth- or twenty-first-century variety, sheds any fresh light on their distinctive achievements.

Monet

Taine would have had no difficulty identifying Monet's milieu. Although born in 1840 in Paris, when he was five he moved to Le Havre, where the Seine meets the sea, and stayed there till 1861, taking his first steps as a painter with Eugène Boudin, the painter of beach scenes, at neighbouring Honfleur. His life thus began with a frequent and intense exposure to the sea and such associated humidities as spray and rain, mist and fog. Later, when he was living by the Seine, first at Vétheuil and then at Giverny, he focused much attention on the river. Towards the end of his life, it was his own lily-filled lake that absorbed him. Water in all its forms became the most important theme throughout his life. As his friend the politician Georges Clemenceau said just after his death: 'The water attracted Monet's brush. The sea, the Seine, the sleeping limpidity where the pink and white corolla of the water lilies brings swarms of will-o-the-wisps.'[17] Clemenceau's list of subjects elegantly epitomises Monet's changes of setting. Moreover, his phraseology is well chosen and recalls Constable's statements about the way his environment had shaped him. Tellingly, Clemenceau avoids any implication that Monet either consciously chose to engage with water or actively loved it. By saying it 'attracted his brush' he suggests rather that the sight of water caused involuntary movements of his hand. We are in the world of Taine's 'involuntary impulses'. Taine thought that the more often or more intensely the brain is engaged with something, the more the neural resources involved are strengthened, as modern neuroscience confirms. The neural networks formed by Monet's early exposure to water endowed him with neural resources that meant that he was always attracted to the element. Each new exposure to it would have only added to the strength and complexity of those resources.

Water as a liquid is the theme of many of his paintings, whether it is the sea on the Normandy coast or on the island of Belle-Île off Brittany (see fig. 233), the Seine at different points between Paris and Le Havre (see fig. 230), or his own lily ponds at Giverny. Important too were natural water vapours and the related forms of steam and smoke. In this there is much in common between Monet and Turner, whose work the French artist had admired when he first visited London in 1870 to avoid the Franco-Prussian War, and with both artists the inspiration is likely to have been similar. The main difference was that while the neural resources of the British painter had been configured primarily by an early exposure to particulate suspensions in the form of smoke and smog, with Monet, growing up in Le Havre, the primary exposure is likely to have been more to water vapours as such. It was only later that these neural resources became attuned to vapours containing particles. This was because in Monet's case the reaction to smoke would, with time, have become more viscerally positive, especially in the context of the widespread feeling that it was France's industrial backwardness that had allowed the country to be defeated by the Germans. Indeed, Paul Tucker has argued that it was Monet's dream of industrial development that inspired not only *Impression, Sunrise* but also other works such as the twelve paintings of St-Lazare Station executed from 1877, not to mention the many others he made of stations in London.[18] London was the city that many French hoped Paris would emulate, industrial pollution included, and we can sense the conscious reactivation of neural resources formed by unconscious early exposures to marine mist in the nearly one hundred paintings of London fog that Monet made from the 1890s onwards. We also still sense the impact of this double exposure to mist and smoke in the many evocations of a humid atmosphere in his last 250 paintings of water lilies.

The argument presented here does not depend on Taine having had a role, either direct or indirect, in shaping Monet's career. It only requires accepting the relevance of the modern neuroscientific knowledge that was anticipated by Taine. Nevertheless, three aspects of the artist's work point towards a direct influence from the thinker. The first is his concern with riverine landscapes. Taine's intense passion

for the arts of Holland and Flanders, both of which he saw as nurtured by the humidity of the Rhine delta, could have been highly contagious for Monet, whose neural networks had early been primed to engage with the watery, and who had greatly enjoyed working alongside an artist who was the latest to embody the Dutch sensibility to the aquatic, Johann Jongkind. The second is his use of the title *Impression, Sunrise*. Monet himself explained his choice of the term 'impression' by saying that: 'Landscape is nothing but an impression, and an *instantaneous* [my italics] one', and this sounds much like Taine, who had used the same term, impression, to capture the notion of a sudden impact on the brain's nervous structure. It is easy to see how Taine's view that true artists do not become great through studying would have been enticing for a painter anxious to get away from the norms of the Salon and academic training. Equally attractive would have been his idea that the painter's achievement starts with 'an original sensation', and ends when he is struck by one characteristic of an object, 'the effect of the shock' being 'a strong and proper impression'. A title that evoked such originality was highly appropriate for a work that was to be exhibited in the first exhibition of the new group of independent artists. The third aspect of Monet's oeuvre that may be directly inspired by Taine is his interest in making series' of paintings of the same theme. Taine had noted that, while in southern Europe, if you return to a painting of a particular subject after a month, you will find the palette you need unchanged, 'in Flanders it necessarily varies with the variations in light and ambient vapour', and it is easy to see how this observation may have played a key role in provoking Monet, working close to Flanders in northern France, to make several series of paintings of the same object from the same view, such as that treating the facade of Rouen Cathedral (fig. 231). He could hardly have provided a better illustration of the 'variations in light and ambient vapour' that Taine found characteristic of a northern riverine environment. Both the series and *Impression, Sunrise* were thus probably conscious responses to Taine's stress on the importance of the artist capturing a truly fresh response to his subject. In both cases Monet's achievement was sharpened by a special neural awareness, probably brought to consciousness by the prominent writer.

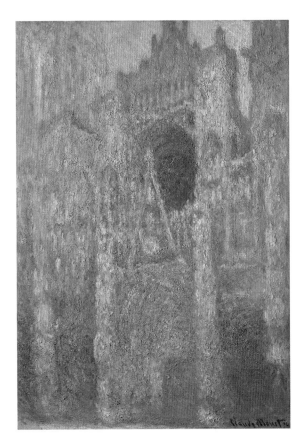

231 Claude Monet, *Rouen Cathedral, the Facade in Sunlight*, c.1892–4, oil on canvas, 106.7 × 73.7 cm. Sterling and Francine Clark Art Institute, Williamstown, Massachusetts

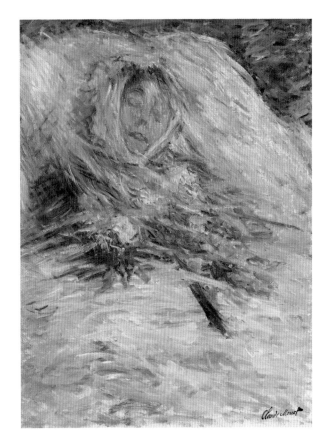

232 Claude Monet, *Camille Monet on her Deathbed*, 1879, oil on canvas, 90 × 68 cm. Musée d'Orsay, Paris, RF1963-3

In much of Monet's art we can argue that this neural awareness was conscious, but there are other cases where, although his achievement was neurally driven, he was not conscious of it. A revealing example is the painting of Camille, his wife, on her deathbed (fig. 232). Monet painted many images of his wife, sensitively evoking the properties of both her flesh and the textiles in which it was enclosed, and we might have expected the deathbed painting to reflect a similar analytical approach. After all, he told Clemenceau: 'I caught myself . . . searching for the succession, the arrangement of coloured gradations that death was imposing on her motionless face.'[19] The painting itself, however, suggests that the painter's response was different, since the canvas evokes nothing so much as a stormy sea with a drowning figure. The whirl of white strokes has, indeed, much in common with his paintings of storms on Belle-Île (fig. 233). This is

233 Claude Monet, *Storm at Belle-Île*, 1886, oil on canvas, 59 × 72 cm. Private collection

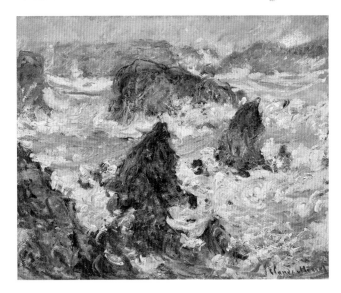

why Paul Tucker was unconsciously moved to call the painting 'windswept', telling how Camille's life literally 'ebbed'.[20] Monet's observation to Clemenceau thus signally fails to acknowledge what sets the painting apart, while Tucker's acute description is not accompanied by any explanation. Neuroarthistory can fill the gap left by both authors by suggesting what combination of factors would have pushed Monet in this particular direction. His sense of the coldness of his wife's body – intensified perhaps by the fact that his physical passion for her had already cooled – when combined with the sight of the disordered white sheets, and associated, perhaps, with the taste of salt tears, could have reactivated neural networks shaped since childhood by memories of the foam of cold waves breaking on a Normandy beach.[21] Monet may refer to this process when he added in his comments to Clemenceau: 'my reflexes compelled me to take unconscious action in spite of myself'. By surrendering to this impulse he was able to bring his wife's death into harmony with the pattern of the tides. This is what gives the painting its power, poignantly illustrating Taine's evocation of how, in the response of a true artist to a powerful sensation, 'the whole thinking and nervous machine reacts with an upheaval. Involuntarily the man expresses his interior sensation, as, driven by an urge, the engaged brain has rethought and transformed the object'. Perhaps it was a recognition of just such a capacity to respond to deep neural memories of intense visual experiences that lay behind Cézanne's characterisation of Monet: 'He is only an eye, but, my god, what an eye!'[22]

Cézanne

With Cézanne it is much easier to establish the connection with Taine. Taine was, after all, much admired, albeit with qualifications, by his intimate friend Zola. He inspired Zola's literary realism and Zola is likely, in turn, to have transmitted that inspiration to the aspirant artist. Besides, Cézanne had failed to get into the Ecole des Beaux-Arts in 1862 and proably would have wanted to know about the teaching that Taine was offering there from 1864. This suggestion is confirmed by the statement by Joachim Gasquet, Cézanne's friend and first biographer, that he was reading Taine at that period, a comment that helps to explain the artist's many references to the critic in their conversations. Indeed, in these Cézanne comes close to presenting himself as Taine's disciple. At one point he asserts: 'I am like Taine . . . I am a sensual man',[23] and at another he takes up the latter's concept of 'temperament', talking of its 'initial force', and explaining how 'after repeated dipping in experiences' the sensitised plate of the brain 'reaches such a level of receptivity that it becomes saturated with an exact image of things'.[24] A dependence on Taine is also clear in his observation to Gasquet that 'The artist is no more than a receptacle of sensations, a brain, a recording machine'.[25]

If this is one area in which Taine may be said to have had a powerful influence on Cézanne, there are several others. One is suggested by Taine's request to the artist to:

> Observe the different appearances of objects, depending on whether you are in a dry landscape, like Provence or the environs of Florence, or in a humid plain, like the Low Countries. In the dry landscape the line predominates and first attracts attention; the mountains present a layered architecture cut out against the sky in a grand and noble style, and in the clear air every object reveals sharp edges.[26]

Such a text, containing as it does a perceptive evocation of Cézanne's native countryside, can hardly have failed to fill the artist with pride. It could also have challenged him to give expression to this particular aesthetic. After all, everyone knew what a painting of the Florentine landscape looked like. No one really knew what would be the Provençal equivalent. The montain with which Cézanne had the greatest familiarity since childhood was the one that dominated his home town of Aix, Mont Sainte-Victoire, being visible from his parents' house, and it is not difficult to see his nearly eighty paintings of this regional eminence as attempts on his part to capture its 'layered architecture' in a 'grand and noble style' (fig. 234). A final note is that Taine's opposition between the landscape of Holland and Flanders and that of Provence and Florence has pronounced echoes of Ruskin's comments on Turner's inability to capture 'a country dotted by campaniles and square convents, bristled with cypresses, partitioned by walls and gone up and down by steps' because

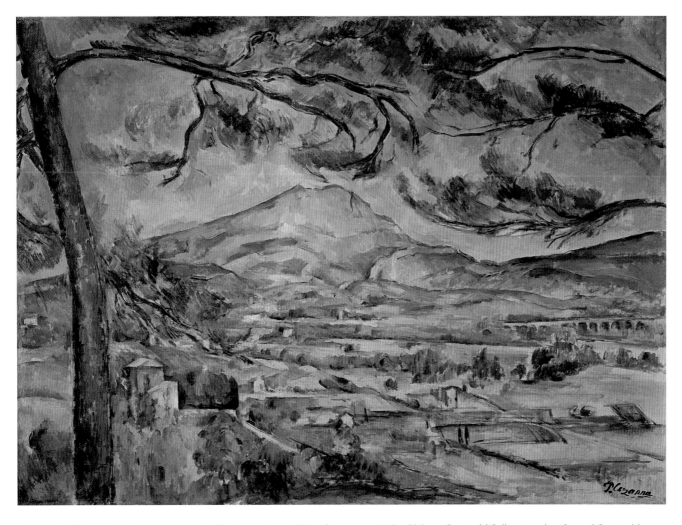

234 Paul Cézanne, *Mont Sainte-Victoire with a Large Pine*, c.1887, oil on canvas, 66.8 × 92.3 cm. Courtauld Gallery, London, Samuel Courtauld Trust: Courtauld Gift, 1934

his sensibility had been shaped by the hills of Yorkshire.[27] If so, Cézanne's aesthetic may have indirect Ruskinian roots.

Taine's neurally based formulation of a Provençal aesthetic may thus have provided the stimulus for Cézanne's persistent concentration on Mont Sainte-Victoire and may even have contributed to shaping his response to it. It may also have informed the Provençal artist's general neural formation and the compositional preferences they supported. Whether or not his reference to the mountain's layered architecture also made Cézanne consciously more interested in buildings as forms, just looking at the limestone massif as frequently and intently as he did would have endowed him with neural networks that had much in common with those shaped by

an exposure to architecture, especially southern architecture, and that would have necessarily increased his preference for facetted volumes. Anything he looked at using networks shaped by those exposures would have tended to take on those properties, making it more likely that they would be the properties that emerged from under his hand. This would have applied at all scales, from representations of masses of masonry to the miniature volumes of individual brushmarks. It would have been likely to affect his treatment even of those things most lacking in facets, the soft flesh of human beings and of fruit, subjects that often engaged him.

Perhaps, though, the most remarkable consequence of Cézanne's repeated and intense exposure to Mont Sainte-

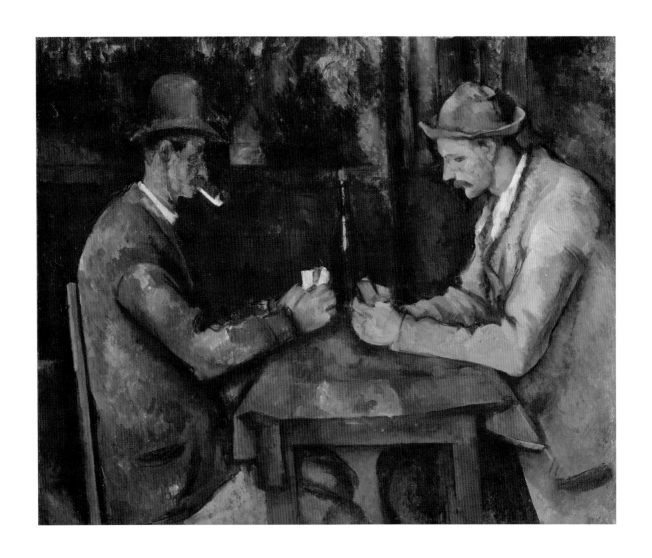

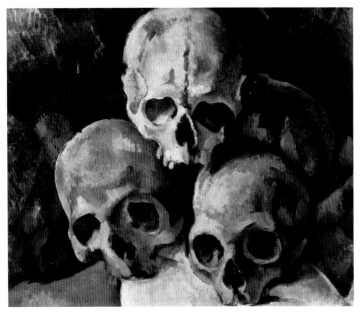

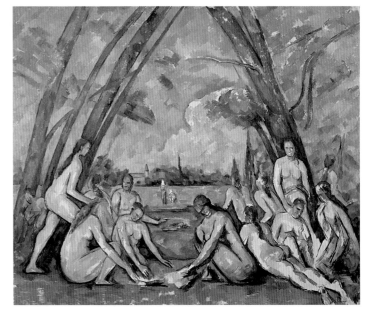

Victoire was its influence on his overall compositions. Typical is the series of five versions of the *Cardplayers* (fig. 235) painted in the early 1890s, with each of which the sense of volume and surface geometry seems to become more condensed. In the early four- and five-figure groups in New York's Metropolitan Museum and in the Barnes Foundation, Pennsylvania, the relation between the participants is still rather loose, but in the two-figure groups, both angularity and bilateral symmetry increase, until in the Orsay painting the pair of players not only echo each other in form, in tone and in hue, but also even their hats have a more mountain-like configuration. Of Cézanne's two hundred still lifes the number that can be said to look mountainous is relatively limited, but those that do, whether featuring soft fruit or hard skulls, have a rare power (fig. 236). However, perhaps the most surprising group of paintings to echo the mountain are Cézanne's late Bathers, above all the *Large Bathers* (fig. 237) in the Philadelphia Museum of Art, which occupied the artist from 1900 to 1906. There both figures and trees take on a triangular configuration. In conversation with Gasquet, Cézanne illustrated the properties of a perfect composition using the image of two hands tightly clasped together, their fingers meshed.[28] That unusual configuration, too, may have particularly appealed to the artist because unconsciously it recalled the geometrical volume of the mountain that had always absorbed him.

Courbet

Although Zola admires Taine and praises him as an 'artist' in several of the pieces he published in *Mes haines*, he expresses an aversion to his notion that artists are shaped by their milieu. Instead, he insists that what interests him, Zola, is a strong statement of artistic individuality. In one passage, though, on Courbet in an 1866 Salon review, he comes close to indicating that the latter may have its roots in the former. This is when he tells how Courbet's art developed after his first steps as an imitator of the Flemings and some Renaissance masters: 'His nature revolted and he felt himself dragged by his whole flesh – do you hear that, by his whole flesh? – to the material world that surrounded him, the fat women and the powerful men, the generous and abundantly fertile land'.[29] Besides the insistence that Courbet is literally dragged by his flesh, which emphasises the involuntary and the unconscious, the most significant aspect of the comment is the assertion that his involuntary engagement is with his material environment, the people and the farmland. What this means comes out more clearly a little later when Zola recalls seeing some of Courbet's early works in his studio: 'Closing my eyes I see again those canvases full of energy, with a single mass, built of lime and sand, real to the point of truth. Courbet belongs to the makers of flesh.'[30] The expression 'built of lime and sand' may be a cliché for something or somebody that is well-built, strong but, juxtaposed with the compliment that Courbet was a 'maker of flesh' and following on from the remark about his 'flesh' dragging, yes, really dragging him, it implies that the 'flesh' he painted was lime-like, an assimilation that takes us back to Courbet's birthplace and home at Ornans.

Ornans was a unique environment. A town in eastern France, almost equidistant between the childhood homes of Monet to the north and Cézanne to the south, it lies in a narrow fertile valley at the bottom of a gorge carved in the limestone geology by the river Loue. Its grassy meadows often ran up against steep cliffs which were themselves topped with more meadows and thick forests. Many who grew up in this landscape of contrasting layers must have found themselves using the same neural resources for the perception of the landscape stage as for the human actors on it. Forests and meadows were to the underlying rock what hair and clothes were to the human body. Everywhere the flesh of the 'fat women and powerful men' found an echo in the white limestone. For most of the inhabitants, possession of such neural resources would have had no obvious consequences. For the young Courbet, who started to paint as an adolescent at the age of fourteen, it had profound implications.

(facing page, top) 235 Paul Cézanne, *Cardplayers*, 1890–95, oil on canvas, 47.5 × 57 cm. Musée d'Orsay, Paris, RF 1969

(facing page, bottom left) 236 Paul Cézanne, *Still Life with Skulls*, c.1901, oil on canvas, 37 × 45 cm. Private collection

(facing page, bottom right) 237 Paul Cézanne, *Large Bathers*, 1900–06, oil on canvas, 210.5 × 250.8 cm. Philadelphia Museum of Art, Purchased with the W. P. Wilstach Fund, 1937, W1937-1-1

238 Gustave Courbet, *The Origin of the World*, 1866, oil on canvas, 46 × 55 cm. Musee d'Orsay, Paris, RF 1995 10

239 Gustave Courbet, *The Source of the Loue*, 1863/4, oil on canvas. Albright-Knox Art Gallery, Buffalo, New York

One of these has long been recognised. This is the assimilation between the cave at the foot of a crag that is the source of the Loue and the female genital tract, as brought out by some of Courbet's most famous compositions. Thus, there is a clear resemblance between the splayed thighs and hair-covered orifice of the woman in *The Origin of the World* (1866; fig. 238) and the rock walls framing the spring in *The Source of the Loue* (1863/4; fig. 239). Courbet would have been intimate with his native landscape before he was intimate with women, which means that the artist painted the *Origin* using neural resources formed when he was painting the *Source*. This, though, is only half the story. As Courbet became more interested in the human body, and especially after he started to study it intensively as part of his training as a painter, he would have increasingly found himself using neural resources formed by exposure to the figure even when working on a landscape. In this sense his painting of the source of the Loue would have already been influenced by his experience of the female form. Putting the relation between the two paintings in these terms brings out the benefits of a neuroarthistorical approach because it adds depth to the original observation of a resemblance between them. Acknowledging the neural links makes us aware that every time Courbet looked at a rock he was apt

to credit it with some of the warmth and vigour of a body and every time he looked at a body he was apt to credit it with the substance of stone. This is why his landscapes are so warm and his bodies so monumental. It is also why, as Zola asserted, for Courbet there was a real kinship between *chair* and *chaux*, flesh and lime.

This case is only the most obvious example of the fruitfulness of such an interchange of neural resources. The *Burial at Ornans* (1849–50; fig. 240) is another. There landscape and people are painted together on equal terms and in a relation of mutual respect. One could almost say that the line of eternal cliffs in the background becomes the model for the row of faces gathered for a brief ceremony immediately below, a row that dips at exactly the point at which the cliffs are interrupted; or that the cliffs part, as do the townspeople around the grave, in tribute to the interment. There is a similar, though less positive, mutual relationship between rock and men in another major work, the *Stonebreakers* (1850; fig. 241). Here Courbet suggests that just as the two men dominate the stones by moving and breaking them, so the stones in their turn bend the back of the younger one and bring the older to his knees. Perhaps because the older man is more broken he is also more stone-like in his colours, with his clogs, hat and shirt all sharing visual attributes with the

240 Gustave Courbet, *A Burial at Ornans*, 1849–50, oil on canvas, 315 × 668 cm. Musée d'Orsay, Paris, RF 325

stones. Courbet's choice of the subject has a moral message, a desire to communicate the hardship that went with poverty and the way people can be dehumanised by materials. One reason why he could do that so well was because his upbringing in Ornans meant that he empathised with the stones as much as with the people.

A particular benefit of neuroarthistory is that it can help us decide whether interpretations arrived at by other means are more or less likely to be correct. One that can be reassessed in this way is that proposed for the *Stonebreakers* by Michael Fried. His observation is that: 'the figures of the old stone-breaker and his young counterpart may be seen as representing the painter-beholder's right and left hands respectively: the first wielding a shafted implement that bears a distant analogy to a paintbrush or palette knife, the second supporting a roundish object that might be likened to the . . . burden of a palette.'[31] Fried does not explain why this should be so, but neuroscience sustains his view. We have already seen that a similar division of roles between right and left hands may lie behind the classic painter's stance that developed in the sixteenth century (see pp. 253–5). Courbet would have been only slightly more aware of the division than most painters.

All it would have taken was an even momentary heightening of the mirroring response to his subject experienced by many artists. Mirroring is especially easy when looking at someone's back and the back view of the younger man holding a tray could have activated the neural resources shaped by looking at many a fellow artist, palette in hand,

241 Gustave Courbet, *Stonebreakers*, 1850, oil on canvas, 165 × 257 cm. Destroyed 1945

313

242 Gustave Courbet, *Wave*, 1870, oil on canvas, 116 × 160 cm. Musée d'Orsay, Paris, RF213

from a similar position. Neuroscience also supports another of Fried's suggestions, that the empathy with the stonebreakers was helped by the homophony of Courbet's name with *courbé*, 'curved', referring to the curve of their backs. Both words would be processed by the same neural pathway, one that only diverged with the different ending.

The predominance in Courbet's visual memory of the long lines of cliffs that ringed his birthplace is evident even in works painted far from Ornans on the Normandy coast. Many of these compositions are reduced to a series of parallel bands representing the beach, the sea and the sky. There is little of the animation in the water or drama in the sky found in the seascapes of other artists. In some, clouds form a repetitive pattern as in a textile. When they gather as dark masses, as

in the pictures of a *Stormy Sea*, they organise themselves into a horizontal band, like a range of distant mountains. When the sea does come to life, the water resolves itself into vertical masses. As the titles tell us, the subject is often not the sea but the wave (fig. 242). What interested Courbet most about the sea was its ability to generate shapes that were cliff-like. A recurring feature of these waves is the white flash of foam and this too is probably a product of visual tastes formed at Ornans. There, for most of the year, the eye is constantly awoken by the light patches of limestone that project from the masses of brown leaves and green grasses, and in winter snow provides an even stronger foil. It is hard to explain Courbet's persistent return to a white palette except in terms of visual memories of such contrasts. For the formation of

a taste for white, the rocks without the snow and the snow without the rocks would not have been enough. Nor would the two phenomena together have been enough, without the addition of flesh. Nothing flashes so incessantly in Courbet's paintings as flesh, especially in his self-portraits and his female nudes. We never find the same effect in the work of the many other artists who painted the same subjects. Only in Courbet's brain were the networks formed by exposure to limestone and snow so strong as to inflect his brush when his apparent goal was only to capture the body. Anyone who has experienced the unique environment of Ornans is likely to understand how distinctive were the talents it nurtured.

Part 9

THE TWENTIETH CENTURY

Art, Communication and Attention

There are few real hinges in human history, moments at which a large proportion of the population of a particular region feel that their circumstances have changed or are changing so decisively that they are entering a new world. The fall of a dynasty or a state's adoption of a new religion may have an impact on a large number of individuals, but the associated change takes place at the level of institutions, not at that of everyone's lived experience. The year 1900 was different. In the years before and after that date the feeling that the world was changing became so widespread that it affected the mood of many of the planet's inhabitants. The environment did not suddenly change physically, as it had sixty-five million years ago when a meteor fell on Yucatan, setting off a cataclysmic transformation of the earth's climate, but the impact of the realisation of the Industrial Revolution on human life was more powerful than anything seen earlier. Not only was manufacturing transformed, in the field of transport the effect first of steam technology on the expansion of ship and rail communication, and then of internal combustion technology on road and air movements, greatly accelerated the circulation of people, raw materials and finished goods. And in the field of communication the arrival first of the telegraph and telephone and then of radio and television had a similar effect on the circulation of ideas. All these developments brought dramatic changes to the economic condition even of those who lived far from the areas where those impacts were most evident.

Of course, these changes took place over time and affected different communities in different ways, but people became aware of them often long before they were affected directly, greatly compressing the period at which that awareness was at its peak, and a series of chance factors ensured that that peak was around 1900. This was partly because the first car and electric train developed just before that date and the first radio transmitter and aeroplane shortly after it, but equally important was the date itself. Although 1900 was a date in terms of the Christian era, and only a small minority of the planet's inhabitants was Christian, it engaged human consciousness globally – not just because Christian states, especially Britain, France, Germany, the Netherlands, Portugal, Russia and Spain

ruled or had recently ruled much of the rest of the world, while others such as the empires of Japan and China were increasingly turning towards Europe as a model, but because the measurement of time had become standardized internationally following the universal adoption in 1884 of the Greenwich Meridian as the base for time-keeping and of midnight as the beginning of the day. This meant that, although local time systems continued to function, midnight 1899 was experienced as a pivotal moment by a significant proportion of humanity.

Nowhere was this more true than in Europe, where the Exposition Universelle, which opened in Paris in spring 1900, looked back to the preceding century and forward to the next. Among the innovations it presented for the first time were the escalator and films with sound, and it was to be technologies such as these that would increasingly extend and transform experience for people over the following decades. Lived experiences were to have a profound influence on people's minds but, at a time when many were preoccupied by the future, imagination also shaped their neural formation. Indeed, with a rise both in imagination and self-consciousness we can guess that activity in people's default mode networks would have both intensified and become more differentiated. Each person would have had their own preoccupations, but many would have looked forward mentally, in both fear and hope for what technology might bring, as H. G. Wells did in *War of the Worlds* (1898) and *Anticipations* (1904). In the process, they would have projected on their visual cortex and associated areas images of the machines and products of their dreams, and in other areas of the brain simulated their operation and enjoyment. Over the following decades the visual and imaginative experience of those machines and products had a profound effect on the neural resources of all those who made or looked at art.

Tracing that effect, though, is far from easy, because the number of individuals involved was great, the amount of art produced was vast, and its character varied. Besides, there are so many other factors to take into account, the physical and cultural context is so complex and rapidly changing, and the information about it so dense that there is simply too much data to be processed. For some

people this alone would be grounds for abandoning the neuroarthistorical project. Others would say that, given the wealth, authority and clarity of contemporary verbal commentary, both oral and written, it is gratuitous, even perverse, to explain anything in terms of influences of which people may never have been conscious. After all, if a new inner self-consciousness is the hallmark of the twentieth century, why look beyond the direct expressions of that self-consciousness, the avalanche of writings by artists and critics? But the twentieth century is not the time to believe what people say. At no period in human history have words been so abused. There are few who would take twentieth-century politicians at their word and the same reasons that undermine the value of their utterances also raise doubts about the statements of those who aspired to be leaders in the field of culture. Politicians in this period shamelessly exploited the new opportunities to disseminate their ideas through the media and so did artists and writers. The sheer volume of writing on art is the main reason why it should be treated with caution. It is also the reason why we need to look for alternative ways into the authors' minds, of which neuroarthistory is one.

There is thus a particular urgency to the enquiry into the factors that unconsciously affected artistic choices in the twentieth century. And there is no period in which a neuroarthistorical approach is so relevant. For a start, one of the problems with other approaches is that they tend to assume a model of the mind that is relatively schematic and coherent and in which verbal communication plays the dominant role in both the formation and expression of ideas. This helps to excuse their use in periods where much of the information on context is itself preserved in words. In the case of the twentieth century, however, the wealth of information on context from other sources, visual, statistical and so on, calls for a model that is both more complex and more flexible. This is where the notion of a mind made up of a hundred billion neurons each with up to a hundred thousand connections – the speed and effectiveness of their mutual communication rising and falling due to changes of connectivity and of myelination in response to experience – comes into its own. Above all, this is true because adopting even a partially neural model

of the mind necessitates consideration of inputs from all the senses, the role of mood and emotion, and a constant acknowledgement of the significance of bodily responses. These factors have always been important, but never more so than during the twentieth century. In earlier periods people could often follow a common pattern of life from the cradle to the grave, whereas in the twentieth century many found those patterns being violently disrupted, sometimes from minute to minute. This was a time when speeches, rallies, demonstrations, terrorist attacks and warfare, as well as sporting events and entertainment, came to exert powerful influences over large groups, both those who witnessed them at first hand and those who followed them through newspapers and film, radio and television. It was also a time when individuals found their subjective feelings being increasingly engaged both by others around them and by advertising in all media, as well as by the vastly increased range of consumer goods and services they marketed. Largely because of developments in technologies of transport, communication and warfare, life in the twentieth century raised the frequency and intensity of the stimulation of people's neural resources to an unprecedented level. There has never been a period when it was more important to understand the processes this involved.

Recognising this situation is one reason for pursuing a neuroarthistorical approach. Another is the density of the information on the neural life of individuals. Not only is there in the twentieth century a much stronger record of available stimuli in the natural and social environment but the record of each individual's neural exposure to that environment is also more robust. We know much more about the real lives of artists, of patrons and collectors, of dealers and critics, and of consumers. We often know in which house they lived in which street, and we can go and see it. We know what books they read, what places they visited, and which exhibitions they saw. We know whom they met and whose studio they visited and which individual works they most admired. We know much about their political and social engagements, when those were important, and we know about the finer details of their private lives. Knowing much more about the experiences to which they were exposed, it is much easier

to reconstruct the potential impact of those experiences on their neural formation.

Each person will make their own decision about which experiences they are most interested in. A neural approach does not predispose you to concentrate on any category. All it does is encourage you to be aware of them all, and to recognise the differences in their potential influences. In the past, people have been most concerned with the experiences of which the artist, patron or collector would have been most aware, those associated with education, the conscious formation of a personal identity and so on. Here, on the contrary, the emphasis is on the experiences that fall outside that category, those of which people would have been less conscious, often ones which they could not choose and whose impact was contingent, relating to when and where someone was born and lived.

It is obvious from all this that the discussion of twentieth-century European art that is offered in this Part, even more than in previous ones, can only be a token of what might be done. The only sense in which it attempts to be fair is by selecting three individuals who exemplify widely different aspects of twentieth-century art. They were at their most productive at three different periods in the century, the beginning, middle and end. They were born in three different countries, Russia, Switzerland and the Netherlands. They are best known for their activity in three different arts, painting, architecture and sculpture. Equally important is that their selection depended on different factors. Malevich was chosen because he wrote so much about his work that he is an excellent test case if one wants to evaluate the relative importance of conscious and unconscious mental formation. Le Corbusier was chosen because I happened on a book by a writer whose enterprise has much in common with neuroarthistory, although it makes no reference to knowledge of the brain. Gerard Caris was chosen because he chose me.

19

Malevich and Painting

Many artists contributed to the emergence of abstraction in the early twentieth century. Each requires his or her own neuroarthistory, but none calls out for it more than Kazimir Malevich (1878–1935; fig. 243). The exhibition of his work at the *Last Futurist Exhibition of Paintings 0.10* in St Petersburg, then Petrograd, in 1915–16 (fig. 244) was probably the most forceful and extreme display of abstract art to have appeared anywhere by that date, and his writings on art composed over the next twenty years were among the most voluminous. It is not that his art and his writings have not been closely studied separately and perceptively related to each other. They have, and the relation between Malevich's work and the general intellectual context has been well established. Much, though, remains unclear about the genesis of his works, both individually and as groups. We know that he was interested in making art that was 'non-objective', *gegenstandlos*, as he put it, art that was about pure feeling,

art that related to the mystical ideas of Peter Demianovich Uspensky, and there is no doubt that that knowledge helps us to understand the generally abstract properties of his art. The problem is that there were many other artists who shared similar interests, but their art lacks the formal interest and the power of Malevich's. There are thus many questions that this knowledge of Malevich's cultural background does not help us to answer.

Malevich's Suprematist Art

Why, for example, do virtually all his works in the *0.10 Exhibition*, works he classified as Suprematist, exploit configurations of rectangles? He himself labelled one image *Airplane Flying* (see fig. 250) and his interest in aeroplanes is well known. His friend the poet Vasily Kamenski caught

243 Kazimir Malevich in Kursk, c.1902/4

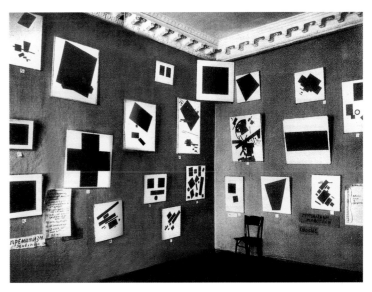

244 Installation of work by Kazimir Malevich in the *Last Exhibition of Futurist Paintings 0.10*, Petrograd (now St Petersburg), 1915–16

conscious intent, it is not possible for him or her to make a piece of visual art without using the neural resources of his or her visual cortex. The neuroarthistorian needs to find out what those resources were.

Malevich's Theory

Reconstructing the neural resources of any artist is never easy but in Malevich's case we are helped by the fact that he was himself a neuroarthistorian. While he knew nothing of modern neuroscience, he was aware enough of the latest ideas on the flexibility of the nervous system to use it as the basis for a whole theory about the history and teaching of art, one he first presented in the early 1920s, in 'An Introduction to the Theory of the Additional Element in Painting'. This sets out two of his fundamental and original convictions, both founded on his understanding of the nervous system: one, that artistic activity is not conscious but 'subconscious' and, two, that the artist's subconscious is profoundly affected by his or her environment.

Malevich begins by stating that religion and science are both good and relate to consciousness, as opposed to

the flying bug when the first planes came to Russia in 1910, decided to become a pilot and survived a crash in 1911. Clearly, since many of Malevich's images involve configurations of rectangles that have much in common with aeroplanes of the period, such as the great Sikorsky bomber also of 1915 (see fig. 249), looking intently at planes could have been a strong influence, but why did he look at planes more intently than others, and how are we to explain such images as the black square (see fig. 247) or the remarkable white on white paintings (see fig. 246)? For a traditional art historian there is less pressure to answer such questions because, from a traditional perspective, such compositions can be seen as ideas freely invented in the artist's mind, sometimes inspired by reality, sometimes not. The pressure on the neuroarthistorian comes from the knowledge that, whatever an artist's

245 Kazimir Malevich, *Colour Circle: Analytical Chart*, 1924–7,
cut-and-pasted paper, watercolor, pencil and ink on paper,
72.4 × 98.4 cm. Museum of Modern Art, New York. 1935 acquisition
confirmed in 1999 by agreement with the Estate of Kazimir Malevich
and made possible with funds from the Mrs John Hay Whitney Bequest
(by exchange). Acc. n.: 823.1935.

art, which relates to subconsciousness, before going on to
bring out the way both factors influence the artist. What
he is studying is the way the behaviour of the painter is
affected by 'consciousness-theory' and 'subconsciousness-
sub-theory'. He is exploring 'how the conscious and the
subconscious of the artist react to surrounding conditions
and vice-versa' in an attempt to develop a 'science of "artis-
tic culture"'.[1] This will involve moving beyond the study of
painting 'solely from the emotional point of view' in order,
for the first time, to 'investigate the influence of circum-
stances and the milieu which conditioned the form of works
in different cultures of painting'.[2] A key to his enquiry is the
'additional element', a concept he adapts from medicine, in
which a change in a person's condition is explained by the
presence in his or her blood or sputum of some new organ-
isms, germs. Such an additional element is liable to change
body temperature from that considered normal. The same
idea of normality applies to art. Rembrandt is thought by
most people to represent the norm, and Cubism is seen as
a variation from that norm, the change being caused by the
presence of a new 'additional element, i.e. a new relationship

of the straight line and the curved', what Malevich calls the
'sickle formula' (fig. 245).[3]

In the next section Malevich goes on to explain how
the change takes place. Human consciousness has an active
role in relation to a disorganised, fallen, unconscious nature,
trying to remain vertical and stable and to organise it. The
artist takes the 'blind elements' of the 'physical conditions of
nature' around him and allows them to influence his con-
sciousness, creating a new view of nature, which is his own
invention. This obscure claim is then clarified by the sugges-
tion that 'the work of the brain in these circumstances is to
be seen as an unconscious condition and phenomenon, i.e.
only the physical senses act on the sensitivity of the nervous
fibres, and whether we are conscious of them by means of
our subconscious, we do not know'.[4] It is by a passive expo-
sure to the environment that we are affected.

Later it emerges that not all artists respond in this way,
being ranked in terms of their susceptibility. The least
important are those who are like passive mirrors of nature.
Above them come those who can change things a little. The
most valuable are the category of 'productivist-inventors',
because what they see through the eye is received on the
'mirror-negative of the brain which is capable of produc-
ing certain changes of phenomena . . . Their nervous system
must evidently suffer from an irritability which leads to a
vision of new images in phenomena, able to generalise and
create new phenomena. This is the main category; without
it we would not have moved on one pace'.[5] Nor are these
artists in conscious control of this process, since Malevich
sees it as axiomatic that 'all works of art are sparked off by an
action of the subconscious centre . . . which calculates more
correctly than the centre of consciousness'.[6]

All this prepares the reader for the core of the book,
which is a set of reflections on the training of artists, being
an attempt to understand the many factors at work in Russia
in the years after the Revolution. Malevich was struck by
how often new artistic movements are treated as sicknesses
and he tries to exploit this notion in his own favour. Thus he
compares the straight line that he associates with Suprema-
tism with the stick-like or line-like property of the tuber-
culosis bacillus identified by Robert Koch (in 1882). Just as
the bacillus can break down the human organism, so 'when a

Suprematist line gets into ordered Cubist structure, an analogous disintegration of the [artistic] organism is produced'.[7] Society may try to 'disinfect the High Schools from the infiltration of the Futurist germ', just as the People's Committee on Health tries to isolate the healthy from the sick, but the idea is hopeless, since isolating artists from 'additional elements' in their environment would require isolating them 'from being'.[8]

Having established the analogy between medicine and art, Malevich then pursues the book's central topic, the question of how artists should be trained. He thinks that: 'In the Schools of Art where one has to study all deviations in painting, just as one studies disease in medicine', 'it is possible to state a correct diagnosis, to establish an appropriate method or diet for everyone'.[9] Accordingly,

> for every person studying in the faculty of painting it is necessary to establish the level of the development of painting in a particular culture with which his additional element is in agreement, and to develop in him a full culture, give him full knowledge. Having precisely established the existence of all the changes in the movement of painting we establish the scientific order of the latter . . .

This will allow us to develop an approach that relates to 'the character and state of each painter'.[10] And it is vital that this process should not be subject to political interference, politics being another additional element that might cause people who have moved from Peredvizhnikism (a realist movement of the 1860s), to Cézannism, to Cubism to Futurism, to Suprematism, to revert to Peredvizhnikism.[11] It was this type of interference at a conscious level that impeded the successful creation of a new art in a burst of subconscious activity after the Revolution, in 1919. This new art might have been accepted even by the masses, had they not been put off by politically motivated criticism.

Malevich then reports on a series of experiments he had conducted at the Institute in Vitbesk, several hundred kilometres to the west of Moscow. He had taken separate groups of students and to some he had presented the structures of Cézanne's painting directly, to others by theory. Those who absorbed it subconsciously, that is from the phenomena themselves, through their nerves – implicitly, visual nerves – got much further in their Cézannism than those who absorbed it consciously, theoretically. The former were also not exhausted by the effort, as were the latter group. Theory, he decided, can help when someone has absorbed an additional element subconsciously, but by itself it cannot bring a student to a solution: 'a theory is some kind of foundation which lies in the consciousness, and solutions remain in the subconscious or pure feeling.'[12] When a student has absorbed the 'fibrous' style of Cézanne he or she may try consciously to move on to the 'sickle' forms of Cubism, or when a student has absorbed Cubism he may try to move on to the straight line and plane of Suprematism, but as long as his attempt is only driven by theory it will not work, and he may revert to an eclectic combination of all styles. Only when a student is isolated from other elements and when he 'establishes his organism in the last culture as a constant activity' will his subconscious allow him to work in one pure system. Once he has achieved this level of subconscious integration, it is possible to safely expose him to a new additional element, out of which he will develop a new system'.[13] As a result of his experiments, Malevich classified artists into A1, who are the only ones able to adapt independently to each new additional element, A2D and A3D, who are 'empty bodied' (able to adopt a culture of painting developed by an A1), A4, who are eclectic, and A5, who are monotypical and constant. The difference between classes A2D and A3D is that the former is flexible and the second is constant. Both, when away from the influence of A1s, are liable to fall back under the influence of the environment.

The process by which people are affected by the environment is predictable: 'Every additional element arouses new visual forms of relationship, establishes a new form of painterly culture' and 'repetition of the same phenomenon makes it necessary to group them, form them, and after this it seems the phenomenon enters a certain norm and becomes for the painter at first a subjective, and, later on, an objective reality of portrayal.'[14] For all its vague gesturing, Malevich's explanation is surprisingly coherent with later psychological and neurological discoveries. His reference to the way repetition of forms leads to 'grouping' sounds like the processes identified around the same time by Gestalt psychologists, while his emphasis on the way repetition of a phenomenon leads from

grouping to forming and from a subjective experience to one that is objective, looks forward to modern views of the impact of repeated exposure to similar shapes on the formation of networks in the visual cortex. The process by which networks of neurons are marshalled to deal with new forms is indeed subjective, while the state that follows, when they acquire properties that are 'view-invariant', that is, when they respond to a particular object from whatever viewpoint it is presented, is more objective.

Recognition of this last property of our neural system also provides support for what is probably Malevich's most important new contribution to how the training of painters is conceived – his insistence that subconscious formation as a result of exposure to a phenomenon is more important than exposure to theory. When he insists that, for the formation of a coherent painterly culture, conscious theoretical education is insufficient, since such a painterly culture can only arise from subconscious formation in front of visual phenomena themselves, his conclusion is coherent with modern neuroscience. He was thus not over-estimating his approach when he described it as scientific and presented his observations in terms of conclusions from experiments. When he noted that a coherent style could never develop out of theory alone, but depends on repeated exposure to particular visual phenomena, he was doing no more than recognising that an individual's painterly culture depends on their possessing a robust configuration of highly specific visual neural resources, such as could only be brought into being by repeated exposure to particular phenomena. The conscious absorption of theory might aid that process, but could not by itself achieve comparable results. A painter's activity ultimately depends on the exploitation of neural resources for whose slow development visual experience is critical.

The acuteness of Malevich's neurological analysis emerges most clearly in his characterisation of the different categories of artists. An A1 artist who looked intently at phenomena and who responded to them subconsciously would indeed be in the best position to develop a new painterly culture in response to new 'additional elements'. This was why it was precisely the inability of the types he called A2D and A3D to look with such unconscious intensity that justified his characterisation of them as 'empty bodied' and depend-

ent on A1s. Instead of allowing their neural resources to be formed by exposure to the complexity of visual phenomena as such, they tended just to follow others who had done so, with diminished results. The emergence of the categories A4 and A5 is also explicable in neurological terms. A4s, on one hand, were artists who, because they looked at many visual phenomena and the works of different artists, would have ended up with a wider range of weaker neural resources, which would indeed have allowed them to produce work whose variety could allow it to be characterised as eclectic. A5s, on the other hand, would have been artists whose visual experience had been so limited in range and so repetitive in character that the neural resources whose formation it stimulated would have led to productions that seemed formulaic. Although it has often come over as eccentric and rambling, when looked at from the perspective of modern neuroscience, Malevich's analysis of the problem of artistic education is remarkably well founded.

So too is his application of it in the following pages, which may be overdetermined, but is also basically sound. Having identified different painterly cultures, he considers how each of them relates to the environment:

> For example, the Cubist and the Futurist are mainly town dwellers, this is their geographical condition; the provinces, like the peasant, are alien to them – the latter are the conditions primarily for painters as such. The Cubist and the Futurist are wholly concentrated on the energy of the town, the factory. They reflect their dynamic geometric force, they are attracted to metallic culture. The painter of the Cézanne culture will have yearnings to get away from the town. The peasantry is not at all foreign to him, or the provinces. But the Cézannist by far prefers the suburbs, the small town or the district town.[15]

Malevich clearly believes that once an artist's character is formed, he or she should be guided by it in choice of residence, following principles that he describes as 'ethnographic': 'Ethnographic conditions therefore become very important for any painter. They form the particular milieu in which an additional element can either develop or perish, and if one wants to receive one hundred percent capacity from the painter, one must keep its conditions'.[16] The reason for this

is the importance of the artist's sub-conscious exposure to phenomena, as he goes on to make clear. Cézannists are thus

> at home in a small district town, with its stone buildings, hillocks, semiparks. This is the first step after Millet and the peasant movement in painting, and this line has its prolongation with the *peredviszhniki* up to the present. It is completely in opposition to the art of the town or the labourer, inasmuch as the labourer produces the dynamics of metallic culture ... For Cézanne's painting the village as a centre was inappropriate, and just as disastrous for his painterly culture would be the town culture of metallic consciousness, i.e. the culture of the labourer, the chauffeur, the pilot, heavy industry which consists more of impenetrable geometric forms, plane and volume.[17]

Malevich evidently sees the history of art as mapping on to the geography of Russia. After the village environment, which fits with Millet and the *peredviszhniki*, comes the provincial town, which fits with Cézanne. Then, 'the first stage of Cubism is on the border of Cézanne's culture of provincial towns, whereas the third and fourth stage is on the boundary of the metallic centre'.[18] Then comes Futurism and after that: 'a new element, the supreme straight, which I have called the Suprematist additional element of dynamic order, the appropriate milieu for it is the air, as the necessary milieu for the aeroplane, for the aerodynamic structure of planites [a Malevich design concept], aerial Suprematism'.[19] It is not clear what real environment he has in mind in this last stage, but what emerges forcefully is the notion that Suprematism is associated above all with flight.

For Malevich the environment is crucial. Suprematist spatial and plane structures 'could not develop in the provinces, outside the metallic culture which is fighting with all the suburbs, all the far away provinces and the architecture of the capitals'.[20] The negative reference to the architecture of the capitals may seem surprising but, as he says elsewhere, the monumental classical architecture used for modern buildings in the capital, such as railway stations, is as alien to Suprematism as is the countryside. What makes Suprematism at home in the capital is the way it relates to the industrial art of 'the worker, the chauffeur and the pilot'. It is not architecture that is its appropriate ecology but technology:

> The town, like a spider, weaves a web of telegraph lines about the provinces and builds railways along them below on the ground and above in the air. It drags the provinces along the railways, just as a spider drags a fly into its centre, reworking the conciousness in its centrifuge, it turns its flabbiness into an energy line and returns as tin, glass, electric current.[21]

Malevich's interest in the environment may have grown out of his need to explain the origins of Suprematism, but now he is ready to use it to sustain any artistic tradition. Being practical, he goes on to say that the state must recognise that each artistic culture needs its own milieu or climate, if it is to thrive. The Cézannists, for example,

> should have an academy away from the capital. The more suited the milieu is to the artistic culture, the less energy is wasted on resisting inappropriate influences. Artistic cultures are like bacteria. Different environments are either favourable or unfavourable environments for different diseases. Urban conditions are favourable ... to Cubism, Futurism and dynamic Suprematism, for which the conditions of the province would be harmful, just as the climatic conditions are harmful to the Koch bacillus, which is the source of tuberculosis. In the country the Suprematist straight line, like Koch's bacillus, is weakened. It can only thrive where wires, rail- and air-ways, tractors, cars, electroagricultural tools have spread.[22]

Suprematism does not employ portraits of such machines. Rather, it uses forms that are distilled from them. These are the principles the state should follow but, as Malevich notes sadly at the end, this is unlikely to happen, as the state has turned against the new art and instead wants to develop propaganda, political art and advertising, requiring representations of the faces of leaders, teachers, martyrs and so on.[23] The state, like the peasant, finds a simple picture of an old-fashioned plough with a single blade to be much preferable to a work that expresses the properties of a new electrical version with multiple blades. Malevich is all too well aware that his ambitious general theory of how and why the best art is shaped unconsciously as a consequence of the artist's exposure to the environment is likely to fall on deaf ears.

This, though, is not the limit of the value of 'An Introduction to the Theory of the Additional Element in Painting' as an aid to the writing of art history. Through its discussion of Suprematism it indirectly sheds light on the unconscious neural formation behind Malevich's own work, preparing the ground for the insights yielded by his 'Autobiography' written about ten years later in the early 1930s.[24] There he makes clear at the outset that the reader should know that from his earliest years he was exceptionally sensitive to his environment, retaining a vivid memory of what he saw: 'Ever since my childhood, and my memory has served me well even to this day – I can remember which forms and states of nature captured my attention'.[25] As readers discover later, this is because Malevich was brought up deep in the Ukrainian countryside, where his father was the manager of a sugar-beet plant. In this empty steppe-like landscape there was little to occupy him visually; so the few sights to which he was exposed he experienced with great intensity. As a result the scenes of his childhood 'were stored by the nervous system somewhere in a suitcase, like negatives which had to be developed'.[26] In this extraordinarily suggestive image, adapted from the then current technology of photography and revealing his empathy with the camera as a machine, he powerfully communicates the extent to which his early visual exposures had affected his neural networks. Their impact was direct but somehow obscure, leaving him with a brain full of unprocessed negative-like images. What this meant for his art comes out later in the 'Autobiography', when he remembers how he felt a growing 'need to develop the negatives' that he was storing up in the suitcase of his brain, but never realised that he might have done so by using pencil and paper.[27] No one in his family had pointed this out and, as he says, at the age of seven 'I was evidently too stupid to think of it myself. I was more interested in watching storks and hawks soaring into the sky'.[28] So he did nothing, until one day his father took him into Kiev and he saw a painting of a girl peeling potatoes. This, unlike the icons they had at home, 'left an indelible image on my memory' because of its lifelikeness.[29] As he went on to explain, using his theory of the way the brain is affected by environmental exposure,

while the icons did not relate to anything in his visual environment, the girl seemed to be part of the nature that was familiar to him. Even then he did not learn to paint, although 'the negatives were lit in my brain'.[30] We are never told what was in the 'negatives' in his brain, nor how they eventually influenced his oeuvre, but we are told enough to enable us to reconstruct the process this involved. All we have to do is to identify which of his early visual experiences were most vivid, and then see if they can be related to his later work.

An intensely vivid experience was looking at the centrifuge at the heart of the sugar-beet processing plant. In the 'Autobiography' he tells of his memories of visiting the plant where he saw, besides an 'amazing apparatus . . . for observing the boiling of treacle and the crystallisation of sugar',[31] 'quickly rotating centrifugal machines in which the sugar turned white', the importance of which had already been brought out in the 'Introduction to the Theory of the Additional Element in Painting'. In that work, besides the reference to the centrifuge already quoted (p. 325), he goes on to use the transformation of material which it makes possible as a key to understanding the weakness and susceptibility to outside influence of an A2D artist. Such an artist may learn from an A1 artist how to work in a Suprematist vein but, once removed from that milieu, the dynamic, metallic surface of their art will break down into brushstrokes and will form a crust-like surface, unless they re-enter a metallic milieu, when the weak lines and spots reacquire some tension. Otherwise, with time, the steel-like surface of the painting begins to grow soft and forms a dough-like mass, changing into a fibrous state, forming shimmering multi-coloured viscous spots, and all this because the brain is like a centrifuge: 'The painterly brain centre, it seems, is applying a brake on its centrifugal movement', the level of which had been 'so strong that, on the walls of the centrifuge, the fibrous lines have taken on a monotonous, straight tense aspect, whereas the colour mass, spread out on the centrifugal walls, has formed one solid, metallic, tone or colour mass', allowing all these changes in the paint substance – that is, unless the centrifuge speeds up again, causing the materials once again to stretch.[32]

The image of paint surface as a viscous mass capable of moving backwards and forwards between states of smooth uniformity and rough irregularity apparently comes out of

246 Kazimir Malevich, *Construction in Dissolution (Three Arches on a Diagonal Element in White)*, 1917, oil on canvas, 97 × 70 cm. Collection Stedelijk Museum, Amsterdam

the notion of the brain as a multi-speed centrifuge. Its vividness and richness is eloquent testimony to the strength of the memory of his visits to his father's plant. It is thus not difficult to imagine the same memory having inspired several of the extraordinary productions of his own brain, the 'white on white' works of 1917 (fig. 246). The changes in speed of the plant's centrifuge would have resulted in the production of differences in the colour and texture of the raw sugar that anticipated the variations in the appearance of white paint which give these works their special interest. In Malevich, the frequency and intensity of his experiences of the magic machine at the heart of the sugar factory

would have laid down neural resources for the perception of whiteness of unrivalled strength and complexity. It is hardly surprising that these resources, laid down in the child by looking at the centrifuge, later influenced the movements of the adult Malevich's brush, especially considering that the same centrifuge had by then become his preferred model for the artist's brain.

If the image of smooth white sugar was one image in his suitcase of unprocessed negatives, another, equally strong, was of an opposite colour. This is the blackness of the night sky, 'dark as a rook', which he could see through the window he recalled near his bed.[33] We may take for granted a black window, but at a time when most children of his class were brought up in towns that were already light-polluted, Malevich's experience would have been untypical. A strong memory of it helps to explain why he would have found all the black rectangles that figure frequently in his paintings much more engaging than would other people. And to no rectangle would that have applied more than *Quadrilateral*, the black square on a white ground, later known as *The Black Square* (fig. 247), which was to be the central work of the *o.10* Suprematist show of December 1915–January 1916, hung high up in a corner (see fig. 244). It seems likely that it was the intense and repeated attention he gave to the black window, which was the most memorable feature of his bedroom, that caused the formation of the exceptional neural resources that later guided the creation of this revolutionary work. Such a connection could be supported by the painting's role at the end of his life. In photographs of Malevich's deathbed we see *The Black Square* hanging directly above his head (fig. 248). Evidently, during his last illness he effectively recreated the bedroom in the home in the steppes where his career began.

That mental suitcase of unprocessed negatives probably also explains the origins of his distinctive interest in aeroplanes. There were, of course, no planes in the 1880s and 1890s but, in the featureless environment of Ukraine, the objects that most absorbed his daily attention were large birds. His comparison of the colour of the Ukrainian night to that of a rook provides one hint of his interest in the heavens, but much clearer is the already quoted reference to his preoccupation with 'storks and hawks soaring into the

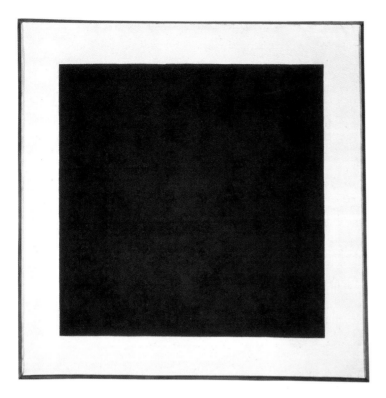

(left) 247 Kazimir Malevich, *Black Square*, 1923 version of 1913, oil on canvas, 106 × 106 cm. State Russian Museum, St Petersburg

(above) 248 Kazimir Malevich on his deathbed, surrounded by his works, 1935

sky'.[34] This is elaborated elsewhere in the text, where we learn that he even put out baby chicks for the hawks to dive at. The fact that the memory of the storks and the hawks is the last he evokes before telling us the stages by which he became a painter gives it a particular authority, and it is easy to see how their silhouettes became deeply etched on his cortex. There they would have laid down neural resources that would automatically have been reactivated by the sight of the flying machines that became a new feature of the Russian skies in the years after 1910. The same resources would then have been reinforced and reshaped as Malevich found himself caught up in the bout of flying mania that almost caused the death of his pilot friend, Kamenski, and which found expression in two collaborations in 1913 with another friend, Aleksei Kruchenykh. One was a lithograph entitled *Simultaneous Death of a Man in an Aeroplane and in a Train*, which he provided for Kruchenykh's text *Explosivity*, and the other was the set for the same author's performance, *Victory over the Sun* (1913), which ended with a plane crashing onto the stage. But what brought planes most to the front of his mind was the First World War. Bombers would have recalled the storks, remarkable for their size, and fight-

ers the hawks, which he remembered for their deadly agility. The biggest impression would have been made on him by the giant four-engined Sikorsky biplane, Ilya Muromets, the largest aircraft in the world (fig. 249). With its rectangular wings and tail and its cuboid body, it turned everybody's heads when it flew from St Petersburg to Kiev and back in 1914. When Malevich first looked at it, he would have done so with neural resources developed to help him search the skies for storks. By using them to look at the big Sikorsky and other planes, he would have found himself retuning the neural resources developed for processing bird silhouettes, endowing him with a visual preference for aerial configurations of rectangles. It is likely that it was above all the strengthening of these particular preferences that caused Malevich in 1915 to abandon the forms he had used earlier in favour of those he exploited in the *0.10 Exhibition*, leading him to make image after image consisting of large and small rectangles outlined against a light background.

The only explicit trace of this influence that Malevich left at the time of the exhibition was the title he gave to one of the compositions, *Airplane Flying* (fig. 250). There is, however, no explicit resemblance between that particular image and a

(above) 249 Ilya Muromets, Sikorsky bomber, 1913

(right) 250 Kazimir Malevich, *Suprematist Composition: Airplane Flying*, 1915 (dated on reverse 1914), oil on canvas, 58.1 × 48.3 cm. Museum of Modern Art, New York, 1935. Acquisition confirmed in 1999 by agreement with the Estate of Kazimir Malevich and made possible with funds from the Mrs. John Hay Whitney Bequest (by exchange), 248.1935

plane, and the title might as easily have been applied to many other works in the show. That Malevich felt, however, that aeroplanes had a wider influence on this group of works is suggested by the short text *Suprematism: 34 Drawings*, from 1920.[35] There he notes that Suprematism represents the signs of a force that has been recognised, before going on to say:

> The form clearly indicates a state of dynamism and, as it were, is a distant pointer to the aeroplane's path in space – not by means of motors and not the conquering of space by disruption, caused by a clumsy machine of totally

catastrophic construction, but the harmonious introduction of form into natural action, by means of certain magnetic interrelations of form.

Suprematism consists of representations not of aeroplanes, but of properties that they possess, as he then explains: 'This form will perhaps consist of all the elements, emerging from interrelations between natural forces, and for this reason will not need motors, wings, wheels and petrol', but it will create 'one whole'.[36] Later still, in the mid-1920s, Malevich and his students experimented with what he called *planits*, or architectural forms inspired by aeroplanes, and they were also influenced by aerial views of landscape.[37] The interest in aeroplanes that all these texts reveal was not unique to Malevich. Many in Russia – and outside – were entranced by the new aerial machines. But only Malevich possessed, since his unique childhood, neural resources specifically adapted to the perception of large flying objects; so that when he was exposed to the mechanical birds his brain reacted much more strongly and positively. Malevich was to argue in 'An Introduction to the Theory of the Additional Element in Painting' that great art was not the product of conscious decisions, only of long intense exposure to phenomena, as we have seen. His own work proved him right. The many other artists who became excited about aeroplanes never produced work that was as powerful as his, because his neural resources for their perception were much older and richer and driven by a more visceral interest.

This is why the suitcase of images that Malevich brought with him from his Ukrainian childhood was crucial. His interest in birds gave him an interest in aeroplanes that was exceptional, like his interest in black windows and sugar centrifuges. The visual poverty of his childhood ensured that those things that did attract his attention in this formative period had a much greater impact on his neural formation than the multitude of objects to which most of his more urban contemporaries were exposed. That is why the art he produced using the neural resources that resulted from that impact is so powerful. Tellingly, this was also the only type of art that he made that possessed this exceptional quality. His earlier and later art, which was all produced much more consciously, using similar resources to those of other

people, fundamentally lacks conviction. The reason why the art made with neural resources formed by looking at birds/ aeroplanes, the centrifuge and the bedroom window – the Suprematist art of the *0.10 Exhibition* and the white on white paintings – is so strong is also the reason why his other art is relatively weak. After he became integrated in normal life, Malevich could never build up such extraordinary resources as those he stored in his brain as a child, in what he called a suitcase of negatives.

In the past it was possible to play down the importance of resources built up by experience by saying that a new work is the product of the artist's free imagination, but today we know that the imagination operates using the same neural networks as those used in vision, networks similarly dependent on experience. So, calling on the imagination hardly reduces the debt to experience. Malevich himself may have believed that his imagination was free, as in his claim that his art was *gegenstandlos*, 'non-objective', but this does not mean that he was free of dependence on the object. If he wanted to develop a new type of painting using rectangular forms, and the rectangular forms to which he had been giving most attention were aeroplanes, then it would be those forms that would be most liable to surface in his drawings and paintings. His art may be non-objective in its intention, but in reality it is object-derived. Malevich's innovation may be cued by his decision to develop a higher form of art using plain rectangular forms, but his ability to realise it was dependent on the preferences embedded in his neural resources, above all those in the visual cortex.

How does this neuroarthistorical approach modify our view of twentieth-century art? At present that view is largely based on assumptions about the primacy of three types of data: first, the statements of artists about their work; second, known and assumed contacts with other artists, through social encounters and visits to studios and exhibitions; and third, known and assumed contacts with other areas of culture, ranging from politics and religion to philosophy and science. All owe their privileged status to their association with conscious mental activity. The artist's statements are direct expressions of his or her self-consciousness. Contacts with other artists and other areas of culture are seen as being the expressions of the artist's conscious choices

in those areas. There is a perception that the authority of such data is greater in the twentieth century than at any earlier period, for three reasons. One is that there is a much larger body of data on these areas than there was at earlier periods, as noted in the introduction to this Part. There simply are more statements by artists and we know more of their certain or potential artistic and cultural contacts. The second reason is that conditions in general brought a general heightening of self-consciousness, often within the framework of 'modernity'. The third reason is that the twentieth century, in its rejection of oppression, has glorified individual freedom and 'agency' and has wanted to see those properties embodied in artists.

Neuroarthistory fully acknowledges that such expressions of conscious mental activity are important data sets. What it questions is their primacy. It does so by raising the possibility, even the likelihood, that such expressions of conscious mental activity may have been affected by types of mental activity of which the artist may never have been conscious. One of the ways it does so is by providing the basis for insights into the neural resources with which the artist is equipped before he or she develops a conscious mental life, and which, as a result, may shape both the artist's material activity and the direction of his or her mental life in ways of which the artist may not be conscious. Since the neuroscience that provides this basis is largely the product of research in the last two or three decades, it may be thought to be an alien element in the world of the early twentieth century, but it is not. The early twentieth century was a period in which the importance of unconscious mental activity was acknowledged more directly than ever before. Whether we talk of *Einfühlung* theory, Freudian psychology, the writings of Virginia Woolf or those of Malevich himself, we are dealing with important new approaches to unconscious mental life, all of which were based on new knowledge of the brain.

20

Le Corbusier and Architecture

A figure whose work in architecture is often thought of as being comparable in originality to that of Malevich in painting, but whose direct influence was far greater, was Le Corbusier (1887–1965; fig. 251). As a subject for a neuroarthistorical approach, Le Corbusier's architecture is both tempting and challenging. It is tempting because of its enormous variety and because of the global range of the settings for which it was designed. It is challenging because Le Corbusier was one of the most self-conscious designers. Indeed, conscious choice played an unprecedented role in his life. There are few figures who so exemplify the freedom of choice that was such a feature of the twentieth century. During a lifetime of extraordinary productivity he changed both his name and his nationality, several times modified his political affiliations and took full advantage of the opportunities for travel. He wrote numerous books and articles in which he formulated highly elaborated theories, including his conception of the anthropometric system of the

modulor. It is easy to feel that these self-conscious texts go so far in explaining his works, and that other self-conscious writings by his contemporaries fill the gaps in such explanations so satisfactorily, that it is unnecessary to look for explanations in terms of neuroscience. Indeed, since Le Corbusier is often taken as the example of someone who formulated clear theories and then constructed buildings that followed them, it can be seen as particularly gratuitous to look beyond his writings and utterances. This, though, misses the point. There may be an exceptionally good match between his theory and his practice, but that does not explain where his designs come from. As was said in the context of Malevich, artists involved with visual design must rely on the neural resources of their visual cortex to guide their pencil, pen or brush. There is no other way if the artist is to avoid copying from others or inventing stilted configurations. So, as with Malevich, we need to ask ourselves what those resources were.

Le Corbusier: Dogmatic or Visually Receptive?

In pursuit of answers to that question I was on the point of engaging with the vast literature on Le Corbusier when I came across a book by an architectural historian who was also dissatisfied with the idea that there was an easy match between his built and written oeuvres, and who, without any knowledge of, or interest in neuroscience, had come up with what was effectively an answer to the question of what were his personal neural resources. The historian is Jean-Louis Cohen and the book in which he presented his ideas is *Le Planète comme chantier* (2005). His argument is spelt out in the book's preface:

> Le Corbusier did not present an oeuvre that was pre-conceived and dogmatic, as has sometimes been charged. Observing the crests of mountains or flying over them, pacing out streets and piazzas, notebook in hand, he shaped his oeuvre in constant reaction to the world around him. Traversing the planet to either give lectures or to check on sites of construction, he moved through landscapes, places, cultures, societies, systems of sociability which were so many stimuli to his formal solutions. As attentive to the inventions of artists as to those of engineers, he formed his visual and affective repertoire out of contact with the mountains of the Swiss Jura, the museums of Italy, the landscapes of Bulgaria, Tuscan and Greek monasteries, German and American factories, the landscapes of India and a long frequentation of the monuments and Faubourgs of Paris. . . . This incessant movement between landscapes and people is transcribed day by day in little notebooks and above all in a sort of fragmentary intimate journal, consisting of his letters.[1]

There is probably no other recent book on art history that presents such a coherently neuroarthistorical point of view and it is not typical of Cohen's other writings. The principal reason why he adopted this approach to Le Corbusier was because, as he visited his buildings and retraced his itinerary, and especially as he studied the drawings made on Corbusier's travels, he found himself coming to the conclusion that the latter had had a much greater influence on the former than had previously been realised. Cohen was certainly sur-

251 Le Corbusier (Charles-Edouard Jeanneret), 1 January 1945

prised when I met him and told him that what he was doing I called neuroarthistory but, when I showed him an article I had written, he agreed that in writing his Le Corbusier book he had operated on similar assumptions.

Le Corbusier: 'Unrepentantly Visual'

These assumptions are apparent from Cohen's first chapter. There he describes Le Corbusier's birth into one of the many families involved in the watch-making industry that dominated La Chaux-de-Fonds, a town in Swizerland close to the French border (fig. 252). He draws attention both to the town's focus on the mechanical and to the geometry of its layout after a fire in the early nineteenth century, both of which he saw as highly formative. Cohen also notes that the interest in the geometrical was strengthened by Le Corbusier's experiences in a kindergarten where Froebel's use of blocks 'familiarised him with the geometrical analysis of natural forms', just as they had done for Frank Lloyd Wright in Wisconsin twenty years earlier.[2] Cohen goes on to note

252 View of La Chaux-de-Fonds, Switzerland, *c.*1900. Fondation Le Corbusier, Paris

that when he went to La Chaux's art school in 1902 he came under the influence of a teacher, Charles L'Eplattenier, a devoted student of Ruskin, who expected his students to study the local landscape and flora with a view to developing decoration and furniture of regional character (fig. 253). Among the many results of this engagement with local nature were the steep roofs, crystal consoles and pine-tree sgraffito of the first house he designed, the Villa Fallet (1906), all of which Cohen rightly credits to his early studies of nature.

Then, between 1907 and 1912, Le Corbusier travelled through Europe, east and west, south and north, sketchbook and camera in hand. 'Acquired on the ground, his knowledge of urban landscapes, of monuments, of indigenous structures would nourish the future Le Corbusier's thesaurus of urban elements, both architectural and sculptural.'[3] In each place he visited on his travels, through Italy, then to Vienna, Paris and Berlin, Florence, on to Eastern Europe, to Turkey and Greece, new forms strike him. Often in his writings he draws attention to the role of the eyes in this process. In a bulletin sent back to a Chaux-de-Fonds magazine he writes how in Istanbul: 'We open our eyes wide at the sights',[4] and after having seen the Parthenon for the first time in 1913 he says: 'I hold it in my eyes'.[5] Those eyes were those of a watchmaker, as Cohen says, and they allow him to see the marble temple as a 'terrifying mechanism'. These are the images that, as Le Corbusier tells us, 'offer themselves to his eyes' and that according to Cohen 'he stores up'.[6] His drawings show how everywhere, as in a 1911 watercolour of Istanbul (fig. 254), he related architecture to the surrounding landscape. Then, when he starts working in Paris he finds another source of inspiration, the female body. He collects photographs of nudes, draws them in brothels and in 1929 designs a chaise-longue reflecting their shapes (fig. 255). When he goes by

253 Le Corbusier (Charles-Edouard Jeanneret), *Stylised Pine Trees*, *c.*1905, drawing. Fondation Le Corbusier, Paris

254 Le Corbusier (Charles-Edouard Jeanneret), *View of Constantinople*, 1911, watercolour. Fondation Le Corbusier, Paris

boat to Buenos Aires to lecture on architecture in the same year, building on his desire to create compositions in which architecture is related to landscape, he at first wants to introduce into the city high towers that would mirror the Andes on the other side of the continent (fig. 256). This conception based on one visual experience he then discards, after the onward flight to Rio de Janeiro and São Paulo provides him with new ones. For the first time, he is able to explore cities and landscapes from the air. As Le Corbusier says: 'the plane gliding over the town becomes a sort of machine for making plans', and, Cohen goes on: 'after this visual shock, the principle of the bunch of skyscrapers conceived for Buenos Aires

255 Pierre Jeanneret, *Charlotte Perriand in a Chaise-Longue*, photograph, 1929. Fondation Le Corbusier, Paris

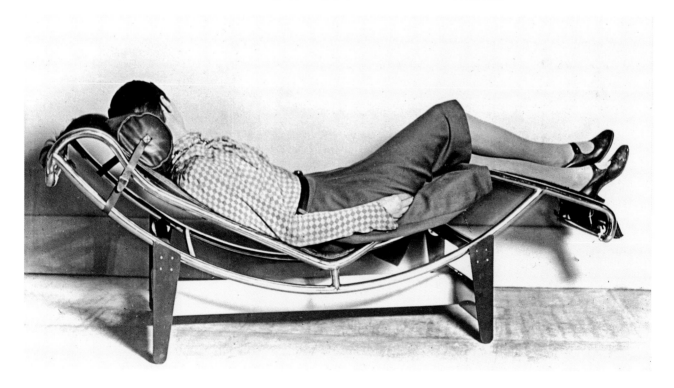

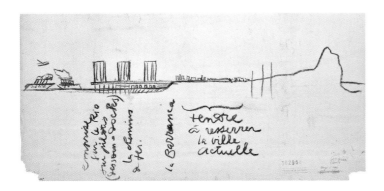

256 Le Corbusier (Charles-Edouard Jeanneret), cross-section drawing of Latin America with Buenos Aires (left) and the Andes (right), 1929. Fondation Le Corbusier, Paris

is abandoned, and it is the suspended ribbon of a habitable autoroute which comes to bind the arabesque of bays and hills, leading to a business city slicing the waves of Guanabara bay' (fig. 257).[7] To bring out the importance of the visual for Le Corbusier at this juncture, Cohen introduces a quotation from a letter written by the architect to the art historian and critic Elie Faure, recording how 'he sees a nature that is exuberant: high mountains, bays, boats fill the visual field 100 per cent'.[8] The new interest in curves is subsequently strengthened first by flying over the maeandering Amazon and then by making drawings of the dancer Josephine Baker in the nude, with whom he travelled on the voyage back home. By this stage Le Corbusier is becoming fascinated by planes. In 1935 he publishes *Aircraft* in London, a book full of pictures of aeroplanes,[9] and the relation becomes so intense that he soon starts to empathise with them. On a second visit to Brazil in 1936 he even credits planes with a 'modern consciousness', so that when one of them looks down on the squalor of cities: 'The aeroplane examines quickly, executes quickly, sees quickly ... with its eagle eye it penetrates the misery of towns'.[10]

In Cohen's book many other such examples follow, with the planning of the Punjab capital at Chandigarh stimulating new visual engagements and the filling of many notebooks

257 Le Corbusier (Charles-Edouard Jeanneret), sketch plan of Rio de Janeiro, Brazil, made on an aeroplane, 1929. Fondation Le Corbusier, Paris

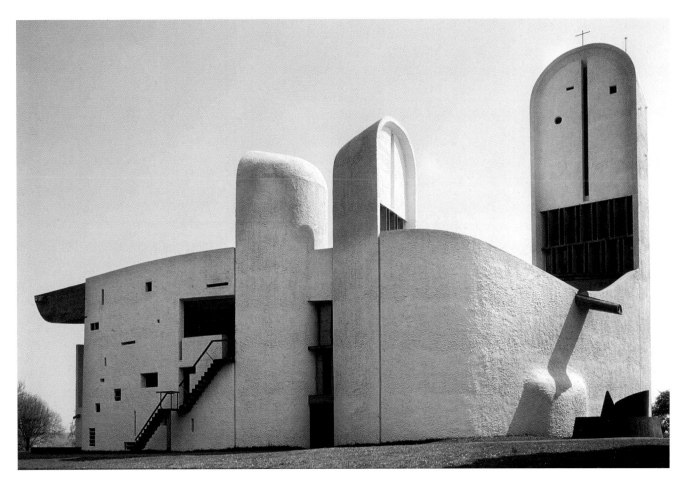

258 Le Corbusier (Charles-Edouard Jeanneret), Notre Dame du Haut, completed 1954, Ronchamp, viewed from the north

with drawings 'of camels or cattle, storing the images for his "bestiary", resources that would sometimes be useful for various zoomorphic details of his building projects'.[11] Some of these surface in Chandigarh itself, and so do the fruits of his 'observations of Indian architecture and daily life'.[12] But the building that draws on the richest store of visual memories is the Chapel at Ronchamp in eastern France commissioned in 1950 (fig. 258):

> He associates an organic inspiration – the roof evokes a crab shell picked up on the shore of Long Island . . . and the principles of the construction of a bird's wing. During the project Le Corbusier also recalls the gargoyles of Topkapi that he had seen in Constantinople in 1911, the Serapeum of Hadrian's Villa and the thick wall of the mosque of Sidi Brahim in El Atteuf, discovered during

his travel in the M'Zab, Algeria, in 1931. The processional path up to the sanctuary reminds him of the Athenian Acropolis.[13]

Cohen appropriately ends his personal procession through Le Corbusier's life with the architect's own 1965 confession: 'I am a donkey, but a donkey with the capacity for sensations. . . . I am and remain unrepentantly visual.'[14] As he rightly saw, Le Corbusier's work is driven less by theory than by intense visual exposures. Other architects might have had as varied experiences, but they would not have looked with his lens-like focus. He reinforced his acute visual memories by the making and preserving of thousands of drawings and photographs, but it was the accessibility of this store of visual memories in his brain that allowed them consciously and unconsciously to fruitfully complicate his design procedures.

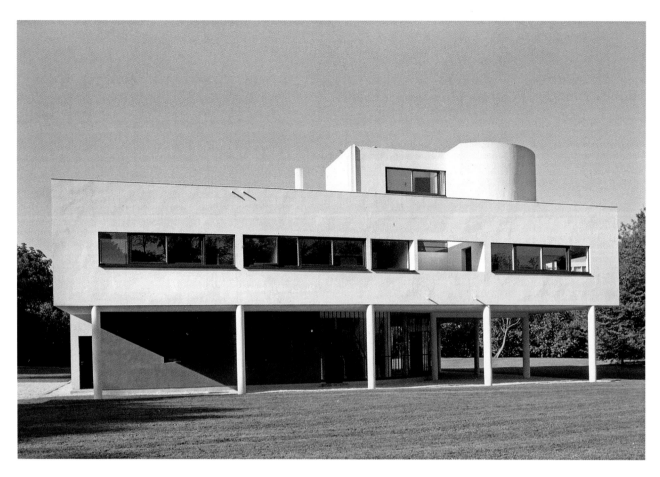

259 Le Corbusier (Charles-Edouard Jeanneret), Villa Savoye, 1928–31, Poissy

It was the strength and the richness of those memories that explains both the compelling power of his buildings and their extraordinary variety.

One response to these and the many other similar observations in this book is to say that, if it is possible to get so far without a knowledge of neuroscience, why do we need neuroarthistory? To which the response must be that if Cohen had known more about neuroscience he could have taken his argument further and applied it with even greater precision. Take, for example, his observation that Le Corbusier's upbringing in La Chaux with its gridplan layout and regular buildings, combined with his Froebel training at school, gave him an interest in the geometrical. The neuroarthistorian would say that the neural resources for the perception of cuboid shapes that he, like everyone else brought up anywhere in rectangular rooms, would have

acquired in the cradle would have been first reinforced in his brain, as in the brain of everyone else who lived in La Chaux, by exposure to the town's unique series of cuboid solid volumes and empty spaces, and would subsequently have become further strengthened and acquired a new flexibility through his education playing with Froebel blocks, each experience making him a member of a smaller group. These were the already unusual resources that Le Corbusier possessed when he went to art school, where he made his first original design, a silver watchcase characterised by a series of superimposed block-like shapes, and it was the work that he produced using these resources that made his teacher, L'Eplattenier, recommend him to study architecture. It was also these resources that L'Eplattenier, following Ruskin, urged him to strengthen by looking intently at the local landscape. Whether or not L'Eplattenier was aware of

Ruskin's insistence that artists should paint their own environment and his belief that Turner's work owed its peculiar strength to the intensity with which he studied the landscape of Yorkshire as a young man, he certainly directed his pupils to concentrate on the local landscape when contributing to what he saw as a local *style sapin*, pinetree style (see fig. 253), and such a concentration on the part of Le Corbusier would have further modified his neural resources. Already attuned to the perception of angles and parallel lines, his networks would have become sensitised by the insistent parallels manifested at all scales in the pine tree, from the fine needles to the thicker branches to the even thicker tree trunks. It was these that gave distinctive authority to many of the designs that he made at that time. Probably too it was the strength of the networks formed by looking at pine forests in which the series of trunks seem to support the mass of foliage that encouraged him later to exploit concrete posts or *pilotis* as the supports for the mass of the Villa Savoye (1928–31; fig. 259). Ruskin noted that Turner was so strongly imprinted with the hills of Yorkshire that they infected all his later hill and mountain views, wherever they were made, and something similar may have happened in Le Corbusier's case. The commission to design a villa outside Paris surrounded by woods reactivated neural memories of the pine forests he had studied intently in his youth, suggesting the idea of the *pilotis* as a new extension of the *style sapin*. Le Corbusier certainly was always ready to draw inspiration for his buildings from landscape features.

Why did seeing and drawing have such a special importance for Le Corbusier? The influence of L'Eplattenier and behind him Ruskin was essential, but other pupils will have done much looking and drawing while at art school and produced little interesting work. Le Corbusier did it all his life and as his looking and drawing constantly added new layers of neural connections, he built a brain containing a richer formal vocabulary, associated with more intense emotions, than any other twentieth-century architect. One reason for his intense engagement with looking and drawing is likely to have been his own weak eyesight. For him spectacles were crucial instruments in his relationship with the world, turning him into a machine for seeing (see fig. 251). Perhaps his reliance on their lenses explains why his note-

books always remained more important to him than photographs. Indeed, I suspect that the reason why he always used spectacles with large circular frames was because he felt, consciously or unconsciously, that they effectively turned him into a camera. Unlike those who did not use spectacles, Le Corbusier was, to quote Malevich, all his life really filling his brain with a suitcase of negatives.

Eyes which do not see

The importance Le Corbusier attached to seeing is confirmed by his most important book, *Vers une architecture*, of 1923, a collection of previously published essays. In it the most powerful passages are those in chapters entitled 'Eyes which do not see' (fig. 260). Dedicated successively to ocean liners, planes and cars, their main argument is that although people are surrounded by these new mechanical wonders,

260 Le Corbusier (Charles-Edouard Jeanneret), 'Eyes which do not see', *Vers une architecture*, 1923. Fondation Le Corbusier, Paris

they do not 'see' them. Indeed, what most surprises him is that it is the rich, who are the most exposed to these triumphs of modern technology, who commission buildings loaded with ornaments and furniture worthy of an archduke. They, truly, have eyes but do not see. Implicitly, Le Corbusier shared Malevich's insight into the principles of neuroscience. Only by looking really intently at modern things will you develop a modern taste. He does not understand the principles governing neural formation, but he understands their consequences from his own experience. He knew that if he looked intently at contemporary artefacts he could produce an architecture expressive of the modern world.

More importantly, though, as Cohen argues, he looked intently at far more. Everywhere he went he took in images of buildings, plants, animals, people, landscape, and because he did so with passion these ended up shaping his art. His buildings were designed using networks that had acquired a great spareness from their exposure to machines, and a great flexibility from their exposure to nature. That is why they are extraordinary. Le Corbusier did not understand the precise neural basis of his achievment, but he did sense the brain's role in it, noting how 'the eye transmits to the brain co-ordinated sensations and the mind derives from these satisfactions of a high order; this is architecture.'[15]

Caris and Sculpture

Malevich's paintings and Le Corbusier's architecture were chosen as subjects for investigation because they appeared, from what I knew of them, to be fruitful subjects for a neuroarthistorical approach. The same is not true of the sculpture of Gerard Caris (1928).

The Artist's Challenge

In his case the initiative came from him. Early in 2009, while I was at the Getty Research Institute in California working on a draft of this book, he emailed me out of the blue asking if I would write about his art. My first reaction when I looked at the series of geometrical configurations and assemblages that I found in catalogues of his exhibitions was that neuroarthistory had found its limits. And that view was only confirmed when I read what he had written about

his work on his website. There I found a clear and conscious programmatic statement that seemed to discourage further enquiry from my perspective: 'I hereby like to present my work which has been a concentration on pentagon dodecahedra forms, the five pointed star shaped by the diagonals of the regular pentagon and the rhombohedra taken directly from the dodecahedron, over a period of forty years as [a] new and authentic artistic art movement like a new ISM.'[1] Nor did things get better when I read the essays by others in the front of the many catalogues. All emphasised the abstraction of his art and made much of references to Plato and geometry, Constructivism and De Stijl, the Sublime and cosmology. The closest there was to an observation of a relation to the real world was the acknowledgement that some of his sculptures anticipated structures later discovered in crystals.

Neuroscience had, admittedly, already been invoked in 2001 by the curator at the Stedelijk Museum, Amsterdam,

Evert van Uitert.[2] He had read Semir Zeki's *Inner Vision* and concluded that Caris must have been using the banks of neurons responding to lines of different orientation discovered by Hubel and Wiesel (see fig. 3). Zeki himself had even been invited to write about Caris's work, but he introduced neuroscience only to bring out deftly the artist's ability to exploit universally valid properties of the brain. He well illustrated the extent to which Caris's art could be fruitfully studied using the framework of neuroaesthetics, but shed no light on the potential relevance of neuroarthistory as outlined here.[3] So even Zeki did not provide me with a starting point. Caris, though, continued to write and I kept the problem at the back of my mind. After all, I thought, if neuroarthistory is an approach that is right in principle, it should have something to add to the understanding of all art. The question was how to apply it in this case. Finally, on Friday 6 March 2009, in order to force myself to attempt the task, I wrote that I would look at his work again over the weekend and on Monday would answer his invitation, 'Yes' or 'No'.

The Neuroarthistorian's Response

The first thing I wanted to know was what objects Caris might have been looking at with such frequency or intensity that they would have had a strong impact on his neural formation; so I went through the curriculum vitae on his website, hoping for hints on his early visual exposures. What I discovered was more than I could have dreamed of. Caris, I found, was as detailed and precise in his record-keeping as he was in his constructions and drawings. His biography revealed that he had been trained as an engineer during the Second World War and, for twenty years afterwards, had supervised the construction of oil derricks and other steel fabrications. His most prestigious assignment, and one of his last, had been in 1961, supervision of the construction of an antenna at Andover, Maine, which I promptly found on the internet (fig. 262). The antenna had been designed to receive the first television pictures from the Telstar satellite, so I found that too on the internet (see fig. 269). His website also told me that the year before the Andover job, when he was on leave from Saudi Arabia, he had by chance been

261 Gerard Caris at technical school, Maastricht, 1942

in Manhattan and, on 17 March 1960, had witnessed the planned destruction of Tinguely's *Homage to New York*. This too was found by my web search (fig. 263). By now my own neural networks had been reconfigured by some of the same series of experiences that had shaped those of Caris, and on the Monday it was easy for me to say 'Yes' to his request. I now felt I was living inside his head and wrote the promised piece in four days. What follows is an expanded version of my argument.

Caris is a passionate individual, as can be seen from the photograph of him at his local Technical School in Maastricht, aged fourteen in 1942 (fig. 261). He loved his steel constructions and looked at them intently (see fig. 262). Perhaps it was partly because he looked at them intently that he found it natural to become interested in art. That was certainly why he was drawn to attend the destruction of Tinguely's *Homage to New York*. When, a few months later, he found himself supervising construction of the Andover antenna, he cannot have failed to be struck by the similarity between it and Tinguely's equally complex and eccentric metal apparatus. Both consisted primarily of open structures in which wheels, rods and a sphere figured prominently, and both he would have looked at using neural networks already formed by repeated exposure to drilling rigs and the other openwork steel structures typical of the oil industry.

That was one reason why he would have looked at the antenna with particular attention. Another was that the con-

(above) 262 View inside the dome of the Andover antenna, Maine, 1961

(right) 263 Jean Tinguely, *Homage to New York*, 1960, painted metal, fabric, tape, wood and rubber tyres, 204 × 73 × 223 cm

struction placed him at the cutting edge of science. Satellite technology, depending on sophisticated rocket-launching facilities and complex electronics, was new, and so was the technology of the 'horn' antenna. The conjunction between them placed humanity at the dawn of a new age. Completion of the Andover facility, which was the first designed to receive and transmit television pictures across the Atlantic, inaugurated the era of global communications, which came to embrace not only television and radio but also many other forms of voice and data transmission, including mobile phones. The new science was also associated with new forms. Its components, both those of the strange antenna and of the nearly spherical dome in which it was housed, were completely unfamiliar. Not only was the dome, with its rounded structure, unlike most buildings, but the horn antenna itself was also an extraordinary composite of conoid cylindrical forms suspended in a cradle of metal bars, none of which were horizontal or vertical and none strictly parallel. This installation was to be Caris's 'baby' and if we imagine the young Caris gazing repeatedly, first at the technical drawings for this construction and then at the construction itself, with the passionate intensity manifest in his earlier photograph, it is easy to see how the experience might have so reshaped

his neural resources that he would have acquired preferences which were unique.

That these preferences might affect his art was made more likely by the fact that the antenna was almost his last major responsibility before his return to study, and by the date and location of that study. This began in 1962 with courses in arts and humanities in Monterey and San Jose, California, and culminated in 1969, after a bachelor's degree in philosophy at the University of California Berkeley, in a master's in fine arts at the same institution. It is significant that at this time art training was undergoing a radical transformation, especially in northern California. While in earlier periods, when life-drawing and training in perspective had been essential elements in the curriculum, the effect of art school training in itself would have had a profound but predictable impact

264 Gerard Caris, *Birth of Form*, 1968, acrylic on linen, 75 × 115 cm. Collection of the artist

on neural formation, at Berkeley this was no longer the case. For artists of Caris's generation, the effect of art school was much more varied and less coherent. Besides the training being less uniform and rigorous there was also a much greater expectation that the student would draw on their own unique resources, something encouraged by his principal mentors, the painters R. B. Kitaj and David Hockney. Experiencing the space-race as a relatively young man in the early 1960s, Caris would have exulted in the experiences to which he had access, especially in the free atmosphere he found at Berkeley later in the decade. when art students were taken weekly to visit the University's nuclear reactor, and when many were consciously engaging with other apects of the latest science. There would have been few obstacles put in his way if those experiences began to affect his artistic activity in the ways suggested here.

Their impact is manifested already in his earliest works, a sequence of silkscreens beginning with *Birth of Form* (1968;

fig. 264) and leading on to the series *Creation of the Elements* (1969) before the production in 1970 of *Creation of the Pentagon* (fig. 265), the print from which all his later ventures in what he called 'Pentagonism' derive. In these works the primary neural driver is likely to have been not visual but imaginative, involving empathy with the antenna's function. Caris will have been as fascinated by what the antenna was supposed to receive, microwaves, as he was by its form, and in the *Birth of Form* the belt of light colour that enters on the left and seems to bend up towards the centre could well be an unconscious evocation of the band of waves that he would have imagined entering the ear of the horn before being bounced back by a large angular plate to the receiving mechanism. Certainly, the same bending of a band of light is the dominant theme first of *Creation of the Elements* and then of *Creation of the Pentagon*. In this last work the pentagon may also evoke the obscure geometry of the horn's reflector. When reversed and turned on its side, *Creation of the Penta-*

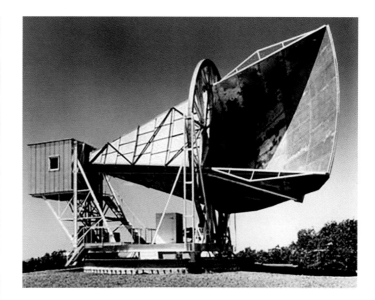

(left) 265 Gerard Caris, *Creation of the Pentagon 2*, 1970, screenprint, 69 × 50 cm. Collection of the artist

(above) 266 Antenna prototype, *c*.1960, at Bell Labs Holmdel, New Jersey

(below) 267 Gerard Caris, *Polyhedral Net Structure 3*, 1973, soldered steelwire, cardboard, linen, paper, acrylic paint, 200 × 200 × 90 cm. Collection of the artist

gon clearly shares formal properties not just with the overall configuration of the Andover antenna, but even more with that of its prototype, the cruder experimental antenna at Bell Labs Holmdel, New Jersey, base (fig. 266), which Caris knew and whose 'ear' shows much of the same geometry as the *Birth*'s pentagon. A latent awareness of these sources may be revealed by his website description of *Creation of the Pentagon* as 'Intuitively conceived . . . in a spontaneous composition'.[4]

These works, though, are two-dimensional and Caris's neural resources had for years been most exposed to three-dimensional structures, which is why it was these that directed his next move, from prints and painting to sculpture. Certainly, the sculptures he now made have many of the same properties as the antenna. The series of *Polyhedral Net Structures* (fig. 267), constructed between 1971 and 1973, consist-

ing of dodecahedral solids made out of cardboard, linen and paper, enmeshed in dizzying webs of straight steel wires, recreate the core relationship between the antenna's solid geometry and the linear lattice of its cradle. They thus become an unconscious homage to his professional masterwork.

Up to this point in Caris's career I had found nothing in the writing by or about him that directly supported any of my claims, that is until I came to 1981. In that year, feeling himself compelled to visit his son who was recovering from a bad accident in a New York hospital, he had arranged to give a talk at the Parsons School of Design, the text of which I could find on his website. This indirectly supported my argument. In the talk he insisted that 'perception is primary to rational intelligence and that relative knowledge of self and the external world depends on interaction between the self and the perceived environment'.[5] This interaction should be 'dynamic' but, he noted, in the present situation this is hardly possible because the majority of buildings exhibit, both as wholes and parts, rectangular configurations. A much better basis for interaction with the environment, he argued, could be developed on the basis of the dodecahedron, a solid made up of twelve pentagons. Its suitability 'as a containing structure for man' is confirmed by its potential for accommodating 'the postural positions of the human body allowing for identification with our very first beginnings in the womb'. His assertion is, he admitted, 'conjectural', but he insisted: 'No matter how vaguely reminiscent of these early experiences, they are still operative unconsciously, affecting us mentally and emotionally'.[6] For Caris it was obvious that rectangular structures were a poor frame for the human body. What it craved was something more responsive to its shape, not as a still, standing figure, but as a configuration moving through a series of poses. That something was the dodecahedron. It was a realisation of the benefits of the rapport between this particular regular solid and the body, he continued, that had allowed him to develop an artistic style that was unique, 'Pentagonism'. Since pentagons can 'almost nowhere be found as a construction motif in art', they allowed him to develop 'a body of work . . . as a candidate to occupy a not yet occupied position in Art History'.[7] This text was helpful at many levels. For a start it showed that Caris was unusually alert to the relation between perception and the environ-

268 Gerard Caris, *Model E-House*, 1983, painted polystyrene and Perspex, 31 × 43 × 37.5 cm. Collection of the artist

ment and that he acknowledged the importance of responses that were unconscious. It also illustrated how his particular sensitivity to the relation between manufactured forms and the body was enabling him to move beyond shapes that correlated with the standing human figure, to ones capable of accommodating all the poses the body goes through during its life, beginning in the womb. His empathy with volumes was profound. He even expressed it in design models of polyhedral homes complete with model inhabitants (fig. 268).

What he said about the rationale for these buildings in his Parsons talk made perfect sense, but it left out an important unconscious influence that I had already identified. This was the Telstar satellite itself (fig. 269). Caris's homes were polyhedral, and so too, ultimately, was Telstar. The transparent triangular sections of which the models were made up resembled the solar panels with which the satellite's exterior was gridded, while their white frames recalled those panels'

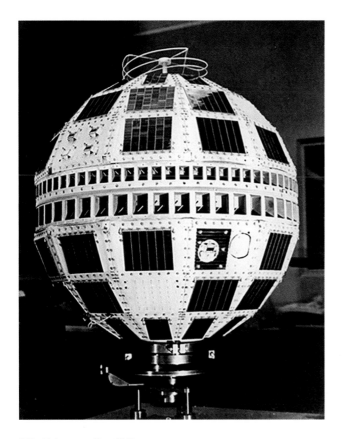

269 Telstar satellite, 1961

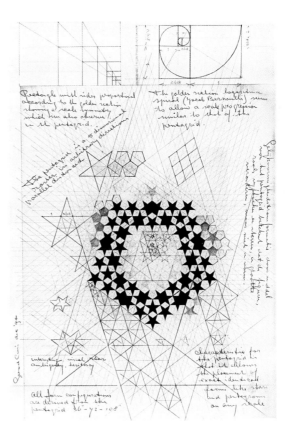

270 Gerard Caris, *Pentagrid*, 1994, mixed media on photostatic paper, 42 × 25.9 cm. Collection of the artist

light-coloured interstices. Whatever the conscious rationale behind the configuration of the houses, it seems certain that the neural resources in Caris's visual cortex that were most important for their conception were those formed by looking repeatedly and with interest at the satellite whose signals were the ultimate *raison d'être* of the Andover antenna.

When discussing these houses in the text of his talk, Caris also explained that the availability of new light construction materials freed designers from the laws of gravity, and one way he would have learned about them was through the new technology of materials associated with the exploration of space and illustrated by the large spherical dome made out of an extremely light translucent material, Dacron, that had protected the Andover antenna (see fig. 262). Spending time inside that dome would have given Caris probably his first experience of life in a gravity-defying near-regular solid. The experience may have inspired the homes he designed

twenty years later in much the same way that spending time inside mammoth carcases inspired the homes at Mezhirich (see figs 25 and 26). In both cases the neural resources laid down by a positive experience of one type of interior space were reactivated later because they suggested how that positive experience could enhance the value of a home.

All his working life, Caris would have spent much time looking not just at metal fabrications but at the technical drawings on which they were based, and that experience seemed to lie behind a new type of two-dimensional work, the *Pentagrid* of 1994 (fig. 270). It is annotated with theoretical pronouncements that recall the comments that might be added to a working drawing and, as if in acknowledgement that such drawings might be turned on a table or looked at by a group of engineers standing round it, these texts demand to be read from different orientations. The distinctive neural resources developed by Caris's involvement in

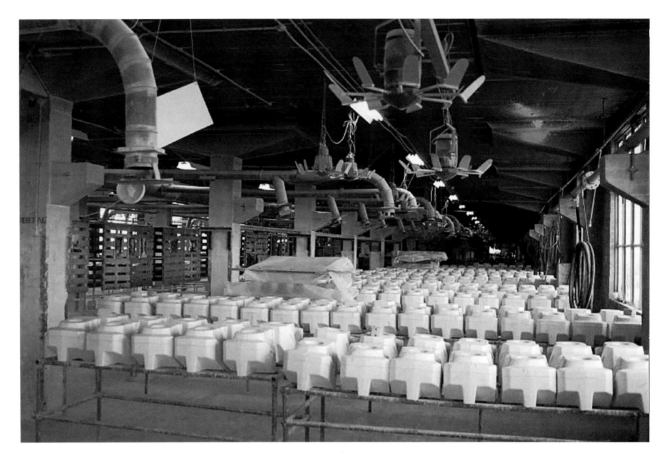

271 Ceramic products lined up inside the Sphinx porcelain factory, Maastricht, March 2009

this highly specialised activity had brought yet another new dimension to his art.

The essay was almost ready to send off when I had a last thought. I knew that the main industry in Caris's hometown of Maastricht was the Sphinx ceramics factory, at that time the source of most of the urinals and bidets in the Netherlands, so I searched for that too on the internet. One of the images I found bore a startling resemblance to yet another category of his sculpture, the regular rows of solids (figs 271 and 272); so I ended my piece by suggesting, cautiously, that neural resources shaped by exposure to such sanitaryware might also have influenced his art. This, I added, would have been more likely if he had lived near the factory or if a family member had worked there. The young Caris's head, I thought, might have been filled with rows of regular ceramic shapes long before it was filled with geometrical metal constructions. His boyhood spent in Maastricht may have been

as important for his innovative contribution to the history of art as his manhood in steel fabrication.

These were the thoughts that I sent off, albeit in a less developed form, on Friday 13 March. I was certainly nervous about Caris's reaction. Most art historians write about artists who are dead, and those who write about the living rarely present them with their findings before publication. In my case there was an added hesitation. I knew that none of the sources that I was suggesting for his work were even hinted at in the voluminous writings by him and his commentators. For both these reasons I was particularly delighted with the contents of Caris's email back the following morning:

Almost to this day I have had to fight with museum directors to correct the misconception that my work is not an exercise of applied mathematics, nor a mere utility [sic] of five fold symmetry . . . I was under an intuitive

impression that I was obediently following some natural drive ... And now, with your beautifully written neuroarthistorical view, I am beginning to understand more clearly the origins of the preferences behind my visual expression, through the knowledge of neural plasticity which you so clearly and powerfully explained.

To which message he added a scan of the illustrated curriculum vitae he had used at the end of his career in construction, which he could now see also provided a key to his subsequent career as an artist. Two days later, too, he wrote that he remembered being taken round the Sphinx sanitaryware factory as a boy by his grandfather who worked there.

Caris's positive response to my argument, like that of Jasper Johns related in the Preface, is not, of course, proof that it is correct. It is inherent in a neuroarthistorical approach that the artist is in no better position to confirm an inferred explanation for an innovation than anyone else. Still, I cannot deny that, having spent years developing such explanations for the work of dead artists, I have been reassured by the positive responses of two senior and highly self-conscious living artists. For them at least an attempted reconstruction of their neural processes contributes to aspects of their work a new understanding.

272 Gerard Caris, *Reliefstructure 1 U 2*, 2002, polystyrene, fibreglass-reinforced epoxy resin, steel, multiplex, paint, 111 × 61 × 21 cm. Collection of the artist

notes

Preface

1 J. Onians, 'Style and Decorum in Sixteenth-Century Italian
Architecture', PhD, London University 1968.

2 E. H. Gombrich, *The Sense of Order: A Study in the Psychology of
Decorative Art*, 2nd ed. Oxford 1984, xii.

3 M. Baxandall, *Painting and Experience in Fifteenth Century Italy:
A Primer in the Social History of Style*, Oxford 1972, 29.

4 D. M. Collins and J. Onians, 'The Origins of Art', *Art History* 1
(1978), 1–25.

5 J. Onians, *Bearers of Meaning: The Classical Orders in Antiquity, the
Middle Ages, and the Renaissance*, Princeton and Cambridge 1990, 4.

6 D. H. Hubel and T. N. Wiesel, 'The Receptive Fields of Neurones
in the Cat's Striate Cortex', *Journal of Physiology* 148 (1959), 574–91, and
'Receptive Fields, Binocular Interaction and Functional Architecture in
the Cat's Visual Cortex', *Journal of Physiology* 160 (1962), 106.

7 J.-P. Changeux, 'Art and Neuroscience', *Leonardo* 27: 3 (1994), 189–201.

8 V. Ramachandran and W. Hirstein, 'The Science of Art:
A Neurological Theory of Aesthetic Experience', *Journal of Consciousness
Studies* 6 (1999), 15–51.

9 S. Zeki, *Inner Vision: An Exploration of Art and the Brain*, Oxford 1999.

10 G. Deleuze, *Negotiations*, trans. Martin Joughin, New York 1995, 60.

11 W. J. T. Mitchell, 'Showing Seeing: A Critique of Visual Culture',
in M. A. Holly and K. Moxey, eds, *Art History, Aesthetics and Visual Studies*,
New Haven and London 2002, 236.

12 N. Bryson, 'Introduction: The Neural Interface', in W. Neidich,
Blow-Up: Photography, Cinema and the Brain, New York 2003, 14.

13 Ibid.

14 D. Freedberg and V. Gallese, 'Motion, Emotion and Empathy',
Trends in Cognitive Sciences 11 (2007), 197–203, and B. Stafford, *Echo Objects:
The Cognitive Work of Images*, Chicago 2007.

15 J. Onians, *Neuroarthistory: From Aristotle and Pliny to Baxandall and
Zeki*, New Haven and London 2007, xiii.

Introduction

1 R. L. Solso, 'Brain Activities in a Skilled versus a Novice Artist: An
fMRI Study', *Leonardo* 34: 1 (2001), 31–4.

2 T. Elbert, C. Pantev, C. Wienbruch, B. Rockstroh and E. Taub,
'Increased Cortical Representation of the Fingers of the Left Hand in
String Players', in *Science* 270: 5234 (1995), 305–7.

3 T. Xu, Y. Yu, A. J. Perlik, W. F. Tobin, J. A. Zweig, K. Tennant, T. Jones and Y. Zuo, 'Rapid Formation and Selective Stabilization of Synapses for enduring Motor Memories', *Nature* 462 (Dec. 2009), 915–19.

4 K. Woolett and E. Maguire, 'Acquiring "the Knowledge" of London's Layout Drives Structural Brain Changes', *Current Biology* 21 (2011), 2109–14.

5 K. Molina-Luna, A. Pekanovic, S. Röhrich, B. Hertler, M. Schubring-Giese, M.-S. Rioult-Pedotti and A. R. Luft, 'Dopamine in Motor Cortex is Necessary for Skill Learning and Synaptic Plasticity', *PLoS ONE* 4: 9 (17 Sept. 2009), www.plosone.org/article/info:doi/10.1371/journal.pone.0007082 (accessed 15 June 2016).

6 U. Schjødt, H. Stødkilde-Jørgensen, A. W. Geertz and A. Roepstorff, 'Rewarding Prayers', *Neuroscience Letters* 443 (2008), 165–8.

7 U. Schjødt, H. Stødkilde-Jørgensen, A. W. Geertz and A. Roepstorff, 'Highly Religious Participants recruit Areas of Social Cognition in Personal Prayer', *Social Cognitive and Affective Neuroscience* 4: 2 (June 2009), 199–207.

8 L. Schilbach, S. B. Eickhoff, A. Rotarska-Jagiela, G. R. Fink and K. Vogeley, 'Minds at Rest? Social Cognition as the Default Mode of Cognizing and its Putative Relationship to the "Default System" of the Brain', *Consciousness and Cognition* 17 (2008), 457–67.

9 M. Baxandall, 'Fixation and Distraction: The Nail in Braque's Violin and Pitcher (1910)', in J. Onians, ed., *Sight and Insight: Essays on Art and Culture in Honour of E. H. Gombrich at 85*, London 1994, 399–415.

10 C. Klein, J. Betz, M. Hirschbuehl, C. Fuchs, B. Schmiedtová, M. Engelbrecht, J. S. Mueller-Paul and R. Rosenberg, 'Describing Art: An Interdisciplinary Approach to the Effects of Speaking on Gaze Movements during the Beholding of Paintings', *PLoS ONE* 9: 12 (2014), http://journals.plos.org/plosone/article?id=10.1371/journal.pone.0102439 (accessed 15 June 2016).

11 R. Arnheim, *Art and Visual Perception: A Psychology of the Creative Eye*, 1954, rev. ed., Berkeley, Cal., 1974.

12 D. H. Hubel and T. N. Wiesel, 'Receptive Fields, Binocular Interaction and Functional Architecture in the Cat's Visual Cortex', *Journal of Physiology* 160 (1962), 106.

13 K. Tanaka, 'Inferotemporal Response Properties' in L. Chalupa and J. Werner, eds, *The Visual Neurosciences*, vol. 2, Cambridge, Mass., and London 2004, 1151–64.

14 M. Baxandall, *Painting and Experience in Fifteenth Century Italy: A Primer in the Social History of Style*, Oxford, 1972, p. 29.

15 N. Spiridon and N. Kanwisher, 'How distributed is Visual Category Information in Human Occipito-Temporal Cortex? An fMRI Study', *Neuron* 35 (2002), 1157–65, and K. Grill-Spector 'The Neural Basis of Object Perception', *Current Opinion in Neurobiology* 13 (2003), 1–8.

16 Qiu, J., D. Wei, H. Li, C. Yu, T. Wang and Q. Zhang, 'The Vase-Face Illusion seen by the Brain: An Event-Related Brain Potentials Study', *International Journal of Psychophysiology* 74: 1 (Oct. 2009), 69–73, http://www.sciencedirect.com/science/article/pii/S0167876009001858 (accessed 15 June 2016).

17 S. Zeki, *Inner Vision: An Exploration of Art and the Brain*, Oxford 1999, 163.

18 D. Freedberg and V. Gallese, 'Motion, Emotion and Empathy', *Trends in Cognitive Sciences* 11 (2007), 197–203.

19 R. Mukamel, A. D. Ekstrom, J. Kaplan, M. Jacoboni and I. Fried, 'Single-Neuron Responses in Humans during Execution and Observation of Actions', *Current Biology* 20 (27 April 2010), 1.

20 Ibid., 5.

21 T. Singer, B. Seymour, J. O'Doherty, H. Kaube, R. J. Dolan and C. D. Smith, 'Empathy for Pain involves the Affective but not Sensory Components of Pain', *Science* 303: 5661 (20 Feb. 2004), 1157–62, http://science.sciencemag.org/content/303/5661/1157 (accessed 15 June 2016).

22 M. Schulte-Rüther, H. J. Markowitsch, G. R. Fink and M. Piefke, 'Mirror Neuron and Theory of Mind Mechanisms involved in Face-to-Face Interactions: A Functional Magnetic Resonance Imaging Approach to Empathy', *Journal of Cognitive Neuroscience* 19: 8 (2007), 1354–72.

23 L. Q. Uddin, M. Jacoboni, C. Lange and J. P. Keenan, 'The self and social cognition: the role of cortical midline structures and mirror neurons', *Trends in Cognitive Sciences* 11, 4 (2007).

24 T. Ishizu and S. Zeki, 'Toward a Brain-Based Theory of Beauty', *PLoS ONE* 6: 7 (July 2011), http://journals.plos.org/plosone/article?id=10.1371/journal.pone.0021852 (accessed 15 June 2016).

25 M. Huang, H. Bridge, M. J. Kemp and A. J. Parker, 'Human Cortical Activity evoked by the Assignment if Authenticity when viewing Works of Art', *Frontiers in Human Neuroscience* (28 Nov. 2011), http://journal.frontiersin.org/article/10.3389/fnhum.2011.00134/full (accessed 15 June 2016).

26 H. Plassmann, J. O'Doherty, B. Shiv and A. Rangel, 'Marketing Actions can modulate Neural Representations of Experienced Pleasantness', *Proceedings of the National Academy of Sciences* 105: 3 (14 Jan. 2008), 1050–54, http://www.pnas.org/content/105/3/1050.full (accessed 15 June 2016).

27 S. M. Kosslyn and W. I. Thompson, 'When is Early Visual Cortex activated during Visual Mental Imagery?', *Psychological Bulletin* 129 (2003), 723–46.

28 R. M. Cichy, J. Heinzle and J.-D. Haynes, 'Imagery and Perception share Cortical Representations of Content and Location', *Cerebral Cortex* 22 (Feb. 2012), 372–80.

29 Ibid., 377.

30 V. Boulenger, O. Hauk and F. Pulvermüller, 'Grasping Ideas with the Motor System: Semantic Somatopy in Idiom Comprehension', *Cerebral Cortex* 19 (Aug. 2009), 1905–14.

31 G. Lakoff and M. Johnson, *Metaphors We Live By*, Chicago 1980.

Part I

1 R. Byrne, *The Thinking Ape: Evolutionary Origins of Intelligence*, Oxford 1995.

2 G.-H.Luquet, *The Art and Religion of Fossil Man*, Oxford 1930.

3 M. Lorblanchet, *La Naissance de l'art: genèse de l'art préhistorique*, Paris 1999, 218.

4 Pliny the Elder, *Natural History*, XXXV, 151.

5 Athenagoras, *Leg. pro Christ.*, 17.

6 Vitruvius, *De architectura*, II: 1, 2.

7 C. K. Taylor and G. S. Saayman, 'Imitative Behaviour by Indian Ocean Bottle Nose Dolphins (Tursiops Aduncus) in Captivity', *Behaviour* 44 (1973), 286–98.

8 J. S. Huxley, 'Origins of Human Graphic Art', *Nature* 3788 (June 1942), 637.

1 Origins of Two-Dimensional Representation

1 The earliness of the dating has led a small group of scholars to express doubts about the experimental procedures involved, which have been published most recently in J. Combier and G. Gouve, 'Nouvelles recherches sur l'identité culturelle et stylistique de la grotte Chauvet et sur sa datation par la méthode du 14C [New investigations into the cultural and stylistic identity of the Chauvet cave and its radiocarbon dating]', *L'Anthropologie* 118 (2014), 115–51, and P. Pettitt and P. Bahn, 'An Alternative Chronology for the Art of Chauvet Cave', *Antiquity* 89 (2015), 542–3. However, the evidence confirming the original dating has also been building steadily, as in B. Sadier, J.-J. Delannoy, L. Benedetti, D. L. Bourlès, S. Jaillet, J.-M. Geneste, A.-E. Lebatard and M. Arnold, 'Further Constraints on the Chauvet Cave Artwork Elaboration', *Proceedings of the National Academy of Sciences of the United States of America* 109: 21 (2012), 8002–6. The doubts appear founded in disbelief at the early date on the part of a few individuals rather than any hard evidence for one that is later.

2 E. H. Gombrich, review of J.-M. Chauvet, E. B. Deschamps and C. Hillaire, *The Dawn of Art: The Chauvet Cave,* New York 1996, and J. Clottes and J. Courtain, *The Cave beneath the Sea: Palaeolithic Images at Cosquer*, New York 1996, *New York Review of Books* (14 Nov. 1996), 8–12.

3 J. Clottes, *Return to Chauvet: Excavating the Birthplace of Art. The First Full Report*, London 2003.

4 V. S. Ramachandran and W. Hirstein, 'The Science of Art: A Neurological Theory of Aesthetic Experience', *Journal of Consciousness Studies* 6: 6 (1999), 18.

5 D. Lewis-Williams, *The Mind in the Cave: Consciousness and the Origins of Art*, London 2002, 88.

6 N. Humphrey, 'Cave Art, Autism, and the Evolution of the Human Mind', *Cambridge Archaeological Journal* 8: 2 (1998), 165–91.

7 M. H. Immordino Yang, A. McColl, H. Damasio and A. Damasio, 'Neural Correlates of Admiration and Compassion', PNAS 106, 19, 12 May, 2009, 8021.

8 V. S. Ramachandran, 'Mirror Neurons and Imitation Learning as the Driving Force behind "the Great Leap Forward" in Human Evolution',

Edge Foundation https://edge.org/conversation/mirror-neurons-and-imitation-learning-as-the-driving-force-behind-the-great-leap-forward-in-human-evolution (1 June 2000), 4 (accessed 5 April 2005).

2 Architecture in the Palaeolithic

1 M. I. Gladkih, N. L. Kornietz and O. Soffer, 'Mammoth Bone Dwellings on the Russian Plain', *Scientific American* 251 (1984), 136–43, O. Soffer, *The Upper Palaeolithic of the Central Russian Plain*, Orlando, Fl., 1985, and O. Soffer, J. M. Adovasio, N. L. Kornietz, A. A. Velichko, Y. N. Gribchenko, B. R. Lenz and V. Yu, 'Cultural Stratigraphy at Mezhirich, an Upper Palaeolithic site in Ukraine with Multiple Occupations', *Antiquity* 71 (March 1997), 48–62. The original publication by I. G. Pidoplichko, the excavator, has been translated and edited as I. G. Pidoplichko, *Upper Palaeolithic Dwellings of Mammoth Bones in the Ukraine: Kiev-Kirillovskii, Gontsy, Dobranchevka, Mezin and Mezhirich*, trans. and ed. P. Allsworth-Jones, Oxford 1998.

2 E. Fernie, 'Stonehenge as Architecture', *Art History* 17 (1994), 147–59.

3 R. L. Gregory, ed., *The Oxford Companion to the Mind*, Oxford 1989, 288–91.

4 E. T. Rolls, 'Invariant Object and Face Recognition', in L. Chalupa and J. S. Werner, eds, *The Visual Neurosciences*, 2 vols, Cambridge, Mass., and London 2004, vol. II, 1165–78.

5 Gladkih, Kornietz and Soffer, 'Mammoth Bone Dwellings', 139.

3 Origins of Abstraction

1 D. Srejović, *Europe's First Monumental Sculpture: New Discoveries at Lepenski Vir*, London 1972.

2 D. Borić, C. French and V. Dimietrijević, 'Vlasac Revisited: Formation Processes, Stratigraphy and Dating', *Documenta Praehistorica* 35 (2008), 261–87.

3 R. G. Bednarik, 'The "Australopithecine" Pebble from Makapansgat', *South African Archaeological Bulletin* 53 (1998), 4–8.

4 Srejović, *Europe's First Monumental Sculpture*, 54.

Part II Ancient Greece 800–100 BC

1 G. Lakoff and M. Johnson, *Metaphors We Live By*, Chicago 1980.

2 J. Feldman and S. Narayanan, 'Embodied Meaning in a Neural Theory of Language', *Brain and Language* 89: 2 (2004), 385–92.

3 G. Lakoff, 'The Neural Theory of Metaphor', *Social Science Research Network* (2 Jan. 2009), http://ssrn.com/abstract=1437794 or http://dx.doi.org/10.2139/ssrn.1437794 (accessed 3 Jan. 2014), rev. ed. of article with same title in R. Gibbs, ed., *The Metaphor Handbook*, Cambridge 2008, 17–38.

4 The Greek Statue

1 B. Calvo-Merino, C. Glaser and P. Haggard, 'Towards a Sensorimotor Aesthetics of Performing Art', *Consciousness and Cognition* 17: 3 (Sept. 2008), 911–22.

2 J. Onians, *Classical Art and the Cultures of Greece and Rome*, New Haven and London 1999, 140–45.

5 The Greek Temple

1 J. Onians, 'The Greek Temple and the Greek Brain', in G. Dodds and R. Tavernor, eds, *Body and Building: Essays on the Changing Relation of Body and Arhitecture*, Cambridge, Mass., 2002, 44–63.

2 J. Onians, *Bearers of Meaning: The Classical Orders in Antiquity, the Middle Ages, and the Renaissance,* Princeton and Cambridge 1990, pp. 34, 35.

3 M. Miller, *The Thalassocracies*, Albany, N.Y., 1971, 22–36.

6 Greek Art and Mathematics

1 J. Onians, *Classical Art and the Cultures of Greece and Rome*, New Haven and London 1999, 30–36.

2 J. White, *The Birth and Rebirth of Pictorial Space*, London 1957.

Part III Rome 100 BC–AD 300

1 W. Alvarez, *The Mountains of St Francis: The Geologic Events that shaped our Earth*, New York 2009.

2 R. Gordon, 'Imagining Greek and Roman Magic', in V. Flint, R. Gordon, G. Luck and D. Ogden, eds, *Witchcraft and Magic in Europe: Ancient Greece and Rome*, London 1999, 159–275, and V. I. J. Flint, *The Rise of Magic in Early Medieval Europe*, Princeton 1991, 3–35.

3 E. Tylor, *Primitive Culture: Researches into the Development of Mythology, Philosophy, Religion, Language, Art and Custom*, London 1871, 116.

4 J. G. Frazer, *The Golden Bough: The Magic Art and the Evolution of Kings*, 12 vols, London 1922, vol. I, 52–4.

5 Ibid., 54.

6 See J. Onians, *Neuroarthistory: From Aristotle and Pliny to Baxandall and Zeki*, New Haven and London 2007, 105 and 106.

7 P. L. Jackson, A. N. Meltzoff and J. Decety, 'How do we perceive the Pain of Others? A Window into the Neural Processes involved in Empathy', *Neuroimage* 24 (2005), 771–9.

8 R. M. Cichy, J. Heinzle and J.-D. Haynes, 'Imagery and Perception share Cortical Representations of Content and Location', *Cerebral Cortex* 22 (Feb. 2012), 372–80.

9 M. Huang, H. Bridge, M. J. Kemp and A. J. Parker, 'Human Cortical Activity evoked by the Assignment of Authenticity when viewing Works of Art', *Frontiers in Human Neuroscience* (28 Nov. 2011), http://http:// journal.frontiersin.org/article/10.3389/fnhum.2011.00134/full, accessed 15 June 2016, and H. Plassmann, J. O'Doherty, B. Shiv and A. Rangel, 'Marketing Actions can modulate Neural Representations of Experienced Pleasantness', *Proceedings of the National Academy of Sciences* 105: 3 (14 Jan. 2008), 1050–54.

7 Roman Shapes, Roman Magic and the Roman Imagination

1 S. Dehaene, *Reading in the Brain*, London 2009.

2 S. Dehaene, 'Inside the Letterbox: How Literacy Transforms the Human Brain', *Cerebrum* 7 (3 June 2013), 1–23, www.dana.org/news/cerebrum/detail.aspx?id=43644, accessed 15 June 2016.

3 Leon Battista Alberti, *De re aedificatoria*, VII, 6, Eng. ed. *On the Art of Building in Ten Books*, ed. and trans. J. Rykwert, N. Leach and R. Tavernor, London and Cambridge, Mass., 1991.

4 S. Zeki, *Inner Vision: An Exploration of Art and the Brain*, Oxford 1999, 197–204.

5 J. Onians, 'Abstraction and Imagination in Late Antiquity', *Art History* 3: 1 (1980), 1–24.

Part IV Europe 300–1200

1 J. Onians, *Classical Art and the Cultures of Greece and Rome*, New Haven and London 1999, 271–82.

2 K. Woolett and E. A. Maguire, 'Acquiring "the Knowledge" of London's Layout Drives Structural Brain Changes', *Current Biology* 21 (20 Dec. 2011), 2109–14.

3 A. Clarke, K. I. Taylor, B. Devereux, B. Randall and L. K. Tyler, 'From Perception to Conception: How Meaningful Objects are Processed over Time', *Cerebral Cortex* 23 (Jan. 2013), 187–97.

4 D. Ahlert, M. Deppe, P. Kenning, H. Kugel, H. Plassman and W. Schwindt, 'How Brands twist Heart and Mind: Neural Correlates of the Affect Heuristic during Brand Choice', *European Advances in Consumer Research* (13 May 2008), 1–36, www.acr.org.

5 U. Schjødt, H. Stødkilde-Jørgensen, A. W. Geertz and A. Roepstorff, 'Rewarding Prayers', *Neuroscience Letters* 443 (2008), 165–8.

6 M. Huang, H. Bridge, M. J. Kemp and A. J. Parker, 'Human Cortical Activity evoked by the Assignment of Authenticity when viewing Works of Art', *Frontiers in Human Neuroscience* (28 Nov. 2011), http://http:// journal.frontiersin.org/article/10.3389/fnhum.2011.00134/full, accessed 15 June 2016, and H. Plassmann, J. O'Doherty, B. Shiv and A. Rangel, 'Marketing Actions can modulate Neural Representations of Experienced Pleasantness,' *Proceedings of the National Academy of Sciences* 105: 3 (14 Jan. 2008), 1050–54, http://www.pnas.org/content/105/3/1050.full, accessed 15 June 2016.

8 Europe 300–750

1 Gelasius Cyzicenus, *Historia concilii nicaeni*, in P. G. Migne, *Patrologia Graeca*, LXXXV, col. 1232.

2 Eusebius, *Vita Constantini*, III, 37.

3 R. Krautheimer, 'Introduction to an "Iconography of Mediaeval Architecture"', *Journal of the Warburg and Courtauld Institutes* 5 (1942), 1–33.

4 J. Onians, *Bearers of Meaning: The Classical Orders in Antiquity, the Middle Ages, and the Renaissance*, Princeton and Cambridge 1990, 62–5.

5 J. Onians, 'Abstraction and Imagination in Late Antiquity', *Art History* 3: 1 (1980), 1–24.

6 Paulus Silentiarius, *Descriptio ambonis*, in C. Mango, ed., *Art of the Byzantine Empire 312–1453*, Englewood Cliffs, N.J., 1972, 95.

7 *Narratio de S. Sophia*, in Mango, *Art of the Byzantine Empire*, 91.

8 G. Lakoff, 'The Neural Theory of Metaphor', *Social Science Research Network* (2 Jan. 2009), http://ssrn.com/abstract=1437794 or http://dx.doi.org/10.2139/ssrn.1437794, accessed 3 Jan. 2014, rev. ed. of article in R. Gibbs, ed., *The Metaphor Handbook*, Cambridge 2008, 17–38.

9 F. van der Meer and C. Mohrmann, *Atlas of the Early Christian World*, Edinburgh 1959, 143.

10 Eusebius, *Ecclesiastical History*, X, 4.

11 R. M. Harrison, *A Temple for Byzantium: The Discovery and Excavation of Anicia Juliana's Palace Church of Istanbul*, London 1989.

12 R. Morris, 'Alcuin, York, and the *alma sophia*', in L. A. S. Butler and R. K. Morris, eds, *The Anglo Saxon Church: Papers on History, Architecture and Archaeology in Honour of Dr H. M. Taylor*, London 1986, 80–89.

13 G. Bandmann, 'Die Vorbilder der Aachener Pfalzkapelle', in W. Braunfels, ed., *Karl der Grosse*, 3 vols, Düsseldorf 1965, vol. III, 452, and G. Kühnel, 'Aachen, Byzanz und die frühislamische Architektur im Heiligen Land', in W. Dessen, G. Minkenberg and A. C. Oellers, eds, *Ex Oriente: Izaak und die weisse Elefant. Bagdad–Jerusalem–Aachen*, 3 vols, Aachen 2003, vol. III, 61.

9 Art and the Mind 700–1100

1 S. Dehaene, 'Inside the Letterbox: How Literacy transforms the Human Brain', *Cerebrum* 7 (3 June 2013), 1–23, www.dana.org/news/cerebrum/detail.aspx?id=43644, accessed 15 June 2016.

2 Bede, *Bede: On the Tabernacle*, trans. with notes and intro. A. G. Holder, Liverpool 1994.

3 Bede, *Bede: On the Temple*, trans. S. Connolly, intro. J. O'Reilly, Liverpool 1995.

4 Ibid., Prologue 1.1.

5 Ibid., Prologue 2.3.

6 Ibid.

7 Bede, *Historia Ecclesiastica Gentis Anglorum*, trans. L. Sherley-Price as *Ecclesiastical History of the English People*, London 1991, II: 1.

8 Origen, *On Principles*, IV, 2, 4.

9 Bede, *On the Temple*, 1.1.

10 G. Bandmann, 'Die Vorbilder der Aachener Pfalzkapelle', in W. Braunfels, ed., *Karl der Grosse*, 3 vols, Düsseldorf 1965, vol. III, 452, and G. Kühnel, 'Aachen, Byzanz und die frühislamische Architektur im Heiligen Land', in W. Dessen, G. Minkenberg and A. C. Oellers, eds, *Ex Oriente: Izaak und die weisse Elefant. Bagdad–Jerusalem–Aachen*, 3 vols, Aachen 2003, vol. III, 61.

11 Bandmann, 'Vorbilder der Aachener Pfalzkapelle', 452.

12 M. Büchner, *Einhard als Künstler*, Strasbourg 1919, 27ff.

13 P. Souchek, 'The Temple of Solomon in Islamic Legend and Art', in J. Gutmann, ed., *The Temple of Solomon: Archaeological Fact and Medieval Tradition in Christian, Islamic and Jewish Art*, Missoula, Mont., 1976, 73–124.

14 Kühnel, 'Aachen, Byzanz und die frühislamische Architektur', 60.

15 Sedulius Scotus cited in J. von Schlosser, *Schriftquellen zur Geschichte der Karolingischen Kunst*, Vienna 1892, repr. Hildesheim and New York 1974, 7.

16 S. Allott, *Alcuin of York: His Life and Letters*, York 1974, 96.

17 Angilbert, *De restauratione monasterii Centulensis*, in J. P. Migne, *Patrologia Latina*, XCIV, col. 840.

18 Hariulf's Chronicle in C. Davis-Weyer, *Early Medieval Art: Sources and Documents*, Englewood Cliffs, N.J., 1971, 95–6.

19 Schlosser, *Schriftquellen*, 206.

20 Davis-Weyer, *Early Medieval Art*, 95.

21 Ibid., 98.

22 Ibid., 94–8.

23 A. Freeman, ed., *Opus Caroli Regis contra Synodum (Libri Carolini)*, Hannover 1998, I: 14, 169.

24 Rabanus Maurus, *De Universo*, in Migne, *Patrologia Latina*, CXI, col. 9.

25 Ibid.

26 Ibid., col. 403.

27 Ibid.

28 L. Chazelle, *The Crucified God in the Carolingian Era*, Cambridge, 2001.

29 Candidus, *Vita Eigili*, in Migne, *Patrologia Latina*, CV, cols 397, 398.

30 H. W. Hammerbacher, *Irminsul und Lebensbaum*, Offenbach-am-Main 1973.

31 Candidus Fuldensis, *Eigil, Vita Metrica*, in Migne, *Patrologia Latina*, CV, col. 416.

32 *Translatio S. Alexandri*, in Schlosser, *Schriftquellen*, 85.

33 Rabanus Maurus, *De Laudibus Sanctae Crucis*, in Migne, *Patrologia Latina*, CVII, col. 145.

34 F. Seitz, *Die Irminsul im Felsenrelief der Externsteine*, Pähl 1962.

35 Ibid., pl. 7.

36 Hammerbacher, *Irminsul und Lebensbaum*, un-numbered plate.

37 F. Tschan, *St Bernward of Hildesheim*, 3 vols, South Bend, Ind., 1942–52, vol. III (1951): *His Works of Art*, 273.

38 Ibid., 275.

39 Eigil, *The Life of St Sturm*, trans. at www.fordham.edu/halsall/basis/sturm.asp, accessed 21 Nov. 2014.

40 J. E. Raaijmakers, *Sacred Time, Sacred Space: History and Identity in the Monastery of Fulda (744–856)*, Amsterdam 2003.

41 Ibid., 171.

10 The Abbey of St Denis

1 L. Grant, *Abbot Suger of St Denis: Church and State in Early Twelfth-Century France*, London 1998.

2 E. Panofsky, *Abbot Suger on the Abbey Church of St Denis and its Art Treasures*, Princeton 1979.

3 Ibid., 47.

4 Ibid., 91.

5 Ibid., 61.

6 Ibid.

7 Ibid., 53.

8 Ibid., 49.

9 Ibid., 63.

10 Ibid., 189–90.

11 Ibid., 62 and 63.

12 Ibid., 49.

13 Ibid., 66 and 67.

14 Ibid., 47.

15 Ibid., 104.

16 For a survey of the issues see P. Draper, 'Islam and the West: The Early Use of the Pointed Arch Revisited', *Architectural History* 48 (2005), 1–20.

17 For twisting see D. Ogden, 'Binding Spells: Curse Tablets and Voodoo Dolls', in V. Flint, R. Gordon, G. Luck, D. Ogden, eds, *Witchcraft and Magic in Europe: Ancient Greece and Rome*, London 1999, 29.

18 A. J. Toynbee, *A Study of History: Abridgement of Vols VII–X*, Oxford 1957, 259.

19 St Bernard of Clairvaux cited in C. Davis-Weyer, *Early Medieval Art: Sources and Documents*, Englewood Cliffs, N.J., 1971, 168 and 169.

20 B. F. Reilly, *The Kingdom of Leon-Castilla under King Alfonso VI 1065–1109*, Princeton 1988, 210–13.

21 W. Cahn, 'Solomonic Elements in Romanesque Art', in J. Gutmann, ed., *The Temple of Solomon*, Ann Arbor 1973.

22 J. B. Pritchard, ed., *Ancient Near Eastern Texts relating to the Old Testament*, Princeton 1969, 347.

23 Hugh of St Victor, *De sacramentis*, in J. P. Migne, *Patrologia Latina*, CLXXVI, cols 417 and 441.

24 Honorius of Autun, *Speculum Ecclesiae*, in Migne, *Patrologia Latina*, CLXXII, col. 802.

25 J. Onians, *Bearers of Meaning: The Classical Orders in Antiquity, the Middle Ages, and the Renaissance*, Princeton and Cambridge 1990, 102–5.

26 Panofsky, *Abbot Suger*, 97.

Part V Western Europe 1200–1600

1 C. H. Haskins, *The Renaissance of the Twelfth Century*, Cleveland 1957, 303–40.

2 G. K. Chesterton, *St Francis of Assisi*, London 1923, 98–112.

3 For skills involved see M. Baxandall, *Painting and Experience in Fifteenth Century Italy: A Primer in the Social History of Style*, Oxford 1972, pp. 29–103.

11 French and English Gothic

1 R. Branner, *St Louis and the Court Style*, London 1965, 57.

2 P. Draper, *The Formation of English Gothic: Architecture and Identity*, New Haven and London 2006, 44–5.

3 P. Binski, *Becket's Crown: Art and Imagination in Gothic England, 1170–1300*, New Haven and London 2004, 45–6.

4 Ibid., 10.

5 T. Heslop, 'Art, Nature and St Hugh's Choir at Lincoln', in J. Mitchell and M. Moran, eds, *England and the Continent in the Middle Ages: Studies in Memory of Andrew Martindale*, Stamford, Lincs, 2000, 60–74, and Binski, *Becket's Crown*, 44–77.

6 Gerald of Wales cited in Binski, *Becket's Crown*, 55.

7 Henry of Avranches cited in ibid., 57.

8 P. Binski, *Gothic Wonder: Art, Artifice, and the Decorated Style, 1290–1350*, New Haven and London, 2014.

9 'The warm phase . . . seems to have broadly continued in Europe until 1300 or 1310': H. H. Lamb, *Climate, History and the Modern World*, 2nd ed, London and New York 1995, 181.

10 Ibid., 287.

11 Ibid., 195.

12 Ibid., 287.

13 Ibid., 195.

14 H. Maxwell, trans. and ed., *The Chronicle of Lanercost*, Glasgow 1913, 279.

15 M. C. Prestwich, *The Three Edwards: War and State in England, 1272–1377*, London 1980, 209–11.

16 R. H. Osbert, ed., *The Poems of Laurence Minot*, Kalamazoo 1996, VII, 85 and 86.

17 S. Armitage, trans., *The Death of King Arthur*, London 2012, 134, lines 3685–6.

18 J. de Wavrin, *Receuil de croniques et anciennes istoires la Grande Bretagne*, Cambridge 2012, V, 1, p. 203.

19 B. Wuetherick, 'A Re-evaluation of the Impact of the Hundred Years War on the Rural Economy and Society of England', *Past Imperfect* 8 (1999–2000), 145–6.

20 *European Magazine and London Review for September 1785*, 179.

21 Froissart, *The Chronicle of Froissart*, London 1901, vol. 1, 298.

22 J. Munby, R. Barber and R. Brown, *Edward III's Round Table at*

Windsor: The House of the Round Table and the Windsor Festival of 1344, Woodbridge 2007.

23 H. Martin and M. Russon, *Vivre sous la tente au Moyen Age*, Rennes 2010, 224.

24 F. Bond, *An Introduction to English Church Architecture*, 2 vols, Oxford 1913, vol. II, 613.

25 P. S. Lewis, *Later Medieval France: The Polity*, London 1968, 24 and 25, quoting L. A. Thorndike, *A History of Magic and Experimental Science*, 9 vols, New York 1923–58, vol. II (1947), 802.

26 Lewis, *Later Medieval France*, 83.

27 Ibid., 65 and 83.

28 A. Lombard-Jourdan, *Fleur de lis et oriflamme: Signes célestes du royaume de France*, Paris 1991, 17–47.

29 Noel de Fribois cited in Lewis, *Later Medieval France*, 64.

30 J. Bony, *The English Decorated Style: Gothic Architecture Transformed 1250–1350*, Oxford 1979.

31 A. M. Morganstern, 'The La Grange Tomb and Choir: A Monument of the Great Schism of the West', *Speculum* 48: 1 (1973), 52–69.

32 L. Neagley, 'The Flamboyant Architecture of S. Maclou, Rouen, and the Development of a Style', *Journal of the Society of Architectural Historians* 47 (1988), 374–96.

33 T. Basin, *Histoire de Charles VII*, ed. and intro. C. Samaran, Paris 1933, I, 138.

34 Ibid.

35 Ibid., 133.

36 Ibid., 144.

37 A.-M. Lecoq, *François Ier imaginaire: Symbolique et politique à l'aube de la Renaissance française*, Paris 1987, 39, figs 8 and b.

38 Ibid., 184.

12 Italy 1300–1600

1 M. Baxandall, *Painting and Experience in Fifteenth Century Italy: A Primer in the Social History of Style*, Oxford 1972, 29.

2 J. Onians, 'Brunelleschi: Humanist or Nationalist?' *Art History* 5 (1982), 259–72.

3 Ibid.

4 For Cennini see E. G. Holt, ed., *A Documentary History of Art*, 3 vols, vol. I: *The Middle Ages and the Renaissance*, New York 1947, 138.

5 For Raphael see ibid., 293.

6 L. Dolce, *L'Aretino: Dialogo della pittura*, Florence 1910, 24.

7 P. Hills, *Venetian Colour: Marble, Mosaic, Painting and Glass, 1250–1550*, New Haven and London 1999.

8 D. Howard, *Venice and the East: The Impact of the Islamic World on Venetian Architecture, 1100–1500*, New Haven and London 2000.

9 W. P. McCrary, *Glassmaking in Renaissance Venice: The Fragile Craft*, Aldershot 1999, and L. Mola, *The Silk Industry of Renaissance Venice*, Baltimore 2000.

10 L. C. Matthew, '"Vendecolori a Venezia": The Reconstruction of a Profession', *Burlington Magazine* 144 (2002), 680–86.

11 C. Hare, *Courts and Camps of the Italian Renaissance*, London 1908, 80.

Part VI Early Modern Europe 1500–1700

1 B. Castiglione, *The Book of the Courtier*, trans. G. Bull, Harmondsworth 1976.

13 Self-Awareness and the Early Modern Artist

1 J. Onians, 'Leon Battista Alberti: The Problem of Personal and Urban Identity', in C. Mozzarelli, R. Oresko and L. Ventura, eds, *La Corte di Mantova nell'età di Andrea Mantegna: 1450–1550*, Eng. ed. *The Court of the Gonzaga in the Age of Mantegna: 1450–1550*, Rome 1998, 207–15.

2 Leon Battista Alberti, *De statua*, 1, in *On Painting and on Sculpture*, the latin texts of *De pictura* and *De statua*, trans. and ed. C. Grayson, London 1972, 121.

3 Alberti, *De pictura*, 3.58, in ibid., 101.

4 Ibid., 3.56, 101.

5 Ibid., 2.41, .81

6 Leonardo, Codex Urb., fol. 7v, in *Leonardo on Painting: Anthology of Writings by Leonardo da Vinci*, trans. and ed. M. Kemp and M. Walker, New Haven and London 1989, 28–32.

7 Ibid., Cod. Urb., fols 61v–62r, in Kemp and Walker, *Leonardo on Painting*, 222.

8 J. Onians, 'On how to listen to Renaissance Art', *Art History* 7, 4 (1984), 411–37.

9 Leonardo, Cod. Urb., fols 44r–v, in Kemp and Walker, *Leonardo on Painting*, 204.

10 Ibid.

11 Leonardo da Vinci, Codex Atlanticus, 221vd/597iir, Biblioteca Ambrosiana, Milan, in ibid., 52.

12 E. H. Gombrich, 'The Mask and the Face', in *The Image and the Eye*, Oxford 1982, 128.

13 *The Literary Works of Leonardo da Vinci*, ed. and trans. J. P. Richter, 2 vols (London 1883; Oxford 1939), London and New York 1970, vol. II, 101 and 102.

14 *The Literary Works of Leonardo da Vinci*, ed. C. Pedretti, London 1977, vol. I, 345.

15 Leonardo, Cod. Urb., 7r–v, in Kemp and Walker, *Leonardo on Painting*, 22.

16 Leonardo, Cod. Urb., 15v–16r, in ibid., 20–21.

17 Ibid., 18–21.

18 *Literary Works*, Pedretti, vol. I, 345.

19 C. Pedretti, *Il Tempio dell'anima: L'Anatomia di Leonardo da Vinci fra Mondino e Berengario*, Poggio a Cajano 2007, 165.

20 J. M. Saslow, trans. and ed., *The Poetry of Michelangelo*, New Haven and London 1991, and Michelangelo and Tommaso Campanella, *The Sonnets of Michelangelo Buonarroti and Tommaso Campanella*, trans. J. A. Symonds, London 1878.

21 A. Condivi, *The Life of Michelangelo*, trans. A. S. Wohl, ed H. Wohl, Oxford 1976, 7.

22 G. Vasari, *Le Vite de'piu eccellenti pittori, scultori e architetti*, first ed., VII, Milan 1927, 191.

23 Michelangelo cited in J. S. Ackerman, *The Architecture of Michelangelo*, Harmondsworth 1986, 37.

24 G. Maurer, *Michelangelo: Die Architekturzeichnungen*, Regensburg 2004, 136: 'Worin besteht das "Bildhauerische" an Michelangelos Architektur?'

25 Vasari, *Le Vite de'piu eccellenti pittori, scultori e architetti*, 270.

26 Condivi cited in J. Pope-Hennessy, *Italian High Renaissance and Baroque Sculpture*, 3 vols, London 1963, Catalogue Volume, n.p.

14 Self-Awareness and the Early Modern Viewer

1 B. Cellini, *La vita*, Rome 1965, 332 (my translation).

2 Leonardo da Vinci, Codex Urbinas Latinus, fols 11r–v, Vatican Library, in *Leonardo on Painting: Anthology of Writings by Leonardo da Vinci*, trans. and ed. M. Kemp and M. Walker, New Haven and London 1989, 24.

3 L. Ariosto, *Orlando Furioso*, trans. G. Waldman, Oxford 2008, 10, 4.

4 H. Bredekamp, *Vicino Orsini und der Heilige Wald von Bomarzo: Ein Fürst als Künstler und Anarchist*, Worms 1991, 76–8. Translations of inscriptions mine.

5 F. de'Vieri, *Discorsi delle Maravigliose Opere di Pratolino e d'Amore*, Florence 1587, 57 (my translation).

6 Ibid., 56.

7 Ibid., 57.

8 F. Bacon, *The Advancement of Learning*, ed. W. A. Wright, Oxford 1869, 8.

9 R. Descartes, *Oeuvres de Descartes*, 13 vols, Paris 1967, vol. XI [*The Passions of the Soul*], 373 (my translation).

10 O. Impey and A. MacGregor, *The Origins of Museums: The Cabinet of Curiosities in Sixteenth and Seventeenth Century Europe*, Oxford 1985.

11 De'Vieri, *Discorsi*, 66.

12 C. Darwin, *The Expression of the Emotions in Man and Animals*, London 1872, 15.

13 Louis XIV, *Mémoires de Louis XIV*, ed. J. Lognon, Paris 1927, 123d (my translation).

Part VII The Eighteenth Century

1 T. Browne, *Religio Medici* (1643), London 1881, 60.

2 T. Browne, *The Garden of Cyrus*, London 1658, ch. 4.

3 T. Willis, *The Anatomy of the Brain and Nerves*, ed. W. Feindel, 2 vols, Montreal 1965, vol. I, 94.

4 B. C. Lega, 'An Essay concerning Human Understanding: How the *Cerebri Anatome* of Thomas Willis influenced John Locke', *Neurosurgery* 58: 3 (2005), 567–76.

5 K. Dewhurst, *Thomas Willis's Oxford Lectures*, Oxford 1980, 65–6.

6 J. Locke, *An Essay concerning Human Understanding* (1690), in *The Philosophical Works of John Locke*, London 1841, 24–5.

7 Ibid., 122.

8 Ibid., 156.

9 J. Richardson, 'A Discourse on the Dignity, Certainty, Pleasure and Advantage of the Science of the Connoisseur', in *Two Discourses* (London 1719), Menston, Yorks, 1972, 110.

10 Ibid., 111.

11 Ibid., 112.

12 Ibid., 57–8.

13 Ibid., 204.

14 J. Richardson Sr and Jr, *An Account of Some of the Statues, Bas-Reliefs, Drawings, and Pictures in Italy*, London 1722.

15 Richardson, 'Discourse', 204.

15 Eighteenth-Century England and the Grand Tour: The Patron

1 J. Vanbrugh cited in J. Dixon Hunt, *The Picturesque Garden in Europe*, London 2002, 23.

2 J. Addison, *Spectator* 414 (25 June 1712), repr. in *The Works*, 3 vols, London 1721, vol. III, 497.

3 A. Pope cited in J. Spence, *Observations, Anecdotes and Characters of Books and Men*, ed. J. M. Osborn, Oxford 1966, 252.

4 R. P. Knight, *The Landscape: A Didactic Poem in Three Books addressed to Uvedale Price Esq.*, London 1794.

5 From *The Rise and Progress of the Present Taste in Planting Parks, Pleasure Grounds, Gardens*, 1767, quoted in Dixon Hunt, *Picturesque Garden in Europe*, 39.

6 J. Richardson, 'A Discourse on the Dignity, Certainty, Pleasure and Advantage of the Science of the Connoisseur', in *Two Discourses* (London 1719), Menston Yorks, 1972, 204.

7 R. P. Knight, *An Analytical Inquiry into the Principles of Taste*, London 1805, 99.

8 Ibid., 100.

9 Ibid., 216–17.

10 Ibid., 225.

16 Eighteenth-Century England and the Grand Tour: The Artist

1 J. G. Links, *Canaletto*, London 1982, 104.

2 M. Clayton, *Canaletto in Venice*, London 2005, 20–22.

3 Links, *Canaletto*, 129.

4 M. Levey, 'Canaletto as Artist of the Urban Scene', in K. Baetjer and J. G. Links, eds, *Canaletto*, New York 1989, 20.

17 Nineteenth-Century England

1 E. de Bièvre, *Dutch Art and Urban Cultures, 1200–1700*, New Haven and London 2015; see esp. 'Amsterdam', 255–349.

2 W. Murdoch, 'An account of the Application of Gas from Coal to Economical Purposes', *Phil. Trans. R. Soc. Lond.* 98 (1 Jan. 1808), 124–32.

3 R. B. Beckett, ed., *John Constable's Correspondence*, 6 vols, Ipswich 1962–8, vol. VI, 76–7.

4 E. H. Gombrich, *Art and Illusion*, London 1960, 324.

5 W. Stokes, *Studies in Physiology and Medicine by Doctor Graves*, London 1863, xii.

6 J. Ruskin, *Modern Painters: Vols I–V plus Index*, Orpington 1888, vol. I, pt II, section 1, ch. 2, 50.

7 Ibid., pt II, section 1, ch. 2, 51.

8 Ibid., pt II, section 1, ch. 7, 122.

9 Ibid., 123.

10 Ibid., 124.

11 Ibid., 130–31.

12 Ibid., vol. V, pt IX, ch. 9, 292–3.

13 Ibid., pt II, section 1, ch. 7, 128–9.

14 Ibid.

15 Ibid.

18 Nineteenth-Century France

1 T. H. Goetz, *Taine and the Fine Arts*, Madrid 1973, and M. Waschek, ed., *Relire Taine*, cycle de conférences, Paris 2001.

2 H. Taine, *Philosophie de l'art*, Paris 1938, 15.

3 Ibid., 11 (my translation).

4 Ibid., 60.

5 Ibid., 44.

6 Ibid., 45.

7 Ibid., 310–11.

8 Ibid., 311.

9 Ibid., 312.

10 H. Taine, *De l'intelligence*, Paris 1870.

11 Ibid., vol. 2, 292.

12 Ibid., vol. 2, 312–13.

13 Ibid., vol. 2, 136–43.

14 Ibid., vol. 2, 312.

15 Ibid., vol. 2, 314.

16 J. H. Rubin, *Manet's Silence and the Poetics of Bouquets*, Cambridge, Mass., 1994; E. Zola, *Mes Haines: Causeries littéraires et artistiques*, Paris 1879, p. 25.

17 G. Clemenceau, *Claude Monet: Les Nymphéas*, Paris 1928, 57.

18 P. Tucker, *Claude Monet: Life and Art*, New Haven and London 1995, 72–5.

19 Clemenceau, *Claude Monet*, 21–2.

20 Tucker, *Claude Monet*, 103.

21 Ibid., 105–6.

22 A. Vollard, *Paul Cézanne*, Paris 1914, 88. See also M. Doran, ed., *Conversations with Cézanne*, Berkeley, Cal., 2001, 122: 'Monet is an eye, the most prodigious eye in the history of painters.'

23 *Joachim Gasquet's Cézanne: A Memoir with Conversations*, trans. C. Pemberton, pref. J. Rewald, intro. R. Shiff, London 1991, 176.

24 Ibid., 152.

25 Ibid., 150.

26 Taine, *Philosophie de l'art*, 310–11.

27 J. Ruskin, *Modern Painters: Vols I–V plus Index*, Orpington 1888, vol. I, pt II, section 1, ch. 7, 130–31.

28 Doran, *Conversations*, 110.

29 Zola, 1866 Salon review, repr. in *Mes haines*, 311.

30 Ibid., 312.

31 M. Fried, *Courbet's Realism*, Chicago 2001, 105.

19 Malevich and Painting

1 K. S. Malevich, 'An Introduction to the Theory of the Additional Element in Painting', in *Unpublished Writings 1922–1925*, vol. III: *The World as Non-Objectivity*, trans. X. Glowacki-Prus and E. T. Little, ed. T. Andersen, Copenhagen 1976, 147.

2 Ibid., 149.

3 Ibid., 150.

4 Ibid., 152.

5 Ibid., 159.

6 Ibid., 161–2.

7 Ibid., 167.

8 Ibid., 170.

9 Ibid., 171.

10 Ibid., 172.

11 Ibid.

12 Ibid., 176.

13 Ibid., 179.

14 Ibid., 186.

15 Ibid., 186.

16 Ibid., 187.

17 Ibid.

18 Ibid., 188.

19 Ibid.

20 Ibid.

21 Ibid.

22 Ibid., 191.

23 Ibid., 193.

24 K. S. Malevich, 'Autobiography', repr. in *Essays on Art, 1915–1933*, trans. X. Glowacki-Prus and A. McMillin, ed. T. Andersen, Copenhagen 1971.

25 Ibid., 147.

26 Ibid., 149.

27 Ibid., 150.

28 Ibid.

29 Ibid., 151.

30 Ibid., 152.

31 Ibid., 148.

32 Ibid., 181.

33 Ibid., 147.

34 Ibid., 150.

35 K. Malevich, *Suprematism: 34 Drawings* (Vitebsk 1920), repr. and trans. B. Shuey, n.p.

36 Ibid.

37 See quotation from J. Bekman Chadaga's still unpublished 'Chaos, Cosmos, and Cartography: On the Origins of Suprematism', conference paper delivered at *Art, Technology, and Modernity in Russia and Eastern Europe*, Columbia University, New York, March–April 2000, cited in Wikipedia entry on Malevich, accessed 10 May 2009.

20 Le Corbusier and Architecture

1 J.-L. Cohen, *Le Planète comme chantier* (The Planet as Building Site), Paris 2005, 7 (my translations unless otherwise specified).

2 Ibid., 15.

3 Ibid., 22.

4 Le Corbusier, 'Vers l'Orient', *La Feuille d'avis de la Chaux-de-Fonds*, 1911, cited in ibid., 37.

5 Le Corbusier, letter to Klipstein, 1911, cited in Cohen, *Planète*, 41.

6 Le Corbusier, letter to Ritter, 1913, cited in ibid.

7 Le Corbusier, 'Brazilian Corollary', lecture, 1929, cited in Cohen, *Planète*, 95.

8 Le Corbusier, letter to Elie Faure, 1931, cited in ibid., 94.

9 Le Corbusier, *Aircraft*, London 1935.

10 Le Corbusier, 1936, cited in Cohen, *Planète*, 104.

11 Ibid., 138.

12 Ibid., 144.

13 Ibid., 152.

14 Le Corbusier, *Mise au point*, Paris 1965, cited in ibid., 168.

15 Le Corbusier, *Vers une architecture*, Paris 1923; Eng. ed. *Towards a New Architecture*, trans. F. Etchells, New York n.d., 35.

21 Caris and Sculpture

1 G. Caris, artist's statement at http://gerardcaris.com/statements.html, accessed 8 March 2009.

2 E. van Uitert, 'Passion and Precision: The Art of Gerard Caris', in *Gerard Caris Pentagonisme/Pentagonism*, texts by R. Fuchs, E. van Uitert, J. van de Craats and R. Salomon, Amsterdam 2001, 27–44.

3 S. Zeki, 'The Art of Gerard Caris and the Brain's Search for Knowledge', in G. Jansen and P. Weibel, eds, *Pentagonismus/Pentagonism*, Karlsruhe 2007, 74–83.

4 Caris, artist's statement.

5 Gerard Caris, 'Conjectures and Observations', typescript of talk at Parsons School of Design, 16 March 1981, p. 1, copy available at gerardcaris.com/statements.

6 Ibid., 4.

7 Caris, artist's statement.

bibliography

General Neuroscience

Kandel, E., J. Schwarts and T. Jessell, eds, *Principles of Neural Science*, 5th ed., New York 2013.

Kolb, B., and I. Whishaw, *An Introduction to Brain and Behaviour*, New York 2001.

Smith, E. E., and S. Kosslyn, *Cognitive Psychology: Mind and Brain*, New York 2007.

The Brain

Allman, J., *Evolving Brains*, New York 1998.

Greenfield, S., *The Human Brain: A Guided Tour*, London 2003.

Ramachandran, V. S., *The Emerging Mind*, London 2003.

Zeman, A., *A Portrait of the Brain*, New Haven and London 2008.

Visual Neuroscience

Chalupa, L., and J. Werner, eds, *The Visual Neurosciences*, 2 vols, Cambridge, Mass. and London 2004.

Grill-Spector, K., 'The Neural Basis of Object Perception', *Current Opinion in Neurobiology* 13 (2003), 1–8.

Livingstone, M., *Vision and Art: The Biology of Seeing*, New York 2002.

Neuroscience and Art

Chatterjee, A., *The Aesthetic Brain: How we evolved to desire Beauty and enjoy Art*, Oxford 2014.

Kandel, E., *The Age of Insight: The Quest to Understand the Unconscious in Art, Mind, and Brain, from Vienna 1900 to the Present*, New York 2012.

Mallgrave, H., *The Architect's Brain: Neuroscience, Creativity, and Architecture*, Chichester 2011.

McGilchrist, I., *The Master and his Emissary: The Divided Brain and the Making of the Western World*, New Haven and London 2010.

Neidich, W., *Blow-Up: Photography, Cinema and the Brain*, New York 2003.

Schellekens, E., and P. Goldie, *The Aesthetic Mind: Philosophy and Psychology*, Oxford 2011.

Skov, M., O. Vartanian, C. Martindale and A. Berleant, *Neuroaesthetics*, Amityville, N.Y., 2009.

Solso, R. L., *The Psychology of Art and the Evolution of the Conscious Brain*, Cambridge, Mass., 2005

Stafford, B., *Echo Objects: The Cognitive Work of Images*, Chicago 2007.

Zaidel, D., *Neuropsychology of Art: Neurological, Cognitive, and Evolutionary Perspectives*, New York 2005.

Zeki, S., *Inner Vision: An Exploration of Art and the Brain*, Oxford 1999.

—, *Splendours and Miseries of the Brain: Love, Creativity and the Quest for Human Happiness*, London 2009.

Works Referenced

For Classical and Early Christian texts see the volumes in the Loeb Classical Library and J. P. Migne, *Patrologia Graeca* (Paris 1857–66) and *Patrologia Latina* (Paris 1841–55).

Ackerman, J. S., *The Architecture of Michelangelo*, Harmondsworth 1986.

Addison, J., *The Works*, 3 vols, London 1721.

Ahlert, D., M. Deppe, P. Kenning, H. Kugel, H. Plassman and W. Schwindt, 'How Brands twist Heart and Mind: Neural Correlates of the Affect Heuristic during Brand Choice', *European Advances in Consumer Research* (13 May 2008), 1–36, www.acr.org.

Alberti, Leon Battista, *On Painting and on Sculpture*, the Latin texts of *De pictura* and *De statua*, ed. and trans., intro. and notes by C. Grayson, London 1972.

—, *On the Art of Building in Ten Books* [*De re aedificatoria*], ed. and trans. J. Rykwert, N. Leach and R. Tavernor, London and Cambridge, Mass., 1991.

Allott, S., *Alcuin of York: His Life and Letters*, York 1974.

Alvarez, W., *The Mountains of St Francis: The Geologic Events that shaped our Earth*, New York 2009.

Angilbert, *De restauratione monasterii Centulensis*, in J. P. Migne, *Patrologia Latina*, XCIV.

Ariosto, L., *Orlando Furioso*, trans. G. Waldman, Oxford 2008.

Armitage, S., trans., *The Death of King Arthur*, London 2012.

Arnheim, R., *Art and Visual Perception: A Psychology of the Creative Eye*, 1954, rev. ed., Berkeley, Cal., 1974.

Bacon, F., *The Advancement of Learning*, ed. W. A. Wright, Oxford 1869.

Bandmann, G., 'Die Vorbilder der Aachener Pfalzkapelle', in W. Braunfels, ed., *Karl der Grosse: Lebenswerk und Nachleben*, 3 vols, Düsseldorf 1965, vol. III.

Basin, T., *Histoire de Charles VII*, ed. and intro. C. Samaran, Paris 1933.

Baxandall, M., *Painting and Experience in Fifteenth Century Italy: A Primer in the Social History of Style*, Oxford 1972.

—, 'Fixation and Distraction: The Nail in Braque's Violin and Pitcher (1910)', in J. Onians, ed., *Sight and Insight: Essays on Art and Culture in Honour of E. H. Gombrich at 85*, London 1994, 399–415.

Beckett, R. B., ed., *John Constable's Correspondence*, 6 vols, Ipswich 1962–8.

Bede, *Bede: On the Tabernacle*, trans. with notes and intro. A. G. Holder, Liverpool 1994.

—, *Bede: On the Temple*, trans. S. Connolly, intro. J. O'Reilly, Liverpool 1995.

—, *Historia Ecclesiastica Gentis Anglorum*, trans. L. Sherley-Price as *Ecclesiastical History of the English People*, London 1991.

Bednarik, R. G., 'The "Australopithecine" Pebble from Makapansgat', *South African Archaeological Bulletin* 53 (1998), 4–8.

Bièvre, E. de, *Dutch Art and Urban Cultures, 1200–1700*, London and New Haven 2015.

Binski, P., *Becket's Crown: Art and Imagination in Gothic England 1170–1300*, New Haven and London 2004.

—, *Gothic Wonder: Art, Artifice, and the Decorated Style, 1290–1350*, New Haven and London 2014.

Bond, F., *An Introduction to English Church Architecture*, 2 vols, Oxford 1913.

Bony, J., *The English Decorated Style: Gothic Architecture Transformed 1250–1350*, Oxford 1979.

Borić, D., C. French, V. Dimietrijević, 'Vlasac Revisited: Formation Processes, Stratigraphy and Dating', *Documenta Praehistorica* 35 (2008), 261–87.

Boulenger, V., O. Hauk and F. Pulvermüller, 'Grasping Ideas with the Motor System: Semantic Somatopy in Idiom Comprehension', *Cerebral Cortex* 19 (Aug. 2009), 1905–14.

Branner, R., *St Louis and the Court Style*, London 1965.

Bredekamp, H., *Vicino Orsini und der Heilige Wald von Bomarzo: Ein Fürst als Künstler und Anarchist*, Worms 1991.

Browne, T., *The Garden of Cyrus*, London 1658.

—, *Religio Medici* (1643), London 1881.

Bryson, N., *Vision in Painting: The Logic of the Gaze*, New Haven and London 1983.

—, 'Introduction: The Neural Interface', in W. Neidich, *Blow-Up: Photography, Cinema and the Brain*, New York 2003, 11–19.

Büchner, M., *Einhard als Künstler*, Strasbourg 1919.

Byrne, R., *The Thinking Ape: Evolutionary Origins of Intelligence*, Oxford 1995.

Cahn, W., 'Solomonic Elements in Romanesque Art', in J. Gutmann, ed., *The Temple of Solomon*, Ann Arbor 1973.

Calvo-Merino, B., C. Glaser and P. Haggard, 'Towards a Sensorimotor Aesthetics of Performing Art', *Consciousness and Cognition* 17: 3 (Sept. 2008), 911–22.

Candidus, *Vita Eigili*, in J. P. Migne, *Patrologia Latina*, CV.

— Fuldensis, *Eigil, Vita Metrica*, in J. P. Migne, *Patrologia Latina*, CV.

Caris, G., http://gerardcaris.com/statements.

Caris, Gerard, Pentagonisme/Pentagonism, texts by R. Fuchs, E. van Uitert, J. van de Craats and R. Salomon, Amsterdam 2001.

Castiglione, B., *The Book of the Courtier*, trans. G. Bull, Harmondsworth 1976.

Cellini, B., *La vita*, Rome 1965.

Chadaga, J., 'Chaos, Cosmos, and Cartography: On the Origins of Suprematism', conference paper delivered at *Art, Technology, and Modernity in Russia and Eastern Europe*, Columbia University, New York, March–April 2000.

Changeux, J.-P., 'Art and Neuroscience', *Leonardo* 27: 3 (1994), 189–201.

Chauvet, J.-M., E. B. Deschamps and C. Hillaire, *The Dawn of Art: The Chauvet Cave*, New York 1996.

Chazelle, L., *The Crucified God in the Carolingian Era*, Cambridge 2001.

Chesterton, G. K., *St Francis of Assisi*, London 1923, 98–112.

Cichy, R. M., J. Heinzle and J.-D. Haynes, 'Imagery and Perception share Cortical Representations of Content and Location', *Cerebral Cortex* 22 (Feb. 2012), 372–80.

Clarke, A., K. I. Taylor, B. Devereux, B. Randall and L. K. Tyler, 'From Perception to Conception: How Meaningful Objects are Processed over Time', *Cerebral Cortex* 23 (Jan. 2013), 187–97.

Clayton, M., *Canaletto in Venice*, London 2005.

Clemenceau, G., *Claude Monet: Les Nymphéas*, Paris 1928.

Clottes, J., *Return to Chauvet: Excavating the Birthplace of Art. The First Full Report*, London 2003.

Cohen, J.-L., *Le Planète comme chantier*, Paris 2005.

Collins, D. M., and J. Onians, 'The Origins of Art', *Art History* 1 (1978), 1–25.

Condivi, A., *The Life of Michelangelo*, trans. A. S. Wohl, ed. H. Wohl, Oxford 1976.

Corbusier, Le (C.-E. Jeanneret), *Aircraft*, London 1935.

—, *Mise au point*, Paris 1965.

—, *Vers une architecture*, Paris 1923, translated as *Towards a New Architecture* by F. Etchells, New York undated.

—, 'Vers l'Orient', *La Feuille d'avis de la Chaux-de-Fonds*, 1911.

Darwin, C., *The Expression of the Emotions in Man and Animals*, London 1872.

Davis-Weyer, C., *Early Medieval Art: Sources and Documents*, Englewood Cliffs, N.J., 1971.

Dehaene, S., *Reading in the Brain*, London 2009.

—, 'Inside the Letterbox: How Literacy transforms the Human Brain', *Cerebrum* 7 (3 June 2013), 1–23, www.dana.org/news/cerebrum/detail.aspx?id=43644.

Deleuze, G., *Negotiations*, trans. Martin Joughin, New York 1995.

Descartes, R., *Oeuvres de Descartes*, 13 vols, Paris 1967, vol. XI [*The Passions of the Soul*].

Dewhurst, K., *Thomas Willis's Oxford Lectures*, Oxford 1980.

Dixon Hunt, J., *The Picturesque Garden in Europe*, London 2002.

Dolce, L., *L'Aretino: Dialogo della pittura*, Florence 1910.

Doran, M., ed., *Conversations with Cézanne*, Berkeley, Cal., 2001.

Draper, P., 'Islam and the West: The Early Use of the Pointed Arch Revisited', *Architectural History* 48 (2005), 1–20.

—, *The Formation of English Gothic: Architecture and Identity*, New Haven and London 2006.

Eigil, *The Life of St Sturm*, trans. www.fordham.edu/halsall/basis/sturm.asp.

Elbert, T., C. Pantev, C. Wienbruch, B. Rockstroh and E. Taub, 'Increased Cortical Representation of the Fingers of the Left Hand in String Players', *Science* 270: 5234 (1995), 305–7.

European Magazine and London Review for September 1785.

Eusebius, *Ecclesiastical History*, X.

—, *Vita Constantini*, Nicene and Post-Nicene Fathers Second Series, vol. I, Buffalo, N.Y., 1890.

Feldman, J., and S. Narayanan, 'Embodied Meaning in a Neural Theory of Language', *Brain and Language* 89: 2 (2004), 385–92.

Fernie, E., 'Stonehenge as Architecture', *Art History* 17 (1994), 147–59.

Flint, V. I. J., *The Rise of Magic in Early Medieval Europe*, Princeton 1991.

Frazer, J. G., *The Golden Bough: The Magic Art and the Evolution of Kings*, 12 vols, London 1922.

Freedberg, D., and V. Gallese, 'Motion, Emotion and Empathy', *Trends in Cognitive Sciences* 11 (2007), 197–203.

Freeman, A., ed., *Opus Caroli Regis contra Synodum (Libri Carolini)*, Hannover 1998.

Fried, M., *Courbet's Realism*, Chicago 2001.

Froissart, *The Chronicle of Froissart*, trans. Lord Berners, six vols., London 1901, vol. 1, 298.

Joachim Gasquet's Cézanne: A Memoir with Conversations, trans. C. Pemberton, pref. J. Rewald, intro. R. Shiff, London 1991.

Gelasius Cyzicenus, *Historia concilii nicaeni*, in J. P. Migne, *Patrologia Graeca*, LXXXV.

Gladkih, M. I., N. L. Kornietz and O. Soffer, 'Mammoth Bone Dwellings on the Russian Plain', *Scientific American* 251 (1984), 136–43.

Goetz, T. H., *Taine and the Fine Arts*, Madrid 1973.

Gombrich, E. H., *Art and Illusion*, London 1960.

—, 'The Mask and the Face', in E. H. Gombrich, *The Image and the Eye*, Oxford 1982, 105–36.

—, *The Sense of Order: A Study in the Psychology of Decorative Art*, 2nd ed. Oxford 1984.

—, review of J.-M Chauvet, E. B. Deschamps and C. Hillaire, *The Dawn of Art: The Chauvet Cave*, New York 1996, and J. Clottes and J. Courtain, *The Cave beneath the Sea: Palaeolithic Images at Cosquer*, *New York Review of Books* 14 Nov. 1996, 8–12.

Gordon, R., 'Imagining Greek and Roman Magic', in V. Flint, R. Gordon, G. Luck and D. Ogden, eds, *Witchcraft and Magic in Europe: Ancient Greece and Rome*, London 1999.

Gouve, G., 'Nouvelles recherches sur l'identité culturelle et stylistique de la grotte Chauvet et sur sa datation par la méthode du 14C [New investigations into the cultural and stylistic identity of the Chauvet cave and its radiocarbon dating]', *L'Anthropologie* 118 (2014), 115–51.

Grant, L., *Abbot Suger of St Denis: Church and State in Early Twelfth-Century France*, London 1998.

Gregory, R. L., ed., *The Oxford Companion to the Mind*, Oxford 1989.

Hammerbacher, H. W., *Irminsul und Lebensbaum*, Offenbach-am-Main 1973.

Hare, C., *Courts and Camps of the Italian Renaissance*, London 1908.

Harrison, R. M., *A Temple for Byzantium: The Discovery and Excavation of Anicia Juliana's Palace Church of Istanbul*, London 1989.

Haskins, C. H., *The Renaissance of the Twelfth Century*, Cleveland 1957, 303–40.

Heslop, T. A., 'Art, Nature and St Hugh's Choir at Lincoln', in J. Mitchell and M. Moran, eds, *England and the Continent in the Middle Ages: Studies in Memory of Andrew Martindale*, Stamford 2000, 60–74.

Hills, P., *Venetian Colour: Marble, Mosaic, Painting and Glass, 1250–1550*, New Haven and London 1999.

Holt, E. G., ed., *A Documentary History of Art*, 3 vols, vol. I: *The Middle Ages and the Renaissance*, New York 1947.

Honorius of Autun, *Speculum Ecclesiae*, in J. P. Migne, *Patrologia Latina*, CLXXII.

Howard, D., *Venice and the East: The Impact of the Islamic World on Venetian Architecture, 1100–1500*, New Haven and London 2000.

Huang, M., H. Bridge, M. J. Kemp and A. J. Parker, 'Human Cortical Activity evoked by the Assignment of Authenticity when viewing Works of Art', *Frontiers in Human Neuroscience* (28 Nov. 2011), http://http://journal.frontiersin.org/article/10.3389/fnhum.2011.00134/full.

Hubel, D. H., and T. N. Wiesel, 'The Receptive Fields of Neurones in the Cat's Striate Cortex', *Journal of Physiology* 148 (1959), 574–91.

— and —, 'Receptive Fields, Binocular Interaction and Functional Architecture in the Cat's Visual Cortex', *Journal of Physiology* 160 (1962), 106–54.

Hugh of St Victor, *De sacramentis*, in J. P. Migne, *Patrologia Latina*, CLXXVI.

Humphrey, N., 'Cave Art, Autism, and the Evolution of the Human Mind', *Cambridge Archaeological Journal* 8: 2 (1998), 165–91.

Huxley, J. S., 'Origins of Human Graphic Art', *Nature* 3788 (June 1942), 637.

Immordino Yang, M. H., A. McColl, H. Damasio and A. Damasio, 'Neural Correlates of Admiration and Compassion', PNAS 106, 19, 12 May, 2009, 8021.

Impey, O., and A. MacGregor, *The Origins of Museums: The Cabinet of Curiosities in Sixteenth and Seventeenth Century Europe*, Oxford 1985.

Ishizu, T., and S. Zeki, 'Toward a Brain-Based Theory of Beauty', *PloS ONE* 6: 7 (July 2011), http://journals.plos.org/plosone/article?id=10.1371/journal.pone.0021852.

Jackson, P. L., A. N. Meltzoff and J. Decety, 'How do we perceive the Pain of Others? A Window into the Neural Processes involved in Empathy', *Neuroimage* 24 (2005), 771–9.

Kemp, M., and M. Walker, trans. and ed., *Leonardo on Painting*, New Haven and London 1989.

Klein, C., J. Betz, M. Hirschbuehl, C. Fuchs, B. Schmiedtová, M. Engelbrecht, J. S. Mueller-Paul and R. Rosenberg, 'Describing Art: An Interdisciplinary Approach to the Effects of Speaking on Gaze Movements during the Beholding of Paintings', *PLoS ONE* 9: 12, 2014, http://journals.plos.org/plosone/article?id=10.1371/journal.pone.0102439.

Knight, R. Payne, *An Analytical Inquiry into the Principles of Taste*, London 1805.

—, *The Landscape: A Didactic Poem in Three Books addressed to Uvedale Price Esq.*, London 1794.

Kosslyn, S. M., and W. I. Thompson, 'When is Early Visual Cortex activated during Visual Mental Imagery?', *Psychological Bulletin* 129 (2003), 723–46.

Krautheimer, R., 'Introduction to an "Iconography of Mediaeval Architecture"', *Journal of the Warburg and Courtauld Institutes* 5 (1942), 1–33.

Kühnel, G., 'Aachen, Byzanz und die frühislamische Architektur im Heiligen Land', in W. Dessen, G. Minkenberg and A. C. Oellers, eds, *Ex Oriente: Izaak und die weisse Elefant. Bagdad–Jerusalem–Aachen*, 3 vols, Aachen 2003, vol. III.

Lakoff, G., 'The Neural Theory of Metaphor' *Social Science Research Network* (2 Jan. 2009), http://ssrn.com/abstract=1437794 or http://dx.doi.org/10.2139/ssrn.1437794, rev. ed. of article in R. Gibbs, ed., *The Metaphor Handbook*, Cambridge 2008.

—, and M. Johnson, *Metaphors We Live By*, Chicago 1980.

Lamb, H. H., *Climate, History and the Modern World*, 2nd ed, London and New York 1995.

Lecoq, A.-M., *François Ier imaginaire: Symbolique et politique à l'aube de la Renaissance française*, Paris 1987.

Lega, B. C., 'An Essay concerning Human Understanding: How the *Cerebri Anatome* of Thomas Willis influenced John Locke', *Neurosurgery* 58: 3 (2005), 567–76.

Leonardo da Vinci, *The Literary Works of Leonardo da Vinci*, ed. and trans. J. P. Richter, 2 vols (London 1883; Oxford 1939), London and New York 1970; ed. C. Pedretti, London 1977.

Leonardo on Painting: Anthology of Writings by Leonardo da Vinci, trans. and ed. M. Kemp and M. Walker, New Haven and London 1989.

Levey, M., 'Canaletto as Artist of the Urban Scene', in K. Baetjer and J. G. Links, eds, *Canaletto*, New York 1989, 17–30.

Lewis, P. S., *Later Medieval France: The Polity*, London 1968.

Lewis-Williams, D., *The Mind in the Cave: Consciousness and the Origins of Art*, London 2002.

Links, J. G., *Canaletto*, London 1982.

Locke, J., *An Essay concerning Human Understanding* (1690), in *The Philosophical Works of John Locke*, London 1841.

Lombard-Jourdan, A., *Fleur de lis et oriflamme: Signes célestes du royaume de France*, Paris 1991.

Lorblanchet, M., *La Naissance de l'art: genèse de l'art préhistorique*, Paris 1999.

Louis XIV, *Mémoires de Louis XIV*, ed. J. Lognon, Paris 1927.

Luquet, G.-H., *The Art and Religion of Fossil Man*, Oxford 1930.

McCrary, W. P., *Glassmaking in Renaissance Venice: The Fragile Craft*, Aldershot 1999.

Malevich, K. S., *Essays on Art 1915–1933*, trs. X. Glowacki-Prus and A. McMillin, ed. T. Andersen, Copenhagen 1971.

—, *Unpublished Writings 1922–1925*, vol. III: *The World as Non-Objectivity*, trans. X. Glowacki-Prus and E. T. Little, ed. T. Andersen, Copenhagen 1976.

Mango, C., ed., *Art of the Byzantine Empire 312–1453*, Englewood Cliffs, N.J., 1972.

Martin, H., and M. Russon, *Vivre sous la tente au Moyen Age*, Rennes 2010.

Matthew, L. C., '"Vendecolori a Venezia": The Reconstruction of a Profession', *Burlington Magazine* 144 (2002), 680–86.

Maurer, G., *Michelangelo: Die Architekturzeichnungen*, Regensburg 2004.

Maxwell, Herbert, trans. and ed., *The Chronicle of Lanercost*, Glasgow 1913.

Meer, F. van der, and C. Mohrmann, *Atlas of the Early Christian World*, Edinburgh 1959.

Michelangelo and Tommaso Campanella, *The Sonnets of Michelangelo Buonarroti and Tommaso Campanella*, trans. J. A. Symonds, London 1878.

Miller, M., *The Thalassocracies*, Albany, N.Y., 1971.

Mitchell, W. J. T., 'Showing Seeing: A Critique of Visual Culture', in *Art History, Aesthetics and Visual Studies*, ed. M. A. Holly and K. Moxey, New Haven and London 2002, 231–50.

Mola, L., *The Silk Industry of Renaissance Venice*, Baltimore 2000.

Molina-Luna, K., A. Pekanovic, S. Röhrich, B. Hertler, M. Schubring-Giese, M.-S. Rioult-Pedotti and A. R. Luft, 'Dopamine in Motor Cortex is Necessary for Skill Learning and Synaptic Plasticity', *PLoS ONE* 4: 9 (17 Sept. 2009), www.plsone.org/article/info:doi/10.1371/journal.pone.0007082.

Morganstern, A. M., 'The La Grange Tomb and Choir: A Monument of the Great Schism of the West', *Speculum* 48: 1 (1973), 52–69.

Morris, R. K., 'Alcuin, York, and the *alma sophia*', in L. A. S. Butler and R. K. Morris, eds, *The Anglo Saxon Church: Papers on History, Architecture and Archaeology in Honour of Dr H. M. Taylor*, London 1986, 80–89.

Mukamel, R., A. D. Ekstrom, J. Kaplan, M. Jacoboni and I. Fried, 'Single-Neuron Responses in Humans during Execution and Observation of Actions', *Current Biology* 20 (27 April 2010), 1–7.

Munby, J., R. Barber and R. Brown, *Edward III's Round Table at Windsor: The House of the Round Table and the Windsor Festival of 1344*, Woodbridge 2007.

Murdoch, W., 'An account of the Application of Gas from Coal to Economical Purposes', *Phil. Trans. R. Soc. Lond.* 98 (1 Jan. 1808), 124–32.

Neagley, L., 'The Flamboyant Architecture of S. Maclou, Rouen, and the Development of a Style', *Journal of the Society of Architectural Historians* 47 (1988), 374–96.

Ogden, D., 'Binding Spells: Curse Tablets and Voodoo Dolls', in V. Flint, R. Gordon, G. Luck and D. Ogden, eds, *Witchcraft and Magic in Europe: Ancient Greece and Rome*, London 1999, 3–90.

Onians, J., 'Style and Decorum in Sixteenth-Century Italian Architecture', PhD, London University 1968.

—, 'Abstraction and Imagination in Late Antiquity', *Art History* 3: 1 (1980), 1–24.

—, 'Brunelleschi: Humanist or Nationalist?', *Art History* 5 (1982), 259–72.

—, 'On how to listen to Renaissance Art', *Art History* 7, 4 (1984), 411–37.

—, *Bearers of Meaning: The Classical Orders in Antiquity, the Middle Ages, and the Renaissance*, Princeton and Cambridge 1990.

—, 'Leon Battista Alberti: The Problem of Personal and Urban Identity', in C. Mozzarelli, R. Oresko and L. Ventura, eds, *La Corte di Mantova nell'età di Andrea Mantegna: 1450–1550*, Eng. ed. *The Court of the Gonzaga in the Age of Mantegna: 1450–1550*, Rome 1998, 207–15.

—, *Classical Art and the Cultures of Greece and Rome*, New Haven and London 1999.

—, 'The Greek Temple and the Greek Brain', in G. Dodds and R. Tavernor, eds, *Body and Building: Essays on the Changing Relation of Body and Arhitecture*, Cambridge, Mass., 2002, 44–63.

—, *The Atlas of World Art*, London 2004.

—, *Neuroarthistory: From Aristotle and Pliny to Baxandall and Zeki*, New Haven and London 2007.

Origen, *On Principles*. ed. G. W. Butterworth, Gloucester, Mass., 1973.

Osbert, R. H., ed., *The Poems of Laurence Minot*, Kalamazoo 1996.

Panofsky, E., *Abbot Suger on the Abbey Church of St Denis and its Art Treasures*, Princeton 1979.

Pedretti, C., *Il Tempio dell'anima: L'Anatomia di Leonardo da Vinci fra Mondino e Berengario*, Poggio a Cajano 2007.

Pettitt, P., and P. Bahn, 'An Alternative Chronology for the Art of Chauvet Cave', *Antiquity* 89 (2015), 542–53.

Pidoplichko, I. G., *Upper Palaeolithic Dwellings of Mammoth Bones in the Ukraine: Kiev-Kirillovskii, Gontsy, Dobranchevka, Mezin and Mezhirich*, trans. and ed. P. Allsworth-Jones, Oxford 1998.

Plassmann, H., J. O'Doherty, B. Shiv and A. Rangel, 'Marketing Actions can modulate Neural Representations of Experienced Pleasantness,' *Proceedings of the National Academy of Sciences* 105: 3 (14 Jan. 2008), 1050–54, http://www.pnas.org/content/105/3/1050.full.

Pope-Hennessy, J., *Italian High Renaissance and Baroque Sculpture*, 3 vols, London 1963.

Prestwich, M. C., *The Three Edwards: War and State in England, 1272–1377*, London 1980, 209–11.

Pritchard, J. B., ed., *Ancient Near Eastern Texts relating to the Old Testament*, Princeton 1969.

Qiu, J., D. Wei, H. Li, C. Yu, T. Wang and Q. Zhang, 'The Vase-Face Illusion seen by the Brain: An Event-Related Brain Potentials Study', *International Journal of Psychophysiology* 74: 1 (Oct. 2009), 69–73, http://www.sciencedirect.com/science/article/pii/S0167876009001858.

Raaijmakers, J. E., *Sacred Time, Sacred Space: History and Identity in the Monastery of Fulda (744–856)*, Amsterdam 2003.

Rabanus Maurus, *De Laudibus Sanctae Crucis*, in J. P. Migne, *Patrologia Latina*, CVII.

—, *De Universo*, in J. P. Migne, *Patrologia Latina*, CXI.

Ramachandran, V., and W. Hirstein, 'The Science of Art: A Neurological Theory of Aesthetic Experience', *Journal of Consciousness Studies* 6: 6 (1999), 15–51.

—, 'Mirror Neurons and Imitation Learning as the Driving Force behind "the Great Leap Forward" in Human Evolution', Edge Foundation https://edge.org/conversation/mirror-neurons-and-imitation-learning-as-the-driving-force-behind-the-great-leap-forward-in-human-evolution (1 June 2000), 4.

Reilly, B. F., *The Kingdom of Leon-Castilla under King Alfonso VI 1065–1109*, Princeton 1988, 210–13.

Richardson, J., 'A Discourse on the Dignity, Certainty, Pleasure and Advantage of the Science of the Connoisseur', London 1719, repr. in *Two Discourses*, Menston, Yorks, 1972.

Richardson, J., Sr and Jr, *An Account of Some of the Statues, Bas-Reliefs, Drawings, and Pictures in Italy*, London 1722.

Rolls, E. T., 'Invariant Object and Face Recognition', in L. Chalupa and J. S. Werner, eds, *The Visual Neurosciences*, 2 vols, Cambridge, Mass., and London 2004, vol. II, 1165–78.

Rubin, J. H., *Manet's Silence and the Poetics of Bouquets*, Cambridge, Mass., 1994.

Ruskin, J., *Modern Painters: Vols I–V plus Index*, Orpington 1888.

Sadier, B., J.-J. Delannoy, L. Benedetti, D. L. Bourlès, S. Jaillet, J.-M. Geneste, A.-E. Lebatard and M. Arnold, 'Further Constraints on the Chauvet Cave Artwork Elaboration', *Proceedings of the National Academy of Sciences of the United States of America* 109: 21 (2012), 8002–6.

Saslow, J. M., trans. and ed., *The Poetry of Michelangelo*, New Haven and London 1991.

Schilbach, L., S. B. Eickhoff, A. Rotarska-Jagiela, G. R. Fink and K. Vogeley, 'Minds at Rest? Social Cognition as the Default Mode of Cognizing and its Putative Relationship to the "Default System" of the Brain', *Consciousness and Cognition* 17 (2008), 457–67.

Schjødt, U., H. Stødkilde-Jørgensen, A. W. Geertz and A. Roepstorff, 'Rewarding Prayers', *Neuroscience Letters* 443 (2008), 165–8.

—, 'Highly Religious Participants recruit Areas of Social Cognition in Personal Prayer', *Social Cognitive and Affective Neuroscience* 4: 2 (June 2009), 199–207.

Schlosser, J. von, *Schriftquellen zur Geschichte der Karolingischen Kunst*, Vienna 1892, repr. Hildesheim and New York 1974.

Schulte-Rüther, M., H. J. Markowitsch, G. R. Fink and M. Piefke, 'Mirror Neuron and Theory of Mind Mechanisms involved in Face-to-Face Interactions: A Functional Magnetic Resonance Imaging Approach to Empathy', *Journal of Cognitive Neuroscience* 19: 8 (2007), 1354–72.

Seitz, F., *Die Irminsul im Felsenrelief der Externsteine*, Pähl 1962.

Selfe, L., *Nadia: A Case of Extraordinary Drawing Ability in an Autistic Child*, London, New York and San Francisco 1977.

Shiff, R., *Cézanne and the End of Impressionism: A Study of the Theory, Technique, and Critical Evaluation of Modern Art*, Chicago 1984.

Singer, T., B. Seymour, J. O'Doherty, H. Kaube, R. J. Dolan and C. D. Smith, 'Empathy for Pain involves the Affective but not Sensory Components of Pain', *Science* 303: 5661 (20 Feb. 2004), 1157–62, http://science.sciencemag.org/content/303/5661/1157.

Soffer, O., *The Upper Palaeolithic of the Central Russian Plain*, Orlando, Fl., 1985.

—, J. M. Adovasio, N. L. Kornietz, A. A. Velichko, Y. N. Gribchenko, B. R. Lenz and V. Yu, 'Cultural Stratigraphy at Mezhirich, an Upper Palaeolithic site in Ukraine with Multiple Occupations', *Antiquity* 71 (March 1997), 48–62.

Solso, R. L., 'Brain Activities in a Skilled versus a Novice Artist: An fMRI Study', *Leonardo* 34: 1 (2001), 31–4.

Souchek, P., 'The Temple of Solomon in Islamic Legend and Art', in J. Gutmann, ed., *The Temple of Solomon: Archaeological Fact and Medieval Tradition in Christian, Islamic and Jewish Art*, Missoula, Mont., 1976, 73–124.

Spence, J., *Observations, Anecdotes and Characters of Books and Men*, ed. J. M. Osborn, Oxford 1966.

Spiridon, N., and N. Kanwisher, 'How distributed is Visual Category Information in Human Occipito-Temporal Cortex? An fMRI Study', *Neuron* 35 (2002), 1157–65.

Srejović, D., *Europe's First Monumental Sculpture: New Discoveries at Lepenski Vir*, London 1972.

Stafford, B., *Echo Objects: The Cognitive Work of Images*, Chicago 2007.

Stokes, W., *Studies in Physiology and Medicine by Doctor Graves*, London 1863.

Taine, H., *De l'intelligence*, 2 vols, Paris 1870.

—, *Philosophie de l'art*, Paris 1938.

Tanaka, K., 'Inferotemporal Response Properties', in L. Chalupa and J. Werner, eds, *The Visual Neurosciences*, 2 vols, Cambridge, Mass., and London 2004, vol. II, 1151–64.

Taylor, C. K., and G. S. Saayman, 'Imitative Behaviour by Indian Ocean Bottle Nose Dolphins (Tursiops Aduncus) in Captivity', *Behaviour* 44 (1973), 286–98.

Thorndike, L. A., *A History of Magic and Experimental Science*, 9 vols, New York 1923–58, vol. II (1947).

Toynbee, A. J., *A Study of History: Abridgement of Vols VII–X*, Oxford 1957, 259.

Trei, L., 'Price changes the Way People experience Wine, Study finds', *Stanford Report* (16 Jan. 2008), n.p.

Tschan, F., *St Bernward of Hildesheim*, 3 vols, South Bend, Ind., 1942–52, vol. III (1951): *His Works of Art*.

Tucker, P., *Claude Monet: Life and Art*, New Haven and London 1995.

Tylor, E., *Primitive Culture: Researches into the Development of Mythology, Philosophy, Religion, Language, Art and Custom*, London 1871.

Uddin, L. Q., M. Jacoboni, C. Lange and J. P. Keenan, 'The self and social cognition: the role of cortical midline structures and mirror neurons', *Trends in Cognitive Sciences* 11, 4 (2007).

Uitert, E. van, 'Passion and Precision: The Art of Gerard Caris', in *Gerard Caris Pentagonisme/Pentagonism*, texts by R. Fuchs, E. van Uitert, J. van de Craats and R. Salomon, Amsterdam 2001, 27–44.

Vasari, G., *Le Vite de'piu eccellenti pittori, scultori e architetti*, first ed., VII, Milan 1927.

Vieri, F. de', *Discorsi delle Maravigliose Opere di Pratolino e d'Amore*, Florence 1587.

Vollard, A., *Paul Cézanne*, Paris 1914.

Waschek, M., ed., *Relire Taine*, cycle de conférences, Paris 2001.

Wavrin, J. de, *Recueil de croniques et anciennes istoires de la Grande Bretagne*, Cambridge 2012.

White, J., *The Birth and Rebirth of Pictorial Space*, London 1957.

Willis, T., *The Anatomy of the Brain and Nerves*, ed. W. Feindel, 2 vols, Montreal 1965.

—, *De Anima Brutorum Quae Hominis Vitalis et Sensitiva est: Exercitationes Duo*, Oxford 1672.

Woolett, K., and E. Maguire, 'Acquiring "the Knowledge" of London's Layout Drives Structural Brain Changes', *Current Biology* 21 (2011), 2109–14.

Wuetherick, B., 'A Re-evaluation of the Impact of the Hundred Years War on the Rural Economy and Society of England', *Past Imperfect* 8 (1999–2000), 125–59.

Xu, T., Y. Yu, A. J. Perlik, W. F. Tobin, J. A. Zweig, K. Tennant, T. Jones and Y. Zuo, 'Rapid Formation and Selective Stabilization of Synapses for enduring Motor Memories', *Nature* 462 (Dec. 2009), 915–19.

Zeki, S., 'The Art of Gerard Caris and the Brain's Search for Knowledge', in G. Jansen and P. Weibel, eds, *Pentagonismus/Pentagonism*, Karlsruhe 2007, 74–83.

Zola, E., *Mes Haines: causeries littéraires et artistiques*, Paris 1879.

photograph credits

index